THE KNOPF
TRAVELER'S GUIDES TO ART

BRITAIN
& IRELAND

Michael Jacobs & Paul Stirton

ALFRED A. KNOPF
NEW YORK 1984

To
Brendan &
Jean

Authors' acknowledgments
The authors wish to thank all the museum curators and librarians, too
numerous to mention individually, who were so helpful in providing
facilities and information for their research. They would particularly like to
thank the following: Jim Birrell, Peter and Nedira Bunyard, Fintan Cullen,
Ian Rae, Gillian Tait, Kaari Thokildsen, Richard and Belinda Thomson,
Dilwyn and Oliver Knox, Malcolm Warner, Adam Yamey and Linda Cole,
series designer.

Editor	James Hughes
Designer	Nigel O'Gorman
Picture Research	Vanessa Whinney
Assistant Editor	Elizabeth Pichon
Editorial Assistant	Barbara Gish
Production	Jean Rigby

Artists' Biographies & Glossary	Ian Reed

Maps and floor plans in two-color by
Eugene Fleury, Colin Salmon, Technical Art Services

THIS IS A BORZOI BOOK
PUBLISHED BY ALFRED A. KNOPF, INC.

Library of Congress Cataloging in Publication Data
Jacobs, Michael, 1952–
 The Knopf traveler's guides to art—Great Britain and Ireland.
 Includes index.
 1. Art, British—Guide-books. 2. Art—Great Britain—Guide-books.
 3. Art, Irish—Guide-books. 4. Art—Ireland—Guide-books.
 I. Stirton, Paul. II. Title.
N6761.J29 1984 914.1′04858 84–7160

ISBN 0-394-72426-7 (pbk.)

Filmsetting by Vantage Photosetting Co. Ltd., Eastleigh, England
Origination by Gilchrist Bros. Ltd., Leeds, England

Printed and bound by New Inter Litho, Milan, Italy
First American Edition

CONTENTS

FOREWORD

Our intention in researching the *Guide* has been not only to visit the maximum number of museums, galleries and country houses with art treasures, but also to bring to light little-known works that deserve recognition, as well as unjustifiably neglected artists. In addition, we have explored the relation between artists and places, and in our discussion of works of art have often given emphasis to artists whose work has a strong regional connection. We have not sought to compile an exhaustive list of works of art, but to make a mature selection concentrating on fine art, with a lesser emphasis on the decorative arts or archaeological items. In consulting innumerable catalogues and publications we have tried wherever possible to verify attributions and to look at traditional masterpieces with a fresh eye.

Few guidebooks are without error, and no guidebook can ever be completely up to date. Without any warning, opening times and telephone numbers change, collections are reorganized, and museums and galleries close for restoration. Works of art in museums may be taken down to make room for temporary exhibitions, and country houses can and frequently do sell their treasures. While every effort has been made to ensure that all information is accurate at the time of going to press, we will be glad to receive corrections and suggestions for improvements, which can be incorporated in the next edition.

How this book is organized

The *Guide* is sectioned into areas, each with its own introduction and map, and these sections are arranged alphabetically by town and museum (see pp. 8–9 for a map of all the areas). Each area map shows (in black) the towns and villages listed in the section, and all these entries are identified by county, region and map references relating them to the area map at the beginning of the section. It should be stressed, however, that these are not intended as road maps, but merely as a general reference.

Entries for museums, galleries and country houses

Addresses and telephone numbers are given for each entry where available. Opening times are provided for museums, galleries and country houses; but for bank holidays, group tours and winter visits it is always advisable to telephone the number listed. Other practical information is provided in the form of symbols (see below).

Italic type is used for entry details; **bold** type for highlighting sections, rooms, artists or works of art; ***bold italic*** for titles of works of art. Single or double stars denote collections and works of art that are, in our opinion, of particular or outstanding importance. However, in the case of certain major art centers, such as the British Museum, where nearly all the items mentioned would rate at least one star if found in another museum, the system of starring outstanding works is not applied.

Special features

An introductory feature explores the range and variety of Britain's and Ireland's art treasures. Features within each area discuss themes of regional interest such as "Constable's Country", or "Celtic art in Ireland". In the middle of the book, a 16-page illustrated colour section reproduces works of special interest and is accompanied by a short summary tracing the development of British and Irish art. Reference sections include illustrated biographies of British and Irish artists (as well as especially influential foreign artists), and a glossary of schools, styles and terms.

Cross-references

Different typefaces are employed to cross-refer to different parts of the book; thus ROYAL PAVILION refers to another museum within the same town, BEDFORD to another town within the same area, and *WESTERN ENGLAND* to another area.

Abbreviations

As far as possible, only standard abbreviations are used. These include Mon, Tues, etc. for days of the week; Jan, Feb, etc. for months; N, S, E, W for points of the compass; C for century; c. for *circa*; m, km, etc. for measurements, mins, hrs, yrs for times. Less common abbreviations are b. for born, a. for active and d. for died.

Key to symbols

Symbols used in text

🏠 Country house

☆ Important collection, not to be missed

☆☆ Outstanding collection, not to be missed

★ Important work of art

★★ Outstanding work of art

▣ Entry free

▨ Entry fee payable

🚗 Parking

𝑓 Guided tours available

▮ Guided tours compulsory

▥ Catalogues, guidebooks and other publications on sale

▮ Refreshments available

🏛 Building of architectural interest

☑ Well displayed and pleasant to visit

❧ Garden or courtyard open to the public

⁝⁝⁝ Temporary exhibitions worth investigating

🖌 Important single artist's collection

Symbols used on maps

⊕ Major art center

O Minor art center

How entries are organized

STOCKTON-ON-TEES — Red capitals for name of town or country house
Cleveland Map C4 — Red italic type for county and map reference

An industrial town with dilapidated ironworks and shipyards, Stockton is said to have the widest high street in England. The town possesses an elegant parish church, completed in 1712, but there is no truth in the claim that Sir Christopher Wren had any part in the design. Stockton was the birthplace of the furniture maker Thomas Sheraton (1751–1806).

Preston Hall Museum — Bold red type for name of museum or gallery
Yarm Rd
Open Mon–Sat 10am–6pm; Sun 2–6pm — Black italic type for entry details
▣ 🏛 ☑ ❧ — Symbols providing other practical information

This pleasant museum, occupying a 19thC house in a large park, is devoted principally to **Victoriana**, including dolls — Bold type for emphasis
and a charming reconstruction of a street and a period room. Incongruously, you will also find in this museum an outstanding 17thC French painting, ***The Dice Players*** ★★ by **Georges de la Tour**. — Bold italic type to denote titles of works
This is kept in a locked room of its own, into which an attendant will take you. — Stars denoting outstanding work

ART TREASURES *of* BRITAIN *and* IRELAND

An artistic tour of Britain can be very enjoyable even if you have no interest in British art, since the "national heritage" of the country consists only in part of works by British artists. You will find a remarkable number of outstanding foreign works in the collections here for, though British collectors have often been neglectful of native contemporary artists, they have excelled themselves in the past in their appropriation of the "heritage" of other nations. One of the earliest and greatest British collectors was Charles I, whose eclectic tastes led him to acquire works by artists then out of fashion. Later British collectors were more concerned to own works by the most highly regarded artists of their time, sometimes irrespective of their quality, and the preferences of this period were mainly for classically inspired art such as that of Rubens, Poussin, Claude and the leading Italian masters. Many of these collections were formed during the Grand Tour of Italy, an almost obligatory part of a cultivated young man's education.

You will find plenty of Dutch 17thC works in British collections, but it was not until the 19thC that these came to be widely collected. The great age of British collecting began late in the 18thC with the dispersal of the main French private collections after the Revolution, when tastes broadened to include not only Dutch art but also previously neglected areas such as Spanish, early Italian, Northern Renaissance and, towards the end of the 19thC, French Rococo art. The omnivorous nature of British collecting during this period reflects not only a growing belief in the elevating powers of art, but also a growing cultural imperialism, seen perhaps most clearly in the 1801 acquisition of 5thC BC sculpture from the Parthenon in Athens – the so-called Elgin Marbles. The collapse of the British Empire saw a corresponding decline in British patronage of the arts.

PRIVATE COLLECTIONS *and* PUBLIC GALLERIES

The major public art galleries of Britain and Ireland, almost all of which were founded in the 19thC, often have gifts of private collections at their nucleus, and many other privately acquired works have found their way into public galleries as loans: most of the great paintings in the National Gallery of Scotland (Edinburgh) belong to the Duke of Sutherland. But numerous important private collections remain in their original homes. The largest of these is the Queen's, and is dispersed between Windsor Castle, Hampton Court and Kensington Palace. The other private collections are almost all in country houses which, despite occasional shortcomings in terms of awkward opening times, crude commercialism and poor displaying conditions, are almost invariably of great architectural interest, are set in magnificent grounds, and can have a charming, homely character not always found in museums. Moreover, they often provide suitable settings for their art, particularly in the case of family portraits. The Van Dyck portraits at Wilton House would look superb anywhere, but have an undoubtedly greater impact when viewed in Inigo Jones's superb Double Cube Room for which they were originally intended.

The smaller museums of England, by contrast, are generally housed in architecturally undistinguished buildings, and the paintings you wish to see may have been removed to make room for some uninteresting temporary exhibition. On the other hand, you may come across a superlative and unexpected treasure: one of Bonington's finest landscapes is at the Astley

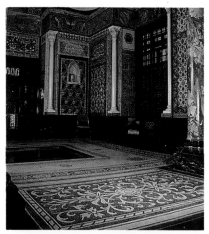

The Arabian Hall, Leighton House Museum, London

The Double Cube Room, Wilton House, Wilton, Wiltshire

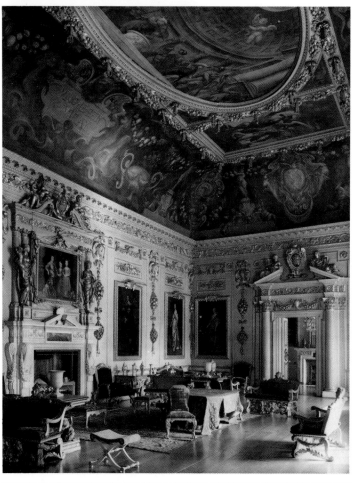

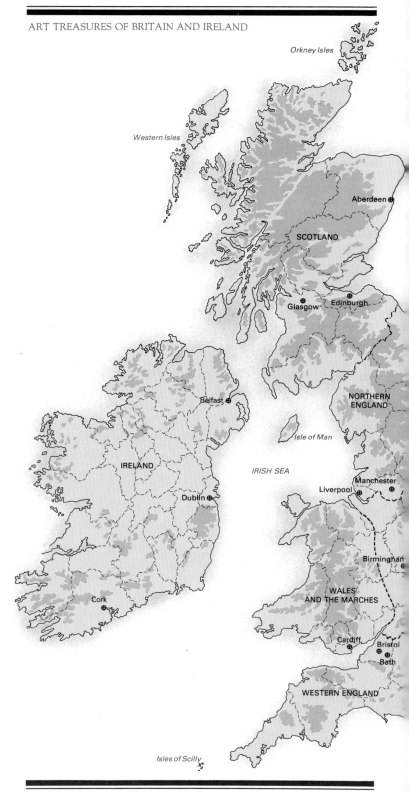

Orkney Isles

Western Isles

Aberdeen ⊕

SCOTLAND

Glasgow ⊕ ⊕ Edinburgh

Belfast ⊕

NORTHERN
ENGLAND

Isle of Man

IRELAND

IRISH SEA

Liverpool ⊕ Manchester ⊕

Dublin ⊕

Birmingham ⊕

WALES
AND THE MARCHES

Cork ⊕

Cardiff ⊕ Bristol ⊕
⊕ Bath

WESTERN ENGLAND

Isles of Scilly

Cheetham Museum in Stalybridge; Northampton County Museum displays a remarkable group of 18thC Italian pictures above a collection of boots and shoes; and Stockton's Preston Hall possesses an early masterpiece by Georges de la Tour in a museum dedicated to Victoriana.

These museums also give you a chance to evaluate the Victorian and Edwardian periods of art – an area that is only now coming back into fashion. The museums acquired works by these artists when they were at the height of their fame and, having banished them to store rooms, are now beginning to bring them out again, thus providing an invaluable and often entertaining insight into the Victorian and Edwardian mentality. In some cases the paintings are displayed in magnificent settings – the Russell-Cotes Museum at Bournemouth, for instance, and the Leighton House Museum in London with its Arabian Hall.

The finest early and medieval monuments, the greatest country houses, and the chosen haunts of artists in the past, are almost all to be found in the most beautiful parts of the country. The best museums, on the other hand, tend to be in the industrial areas of Britain. The *Guide* is divided into convenient touring sections, each consisting of a separate mapped gazetteer of notable places and interesting features. The map opposite shows major art centers only; minor centers and other towns appear on the more detailed area maps that introduce each section.

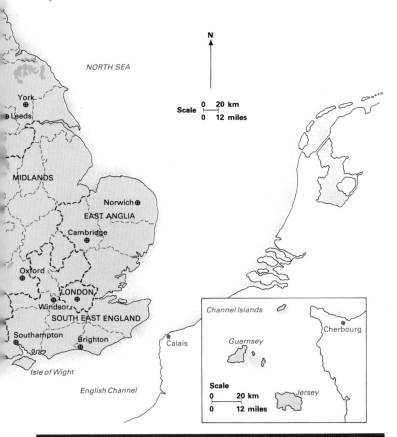

SOUTH EAST
ENGLAND

This section of the *Guide* includes the area often referred to as the "Home Counties", a term that well conveys their pleasant if generally unexciting character. Here you will see stretches of green rolling landscape and many self-consciously pretty villages and small towns much loved by antique dealers. This is England at its cosiest and most traditional. Yet its very Englishness, combined with its proximity to London, has in the past attracted many artists. In the early 19thC Samuel Palmer saw in the Kent village of Shoreham a "valley of vision", and in Victorian and Edwardian times artists established themselves in what are now such favourite retirement places as

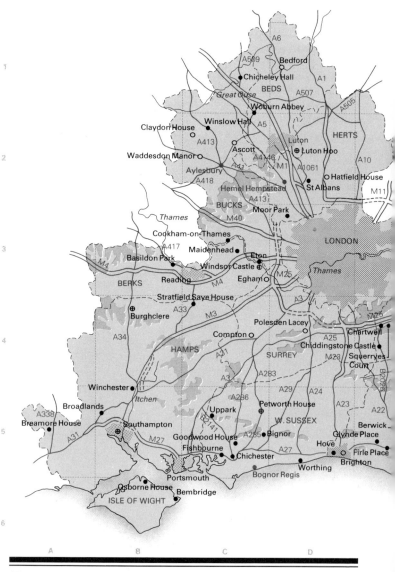

Cranbrook, Rye, Amberley, Ditchling, Rottingdean, Bosham and Whitley. G.F. Watts spent his last 13 years at COMPTON, Surrey. In this century Graham Sutherland, a great admirer of Palmer, based himself at Trotiscliffe, 7 miles S of Shoreham; Stanley Spencer saw no need to seek inspiration farther than his native village of COOKHAM; leading artists of the Bloomsbury group lived at Charleston in Sussex and Tidworth in Kent; and Ivon Hitchens, one of England's best-known landscapists of recent times, rarely strayed from his garden on Lamington Common in Sussex.

STATELY HOMES *and* ROMAN REMAINS

Appropriately, this is the part of England with the highest concentration of stately homes, and it is in these that most of the region's art treasures can be found. LUTON HOO owns a superb collection of medieval and Renaissance art; WADDESDON MANOR is almost unrivalled in its holdings of 18thC decorative art; but perhaps the finest of all is PETWORTH, which is not only fascinating for its paintings but also for its close associations with one of Britain's most celebrated artists, J.M.W. Turner.

The area is also rich in Roman art, with well-preserved mosaics at ST ALBANS, FISHBOURNE and BIGNOR; and there are magnificent cathedrals at CANTERBURY, CHICHESTER and WINCHESTER. But overall the area is deficient in important public art galleries. Two of the most interesting are small galleries devoted to individual painters, the Watts Gallery at COMPTON near Guildford, and the gallery at COOKHAM commemorating Stanley Spencer, whose most outstanding works are in the Sandham Memorial Chapel at BURGHCLERE. The one major civic art gallery is at SOUTHAMPTON, a town which is rarely visited by tourists, yet is worth seeing for this gallery alone.

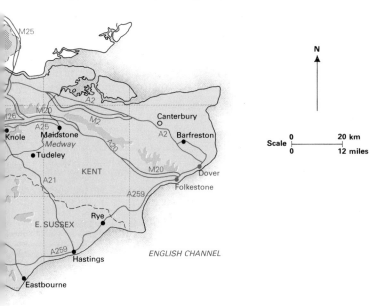

ASCOTT 🏠
Wing, Buckinghamshire Map C2

*Open Apr–Sept Wed Thurs 2pm–6pm,
 Aug–Sept Sat 2pm–6pm*
Closed Mon Tues Fri Sun Apr–Sept
🗙 ➡ ⛟

A late 19thC half-timbered house
incorporating a 17thC farm building,
Ascott has on the outside little to
distinguish it from the many other
pretentious buildings in this style
incorporated within London's so-called
"stockbroker belt". One of the few
National Trust properties accepted for
other than architectural reasons, its
interest lies in its magnificent gardens,
and, above all, in the collections
assembled mainly by Leopold de
Rothschild and his son Anthony.

As with the other principal property
connected with this family, nearby
WADDESDON MANOR, the house contains
much fine **French and English 18thC
furniture**. Alongside these are
outstanding examples of **Ming** and **K'ang
Hsi porcelain ★** (the so-called *san ts'ai*, or
three-colour wares of the late Ming
Dynasty, 17thC, at Ascott are some of
the finest in England). Nor should you
miss the sumptuous **Persian carpets**, as
well as a good collection of **paintings**,
mainly of Italian, English and Dutch
schools.

The Italian school holdings include a
***Madonna and Child with the Infant St
John*** by Andrea del Sarto and a vivid oil
study of the ***Ascension of the Virgin*** by
G. B. Tiepolo. The English school has
striking portraits by **Gainsborough**,
Reynolds, **Romney** and **Hogarth**, a
frieze-like composition by Stubbs of ***Five
Mares ★***, and a brilliantly coloured late
work by Turner of ***Cicero at his Villa
Tusculum ★***. The Dutch school pictures
are particularly renowned and
representative, with fine examples of the
art of **Hobbema**, **Mies**, **Jan Steen**, the
Ostades, **Berchem** and **van der Heyden**.
Most notable of all is a glowing painting
by Cuyp of the ***Harbour of Dordrecht ★***,
another less impressive version of which
is at Kenwood House in *LONDON*.

BARFRESTON CHURCH
Barfreston, Kent Map G4

The Norman Church of St Nicholas in
the village of Barfreston has extremely
elaborate **12thC carvings ★** on its
exterior, the finest of which are on the
tympanum of the south doorway. It is
likely that these were the work of the
same school of artists responsible for the
carvings in the crypt of CANTERBURY
CATHEDRAL; but just why these craftsmen
should have been employed to work on
such an insignificant church as this is not
clear.

BASILDON PARK 🏠
Nr Pangbourne, Berks Map B3

Tel. (07357) 3040
Open Apr–Oct Wed–Sun 2–6pm
Closed Mon Tues Apr–Oct; Nov–Mar
🗙 ➡ 🄿 ⛟

Basildon Park, one of the most recent
additions to the properties owned by the
National Trust, was built in the late
18thC but fell into disrepair after being
vacated in 1910. Since then it has been
restored by Lord and Lady Iliffe who have
saved the **plasterwork** and replaced many
of the fittings such as the scagliola
(imitation marble) fireplaces. They have
also furnished the house with mainly
English 18thC–19thC pieces and hung
the rooms throughout with a collection of
18thC European paintings. Here you can
see paintings by **Batoni**, **Pittoni** and
Pannini. In the Green Drawing Room
there is a large picture of ***Rebecca at the
Well*** by Galeotti, one of the leading
north Italian decorators of the early
18thC.

BEDFORD
Bedfordshire Map D1

Although it has a number of industries,
Bedford retains the character of a
pleasant residential town. Much of its
charm is due to its position on the River
Ouse and its numerous old houses,
particularly of the Georgian and Regency
periods. In the middle of an attractive
garden near the river is the mound of a
once famous castle, which was destroyed
in 1224. Adjoining this is the CECIL
HIGGINS ART GALLERY.

Cecil Higgins Art Gallery
Castle Close
Tel. (0234) 211222
*Open Tues–Fri 12.30–5pm, Sat
 11am–5pm, Sun 2–5pm*
Closed Mon
🗙 ⛟

Cecil Higgins was a prosperous brewer
and art lover, who in the 1940s donated
his house and collection to Bedford,
together with a trust fund for the
purchase of other works of art. When it
opened in 1949 the museum was an
enjoyable, old-fashioned place set in
Higgins's very attractive early 19thC
house. The house, which is filled with

18thC and 19thC furnishings, still has much charm, but the bulk of its collections have been transferred to an ugly modern extension dating from the early 1970s. You now see Higgins's excellent collection of old Bedford **lace**, and British **glassware** and **porcelain** on the second floor of this new building, displayed in a dramatic and sometimes remarkable way – for example, a spotless **18thC porcelain swan** is suspended on glass over a goldfish pond.

The celebrated collection of **British watercolours, prints and drawings ★** – which is the main strength of the museum – is housed on the first floor and suffers even more from the harsh modern environment. To make matters worse, the works are accompanied by somewhat clumsy and over-simplified information panels. Nonetheless the place displays one of the largest collections in the country of **British graphic art**, and a visit here is still a wonderful way of finding out about its development. Nearly all the major British artists from **Gainsborough** up to the present day are represented by good examples of their work, although, of course, you will have the opportunity of seeing only a fraction at any one time.

BEMBRIDGE
Isle of Wight Map B6

The village of Bembridge is a popular seaside resort with one of the most important yachting clubs in the south of England.

The Ruskin Gallery
Bembridge School
(By appointment)
📷 🖝

The leading Victorian writer on art, John Ruskin, was also a painter of extraordinarily detailed architectural and landscape **watercolours** and **drawings**. The great bulk of these are divided between his home at Brantwood in the Lake District and the Ruskin Gallery at Bembridge School on the Isle of Wight. This school (opened in 1919) has no connection with Ruskin other than that its founder, J. Howard Whitehouse, was a great admirer of the man. During World War II the school was evacuated to Coniston (see *NORTHERN ENGLAND*), and Ruskin's house there, Brantwood, was used for art teaching. There are two galleries at the school filled with drawings, paintings and manuscripts by Ruskin and his contemporaries. However, at present there is talk of all these being eventually transferred to the more appropriate setting of Brantwood.

BERWICK CHURCH
Berwick, East Sussex Map E5

The main artists associated with the Bloomsbury group, **Duncan Grant** and **Vanessa Bell**, lived for much of their lives in the Sussex farmhouse of Charleston, the rooms of which they covered with **painted decoration** and furnished with products from the **Omega workshop** (the craft group founded in 1913 by Roger Fry to bridge the gap between the fine and decorative arts). At present negotiations are under way to save Charleston for the nation; but until this happens the main examples of Bloomsbury decoration to be seen in Sussex are in the church of Berwick.

The decorations were executed between 1941 and 1943 by Duncan Grant, Vanessa Bell and two of Vanessa's children, Angelica and Quentin. Comprising scenes of the ***Annunciation***, ***Christ in Glory***, ***The Nativity***, ***The Parable of the Wise and Foolish Virgins*** and ***The Four Seasons***, they feature views of the local landscape and representations of local figures and members of the Bloomsbury group. It is difficult now to share the enthusiasm which these dull and amateurish works inspired when first unveiled. The architect Charles Reilly even went so far as to say that the experience of entering the decorated church was "like stepping out of a foggy England into Italy".

BIGNOR ROMAN VILLA
Bignor, W. Sussex Map C5

Tel. (07987) 259
Open Apr – Sept 10am – 6.30pm;
Oct – Mar 10am – 5.30pm
Closed Mon (except August)
📷 🖝 📖 ☑

The **Roman villa** discovered near the hamlet of Bignor in 1811 is one of the largest in Britain. A tour of the now covered site gives you an idea of what such villas must have been like, but it is particularly interesting for its 4thC **mosaic floors**, including an amusing series of scenes of Cupids dressed as gladiators.

BREAMORE HOUSE 🏠
Nr Fordingbridge, Hampshire Map A5

Tel. (0725) 22270
Open Apr – Sept Sun 2 – 5.30pm
Closed Mon Fri Apr – Sept; Oct – Mar
📷 🖝 📖 🏛
Breamore House, at the edge of the New

Forest, is an Elizabethan manor house which has retained many of its fittings, such as the **carved fireplaces and overmantles**, despite a disastrous fire in 1856. Since then the interior has been refurbished with a range of **17thC and 18thC English furniture**, and there is a good collection of paintings dispersed throughout the house. The bulk of these are **family portraits, 17thC Dutch still-lifes and genre scenes**, but there are also some less usual works. **Hudson's** mid 18thC *Portrait of a Boy with a Bat* in the West Drawing Room is one of the earliest representations of cricket in painting, while a 17thC series of **pictures of Mexicans** is reputed to be by the son of the great Spanish artist **Murillo**.

BRIGHTON
East Sussex Map D5

The largest seaside resort in SE England, Brighton was first popularized in the mid 18thC when a doctor from nearby Lewes, Dr Richard Russell, advised sea-bathing and the drinking of seawater as the cure for most ills. Its growing reputation as a fashionable resort was considerably enhanced with the arrival here in 1783 of the Prince of Wales (later King George IV), the instigator of the town's celebrated **Royal Pavilion**. In addition to the Pavilion, the town has numerous other Regency houses, and its fine piers and Victorian terraces testify to its importance as a seaside holiday center in the 19thC.

The Royal Pavilion ☆☆
The Old Steine
Tel. (0273) 603005
Open Jun–Sept Mon–Sun
* 10am–6.30pm; Oct–May Mon–Sun*
* 10am–5pm*
🔲🕮🎨🏛

The Royal Pavilion was built for the Prince Regent, the future George IV, in the late 1780s. Its exterior was originally in a classical style, but its interior has many rooms in the then fashionable "Chinese" style. Three years after George formally became Prince Regent in 1812, the leading Regency architect **John Nash** was commissioned to do extensive work on the house. He kept much of the "Chinese" interior but embellished the Pavilion's outside in an Indian Mogul style with the extraordinary onion-shaped domes, tent-like pavilion roofs, pinnacles and minarets, which make it one of the most entertaining examples of English architecture.

The interior, which retains most of its original furnishings, has equally

fantastical features, in particular the **Banqueting Room**, which has a **ceiling** resembling a large palm tree and a **chandelier** in the form of a dragon. A fire broke out inside the Pavilion in the late 1970s causing much damage; at present careful restoration work is still being carried out.

Brighton Museum and Art Gallery ☆
Church St
Tel. (0273) 603005
Open Tues–Sat 10am–5.45pm, Sun
* 2–5pm*
Closed Mon
🔲🕮🏛🎨

The buildings housing the town's art gallery, museum and public library form part of the Royal Pavilion Estate, and were originally used as stables, coach houses and a cavalry barracks. The architectural detailing of the exterior is a restrained version of the fantastical ornamentation to be found in the famous building it adjoins. The interior, which was converted for its present use between 1868–73, has an old-fashioned charm and something of the cramped jovial character of a fairground booth.

Its collection of paintings, however, is for the most part disappointing. The **Old Master works** are housed on the first floor. Among the earliest of these is an interesting but not very attractive pair of works attributed to Dürer's teacher, Michael Wohlgemat (*St Jerome and Gregory the Great*), and a fine Crivelli of *St Catherine of Alexandria with St Mary Magdalene*. There are countless dull **Dutch 17thC paintings**, the best of which is a *Marriage Contract* by Rembrandt's pupil Aert de Gelder and a powerful and remarkably original *Raising of Lazarus* by Jan Lievens, Rembrandt's companion of Leyden years, who began his career with the same promise and recognition as his famous friend.

The 18thC is represented by some slight **oil sketches** by north Italian decorators and an excellent *Self-Portrait* ★ by **Vigée-Le Brun**, an early visitor to Brighton. There are many 19thC British works, including a portrait of *King George IV* by Sir Thomas Lawrence, and two amusing canvases by Alma-Tadema, *The Secret* and *The Proposal*.

A small selection of the gallery's 20thC holdings (which feature principally works by British artists, including, **Peploe, Brangwyn, Algernon Newton, Robert Bevan, Duncan Grant** and **Mark Gertler**) are arranged in a ground floor room. Here you can also see what is undoubtedly the gallery's most impressive and enjoyable feature, its

collection of **Art Nouveau, Art Deco,** and **1930s furniture** (an excellent new catalogue of this is on sale in the museum).

Among the many beautiful objects displayed here is an item largely of amusement value: a **sofa** in the shape of lips designed by the Surrealist painter **Salvador Dali**. It is on a long loan to the museum from the millionaire eccentric Edward James, who also used to keep here a large collection of **Surrealist paintings and drawings**, which he is now slowly withdrawing in order to fund his bizarre house and mausoleum now being built in a remote part of Mexico.

BROADLANDS 🏠
Romsey, Hampshire Map B5

Tel. (0794) 516878
Open Apr – Sept Tues – Sun 10am – 6pm;
* Aug – Sept Mon 10am – 6pm*
Closed Oct – Mar
🖼 🛒 💷 🏛 🌱

The present house of Broadlands is largely the result of a collaboration between **Capability Brown**, the great landscape gardener who laid out much of the park, and his son-in-law, the architect **Henry Holland**. Working in the style of Robert Adam, Holland designed the E portico and many of the state rooms which provide such an appropriate setting for the collection of paintings and sculpture. This is particularly true of the restrained **Neoclassical sculpture hall**, which houses the **Greek and Roman marbles**, as well as a few 18thC pieces acquired by the second Lord Palmerston in Rome during the 1760s. Elsewhere in the house, a fine collection of family portraits by **Reynolds, Romney, Raeburn, Lawrence** and **Landseer** is set off by furniture and fittings of the same period. The most important pictures, however, are the four portraits by **Van Dyck** in the dining room.

In the 19thC Broadlands was the home of Viscount Palmerston, the British statesman, but more recently it fell by inheritance to Lord Mountbatten (1900 – 79) whose interests are everywhere in evidence. Many of the European aristocratic **portraits** on the stairway are clear references to his cosmopolitan background, but a more unusual feature is the excellent collection of British and European porcelain, including examples of **Sèvres, Meissen** and **Wedgwood**, which were reputedly arranged in their present distribution by the earl's brother-in-law, King Gustav of Sweden.

BURGHCLERE
Hampshire Map B4

In the tiny village of Burghclere you can see, housed in a dull building of the 1920s, the finest **church decorations ★★** executed in England in this century. The artist was the great individualist, **Stanley Spencer**.

Sandham Memorial Chapel ☆
Tel. (063527) 394
Open Mon – Sun 10.30am – 1pm, 2 – 6pm
🖼 🛒 ☑ 🌱

Spencer had the idea for the chapel decorations while serving in World War I at Salonica (Thessaloníki). After the war he executed some preliminary drawings while staying with his painter friend, Henry Lamb, at Coole. These made a great impression on Mr and Mrs J.L. Behrend, who offered to pay for a chapel to house the decorations with the intention that it should be dedicated to the memory of Mrs Behrend's brother, H.W. Sandham, who was killed during World War I.

Spencer worked on the chapel between 1927 and 1932. His decorations, which are dominated by a tumble of crosses in a scene representing the *Resurrection*, are based on his wartime memories. Unlike so many other paintings that commemorate war, they do not attempt to depict any heroic act; on the contrary, they emphasize the more human and mundane aspects of the soldier's life, such as filling hotwater bottles, sorting and moving kitbags, and dismantling latrines.

CANTERBURY
Kent Map G4

Canterbury is likely to be the first town of major architectural interest that visitors will see when they come to Britain from across the Channel. Though it was severely bombed during World War II, it retains an unusually large number of fine **11thC/13thC churches** as well as its celebrated **cathedral ★★**. This last was founded by St Augustine in 597, though the present structure was constructed between the 11thC and 15thC being completed in 1503.

The Archbishop Thomas à Becket was murdered here in 1170 following a long feud with Henry II. Two years later he was canonized and his miracle-working shrine made Canterbury one of the main pilgrimage points in Europe until 1538, when Henry VIII demolished the wealthy shrine and robbed it of its treasures. The

oldest part of the cathedral is the **crypt** of c.1100, which has magnificently carved **Norman capitals** and traces of **wall paintings** of this date. The main body of the cathedral has fine monuments from the 12thC onwards, including the excellent copper gilt **effigy-tomb of Edward the Black Prince** (who died in 1376). But your most lasting impression of the interior is likely to be of the numerous 13thC to 14thC **stained glass ★** windows.

The Royal Museum and Art Gallery
The Beaney, High St
Tel. (0227) 52747
Open Mon – Sat 10am – 5pm
Closed Sun
[icons]

The Royal Museum and Art Gallery is housed in a large Victorian building, and contains items of historical and archaeological interest, and small collections of **pottery and paintings**. The paintings are mainly by local artists, the most notable of whom, the Victorian animal painter **Thomas Sidney Cooper**, spent the latter part of his life in a large house (now the Junior Kent College) just outside Canterbury. It is difficult for us today to appreciate the enormous success that Cooper enjoyed in his lifetime. The main painting by him in the museum, one of the most ambitious of his career, is a huge canvas of a solitary cow, and it is less interesting for its artistic qualities than for its title, *Separated but not Divorced*.

CHARTWELL ⊞
Westerham, Kent Map E4
Tel. (0732) 866368
Open Apr – mid Oct Tues – Thurs 2 – 6pm,
 Sat Sun 11am – 6pm; July, Aug Wed
 Thurs 11am – 6pm
Closed Mon Fri Apr – mid Oct; late
 Oct – Mar
[icons]

Chartwell attracts many visitors on account of its association with Sir Winston Churchill, who acquired the house in 1922 and kept it until his death in 1965. The house itself, essentially a heavily restored and altered mid-19thC building, is not very interesting architecturally, but it has a number of fine paintings that testify to Churchill's great interest in art. He had many distinguished painter friends who often visited Chartwell, including Sir John Lavery, Sickert, Sir William Orpen and Sir William Nicholson. It was Lavery and Orpen who first encouraged Churchill himself to paint, and he did so for much

of his life, finding it a pleasant break from the strains of political life. The most notable painting in the house is a Thames scene by **Monet**, an artist whom Churchill greatly admired. There are also works by **Lavery** and **Nicholson**, and of course countless canvases by **Churchill**, most of which can be seen in his studio in the garden, where his painting materials are also kept. Churchill was a competent if not very imaginative painter working in an Impressionist style.

CHICHELEY HALL ⊞
Newport Pagnell, Buckinghamshire Map C1
Tel. (023065) 252
Open Apr – Sep Sun 2.30 – 6pm; July, Aug
 Wed 2.30 – 6pm
Closed Mon – Sat Apr – June, Sept; Mon
 Tues Thurs Sat July, Aug; Oct – Mar
[icons]

The redbrick Baroque house at Chicheley near Bedford was built in the early 18thC to replace an earlier house destroyed during the Civil War. This project was undertaken for Sir John Chester, but in 1952 Chicheley was acquired by the Earl of Beatty, son of the World War I commander of the fleet, and many of the contents now have a nautical flavour. There are some mementoes of the admiral's career and his portrait by **Sargent**, as well as a number of **seascapes** by various artists. The furniture and fittings, however, are more closely linked to the earlier history of the house, particularly the panelling, and there is a decorative **ceiling painting** inspired by Ovid in the hall by the English artist **William Kent**.

CHICHESTER
West Sussex Map C5

Chichester, one of the finest towns in Sussex and the scene of an important annual arts festival, has many attractive old houses, particularly of the Georgian period. Its main monument, the **cathedral**, was begun in the late 11thC by Bishop Ralph de Luffa, and though considerably altered in later periods, it remains substantially the building as erected by de Luffa.

In the S aisle are two carved **12thC panels★★** of Purbeck stone, which were found in 1829 built into the E piers of the crossing of the cathedral. Representing respectively *Christ Going to Raise Lazarus*, and *The Miracle Achieved*, these two deeply modelled and emotionally powerful works are two of

the most outstanding examples you will
see of early Romanesque sculpture in
Britain.

Pallant House Gallery
9 North Pallant
Tel. (0243) 774557
Open Tues – Sat, 10am – 5.30pm
Closed Sun Mon
🎨 🏛 ⊡
The Pallant House Gallery occupies an
attractive **Queen Anne house** with
furnishings and other interior
decorations of that period. It is mainly
devoted to temporary exhibitions, and
though it does have a small collection of
modern British art the paintings are of a
generally minor kind.

CHIDDINGSTONE CASTLE 🏰
Nr Edenbridge, Kent Map E4

Tel. (0892) 870347
Open Mar – Oct Tues – Sat 2 – 5.30pm,
Sun 11.30am – 5.30pm
Closed Mon Mar – Oct; Nov – Feb
🎨 🍴 🛍 ⊡
An unusually ugly country house,
Chiddingstone owes its grim appearance
to a Gothic remodelling of c.1810. The
interior resembles an old-fashioned,
poorly arranged museum rather than a
country house, and the building was in
fact purchased in 1956 as a potential
museum. The person behind the whole
enterprise was an eccentric banker,
Denys Bower, who had devoted most of
his life to building up an extraordinarily
diverse collection of objects and wished
to show them to the public. He was
assisted financially in the purchase of the
house, but when first opened the museum
failed to attract many visitors. Now,
however, a regular stream of people come
here, though Chiddingstone's collections
are still not as widely known as they
perhaps should be.

Bower's treasures are often fascinating
and their range alone is worth the visit.
The collections are strongest in **Egyptian
antiquities** (note in particular a rare
bright blue faience **libation cup** of
Princess Mesi-Konsu of the 22nd
dynasty) and in **Chinese and Japanese art**
(including some wonderfully intricate
metal insects ★ executed by Japanese
armourers as a test of their skill). There
are also a few paintings, most notably two
fine Spanish works (*Five Saints ★* by El
Greco's pupil, Luis Tristan, and *The
Immaculate Conception* by Alonso
Cano); and a wonderful nude by Sir Peter
Lely purporting to be of Charles II's
favourite, *Nell Gwyn ★*, and supposedly
commissioned by the king.

CLAYDON HOUSE 🏰
Middle Claydon, Nr Winslow
Buckinghamshire Map C2

Tel. (029673) 349
Open Apr – Oct Mon – Wed Sat Sun
2 – 6pm
Closed Thurs Fri Apr – Oct; Nov – Mar
🎨 🍴 🔎 🛍 ⊡
Claydon House is a 16thC manor house
which was enormously enlarged in the
mid 18thC by the 2nd Earl Verney in an
attempt to rival Stowe Mansion, the
house of his political opponents, the
Greville family. At the same time, the
Earl employed an eccentric craftsman-
contractor, **Luke Lightfoot**, to embellish
the rooms of this externally austere
classical house with the most elaborate,
fantastical and fully formed **Rococo
plasterwork ★★** to be seen in England.

Lightfoot's Rococo creations at
Claydon, in particular those in the
Chinese Room, constitute the main
reason for visiting the house. They are
completely contrary to conventional
British taste and would seem more at
home in a Rococo palace in the south of
Germany. They were criticized by many
of the 2nd Earl's contemporaries, who
preferred the more restrained Palladian
decorations also in the house; and even
today they draw disapproving glances
from many English visitors. The expense
of enlarging and decorating his home was
too much for the 2nd Earl, who was
forced to close down the house before it
was completed, sell its contents and flee
temporarily to France. As an old man he
was once seen by a stable boy wandering
around the shuttered rooms of the empty,
unfinished house, which was later partly
demolished to reduce it to a more
manageable size.

COMPTON
Surrey Map C4

The tiny, pleasant village of Compton
has a fine **Norman church** with a **Saxon
tower and chapel**, the latter containing a
wooden altar rail which is probably the
oldest in England. Half a mile to the N of
the village is the WATTS GALLERY.

Watts Gallery ☆
Tel. (0483) 810235
Open Apr – Sept Mon – Wed, Fri – Sun
2 – 6pm; Oct – Mar Mon Tues Fri Sun
2 – 4pm; Wed Sat 11am – 1pm
Closed Thurs
📷 ⊡ 🚻
The distinguished Victorian painter,
George Frederick Watts, moved to

Compton at the age of 74 and spent most of the last 13 years of his life there. He lived in a specially built house, which he called "Limnerslease" after the old English word for painter *limner*: Watts's friend, Burne-Jones, preferred affectionately to refer to the house as the "Dauber's Den". The Watts Gallery, a few hundred yards from the house, was built under the supervision of the painter's wife as a memorial to her husband.

Though almost within sight of a busy road, the place has a quiet rural charm. Its overgrown grounds, which it shares with the Normandy Bacon Company (where the 19thC Compton Pottery stood), provide a suitable approach to a delightfully dilapidated building. The eccentric and informal character of its dark, crumbling interior is to a certain extent due to its creator, the writer Wilfrid Blunt. He has given a personal quality to the place with such delightful details as sticking on the walls a Jordanian postage stamp of 1974 that reproduces Watts's picture of **Hope**.

This is one of the most enjoyable of Britain's small galleries. Watts was known in his day as "England's Michelangelo", but his work may now seem to be rather heavy-handed in its symbolism and technically crude. The gallery will at any rate give you ample scope to decide for yourself on the abilities of this immensely successful painter, who is synonymous with high-minded and intensely moralistic Victorian art. It contains many of his best-known works, ranging from a very sensitive **self-portrait** as a young man, to the celebrated **Love and Death ★**. In addition, there are minor works by Watts's friends and contemporaries, **Albert Moore**, **Lord Leighton** and **Burne-Jones**.

A visit to the Compton Gallery is completed by a quick look inside the nearby **Watts Memorial Chapel**, which was designed and executed by Mrs Watts between 1895–1906. The rich decoration in the dark interior of this monument is in what might be called a Celtic-Byzantine style, and it is certainly an interesting example of English **Art Nouveau**.

COOKHAM-ON-THAMES
Berkshire Map C3

Cookham-on-Thames, now a self-consciously pretty village over-endowed with antique shops, is famous above all for its associations with England's most individual and perhaps outstanding

painter of this century, **Sir Stanley Spencer**. Spencer, who was born in a semi-detached villa called "Fernlea" in the village high street (where there is a plaque), had a life-long obsession with the village. At the Slade Art School in London he was referred to as "Cookham" by his fellow students and when, as an old man, he paid a visit to China and told his host that there were finer things in "Formosa", he was not referring to the island off the Chinese coast but rather to Sir George Young's riverside estate near his home village.

Anyone familiar with his works will recognize almost every part of the village, which was not only the main inspiration for the straightforward landscapes that he did primarily to make money, but also for most of his numerous fantasy pieces. The main pilgrimage point for those interested in Spencer's work should be the village church, the graveyard of which inspired the celebrated **Resurrection** in the Tate Gallery in *LONDON*. Inside the church is one of the finest of his paintings to be seen in the village, an amusing **Last Supper** (1920) dominated by the feet of the apostles.

Stanley Spencer Gallery
King's Hall
Tel. (06285) 24580
Open Easter–Oct Mon–Sun
* 10.30am–5.30pm; Nov–Easter Sat*
* Sun 11am–5pm*
Closed Mon–Fri Nov–Easter
🚗 ♿

In 1962 a memorial gallery was opened in the small Methodist chapel where Spencer's mother used to take him as a child. Here you will see various **memorabilia** relating to this eccentric man, including his spectacles and the baby carriage which he used to take with him on his painting expeditions, together with the easel, paints, folding stool and large sunshade that were strapped to it. The gallery's small permanent collection of his works includes several naturalistic **landscapes** and **portraits**, as well as **pencil studies** for the mural in the Sandham Memorial Chapel in *BURGHCLERE*, the **Ship-building in the Clyde** series in the Imperial War Museum in *LONDON*, and the **Christ Carrying the Cross** in the Tate Gallery.

There are also two oils reflecting the artist's febrile erotic imagination: one, **Contemplation**, was part of a series called the **Beatitudes of Love**, intended to decorate a chapel devoted to "the glories of sex". The other, the more powerful of the two, was a grotesque study of **nude sunbathers** at nearby Odney. The collection is enhanced by frequent loans.

On near-permanent loan is an enormous canvas left unfinished at the time of the artist's death: entitled **Christ Preaching at Cookham Regatta**★, it is a memory of boat-racing in Edwardian times.

EASTBOURNE
East Sussex Map E5

Within sight of the spectacular chalk cliffs that fall 600 feet down to the sea at Beachy Head, Eastbourne developed as a popular resort from the early 19thC. Today it is a sprawling place with little architectural character.

Towner Art Gallery
Manor Gdns, High St, Old Town
Tel. (0323) 21635/25112
Open Mon – Sat 10am – 5pm, Sun 2 – 5pm
Closed Mon Winter
▣ 🏛 ✦ 🖿

The Towner Art Gallery is in a hillside park in one of Eastbourne's extensive surburban districts. The elegant mid-18thC building which it occupies has a most pleasant light and airy interior. Though partly a museum of local and natural history, the place serves principally as an art gallery. Much of its available space is generally taken up by temporary loan exhibitions, often of **20thC British art**, which is also the main strength of its permanent collection. Among the many **oils**, **drawings** and **watercolours** by leading British artists of this period are a considerable number of works by the Bloomsbury painters **Vanessa Bell** and **Duncan Grant**, who lived for much of their lives at nearby Charleston. In addition, the museum has a large collection of **caricatures by Cruikshank** and other Georgian artists, and a small group of minor works by Victorian artists such as **T.S. Cooper**, **William Müller** and **Alma-Tadema**.

EGHAM
Surrey Map C3

The riverside town of Egham, adjoining the fields of Runnymede where the Magna Carta was signed in 1215, is a place of little architectural distinction. Its principal attraction, the ROYAL HOLLOWAY COLLEGE, lies on its outskirts.

The Picture Gallery, Royal Holloway College
Tel. (07843) 34455
Open by appointment only
🖼 📖 🏛

The college building, a full-scale Renaissance château that would be more at home in the Loire Valley, is a strange and wonderful apparition well worth a visit for its own sake. Opened by Queen Victoria in 1886 as an independent ladies' college, Holloway later became part of the University of London and in recent years has begun to accept male students as well as female. It takes its name from its founder, Thomas Holloway, who also formed and donated the collection of paintings hanging in the so-called Recreation Hall. As a Victorian collection put together by one man, and still intact, it is virtually unique. It provides a fascinating insight into the taste of the wealthy, self-made men who dominated the patronage of art in this period. Thomas Holloway was the creator of "Holloway's Pills", which he promoted through lavish advertising campaigns. Though regarded by doctors as of dubious medical benefit, the pills did no one any actual harm and turned Holloway into a millionaire. His firm remained in business until the 1930s, when it was taken over by Eno's Fruit Salts. Among the paintings, which were all bought from Christie's auctions in the period 1881–3, are several of the best known images of Victorian art, including Frith's **The Railway Station**★ and Luke Fildes's harrowing **Applicants for Admission to a Casual Ward**★. Contemporary scenes such as these are complemented by works reflecting the Victorian view of history, notably Millais's **The Princes in the Tower** and Edwin Long's **The Babylonian Marriage Market**. Interesting and uplifting though these may be, your most vivid memory of Holloway is likely to be the nightmarish polar bears depicted in a painting of Franklin's expedition in search of the North West Passage. This is **Man Proposes – God Disposes**★ by Queen Victoria's favourite painter, Sir Edwin Landseer, who by this stage in his career was suffering from alcoholism and bouts of insanity.

ETON
Berkshire Map C3

The small riverside town of Eton, lying almost under the shadow of Windsor Castle is famous principally for its exclusive boys' school.

Eton College Chapel
Open Mon – Sat 11.30am – 12.30pm,
2.30 – 5pm
Closed Sun
▣ 🏛

Eton College was founded in 1440 by Henry VI and it retains various **15thC**

buildings, including the chapel, which was originally just the choir of a projected, much larger structure. Inside you will see a series of finely detailed narrative **wall paintings** of the 15thC, which are the best of their kind preserved in England.

FIRLE PLACE ⌂
Nr Lewes
East Sussex, Map E5
Tel. (079159) 335
Open June – Sept Mon Wed Sun 2.15 – 5pm
Closed Tues Thurs Fri Sat June – Sept;
* Oct – May*
🏰 🚗 🏛 ⌂ 🅿 ☙

Firle Place is a pleasantly rambling house built in Tudor times but extensively altered in the early 18thC. Amid much fine **Sèvres porcelain** and **18thC French and English furniture**, there are numerous **Old Master paintings**, particularly of the Italian, Dutch and English Schools. High points include a *Holy Family* by the 16thC Florentine painter **Fra Bartolommeo**; two small views of Venice by **Guardi**; a large landscape by **Koninck**; and a playful portrait by Reynolds of *The Children of the 1st Viscount Melbourne*. You are best advised to visit the house on a Connoisseur's Day (held on every first Wednesday of the month), when a greater number of rooms are opened to the public than at other times, and you are allowed to wander around without a guide.

FISHBOURNE ROMAN PALACE
Salthill Road Map C5
Tel. (0243) 785859
Open Mar – Apr, Oct 10am – 5pm,
* May – Sept 10am – 6pm; Nov*
* 10am – 4pm, Dec – Feb Sun 10am – 4pm*
🏰 🚗 🅿 🅿

The Roman Palace at Fishbourne was discovered in the Middle Ages, but was not properly excavated until the early 1960s. It is considered a palace rather than a villa because of its exceptional size: not only is it the largest Roman building in Britain, but it is also one of the largest anywhere, including Rome itself. The glass structure covering much of it makes for lighter and more pleasant viewing conditions than at the nearby villa of **BIGNOR**; but like Bignor its main interest lies in its magnificent **mosaic floors** ★ (early 3rdCAD), one of the finest of which has at its centerpiece a **boy riding a dolphin**.

GLYNDE PLACE ⌂
Nr Lewes, East Sussex Map E5
Tel. (07916) 71743
Open Mid May – mid Oct Wed Thurs
* 2.15 – 5.30pm*
Closed Mon Tues Fri – Sun mid May – mid
* Oct; Nov – Apr*
🏰 🚗 🅿 🏛 ☙

From the outside a beautiful example of a 16thC quadrangular mansion built of flint and brick, Glynde Place has an interior that was much altered in the mid 18thC. Its treasures include a good collection of **Italian Renaissance** and **Baroque bronzes**, portraits by **Kneller**, **Hoppner**, **Lely** and **Zoffany**, and a very vivid oil sketch by **Rubens** for the ceiling of the Banqueting House in *LONDON*.

GOODWOOD HOUSE ⌂
Chichester, West Sussex Map C5
Tel. (0243) 774101
Open May – July, Sept – mid Oct Sun Mon
* 2 – 5pm, Aug Tues – Thurs 2 – 5pm*
Closed Tues – Sat May – July, Sept – mid
* Oct; Mon Fri – Sun Aug; Nov – Apr*
🏰 🚗 🅿 🏛 ☙

Goodwood was the home of the Dukes of Richmond, and this aristocratic background still dominates the character of the house and its contents. The principal paintings, for example, are the royal and family portraits by **Van Dyck**, **Lely**, **Kneller**, **Reynolds** and **Lawrence**, but there are others outside this category, notably the 4 scenes by Canaletto which includes *St Paul's* ★ and *The Thames from Richmond House* ★. Goodwood has also been associated with equestrianism and hunting for over 200 years, and this aspect is brought out in a number of **sporting pictures** from the 18thC and 19thC, the finest of which is *The Duke of Richmond's Racehorses at Exercise* by George Stubbs.

 If the paintings are largely from what would be described as the English school, the best of the furniture is 18thC French accompanied by a good collection of European **porcelain** in the Card Room and Yellow Drawing Room. There is more **French furniture** in the Tapestry Drawing Room, where the four **Gobelins tapestries** illustrating scenes from *Don Quixote* are the most notable.

Hastings, bordered by steep hills and the sea, is an attractive resort with a

reasonably well-preserved old fishing quarter. Numerous artists have been associated with the town, most notably **William Holman Hunt**, **Dante Gabriel Rossetti** and the American painter **James McNeill Whistler**. A plaque at 43 St Mary's Terrace records the house which once belonged to Whistler's mother, the subject of his celebrated portrait (***Arrangement in Grey and Black***) in the Louvre in Paris.

Museum and Art Gallery
Cambridge Road
Tel. (0424) 435952
Open Mon – Sat 10am – 1pm, 2 – 5pm, Sun 3 – 5pm
Closed
The Museum and Art Gallery, lying in the grounds of a hospital behind the town center, has a slightly moribund character. Among the crammed and badly displayed objects are modest collections of **English pottery** (including Wealden pottery), **Oriental art** and **Islamic ethnography**. The high point of the interior is undoubtedly its Indian-style hall, a masterpiece of late Victorian fantasy.

HATFIELD HOUSE
Hatfield, Bedfordshire Map D2
Tel. (07072) 62823
Open Mar – early Oct Tues – Sat noon – 5pm, Sun 2 – 5.30pm
Closed Mid Oct – Feb
The large redbrick mansion at Hatfield was built by Robert Cecil, 1st Earl of Salisbury, in 1607 – 11 as the principal seat of a family who had provided chief ministers to three successive monarchs: Henry VIII, Elizabeth I and James I. At the time it was built, the power and influence of the Cecils was distinctly in decline, but Hatfield's interior with its **Great Hall**, **carved chimneypieces** and **Italian Renaissance staircase** gives no indication of this, being a splendid example of both Elizabethan and Jacobean design.

The Elizabethan element is without doubt the strongest because Elizabeth I spent part of her childhood in the earlier royal palace on the site, and Hatfield now contains various mementoes of her reign. The portraits you can see here, for example, are dominated by two famous representations of the Queen: ***The Ermine Portrait*** ★ by Nicholas Hilliard, in which the white animal at her sleeve represents purity, and the anonymous ***Rainbow Portrait*** ★, an allegory of peace. Of the other works there is a good

series of family portraits by **Reynolds**, **Romney** and **Lawrence**, *Charles I* by Mytens and an unusual lifesize statue of *James I* over the fireplace in the drawing room by the French sculptor Maximilien Colt. The **furniture** in the house is mainly English and French 17thC and 18thC but the collection overall does range more widely than this, and you will be able to see **Flemish tapestries**, **Italian fabrics** and, in the chapel, some early **stained glass**.

HOVE
East Sussex Map D5
Hove, now an extension of Brighton, has at its eastern end many splendid **Regency squares and terraces** overlooking the sea, including Regency Square, Palmeira Square, and Brunswick Square and Terrace. However, as you go W, the place gradually turns into a dull, suburban sprawl which continues most of the way along the coast to Worthing. One of the most striking buildings on this side of the town is now occupied by the HOVE MUSEUM AND ART GALLERY.

Hove Museum and Art Gallery
19 New Church Rd
Tel. (0273) 779410
Open Tues – Fri 10am – 1pm, 2 – 5pm, Sat 10am – 1pm, 2 – 4.30pm
Closed Sun Mon
The building housing the Hove Museum and Art Gallery is in the style of an Italian villa, and is like a smaller version of **OSBORNE HOUSE** on the Isle of Wight. It was built as a private residence between 1873 – 6, and was converted for use as a museum after it was acquired by the Hove Corporation in 1926. As you approach the building you will pass on your right a small **Indian gateway** carved in teak by the subjects of the Maharajah of Jaipur for use as an entrance gateway to the Colonial and Indian exhibition in 1886.

The main house comprises essentially collections of local history, and of 18thC and 20thC **British ceramics and painting**. The 18thC holdings, displayed on the first floor, are rather dull (two landscapes by **Gainsborough** and **Bonington** barely rise above the general level of mediocrity). But the 20thC collection includes many fine recent purchases of British art. The works, which are admittedly of a largely conventional nature, include paintings by members of the **Camden Town School** (note in particular *Old Houses at Lancaster* by Charles Ginner), **Duncan Grant**, **Bernard Meninsky** (a now little-

known artist represented here by a beautiful portrait of his son, 1925), and three artists in the orbit of Stanley Spencer, his wife **Hilda Carline**, his brother **Gilbert Spencer** and his close friend **Henry Lamb**.

Among the 20thC ceramics is an erotic and humorous piece by Quentin Bell, who is less known as a potter than as an art historian and a nephew of Virginia Woolf. This is entitled *Racial Harmony*, and the artist has depicted a naked black woman lying on a couch beside an exotically dressed white female companion.

KNOLE 🏠
Sevenoaks, Kent Map E4

Tel. (0732) 453006
*Open Apr–Sept Wed–Sat 11am–5pm,
Sun 2–5pm; Oct–Nov Wed–Sat
11am–4pm, Sun 2–4pm
Closed Mon Tues Apr–Nov; Dec–Mar*
🖼 🛏 🏛 �という

Knole, one of the largest country houses in Britain, is a somewhat austere, rambling pile from the exterior, and you may find this impression to some extent confirmed within. Certainly its scale and innumerable rooms make it difficult to approach as a domestic residence, but its collection of paintings and furniture is correspondingly impressive. Elizabeth I gave the house to the Earl of Dorset, and it has been occupied by the same family for nearly 400 years, so you can almost be sure of a good series of family portraits. In fact you can see works by **Van Dyck**, **Dobson**, **Kneller**, **Gainsborough** and **Romney**. A separate room devoted to the work of **Sir Joshua Reynolds** has portraits of his literary acquaintances such as *Dr Johnson*, *Oliver Goldsmith* and the 18thC Shakespearean actor *David Garrick*.

Knole also has an excellent collection of **17thC furniture**, some of which was originally in the royal collections. In the **Venetian Ambassador's Room** for example, so named because it was once occupied by Nicolo Molino, ambassador to James I, there is an impressive **bed** and suite of furniture which probably belonged to James II, a series of **17thC Flemish tapestries**, and a portrait of *Molino* by Daniel Mytens. In contrast, the **Cartoon Gallery** contains a set of 17thC French furniture by the royal *ébéniste* **Pierre Golle**, which was presented to the 6th Earl by Louis XIV. But even this tends to be overshadowed, at least in popularity if not artistic merit, by the **silver furniture** in the King's Bedroom.

LUTON HOO 🏠 ☆
Luton, Bedfordshire Map D2

Tel. (0582) 22955
*Open Apr–mid Oct Mon Wed Thurs Sat
11am–5.45pm, Sun 2–5.45pm
Closed Tues Fri Apr–mid Oct; late
Oct–Mar*
🖼 🛏 🏛

Much of the exterior of this grand and forbidding house was the work of the celebrated 18thC architect, Robert Adam, but after later alterations the place was gutted by fire in 1843, and finally refashioned at the turn of the last century. But the main attraction is neither the architecture nor the fine park, but the famous **art collection**, assembled mainly by the diamond magnate Sir Julius Wernher and his son Sir Harold.

The collection is for the most part arranged as an old-fashioned museum, with paintings seen alongside floor cases filled with applied art objects. As in so many English country houses, there are numerous 17thC Dutch paintings (including works by **Frans Hals**, **Dou**, **Cuyp**, **Hobbema**, **Metsu**, **Ostade**, **Steen** and **de Hoogh**, and portraits by 18thC English masters (note in particular **Reynolds'** fine half-length portrait of *Lady Caroline Price* and a picture by Hoppner of *Henrietta Hanby Tracy* playing with her toys on the floor).

A more unusual feature of the Wernher collection is the large number of **Russian objects and memorabilia**, especially the splendid display of **Fabergé jewelry**: the reason for these lies in the fact that Sir Harold Wernher was married to a Russian aristocrat who was connected with the Russian Imperial family and whose grandfather was the poet Alexander Pushkin.

But Luton Hoo's most impressive feature is its collection of **medieval and Renaissance art** ★, perhaps the largest to be seen in any country house. Among the applied art objects are the **medieval ivories**, **Limoges enamels**, **German 15th and 16thC metalwork**, and one of the largest groups in private ownership of **Italian Renaissance bronze statuettes**. Two of the high points of this collection are an elaborate **incense burner** ★ by **Riccio** and a sensitively modelled *St John the Baptist* ★ by Sansovino. One of Luton Hoo's greatest paintings, Altdorfer's *Christ taking leave of his Mother before the Passion* ★, was recently sold to the National Gallery, but many other fine 15thC and 16thC paintings remain, including works by **Memling** ★, **Francesco Francia** ★, and

Filippino Lippi ★.

The most famous painting in the collection is *St Michael* ★★ by the late 15thC Spanish master, **Bartolomé Bermejo**. Like other Spanish artists of his generation, Bermejo was strongly influenced by contemporary Flemish art, an influence apparent here in the realistic portrayal of the donor's face and the extraordinary attention to detail in the rendering of St Michael's bejewelled armour, which is even seen to reflect a view of a town. However, the work remains unmistakably Spanish, both in its use of a gold background at this relatively late date (c.1480) and in the earthy vigour of the overall composition.

MAIDENHEAD
Berkshire Map C3

The Thames-side town of Maidenhead, once an important staging-post on the London to Bath road, is a green and attractive little town much favoured in summer by rowboat enthusiasts. The railway bridge, designed by **Brunel**, features in Turner's famous *Rain, Steam and Speed* in the National Gallery.

Henry Reitlinger Bequest
Oldfield, Guards Club Rd
Tel. (0628) 21818
Open Apr – Sept Tues Thurs
* 10am – 12.30pm, 2.15 – 4.30pm Sun*
* (1st of every month) 2.30 – 4.30pm*
Closed Mon Wed Fri Sat Apr – Sept;
* Oct – Mar*
🎦 🛍 ☑

This typical Edwardian riverside house contains the Henry Reitlinger Bequest. The collection consists principally of Chinese, Persian, Italian and English **ceramics**.

MAIDSTONE
Kent Map F4

A busy agricultural town and the county town of Kent, Maidstone has a few pleasant old houses.

Museum and Art Gallery
St Faith's St
Tel. (0622) 54497
Open Mon – Sat 10am – 5.30pm
Closed Sun
🎦 🛍

The Maidstone Museum and Art Gallery occupies a dark, rambling and over-restored Tudor mansion. The art gallery section of the museum is currently undergoing extensive renovation and is not expected to be reopened until 1986,

which means that its paintings by obscure 16thC–18thC Flemish, Dutch and Italian artists, and generally minor 19thC British artists, are not displayed. However, a selection of some of the finest of the holdings is on show in the main part of the museum. These pictures include two *capricci* by the 18thC artist **Giovanni Paolo Panini** and a good canvas by the late Victorian painter, Arthur Hughes (*The Skipper and his Crew Saying Grace*). A famous locally born figure was the 19thC essayist and writer on art **William Hazlitt**, who began his career as a painter. There is a case devoted to him in the museum.

MOOR PARK MANSION 🏛
Nr Rickmansworth, Hertfordshire
Map D3

Tel. (0923) 776611
Open Mon – Fri 10am – 4pm, Sat
* 10am – noon*
Closed Sun
🎦 🛍 ☑

Moor Park, now owned by a golf club, is a late 17thC house which was considerably altered by **Sir James Thornhill** in 1720 – 28. Thornhill, who was first and foremost a decorative painter, was originally commissioned to do painted decorations within the house, but he became involved in a law suit with the owner concerning payment for the work he had already done, and was succeeded by one of Venice's leading painters, **Jacopo Amigoni**. Amigoni, who worked in England between 1729 and 1739, executed in the main hall of the house 4 vividly coloured **mythological canvases ★**, which together with the surrounding **stuccowork** and the **trompe-l'oeil ceiling**, constitute one of the finest decorative ensembles carried out in this country during the Baroque period. The ceiling and walls of the dining room were painted by a North Italian contemporary of Amigoni's, but these works, comprising mythological scenes surrounded by extremely elaborate painted **Rococo ornamentation**, are now in a dark and damaged state.

OSBORNE HOUSE 🏛
East Cowes, Isle of Wight Map B6

Open Apr – June Mon – Sat, 11am – 5pm;
* July – Aug Mon – Sat 10am – 5pm; Sept*
* Oct Mon – Sat 11am – 5pm*
Closed Sun
🎦 🅿 🛍

Despite its palatial Italianate style, complete with two campaniles, Osborne

has a rather dull appearance which is probably due to Prince Albert's efforts at designing this new royal residence himself as a holiday home for his enormous family. But perhaps for this reason Osborne was one of Queen Victoria's favourite residences and she died there in 1901. It has also retained its high Victorian character more than most houses of this period because she insisted that its interior remain unchanged following her beloved Albert's death in 1861. As a result, royal apartments such as the Durbar Room or the Billiard Room have a rich assortment of **furniture, carpets, paintings, ceramics** and **objets d'art** which were mostly brought together during the 1850s and 1860s. The former is particularly interesting since it contains a number of unique **Indian and Burmese pieces** in a setting designed by John Lockwood Kipling, Rudyard Kipling's father, who was curator of the museum in Lahore. To complement this the adjacent corridor is hung with **paintings of Indian subjects** such as those of Indian soldiers by the Czech artist **Rudolph Swoboda**.

Elsewhere in the house you should enjoy the royal portraits by the German painter Winterhalter (look for *The Empress Eugénie with her Handmaidens*), whose work found particular favour with Queen Victoria, and a large allegory of British naval power by **William Dyce**, resoundingly entitled *Neptune Resigning to Britannia the Empire of the Sea* (1847).

PETWORTH HOUSE 🏠 ★★
Petworth, West Sussex Map C5

Tel. (0798) 42207
Open Apr – Oct Tues – Sun 2 – 6pm
Closed Mon Apr – Oct; Nov – Mar
🗠 🛏 🚻 💆 🏛 ♨ 🥢

The small town of Petworth stands at the gates of the renowned Petworth House and is in itself worth a visit, having various **16thC – 17thC houses** (some timber-framed) arranged in a cluster of narrow streets around the small market square, dominated by the arcaded late 18thC town hall.

Only the chapel and cellar survive of the original **Petworth House**, which was transformed at the end of the 17thC by Charles Seymour, 6th Duke of Somerset, into the long, imposing pile that you see today. The nucleus of the house's many fine **antiques** and **Old Master paintings** was assembled in the mid 18thC by Charles Wyndham, 2nd Earl of Egremont, who was also responsible for having the grounds landscaped by **Capability Brown**. Brown's great

triumph was the creation of a serpentine lake with clumps of trees on either side and on the hills behind. The view looking down the gentle incline that leads from the main side of the house to the lake suggests the landscape paintings of Claude Lorraine, an effect reinforced by the presence elsewhere in the park of a **Doric temple** and an **Ionic rotunda**.

For all the work that the 2nd Earl carried out at Petworth, the house is best remembered today for the achievements of his successor, George Wyndham, the 3rd Earl. An important agriculturalist and patron of the arts, he was known also for his great hospitality, which led to frequent visits to the house by many of the leading English painters of his day, among whom were **Northcote, Turner** and **Benjamin Robert Haydon**. The latter wrote of the Earl's munificence that "the very flies at Petworth seem to know there is room for their existence."

In the state rooms on the ground floor of the house you can see the most outstanding piece of ancient sculpture in the building, the so-called *Leconfield Aphrodite* ★, which is thought to be by the same hand as the *Hermes of Olympia* (attributed by Pausanias to Praxiteles) and is dated to the 4thC BC. Also here, among a remarkable range of **17thC – 18thC French, Italian, Dutch and English works** are many fine portraits by **Reynolds** and **Van Dyck**, and a magnificent picture by Claude Lorraine, *Jacob with Laban and his Daughters* ★. The main staircase, decorated with impressive *trompe-l'oeil* murals by Louis Laguerre in 1714, leads you to the little dining room, where some of the oldest of the house's paintings are kept: among these are two fragments of **altarpieces** attributed to **Rogier van der Weyden**. Beyond is the **Carved Room** ★, where the long E wall displays some of the most extensive and intricate examples of the art of the late Baroque woodcarver **Grinling Gibbons**.

Farther still, you arrive at the **Turner Room**, containing 14 pictures by Turner, perhaps the most famous feature of Petworth's collection. Though never an intimate friend of the Earl's, Turner enjoyed with him a relationship based on mutual non-interference and was a frequent guest to the house in the 1820s and 1830s. Turner was reputedly extremely happy here, spending much of his time fishing and making paper boats for children on the lake, and taking great pleasure in the fancy dress parties and other forms of entertainment that were a renowned characteristic of the life at the house.

The most unusual and striking of the

works that he painted here (he was given
the old library above the chapel for use as
a studio) were the **watercolours** and oils
that he painted of the interior, now
divided between the British Museum and
the Tate Gallery (see *LONDON*). The
works preserved in the Turner Room at
Petworth are all **landscapes**, and include
4 oils specially commissioned around
1828 to hang in the Carved Room. Two
of these works (including the finest, the
glowing *Sunset: Fighting Bucks* ★) are of
Petworth Park, while the other two
feature the *Chain Pier* at Brighton and
the *Chichester Canal*, in both of which
the Earl had a financial interest. You can
see other works by **Turner**, together with
antique statuary of varying quality, and
painting and sculptures by such British
18thC/19thC artists as **Northcote**,
Wilkie, **Fuseli**, **Flaxman** and
Westmacott in the adjoining North
Gallery, specially built by the 2nd Earl.

POLESDEN LACEY 🏛
Nr Dorking, Surrey Map D4

Tel. (31) 52048
Open Mar–Nov Sat Sun 2–5pm;
 Apr–Oct Tues–Thurs Sat Sun
 2–6pm
Closed Mon Fri Apr–Oct; Mon–Fri
 Mar–Nov; Dec–Feb
🎫 🎧 🅿 🏛 ⚘

Polesden Lacey, a grand, extensive and
excellently restored house in the middle
of enormous, beautiful grounds, was
originally a modest Regency mansion. It
was substantially altered and added to in
the Edwardian period, when it was
purchased first by Sir Clinton Dawkins
(1902), and then by Captain the Hon.
Ronald Greville (1906). Though most of
the house's superb **furniture and
furnishings** are of the 18thC, the
character of the place is very much that of
a lavish Edwardian mansion. Its well-
known collections of fine and applied art,
which are now administered by the
National Trust, were mainly brought
together by Mrs Greville, who inherited
the nucleus of them from her father,
William McEwan.

As you enter the hall your attention
will be caught immediately by a
marvellously flamboyant full-length
portrait of *Mrs Greville* ★ by **Carolus-
Duran**, the fashionable late 19thC
society portraitist and teacher of Sargent.
But it is the dining room, which adjoins
the hall, that contains perhaps the most
striking paintings in the house. These are
a Titian-like *Venus and Piping Boy* ★ by
Sir Joshua Reynolds; four outstanding
portraits by **Raeburn**, the best of which,

The Paterson Children ★★, hangs over
the fireplace; and Sir Thomas Lawrence's
superlative *The Masters Pattison* ★★,
one of the finest of Lawrence's portraits
to be seen in any English country house.
The latter work was painted over a very
long period (1811–17), during which the
parents of the sitters became very
impatient and, at one stage, even seemed
to have taken the painting in an
unfinished state; Lawrence kept making
excuses for the delay, claiming, for
example, that the children's appearances
were changing. Elsewhere in the house is
a small and interesting, though not
especially attractive Pietro Perugino,
*The Miracle of the Founding of Santa
Maria Maggiore*, a vivacious *Cavalier* by
Bernardo Strozzi, and many fine Dutch
17thC pictures, including works by
Teniers, **de Hoogh**, **Cuyp**, **Ostade**,
Everdingen and **Terborch**.

PORTSMOUTH
Hampshire Map B5

As the chief naval station of England,
Portsmouth suffered greatly from
bombing during the World War II, and
has now little of architectural interest. So
called "Old Portsmouth" has in fact few
surviving old buildings, though it has a
certain quiet charm, with pleasant alleys
and fine views out to sea.

City Museum and Art Gallery,
Museum Rd
Tel. (0705) 827261
Open Mon–Sun 10.30am–5.30pm
🎫 🅿 ☑ ▭
The Portsmouth City Museum and Art
Gallery occupies a recently and
attractively converted mid-19thC
building once used by the army. Period
furniture, and local glass and ceramics
take up much of the ground floor, while
the upper floor galleries show temporary
exhibitions and selections from the
gallery's fine art holdings. These
comprise mainly minor works by **20thC
British artists**, among which,
appropriately enough for Portsmouth, is a
"poem-print" by the Scottish artist Ian
Hamilton Finlay of sailors from the
British navy pulling in a cable: the
inscription reads, "Someone somewhere
wants a cable from you."

READING
Berkshire Map C3

Reading, an industrial center and
university town, is the site of a celebrated
Benedictine Abbey founded by Henry I

in 1121. Only the scanty ruins of this survive, adjoining the town jail made famous by Oscar Wilde (*The Ballad of Reading Gaol*).

Museum and Art Gallery
Blagrave St
Tel. (0734) 55911 ext 2242
Open Mon–Fri 10am–5.30pm, Sat
 10am–5pm
Closed Sun
🔟 🔲

The small Reading Museum and Art Gallery shares a Victorian building with the town library. Its collections include various **Roman finds** from the town of Silchester; a fine **Bronze Age gold torc**; minor **paintings by local artists**; displays relating to the local Huntley & Palmer Biscuit Factory; and a woven, full-scale **reproduction of the Bayeux tapestry**. The main artistic treasures are some beautifully carved early **12thC capitals** from Reading Abbey, but only a few can be shown at any one time.

RYE
East Sussex Map F5

Though now nearly two miles inland, Rye was a flourishing seaport until the late 16thC. Built on a hill, with winding cobbled streets and attractive **15th–18thC houses**, it is today perhaps the most picturesque town in southern England. Rye's most distinguished former resident was the American novelist Henry James, who in 1900 acquired the freehold of Lamb House, a well-maintained early **Georgian building** with an enchanting **walled garden**.

Rye Art Gallery
Tel. (0797) 223218
Opening details unavailable
The Rye Art Gallery occupies an old grain store, which was converted into a house in the late 19thC. Most of its light and pleasant interior is taken up by temporary exhibitions, though it does have a small collection of mainly 20thC English oils and watercolours, including works by **Graham Sutherland**, **Paul Nash**, **Eric Gill**, **John Piper** and **Edward Burra**. The latter, surprisingly for a painter known principally for his obsession with scenes of low life, the grotesque and the macabre, lived in and around Rye for most of his life.

ST ALBANS
Hertfordshire Map D2

St Albans with its hilly streets, lined with old houses and wide green expanses, is one of the most attractive towns within easy reach of London. Its 12thC–13thC **abbey**, in large pleasant grounds, has a **Norman nave** with piers containing fascinating traces of 13thC and 14thC **wall paintings**. But the town's main claim to fame is its status as the site of the most important Roman settlement in Britain, **Verulamium**.

The ruins of this ancient city, which were only excavated this century, include the only **Roman theatre** in Britain, and a beautifully preserved multi-coloured **mosaic floor** dating from the 2ndC and featuring a lion killing a stag. But it has to be said that, as with so many ancient sites in Britain, St Albans has rather little appeal to the imagination. Perhaps the grass is too neatly mown, and the green fencing and signboards are too prominent.

The Verulamium Museum
Museum St
Tel. (0727) 54659/59919
Open Apr–Oct Mon–Sat 10am–5.30pm,
 Sun 2–5.30pm; Nov–Mar Mon–Sat
 10am–4pm, Sun 2–4pm
🔟 📖 ☑

The Verulamium Museum stands on the site of Roman St Albans and contains numerous local finds, most notable among which are the **mosaics** and the **pots** made in the district of Carton near Petersborough with **reliefs** depicting hunting scenes.

SOUTHAMPTON
Hampshire Map B5

Southampton, a seaport much damaged in World War II, is a not especially attractive place. Its bleak civic center, a group of white stone buildings in a modern Neoclassical style, is reminiscent of those at Portsmouth and Cardiff, and is an uninspiring setting for Southampton's excellent art gallery.

Southampton Art Gallery ☆☆
Civic Centre
Tel. (0703) 23855 Ext 769
Open Tues–Fri 10am–5pm, Sat
 10am–4pm, Sun 2–5pm
Closed Mon
🔟

You will find the spacious and tastefully modernized interior of the Southampton Art Gallery a pleasant surprise after its forbidding exterior. What is more, it has one of the most remarkable collections of any British gallery.

The paintings, all shown on the first floor, are hung mainly in chronological

order, though in the main hall there is a disparate collection of Old Master paintings together with floor cases containing works by modern British artists such as **Barry Flanagan** (a beautiful example in gold and blue of one of his recent leaping hares) and piers with glass-covered niches containing a good collection of **oriental and modern pottery**, including works by **Bernard Leach** and **Shoji Hamada**.

Among the early foreign school paintings are a triptych of the *Coronation of the Virgin* by the 14thC Sienese artist, Allegrato Nuzi and a *Madonna and Child* by Giovanni Bellini in rather bad condition. The 17thC and 18thC foreign holdings have works of a generally higher quality, in particular an extremely earthy *Holy Family* ★ by Jordaens; a strikingly simple **portrait** ★ by the now fashionable **Sofonisba Anguisciola** of her sister dressed as a nun; and a haunting *Allegory of Winter* ★ by a little-known Dutch artist, Cesar Boëtius van Everdingen, showing with an impressively luminous technique a woman warming her hands over a brazier. The gallery's French works are almost exclusively 19thC, with a splendid full-length portrait of *Napoleon* ★ by Gérard, and generally minor paintings by **Corot**, **Daubigny**, **Boucher**, **Sisley**, **Camille Pissarro** and **Renoir**, as well as sculptures by **Rodin**, **Degas** and **Maillol**.

The gallery's finest holdings are of British art, beginning with an outstanding full-length portrait by **Gainsborough** of the *2nd Lord Vernon* ★ being gently pawed by his dog. Another wonderful 18thC work is a *Landscape with Sunset* ★ by Joseph Wright of Derby, which has something of the mystical, contemplative quality inherent in the works of the German romantic painter, Casper David Friedrich. Next you will see a dramatic landscape by Turner of *Fishermen upon a Lee-shore in Squally Weather* ★ and a darkly atmospheric portrait by Lawrence of *Dr John Moore, Archbishop of Canterbury* ★, who is portrayed within the setting of his cathedral. The most famous of the British romantic works is John Martin's *Sadak in search of the Waters of Oblivion* ★, showing a tiny figure struggling upon a ledge in an infernal landscape of rocks, caverns, and rushing water: it is perhaps the finest of all Martin's works, being (for him) an unusually simple and direct composition.

An artist of a generally more subtle imagination than Martin was **Burne-Jones**, represented in the museum by 10 of his more bizarre and symbolically

suggestive **works** ★. These are enormous, full-sized studies in opaque colour for a series of canvases intended to decorate the London home of the politician Arthur Balfour (8 of these paintings were executed and are now in the Staats-galerie, Stuttgart); although the subject is the Perseus story, they are essentially reflections on the theme of life, death and the human spirit. To move from the sublime to the ridiculous, you then come to *The Captain's Daughter* by J.S. Tissot, a late Victorian work showing two sailors on a riverside eyeing a young woman: the detail of the telescope on the sailor's table is of obvious phallic significance and is typical of veiled Victorian allusions to sexuality.

The gallery's holdings of **20thC British art** are especially renowned, and open with one of the largest groups of work by the **Camden Town Group** to be seen in any British museum. Oddly enough two of the most impressive of these works are by the least known members of the group, **Malcolm Drummond** and **William Ratcliffe**: look for a sad, atmospheric study by Drummond of a solitary figure in St James's Park; and Ratcliffe's *The Coffee House*, a carefully structured composition portraying all the tatty ordinariness of a London "caff". You will also find much to enjoy among the early 20thC works, particularly two powerful painted portraits by **Gaudier Brzeska** ★ (of himself and of his companion Sophie Brzeska); a **Seated Nude** ★ by Mark Gertler; a characteristically child-like Breton Woman at Prayer by Christopher Wood; two works by Stanley Spencer – a long, narrow *Resurrection with the Raising of Jairus's daughter* ★, and a portrait of his second wife, **Patricia Preece**, the subject of the Tate Gallery's grotesque *Leg of Mutton Nude* (see LONDON); and good portraits by **Matthew Smith** (look for a Matisse-like study of a woman, *Dulcie*); Augustus John (*Kit*) and Gwen John (*Mère Poussepin*).

Further on, you should not be deterred by a room that contains three characteristic examples of poorly painted pornographic kitsch by the Belgian Surrealist **Paul Delvaux** – the same room has a fascinating selection of British paintings with a Surrealist character, including works by **Edward Burra** and **Rowlandson Rose**. Among the more obscure artists represented here is the Hampshire-born **Maxwell Armfield**, who did some small, strange works in tempera. He loved America, and his masterpiece is a humorous yet also powerfully enigmatic study of New York's *Central Park* ★.

Turner's Britain

Constable's art, though now seeming outwardly far less revolutionary than Turner's, broke away completely from the conventions of his time. In contrast, Turner's art, which is often seen to prefigure such recent and innovative artistic developments as Abstract Expressionism, was deeply rooted in tradition.

The TOPOGRAPHICAL TRADITION

Whereas Constable hated the idea of being a topographical artist, Turner was trained in this tradition and he remained faithful to it for the rest of his life. He began his career by doing the meticulously detailed watercolours and drawings that this mechanical art demanded. The free and evocative art of his contemporary Cozens, with which he came into close contact in the mid 1790s, showed him that topographical accuracy could be subservient to poetic and personal feeling; and soon the effects of light and colour in his watercolours and oils came increasingly to blur representational detail. Yet even some of the most poetic and freely handled works of his maturity were intended, like so much conventional topographical art, to provide engravings for series of views of famous landscapes and buildings, such as the *Picturesque Views of England and Wales* on which the artist was engaged for much of the 1820s and 1830s.

None of the sites that Turner chose to portray had the deep personal significance of Constable's chosen landscapes. They were all well-known beauty spots, which the artist could visit on annual tours around different parts of Britain. The rest of the year he was based in London, a place he rarely

Self-Portrait, J.M.W. Turner, Tate Gallery

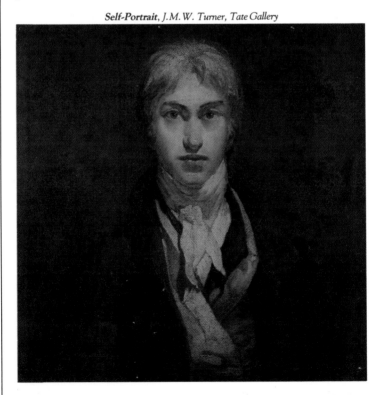

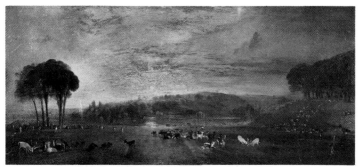

The Lake, Petworth, J.M.W. Turner, Petworth House

portrayed. One of the earliest of Turner's trips outside London was to the
Wye Valley, where he was encouraged to go, like many other artists, after
having read the writings on it by the famous spokesman of the "Picturesque",
Gilpin. His later tours took in almost every part of Britain, from the tip of
Cornwall to the north of Scotland. At first the Napoleonic blockade put the
continent of Europe out of bounds to him; and it was not until the brief
cessation of Anglo-French hostilities in 1802 that he was able to go abroad for
the first time. But after Napoleon's defeat at Waterloo in 1815 he paid regular
trips to France, Italy and Germany. It is difficult to tell from Turner's writings
and works whether or not he had a preference for any particular part of
Britain among the many areas where he worked, though Ruskin claimed that
he loved the Yorkshire Dales above all, and the woody and rocky estuarine
scenery around Plymouth.

TURNER *and his* PATRONS

Apart from portraying popular tourist places, another important activity of
the topographical artist was to represent property owned by the aristocracy.
Of the countless views that Turner did of country houses, one of the most
interesting is his oil of **Somer-Hill near Tunbridge Wells** in Sussex
(National Gallery of Scotland, Edinburgh), which shows how the artist was
able to give new life even to this generally rather dreary tradition: paying little
attention to architectural detail, and placing the building right at the back of
the painting, he is nonetheless able to give a sense of the grandeur of the
house within the landscape through a dramatic use of light and colour.

Turner became close friends with a number of his aristocratic patrons,
including Walter Rusden Falkes, whose home at Farnley in West Yorkshire
he visited virtually every year from 1814 to Falkes' death in 1825: according
to Falkes' son, Hawksworth, a storm observed from the house on the artist's
first visit there gave him the idea for the **Hannibal Crossing the Alps** in the
Tate Gallery. Turner was never on such intimate terms with Lord Egremont
of Petworth House in Sussex, but his stays there in the late 1820s and early
1830s were especially fruitful for his work. The duke's collection of Old
Master pictures inspired Turner to make some strange pictorial homages to
the art of Van Dyck and Rembrandt (for example, the **Jessica** in the Tate
Gallery, a Rembrandt-like half-length portrait of a woman at a window). But
it was the house generally, with its potent atmosphere and succession of
costume parties, that seems to have had a particular effect on the artist,
leading him to paint the only interiors of his career. The most striking of
these is undoubtedly the Tate Gallery's **Interior at Petworth**.

SQUERRYES COURT ⊞
Westerham, Kent Map E4

Tel. (0959) 62345
Open Mar, Oct Sat Sun 2 – 6pm;
* May – Sept Wed Sat Sun 2 – 6pm*
Closed Mon Tues Thurs Fri May – Oct;
* Nov – Feb*

🖾 ➜ 🏛 🌢

Squerryes Court is a charming redbrick
house dating mainly from the late 17thC
and overlooking a small lake. Its light and
airy rooms make a fine setting for a
collection of paintings that deserves to be
better known. The dining room has
numerous **Dutch pictures** brought
together in the mid 18thC, including a
marvellous **family group ★** by **van der
Helst** and a fine landscape by **Cuyp**; in
the drawing room is an attractive
landscape by **Zuccarelli**, an 18thC
Venetian artist who was very popular in
England. On the staircase leading to the
first floor picture gallery you can see two
enormous and impressive canvases by the
17thC Neopolitan painter, Luca
Giordano (*Triumph of Bacchus and
Ariadne* and *Aeneas killing Turnus ★*)
The first floor gallery also shows an
interesting *St Sebastian* by Van Dyck,
though some of the other pictures here
are of more dubious attribution.

 Throughout the house are numerous
portraits of the Warde family, who have
owned Squerryes Court since 1731:
among these are works by **Devis**, **Opie**,
Wootton and **Stubbs** (a very good picture
of *John Warde the Foxhunter ★* as a
young man holding a horse). The daring
General Wolfe of Quebec fame, who was
a great friend of General George Warde,
is commemorated by various items,
including the sword worn by him during
the Quebec campaign.

STRATFIELD SAYE HOUSE ⊞
Nr Basingstoke, Hampshire Map C4

Tel. (0256) 882882
Open Late Mar – late Sept Mon – Thurs,
* Sat, Sun 11.30am – 5pm*
Closed Fri late Mar – late Sept; Oct – mid
* Mar*

🖾 ➜ 🅿 🌢

Stratfield Saye was the relatively modest
17thC house presented to the Duke of
Wellington after the Battle of Waterloo,
and you will see various references to the
general's military career throughout the
interior. As you might expect, there are
numerous trophies and mementoes of the
Duke's campaigns, but you should not
miss some interesting paintings and
furniture which came his way as a direct

result of the Napoleonic wars. The **Louis
XIV furniture** was acquired in Paris after
the peace treaty, while many of the
paintings, particularly those in the
drawing room from the **17thC Dutch and
Flemish schools**, were captured from a
French armed force that had earlier
removed them from the Spanish royal
collection. Elsewhere in the house there
are family portraits and military scenes,
such as Haydon's *Wellington showing
the Field of Waterloo to George IV* and
in the library there is an *Ascension* by
Tintoretto. The Duke also had an
interest in prints, which are liberally
distributed throughout the house, as well
as in the **Print Room** which was specially
designed for this purpose.

TUDELEY CHURCH
Kent Map E4

The architecturally unremarkable
Church of All Saints in the village of
Tudeley contains the only **stained glass
window** (1967) in Britain by **Marc
Chagall**. The window commemorates the
21-year-old daughter of Sir Henry and
Lady d'Avigdor-Goldsmith, who was
drowned in 1963 while sailing. Its
dominant colour is blue and it represents,
in its lower half, the girl floating in water
surrounded by mourners, and, above this,
the Crucifixion, with the girl climbing a
ladder to Paradise.

UPPARK ⊞
*South Harting, Nr Petersfield, West
Sussex Map C5*

Tel. (073 085) 317
Open Apr – Sept Wed Thurs Sun 2 – 6pm
Closed Mon Tues Fri Sat Apr – Sept;
* Oct – Mar*

🖾 🅿

Situated high up on the Downs, with
marvellous views of hilly and remarkably
unspoilt countryside, Uppark is a
charming, late 17thC house designed by
William Talman, the architect of
Chatsworth in Derbyshire (see the
MIDLANDS). The writer H.G. Wells
spent much of his childhood here, his
mother having been employed as
housekeeper from 1880 – 93. He wrote of
it: "The place had a great effect on me; it
retained a vitality that altogether
overshadowed the intermittent ebbing
tricks of upstairs life, the two elderly
ladies in the parlour following their
shrunken routine. . ."

 Even today Uppark is special among
English country houses in that it
maintains a lively, homely character, and

is not just a repository of fine old objects. Its uniqueness lies largely in the fact that its interior has remained almost untouched since the time it was altered in late 18thC, even to the extent of having kept its original **wallpapers** and **damask curtains**. The overall effect of the house is more important than the individual objects, but among the many **paintings** on display here look for a particularly splendid group of portraits and other works by **Pompeo Batoni**.

WADDESDON MANOR 🏠 ☆
Nr Aylesbury, Bucks Map C2
Tel. (0296) 251211
Open Late Mar – Oct Wed – Sun 2 – 6pm
Closed Mon, Tues late Mar – Oct;
 Nov – mid Mar
🖼 🛥 🍴 🅿 ♿

In its architecture and furniture, Waddesdon Manor is so unlike any other English country home that visitors may briefly imagine that they have accidentally arrived in France. It was built for Baron Ferdinand de Rothschild between 1876 – 84 by a French architect, Gabrielle Hippolyte Destailleur. The pompous, elaborately decorated exterior is in the style of a 16thC French château in the Loire Valley, while the no less richly decorated interior has more the character of the French 18thC.

Waddesdon's magnificent collections include paintings by **Rubens**, **Cuyp**, **Gainsborough**, **Reynolds** and **17thC Dutch artists**; but the main emphasis is on the **French Rococo**. There is an extraordinary range of **Sèvres porcelain** and furniture by such fine 18thC Parisian cabinet-makers as **Charles Cresson**, **Martin Cavela** and **Jean-Henri Riesener** (note in particular the small **writing table** made for Marie Antoinette at the Petit Trianon). In addition, there are paintings, drawings and decorative designs by artists such as **Watteau**, **Boucher** and **Audran**, and an unrivalled collection of the highly sensual and life-like **terracotta statuettes** ★ of **Clodion**. As a further treat you will find dispersed in the extensive formal grounds, which include a 19thC aviary with rare birds, a large number of **garden sculptures** by French, Italian and Dutch 17th and 18thC artists.

WINCHESTER
Hampshire Map B5

Winchester, which lies in a valley hollowed by the River Itchen, is historically one of England's most important towns. A major city in Roman times, it became the capital of England under the Anglo-Saxons, and, with London, remained the capital under William the Conqueror and his immediate successors.

Chief among its many fine medieval buildings is the splendid 11th – 14thC **cathedral** ★, the longest medieval church in Europe. Here you can see an outstanding **12thC font** from Tournai in Belgium, showing with remarkable vigour of execution legends from the life of St Nicholas, including the putting back of decapitated heads and the saving of a boy from drowning. In the cathedral library is another 12thC masterpiece, the **Winchester Bible** ★: this Bible, the finest illuminated manuscript produced in England at this time, was the work of at least six artists, one of whom is known as the "Master of the Leaping Figures" because of his ability at representing figures in motion.

A number of Winchester's most attractive **medieval buildings** form part of its celebrated school, which was founded in 1382 by William of Wykeham and boasts the rather questionable motto, "Manners Makeyth Man". One of the college buildings has a small collection of **Greek Attic vases** and **English watercolours**, which can be seen on request.

WINDSOR
Windsor, Berkshire Map C3

The attractive town of Windsor still has cobbled streets and many fine 18thC houses, and is dominated by its enormous **royal castle**, which commands fine views down to Eton and along the Thames Valley.

St George's Chapel ☆
Windsor Castle
Open Apr – early Sept Mon – Sat
 10.45am – 4pm, Sun 2 – 4pm;
 Oct – Mar Mon – Sat
 10.45am – 3.45pm, Sun 2.15 – 3.45pm
🖼 🅿 🏛

Windsor Castle was established by William the Conqueror, but its present appearance is due principally to 19thC renovations and additions. The most important architectural structure within the castle is the **15th – 16thC St George's Chapel**, which ranks with King's College Chapel in Cambridge (see *EAST ANGLIA*) and Henry VII's Chapel in Westminster Abbey (see *LONDON*), as the finest example of English late Gothic work. Of the numerous **tomb sculptures** inside St George's Chapel, the most striking

is a highly theatrical 19thC monument by M.C. Wyatt to *Princess Charlotte of Wales*, who is shown ascending bare-breasted from her shrouded corpse. Behind the Chapel is the Albert Memorial Chapel, built originally by Henry VII but converted in a rather fantastical way by Queen Victoria. In addition to a **cenotaph to Prince Albert** by **Baron Triquetti**, it contains a magnificently elaborate **Art Nouveau memorial ★** to the Duke of Clarence by **Alfred Gilbert**, the sculptor of the *Eros* statue in Piccadilly in London.

State Apartments ☆
Windsor Castle
Open Apr Mon – Sat 10.30am – 5pm;
 May – Oct Mon – Sat 10.30am – 5pm,
 Sun 1.30 – 5pm; Nov – Mar Mon – Sat
 10.30am – 3pm
Closed Sun Apr Oct – Mar; also when Royal
 Family are in residence
▨ 𝄢 ♅ 血

As with the state apartments at the other major royal residences that you can visit – Hampton Court and Kensington Palace (see *LONDON*) – those at Windsor Castle are filled with numerous major works of art, shown in rooms with a cold and impersonal atmosphere. The works you can see here include portraits by **Memling**, **Clouet**, **Dürer** and **Holbein**, and an enormous group of *Venetian views ★* by **Canaletto**, which were acquired in Venice by the notorious entrepreneur Consul Smith (known as the "Merchant of Venice") and sold by him to George III.

The two leading Flemish painters of the 17thC, **Rubens** and **Van Dyck**, are also very well represented. Among the works by Rubens is a fine **Self–portrait ★** and a glowing landscape with *St George and the Dragon ★*, which was painted shortly after the artist visited England in the 1630s. The saint and the princess are almost certainly idealized representations of King Charles I and Queen Henrietta Maria, and Rubens also incorporated into the extensive background fanciful impressions of London buildings. The earliest Van Dyck on show is *St Martin dividing his Cloak* (c.1620 – 21), which was painted in Flanders on the eve of the artist's departure for Italy and is clearly influenced by his master Rubens, to whom indeed it seems originally to have been presented.

The other major Van Dycks are **portraits of Charles I and his family** at court, including a large and sweeping **equestrian painting ★** of the king, a portrait of the **king's head ★** in three positions, which was intended as an aid to the Italian sculptor Bernini in making a

marble bust of him, a half-length portrait of **Henrietta Maria**, and a charmingly playful study of their **three eldest children ★**. There are, of course, numerous other royal portraits by other masters, ranging from a painting of the *Princess of Orange* by Honthorst in a frame carved by **Grinling Gibbons**, to full-length works by **Landseer**. One room, the Waterloo Room, contains many fine portraits by **Sir Thomas Lawrence** of British figures responsible for the downfall of Napoleon.

The most celebrated feature of the art treasures of Windsor Castle is the **Print Room**, which is one of the most important in the world and contains the largest collection to be found anywhere of **drawings and manuscripts by Leonardo da Vinci ★★**: a small selection of works from the Print Room is on view in the adjoining gallery.

WINSLOW HALL 🏛
Winslow, Buckinghamshire Map C2

Tel. (029671) 2323
Open July – mid Sept Tues – Sun
 2.30 – 5.30pm; mid Sept – early Oct Sat
 Sun 2.30 – 5.30pm
Closed Mon July – mid Sept; Mon – Fri mid
 Sept – early Oct; mid Oct – June
➷ ◨ 血 ♈

The impressive Baroque house of Winslow Hall, which was almost certainly designed by **Sir Christopher Wren** (although there has always been some doubt over its authorship) was begun in 1697 for William Lowndes, Secretary of the Treasury. The overall conception of the building is certainly masterful and the interior is appropriately furnished in English 18thC style. There are also a number of paintings, particularly **Dutch 17thC works** and a series of four decorative fantasies in the principal bedroom attributed to **Daniel Marot**. Those apart however, the most interesting items in the house are the **Chinese ceramics and jade**, including several earthenware figures from the T'ang dynasty.

WOBURN ABBEY 🏛
Bedfordshire Map C1

Tel. (052525) 666
Open Feb – Mar Nov Mon – Sun
 1pm – 4.45pm; Apr – Oct Mon – Sat
 11am – 5.45pm, Sun 11am – 6.15pm
Closed Dec – Jan
▨ ➷ ◨ 血 ♈

Featuring such attractions as a wildlife park and large antiques and pottery

sections, Woburn Abbey is England's most commercialized country house. You may find a visit here both expensive and not particularly enjoyable, for the scale of this mainly 18thC house is tiresomely large, and the crowds that file past the stately rooms make it difficult to enjoy the art collection. This includes a celebrated **Sèvres dinner service** presented to the 4th Duke of Bedford by Louis XVI, and paintings by such masters as **Eworth**, **Gainsborough**, **Van Dyck**, **Cuyp** and **Reynolds**. But if you want to see what are perhaps Woburn's finest paintings – a large and famous group of **Venetian views** ★ by **Canaletto** – you may be somewhat annoyed to find that you have to pay an additional fee.

WORTHING
West Sussex Map D5

Worthing, a popular seaside place of retirement, has a placid, suburban character appropriate for such a town.

Worthing Museum and Art Gallery
Chapel Road
Tel. (0903) 39999 Ext 121
Open Apr – Sept Mon – Sat 10am – 6pm;
 Oct – Mar Mon – Sat 10am – 5pm
Closed Sun
☎ ♡ ⊡

The Worthing Museum and Art Gallery, an unremarkable turn-of-the-century building, has on its ground floor principally items of local historical interest. Mounting the staircase leading to the first floor you will see at the top a very good collection of 18th and 19thC **Worthing glassware**. Adjoining this is a room containing the art gallery, which is frequently hung with loan exhibitions. As a result you may miss the gallery's permanent collection, which includes watercolours by **Rowlandson**, a marvellously intricate half-length portrait by **Holman Hunt** ★ of a woman in Renaissance dress playing a lute, and a number of works by 20thC British artists, such as **Ginner**, **Sickert**, **Ivon Hitchens** and **Keith Vaughan**.

LONDON

Few major cities are as difficult to get to know as London. Certain of its features, such as the views from the bridges of Westminster or Waterloo, and the celebrated parks that enable you to cross from one end of the central district to the other, make an immediate and deep impression. But compared to, say, Paris or Rome, London's beauty is not obvious because it lacks homogeneity. The capital consists of numerous distinctive areas, each with its own social and cultural identity, and each with places of interest often unknown even to many Londoners.

The oldest part of London, known as the City, ironically has the most modern appearance. You can still find traces of its ancient walls, built by the Romans, but virtually nothing remains of the medieval town, which was destroyed by the Great Fire of 1666. The rebuilt City was again almost totally destroyed by bombing in World War II, but St Paul's Cathedral and many other fine late 17thC and 18thC churches have miraculously survived the devastation. London's other area of early settlement, Westminster, developed after the 11thC, when King Edward the Confessor established his palace and an abbey by the Thames. The district expanded far from the river, and now incorporates the capital's shopping and entertainment district, the West End.

LONDON'S VILLAGES

London's economic life is based on the City, and its tourism revolves round the West End, but outside these areas you will find quieter and more charming enclaves which retain a so-called "village character" and have traditionally had a greater appeal for artists than the central districts. In the 18thC and early 19thC leading British artists tended to live by the Thames, near what was then the village of Richmond. By the mid 19thC Kensington had superseded it as the favoured residence for successful artists, but soon afterwards the neighbouring district of Chelsea, then an area of modest, somewhat dilapidated Georgian and Regency houses, began to attract the more avant-garde artists of the time. These included associates of the New English Art Club, an exhibiting institution set up in 1885 in opposition to the Royal Academy. By the turn of the century an area just to the N of the West End, Bloomsbury, began to find favour with artists, partly because of the presence here of London's liveliest art school, the Slade, and this district eventually gave its name to the writers, artists and intellectuals known as the Bloomsbury Group.

At the same time, artists were moving farther N, following the example of Sickert and his colleagues such as Bevan, Gilman, Ginner and Gore, who were among the first to take a pictorial interest in London's then less salubrious districts such as Camden Town, Highbury and Islington. In the 1930s Hampstead became the focal point of London's cultural and intellectual life, receiving many distinguished writers and artists who had fled the Continent to avoid Nazi persecution.

Today London lacks an area of really thriving artistic activity (though there are many artists working in the capital's run-down dockland area). Famous for its drama and music, the capital has ceased to play an important role in contemporary art. But what it does have to offer is an almost unrivalled range of museums stretching from the city's center to its peripheries. You will find major art treasures in galleries from DULWICH to Hampstead Heath (KENWOOD HOUSE) and, though you may feel reluctant to journey so far by bus or underground, an expedition to the outskirts will help you to discover a city that seems perversely to conceal so many of its charms.

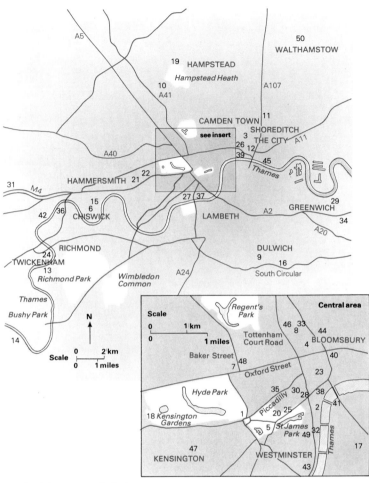

London museums and galleries

1	Apsley House (Wellington Museum)	26	The Museum of London
2	Banqueting House	27	National Army Museum
3	Barbican Arts Centre/Art Gallery	28	National Gallery
4	British Museum	29	National Maritime Museum
5	Buckingham Palace (The Queen's Gallery)	30	National Portrait Gallery
6	Chiswick House	31	Osterley Park
7	Courtauld Institute of Art	32	Palace of Westminster (Houses of Parliament)
8	Courtauld Institute Galleries	33	Percival David Foundation of Chinese Art
9	Dulwich Picture Gallery	34	Ranger's House
10	Fenton House	35	Royal Academy
11	Geffrye Museum	36	Royal Botanic Gardens
12	Guildhall	37	Royal Hospital, Chelsea
13	Ham House	38	Royal Society of Arts
14	Hampton Court Palace	39	St Paul's Cathedral
15	Hogarth's House	40	Sir John Soane's Museum
16	Horniman Museum	41	South Bank Arts Centre
17	Imperial War Museum	42	Syon House
18	Kensington Palace	43	Tate Gallery
19	Kenwood House	44	The Thomas Coram Foundation for Children
20	Lancaster House	45	Tower of London
21	Leighton House Art Gallery and Museum	46	University College
22	Linley Sambourne House	47	Victoria and Albert Museum
23	The London Transport Museum	48	Wallace Collection
24	Marble Hill House	49	Westminster Abbey
25	Marlborough House	50	William Morris Gallery

**Apsley House
(The Wellington Museum)** ☆
149 Piccadilly, W1
Tel. 499-5676
Open Tues – Thurs Sat 10am – 5.50pm,
Sun 2.30 – 5.50pm
Closed Mon Fri
◙ 🍴 🏛

Apsley House, known as "No. 1 London"
because it was once the first of a row of
aristocratic houses that a traveller would
see on approaching London from the
west, is now a solitary building
overlooking Hyde Park Corner and often
surrounded by heavy traffic. Originally a
relatively modest red-brick house built in
the late 18thC by Robert Adam, it was
transformed by the Duke of Wellington
in 1828 into a grand mansion befitting
someone who was then at the height of
his political career. Its lavish interior
contains various **memorabilia** relating to
the Duke as well as a remarkable group of
art treasures once owned by him.

The Duke made several important
purchases of 17thC Dutch paintings; but
the great majority of the works in his
collection came into his possession quite
by chance. They were found in a carriage
abandoned by Joseph Bonaparte (who
had been placed on the Spanish throne by
his brother in 1808) while fleeing from
Spain after being defeated by the Duke in
the Battle of Vitoria in 1813. It soon
emerged that these works had been stolen
from the Spanish royal collections. The
Duke immediately offered to return
them, but after a long period in which
there was no reply to this offer, the
Spanish Court allowed him to keep them.

Given the choice of the entire royal
collections (now the basis of the Prado in
Madrid) it is surprising that Joseph
Bonaparte did not choose to plunder an
altogether more distinguished group of
works. The Duke's immediate reaction to
the hoard was in fact to comment on the
number of indifferent Italian paintings
that it contained. This is certainly true,
though among these is a small but
exquisitely beautiful and atmospheric
painting by Correggio, *The Agony in the
Garden*★. Another jewel-like picture is
Judith and Holofernes★ by Adam
Elsheimer, a German painter active in
Rome in the early 17thC. Here the artist
has accentuated the drama of Holofernes'
beheading through the use of a nocturnal
candlelit setting.

Understandably, however, the
Spanish paintings at Apsley House
represent an especially impressive group.
There are fine works by Murillo (*Isaac
Blessing Jacob* and a *Portrait of an
Unknown Man*★), and **Ribera** (note in
particular the small, extremely bizarre,

The Carcase★ which shows a witch being
drawn to the Sabbath on the skeleton of a
monster, and is based on an engraving
after Raphael). Three paintings by
Velazquez constitute the outstanding
masterpieces in the collection: a portrait
of *A Spanish Gentleman*★ possibly José
Nieto, Chamberlain to Queen Marianna,
wife of Philip IV; *Two Young Men
Eating at a Humble Table*★, and *The
Water Carrier of Seville*★★. The last two
pictures were painted when the artist was
a youth in Seville, a period in his career
characterized by a love of dark interior
genre scenes with prominent still-life
details. *The Water Carrier of Seville*,
perhaps the greatest of all the artist's
surviving works from this period, portrays
an elderly Corsican water carrier (who
was a well-known character in the streets
of Seville) handing a glass of water to a
young boy, the model for whom was one
of the artist's studio hands. Quite apart
from its technical brilliance in the
rendering of still-life details, such as the
glass or the large ceramic pitcher with
water dripping down its side, the painting
is also a penetrating study of youth and
old age, contrasting the shy and
apprehensive face of the boy with the
worldly resignation expressed in the
features of the old man.

The other great strength of the Apsley
House collection is the **17thC Dutch
paintings**, in particular those by **Jan
Steen**, an artist who was no less
perceptive than Velazquez in his
observation of human behaviour, but
who expressed these perceptions in a
funny, sometimes bitingly satirical way.
One of the finest of his many paintings in
Apsley House is the *Dissolute
Household*★, a work full of subtle details
suggesting a world that has gone astray, as
when a monkey tampers with the
mechanism of an elegant wall clock. The
large *A Wedding Party*★, another study
of human folly, is less subtle in its
detailing, but is a wonderful reminder of
the purely pictorial brilliance of Steen's
art, combining with the complexity of its
lively composition a beautiful clarity in
the handling of paint and colour.

Among the various 19thC portraits in
the house, you should not miss a dramatic
full-length portrait by **Wilkie** of *William
IV*★. The Duke himself is represented in
various portraits, including a finely
observed half-length **portrait**★ by
Lawrence (which features on the British
£5 note) and an enormous, dark, and
slightly disappointing **equestrian portrait**
by **Goya**. Undoubtedly the most curious
portrait in the house is a nude statue of
Napoleon (1810) by **Canova**, which is so
colossal that it barely fits into the

staircase vestibule. Napoleon greatly
disliked this work, and also regarded as
ominous the detail of the winged victory
on the point of flying away from his right
hand. After being kept hidden in the
Louvre until 1816, it was bought by the
British government, and, perhaps with a
degree of intentional humour, presented
to Napoleon's great military rival.

Banqueting House ☆
Whitehall, SW1
Open Tues – Sat 10am – 5pm, Sun 2 – 5pm
Closed Mon
🔲 🕮 🏛

The Banqueting Hall is virtually all that
remains of the enormous royal palace of
Whitehall, which was destroyed by fire in
1698 (parts of the Tudor wine cellar are
to be found under the neighbouring
Ministry of Defence building). It was
built by **Inigo Jones** between 1619 and
1622, and was the first truly successful
assimilation in England of the Italian
Classical style, as represented principally
by the Renaissance architect, Palladio.
The light and spacious interior is notable
for its **ceiling canvases** ★★ by Rubens,
which were commissioned by Charles I
and installed in 1635. These
energeticallly painted and brilliantly
coloured works constitute perhaps rather
excessive praise for Charles's predecessor
James I: the central panel shows the
monarch ascending to heaven, while the
surrounding panels contain allegorical
subjects such as *The Benefits of the
Government of James I* and *The
Triumph of Royal Bounty*. Unlike many
ceiling paintings, you can enjoy these
works without straining your neck,
thanks to the thoughtful provision of a
mirror on a movable glass table, and,
better still, reclining armchairs.

Barbican Arts Centre/Art Gallery
Tel. 638 4141 (ext. 306)
*Open Tues – Sat 10am – 7pm, Sun
noon – 6pm*
Closed Mon
🔲 ▢

The Barbican Arts Centre, comprising
theatres, a concert hall and an art gallery,
is situated in an island of exclusive high-
rise residential blocks in the heart of
London's commercial district. Planned in
a moment of cultural euphoria in the late
1950s (though not opened till 1981), it
now seems a labyrinthine monument to
all that is pretentious, unadventurous and
misguidedly "tasteful" in contemporary
British architecture and design. The art
gallery here is devoted to important
temporary exhibitions; recent examples
include French art of the 1930s and 1940s
and a major retrospective of the work of

Matthew Smith. The gallery also shows
selections from the permanent collection
of the GUILDHALL for extended periods.

British Museum ☆☆
Great Russell St, WC1
Tel. 636 – 1555
*Open Mon – Sat 10am – 5pm, Sun
2.30 – 6pm*
📷 🕮 ▣ 🏛 ☑ ▢

*All the items mentioned here would rate at
least one star if found in another museum.
The system of starring outstanding works is
therefore not applied in this entry.*

The British Museum is in many respects
the expression of an age in which
territorial expansion and curiosity about
the world went hand in hand. Only
during the period of Britain's greatest
colonial power and influence could the
finest products of so many different
civilizations be gathered together to
create this museum of unparalleled range
and significance. Founded in 1753 from
the bequest of a physician, Sir Hans
Sloane, its expansion over the following
century, when many of its greatest pieces
were acquired (including the *Elgin
Marbles*, the *Rosetta Stone*, the
Hamilton collection of **Greek vases** and
most of the **Assyrian sculptures**) was
little short of astonishing. Thereafter
British colonial developments continued
to supplement the collection, notably in
the case of the **Benin Bronzes** from W.
Africa and the **Indian exhibits**, and
during the present century archaeological
expeditions, purchases, bequests and the
occasional treasure trove have been
responsible for its continued growth and
development.

The building itself, designed by
Smirke in the early 19thC, is something
of a national monument, partly because
of the architect's magisterial Grecian
façade, but equally because it has
incorporated the British Library, a
copyright library with immense and
constantly expanding stocks (it receives,
by law, a copy of every work published in
the UK). During the 19thC the library
was used by many famous scholars, and
the large circular **Reading Room** (for
members only) has entered the
hagiography of socialism as the place
where Marx toiled for nearly 30 years in
the preparation of *Das Kapital*. The
interior of the museum still has an air of
conservatism and authority, which seems
perfectly appropriate, and the displays in
general are clear and informative, at least
in the sections which have been updated.
The authorities have begun a programme
of renovations which some departments
have already undergone – the **Egyptian
gallery** and the **Wolfson Gallery** of

antique sculpture have both been reopened in the past decade following extensive remodelling. They have also tried to make the museum more accessible to the public in other ways, and there is an excellent publications department in the entrance hall offering books, pamphlets, slides and replicas. In addition, each department mounts a series of temporary exhibitions allowing a wider selection of items to be shown at any one time.

Since its foundation the museum has undergone several changes in its departmental structure, and some of the early departments such as Natural History or Ethnography have gone to form separate museums. However, you can see a reminder of the Ethnography collection on the main staircase in the superb group of **Benin Bronzes** which were confiscated by the British during a "punitive" expedition to Nigeria in the 1880s. At present there are 8 departments: Greek and Roman Antiquities, Prehistoric and Romano-British Antiquities, Egyptian Antiquities, Western Asiatic Antiquities, Oriental Antiquities, Medieval and Later Antiquities, Coins and Medals, and Prints and Drawings. These are spread throughout the building, some being split into two or three separate areas. This can be confusing, but the layout of the museum is relatively straightforward since, basically, it takes up two floors of a rectangle with a large rear extension.

The British Library, though it is not a department of the museum, and will soon be transferred to a new building, maintains apart from printed books for research a large display of treasures in the 5 galleries to the R of the entrance hall. Here you can see literary and historical manuscripts such as the **Magna Carta** and autographed letters of famous writers, and you should not miss the outstanding illuminated manuscripts on display, the finest of which is the *Lindisfarne Gospels*. Painted by a monk named Eadfrith on the Holy Island of Lindisfarne, this is the **outstanding masterpiece** of early English medieval art. In the same room are other impressive works, such as the *Benedictional of St Ethelwold*, the *Echternach Gospels* and the *Sherborne Missal*, as well as a comprehensive range of Oriental, Islamic, Hebrew and Indian manuscripts.

The Greek and Roman Antiquities (rooms 1–23 and 68–73).

The British Museum is still probably best known for its Greek and Roman collection, an area in which it remains pre-eminent. At the heart of the collection are the *Elgin Marbles*, sculptures that were carved by Pheidias (5thC BC) on the frieze and pediment of the Parthenon temple in Athens. They are the finest surviving examples of Greek Classical art. In fact the Parthenon remained virtually intact until an explosion in the late 17thC destroyed much of the building. Thereafter the fragments were left to deteriorate until Lord Elgin saved or appropriated (depending on your point of view) the finest pieces, bringing them to London where they are now displayed in a spacious gallery. The frieze was originally thought to depict the Panathenaic procession that was annually celebrated in Athens, but is now considered by some to be a representation of the heroes of the battle of Marathon (scene of the famous Greek victory over the Persian invaders, 490BC). This is perhaps the finest part of the collection, and despite some weathering the sculptor's subtle low relief has been well preserved. A small introductory room at the entrance to the Duveen Gallery provides background information with models and casts.

However, the Elgin Marbles are only the most famous items of an extensive collection that covers virtually all aspects of the Greek and Roman world, from the **Cycladic period** (c. 3000BC) to the final stages of the **Roman Empire** (late 5thC AD). The early rooms, which have undergone a recent reorganization, now display entire monuments as the focus of attention, and several of these have been completely reconstructed inside the museum. You can see this in the **Harpy Tomb** (room 5), the **Nereid Monument** (room 7) and the **Tomb of Payava** (room 10). Elsewhere the **Kouroi** (two fine 6thC BC statues of nude youths), the **Bassae Frieze**, the **caryatid** from the Erechtheion temple at Athens (c. 410BC), and the sculptures from the **Mausoleum at Halicarnassus** are given pride of place in separate rooms alongside related works from the same period. Moreover, the recently opened **Wolfson Gallery** provides an opportunity to see the **Townley collection** of antique sculpture for the first time in many years. Greek vases figure prominently throughout this whole section, notably those painted by **Douris**, **Exekias** and the **Berlin Painter**, but the bulk of this huge collection, part of which was presented by Sir William Hamilton, is displayed on the first floor.

The first major work in the Roman rooms, a blue and white glass jar known as the *Portland Vase*, was also given to the museum by Hamilton, and it soon came to have a huge influence on Neoclassical

decoration, particularly Wedgwood pottery. Following this you will see some **Pompeiian frescoes** of landscape scenes, **bronze and marble sculptures** and, in room 15, a **marble floor** from Saint-Romain-en-Gal in France.

The first floor galleries display further collections of Greek and Roman antiquities, most of which are arranged so as to describe the everyday life of the ancient world. This layout inevitably places greater emphasis on the minor arts (coins, bronzes, terracottas, etc.) but a new display entitled "The Image of Augustus" makes an interesting attempt to give **Roman portrait sculpture** a popular appeal.

Prehistoric and Romano-British Antiquities (rooms 35 – 40)

Appropriately placed beside the last of the Roman galleries, the Romano-British section opens with a large **mosaic pavement** from the Roman villa at Hinton St Mary in Dorset. You then enter a small series of rooms of mainly Celtic art, where the **jewelry**, ornamented **mirrors** and **armour** are of particular interest. There is also the famous *Mildenhall Treasure* comprising 34 pieces of silver tableware which were discovered in a field in Suffolk during World War II. The sophisticated relief decoration, particularly on the platters and the Great Silver Dish, suggests that they were imported from the Mediterranean.

Egyptian Antiquities (rooms 25 and 60 – 66).

The department of Egyptian Antiquities has recently undergone a major reorganization, and it is now one of the most striking and attractive sections in the whole museum. When you enter the main gallery (a large open space on the ground floor) you pass between two magnificent black granite statues of *Amenophis III* from the 18th dynasty (c.1400BC). Further on there is a display devoted to decipherment, centred on the famous *Rosetta Stone*. This black basalt slab, discovered by the French in 1799, has three separate scripts of the same text in Egyptian hieroglyphs, Demotic (everyday Egyptian) and Greek, as a result of which scholars were able to decipher the hieroglyph script of the ancient Egyptian civilization. The bulk of the main gallery, however, is taken up with tombs and monumental sculpture, especially the colossal *Head of Rameses II* (c. 1250BC) as well as a number of fine smaller pieces such as the granite statues of *Sesostris III* and the quartzite figure of a *baboon*. The central area is devoted to

an excellent collection of Egyptian **jewelry** and **figurines**.

There are more smaller items in the side gallery, including two beautiful mural fragments from the *Tomb of Nebamum* (a banquet and a hunting scene), an 18th dynasty *Royal Head* of green schist, and the gilded wooden inner coffin of the *Chantress of Amen-Re, Henut mehgit*.

These works represent a selection of the very finest pieces from the museum's extensive holdings, but you will also find a large number of other items such as the *Benson Head*, as well as some textiles, papyri and bronzes on the first floor galleries. Many of these have been arranged to illustrate different aspects of daily life in ancient Egypt: the tools and sketches, for example, give some insight into the working methods of early Egyptian artists. There is also a room of **mummy cases** with illustrative murals from the *Book of the Dead* and, in a more macabre vein, a desiccated corpse known affectionately as Ginger from the colour of its hair. The cult of the dead also gave rise to such works as the **Fayum Portrait**, executed in encaustic and used to decorate sarcophagi before burial. The Coptic Corridor has a selection of these works including that of *Artemidorus*, one of the finest in existence and also very well-preserved.

Western Asiatic Antiquities (rooms 16 – 21, 24, 26 and 51 – 59).

In comparison to Egypt and the Classical world of Greece and Rome the early civilizations of the Near East are still relatively obscure. The Sumerians, Babylonians, Persians, Hittites and Assyrians who flourished in Mesopotamia between 7000 BC and AD 700 never exerted much direct influence on the culture of Western Europe, which is why their art is relatively unfamiliar. Since the 19thC, however, major archaeological discoveries have fleshed out our knowledge and in the case of Assyrian sculpture brought to light works of the utmost sophistication. *The Lion Hunt*, for example, a long stone relief from the palace of Ashurbanipal at Nimrud (c.645BC), which depicts the king engaged in this royal sport, is a work of such artistry as to be comparable only with the Parthenon frieze of two centuries later. The lions are beautifully described in shallow relief across an expansive stone surface traversed by the king in his chariot. There are also three cycles of military reliefs recording the victorious campaigns of *Tiglath-pileser II*, *Sennacherib* and *Ashurbanipal*, but in terms of scale alone these works are

overshadowed by the monumental sculptures such as the huge **gateway from Khorsabad** with its human-headed winged bulls, and the **statue of Ashurnasirpal**, the founder of the Assyrian empire in the 9thCBC. There is also a reconstruction of the tall bronze **gates of Shalmaneser III**, which stresses the military character of most Assyrian art with reliefs of victories, processions and tribute bearers.

Most of the smaller items such as jewellery, pottery and arms, as well as sculpture in bronze, wood and ivory, are displayed in the galleries on the first floor (rooms 51–59) where there are also some examples of cuneiform ("wedgeshaped") script and cylinder seals. One room is devoted to early Sumerian art such as the **Goat and Tree Statuette** (c.2500BC) from the evocatively named "Great Death Pit" of the royal cemetery at Ur, but there is also a significant amount of Babylonian and Persian material in the **Oxus Treasure** of Achaemenian golden jewelry, most of which dates from the 5thCBC.

Oriental Antiquities (rooms 34, 74 and 75).

The bulk of the Oriental works are housed in one large gallery at the rear of the main building, where you can see the **Indian**, **Chinese**, **Korean** and **Islamic** antiquities. This collection, mainly of ceramics, sculpture and metalwork, is arranged by cultural region and, as you might expect, is richest in the works from the Indian subcontinent. The **Indian collection** here is probably the most comprehensive in the West, covering the period from the 3rd millennium BC to the 19thC, when the British were largely responsible for replacing many native traditions with their own. The **Buddhist sculptures** from Gandhara, including a unique **golden reliquary** from the 3rdC AD, are particularly interesting, but the rest of the collection maintains such a high standard throughout that it would be almost invidious to select any pieces for particular note. However, the general displays could have benefited from more overall attention, for their sheer size is often bewildering and there is very little attempt to explain the background or significance of various works. This aspect is better handled in the temporary exhibitions, generally of **Japanese**, **Chinese** or **Persian paintings** and **prints**, held in room 74 on the upper floor.

Medieval and Later Antiquities (rooms 41–47 and 71).

The title of this department is rather modest for an area covering the art and archaeology of Europe and other Judeo-Christian cultures from the early Christian period right up to the 20thC. The quality and sheer quantity of exhibits in this field defy any simple description, but the early rooms at least are undergoing a lengthy renovation that has forced the authorities to restrict some displays to only the most important items. Many of the Byzantine ivories are on exhibition, and you can also see the **Lothar Crystal**, the **Lewis Chessmen**, a number of medieval tiles, alabasters and enamels, and the 14thC *Royal Gold Cup* of the kings of England and France. The Anglo-Saxon treasures from the **Sutton Hoo ship burial** are also on display; these include a belt buckle, purse lid and reconstructed helmet that are among the finest examples of early medieval art to be seen in Britain.

In the Renaissance and later rooms the sophistication and refinement of the exhibits seem to be the most obvious characteristics; a reflection perhaps of the fact that ceramics, metalwork and jewelry had already been relegated to the rank of "minor arts" and therefore were required mainly for entertainment. Here the display in the British Museum is outstanding for its quality rather than its size, and contains nothing but the finest examples of the principal porcelain factories and goldsmiths' workshops. Among these you should not miss the **Nef** or **Ship Clock** of 1580, the *Lyte Jewel* from the Waddesdon Bequest with a miniature of James I by **Hilliard**, the **Stoneware bust of Prince Rupert** and the Wedgwood *Pegasus Vase* – all items of particular note.

Coins and Medals (room 50).

This was one of the earliest departments in the British Museum, but unfortunately the bulk of the huge collection is not on permanent display. Many items appear in the galleries of other departments and there is a survey of British coins and medals in room 50.

Prints and Drawings (room 67).

The collection of prints and drawings is one of the finest in existence as well as one of the most representative. Of the prints there are woodcuts, engravings and etchings from the earliest phase in the 15thC down to the present day, including virtually complete series of the work of **Dürer** and **Rembrandt**, while such later techniques as lithography are well represented in a large number of original prints and posters. British artists take up the largest part of the drawings collection, which incidentally includes

watercolours by **Turner**, **Girtin**, **Cozens** and **Cotman**, but all the greatest European artists are represented, including **Michelangelo**, **Raphael**, **Dürer**, **Lucas van Leyden**, **Rubens**, **Rembrandt**, **Claude** and **Watteau** being the finest.

These works are not on permanent display, but the gallery on the second floor holds regular temporary exhibitions illustrating different aspects of the collection. The entrance is marked by **Dürer's** monumental woodcut, *The Triumphal Arch of the Emperor Maximilian*, and in the gallery is **Raphael's** full-size cartoon for *The Madonna with the Tower* (the painting is in the NATIONAL GALLERY).

Buckingham Palace (The Queen's Gallery)

Buckingham Palace Rd, SW1
Tel. 930-4832
Open Special annual exhibition Tues – Sat and Bank Holiday Mondays 11am – 5pm, Sun 2 – 5pm
Closed Sun
🎦 📖 🗖

Buckingham Palace, though shielding a Regency building by John Nash, is essentially a monumentally pompous example of early 20thC civic architecture. The only part open to the public is the former chapel, which is now used as the Queen's Gallery. This puts on temporary exhibitions selected from the outstanding **works of art ★★** contained both in this palace and in the other royal residences such as WINDSOR, HAMPTON COURT and KENSINGTON PALACE . The present Royal Family has distinguished itself more by its devotion to horses than to art; but its predecessors assembled what is certainly the greatest private art collection in the world, with masterpieces from all the main European schools from the 16thC to the 19thC. In particular, the royal collection of **European drawings ★★** is among the largest and finest anywhere, public or private, with unique collections of works by **Leonardo**, **Holbein** and **Canaletto**.

Chiswick House

Burlington Lane, Chiswick, W4
Tel. 994-3299
Open mid Mar – mid Oct daily 9.30am – 6.30pm, mid Oct-mid Mar Wed – Sun 9.30am – 4pm
Closed Mon and Tues mid Oct-mid Mar
🎦 🚶 📖 🅿 🏛 🆑 ♨

A strong aura of Italy emanates from this delightful enclave of Chiswick where Chiswick House is situated. The gardens, laid out in the 18thC by **William Kent**, feature umbrella pines shading urns, sphinxes, and numerous Classical statues. In the middle of all this, attached to an earlier structure, is a **villa** (1725 – 9) closely modelled on Palladio's celebrated Villa Capra (the Rotunda) near Vicenza. Its original owner was also its architect, **Richard Boyle**, the 3rd Earl of Burlington. Lord Burlington, one of the most important British patrons of the arts of the early 18thC, turned to practising architecture after studying the works of Palladio in the course of his grand tour in Italy. The beautifully **decorated interior** of this house is mainly the work of his protegé, Kent: it contains a number of minor 17thC and 18thC paintings, one of the finest of which is a mythological scene (*Diana and Endymion ★*) by the contemporary Italian artist greatly patronized by Burlington, the Venetian painter **Sebastiano Ricci**.

Courtauld Institute of Art

20 Portman St, W1
Tel. 935 9292. Guided tours compulsory.
Open by appointment on weekdays out of term times.
📷 🏛

Built by **Robert Adam** in the early 1770s for the aged and eccentric Countess Home, the Courtauld Institute contains one of the best-preserved 18thC interiors in London. Its outstanding feature is the **staircase hall**, which is so tall that it gives the impression that the house must be bigger than it actually is. The staircase itself, perhaps the greatest of its period in England, is not only a masterly piece of engineering, but also has an exquisitely designed metal balustrade that reveals Adam's obsessive care with details. The main rooms have painted panels by **Antonio Zucchi** (later husband of Angelica Kauffmann) incorporated into delicately stuccoed ceilings. The most striking of these ceilings is that of the first-floor **Etruscan Room**, which seems originally to have been the bedroom of Countess Home. The ceiling here is one of the earliest important examples in Europe of the use of a decorative style derived from ancient Etruscan vases.

The industrialist Samuel Courtauld lived in the house 1927 – 31, and displayed here his celebrated collection of Impressionist paintings now in the COURTAULD INSTITUTE GALLERY in Bloomsbury. But the house still has some fine paintings of an earlier period, most notably works by the 17thC Italian artists **Solimena** and **Pietro da Cortona**. The building is now occupied by an art historical institute attached to London University, to which it was bequeathed after Samuel Courtauld's death. This was the first art historical institute in Britain, and remains to this day the best known.

The type of art history that it fosters has mainly been influenced by two of its best-known associates: Johannes Wilde, who encouraged the historian always to consider the original context for which the work of art was intended, and Anthony Blunt, who insisted on the application of common sense and clear English.

Courtauld Institute Galleries ☆☆
Woburn Sq, WC1
Tel. 580-1015
Open Mon – Sat 10am – 1pm, 2 – 5pm, Sun 2 – 5pm
⊙✓

This gallery, reached by a service lift, is on the top floor of a drab university building. But ignore this unpromising situation, for it is undoubtedly one of the major small galleries of Europe; and it is also a very pleasant place to walk around, being beautifully carpeted and with attractive old furniture. The gallery's name and reputation are due to the outstanding **Impressionist** and **Post-Impressionist pictures ★★** donated to it by the industrialist Samuel Courtauld, who also established the university's art historical institute at Portman Square. But the gallery comprises six other important bequests, with works ranging in dates from the 12thC to almost the present day. You will particularly enjoy being able to see so many good works in a gallery of small, untiring proportions; but these same restrictions of space also mean that only a tiny selection of the gallery's magnificent holdings can be shown at any one time.

Most of the earlier paintings in the collection are from the Gambier Parry Bequest, which comprises mainly **Sienese** and **Florentine works** from the 14thC and early 15thC. Some of these may be of minor importance and of dubious authenticity, but look for an important early work by Lorenzo Monaco – a *Coronation of the Virgin ★* (1390s) from the high altar of San Guggi in Florence. The Lee Collection takes this gallery's holdings into the 16thC and 17thC, and includes an *Adam and Eve* by **Cranach**, as well as a marvellous and unusual allegorical portrait by the Elizabethan artist **Hans Eworth** of the soldier and merchant adventurer *Sir John Luttrell ★*; the subject is portrayed half-naked and standing in a strong sea with his hand held out to a nude female figure perhaps representing peace. The painting is essentially an allusion to Luttrell's virtues; you can see fragments of mottoes in the background, one of which proclaims "the Constant Heart no Danger Dreddys nor Fearys".

Of the 17thC pictures from the Lee Collection, particular mention should be made of a small, extremely vivid **oil sketch** by Rubens for his famous *Descent from the Cross* in Antwerp Cathedral. No less than 32 paintings by **Rubens** are included in the most recent bequest to be made to the gallery, that of Count Seilern. Seilern was a wealthy Austrian who moved to England in the 1930s, and acquired a house at Princes Gate in London. His first interest in life was hunting, and a striking feature of his London house was its large group of hunting trophies hanging round the staircase. His friendship with the art historian and influential teacher Johannes Wilde radically changed his direction as a collector, and he began to accumulate perhaps the most important private art collection in London. The works range from a *Landscape with Flight into Egypt ★* by Pieter Bruegel and an *Entombment ★* by Campin to works by contemporaries such as **Kokoschka**. Seilern was special among collectors in having an impressively thorough knowledge of art history, particularly in relation to the works he owned. This may partly explain why many of his acquisitions, though by famous artists, often have a largely academic interest. Thus Rubens' copy of Raphael's famous portrait of *Baldassare Castiglione* is fascinating for the insight it gives into the way Rubens interpreted a painter of a completely different style to his. But it does not impress in the same way as, for instance, the Lee Collection's *Descent from the Cross*. But you cannot argue with the quality of Seilern's purchases when you see the splendid group of **oil sketches** by the 18thC Venetian artist **G.B. Tiepolo**, most notably the **five studies ★★** for the altarpieces commissioned from him for the Monastery Church of San Pascual in Aranjuez near Madrid. They were painted at the end of this artist's career, shortly after he had decided to continue working at the court of Madrid rather than to return to his native Venice, where he had left his family. As it turned out, his last years in Spain seem to have been the unhappiest period in his life. His privileged position within the court aroused the jealousy of other painters, and his last Aranjuez canvases were removed from the church for which they were originally intended and later dispersed and partially cut down in size. The sketches for them in the Seilern Collection remain the most impressive of the works of Tiepolo's Spanish period: featuring glimpses of the bleak Castilian plateau, and incorporating movingly

simple still-life details such as an old wicker basket, they have a quality of intense pathos and directness so removed in spirit from the ethereal *Apotheoses* of the artist's earlier years.

Count Seilern has a few late 19thC French pictures by artists such as **Pissarro** and **Cézanne**, but these are overshadowed by the French works of this period gathered by Samuel Courtauld. These represent perhaps the finest group of **Impressionist and Post-Impressionist paintings** ★★ to be seen in Britain. **Manet** is represented by an oil sketch for the *Déjeuner sur l'herbe* in the Louvre in Paris, and, more impressively, by one of his most outstanding and famous late compositions, the **Bar at the Folies-Bergère** ★★. You will see of **Pissarro's** work a wonderful oil of **Lordship Lane Station** ★, painted when the artist was in London to escape from the Franco-Prussian war. **Degas** stands out with a small and delicate *Dancers on the Stage* ★, and you should not miss **Renoir's** charming *La Loge* ★, a painting of a young girl at the theatre exhibited at the first Impressionist group show of 1874.

The Post-Impressionist works include a rather absurdly formal study of a young woman at a powder table by **Seurat** (the matronly subject was his mistress, Madeleine Knobloch), and a *Self-Portrait* ★ by Van Gogh painted in January 1889 shortly after he had cut off part of his ear. Incidentally, the Japanese prints hanging in the background of this work are now actually owned by the gallery. There are two paintings by Gauguin, *Te Rerioja* ★ (daydreaming), and the haunting *Nevermore* ★, once owned by the composer Delius. Of this work Gauguin wrote, "I wanted to suggest by means of a simple nude a certain long-lost barbarian luxury. The whole drowned in colours which are deliberately sombre and sad . . . as a title *Nevermore* is not at all the name from Edgar Allen Poe, but the bird of the devil that is on watch."

Finally mention must be made of Courtauld's wonderful **Cézannes**, the most impressive group of canvases by a single artist in the collection. These include *Still-life with Plaster Cast* ★, a superlative version of the *Card Players* ★ (he painted 4 other works on this subject at Aix in the early 1890s), and one of the finest of his many paintings of *Montagne Sainte Victoire* ★★, the favourite motif of his art. The most unusual of the paintings by Cézanne in the collection is the *Lake of Annecy* ★, a unique example of a late landscape by him that was not painted in Provence.

The emphasis on late 19thC French art and in particular Cézanne in the Courtauld Collection is due largely to the influence on Samuel Courtauld of his friend, the art critic **Roger Fry**, who played a major role in encouraging the appreciation in England of French art of this period: the Post-Impressionist exhibition which he organized in the Grafton Galleries in London in 1910/11 represented a key moment in the history of English art. Fry, a painter himself in a style strongly indebted to Cézanne, bequeathed to the gallery his own art collection, which includes much work by himself and other "Bloomsbury" artists. These include many examples of the now rather dated art objects produced by the Omega workshops, which were founded by Fry to bridge the gap between the fine and decorative arts. A selection from both the Fry Bequest and the gallery's enormous, wide-ranging holdings of **drawings** and **watercolours** (which include the Witt and Spooner collections) are shown in the end rooms of the gallery.

Dulwich Picture Gallery ☆
College Rd, SE21
Tel. 693-5254
Open Tues – Sat 10am – 1pm, 2 – 5pm, Sun 2 – 5pm
Closed Mon
📷 💟 🏛

Its history, its building and above all its paintings make Dulwich Picture Gallery one of the outstanding small museums in the country. Most unusually, this great collection of **Old Master pictures** is closely linked to a school, Dulwich College, and is set among fields even though it is only 4 miles from Westminster.

Most of the Dulwich collection was bought as a national gift for Poland. In 1790 Stanislas Augustus, the last Polish king, commissioned Noel Desenfans, a French picture dealer living in London, to assemble a suitable collection of pictures. By 1795 Desenfans had made some spectacular acquisitions, but in that year Stanislas was deposed and Poland ceased to exist as a kingdom. Desenfans was left with the pictures. He decided to leave them as a group to an institution which would look after them and show them to the public. Sir Francis Bourgeois, the Royal Academician who had the task of finding the right place, settled on Dulwich College, at that time a quiet, charitable foundation which already possessed some paintings (notably the curious Jacobean **theatrical portraits** left by William Cartwright in 1686). **Sir John Soane**, a leading architect at the time, who is also known for the Bank of England and the SOANE MUSEUM,

designed the unusual structure in a plain, almost primitive style, incorporating a mausoleum for the founders.

The interior of the gallery, with its pictures set off by fine **18thC** and **19thC furniture**, retains the character of an early 19thC museum with few visitors. The great strength of the collection is in its 17thC paintings, however. The two major Flemish artists of this period, **Rubens** and **Van Dyck**, are wonderfully represented. The former's *Landscape with a Shepherd and Flock* ★★ is one of the artist's finest, with a spontaneity and freshness that make you feel as if you are in the landscape yourself. Also superb are the artist's large group of **oil sketches** ★ here, including a study (*The Flight of St Barbara*) for one of the ceiling panels in the Antwerp Church of St Charles Borromeo, and a painting of his second wife, *Hélène Fourment* ★, sitting by a pool. Van Dyck, Rubens' pupil, is represented by a good and very dramatic example of his early work, *Samson and Delilah*, which was painted when strongly under his master's influence. The most striking of Van Dyck's later English works is a sombre portrait, painted in greys and whites, of *Lady Venetia Digby on her Deathbed* ★: the portrait was commissioned by her grief-stricken husband, Sir Kenelm Digby, and was painted exactly as she lay two days after her death, the only addition being the rose in her hand symbolizing the brevity of her life.

The high points of the French 17thC collection are a masterly late landscape by **Claude** (*Jacob with Laban and his Daughters* ★) and a group of pictures by **Poussin**. These range from a charming scene from Tasso's *Gerusalemme Liberata*, (*Rinaldo and Armida* ★), showing how sensual this artist could be in his early years, to the majestic *The Triumph of David* ★, a work inspired by processions portrayed in Classical sarcophagi. The extensive Dutch holdings are notable for their magnificent group of sunlit **landscapes** ★ by **Cuyp** and three paintings by **Rembrandt**: a portrait of his son *Titus*, a delightful if rather sentimental *Girl in a Window* ★, and a portrait of *Jacob de Gheyn III* which seems to be particularly admired by burglars (it has been stolen more than once).

The paintings by **Murillo** are another outstanding feature of the gallery. The finest of these are all genre scenes, a side to Murillo's art which met with particular success in 18thC and early 19thC England. The essayist Hazlitt considered the gallery's *Two Peasant Boys* ★ to be one of the 10 best paintings in the world. English art of this period is represented principally by the set of **Linley family portraits** ★ by **Gainsborough**, an artist who was deeply influenced by Murillo. Of the other 18thC works in the collection special mention should be made of two very vivid **oil sketches** ★ by the Venetian artist G. B. Tiepolo, intended as preliminary sketches for one of his most important Italian villa decorations, that he executed at the Villa Cordellina at Montecchio Maggiore near Vicenza.

Fenton House
Hampstead Grove, Hampstead, NW3
Tel. 435-3471
Open Mar Sat Sun 2–6pm, Apr–Oct
 Sat–Tues Mon 2–6pm, Wed 2–dusk
Closed Mar Mon–Fri, Apr–Oct Thurs Fri;
 Nov–Feb
🎫 🕮 🏛 ☑

Fenton House is situated in one of the quietest and most attractive parts of Hampstead. It is a small, red-brick house built in 1693, and occupying a charming walled garden. The chief feature of its pleasant, well-maintained interior is its collection of **early musical instruments**; but you will also find much else of interest, including **18thC furniture** and other objects of applied art, as well as a fine collection of **Chinese and Meissen porcelain**.

Geffrye Museum
Kingsland Rd, Shoreditch, E2
Tel. 739-8368
Open Tues–Sat 10am–5pm; Sun
2–5pm
Closed Mon
🎫 🕮 🏛

Situated in an area of considerable urban devastation, the buildings that house the Geffrye Museum are a charming survival. This group of early 18thC almshouses, arranged around a central courtyard, fulfilled their original function until as late as 1908, shortly after which they were converted into the museum. This comprises a series of authentically **furnished rooms** ranging from a panelled **Elizabethan Room** to a splendid **Art Déco** suburban "lounge" of the mid 1930s. A few paintings are shown in rooms of the appropriate period, including an excellent portrait by **Pompeo Batoni** of *John Monck* in the Late Georgian Room, which also boasts a mahogany writing table on which Jane Austen is said to have written *Mansfield Park*. One of the finest of the later rooms is named after the architect and designer **C.F.A. Voysey** (1857–1941), and here you can see some of his beautifully simplified **arts and crafts furniture**, displayed to maximum advantage.

Guildhall
Aldermanbury, EC2
Tel. 606-3030
Open Mon – Sat 10am – 5pm; May – Sept
Sun 10am – 4pm
Closed Sun Oct – Apr
☒ ▊ (by appointment only) ⬙ ⊞ ⫇
The Guildhall's late 18thC façade with
its bizzarre Gothic detailing shields a
much older building. The art gallery, in
an adjacent building, puts on temporary
and loan exhibitions of the work of
London artists and art societies.
Unfortunately, plans to make the gallery
suitable for showing the Guildhall's
excellent permanent collections of
British 19thC art have been temporarily
shelved; but selections can often be seen
at the nearby BARBICAN ARTS CENTRE.
Though this collection includes a large
and important oil sketch by Constable of
*Salisbury Cathedral from the
Meadows* ★, it is the Victorian subject
pictures that are the most memorable
works here, even if for reasons not always
connected with their artistic merit. Two
of the best of the Pre-Raphaelite
paintings are Holman Hunt's *The Eve of
St Agnes* ★ and Millais' *The Waterman's
Daughter* ★. Tissot attempts emotion in
his contemporary genre scenes, *Too
Early* and *The Last Evening*, while
Alma-Tadema brings the trivial
anecdotal qualities of Victorian art to his
three interpretations of ancient Rome in
The Pleading, the *Pyrrhic Dance* and
The Wine Shop.

Ham House
Petersham, Richmond
Tel. 940-1950
Open Apr – Sept Tues – Sun 2 – 6pm;
Oct – Mar Tues – Sun noon – 4pm
Closed Mon
☒ ⬙ �P (Apr – Sept) ⊞
Ham House, situated in wooded grounds
by the Thames, was built in 1610, partly
remodelled in 1637 – 8 and added to in
the late 17thC and early 18thC. Its
comparatively simple brick exterior with
stone dressing gives little hint of the
riches to be found inside. The interior has
preserved much of its splendid **original
decoration** and **furniture**, and contains
an impressively large collection of **17thC
and 18thC paintings** which is certainly
well worth a visit.
 The principal function of most of
these paintings is to enhance the
sumptuousness of the setting, and few of
them are particularly interesting in
themselves. The most impressive of the
rooms, the Long Gallery, was intended
initially more as a showpiece than as a
room to be occupied. The 20 portraits
that constitute this room's chief glory

include a fine group of works by **Lely**,
among which is the glowingly coloured
*Duchess of Lauderdale with a Black
Servant*; but the portraits are especially
striking when seen as a whole, and in
conjunction with their magnificent,
elaborately carved gilt frames of the late
17thC. Two curiosities in the house are a
pair of family portraits by **John Constable**
(a frequent visitor to the house), painted
early in his career.

Hampton Court Palace ☆
East Molesey, Surrey
Tel. 977-8441
Open May – Sept Mon – Sat 9.30am – 6pm,
Sun 11am – 6pm; Mar, Apr, Oct
Mon – Sat 9.30am – 5pm, Sun 2 – 5pm;
Nov – Feb Mon – Sat 9.30am – 4pm,
Sun 2 – 4pm
☒ ⇤ ▊ ⬙ �P ⊞ ⬙
The royal palace of Hampton Court, in
size the most impressive building on
London's periphery, occupies wonderful,
extensive grounds overlooking the
Thames. The turreted Tudor part of the
palace, begun in 1514, was built for
Thomas Wolsey, Archbishop of York and
later Lord Chancellor of England. Its size
and magnificence, coupled with Wolsey's
own ostentation, was a source of anger to
Henry VIII, to whom it was subsequently
handed by Wolsey in 1526, three years
before his fall, in a vain attempt to
appease the king. Henry VIII made
various additions to the palace, including
that of the Great Hall.
 The next important phase in the
building's history began after the
accession to the throne in 1689 of
William III, who called in England's
leading Baroque architect, **Christopher
Wren**, to design the enormous eastern
section of the palace, centred on the
Fountain Court. Most of the rooms to be
seen inside the palace today are in this
part of the building.
 To approach these from the palace
grounds you cross the Moat Bridge into
the magnificent Tudor Base Court, and
beyond into another courtyard
dominated at its far end by Wren's
Baroque building. As soon as you enter
you are confronted with an enormous
staircase well decorated on its walls and
ceilings with grandiose illusionistic
murals by the Italian painter **Antonio
Verrio**, who died in the palace in 1707.
The subject matter of these is extremely
complex, but probably contains obscure
political allegories intended to flatter
William III. At the top of the stairs is the
dauntingly large Guard Room, to the
right of which a series of small rooms
(The Wolsey Suite) opens into the Tudor
part of the palace. Here you will see

various 16thC paintings, one of the finest of which is a *Portrait of a Woman* ★ in a beautifully ornate floral dress by **Marcus Gheeraerts**, a Flemish painter active in England. After making your way back to the Guard Room, you begin your tour through the main state rooms. You may not find it an unreservedly enjoyable experience, for the succession of rooms seems interminable, and the rooms themselves are generally large, dingy and, though filled with many major paintings, possessing a curiously bleak character. If you decide to bring children with you to the palace, you would be best advised to leave them outside, where they can happily amuse themselves for an hour or so by trying to get out of the famous **18thC maze**.

The most important of the paintings in the palace's state rooms are almost all of Italian 16thC–18thC schools, among the earliest of which are fine works by Pontormo (*Virgin and Child*), Parmigianino (*Portrait of a Boy*), and Tintoretto (a superb *Esther and Ahasuerus* ★). A further group of Renaissance paintings, including not only Italian works but also important paintings by artists such as **Bruegel** and **Cranach** will soon be shown in a Renaissance picture gallery at present being laid out in the Tudor part of the palace.

The largest and in many ways the most outstanding group of Italian paintings to be seen in the state rooms are of the Baroque and Rococo periods. The high points here include a number of works by the leading Bolognese painter of the early 17thC, **Annibale Carracci**: look for his *Allegory of Time and Truth* ★ painted when Carracci was a young man in Bologna. The atmospheric effects and sensual handling of paint and colour clearly reveal his early debt to the art of the great Venetian Renaissance painter, Titian. Carracci's Bolognese contemporary, **Domenichino**, is represented at the palace by a magnificent *St Agnes* ★. The small but vivid landscape background recalls the artist's important role in the early history of landscape painting (he had a great influence on Claude Lorraine).

The Italian 18thC is represented here above all by the works of the Venetian painter **Sebastiano Ricci**. Ricci was an extremely uneven painter, whose notoriously promiscuous life no doubt contributed to the speed with which he always painted. The finest of his works in the palace is the *Continence of Scipio* ★, a work much indebted to Veronese, but painted with such vividness of colour and vigour of execution that the latter's work

seems almost cold in comparison.

But the most outstanding and renowned works of art at Hampton Court are not to be seen on a tour of the state rooms. These, a series of 9 large paintings by **Mantegna** of *The Triumph of Caesar* ★★ (c. 1486–92), are housed in the Lower Orangery, which can only be reached from the grounds of the palace. Like many of Mantegna's greatest works, they were painted for the Gonzaga family at Mantua, where the artist was court painter. The collapse of the Gonzaga family at the end of the 16thC led to the works being put on the market, and eventually, after stiff competition from other impressive potential buyers such as Cardinal Richelieu and Maria de Medici, they were acquired by Charles I. Their condition, poor even then, was further worsened when Verrio "restored" them at the end of the 17thC; by this century little could be seen of the original paintwork. However, thanks principally to the initiative of the then curator of the Queen's pictures, Anthony Blunt (who wrote an exceptionally informative booklet on the works on sale at the palace) the paintings were magnificently restored in the 1960s and 1970s. Though their colour has much faded, you can now once again appreciate them as among the greatest large-scale Italian Renaissance works to be seen outside Italy. And you can also see how, not only in their subject matter but also in their detailing, they pay eloquent Renaissance homage to the art of antiquity. In recognition of this, a small selection of Classical statuary, including a **sarcophagus** of the 2ndCAD on loan from the BRITISH MUSEUM, has been placed in the same room.

Hogarth's House
Hogarth Lane, Great West Road, Chiswick, W4
Tel. 994–6757
Open Apr–Sept Mon–Sat 11am–6pm, Sun 2–6pm; Oct–Mar Mon Wed Sat 11am–4pm, Sun 2–6pm
Closed Tues, Thurs Fri Oct–Mar
🄿 ⌂ ⌂ ♿

The artist Hogarth used this "little country box by the Thames" as a country villa from 1749 until his death in 1764. It is a charming Queen Anne house, but the charm is slightly marred today by the presence of the busy Great West Road (though no doubt Hogarth would have benefited from this by turning his satirical gifts to the observation of the violent, irrational behaviour of people caught in traffic jams). The simple interior of the house contains many of the artist's famous engravings, including

the series *A Harlot's Progress* (1732),
Marriage à la Mode (1745) and *An
Election* (1755–8).

Horniman Museum
London Rd, Forest Hill, SE23
Tel. 699–1872/2339/4911
*Open Mon–Sat 10.30am–6pm, Sun
 2–6pm*
📷 🏛 🖭

The Horniman Museum, an interesting
Art Nouveau structure built in 1901 by
C. Harrison Townsend (the architect of
the Whitechapel Art Gallery), is named
after its founder, Frederick J. Horniman,
a tea importer who in the course of his
numerous exotic travels assembled this
remarkable collection. It is primarily
ethnographic, though including also
some natural history items, and has a
number of fine works. The character of
the place is like that of an old-fashioned
provincial museum, with a crammed but
excellent display of an extraordinary
variety of objects, ranging from the
exposed brain of a cat to a beautiful
Aborigine sand painting ★ Such works
greatly influenced American abstract
Expressionists such as Jackson Pollock.

Imperial War Museum ☆
Lambeth Rd, SE1
Tel. 735–8922
*Open Mon–Sat 10am–5.50pm, Sun
 2–5.50pm*
📷 🏛 🖭 🏛

The Imperial War Museum was founded
shortly after World War I to
commemorate the dead with a display of
relics from that war. Since then its scope
has been expanded to cover all wars since
1914 that have involved Britain or the
Commonwealth. The imposing but
rather grim building that it occupies
incorporates an early 19thC structure
which originally formed part of the
Bethlehem Hospital for the Insane, the
original "Bedlam". (One of the inmates
of this famous hospital was the celebrated
Victorian painter of fairy scenes, **Richard
Dadd**, who was incarcerated here for
murdering his father).

Art and war are generally regarded as
diametrically opposed activities. It might
thus come as a surprise to find that the
museum has an outstanding collection of
20thC British art, much of it
commissioned by the War Artists'
Advisory Committee, which to this day
sends artists to the front to record the
activities of British soldiers.
Unfortunately, this cramped, clumsily
arranged museum has space to show only
a tiny fraction of this collection. At
present funds are being raised to pay for a
large new extension, in which the

pictures will be properly housed. The
paintings on display usually include two
large works hung at the top of a staircase
leading to the ground floor, Sargent's
Gassed (a depressing work both formally
and in terms of its subject) and, a more
impressive piece, *The Battery Shell* by
the Vorticist painter Wyndham Lewis.
The futuristic, machine-like forms of the
Vorticists seem particularly suited to the
representation of the inhumanity of war,
and another of the more striking
paintings in the collection is *Marching
Men* (1916), by Lewis's Vorticist
companion, **C.R.W. Nevinson**.

Stanley Spencer, one of the few
artists to commemorate the more human
aspects of war (most notably in the
Sandham Memorial Chapel in
Burghclere, see *SOUTH EAST ENGLAND*)
is represented by a series commissioned by
the War Artists' Advisory Committee,
Ship-Building on the Clyde ★. Sadly,
these intriguing, obsessively detailed
works are rarely shown for lack of space.
Instead you can see another rather less
interesting work by him, *The Tranvoys
Arriving with Wounded at a Dressing
Station at Smol, Macedonia* (September
1916). Of greater power is a large
painting by Spencer's friend Henry
Lamb, *Irish Troops on the Judaean Hills
Surprised by a Turkish Bombardment* ★,
a work combining intensely human
observation with an almost apocalyptic
vision. Among the numerous works here
by a remarkable cross-section of Britain's
leading artists of this century, look for
two by artists who are today little known:
a portrayal of Sir Ernest Gower and others
in the *London Regional Civil Defence
Control Room* ★, by Meredith Frampton
(a major artist in the 1930s who was
almost completely forgotten until a
recent retrospective at the Tate Gallery),
and a black wooden sculpture of
Mussolini by the obscure **R. Bertellini**, a
completely abstract work which
nonetheless brilliantly captures the
physiognomy of the dictator.

Yet ultimately the finest war artist to
emerge from the museum's collection is
Paul Nash. His *We are Making a New
World* ★, and, above all, *The Menin
Road* ★★, are not simply representations
of a devastated no-man's-land. They
have a mystical intensity which
transcends the reality of war:

Kensington Palace
Kensington Gardens, W8
Tel. 937–9561
Open Mon–Sat 9am–5pm, Sun 1–5pm
📷 🏛 🐾

Kensington Palace is a Jacobean mansion
of c.1605 which was remodelled by **Sir**

Christopher Wren and **Nicholas Hawksmoor** after 1681, when the place was acquired for the 2nd Duke of Nottinghamshire by William III. Today it is the home of Princess Margaret, but a large section is open to the public. One of its most attractive features is its situation in the middle of Kensington Gardens, now one of London's finest public parks but originally the private grounds of the palace. The interior is on a more pleasant and intimate scale than that of the main royal residences which can be visited, WINDSOR and HAMPTON COURT, but few of the rooms have any great personal charm. Much of the interior was refashioned in the 1720s by the architect and painter **William Kent**, who was responsible for the various large-scale decorations on walls and ceilings, most notably those on the King's Grand Staircase. Two of the finest of the many paintings here are in the long King's Room. One is an outstanding *Self-Portrait* ★ by the 17thC artist **Artemisia Gentileschi**. This artist acquired much notoriety in her time for alleging that she had been raped by the decorative painter, Agostino Tassi. The self-portrait in the palace shows her to have been an outstanding artist who painted with remarkable vigour and spontaneity. The other is **Van Dyck's** vividly composed and coloured *Cupid and Psyche* ★. The model for the voluptuous and very life-like Psyche was possibly the artist's mistress Margaret Lemon, who was known for the wild fits of jealousy that once led her to try and bite off one of the artist's fingers to prevent him from painting again.

In Queen Victoria's Bedroom (the room where the young Victoria was woken up to be told of the death of her uncle and of her accession to the throne) and in two adjoining rooms are a number of 19thC English paintings, many of which were given to Queen Victoria as birthday presents by Prince Albert. Of particular note are the *Eve of the Deluge* by the visionary Newcastle artist **John Martin**, and three narrative works by the Irish painter **Maclise** (*Midas*, *Gil Blas*, and *Scene from Undine*).

Kenwood House ★★
The Iveagh Bequest
Hampstead Lane, NW3
Tel. 348–1286
Open Apr – Sept 10am – 7pm; Oct – Mar
10am – 5pm or dusk
⬛ 𝑘 ♨ ▯ 🏛 ☑ 🌱
If you have time to spare, the finest approach to Kenwood House is from Hampstead Underground station up to Whitestone Pond and then right across

the hilly and wooded Hampstead Heath. Soon you begin to feel that you are miles from London and in the heart of the countryside. Towards the end of the walk you might think yourself in the 18thC. Your first glimpse of the house is from the top of a hill where it appears as a distant white structure rising above trees. As you get closer, and into the grounds laid out by the distinguished 18thC designer **Humphrey Repton**, you can see that the house stands on top of a lawn sloping gently down to a lake with a folly bridge. The house, a 17thC structure remodelled in the late 18thC by **Robert Adam** and with later additions, has a light and well-restored interior with beautiful views down to the lake, and contains marvellous examples of Adam's decorative work. Note in particular the library, which has the most delicate plasterwork ceiling with roundels by **Antonio Zucchi**. The setting could hardly be better or more relaxing for one of London's finer small collections of paintings, most of which were acquired in the 1880s and 1890s by Lord Iveagh, who bought the house in 1925.

Holdings of 17thC Dutch art at most English houses usually consist of a group of pleasant but generally unremarkable small landscapes and genre scenes. But at Kenwood almost all the paintings on display are of exceptionally high quality. Certainly few places of its kind can boast having excellent examples of the art of **Frans Hals** (a small, characteristically informal portrait of *Pieter van der Broecke* ★), Vermeer (*The Guitar Player* ★) and Rembrandt (*Self-Portrait* ★★). The latter work is indeed one of the greatest self-portraits of the artist's old age: the power of this large half-length composition is strengthened by two segments of circles painted on the background, which have been the subject of much scholarly debate and might possibly have some hidden, perhaps masonic, significance.

Appropriately for the setting, the great majority of the gallery's paintings are of the 18thC. These are fine works by such artists as **Guardi, Bellotto, Panini** and **Boucher,** you should on no account ignore the English paintings of this period. Few other places beside Kenwood offer such an excellent opportunity to look at the work of the leading **English 18thC portraitists**. It is interesting to note how so many of the magnificent portraits in the collection flatter the sitters by cloaking them in some fantastical guise. Romney shows *Lady Hamilton* ★ as a simple country girl at the spinning wheel, while **Reynolds** portrays *Mrs Musters* ★ as the Greek

goddess Hebe, and Kitty Fisher (a daughter of the 3rd Duke of Marlborough said to have died "a victim of cosmetics") as **Cleopatra** ★ about to dissolve one of her pills in a glass of vinegar. Among the many outstanding portraits you may particularly enjoy those by **Gainsborough** in the Music Room, especially the full-length *Mary, Countess Howe* ★★. This, like the other portraits by Gainsborough in the room, is a late work. Painted in an impressive range of silvery greys, it shows the artist fully in command of a remarkable technique involving a daringly free handling of paint which, on closer inspection, seems just a mess of brush strokes, but which from a distance creates effects of the utmost subtlety.

Lancaster House
Stable Yard, St James's, SW1
Tel. 839–3488
Open Apr–Nov Sat Sun 2–6pm
Closed at times for special functions
📷 ⛩ 🏛

This grand early 19thC house has a sumptuous Victorian interior, and is hung with a changing selection of mainly 17thC portraits from the government's picture collection, as well as minor works on loan from the National Gallery and elsewhere. They include paintings by **Van Dyck, Fetti, Teniers the Younger** and **Pozzoserrato**. Two major paintings in the house are both incorporated into the ceiling: a *Cupid and the Three Graces* by **Veronese**; and, the more important of the two, **Guercino's** powerful and dramatic *Assumption of St Chrysogonos* ★ (1622), originally in the church of that name in Rome.

Leighton House Art Gallery and Museum ✩
12 Holland Park Rd, Kensington, W14
Tel. 602–3316 (Curator)
Open Mon–Sat 11am–5pm Mon–Fri
* 11am–6pm (during exhibitions)*
Closed Sun
📷 𝄪 ⛩ 🏛 ☙ ⚶

The younger and more progressive British artists of the late 19thC tended to live in Chelsea or Bloomsbury, but the older, more established ones favoured Kensington, in particular the streets around Holland Park. This area is full of grand studio residences that once belonged to successful Royal Academicians, among which Leighton House (adjoining the house and studio of another leading late Victorian painter, Val Prinsep) is the most important of those open to the public. Built for the painter **Lord Leighton** in 1866 by George Aitchison, and now a museum to this artist, it is one of the most magnificent

surviving **High Victorian interiors** in London (see p. 7). The atmospherically lit **inner hall**, with its rich tiles and mosaics and a case containing a stuffed peacock, is striking enough. But the tall **Arab Hall** ★★, a recreation of a Moorish interior based on drawings made by Aitchison in the S of Spain, is even more splendid. Here a pool with a single jet fountain stands in the middle of a marble and mosaic floor, above which tiles and mosaic friezes in dazzling blues, coppers and whites are illuminated by the light from stained glass windows and latticed wooden screens. Though some of the ornamentation is genuinely old and Arabian (a number of the tiles were gathered by Lord Leighton on his travels), most of it was the work of the leading High Victorian decorators, **William de Morgan** and **Walter Crane**.

The other rooms in the house are filled with **paintings** by **Lord Leighton** and his Victorian contemporaries. Many of these are on loan, and the selection and display of works in the house, particularly on the first floor where the artist's studios are to be found, are subject to change. Leighton was one of the main artists associated with the so-called "Victorian High Renaissance". This group of artists was obsessed with the exotic and the distant past, in particular ancient Greece. They borrowed the forms of ancient Greek art, as well as illustrated scenes from the life of ancient Greece (sometimes as an excuse to create thinly veiled pornography). One of the finest works by Leighton at present in the house (it is on long loan) is *The Syracusan Bride*, a characteristically sensual work in the form of a Classical frieze. Other paintings by like-minded Victorian artists in the museum include a palely coloured *Renaissance of Venus* by **Walter Crane**, several works by **Burne-Jones**, and the rather overblown "*For he Had great Possessions*" by the artist once hailed as "England's Michelangelo", G.F. Watts, a close friend and neighbour of Leighton.

Linley Sambourne House
18 Stafford Terrace, W8.
Tel. 994–1019 (The Victorian Society)
Open Mar–Oct Wed 10am–4pm, Sun
* 2–5pm*
Closed Mon Tues Thurs Sat; Nov–Feb
📷 𝄪

LEIGHTON HOUSE is the more splendid and important of the two artist's houses in Kensington that you can see, but the recently opened Linley Sambourne House is a place of more human character. This was the home from 1874 to his death in 1910 of Edward Linley

Sambourne, the chief political cartoonist for the magazine *Punch*. Here you will find an interior that has been virtually untouched since the Victorian and early Edwardian periods, even down to the marvellous fittings in the downstairs lavatory. The walls are close-hung with drawings and prints by Sambourne, and with paintings and drawings by his Victorian associates such as **Kate Greenaway, Luke Fildes, E.A. Abbey, Birkett Foster**, and **George du Maurier** (the author of the famous novel of Parisian art life, *Trilby*). Among the various personal memorabilia that greatly enhance the house's intimate character is a fan signed by some of du Maurier's distinguished artist friends: Alma-Tadema, Frith, Millais and Watts.

The London Transport Museum
Covent Garden, WC2
Tel. 379–6344
Open Mon–Sun 10am–6pm
🖼 🕩 🄿

The Victorian complex that was once the Covent Garden Flower Market, and is now the lively focus of London's fashionable young, contains the beautifully displayed and extremely popular London Transport Museum. Here you can see some of the museum's enormous **collection of posters**, either incorporated within its historical displays, or arranged on two large wall areas. Between December and May the selection is augmented by a special poster exhibition devoted either to a special theme such as zoo posters, or to an individual artist.

The great age of London's transport art was the 1920s and 1930s, when leading British artists such as **Graham Sutherland, Paul Nash** and **Edward Bawden** produced designs of remarkable inventiveness that also have a strong surreal character. The most famous artist working principally in this medium during this period was the American **Edward McKnight Kauffer**, who designed atmospheric views of the London Underground. Full-sized reproductions and postcards of a large number of the posters in the collection are on sale here.

Marble Hill House
Richmond Rd, Twickenham
Tel. 892–5115
Open Feb–Oct Mon–Thurs Sat Sun
* 10am–5pm; Nov–Jan Mon–Thurs Sat*
* Sun 10am–4pm*
Closed Fri
🖼 🕩 🏛 🄲

Occupying a large park overlooking the Thames, this elegant Palladian house was built in the early 18thC for George II's mistress, the Countess of Suffolk, and was later lived in by George IV's "secret" wife, Mrs Fitzherbert. The interior is more interesting for its architecture and **18thC furnishings** than for its paintings, which comprise mainly minor British works, including ones by **Reynolds, Thornhill** and **Richard Wilson**. The Dining Parlour provides a charming, intimate space for small temporary exhibitions, which are frequently devoted to 18thC art and architecture. When these are not on, the space is taken up by an exhibition of photographs and texts on the theme of Palladio and his English imitators.

Marlborough House
Pall Mall, SW1
Tel. 930–2100
Open By prior arrangement. Also Queen's
* Chapel Open Mon–Fri by arrangement*
* with the Administration Officer*
🖼 ⫻ 🕩 🄿 🏛

Marlborough House, one of a number of grand buildings flanking St James's Palace, is a red-brick mansion built by **Sir Christopher Wren** for the Duke of Marlborough in c.1705, though altered in the late 19thC when occupied by the future Edward VII. The large early **18thC murals** by **Laguerre** in the tall Blenheim Saloon and around the E staircase, representing the Duke of Marlborough's various military victories, are a main feature of the interior. On the ceiling of the **Blenheim Saloon** is an impressive though partially damaged decoration by the Italian Baroque artist **Orazio Gentileschi**, originally painted for the ceiling of the Queen's House in Greenwich. The central roundel depicts *Peace Surrounded by the Liberal Arts and the Virtues*. Among the other paintings in the house are a group of fine **Gainsborough portraits** (on loan) in what is now the Prime Minister's Conference Room.

The Museum of London
London Wall, EC2
Tel. 600–3699
Open Tues–Sat 10am–6pm,
* Sun 2–6pm*
Closed Mon
🄾 🕩 🄿

The Museum of London is in the heart of the City and adjoins some of the major surviving remains of the Roman Wall. It is a far livelier, more excitingly modern place than the nearby BARBICAN CENTRE with its imaginatively displayed collections, which include numerous archaeological items, furniture, furnishings, and other objects illustrating

different periods in London's history. The costume collections are particularly fine, and there are also a few paintings and sculptures, including a bust of a man by **Roubiliac**, and a charming painting by **Francis Hayman**, showing the actors Garrick and Hannah Pritchard in *The Suspicious Husband* (1747).

National Army Museum
Royal Hospital Rd, SW3
Tel. 730–0717
*Open Mon – Sat 10am – 6.30pm, Sun
2 – 4.30pm*
▨ 𝒳 ▣
You will find a small art gallery on the second floor of this modern museum adjoining a large military barracks. The paintings (some of which are on loan) are all of the 17thC to early 19thC British school, and mainly represent battle scenes or portraits of military figures. The works are in general of mediocre quality, though such important artists as **Romney**, **Lawrence**, **Reynolds** and **Wootton**, are included. Perhaps the most striking painting is a flamboyant full-length portrait by **Beechey** of *Captain John Clayton Cowell*.

National Gallery ☆☆
Trafalgar Sq, WC2
Tel. 839–3321
Open Mon – Sat 10am – 6pm, Sun 2 – 6
▨ 𝒳 ▥ ▣ ⏛ ☑
All the items mentioned here would rate at least one star if found in another museum. The system of starring outstanding works is therefore not applied in this entry.
The National Gallery is one of the smallest of the great European galleries. It is nevertheless the most comprehensive and you cannot fail to be impressed by the consistently high quality that is maintained over all aspects of the collection. This is its exceptional feature, and the reason why it is not only an outstanding gallery but also a real pleasure to visit.

It is also one of the youngest of the major galleries, founded in 1824 to display a collection of 38 Old Master paintings which the government had purchased from the estate of John Julius Angerstein. From this nucleus the collection quickly grew in size as a result of bequests and further purchases, and within a decade larger premises were required. **William Wilkins** won the commission to design a new building overlooking Trafalgar Square, and it is a measure of his success that the façade has retained its traditional authority while the interior has proved to be adaptable to the requirements of sparse modern

displays. The rooms are spacious and well lit without the intrusion of over-elaborate period decoration of the kind that detracts from many 19thC galleries. It has not remained unchanged, however, and there are controversial plans for a major new extension to be built to the W of the main building which will greatly enlarge the exhibition space. Even now, however, the bulk of the collection is on permanent display either in the main galleries or in the reserve collection in the basement which is also open to the public.

There are two entrances to the gallery, with the main one on Trafalgar Square leading in to the vestibule with unusual mosaic pavements by the Russian artist **Boris Anrep**. Beyond this is an excellent bookshop and publications department, which stocks catalogues of virtually the whole collection at surprisingly modest prices, as well as a range of other books.

The collection itself is divided into national schools, beginning with the Italian School to the left of the vestibule.

The Italian school
Traditionally regarded as the backbone of European art, at least in the Renaissance period, the Italian school is the largest of any group in the collection, occupying the first 14 rooms of the gallery and two more besides. The works are displayed in approximately chronological order, beginning with the Trecento masters **Giotto** and **Duccio**, although in the later rooms attention is focused on particular individuals or local schools. Here you will see a panel of *The Pentecost* attributed to Giotto, but you may feel that Duccio, the founder of the Sienese school, is better served by an attractive small *Virgin and Child* and three panels from the predella of his greatest work, the *Maestà* of 1308 – 11. *The Anunciation* and *The Transfiguration* by the same artist emphasize not only his dependence on Byzantine art but also the strong narrative sense that characterizes his finest work. In the following room you can see work by the two leading Sienese painters of the 15thC, **Sassetta** and **Giovanni di Paolo**. *The Wilton Diptych*, an Anglo-French work of the late 14thC, is also displayed in a recess at the edge of this first room. Finer in its execution than many of the Italian pictures, the detailed treatment of the costumes is typical of northern International Gothic art. The reverse of the panels also has attractive heraldic animals painted in tempera.

With the 15thC works the authorities have tried to keep together the more decorative "Gothic" pictures in the earlier rooms, placing Uccello's *St*

George and the Dragon and *Battle of San Romano* alongside Pisanello's more flamboyant *Virgin and Child with SS George and Anthony Abbot* and *Vision of St Eustace*. It is with Masaccio's robust *Madonna and Child*, the central panel of the now dispersed Pisa Polyptych, that the full Renaissance manner is established, and thereafter the bulk of the Italian works have a clearer identity. You will find most of the leading painters of 15thC Florence here, notably **Pollaiuolo** (*The Martyrdom of St Sebastian*), Filippo Lippi, Baldovinetti, Verrocchio, **Piero di Cosimo** (*Mythological Subject*) and **Filippino Lippi** but look for the particularly strong groups of works by both **Piero della Francesca** and **Botticelli**. Here you can see Piero's large *Baptism* and an unfinished *Nativity*, while the selection of Botticelli's pictures includes *Venus and Mars*, a panel from a wedding chest or *cassoni* that may have belonged to Simonetta Vespucci (the model for many of his works), and the *Mystic Nativity*, one of his finest late paintings.

The **Venetian** and **North Italian** pictures of this period represent one of the great strengths of the collection overall, including several works by each of the three principal figures: **Mantegna** (an altarpiece of the *Madonna and Child with the Magdalene and St John the Baptist* and *Samson and Delilah*); **Bellini** (*Portrait of Doge Leonardo Loredan*, the *Pietà* and the *Madonna of the Meadow*); and **Antonello da Messina** (*St Jerome in his Study*). Mantegna and Bellini were related by marriage and probably worked together during the 1450s, but their styles developed along different paths, as can be seen from their separate versions of *The Agony in the Garden*, both of which are outstanding. A less well-known strand in North Italian art is represented by the work of **Crivelli**, **Tura** and **Costa**. British collectors of the 19thC showed a taste for the work of this group, which accounts for the number and quality of their pictures in the National Gallery, particularly the *Anunciation* and the 13 panels of the *Demidoff Altarpiece* by Crivelli.

The High Renaissance is introduced by Leonardo's *Cartoon*, a full-sized preparatory study for an altarpiece of the *Madonna and Child with St Anne and St John the Baptist*. This work was largely ignored until the threat arose in the 1960s that it might be sold abroad. Saving it for the nation immediately became a big issue and since its acquisition it has been displayed in its own shrine-like setting in room 7. The gallery has another work by **Leonardo**, the disputed second version of

the *Madonna of the Rocks* (the first version is in the Louvre), and two even more disputed works by **Michelangelo**, but the most substantial body of Italian 16thC pictures is a group of 5 works by **Raphael**, including the early *Mond Crucifixion* and *Ansidei Madonna*. There are also several outstanding works by contemporaries of these artists in Rome, particularly Sebastiano's *Raising of Lazarus*, painted under the encouragement of **Michelangelo**, and **Bronzino's** refined and highly erotic *Allegory*.

Dominating the **Venetian High Renaissance** gallery (room 9) is a magnificent series of oil paintings by **Titian** spanning the complete range of his lengthy career. From the early religious work, *Noli me Tangere*, to the small *Madonna and Child* painted in the last decade of his life, you can see examples of his portraits, altarpieces and mythologies (*poesie*) including the large *Bacchus and Ariadne* which was originally hung in the studio of Alfonso d'Este at Ferrara. This room also contains Giorgione's *Landscape with Saints*, Tintoretto's *Creation of the Milky Way* and Veronese's *Family of Darius Before Alexander*, the artist's greatest mythological work revealed in all its sumptuous colour as a result of a recent cleaning. Room 14 displays a further group of Italian paintings from the early 16thC, the North Italian schools and, in particular, the work of the two Parmesan masters **Correggio** and **Parmigianino**. Correggio is undoubtedly one of the most sensitive painters of this period, as you can see in the *School of Love* and the beautiful *Madonna of the Basket*, but something of the same quality is found in Parmigianino's unusual *Vision of St Jerome* painted (according to Vasari) during the hostilities which led to the Sack of Rome in 1527.

The Italian school of the 17thC is located in the appropriately grand setting of room 37, where **Guido Reni's** large *Adoration of the Shepherds* is displayed in the heavy architectural framework of a full Baroque altarpiece. On the side walls you will see further examples of this school, the finest being **Caravaggio's** dramatic *Supper at Emmaus* and Annibale Carracci's *Quo Vadis*, but do not miss a very good picture from the same period of *A Man Holding an Armless Statuette* by an unknown painter.

To see the 18thC Italian works you must go to room 34, where an impressive range of pictures covers all aspects of Italian art in the period. From a large group of Venetian scenes by **Canaletto**,

The Stonemason's Yard is probably the finest, and the same artist's period in England is reflected in a good view of *Eton College*. Elsewhere in the room there are works by **Batoni**, **Giordano**, **Guardi** and **Longhi**, but the most outstanding are those by **Tiepolo**, the greatest Italian painter of this period and the last exponent of the Venetian Renaissance tradition. Look for his *Allegory with Venus and Time*, originally in the Ca'Contarini in Venice but discovered, somewhat improbably, in 1969 on the ceiling of a house in London.

The Early Netherlandish and German schools (rooms 23–25).
Early Netherlandish or Flemish paintings of the 15thC first became popular in Britain at the time of the National Gallery's foundation, which explains why the most important picture in this area, Jan van Eyck's *Arnolfini Marriage*, came to be acquired in the gallery's first few years. Thereafter the holdings in this school steadily expanded until virtually all the principal painters were represented. Apart from the Arnolfini painting you can see two excellent portraits by van Eyck, (*A Young Man – "Leal Souvenir"* and *A Man in a Turban*); a Madonna by **Robert Campin**, four works by **Rogier van der Weyden**, including *St Ivo* and a fragment of the *Magdalene Reading*, and various other works by **Bouts**, **David**, **Christus**, **Bosch** and **Breughel**. **Memling** too has been popular in Britain from an early stage, and his small altarpiece known as the *Donne Triptych*, after the Englishman Sir John Donne who commissioned it in the 1470s, is one of the best preserved works from this period.

The early German school was to a large extent influenced by these Netherlandish painters, although in the following century a distinct German Renaissance manner emerged in the work of **Dürer** and **Holbein**. Dürer has only one picture in the collection, a *Portrait of the Artist's Father*, but Holbein (who was a court painter to Henry VIII) is represented by two superb works, *The Ambassadors*, a complex double portrait with an anamorphic skull in the foreground, and *Christina of Denmark*, a prospective bride for the king who nonetheless was able to resist any plans for a marriage. A major work by Altdorfer, *Christ Taking Leave of His Mother*, has recently been added to these, giving greater emphasis to the so-called **Danube school** who were responsible for the development of a rich landscape style in the early 16thC. **Cranach** was associated with this group,

and his interest in landscape settings can be seen in the playfully erotic picture *Cupid Complaining to Venus*. Baldung's *Mystic Pietà* reflects a different strand in German art, the donors at the bottom giving the main scene a visionary significance.

The Dutch school (rooms 15–19 & 26–28).
In view of the common religion and the many shared commercial interests of the two countries, it is understandable that Dutch 17thC art should have been popular in Britain from the beginning. At the time of its foundation the gallery purchased a number of excellent works from the collection of the prime minister Sir Robert Peel, some of which, like Hobbema's *Avenue at Middelharnis*, are still extremely popular, and the Dutch school is now one of the largest groups in the gallery after the Italians. Here you will find virtually all aspects of the various classes of Dutch painting, often represented by works of great individual merit. Of the landscapes, **van Goyen**, **Ruisdael**, **Cuyp** and **Hobbema** are probably the most prominent while the genre and still-life painters are best represented by **de Hoogh**, **Terborch** and **Kalf**. **Vermeer** is strictly speaking a painter of this type, although the peculiarly luminous quality of his light tends to separate him from his contemporaries. You can see this effect in two beautifully controlled depictions of a *Woman at a Virginal*, showing the subject seated in one picture and standing in the other. **Rembrandt** likewise is generally seen as an artist apart, thanks to the depth and universality of his art; the gallery has a superb group of over 20 pictures spread throughout three rooms, of which the finest are probably *The Woman Taken in Adultery*, *Belshazzar's Feast*, *A Woman Bathing in a Stream*, *The Portraits of Jacob and Margaretha Trip* and the *Self-Portrait Aged 34*. There is also a large *Equestrian Portrait* which is not only unusual in Rembrandt's work but virtually unique in the history of Dutch art.

The portraitist **Frans Hals**, who was Rembrandt's contemporary, is also well represented, and you should look for the recently acquired *Boy with a Skull*. The enigmatic artist **Elsheimer** (German-born but displayed in this section) is seen in a group of four works including *Tobias and the Angel* and a night scene *St Paul on Malta*. The Dutch rooms also have an unusual and interesting item in Samuel van Hoogstraten's *Peepshow with Views of the Interior of a Dutch House*. Van Hoogstraten was a pupil in Rembrandt's

studio, and perspective boxes of this kind were quite common among the landscape and view painters of 17thC Holland.

The Flemish school (rooms 20–22).

In contrast to the Dutch school with its essentially descriptive art of landscape, portrait, still-life and genre, Flemish art during the 17thC placed greater emphasis on expressive and emotional qualities which find their highest form in the work of **Rubens**. The National Gallery possesses in all some 15 paintings by this master as well as some sketches and studies from his studio, and you will particularly enjoy the later *Judgment of Paris* (1632–5), the *Chapeau de Paille* and the two landscapes *A View of Het Steen* and *The Watering Place*. *Minerva Protects Pax from Mars* is an elaborate mythological allegory on the fruits of peace, given to Charles I by the artist who, in his capacity as ambassador, had concluded a treaty between Britain and the Netherlands in 1629.

Alongside these are works by **Jordaens** and **Van Dyck**, who both worked in Rubens' studio at some stage in their careers. Van Dyck was also court painter to Charles I, as witnessed by the gallery's large *Equestrian Portrait of Charles I* as well as a number of other portraits of the English nobility.

The Spanish school (rooms 41–42).

The Spanish pictures are as impressive as any in the collection, and Spanish art is rarely so well represented outside its native country. Beginning with El Greco's *Christ Driving the Moneychangers from the Temple* there is a fine group of works from the 16thC and 17thC, the golden age of Spanish art, including pictures by **Murillo**, **Zurbarán** and **Ribera**. But **Velazquez's** works are the real high point here, and from the 7 or so pictures generally on display it is perhaps sufficient to mention the *Rokeby Venus*, one of the greatest Spanish paintings in existence and a supreme masterpiece of 17thC art.

In the second and smaller Spanish room, there is a good group of works by **Goya** including three portraits, those of *Peral*, *Dona Isabella*, and *The Duke of Wellington*, the last of which achieved considerable fame when it was stolen and recovered during the 1960s.

The British school (rooms 35–39).

The National Gallery has had from its very beginning (with the Angerstein collection itself) a strong British element, and not surprisingly this has been maintained over the years. The result is a small but representative selection of works by the leading painters of the British school, displayed in 5 rooms to the right of the bookshop (numbering in reverse order 39 to 35), beginning with Hogarth's *Marriage à la Mode*, a series of 6 paintings from the mid 1740s. Hogarth frequently painted these "modern moral subjects" in a rough and slipshod manner, placing greater emphasis on the prints which would be taken from them, but in this case he set out to demonstrate his abilities as a painter, making them his finest and most delicately executed works without losing the bitter edge of his social satire. The same room also contains Gainsborough's early masterpiece, *Mr and Mrs Andrews*, and you can see further fine works by him in the following two rooms alongside those of his contemporaries Wilson (*Holt Bridge*) and Reynolds (*Lord Heathfield*). Room 35 brings together the two great masters of British Romantic art, **Constable** and **Turner**: the former with a group of his major landscapes, *The Haywain*, *The Cornfield* and *Salisbury Cathedral from the Meadows*, while Turner is best seen in *The Fighting Téméraire Tugged to her last Berth to be Broken up*.

The French school

During the 18thC, when the Grand Tour fostered an interest in the antique, British connoisseurs regarded the French artists **Poussin** and **Claude** as closest in spirit to the Classical world. As a result you find their work in many British collections, but it is at its finest in the National Gallery where these Classical associations have been emphasized by a number of antique marbles. Poussin's rigorously controlled design can be seen in the *Adoration of the Golden Calf*, *The Bacchanalian Revel* and the recently acquired *Triumph of Pan*, while Claude Lorrain is represented by some of his most sublime essays in the poetic landscape, particularly *The Embarkation of St Ursula*, *A Seaport*, *The Enchanted Castle* and *Landscape: Narcissus*. Claude's huge influence on British landscape art is encapsulated in the small *Hagar and the Angel* which belonged to Sir George Beaumont and was adapted by both Turner and Constable in their own work. So great was Turner's admiration for the French master that the terms of his bequest stipulated that his own *Dido Building Carthage* should hang alongside Claude's *Queen of Sheba*, a comparison which does not reflect well on the English artist.

Of the other principal French artists of the 17thC **Philippe de Champaigne's**

magisterial full-length portrait of
Cardinal Richelieu is the most important
and is accompanied by a study of **Three
Heads of Richelieu** by the same artist.

French art of the following century
(room 33) was never as popular in Britain
despite the fact that the Rococo did exert
a considerable influence on such artists as
Hogarth and Gainsborough. There are
nevertheless some good paintings by
Watteau and the other Rococo artists,
Boucher, **Fragonard**, **Nattier** and
Drouais, but you may find **Chardin's**
Still Life and the perhaps rather didactic
child studies, *House of Cards* and **The**

Lesson more substantial. There is also an
interesting scene of a street show in Paris,
Une Parade, by the little known painter
G.J. de Saint-Aubin.

19thC France is arguably the area
where the National Gallery is least
representative, a position which has been
made more obvious by the absence of
pictures from the Lane Bequest. Under
the present arrangements the pictures
from Lane's collection are divided
between London and Dublin (see the
Hugh Lane Gallery of Modern Art,
IRELAND), the two groups being
exchanged every seven years. Certainly,

*The National Gallery, a selection of the
finest works:*
1 Uccello, *The Battle of San Romano*,
c.1455
2 Piero della Francesca, *The Baptism of
Christ*, c.1442
3 Botticelli, *Mystic Nativity*, 1500
4 Leonardo da Vinci, *The. Virgin and
Child with St Anne and St John the
Baptist* c.1495
5 Bronzino, *An Allegory (Venus,
Cupid, Folly and Time)*, c.1546
6 Veronese, *The Family of Darius
before Alexander*, c.1570
7 Titian, *Bacchus and Ariadne*, 1523
8 Mantegna, *Agony in the Garden*,
c.1460
9 Giovanni Bellini, *Portrait of the
Doge, Leonardo Loredan*, c.1501

10 Rembrandt, *The Woman Taken in
Adultery*, 1644
11 Van Dyck, *Equestrian Portrait of
Charles I*, c.1638
12 Rubens, *A View of Het Steen*,c.1636
13 Van Eyck, *The Arnolfini Marriage*,
1434
14 Holbein, *Christina of Denmark,
Duchess of Milan*, 1538
15 Vermeer, *A Young Woman
Standing at a Virginal*, c.1670
16 Claude, *Psyche outside the Palace of
Cupid (The Enchanted Garden)*, 1664
17 Turner, *The Fighting Téméraire
Tugged to her Last Berth to be Broken
up*, 1838
18 Gainsborough, *Mr and Mrs
Andrews*, c.1752
19 Velazquez, *The Rokeby Venus*,
c.1649
20 Seurat, *Bathers, Asnières*, 1884

Lane's bequest contains some of the most important paintings in this section, including Manet's *Music in the Tuileries*, Corot's *View of Avignon* and Vuillard's *Chimneypiece* (Manet's *Portrait of Eva Gonzales* and Renoir's *Umbrellas* are currently in Dublin), but there are some equally good paintings on permanent display such as Ingres' *Madame Moitessier*, Degas' *Miss Lala at the Cirque Fernandez* and Pissarro's *Upper Norwood*. You will also see a large number of works by Monet, *The Thames below Westminster*, *The Japanese Bridge* and the large *Waterlilies* (or *Nymphéas*) being the finest. The Post-Impressionists are best seen in Van Gogh's *Sunflowers*, Cézanne's *Self-Portrait* and, most significantly, Seurat's *Bathers, Asnières*, the painting which established his reputation as the leading figure in the Paris avant-garde of the 1880s. The Douanier Rousseau is not really of this circle but his contemporary naive style can be seen to great effect in the *Tropical Storm with a Tiger*. The exotic setting was painted in the Paris botanical garden.

In recent years the National Gallery has begun to extend its holdings of masters of early 20thC art, a period that was traditionally covered by the Tate Gallery. This policy remains slightly unclear but a still-life by Picasso (*Bowl of Fruit*, 1914) and Matisse's portrait of the artist *Greta Moll* (1908) have already entered the collection. These and other paintings indicate perhaps one of the principal areas of future development.

National Maritime Museum ☆
Romney Rd, Greenwich, SE10
Tel. 858–4422
Open Tues–Sat 10am–5pm, Sun 2–5pm
Closed Mon
📷 👝 💼 🏛

The National Maritime Museum forms part of a magnificent, grandiose architectural ensemble marking the site of a royal residence that dates back to the early 15thC. When seen from the Thames this resembles a Baroque stage set: buildings arranged on either side of a central vanishing perspective lead the eye back to Inigo Jones's **Queen's House**, behind which rises a hill in Greenwich Park topped by the diminutive Royal Observatory. The two massive blocks directly overlooking the river were designed by **Sir Christopher Wren** after 1664, though with substantial later alterations by **Sir John Vanbrugh** and **Nicholas Hawksmoor**, amongst other leading architects. Commissioned initially as a residence for William III, in 1694 they were designated a Royal

Hospital for disabled and aged naval seamen; since 1873 they have housed the Royal Naval College.

The only parts of the college interior which are open to the public are the **chapel**, redecorated in a light, Neoclassical style after a fire in the late 1770s, and the **Painted Hall**. The enormous ceiling of this hall is covered by an early 18thC painted **decoration** ★ by **Sir James Thornhill**. Representing the glory of the Protestant monarchs, it is Thornhill's most impressive surviving work, and also the most dramatic example of painted illusionism to be seen in England.

Behind the college is the National Maritime Museum, at the heart of which is Inigo Jones's **Queen's House**. This elegant two-storeyed house, begun in 1616 for Anne of Denmark, consort of James I, is in the form of an Italian villa, and was the first Palladian building in England. The museum buildings that flank it were designed in the early 19thC, and are joined to it by a colonnade. The museum, devoted to the maritime history of Great Britain, is the most renowned seafaring museum in the world. Its varied collections include a large group of paintings, many of which you can see, together with some marvellous early ship models, in the beautiful if now slightly faded interior of the Queen's House. The splendid hall of this building had originally a ceiling decoration by **Orazio Gentileschi**, which was transferred to MARLBOROUGH HOUSE and replaced by a work by Thornhill, *Minerva as Patron of the Arts*. Elsewhere in the building are various 16thC and 17thC portraits of important naval figures by such artists as **Lely, Dobson** and **Mytens**; numerous **17thC Dutch maritime pictures** (the best-known Dutch specialists, in this genre were the **van de Veldes**), and some 17thC – 20thC views of Greenwich, including works from **Canaletto** to **L. S. Lowry**. In the museum's W wing are some excellent pictures by leading 18thC English artists. Among these are Zoffany's *Death of Cook*, and a famous portrait by Reynolds of *Admiral Lord Keppel* ★ walking along the seashore in the pose of the Apollo Belvedere. Two rooms in the wing are devoted to Nelson, and include a charming portrait by **Romney** of Lady Hamilton as Ariadne, and a large, curious and rather strained composition by **Turner** of the *Battle of Trafalgar* (1823). Further works by **Turner** and other 19thC English artists (including by the marine specialist, **Clarkson Stanfield**) can be seen in the painting galleries in the museum's E wing.

National Portrait Gallery ☆
2 St Martin's Place, W1
Tel. 930–1552
Open Mon–Sat 10am–6pm, Sun 2–6pm
◎ ✗ ♡

The National Portrait Gallery was set up in 1856 to record the most important figures from British history and public life, and from the beginning its aim was "to look to the celebrity of the person represented, rather than to the merit of the artist" when acquiring works for the collection. As a result, the collection is uneven if judged in purely aesthetic terms, but you will still find many interesting pictures here.

The present building is itself a reflection of the Victorian age, the interior being designed as a series of rooms and corridors on three floors with quasi-medieval doorways and plasterwork. Interesting this may be, but it is not the best environment for an art gallery, and considerable effort has gone into the wall coverings, props and fabrics in each room to create the appropriate atmosphere. The layout does however enable the collection to be split up into several period sections corresponding to particular monarchs or families, and you can view these chronologically, beginning on the top floor. Use the elevator in the entrance hall if you want to avoid the alternately dull and dreadful modern portraits of the royal family on the stairs, which will have the effect of lowering your expectations of the collection overall.

Quality may not be the principal concern in the acquisition of portraits, but the Middle Ages and the Early Tudor period saw a great deal of very sophisticated court portraiture in Britain, so you might expect an impressive display. It is all the more disappointing, therefore, to see only second-rate paintings and many later copies of the monarchs and public figures of the period. **Holbein** is represented only in the large cartoon of *Henry VII and Henry VIII* for a lost fresco in the Privy Chamber in Whitehall – an important work, to be sure, but one which has deteriorated, giving no indication of the powers of observation and description with which he recorded the members of the royal court.

The Elizabethan period, however, makes up for this with two excellent portraits of the queen, (Elizabeth I). One, a half-length by an unknown artist, is a formal hieratic image of the type used in coins and medals, while the other is a magnificent expression of regal power painted by **Gheeraerts** in 1592, showing the queen in resplendent costume and standing on a map of England. Miniature painting reached its highest level of accomplishment during this period, and there are examples of the work of **Nicholas Hilliard** depicting such figures as *Sir Walter Raleigh*, *Robert Dudley, Earl of Leicester* and the naval hero *Sir Francis Drake*.

The Stuart, Commonwealth and Restoration rooms, while interesting in themselves, suffer like the earlier sections from a dearth of works by the great artists who fashioned the image of the period, notably Van Dyck and Dobson. Nevertheless there are some fine portraits by **Honthorst** and **Mytens**, and a good double portrait of *James II and Anne Hyde* by **Sir Peter Lely**.

The Georgian period was the great age of English portraiture, and you will see some excellent examples of the work of **Reynolds**, particularly those depicting his friends *Warren Hastings*★, *Laurence Sterne*, *Dr Johnson* and *James Boswell*. This period also saw the rise of a native tradition in painting, and some of the most attractive works here are artists' **self-portraits**, including paintings by **Hogarth, Hayman, Ramsay, Stubbs** and **Gainsborough**. You will find more self-portraits in the succeeding rooms.

The Victorians occupy most of the first floor, but it is disappointing to find that official portraiture, which flourished during this great era of expansion, tended to rely on an outworn or overblown rhetoric of gestures, poses and props. You may do better to concentrate on the informal and less conventional works, such as the **Pre-Raphaelite drawings**, Tissot's *Captain Frederick Burnaby* or Watts's portrait of his wife, the young *Ellen Terry*. Also worth attention are the portrait photographs by the early pioneers of this medium, **Hill** and **Adamson** and **Julia Margaret Cameron**. Ellen Terry reappears as *Lady Macbeth* in a striking portrait by **Sargent**. This is part of a display covering the 1880s and 90s which includes many of the famous literary and artistic figures such as Beardsley, Wilde, Beerbohm and Whistler. The last section on the first floor is devoted to the Edwardians, best seen in the portraits of the artists **Gore, Bevan** and **Gwen John**; and here you can also see works by the already over-exposed Bloomsbury group. Duncan Grant's portrait of *Virginia Woolf* is probably the best of these.

The modern gallery on the ground floor has recently undergone a complete reorganization which, on balance, definitely improves the displays. You may find this the liveliest part of the gallery because the paintings, though

often somewhat slick and superficial, have none of the didactic associations of the history lesson. All the leading public figures are represented, notably **Winston Churchill** and **Lord Beaverbrook** by **Sickert**, the composer **Vaughan Williams** by **Sir Gerald Kelly** and **T.S. Eliot** by **Patrick Heron**, but there are also several self-portraits by such painters as **Spencer**, **Lamb**, **Rothenstein** and **Hockney**.

One aspect of the gallery that often escapes attention is its policy of stimulating interest in contemporary portraits through grants and competitions. By this method several recent works have come into the public eye, notably Humphrey Ocean's **Lord Volvo and his Estate**, a portrait of the artist's friends that both parodies and updates the British portrait tradition. The basement gallery has temporary exhibitions.

Osterley Park

Isleworth, Middlesex
Tel. 560–3918
Open Apr–Sept Tues–Sun 2–6pm;
 Oct–Mar noon–4pm
Closed Mon
📷 🅿 (in summer) 🏛
From the outside, Osterley Park has all the signs of a simple yet immensely successful 18thC modernization, with **Robert Adam's** white Classical portico transforming the dull red-brick exterior into a house of great style and elegance. With the interior however, the architect had a completely free hand and he created a superlative series of contrasting rooms, furnished to his own designs. The Tapestry Room is generally considered the most successful of these, and displays **Gobelins tapestries** that were specially woven for Osterley by a Franco-Scot with the unlikely name of **Jacques Neilson**.

Apart from some portraits, there are few paintings of note here, although the Eating Room has some decorative panels by **Antonio Zucchi**. Otherwise, the most interesting room is probably the Etruscan Dressing Room, decorated with elaborate "grotesque" designs based on Greek vase painting.

Palace of Westminster (Houses of Parliament) ☆

Parliament Sq, SW1
Tel. 219–4272 (House of Lords)
 219–3107
Visiting arrangements subject to repeated
 change. During parliamentary sittings
 admittance to public galleries from St
 Stephen's entrance
☆ 🔲 🚹 🏧 🏛
The Houses of Parliament are officially

referred to as the Palace of Westminster, which was the seat of the kings of England from the 11thC to the 16thC, when Henry VIII moved his residence to the nearby Whitehall Palace. From that time onwards the Palace of Westminster became the permanent place of the Parliament. The medieval buildings, together with 17thC and 18thC additions, were largely destroyed by fire in 1834, an occasion which moved Turner to commemorate it in a famous painting (now in the Philadelphia Museum of Art). A competition was held to choose an architect for the new building, stipulating that the design should be either in a Gothic or Elizabethan style.

This was an important moment in the history of British architecture, for the terms of the competition essentially meant official acceptance of the Gothic Revival style, which led to some of the greatest examples of Victorian architecture. The competition, strangely enough, was won by an architect of pronounced Classical taste, **Charles Barry**, who adopted the Gothic style here only reluctantly. However, he was aided by a brilliant young assistant, **A.W. Pugin**, one of the most fervent "Gothicists" of the time. Barry, a more stable personality than Pugin, was more capable both of planning a monumental building and of coping with the endless committee battles that this planning entailed, while Pugin was far more suited than Barry to design and supervise the profuse and elaborate ornamentation which the building required.

The result of their collaboration is such a familiar element of today's London scene that you tend to forget that it is one of the most outstanding architectural achievements of the 19thC. Much of the effect of the exterior is due to its picturesque, variegated skyline, and to its rich panelling, which was strongly influenced by that of the neighbouring Henry VII Chapel attached to WESTMINSTER ABBEY. The interior provides a further wonderful opportunity to study the richness and inventiveness of Pugin's ornamental vocabulary, and includes such finely conceived masterpieces of his as the **Throne of the Sovereign**. ★ There are also numerous **frescoes**, most notably those by **William Dyce** and the Irish painter, **Maclise**. The idea of having so much frescoed decoration inside the building was due largely to Prince Albert, who believed both in the elevating capabilities of art, and – as a passionate medievalist – in the supremacy of the fresco over other forms of wall-painting. His views led to the

setting up in 1841 of a select committee "to take into consideration the promotion of the Fine Arts of the country in connection with the rebuilding of the New Houses of Parliament".

A tour of the Houses of Parliament should include a visit to the major structure to have survived the fire of 1834, **Westminster Hall**. This, perhaps the largest Norman hall in Europe, was built in the 11thC, though it was much altered in the late 14thC, when the impressive medieval hammerbeam roof was added, the largest of its kind.

Percival David Foundation of Chinese Art

53 Gordon Sq, WC1
Tel. 387–3909
Open Mon 2–5pm, Tues–Fri
10.30am–5pm, Sat 10.30pm–1pm
Closed Sun
📷 🎒

The scholar and connoisseur Sir Percival David presented his collection of some 1,400 examples of **Chinese ceramics** from the 9thC to the 19thC to London University in 1951. You can see works in this collection, together with ceramics from a later bequest, in a small gallery occupying one of the university's characteristically dreary Bloomsbury buildings. The display is simple and unfussy, though perhaps unlikely to stimulate enthusiasm for Chinese art in those not already interested in it.

Ranger's House

Chesterfield Walk, SE10
Tel. 853–0035
Open Mon–Sun 10am–5pm
📷 🎒 🏛

If the weather is fine, you will enjoy the walk from the NATIONAL MARITIME MUSEUM through Greenwich Park to Ranger's House, an elegant early 18thC red-brick mansion situated at the far northern end of the park, on the confines of Blackheath. The well-restored ground floor rooms of this little-visited house provide a most pleasant setting for the **Suffolk collection** of pictures, which are all 17thC and 18thC English portraits, including works by **Cornelius Johnson** (who was born in London of Flemish parents), **Sir Peter Lely, Sir Godfrey Kneller, Thomas Hudson** and **William Hogarth**. But the most charming of the works are 7 female full-length **portraits** that may have formed a set commemorating the marriage in 1614 of Elizabeth Cecil to Thomas Howard. Painted by the little documented artist **William Larkin**, these stiff icon-like figures, painted in vivid, glowing colours with a great emphasis on stylized

ornamentation, seem completely medieval in spirit, and provide an interesting indication of the state of English portraiture shortly before Van Dyck brought it into line with Continental Baroque tendencies.

Royal Academy

Burlington House, Piccadilly, W1
Tel. 734–3471
Open Mon–Sun 10am–6pm
📷 🍴 🏛 📖

Founded in 1768 with Sir Joshua Reynolds as the first president, the Royal Academy still exists as an association of artists and as an art teaching establishment. Today, however, it is probably best known for its major temporary exhibitions. Nonetheless, it possesses a considerable collection of paintings, such as the two large mythological works by Sebastiano Ricci (**The Triumph of Galatea** and **Diana and the Nymphs Bathing**) on the stairs. The principal treasure is Michelangelo's **Taddei Tondo**, a marble relief of the Madonna and Child carved in 1504 and presented to the RA from the collection of Sir George Beaumont. There are perennial threats to sell this work as the academy's financial problems increase, but for the moment at least it is displayed at the side of the ballroom.

A condition of election to the RA is that the artist must present one work, with the result that this **Diploma Collection** is a virtual survey of British art since the late 18thC. Many important painters are represented, including **Reynolds, Gainsborough, Turner** and **Constable**, and a few individual items can be glimpsed in different parts of the building (in particular on the staircase to the Diploma Gallery), but the collection as a whole is rarely seen by the public.

Royal Botanic Gardens

Kew Gardens
Tel. 940–1171
Open Mon–Sun 11am–5.30pm
📷 🎒 🏛 ☑ 🍴

These enormous and hugely enjoyable gardens by the Thames contain, in addition to their numerous exotic plants and flowers, much of artistic and architectural interest. Here you will see some marvellous **18thC follies** by Sir William Chambers, most notably a famous **pagoda** 163ft (50m) high, as well as a ruined, overgrown **Classical gateway** once painted by the 18thC landscapist **Richard Wilson** in a work which could easily be taken for a view of a Roman Campagna. Then there is the celebrated **Palm House**, a masterpiece of Victorian steel and glass architecture by

Decimus Burton. Finally, you should go and see the **Dutch House** and the **Marianne North Gallery**. The first is all that remains of the 18thC buildings that once formed Kew Palace. It has an attractively furnished interior containing, among its many minor 17thC–18thC pictures, royal portraits by **Reynolds** and **Zoffany**, and two amusing conversation pieces by **Marcellus Laroon**, a *Dinner Party* and a *Musical Tea-Party*. The more unusual Marianne North Gallery was built in the late 19thC to house 848 paintings of plants, insects and views executed by the eccentric and intrepid **Miss North** in the course of various travels around the world in 1871–84. These works reveal considerable technical ability, but they are hung in such profusion that it is the overall effect that impresses.

Royal Hospital, Chelsea
Royal Hospital Rd, SW3
Tel. 730–0161
Open Mon–Sat 10am–noon, 2–4pm, Sun 2–4pm
Chelsea Royal Hospital consists of a handsome group of brick buildings designed by **Sir Christopher Wren** in the late 17thC. It is situated in attractive grounds incorporating Ranelagh Gardens, one of London's most popular places of entertainment in the 18thC. The hospital accommodates old and disabled soldiers, whose bright red costume delights many tourists. The chief object of artistic interest inside is a dramatic *Resurrection* ★ by one of Venice's leading 18thC decorators, **Sebastiano Ricci**: it was painted on a lunette in the chapel, and gains considerably from being seen in the context of the excellently preserved **Baroque interior** of this room. Another section of the hospital houses a small museum, which displays various memorabilia connected with the British army, and also a characteristically large and high-flown work by B.R. Haydon, *Wellington describing the Field of Waterloo to George IV* (1844).

The Royal Society of Arts
8 John Adam St
Tel. 839–2366
Open on application Mon–Sat
The Royal Society of Arts, occupying a handsome late 18thC building by **Robert** and **James Adam**, was founded as a society for the "encouragement of arts, manufactures and commerce" in 1754. The outstanding feature of the interior is the series of **mural paintings** ★ by the Irish artist **James Barry** in the Great Hall (now

the lecture hall). Painted between 1777–84, these depict progress from barbarism to civilization, with comparisons between ancient Greece and 18thC England. They represent the most ambitious history paintings of this period, but were heavily criticized at the time.

St Paul's Cathedral
Entrance and movement restricted during services
Built to replace a medieval cathedral destroyed by the Great Fire of London in 1666, and miraculously almost untouched by the bombing which devastated the surrounding area in World War II, **St Paul's Cathedral** ★★ has come to be seen as a monument to undiminished self-confidence in the face of adversity. It is the masterpiece of **Sir Christopher Wren**, and the most famous Baroque building in Britain. Its outstanding feature is its **dome**, which was inspired by the example of the great Renaissance and Baroque churches of Italy, and was the first of its kind in England. The prospect of winning a commission to paint its inner face attracted many of Europe's leading decorative artists of the early 18thC, and artists like G.A. Pellegrini and Sebastiano Ricci came to England largely with this in mind. However, in a moment of patriotism it was decided to give the commission to an English rather than an Italian artist. The choice was **Sir James Thornhill**, then virtually the only Englishman capable of working successfully on a large scale, though the monochrome illusionistic frescoes of the **Life of St Paul** that he did here are not among his most exciting works. Some of the finest of the furnishings within the interior date from the late 17thC. These are **Grinling Gibbons'** intricately carved **choir stalls and organ case**, and the equally elaborate wrought-iron screens by the celebrated French craftsman **Tijou**, placed at the entrance of the N and S chancel aisles in 1890. As with WESTMINSTER ABBEY, the **funerary monuments** in St Paul's Cathedral constitute an extraordinary anthology of the work of British 17thC–19thC sculptors. The earliest of these, and indeed the only monument to have survived from the medieval cathedral, is **Nicholas Stone's** monument to the poet **John Donne** ★ in the S chancel aisle. The sculpture shows Donne, who was Dean of St Paul's from 1620–31, standing on an urn and wrapped in a shroud. It was made from a painting for which Donne had posed during one of his melancholic bouts preceding his death, and in its combination of realistic detailing with

rigid stylization of almost mystical intensity, it has a quality akin to some of Donne's greatest poems.

The later monuments in the main body of the Cathedral include (in the transept nave), **Flaxman's** remarkably lifelike portrait of **Napoleon** and, in the N aisle of the nave, **Alfred Stevens's** enormous and elaborate monument to the **Duke of Wellington ★**, which shows the duke on horseback surrounded by allegorical figures. In the opposite aisle you will find the Pre-Raphaelite painter Holman Hunt's *Light of the World*, a much later version of the painting in Keble College, Oxford (see *MIDLANDS*). Many of Britain's leading painters are commemorated in the cathedral and in the crypt, with monuments to Reynolds, Turner, Van Dyck, Constable, William Blake and Sir Edwin Landseer. **Woolner's** monument to Landseer (which is in the crypt) features a relief of the artist's famous painting now in the VICTORIA AND ALBERT MUSEUM, *The Shepherd's Chief Mourner*. Also in the crypt is the tomb of **John Singer Sargent** (the American painter active in Britain in the late 19thC and early 20thC) with bronze figures in relief by the artist himself.

Sir John Soane's Museum ☆
13 Lincoln's Inn Fields, WC2
Tel. 405–2107
Open Tues–Sat 10am–5pm
Closed Sun, Mon
📷 🏛 ♿

Sir John Soane's Museum, comprising the house and collection of England's greatest Neoclassical architect, is one of the most individual and interesting museums in the country. Soane designed the house himself in 1812, and you will find some of the rooms, notably the domed **Breakfast Room**, fascinating examples of his innovative use of space. An avid collector, he planned much of the interior as a setting for his **paintings**, **prints** and **antiquities**, using complicated floor levels and ingenious top lighting to create the required effects. The terms of his bequest required that nothing be altered, so this collection is still displayed in an eccentric 18thC manner. The paintings hang in several ranks across the walls, antiquities are distributed freely throughout the house, and the tall chambers running the whole height of the building contain an accumulation of architectural fragments reminiscent of Piranesi's richly abundant prints.

Within this mass of items there are numerous good pictures, the most important of which are **Hogarth's** two "modern moral cycles", *The Rake's Progress* ★★ and *The Election* ★★ – 12 paintings in all, hung on the ingenious hinged shutters of the **Picture Room**. The same room has sketches by **Piranesi** and **Clérisseau** and Fuseli's *The Italian Count*, and elsewhere in the house you can see works by **Watteau**, **Reynolds**, **Lawrence** and **Turner**. Another interesting feature is the large number of finished works and studies by the English Neoclassical sculptor **John Flaxman**.

In the basement Soane planned several rooms around particular themes in English taste of the period: the **Monk's Parlour** provides a Gothic setting for some medieval antiquities, while the **Catacombs** have a range of **Roman sculpture**. The **Sepulchral Chamber** contains his most important piece, a large **sarcophagus** of **Seti I** (c. 1290BC) which was discovered at Thebes in 1815.

Apart from the museum the house also contains an important **library** of early books on architecture, and Soane's collection of architectural drawings which can be consulted by students.

South Bank Arts Centre
Waterloo
See below for opening times
📷 🎭 🎪 ☑

In contrast to the newly opened BARBICAN ARTS CENTRE, the older complex on the South Bank enjoys one of the finest sites in London, with magnificent views across the Thames to the Houses of Parliament and down the river to St Paul's. It was developed after the Festival of Britain was held here in 1951. The first of its buildings to be put up was the enormous concert hall, the **Festival Hall**, which was completed in 1956. Whereas this building is a relatively light and pleasant place making extensive use of glass, the **Hayward Gallery** and the **National Theatre** (opened respectively in 1969 and 1978) are "brutalist" concrete structures, rather in keeping with the enormous, grim tower block that rises behind them, the Shell Building.

Hayward Gallery
Tel. 629–9495
Open Mon–Wed 10am–8pm, Thurs–Sat 10am–6pm, Sun noon–6pm
📷 🎭 🖼

The Hayward Gallery, not an attractive building, has an interior which seems to have been built principally for the benefit of the handicapped, being designed around an enormous ramp. Nevertheless, this is the main exhibiting institution of the Arts Council of Great Britain and regularly mounts **important exhibitions**. The Arts Council's other

London gallery is the small, delightful **Serpentine Gallery** in Hyde Park.

National Theatre
Tel. 928–2033
Open Mon–Sat 10am–11pm
Closed Sun
◙ ☑

The only "permanent" collection of works to be seen on the South Bank is in the National Theatre. The interior of this building is surprisingly enjoyable and lively, once you have got over the feeling that you are in an airport lounge. Scattered around its multi-floored foyer, animated in the evenings by the sound of performing musicians, is a most impressive collection of **18thC theatrical portraits** gathered by the novelist Somerset Maugham and originally hung in his villa in Cap Ferrat near Nice. The most striking are by **Zoffany**, particularly Charles Mackling as Shylock, and two works featuring Britain's leading 18thC actor, David Garrick: an exceedingly melodramatic moonlight scene, *Garrick and Susanna Maria Cidder in Otway's Venice Preserved* ★ (of which another version is in Budapest) and *Garrick as Sir John Brute in Vanbrugh's The Provok'd Wife* ★.

Syon House
Brentford, Middlesex
Tel. 560–0881
Open Apr–Sept Sun–Thurs noon–5pm;
Oct Sun noon–5pm
Closed Nov–Mar
▩ 𝒴 ⋔

Syon House was originally a convent in the 15thC, but despite its considerable historical associations (Catherine Howard was held here during her trial and execution by Henry VIII) it now has a dull, block-like exterior that is one of the most unattractive of any major house in Britain. Fortunately the **interior** is in marked contrast because many of the rooms were remodelled by **Robert Adam** in the 1760s. The first of these, the **Great Hall** ★, is quite simply a masterpiece of restrained Neoclassical design marked at either end by copies of the famous antique statues, the *Apollo Belvedere* and *The Dying Gaul*. This is followed by the **Ante-Room**, one of Adam's most ornate and richly coloured interiors, while at the rear of the house you will find his famous **Long Gallery**, where he adapted an Elizabethan Renaissance form to elegant 18thC effect in the plasterwork. This last room also contains some landscape paintings by the Italian 18thC artist **Zuccarelli** and a series of **portrait medallions** tracing the lineage of

the Dukes of Northumberland.

Elsewhere the collection of paintings is largely made up of family portraits, including works by **Gainsborough** and **Reynolds**, but the Red Drawing Room contains a number of royal portraits such as Lely's *Charles I with James Duke of York* and a *Portrait of Henrietta Maria* by Van Dyck.

Tate Gallery ★★
Millbank, SW1
Tel. 821–1313
Open Mon–Sat 10am–6pm; Sun 2–6pm
◙ 𝒴 ⫿ ◪ ⊞

All the items mentioned here would rate at least one star if found in another museum. The system of starring outstanding works is therefore not applied in this entry.

The Tate Gallery is virtually two museums, one of British and the other of modern international art, which co-exist uneasily in a Neo-Baroque building overlooking the Thames. Their separation is emphasized by the clear division of the building along its central axis: the British historic collection to the left (or W) and the modern collection to the right. But, distinct and separate though they are, the association of these two collections at the Tate has given the gallery a vital and active role in the British art world of the present century. So often new artists from abroad have been introduced to the British public in exhibitions here, and collaboration between artists and the gallery has led to the formation of an important archive of documentary material on British art.

The building itself was donated to the nation in 1897 by the sugar millionaire Sir Henry Tate, along with a collection of recent British paintings and sculpture. It is fairly typical of many museums erected at that time, but the entrance hall and cupola make an unusual space that deserves to be better used; its present appearance is not especially attractive, giving an initial impression of disorder and untidiness that, with the modern collection at least, is often carried over into the main galleries. The interior at the Tate has undergone considerable renovation, most recently in 1979 when the exhibition space was greatly expanded (although it will continue to be periodically altered with rehanging), and especially after the opening of the nearby Clore Gallery, which is solely devoted to the work of **J.M.W. Turner**.

The British collection
The unrivalled position of the British historic collection at the Tate Gallery rests partly on the relatively poor reputation of British art during the 18thC

and 19thC. At a time when the art of
Italy, France and Spain was admired and
collected throughout Europe, British
paintings found little favour abroad and
tended to remain in their country of
origin. As a result the national collection
here is really comprehensive, containing
excellent examples of the work of all the
major and minor figures, and there is no
serious alternative to the Tate if you wish
to see the full range of British art.

The collection is displayed
chronologically in a series of galleries on
the ground floor and basement,
beginning in the entrance area with a
number of miscellaneous **17thC works**
and continuing more seriously in Gallery
3. Along the partitioned bays of this
room you can see how British painting
developed from its early 16thC origins to
a maturity in the work of **Hogarth**. The
earliest work is John Bettes' portrait of *A
Man in a Black Cap* (1545), a close
adaptation of Holbein's manner and a
reminder that virtually all British art of
the following two centuries was to some
extent derived from Continental models.
With this in mind you can follow the
succession of European artists working in
Britain – **Eworth, Mytens, Van Dyck,
Lely** and **Kneller** – whose portraits
gradually prompted the rise of native
talent. **William Dobson** was probably the
first painter to rival those artists, and his
masterpiece *Endymion Porter* (1645)
demonstrates his understanding of Van
Dyck's style. Alongside this there are
numerous works from the 16thC and
17thC, which lack the sophistication and
technical accomplishment of much
European art but which, nevertheless,
have an appeal and quality of their own.
David des Grange's *Saltonstall Family*
(1637) is an unusual and sensitive
deathbed scene, while the stylized
Cholmondeley Sisters (1610) by an
anonymous artist contrasts sharply with a
refined version of a similar subject by
Lely, *Two Ladies of the Lake Family*,
painted 50 years later.

The early 18thC is dominated by
Hogarth, the first British artist to strike a
mature and independent note by
combining, as he implies in his *Self-
Portrait*, the qualities of English
literature with a strong pugnacious spirit.
Here and in the nearby Octagon Gallery
you can see the finest of his portraits
(*Archbishop Herring* and *Bishop
Hoadly*), conversation pieces (*The
Graham Children*) and "modern moral
subjects" (*the Roast Beef of Old
England*) as well as work by **Highmore,
Hayman** and **Devis**.

Room 4 and the succeeding four
rooms introduce the principal figures of

the **mid to late 18thC**, in many respects
the greatest phase of British art. Here
portraiture is still dominant, but in the
work of **Richard Wilson**, notably the
Welsh scenes *Llyn-y-Cau* and *Cader
Idris*, **landscape art** begins to emerge as a
major theme. Sporting subjects also came
to prominence in this period with the
work of **George Stubbs**, whose *Mares
and Foals in a Landscape* is one of the
most perfect conceptions of the English
school. But the principal figures of the
time were **Gainsborough** and **Reynolds**.
Gainsborough is represented by both
portraits and landscapes, the intimate
portraits of his daughters and the full-
length depiction of the Italian dancer
Giovanna Baccelli illustrate one aspect,
while the *Suffolk Landscape and a
Market Cart* introduces the other.
Reynolds's more academic manner is seen
in the *Three Ladies Adorning a Term of
Hymen*, in fact portraits of the three
Montgomery sisters, as well as several of
his less formal **self-portraits**.

Following on from these two seminal
artists, you can see other portraits by
Romney, Raeburn, Zoffany and
Lawrence, but perhaps the most
interesting feature of the later rooms is
the diverse range of **history paintings**.
Wright's *Experiment with an Air Pump*,
Copley's *Death of Major Peirson*, Barry's
*Lear Weeping over the Body of
Cordelia*, and Fuseli's *Lady Macbeth
Seizing the Daggers* give some indication
of the prevailing taste in these early years
of the Royal Academy. Room 7 is
devoted to the smaller-scale and more
fragile work of **William Blake** and his
followers. These early **illuminated books,
large prints, drawings** and **watercolours**
covering the full extent of his career are
displayed in subdued lighting but in a way
that allows you to inspect each detail.

In rooms 9 and 10 **Turner's** work
comes as something of a contrast. The
two large galleries, although slightly
cramped, have only a small part of the
huge **Turner Bequest** (which will
eventually be housed in the Clore
Galleries) but they do suggest the range
and breadth of his interests. Between the
early *Fishermen at Sea* (1796) and
Norham Castle (1840) there are
Claudean works such as *Crossing the
Brook*, Venetian scenes and poetic
landscapes of **Petworth**, as well as the
dynamic expressions of natural power
such as *Steamboat off a Harbour's
Mouth* for which Turner is perhaps best
known. In nearby room 13, a selection of
his watercolours is also on display. The
Constable collection in room 11 suffers
slightly from the power of the Turner
rooms, but even so you may feel that the

group of works on display could be stronger. Only the oil sketch for *Hadleigh Castle* suggests the majestic quality that Constable could introduce to the simplest rural scene, but all the works here, including *Flatford Mill* and *Branch Hill Pond*, as well as a selection of oil sketches, are of great interest.

Rooms 12 and 14 introduce several themes in early 19thC art from the landscapists **Crome** and **Bonington** to the visionary artists **Martin** and **Danby**. **Ward's** huge *Gordale Scar* would seem to be a bridge between these two groups, but the most important artist of the period was probably **Wilkie**, whose genre scenes such as *The Blind Fiddler* influenced Maclise, Landseer and even Frith. The latter's *Derby Day* is one of the most popular works in the gallery.

The **Pre-Raphaelites**, who first appeared as a group in 1848, are all well represented in room 15. Millais' *Ophelia* and Hunt's *The Awakening Conscience* demonstrate their meticulously detailed technique, but it was the symbolism and spirituality of such paintings as Rossetti's *Ecce Ancilla Domini* and *Beata Beatrix* that carried over most strongly to the artists of the later 19thC. Two of these, **Burne-Jones** and **Whistler**, figure prominently in the following rooms, the former with *King Cophetua and the Beggar Maid* and the latter with a series of *Nocturnes*. Alongside them are a number of High Victorian pictures by **Leighton**, **Moore**, **Watts** and **Alma-Tadema**, but from this company it is worth singling out the vivid *Carnation, Lily, Lily, Rose* by the American artist **Sargent**, who at this stage had some experience of French Impressionist art.

From here the British collection continues in the basement (accessible from the stairs in room 10), beginning with a gallery for **drawing and watercolour exhibitions**. Thereafter the four remaining rooms are devoted to smaller-scale works from the late 19thC and early 20thC. **Wilkie**, **Landseer**, **Etty** and **Egg** represent the subject painters, Egg's moral triptych *Past and Present* being the most memorable, while **Dyce's** atmospheric *Pegwell Bay* is the finest of the landscapes. The final galleries have been allocated to **sporting art**, although at present this area still has a number of late 19thC and early 20thC works which do not fit easily into the modern collection. **Orpen**, **Rothenstein** and **John** apparently fall into this category, as do several others, emphasizing the need for a coherent display of this confused period. In the meantime, however, the British collection closes, appropriately or not, with a series of caricatures by **Max**

Beerbohm of the leading artists and writers of the Victorian period.

The modern collection

Like the British collection, this seems to start somewhat uncertainly in the entrance area. Here, for example, you can see Rodin's *The Kiss* and Gabo's *Head No. 2*, even though the collection proper does not begin until room 30 to the right. From here it proceeds through some 20 or so galleries, each devoted to a particular artist or group, and providing in all a representative survey of virtually all the **major 20thC movements**. There are, however, obvious weaknesses if not actual gaps in many areas, which serve to undermine the Tate's reputation when compared to similar institutions on the Continent and in America. This is partly due to the relative insularity and indifference of British artists and collectors in the past, and the early history of the Tate is punctuated by stories of important bequests that were turned down because artists such as Picasso or Kandinsky were not considered important at the time. In recent years the Tate has adopted a more assertively "modernist" stand, which has drawn the criticism and ridicule of the popular press while at the same time stimulating greater public interest in the gallery as a whole.

The late **19thC French** section in room 33 has few surprises, dominated as it is by Monet's *Poplars on the Epte*, **Gauguin's** frieze-like *Faa Iheihe* and **Van Gogh's** well-known *Chair and Pipe*, but some of the minor works are at least as interesting. Pissarro's *Self-Portrait* and Toulouse-Lautrec's *Portrait of Emile Bernard* are both excellent, as is **Bonnard's** sensuous depiction of his wife in *The Bath* (1925). Nor should you miss Degas's bronze *Little Dancer*, the only one of his sculptures to be exhibited during his lifetime. The British artists of the early 20thC complement these works interestingly for many of these painters, notably **Bevan**, **Steer** and **Ginner**, were directly influenced by the French. Sickert's *Ennui* and Gilman's *Mrs Mounter* are probably the most successful works of this group.

Of the **Fauvists** in room 31 Derain's pictures (*Port of London* and *Portrait of Matisse*) seem more substantial than those of **Matisse**, although the latter is well served in the later period with *The Back*, a series of bronze reliefs, and *The Snail*, one of his last works using coloured paper "cut-outs". Likewise in the **Cubist section** in room 37, Braque's *Mandolin and Clarinet* and *Bottle of Rum on a Mantlepiece* are finer than any of Picasso's works, although the Spanish

artist is represented by a selection of pictures from various stages in his career, including the early *Girl in a Chemise* (1905) and *The Three Dancers* (1925). There is also a good selection of pictures and sculptures by the Cubists' contemporaries in room 32: Léger (*Still Life with a Beer Mug*), Modigliani (*The Little Peasant*) and Boccioni (*Unique Forms of Continuity in Space*).

The *Expressionists* in room 39 are introduced by Munch's *Sick Child* (1907) after which the principal figures of *Die Brücke* and *Der Blaue Reiter*, **Nolde**, **Kirchner** and **Kandinsky**, are shown alongside the later German artists Beckmann (*The Carnival*) and Grosz (*The Suicide*). There are also some early 20thC Russian works such as Larionov's deliberately primitive *Soldier on a Horse* (1911).

As one moves out of the first two decades or so, the "heroic phase" of modern art, arranging the collection into coherent patterns becomes more difficult, but the Abstract artists of the inter-war period—**Mondrian**, **Malevich**, **Kandinsky** and **Moholy-Nagy**—tend to be exhibited together. There is also a selection of **Dadaist and Surrealist** works in room 36, including Chagall's *The Poet Reclining*, De Chirico's *Melancholy of Departure*, Miró's *Woman and Bird in the Moonlight*, Magritte's *The Reckless Sleeper*, Dali's *Autumn Cannibalism* and Max Ernst's *Elephant Celebes*. The original version of Duchamp's *The Bride Stripped Bare by her Bachelors, Even*, an elaborate construction of painted glass, fell and was smashed in 1926, but there is a reconstruction prepared by the artist Richard Hamilton in this section, and, in the adjoining room, a series of bronze figures by the French sculptor **Giacometti**.

The British art of this period has some connections with these European movements, at least in the work of **Ben Nicholson**, **Barbara Hepworth** and **Henry Moore**, the three principal figures who are well represented in the collection. But there are a number of other artists such as **Burra**, **Lowry**, **Nash**, **Hitchens** and **Sutherland** whose work cannot be so readily defined. As a general point, however, sculpture did flourish in Britain at this time and there is an impressive array of works by **Gaudier-Brzeska**, **Epstein** and **Gill**, as well as those mentioned earlier, Nicholson, Hepworth and Moore, in room 29.

In the post-war period the gallery has been able to acquire a very good selection of **American art**, which you can see in rooms 40–43. This selection includes pictures by **Pollock** (6 in all), **Newman**,

Reinhardt, **Still**, **Louis**, **Gorky** and **De Kooning**, although the most impressive group is the series of 8 canvases by Rothko, *Black on Maroon*. These were painted in 1958 for the Four Seasons Restaurant in New York, but withheld by the artist because he did not feel that this worldly setting was appropriate for their brooding meditative character. They were presented to the Tate in 1969 on condition that they would be hung in their own enclosed space. Of the American **Pop artists** there are works by **Johns**, **Stella**, **Rauschenberg**, **Warhol** and **Lichtenstein**, while more recent developments are best seen in Sol LeWitt's *Six Geometric Figures, Plus Two* (1981), and Carl Andre's notorious "Bricks", *Equivalent VIII* (1966).

European artists of the post-war period who figure prominently at the Tate (room 44) include **Dubuffet**, **Appel**, **Manzoni**, **Klein** and **Broodthaers**. But British art, at least in the 1960s and '70s, has achieved greater international recognition, and the Tate's comprehensive coverage of this field, from the works of **Lucian Freud** and **Bacon** (room 28) to the most recent developments of **Barry Flanagan** and **Bill Woodrow**, takes in all the famous figures. The holdings include works by such artists as **Peter Blake**, **Hockney**, **Kitaj**, **Hamilton** and **Paolozzi**, but only a small part of this collection can be displayed at any one time.

Finally, two important features of the Tate Gallery should not be overlooked: first, its important **temporary exhibitions** of British and foreign contemporary art are often essential viewing for any art lover, and, second, it has a very pleasant restaurant in the basement with charming illusionistic murals painted by the English artist **Rex Whistler** in the 1930s. These recently renovated decorations are among the most enjoyable features in the gallery.

The Thomas Coram Foundation for Children

40 Brunswick Sq, WC1
Tel. 278–2424
Open Mon–Fri 10am–4pm
Closed Sat Sun
🚇 📷 🏛

In the early 18thC, when there were no exhibition galleries in Britain, Hogarth encouraged several artists to donate works to the Foundling Hospital (established in 1739 by the English sea-captain Thomas Coram) on the understanding that they would be shown to the public for fund raising. It was in many respects an ambitious scheme, which was eventually superseded by the

Royal Academy, but the reconstructed building remains to this day an interesting museum of **English 18thC art**. Hogarth's portrait of the hospital's founder *Captain Thomas Coram* ★ is itself a milestone in British portraiture which established a modern form for the Baroque "full-length", and there are two other paintings by the artist in the collection: *Moses and Pharaoh's Daughter*, an appropriate subject for an orphanage, and *The March of the Guards to Finchley*. Of the other artists who participated in the scheme there are works by **Highmore**, **Hayman**, **Ramsay**, **Reynolds** and **West**, and in the Court Room there is a series of 8 views of London hospitals, two of which are by **Richard Wilson** and one by the young **Thomas Gainsborough**.

Handel was another benefactor of the hospital, and the foundation has a manuscript of his great oratorio *The Messiah* as well as a terracotta bust of the composer by **Roubiliac**.

Tower of London
Tower Hill, EC3
Tel. 709–0765
Open Mar–Oct Mon–Sat 9.30am–5pm,
Sun 2–5pm; Nov–Feb Mon–Sat
9.30–4pm
Closed Sun Nov–Feb
▨ 𝑘 ⛨ 🏛

The Tower of London, and the red Tudor costumes of the so-called "Beefeaters" who guard it, have come almost to symbolize London in the imagination of many. Today the place serves not simply as a major tourist attraction but also as an arsenal with a garrison attached to it. In the past it has functioned variously as a fortress, a royal residence and even a zoo (the royal menagerie was housed here from the 13thC until 1834, when it was transferred to Regent's Park to form the basis of the London Zoo). But most people prefer to think of it as a notorious state prison, where many famous people were imprisoned, murdered, or executed.

Dominating the vast, grim complex of towers, moats, and massively fortified walls that make up the Tower of London, is the **White Tower**, the place's oldest and most architecturally interesting part. Inside is the **Chapel of St John**, one of the finest surviving examples of early Romanesque architecture in England, though bare of ornament. The other rooms in the Tower contain an impressive collection of **arms and armour** begun by Henry VIII, including magnificent examples of **English** and **European armour** with engraved decoration of the 16thC and 17thC (note the suits of Henry VIII especially).

The main tourist attraction of the Tower of London is the **Crown Jewels**, which are kept below the 19thC Waterloo Barracks, but you are unlikely to find the experience an unqualified success. After waiting interminably for the privilege of seeing them, you may be required by the guards to walk past at top speed. The objects range from a **decorated spoon** possibly made for King John's coronation in 1199 to a **crown**, used at the Queen Mother's coronation in 1937, incorporating one of the largest diamonds in the world.

University College
Gower St, WC1
Open by arrangement
▨ 🏛

The early 19thC University College, a domed Neoclassical building with a grandiose Corinthian portico, is by far the most impressive of Bloomsbury's university buildings. One of the attractions of the interior is the embalmed body of the Utilitarian economist and philosopher **Jeremy Bentham** (1748–1837). Rather more rewarding is a group of 120 plaster models by the Neoclassical sculptor **John Flaxman**, which were presented to the college in 1848 by the artist's sister-in-law and adopted daughter, Maria Denman. One of the more impressive of these models is the monument to the Orientalist *Sir William Jones*, who is shown in the company of three Orientals at work on his *Digest of Hindu and Mohammedan Law*; the others are mainly for church monuments, and are interesting for the way in which they fuse the Classical style with Christian sentiment. The works are shown in the octagon supporting the dome, and gain immeasurably from this dark and grand setting, reminiscent of a print by Piranesi.

Victoria and Albert Museum ☆☆
Cromwell Rd, South Kensington, SW7
Tel. 589–6371
Open Mon–Thurs Sat 10–5.50pm
Sun 2.30–5.50pm
Closed Fri
▨ 𝑘 ⛨ ▣ 🏛 ☑

The Victoria and Albert Museum (or V & A as it is generally referred to) is just one of a number of cultural and educational institutions founded in South Kensington in the 19thC. On the other side of Exhibition Road is the neo-Romanesque **Natural History Museum**, which recent cleaning has restored to its former ornamental glory, and farther up the road on the left-hand side is the **Science Museum**. Though not opened until this century, this institution

inherited the scientific part of the V & A collection. There you can see a few paintings of scientific subject matter, most notably Loutherbourg's superlative *Coalbrookdale by Night* ★. Opposite this building is the **Royal College of Art**, founded in the 19thC as the government school of design, and at the top of the road is London's major Victorian concert hall, the **Albert Hall**. Sir Gilbert Scott's magnificent **Albert Memorial** ★, a celebration of Queen Victoria's conscientious and high-minded consort, is directly in front of the Hall in Hyde Park, and it serves as a fitting conclusion for this group of monuments to Victorian self-confidence and optimism.

The V & A, the brainchild of both Prince Albert and his friend, Sir Henry Cole, developed out of the Great Exhibition of 1851, the profits of which were used to purchase the South Kensington site. Originally called the Museum of Ornamental Art, it was founded in an attempt to improve the standards of British design by furnishing examples of applied art, ancient and modern, as models for craftsmen to copy. Large bequests of paintings, the loan from Queen Victoria of Raphael's tapestry cartoons, and the general desire to acquire great works of art soon led to an erosion of the original purpose behind the museum. Today the V & A is by far the most complex of London's museums; but it is also one of the most enjoyable, with something to suit everyone's tastes, whether this be for **costumes, musical instruments, sculptures, jewelry, paintings**, or **furniture**.

The scale of the building is too large, and the arrangement of the rooms too confusing, to warrant any attempt at seeing everything. Indeed one of the great pleasures of the place is that of casual browsing, and of coming across unexpected items. Another of its pleasures is to be had from the building itself, which was essentially constructed in two main phases, the 1850s and the first decade of this century. In contrast to London's other major museums, the V & A retains many charming Victorian features, such as a **staircase** covered with polychrome ceramic tiles and a suite of former refreshment rooms lavishly decorated in a rich variety of materials by **William Morris, James Gamble** and **Edward Poynter**. Perhaps the most striking of the Victorian features is the now wonderfully restored **Cast Room**, where you find yourself confronted with full-size reproductions of some of the world's greatest **sculptured monuments**, including *Trajan's Column* in Rome and the main Romanesque doorway from

Spain's Cathedral of Santiago de Compostela.

The works on show in the main building are both Western and Oriental, and comprise mainly **sculpture** and **applied art objects** (the bulk of the museum's painting collection is now displayed in the newly opened Henry Cole Wing). They are broadly divided between what are called the "primary collections" (masterpieces of all the arts brought together by style, period or nationality, and sometimes shown in reconstructions of interiors appropriate to the objects) and "study collections" (objects grouped together according to their material, e.g. glass, metalwork, etc.).

The extensive **Oriental collections**, soon to be rearranged and rationalized, include wonderful **Japanese lacquerwork**, **Chinese ceramics**, **Persian miniatures**, and the enormous **Ardabil Carpet** ★ of 1540, perhaps the most famous of all Persian carpets. Among the earliest high points of the Western collections are a beautiful, intricately carved whalebone relief of the *Adoration of the Magi* ★ (11thC–12thC and probably the work of English craftsmen); the early 12thC **Gloucester Candlestick** ★ (an elaborately worked object comprising numerous curious and amusing details); and the celebrated 12thC **Eltenburg Reliquary** ★, a masterpiece of the Rhenish goldsmith's art, taking the form of a Byzantine church and decorated with copper and bronze gilt, ivory figures and reliefs; and the **Champlevé enameled panels**.

Of later medieval art, you should not miss the four **Devonshire Hunting Tapestries** ★ (1425–30, probably made in Arras), which are among the finest and largest tapestries to have survived the Middle Ages, and feature hunting scenes against a fairy-tale background of castles and glittering streams. Belonging to the Renaissance period, though completely medieval in spirit, are the German early 16thC limewood sculptures by Veit Stoss (*Virgin and Child* ★) and Tilman Riemenschneider (**two candle-bearing angels** ★ and *Mary Salome and Zebedee* ★, which portrays this biblical pair in contemporary German costume).

The Renaissance collections are dominated by the enormous room containing **Raphael's tapestry cartoons** ★★ (or full-scale designs) which were painted around 1515 for tapestries commissioned by Pope Leo X: the stories represented deal principally with scenes from the life of St Peter. Once regarded as among the greatest works of art of all time, the cartoons, though undoubtedly very impressive on account of their size

and dynamic compositions, have spawned too many cold, academic imitations to be fully appreciated by today's public.

Spanning almost all the centuries covered by the museum's collections are the superb holdings of Italian sculpture, beginning with **Giovanni Pisano's** expressive and deeply carved statue of the prophet *Haggai*★ from the façade of Siena Cathedral (13thC). The Italian Renaissance collections boast a delicate **marble relief**★ by **Agostino di Duccio**, and the finest group of works by **Donatello** to be found outside Italy, including a relief of the *Dead Christ Tended by Angels*★, and *The Ascension with Christ Giving the Keys to St Peter*★★, which, though executed in a very shallow relief known as *rilievo staccato*, manages to create an extraordinary sense of depth, and also has beautiful landscape details. Later 16thC Italian sculpture is represented principally by **Giovanni da Bologna's** sculpture group, *Samson and the Philistines*★, which encourages the spectator to walk around it and revel in its complex forms. In contrast, Bernini's *Neptune and Triton*★, originally designed as the dominating feature of a decorative pond belonging to a Roman cardinal, is dependent on its impact when seen from the front. Another masterpiece by **Bernini** is the dynamically posed though finely detailed portrait bust of *Thomas Baker*★, situated in a room containing busts by Italian Baroque contemporaries of Bernini such as **Algardi**.

The museum's later holdings of sculpture include works by the Neoclassical sculptor **Canova**, but are more notable for their works by French and British artists, among which is a highly sensuous terracotta group by Clodion (*Cupid and Psyche*★), and a famous marble statue of *Handel Playing Apollo's Lyre*★ by Roubiliac.

The museum's extensive collection of **bronzes**★ by **Rodin** (all presented by the artist) takes you to the most recently opened sections of the museum, the "**Boilerhouse Project**" and the **Henry Cole Wing**. The former, housed in the basement and containing beautifully displayed examples of products by **living British designers**, represents an admirable attempt to revive the museum's original function. However, the Henry Cole Wing is the most splendid and important of the new additions to the museum. This brilliantly converted mid-19thC building, originally part of the Imperial College of Science, has a most impressive and

immensely tall **staircase well**, one of the most grandiose examples of the Victorian Classical style in London but hardly known till the wing was opened in 1982.

The Henry Cole Wing is divided into "levels", on the second of which is the museum's collection of **18thC** and **19thC British paintings**. Though there are some fine works here by 18thC masters such as **Gainsborough, Reynolds** and **Morland**, the most enjoyable aspect of this collection is the Victorian **subject pictures**, the great majority of which were bequeathed in 1857 by a wealthy Leeds cloth manufacturer, John Sheepshanks. Here you will find one of the great tear-jerkers of the Victorian age, Sir Edwin Landseer's *The Old Shepherd's Chief Mourner* (1837), a portrait of a dog resting his head on his master's tomb.

The third level contains a selection from the V & A's extensive holdings of **watercolours**, which feature not only works by later 18thC and 19thC British watercolourists such as **Turner, Cozens, Girtin, Cox** and **De Wint** but also an outstanding group of works by some of the leading **20thC British** and **European artists**. The rest of this level is used by the recently formed **photographic department**, which shows a display relating to photographic processes, selections from its impressive permanent collection and temporary exhibitions.

One of the great delights of the fourth level is L. Carraciolo's *Circular Panorama of Rome*★, which gives an uncannily realistic impression of what the city must have been like in the early 19thC: this is the only example on display in London of a type of art form that was extremely popular before the advent of photography. Nearby is another curiosity, a group of **landscapes** painted on glass by **Gainsborough**, which create a most luminous effect when lit from behind. This level is also filled with numerous other art treasures. A darkened room is devoted to the museum's superb collection of English **portrait miniatures**, the most famous of which are those by the Elizabethan artists **Isaac Oliver** (note especially his very stylized portrait of a woman said to be *Frances Howard*★ in an intricate lace garment) and **Nicholas Hilliard** (most notably his deeply romantic *A Young Man Leaning Against a Tree Among Roses*★). Another section of this level houses the bequest of paintings made by Constantine Ionides, a 19thC Greek industrialist and resident of London, who was the friend and patron of a number of Britain's leading artists.

This collection begins with a *Coronation of the Virgin* by the 14thC

painter **Nardo di Cione** and includes various **17thC Dutch and Flemish works**, and a wonderfully fresh rural genre scene (*Landscape with Figures*★) by the 17thC French artist **Louis Le Nain**. But its **19thC pictures** are its greatest strength. Among these is a small, turbulent oil sketch by Delacroix of *The Shipwreck of Don Juan*★, Millet's *The Wood Sawyers*★ (1850), Degas' large *The Ballet Scene from Meyerbeer's Opera Robert le Diable*★, and various works by English artist friends of Ionides such as **Watts** and **Rossetti**.

The museum's other 19thC European paintings are also displayed on this fourth level, but these are of minor importance, being principally of interest to lovers of **Swiss genre paintings** of this period. The by now exhausted visitor to the Henry Cole Wing still has the sixth level to see, which not only has superb views over London, but also one of the largest collections anywhere of works by the 19thC landscapist **John Constable**. Though these include finished paintings such as the marvellous *Salisbury Cathedral*★ of 1823, the principal items of interest in the collection are the **watercolours** and **oil sketches**, which were painted mainly for his own benefit and thus have a greater spontaneity than they would have had had they been intended for public exhibition. For his larger exhibited pictures the artist adopted the unusual practice of executing full-scale **oil studies**, which today are generally preferred to the final works. The best known of these are the *Leaping Horse*★ and *The Haywain*★.

In addition to the paintings in the Henry Cole Wing, some of the **Period Rooms** in the main building are enhanced by pictures. For example, a large and rather gruesome **15thC Spanish** retable of St George dominates the long gallery devoted to European Gothic art, and a superlative portrait of *Madame de Pompadour*★ by Boucher is hung in one of the fine 18thC Continental rooms.

Wallace Collection ★★
Hertford House, Manchester Sq, W1
Tel. 935–0687
Open Mon – Sat 10am – 5pm; Sun 2 – 5pm
▣ ⏛ 🏛

The Wallace Collection of **paintings, sculpture, decorative arts** and **armour** is one of the greatest personal collections of modern times. It was begun by the 4th Marquis of Hertford and greatly expanded by his grandson Sir Richard Wallace, both of whom were able to profit from the disruption of the old noble families of Continental Europe during the 19thC. Hertford, for example,

acquired a number of pieces at auctions which had originally graced the French royal palaces before the Revolution, and Wallace was able to assemble an outstanding collection of European armour at a stroke by purchasing the entire collections of the Niewerkerke and Meyrick families following the Franco-Prussian War of 1870. At about this time Wallace adopted Hertford House in London's Manchester Square as his principal residence, where the collection was installed and has since been held following the bequest to the nation in 1897.

In the past much has been made of the domestic atmosphere that is supposed to pervade the building, but it is difficult to imagine these large remodelled galleries as the setting for any kind of private life, nor is the personality of any individual detectable. Nevertheless, the collection is laid out in a richly diverse manner, bringing together **paintings, sculpture, furniture, ceramics** and a host of decorative items in a way that is constantly fascinating. It is also remarkable for the number of outstanding works highlighting each area, especially the **French 18thC**.

The Rococo painters are particularly well represented, **Watteau** alone being seen in a number of works including *The Music Party*★, *The Champs Elysées*, *The Halt* and the unusually direct *La Toilette*. **Boucher** and **Fragonard** are equally evident, the former with a small portrait of *The Marquise de Pompadour* and a series of four magnificent tapestry designs (*The Rising of the Sun*★, *The Setting of the Sun*★, *Autumn Pastoral*★ and *Summer Pastoral*★), while Fragonard is best seen in *The Swing*, ★ probably his most famous painting. Of their contemporaries there are works by **Pater, Lancret** and **Greuze**, and several still-lifes by the great sporting artists **Oudry** and **Desportes**, the former's *Dogs and Still Life (The Dead Wolf)* being the most memorable.

Throughout the house there are excellent examples of **18thC French furniture**, much of it with a royal provenance and ultimately deriving from Versailles, Fontainebleau or Marly. It is perhaps sufficient to mention one piece: the **marquetry desk** ★ made for the Polish king, Stanislas Lescynski, by **Riesener** and **Oeben** (c.1760), which is perhaps the finest surviving example of Louis XV furniture. To match this, there is an unparalleled collection of **Sèvres porcelain**★ in room 2, and a magnificent group of **gold boxes** in room 12. Even the **balustrade**★ on the main stairway was originally made for the Palais Mazarin in

Paris and is generally regarded as the greatest surviving example of early 18thC metalwork.

The French collection here extends beyond the 18thC. Do not miss the fine 17thC paintings by **Philippe de Champaigne** and **Claude Lorrain**, although the most important 17thC work here is Poussin's *A Dance to the Music of Time*★, which inspired Anthony Powell's title for his sequence of novels. From a later period there are several Romantic paintings, Delacroix's *Execution of the Doge Marino Falieri*★ being the finest and the artist's own favourite. Alongside this is a series of oils and watercolours by the precocious English artist **R.P. Bonington**, who introduced Delacroix to the techniques of English landscape art. Bonington died in his late twenties without developing his original promise, but here you can see probably the most substantial group of his works anywhere.

With the exception of 4 watercolours by **Turner**, the other British paintings are predominantly 18thC portraits, among which Reynolds' *Nelly O'Brien* is the most attractive. This collection also includes three portraits by different artists of the same subject **Mrs Robinson**, (as Perdita in *A Winter's Tale*) by **Reynolds, Gainsborough** and **Romney**; these are all hung in the large gallery on the first floor (room 19) alongside the principal works from the other European schools. Here you can find Velazquez's *Lady with a Fan*★, Andrea del Sarto's *Virgin and Child with St John the Baptist and Angels*, and Titian's *Perseus and Andromeda*★★, one of the great series of mythological works, or *poesie*, painted for Philip II of Spain in the 1550s. Some later Italian pictures, such as the 18thC views of Venice by **Guardi** and **Canaletto**, are kept in room 13.

The finest of the Dutch and Flemish pictures are also hung in the large gallery, notably Rubens' *Rainbow Landscape*; Van Dyck's portraits of *Philippe le Roy*, *Seigneur de Ravels*, and his young wife *Marie de Raet*; and Frans Hals's *Laughing Cavalier*★, a title that has remained with this famous picture although it is clearly inappropriate. **Rembrandt's** companion portraits of *Jan Pellicorne with his Son* and *Susannah Pellicorne with her Daughter* are more restrained, as is the smaller portrait of the artist's son *Titus*. Elsewhere in the collection you can see further Dutch and Flemish works, including several oil sketches by **Rubens** and his studio, and a number of still-lifes, landscapes and genre paintings, notably Cuyp's *Avenue at Meerdevoort, Dordrecht* and de

Hoogh's *Interior – Woman Peeling Apples*.

Outside the broad areas described above the Wallace Collection is curiously disparate, but you will find it is large enough to accommodate various interesting pieces which might seem rather out of place. These include some English **medieval alabasters**, **Elizabethan miniatures**, and two excellent decorative objects: the **Horn of St Hubert**, a relic that was elaborately decorated in the 15thC, and the **Bell of St Mura**, a 7thC Irish bell-cover inlaid with semi-precious stones and Celtic tracery. In the field of contemporary art Wallace was fairly cautious. He did buy pictures by living artists, but in the case of artists like **Corot, Ziem** and **Rousseau** he was almost certainly looking to the great traditions of European landscape art.

Westminster Abbey ✫
Broad Sanctuary, SW1
Tel. 222–5152
Open (Royal Chapels) Mon–Sat
 10am–4pm
🚇 ♿ 📖

The scene of the coronation, marriage and burial of English monarchs since the time of William the Conqueror, and the resting place of many of Britain's greatest people, Westminster Abbey can be regarded as England's mother church. It is not known when the abbey church was founded, though there was certainly a religious foundation here by the 9thC. Work began on the present building under Edward the Confessor in 1050, but only fragments of the early structure remain. Westminster Abbey today is largely the result of the work carried out between the mid 13thC and the mid 14thC in a Gothic style closely indebted to the French cathedrals of Reims and Amiens. **Henry VII Chapel**★★, at the far end of the cathedral is a masterpiece of the English late Gothic style; it was finished in 1519; and the W towers and façades of the building, largely designed by **Sir Christopher Wren** in 1698, were brought to completion by **Nicholas Hawksmoor** in a pseudo-Gothic style in 1745.

Apart from the famous icon-like portrait of *Richard II* (c. 1398) hanging in the nave, the main medieval treasures inside the abbey are to be found in the chancel and the Henry VII Chapel. You have to pay to enter this part of the church, and are encouraged by signs and vergers to file as quickly as possible through the chancel, which can become unpleasantly congested with tourists. The main attraction here is the **Coronation Throne** of 1300–01, which

contains under its seat the **Stone of Scone**, the mystical coronation stone of the Scottish kings (see Scone Palace in *SCOTLAND*). Only the base remains of the once highly praised shrine of *Edward the Confessor★*, commissioned by Henry III in 1241. The base was executed by Italian craftsmen, and is an outstanding example of Cosmati work, which is characterized by a mixture of porphyry slabs in red and green and glass mosaic.

A bridge leads from this section of the chancel to the **Henry VII Chapel**, which is covered in a profusion of **carvings** and has exquisitely elaborate tracery on the ceiling. The bronze recumbent monument of *Henry VII★* is by the Florentine sculptor **Pietro Torrigiano**, who is perhaps best known as the man who broke Michelangelo's nose in a quarrel. Its importance lies in its status as the first Renaissance-style sculpture in Britain, having such characteristics as medallions surrounded by wreaths and winged putti.

One of the most notable features of the abbey interior is that it is crammed with so many monuments from the **Baroque** to the **Neoclassical periods**. These were a source of great annoyance to Victorian medievalists such as Pugin, who referred to them as "incongruous and detestable monuments"; William Morris went even further and spoke of them as "Cockney nightmares" and "the most hideous specimens of false art that can be found in the whole world". In fact, these later monuments include some of the greatest masterpieces of English sculpture. Particularly impressive are those by the French-born artist active in England in the mid 18thC, **Roubiliac**. Those on the s and w walls of the transept commemorate respectively the *Duke of Argyll★* (1748–9) and *Handel★* (1761): the duke is shown lying pensively on his tomb while behind him the figure of Fame is busily writing his name and titles on an obelisk; the Handel monument is a lively and life-like statue of the composer with an angel playing a harp in the clouds above him. The Baroque elements in these works are brought to a spectacular and gruesome conclusion in Roubiliac's **Hargrave** and **Nightingale** monuments, which were considered by John Wesley, the founder of Methodism, to be the most moving monuments in the whole abbey.

The monument to *General Hargrave★* (1757), situated in the s aisle, is a sensational creation involving a collapsing pyramid of massive stone blocks. *The Nightingale Monument★★* (1761), on the w wall of the N transept, commemorates Mrs J.G. Nightingale who died at the age of 27 after the shock

of almost being struck by lightning while out walking. Her collapsed body is supported by her husband, who died 18 years later and who has a look of extreme terror on his face, holding out his free hand in self-protection, as well he might, for a most hideously realistic skeleton has pushed open the heavy door of a vault below and is pointing a lance in the couple's direction. Perhaps the prejudices expressed by Pugin, Morris and others still linger on, for this monument, one of the outstanding Baroque creations of Europe, is situated in a part of the abbey blocked off by a wooden hoarding.

You should leave the abbey by way of the charming cloister, on the E side of which is the mid-13thC **chapter house** with **wall paintings** of the Apocalypse and a beautiful **tiled pavement**.

William Morris Gallery
Water House, Lloyd Park, Forest Rd, Walthamstow, E17
Tel. 527–5544 ext. 4390
Open Tues–Sat 10am–1pm, 2am–5pm. Also first Sunday in each month 10am–noon, 2am–5pm
Closed Mon

The poet, early socialist and major associate of the Arts and Crafts movement, William Morris, was born in Walthamstow in 1834. His family subsequently moved out of the area, but returned in 1848, acquiring the Water House, which was Morris's home during his years as a schoolboy at Marlborough and an undergraduate at Oxford. This attractive **Georgian house**, set in a fine park with exotic waterfowl, is now a museum to him. The ground floor contains displays relating to Morris's life, as well as **furniture**, **ceramic tiles**, **textiles**, **metalwork**, **embroidery** and other **craft products** by both him and his associates, notably **Burne-Jones** and **Rossetti**; there are also some splendid ceramic tiles by **William de Morgan** and some works by later members of the Arts and Crafts movement, in particular **Voysey**. The first floor shows selections from the bequest made to the museum by the Welsh artist **Sir Frank Brangwyn**, who knew Morris personally and was greatly influenced by him. Brangwyn freely donated his own paintings, prints and drawings to various museums in Britain and elsewhere. However, in Walthamstow you can see, in addition to these, furniture and ceramics designed by him, as well as his impressively representative collection of late **19thC** and **early 20thC British art**, from the **Pre-Raphaelites** to Edwardian artists such as **Sir John Lavery**.

Artists and the Thames

London is seen at its best from the river; Waterloo and Charing Cross bridges provide particularly fine views of the city. However, beautiful though the riverside aspect of London may be, the artists who have chosen to portray it have often transformed London into an implausibly magical place, with strong overtones of Venice.

The first important artist to paint London was in fact Venetian, the view painter Canaletto, who came here in 1746 during a lull in the tourist trade in Venice and stayed until 1750. The English had always been his greatest admirers, though they were slightly disappointed by the works that he painted in England, perhaps because the subjects were more familiar to them. Yet to us now his views of the Thames, which he depicted with intense clarity and in bright sunlight, recall those that he did of the Grand Canal in Venice.

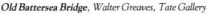

VIEWS of the RIVER

In the late 18thC the then riverside village of Richmond became a popular place for successful artists. Sir Joshua Reynolds bought Wick House (now a nurses' residence attached to the Star and Garter Home) on Richmond Hill, the view from which is the subject of a painting in the Tate Gallery with a rather Arcadian, paradisal character (**The Thames from Richmond Hill**, before 1788). Richard Wilson and the young Turner also did a number of Thames scenes at Richmond, all of which give the river an idyllic, Italianate quality reminiscent of the works of the 17thC Rome-based artist, Claude.

As an old man of 71 Turner decided that he wanted a studio overlooking the river and acquired a cottage at what is now 119 Cheyne Walk, Chelsea, where he died in 1858. At 104 Cheyne Walk lived a boatbuilder called Greaves, whose two sons, Walter and Harry, would row the aged Turner out onto the Thames. This family later became good friends with another distinguished artist neighbour, the American-born James Whistler.

Old Battersea Bridge, Walter Greaves, Tate Gallery

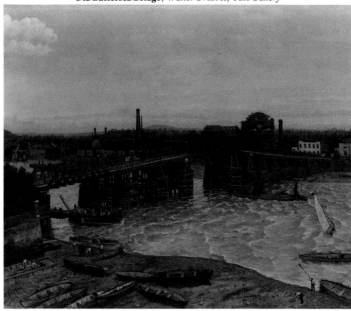

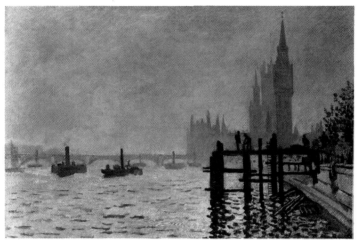

Houses of Parliament, *Claude Monet, National Gallery*

Whistler came to London from Paris in 1859, acquiring a studio in 1863 at 101 Cheyne Walk, and in 1866 at 96 Cheyne Walk which he kept for 12 years. Whistler's first Thames views were done at Wapping in the East End, where he frequented the Angel Inn on Bermondsey Wall East. But his famous "nocturnes" are almost all of Chelsea and date from the 1870s. Painted in the studio from sketches made when out on a boat with the Greaves brothers, they invest London's river landscape with the magical elusive qualities characteristic of Japanese prints, as in *Blue and Gold – Old Battersea Bridge* (Tate Gallery). Under the influence of Whistler, Walter Greaves took up painting himself, working at first in a delightfully naive style, but soon producing mere Whistlerian pastiches.

IMPRESSIONIST LONDON

In 1870, after the outbreak of the Franco-Prussian War, the French Impressionists Pissarro and Monet came to London. The former was exceptional among foreign artists in choosing to paint some of London's less obvious attractions, most notably scenes around the dull southern suburb of Norwood, where he and his family stayed. Little is known of Monet's first trip to London, though on this occasion he did paint the view of the Thames looking from the Embankment to the *Houses of Parliament* that is now in the National Gallery. His celebrated canvases of the Thames seen in different atmospheric conditions date from his visits to London between 1899 and 1901. Two of the three viewpoints that he adopted for these were from his fifth-floor window at the Savoy Hotel.

Other French artists who painted the Thames include the Impressionist Sisley, who did numerous views in 1874 of the river at Hampton Court and nearby Molesey (for example, *The Weir at Molesey* in the National Gallery of Scotland, Edinburgh), and the Fauve Derain, who came in 1875 and 1906, and executed views of the *Palace of Westminster, Charing Cross Bridge* (Leeds City Art Galleries) and the *Pool of London* (Tate Gallery). The Austrian Expressionist Kokoschka first visited London in 1925, and was inspired by the stretch of the Thames from Charing Cross to Waterloo, painting wide-angle views of it in a near-apocalyptic character.

London's public statuary

Public monuments tend quickly to become an accepted part of the urban scene, acquiring such a familiarity that they generally attract little public attention. Yet they are important indicators, perhaps more so than any other art form, of a nation's attitude not only to its history but also to its art.

London has little public medieval statuary, thanks to the image-breakers of the Protestant Reformation and, later, to the Great Fire of 1666. The elaborate cross outside Charing Cross Station is a Victorian Gothic interpretation by E.M. Barry (1863) of a 13thC Eleanor Cross erected by Edward I (the last of 12 marking the place where his queen Eleanor's funeral cortège paused on its way from Lincolnshire to Westminster Abbey). Until its destruction in the Civil War in 1647 the original cross stood on the S side of Trafalgar Square, a site now occupied by **Hubert Le Sueur's** equestrian statue of *Charles I*. This, one of London's finest public statues, was made in 1633, dismantled and concealed during the Civil War, and re-erected in its present location in 1675 by Charles II.

A statue by **Cibber** in Soho Square commemorates *Charles II*, but this has a rather forlorn look today, partly because it has lost the 4 large figures representing English rivers that flanked the pedestal, and partly because the once fashionable square itself has now come down in the world.

COMMEMORATIVE MONUMENTS

The great majority of London's statues date from Victorian times, reflecting the self-confidence of this period and the importance it gave to public

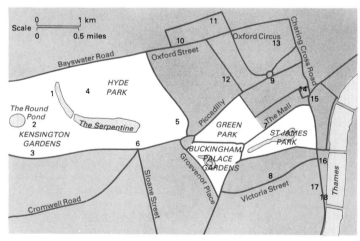

1 *Peter Pan*, George Frampton (1901), Kensington Gardens

2 *Physical Energy*, G.F. Watts (1903), Kensington Gardens

3 *Albert Memorial*, designed by Gilbert Scott (1863), Kensington Gardens

4 *Rima*, Jacob Epstein (1925), Hyde Park

5 *Achilles Statue* – Duke of Wellington Memorial, Sir Richard Westmacott (1822), Hyde Park

6 *Pan*, Bowater House, Jacob Epstein (1959), Knightsbridge

7 *Queen Alexandra Memorial*, Alfred Gilbert (1932), Marlborough Gate

8 **Broadway House**, Jacob Epstein, Henry Moore and Eric Gill (1929), Broadway

9 *Eros*, Alfred Gilbert (1893), Piccadilly Circus

10 **Façade** of Department Store, Oxford St

11 *Virgin and Child*, convent of the Holy Child Jesus, Jacob Epstein, Cavendish Sq

12 **Time-Life Building**, Henry Moore (1953), Bond Street

13 *Charles II*, Caius Cibber (1681), Soho Sq

14 *Statue of Nelson*, Edmund Hodges Bailey (1839–1843), Trafalgar Sq

14 *Lions*, modelled by Sir Edwin Landseer and cast by Baron Marochetti (1867), Trafalgar Sq

15 *Charles I*, Hubert Le Sueur (1633), Trafalgar Sq

16 *Richard I*, Baron Marochetti (1860), Old Palace Yard

17 *Knife Edge*, Henry Moore (1967), Abingdon St Gardens

18 *Burghers of Calais*, Auguste Rodin, Victoria Tower Gardens

Charles I, H. Le Sueur, 1633 *Albert Memorial (det.),1863*

gestures. These works invariably aroused considerable public interest in their time but have now suffered a reversal in their critical fortunes and are often dismissed as tedious examples of Victorian pomposity. However, signs of a reappraisal are now beginning to appear. Outside the Houses of Parliament you can see a splendid equestrian statue of **Richard Coeur de Lion**, favourably compared at its unveiling in 1860 with works by Verrocchio in Venice and Donatello in Padua. The sculptor was in fact an Italian, **Baron Marochetti**, a man accused by his colleagues of using friends in high places (notably Prince Albert) to obtain commissions.

Marochetti also played a part in one of London's best-known monuments, that to **Nelson** in Trafalgar Square. This was largely executed between 1839 and 1843 by Edmund Hodges Bailey, whose dreary statue of Nelson, which surmounts the column, is fortunately placed at a sufficient height to be appreciated only by pigeons. The magnificent **bronze lions** at the base of the column, unveiled in 1867, caused much annoyance to English sculptors: not only were they cast by a foreigner, Baron Marochetti, but also they were modelled by someone who was not a sculptor at all. This was the animal painter **Edwin Landseer**, who used as his model a lion supplied by the London zoo that died shortly afterwards. The artist then had the disagreeable experience of working from the animal's decaying corpse.

Nelson's great military contemporary, the Duke of Wellington, is commemorated by a less prominent monument at the edge of Hyde Park near the Duke's London home, Apsley House. Executed by **Sir Richard Westmacott** in 1822, it comprises an enormous nude bronze of the Greek hero **Achilles**. Nude commemorative statues were then fashionable (see Canova's absurd statue of Napoleon in APSLEY HOUSE itself), but this naked male evoked amusement at the time since its inscription records that it had been erected in the Duke's honour by "his countrywomen".

VICTORIAN *and* EDWARDIAN STATUES

The most extravagant and impressive monument of Victorian England is the **Albert Memorial**, designed by **Sir Gilbert Scott** in 1863. In deference to the Prince's passion for the Middle Ages, this takes the form of an elaborately detailed Gothic canopy rising above Prince Albert's statue and inlaid with mosaics and precious stones. Sculptural groups representing Commerce,

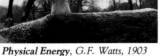

Physical Energy, *G.F. Watts, 1903* ***Lion***, *E. Landseer, 1867*

Engineering, Manufactures and Agriculture form the base of the canopy, together with a frieze illustrating "the edifying arts". The choice of poets, architects, painters and sculptors to be featured in the frieze was the subject of great discussion, and throws much light on the taste of the time. The whole monument rests on steps at the bottom of which are four groups representing the continents. Numerous leading sculptors were involved in the Albert Memorial, including the Irish sculptor **John Henry Foley**, who executed the statue of the prince himself and the magnificent sculptural group of Asia.

Among the finer monuments of the late Victorian and Edwardian periods is **Sir George Frampton's** well-known *Peter Pan* statue (1901), which stands on the spot in Kensington Gardens where Barrie's boy hero landed for his nightly visits, as related in *The Little White Bird*. The model for the boy was Michael Llewellyn Davies, the brother of the boy who originally inspired Peter Pan.

A work of a different kind in Kensington Gardens is **G.F. Watts's** *Physical Energy* (c. 1883 – 1904), a vigorously modelled study of a naked man on a rearing horse. For Watts – who is better known as a painter – the qualities of energy and progress that he wanted to express in this work were the essential characteristics of his age.

No British sculptor of the late 19thC is remotely comparable in stature to **Rodin** (a version of whose bronze *Burghers of Calais* can be seen in Victoria Tower Gardens). But perhaps the closest equivalent is **Sir Alfred Gilbert**, who was much more sensitive as a sculptor than his contemporary Watts, and was far more suited to convey the languorous high aestheticism of the late Victorian period. His best-known work is the so-called *Eros* (1886 – 93) in Piccadilly Circus, London's best loved monument, though not for reasons of its artistic value. It was intended as a memorial to the philanthropic 7th Earl of Shaftesbury.

By 1900 Gilbert, who had been severely criticized for his Eros, was beginning to fall out of favour, and was soon to lapse into poverty and obscurity in Brussels. However, at the very end of his life he was summoned back to London to execute the memorial to his old friend *Queen Alexandra* at Marlborough Gate (see p.110). Though carried out as late as 1928–32, the spirit of the work is firmly in the late 19thC: it is a brilliant Art Nouveau creation with a strong allegorical content.

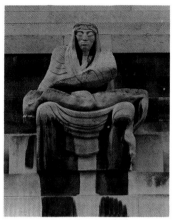

Day, J. Epstein, 1925 *Reclining Figure, H. Moore, 1963–4*

SCULPTURE *in the* 20THC

Public sculpture in London this century has generally been hampered by conservatism on the part of both the commissioning bodies and the public. One of the most original sculptors working in Britain in the early 1900s was **Sir Jacob Epstein**, whose first major public commission in 1908 was to execute 18 figures for the former British Medical Association in the Strand. These shocked the public with their realistic nudity, *The Evening Standard* complaining that "they are a form of statuary which no careful father would wish his daughter, or no discriminating young man his fiancée, to see."

Also controversial was Epstein's ***Rima*** memorial in Hyde Park, which was dedicated to the wildlife author W. H. Hudson, and was described by Members of Parliament who wanted to have it removed as "this bad dream of the Bolshevist in Art". Further indignation was perhaps inevitable in 1929 when Epstein executed his reliefs of ***Day*** and ***Night*** for London Transport's Broadway House, one of London's finest modernistic buildings of the 1920s. But after World War II Epstein became an accepted figure of the Establishment, and his many public works of this period are at best conventional and competent (such as the ***Virgin and Child*** in Cavendish Square) and at worst ludicrous (most notably his group of demented nudists rushing off vigorously from underneath Bowater House in the direction of Hyde Park).

Another major recent sculptor to have produced London monuments is **Henry Moore**, who began his public career with his ***West Wind*** of 1929, one of 8 reliefs of horizontal figures carved above Epstein's work at Broadway House (three of the others are by Eric Gill). Moore's monumental rendering of the figure here, which was greatly inspired by pre-Columbian sculpture, was considered primitive and revolutionary at the time. After World War II Henry Moore's sculpture began to appear all over London, for example in Battersea Gardens, on the Time-Life Building in Bond Street, outside the Houses of Parliament, and in the grounds of Kenwood House (see photo above). But his tasteful organic forms became almost as conventional as Epstein's later work. The even blander work of Barbara Hepworth now receives approval from even the most conservative members of the public. It can be seen almost everywhere, including the façade of the John Lewis Store in Oxford Street and Kenwood House.

EAST ANGLIA

East Anglia has played a major role in the history of English landscape painting, and much of the countryside that inspired its painters has remained remarkably unspoilt to this day, despite its proximity to London. The ugliest and most built-up part of the region is Essex, much of which is historically not part of East Anglia even though it is often bracketed with it today.

LANDSCAPES *and* VILLAGES

East Anglia properly begins with the Stour Valley, which divides Essex from Suffolk. This beautiful wooded valley, with attractive towns and villages, and extensive views from its sides, has been referred to ever since the 19thC as "Constable's country", and many visitors will already be familiar with it from the paintings of this most popular of English artists. Constable himself, when he explored the valley in his youth, was reminded everywhere of another painter native to the valley, Gainsborough, who though best known as a portraitist, also did numerous landscapes (an activity which he claimed always to have preferred). Other painters moved into the valley at a later date: Sir Alfred Munnings, the popular Edwardian painter of English rural life, settled in DEDHAM; and John Nash, one of the more subtle British landscapists of this century, spent much of his life at Wormingford.

Just N of the Stour you will come to Suffolk's celebrated "wool villages", the finest of which are LONG MELFORD and Lavenham. Wool was the main source of Suffolk's prosperity from the Middle Ages up to the 17thC, and the numerous medieval and Tudor houses that make up these villages bear splendid witness to those times. As you go farther still from the Stour, the countryside becomes almost completely flat, and remains so throughout the rest of East Anglia. On the Suffolk coast are Aldeburgh, the scene of a famous music festival initiated by Benjamin Britten, and Walberswick, a charming, secluded place which was an important artists' colony in the late 19thC, attracting among many others the Scottish Art Nouveau architect Rennie Macintosh and Wilson Steer, who produced here some of his finest works. Suffolk does not have any major art gallery, though works by Gainsborough, Constable, Alfred Munnings, John Nash and Wilson Steer can be seen in the very pleasant small museums at SUDBURY, DEDHAM and IPSWICH.

The FENS

To the E and N of Suffolk you come into the Fenland, an area crisscrossed by irrigation canals and rivers. One of the most striking landmarks is ELY CATHEDRAL (Cambridgeshire), which rises impressively above the surrounding fens on what was once an island. As a whole this county is frankly dull and monotonous, but CAMBRIDGE itself is one of England's greatest attractions, and thanks to its university is certainly the East Anglian town richest in art treasures, possessing not only the superlative Fitzwilliam Museum, but also the intimately displayed collection of modern art at Kettle's Yard, as well as many fine works scattered around the colleges.

The Norfolk countryside, though as flat as that of Cambridgeshire, has a generally more interesting aspect, as well as possessing (outside the tourist season) a quality of great remoteness. Several of its fine medieval churches, such as RANWORTH, seem to have been little touched by time, and have preserved many of their original furnishings. Near HOLKHAM HALL, one of England's greatest country houses, are magnificent sandy beaches where you can find yourself almost undisturbed. And, in the middle of that popular sailing area, the Norfolk Broads, you will see one of England's most romantic

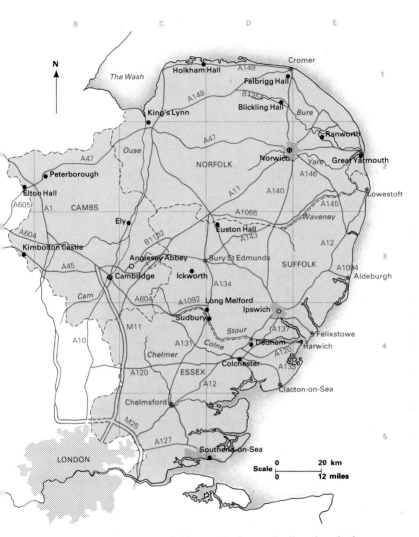

sites, St Benet's Abbey, a ruined abbey in which a windmill was later built: this site, which is best reached by boat, has been painted by almost all the artists associated with the county.

Writers on Norfolk have invariably compared its landscape to that of Holland, and the mercantile connections between the two places have led to many similarities in their architecture – the delightful quay front at GREAT YARMOUTH being unmistakedly Netherlandish in character. Appropriately, the thriving school of landscape artists who worked in the region in the 19thC, the so-called Norwich school, were closely imitative of the great Dutch landscapists of the 17thC. You can see much of their work in the Castle Museum at NORWICH, which is East Anglia's most important art center outside Cambridge. For those who have begun by this stage to tire of landscape painting, Norwich also offers, just outside the town, in the University of East Anglia, one of England's most imaginative museums devoted to contemporary art – the Sainsbury Centre.

ANGLESEY ABBEY 🏛
Nr. Cambridge Map C3

Open Apr – mid Oct Wed – Sun 2 – 6pm
Closed Mon – Tues Apr – mid Oct; mid
Oct – Mar

🖼 ⇆ 💷 🏛 ☑

Originally an Augustinian priory founded in 1135, Anglesey Abbey was transformed into a country house in about 1600. The house was radically altered again after 1956, when it was purchased by Lord Fairhaven to house his extraordinary collections. At the same time the magnificent formal **gardens** that now encircle the house and are today perhaps the most popular feature of the place were created out of the unpromising marshy fenland surroundings. The lavish, eclectic interior of the house calls to mind some of the millionaires' "palaces" on the East Coast of America. Indeed Lord Fairhaven had strong American connections, as his father made his fortune in the United States and his mother was a New York heiress. The objects on show are remarkable in their diversity, comprising such miscellaneous items as an ancient **Egyptian bronze cat**, **Renaissance cabinets**, a life-size terracotta goat by the 18thC sculptor **Rysbrack**, and the paintbox owned by Gainsborough. Among the paintings are works by **Cuyp**, **Oudry**, **Gainsborough** and **Bonington**. But the ones that leave the most lasting impression on the visitor are two **landscapes ★★** by **Claude**. The first of these large works, *Landscape with the Father of Psyche Sacrificing to Apollo*, was painted in the early 1660s for Angelo Paluzzi Degli Albertoni, Marquess of Rosina and later Prince Altieri; the other work, the *Landscape with the Arrival of Aeneas at Pallanteum*, was commissioned as a pair to it in 1675 by the prince's son. Both works – known as the "Altieri Claudes" – are masterpieces of the artist's late style, which is noted for its noble rhythms and use of muted blues, greens and silvery greys. They are among the best known of Claude's works and when they reached England in the late 18thC they made an immediate sensation. Turner was one of the many artists who saw them at this time, and his reaction to one of them was recorded by the diarist Farrington: "He was both pleased and unhappy when he viewed it as it seemed beyond the power of imitation." However, it was probably their influence that inspired Turner to paint his first Claudean picture, *Festival upon the Opening of the Vintage at Maçon* (Graves Art Gallery, Sheffield, *NORTHERN ENGLAND*).

BLICKLING HALL 🏛
Aylsham, Norfolk Map D1

Tel. (026 373) 3084
Open Apr – Oct Tues, Wed, Fri – Sun
2 – 6pm
Closed Mon, Thurs Apr – Oct; Nov – Mar

🖼 ⇆ 🎠 💷 🏛 🌿

Blickling, built for Sir Henry Hobart between 1616 and 1627 by Robert Lyminge, is one of the finest Jacobean houses in the country. The red brick façade supports an orderly yet elaborate range of decorative motifs, which are further emulated in much of the interior with a great **carved staircase**, several **chimneypieces** and above all the intricate **plasterwork** ceiling of the long gallery. The collection of mainly **English furniture** and **family portraits** is perhaps most notable for its **tapestries** and includes one depicting *Peter the Great Triumphing over the Swedes at Poltava in 1709*, which was woven in St Petersburg. There are also some 18thC pictures, the finest being Canaletto's *Chelsea from the Thames ★* (1751).

CAMBRIDGE
Cambridgeshire Map B3

Cambridge is famous as the seat of one of England's greatest universities, the origins of which date back to the schools of monastic learning that were established here in the 12thC. Any discussion of Cambridge invariably involves some form of comparison between it and its main English rival, Oxford. But it is generally agreed that Cambridge is more concentrated in its architectural beauty than Oxford; and indeed most of its many fine college buildings can be seen by walking along the main thoroughfare that runs parallel to the River Cam and leads N from the Fitzwilliam Museum to the junction of St John St and Bridge St. The special feature of Cambridge is its "Backs", or grounds, on the other bank of the Cam, where picnic parties on the riverside traditionally take place in the summer.

The town exists principally for its university, and out of termtime and the tourist season the place can seem slightly depressing. But in any season the appearance of Cambridge does not suggest the fact that – to a far greater extent than Oxford – the university has a reputation for being a hotbed of radicalism. In the 1930s the university was an important breeding ground for radicals, and more recently progressive elements within the university have led

to the construction here of some of the more interesting examples of British architecture of the 1960s and early 70s. Particularly striking and notorious is the **Sealy History Library**, a very uncompromising and un-English example of "brutalism" by James Stirling, though unfortunately structurally unsound and still the subject of a protracted lawsuit against the architect.

As with Oxford, Cambridge's art treasures are not just contained within its magnificent museums, but are also to be found scattered around its colleges. Only a hint of these can be given here. Superlative illuminated **medieval manuscripts** can be seen in many of the college libraries, most notably in that of Trinity, which has the celebrated ***Trinity Apocalypse*** ★ (c. 1280), one of the finest manuscripts of this period. In the same library is a masterly sculpture by one of the leading Neoclassical sculptors of the 19thC, the Danish artist **Bertel Thorvaldsen**. It represents Byron sitting among the ruins of Athens, composing part of *Childe Harold*, and was originally intended for Westminster Abbey, but was turned down by the authorities there. In the medieval hall of Corpus Christi are paintings by **Reynolds**, **Romney**, **Poussin** and **Kneller**; while in that of Peterhouse there are portraits and stained glass by the Pre-Raphaelite artists **Madox Brown**, **Burne-Jones** and **William Morris**, all of whom also produced **stained glass** for the Chapel of Jesus College. Clare College was once known for its patronage of contemporary art, and in the grounds of its new buildings on the left hand side of the Cam is a fine early bronze by Henry Moore of an ***Unknown Warrior***, one of a group of works inspired by the preserved human figures from Pompeii; in the same grounds there was once also an exciting steel construction by **Anthony Caro**, now sadly removed following numerous flippant and even indignant comments by students to the effect that it resembled a piece of discarded garden machinery. The one university building that will almost certainly be visited by those coming to Cambridge is the 15thC **King's College Chapel** ★★, a magnificent Perpendicular structure based on the Sainte Chapelle in Paris, and the town's dominant landmark when seen from the "Backs". Its elaborate **fan vaulting**, inspired by that of Gloucester (see WESTERN ENGLAND), is among the finest in England and it is the only medieval English church, apart from York Minster, to preserve its **stained glass**. And here too is the town's greatest painting outside the FITZWILLIAM MUSEUM, Rubens' ***Adoration of the Kings*** ★.

Fitzwilliam Museum ★★
Trumpington St
Tel. (0223) 69501/3
Open Tues – Sat Lower Galleries
* 10am – 2pm; Upper Galleries 2 – 5pm;*
* Sun (all galleries) 2.15 – 5pm*
Closed Mon
🖼 📖 🏛 ☑

The Fitzwilliam Museum was founded in 1816 by Richard, 7th Viscount Fitzwilliam of Merion. He bequeathed to the university, where he had taken his degree in 1764, his fine art collection (featuring 144 pictures, including a Titian and a Veronese, and what was then regarded as the finest collection of Rembrandt etchings in England), as well as his library (with its magnificent medieval manuscripts) and the sum of £100,000 to provide a museum to house all this. Work on the present enormous porticoed building was only begun in 1827 and was not fully completed until 1875. Numerous later donations in many different fields necessitated various extensions this century. The new galleries added during Sir Sidney Cockerell's tenure as director (1908 – 37) enabled him to initiate what was then a revolutionary method of display, involving exhibits shown in wall cases, and picture galleries enhanced with furniture, oriental rugs, sculptures and flowers. This approach has now become a permanent feature of the museum. Although the Fitzwilliam, in common with the Ashmolean in Oxford, is intended partially as a teaching institution for the university, you feel that in contrast to the latter place its main priority has been to ensure that a visit here is as enjoyable as possible. It is a matter of opinion which of these two museums is richer in its treasures, but the Fitzwilliam is undoubtedly the better of the two in terms of its display.

On the ground floor are shown the bulk of the museum's archaeological, oriental and applied arts collections. Encompassed by the extraordinary range of these collections are some superb **Assyrian and Egyptian reliefs**; **Greek Attic vases**; a beautifully carved Roman marble **sarcophagus**; a delightful mosaic **fountain niche** of the 17thC featuring representations of birds; **oriental ceramics** and **textiles**; a **Limoges enamelled tryptych** of 1538; much **Renaissance armour** (including a 16thC Italian parade helmet); **Meissen** and **Capodimonte porcelain**; magnificent engraved English **glassware**; and 17th – 19thC **portrait miniatures**.

The extensive and equally wide-ranging painting collection is housed on the first floor. Perhaps its greatest

strength is its holdings of **Italian art**. The 13thC and 15thC Italian paintings are shown in a gallery which also has Italian **Renaissance majolica** and **medals**; a splendid **alabaster** of a boy from a tomb at Ocaña in Spain (c. 1500); and a powerful and grotesque late 15thC *Road to Calvary* by the Andalusian artists Antonio and Diego Sanchez. The most celebrated of the early Italian works are two small, luminous **panels** ★ by the early 15thC Florentine painter, **Domenico Veneziano**: one is of the Annunciation, and the other, featuring a fascinating perspectival view of Florence, shows St Zenobius, Bishop of Florence, on the point of restoring to life a little boy run over by an ox cart in the streets of the city.

Leading from the small gallery is a much larger one taken up by the museum's later Italian paintings. The Italian Renaissance collections are particularly notable for their Venetian paintings, one of the earliest of which is a slightly precious though nonetheless charming study of *Venus and Cupid* by Palma Vecchio. More impressive Venetian works, and indeed perhaps the two most outstanding paintings in the whole museum, are Titian's *Tarquin and Lucretia* ★★ and Veronese's *Hermes, Herse and Aglauros* ★★. In spirit these paintings could hardly be more different from each other. Titian's dramatically composed and painted picture brilliantly conveys a sense of the brutal passion of a man on the point of forcing a knife into a terrified naked woman. Veronese's picture illustrates an obscure passage in Ovid when Hermes, the lover of Herse, transforms her jealous sister Aglauros into a black stone. Though the work is given a certain pictorial drama through the use of abrupt foreshortening and an arrestingly asymmetrical composition, it has none of the emotional power of Titian's painting (thus Herse shows only the mildest concern at the fate of her sister): instead Veronese has concentrated his attentions on the rendering of different sensual textures, from the pink marble column supporting billowing red drapery to the rich damask table-covering, and the blue and yellow cloth swathed round the scantily clad Herse.

The 17th and 18thC Italian collections comprise good works by a large number of the leading artists of this period, including a delicate and atmospheric *Holy Family* by Sassoferrato, a very powerful *Betrayal* ★ by Guercino and a vividly painted *Bacchus and Ceres* by Sebastiano Ricci. Particularly striking is a sinister

allegorical work by Sebastiano Ricci, *Human Frailty* ★, featuring a winged skeleton, a boy blowing bubbles and other symbols of mortality. Another bizarre but earlier painting in the collection is *King Ansa of Judah destroying the Idols* by an artist active in Naples who may well have had some influence on Rosa, the so-called "Monsù Desiderio".

If you follow the Italian paintings in a roughly chronological order you will be led into a room at the end of the long gallery containing the museum's small but choice collection of Flemish paintings. Among these are a superb **Joos van Cleve** showing the child Jesus placing his head on the exposed breast of the smiling Virgin; a self-portrait against a background of the Colosseum by the Holland Mannerist **Heemskerck**; and three oils by **Van Dyck**, including a very life-like portrait of an old woman belonging to the Flemish period of his career. Showing in the same room as these is a small group of Spanish works, of which the most notable are an *Adoration of the Magi* by El Greco's follower Louis Tristan and a Murillo of *St John the Baptist with the Scribes and Pharisees*. The museum's numerous and generally dull Dutch paintings take up a room at the other end of the long gallery. An interior scene by **Jan Steen**, a woman tuning a lute by **Terbrugghen** and, above all, a portrait of a rather debauched-looking man by **Frans Hals**, are among the few works worth noting here. The portrait of a man in a military costume was until very recently ascribed to **Rembrandt** and thought to be one of the greatest treasures in the museum, but it has now been found to have a false signature and date, which were probably added to a work by a follower of Rembrandt.

The museum's French and British school paintings are housed in rooms around its principal and very impressive Victorian staircase. This is the part of the museum with the most old-fashioned character; and many of the paintings on show here, in particular those of the 19thC, are crowded together, just as they would have been in the last century. It is thus easy to miss some very important works. The museum has relatively few French paintings before the 19thC, but it is worth drawing attention to a small and jewel-like *Entombment* ★ by Simon Vouet and a fine pastel *Landscape with Lake Albano and Castel Gandolfo* by Claude Lorrain. The French 19thC collections are very representative, beginning with some oil sketches by **Delacroix** and various small, and

characteristically subtle, landscapes by **Corot**, and culminating in an excellent group of **Impressionist** and **Post-Impressionist works**. Among these are several paintings by Monet (most notably *Poplar Trees* like *Port Coton, the Lion Rock, Belle Île*, 1886); one of the best landscapes by Renoir to be seen anywhere (this small work, *The Gust of Wind* ★ is a brilliantly lifelike evocation of the effects of wind on a landscape); a *View of L'Estaque* ★ by Cézanne; and various small oils by Seurat, including a broadly painted study for *La Grande Jatte* (1884–6, now at the Chicago Art Institute) and a minutely detailed study of the *Beach at Gravelines* ★, the composition of which is almost all taken up by a flat expanse of foreground sand.

There are also a number of 20thC French paintings, including works by Vuillard (*Interior with Dog*)★, Matisse (note especially his small early canvas, *L'Atelier sous Le Toit* ★, painted in his parents' house in the north of France and showing a dark attic with a colourful landscape seen through the window); **Picasso** (an interesting early Cubist head of 1910); Modigliani (a portrait of his mistress and fellow hashish smoker, *Beatrice Hastings*); and Rouault (a small landscape depicting *St George and the Dragon* ★), and de Staël (a *Still Life with Fruit*).

The British School collections open with a female portrait by the Elizabethan artist **Hans Eworth**; but the first major work is a double portrait by Van Dyck of *Rachel de Ruvigny* (wife of Thomas, 4th Earl of Southampton), who is shown seated in clouds with her hand holding a sceptre and her foot over a skull. The 18thC is represented by Gainsborough's dark portrait of *Heneage Lloyd and his Sister* ★ a work rather reminiscent of the same artist's *Mr and Mrs Andrews* in the National Gallery in *LONDON*, and a pair of amusing erotic paintings by **Hogarth** ★ (*Before* and *After*), both commissioned by John Thomson, a member of the Commons Committee on Prisons who was also associated with the charitable Corporation for the Relief of the Industrious Poor. These two works can be seen as a pastiche of the contemporary French fashion for *sujets gallants*: *Before* shows a man making advances to a coyly retreating woman and is typical of this tradition; but *After*, with Hogarth's typically earthy realism, makes a point of showing the flushed, panting aftermath that contemporary French artists delicately avoided.

The 19thC and early 20thC English collections are particularly full and rewarding. There are three works by

Constable, including one of his most vivid views of *Hampstead Heath* ★. Less well known, though extremely famous in its time and now coming into fashion again, is a melodramatic Victorian moralizing picture by Alfred Elmore, *On the Brink* ★ (1865), representing a still virtuous woman on the point of being urged into a gambling hall by a rather shadowy male figure. A different view of Victorian life is provided by *94° in the Shade* ★ by Sir Lawrence Alma-Tadema. This artist is usually known for minutely handled genre scenes set in ancient Rome, but here is a recumbent young man in contemporary dress reading a book in an idyllic English rural setting. Among the high points of the Edwardian collection are a lush female portrait by Steer (*Hydrangeas*); two works by Augustus John (a commanding seated portrait of the painter *Sir William Nicholson* ★ and a sensitive head of his son *Caspar* ★ as a boy); a **portrait of a convalescent** by John's sister Gwen; and a fine painting by John's close Welsh friend, **J.D. Innes** that provides an excellent example of one of his many obsessive studies of the mountain *Arenig Fawr* ★ in North Wales.

Kettle's Yard ☆
Northampton St
Tel. (0223) 352 124
Open Mon – Sat noon – 6pm; Sun 2 – 6pm
📷 ☑ ♿

Kettle's Yard, situated just outside the city center across the bridge from St John's College, is one of the most unusual museums of contemporary art in Europe. In fact it is not really a museum at all. Originally the **house** and **collection** of **J.S. Ede**, it intentionally maintains the character of a private home. At first the place comprised four tiny condemned slum buildings, which Ede beautifully converted in the late 1950s. Every afternoon during term time he used to open his house and collection to the public; and in recognition of this the university had an extension built to the property in 1970. Ede has left Cambridge and now lives a reclusive and ascetic life in Edinburgh.

The interior of Kettle's Yard represents the British middle-class ideal in the decoration of the home. But Ede had the advantage of exceptional taste, as well as an outstanding range of art treasures, most of which were purchased for very little. The display is extremely thoughtful, and few visitors can enter the house without feeling a profound sense of peace and order. A bronze head by Brancusi (*Prometheus* ★, 1912) lying on the black lid of a Bechstein piano is

particularly memorable. The collection as a whole, and indeed the spirit of the place itself, belongs firmly to what the Scottish artist Ian Hamilton Finlay (himself a great admirer of Kettle's Yard) has identified as the "pebble tradition" in British art. The main exponents of this were artists who in the 1920s and 1930s sought to achieve effects of ever greater simplicity by basing their work on abstract organic forms. Appropriately, pebbles themselves and other natural objects found in the landscape, play a central role in Ede's display, whether placed in simple ceramic bowls, or tastefully arranged on window ledges and wooden table tops. Ede's first important purchases of contemporary works of art were of the simple and highly sensitive paintings and watercolours of **Ben Nicholson**. Through Nicholson, Ede came to know **Christopher Wood**, today a much less known artist but in the 1920s one of the most important painters associated with the movement away from conventional figurative representation. Kettle's Yard has one of the finest collections anywhere of Wood's work, including a marvellous **self-portrait** of 1927 and a highly imaginative composition entitled *Mermaid*. A self-taught artist who had a great influence on Wood's generation was **Alfred Wallis**, a near-illiterate Cornish fisherman who took up painting at the age of 70 to console himself for the loss of his wife. Nicholson and Wood "discovered" Wallis on a visit to St Ives in 1928 and thereafter vigorously promoted him. However, despite this support, and that of a number of Hampstead-based artists and intellectuals (including Ede), Wallis died in extreme poverty in 1942. Kettle's Yard has about 100 of his naive representations of sailing ships from the great days of the Cornish fishing industry, most of which were painted from memory and executed with decorators' paint on scraps of board given to him by the local grocer.

Another, rather different, English artist favoured by Ede was the Welsh watercolourist and writer, **David Jones**. Jones's strange, intricate and very delicate watercolours – of which Kettle's Yard has several important examples – have the mystical, highly individual qualities of artists such as Blake or Palmer. But the most outstanding feature of Kettle's Yard are the sculptures and drawings of **Henri Gaudier-Brzeska ⋆**, the largest collection in the world of this artist's work apart from that in the Musée d'Art Moderne in Paris. This French-born artist came to England in 1910, where he became associated with the

avant-garde group of artists called the Vorticists; he was killed in action in 1915, aged only 24. Ede was one of the first people to recognize his genius, and indeed put together a book on him, *The Savage Messiah*, which was later adapted into a film by the British director, Ken Russell. Gaudier-Brzeska's works are characterized by their primitive vitality, a brilliant synthesis of form and frequent humour. All these qualities can be observed in the superb *Bird Swallowing a Fish ⋆*, of which the museum has the original cast.

COLCHESTER
Essex Map D4

Colchester, the first Roman colony in Britain, was also an important town under the Normans, who built the largest keep in Europe on top of the vaults of the **Roman Temple** of Claudius. In addition to this massive structure, the town retains parts of its old walls and various monuments from later periods, including many fine Georgian houses.

The keep of the **Norman Castle** contains the most important collections from the Colchester and Essex Museum. These informatively displayed collections are essentially of archaeological interest, containing in particular **jewellery**, **glassware**, **pottery**, **bronzes** and **statues** from the Roman period, including the intriguing **tombstone of the Centurion**, one of the finest and probably earliest gravestones to have survived from Roman Britain.

The Minories Art Gallery
74 High St
Open Tues – Sat 11am – 5pm; Sun 2 – 6pm
Closed Mon
▓ ▨ 血 ❦ ⸬

The Minories Art Gallery is housed in an extremely attractive Georgian house with a large garden. Although the place has pleasant **18thC furnishings** and some minor works by **Constable**, it is essentially an exhibiting institution which puts on interesting exhibitions. These are frequently of East Anglian art, and are often drawn from private collections in the region.

DEDHAM
Essex Map D4

The now over-prettified village of Dedham, with its tearooms and antique shops, is a haven for tourists, many of whom are attracted here by the place's associations with **John Constable**. The

mill at Dedham (which was owned by Constable's father and has now been replaced by modern mill buildings) and the **Perpendicular village church** were among his favourite motifs.

Castle House
Tel. (0206) 322127
Open May – early Oct Wed, Sun 2 – 5pm;
 Aug Thurs, Sat 2 – 5pm
Closed Mon, Tues, Fri May – early Oct; mid
 Oct – Apr
🏛 ▣ ♿

Another artist associated with Dedham was **Sir Alfred Munnings**, who in 1919 purchased the partly Tudor, partly Georgian Castle House. He described it as "the house of my dreams" and lived there until his death in 1959. The house has now been converted into a museum containing more than 100 of his paintings and sketches. This is an exceptionally popular place, though perhaps more with people who prefer country life to art. Of an East Anglian farming family, Munnings specialized above all in the painting of horses. As he grew older, he became increasingly slick and repetitive in his work, and also more and more outspoken in his views on contemporary art: in 1948 he gave a notorious speech in Newlyn in Cornwall condemning the Tate Gallery's holding of Matisse. As a personality and artist you might feel that he stands for all that is reactionary and unlikeable in British culture; yet the fact remains that in his youth he was a painter with outstanding technical abilities. His greatest works – of which there are several examples here, including a masterly **nude study** executed in Julien's Atelier in Paris in 1901 – all date from the first decade of the century. They reveal an extraordinary vigour in the handling of paint, colour and composition.

ELTON HALL 🏛
Nr. Peterborough, Cambridgeshire
Map A2

Tel. (083 24) 468
Open May – July Wed 2 – 5pm; Aug Wed,
 Thurs 2 – 5pm
Closed Mon, Tues, Thurs – Sun May – July;
 Mon, Tues, Fri – Sun Aug; Sept – Apr
🏛 ⚓ ▣ ♿

The most interesting parts of Elton Hall on the River Nene are undoubtedly the **15thC gatehouse** and **vaulted crypt**. These belonged to an earlier house ruined during the Commonwealth but were preserved by Thomas Proby when he began the present house in the later 17thC. The contents are probably best

known for the library of **early English Bibles** but there are some interesting pictures, including family portraits by **Reynolds** and a landscape by **Constable**.

ELY
Cambridgeshire Map C3

Ely Cathedral with its small surrounding town stands impressively on a bluff that was originally an island in the middle of an enormous expanse of marshy fenland. The extremely impressive **cathedral** ★★ dates mainly from the 12thC, though the most individual feature of the interior, the **octagonal lantern tower**, was constructed in the early 14thC after the Norman crossing tower had collapsed. Excellent 12thC **carved decoration** can be seen on the exterior of the north wall of the nave; while further carvings of the same date are on the three doorways that lead to the now ruined cloisters.

The Stained Glass Museum
Ely Cathedral
High up in the triforium of the cathedral there has recently been installed the Stained Glass museum, in which 14thC **stained glass** is shown at eye level through internally lit showcases, as well as exhibitions of contemporary works in this medium. This museum also offers exciting vertiginous views of the cathedral's interior. Opened in 1979, it includes among its exhibits some handsome panels by **Burne-Jones**.

EUSTON HALL 🏛
Thetford, Suffolk Map D3

Open June – Sept, Thurs 2.30 – 5.30pm
Closed Oct – May; June – Sept Mon – Wed,
 Fri – Sun
📷 ⚓ 🏛 ♿

Euston Hall in Suffolk was built in 1670 by the Earl of Arlington, a minister in the so-called "cabal" of Charles II, and it is his collection of Stuart portraits which remains the principal attraction of the house. Works by **Van Dyck**, **Lely**, **Mytens**, **Van Loo**, **Mignard** and **Philippe de Champaigne** record the features of many 17thC protagonists in English history, but the finest are Van Dyck's *Portrait of Henrietta Maria* (1636), queen of Charles I, and Mytens' *George Villiers*, **Duke of Buckingham**, one of the greatest patrons of the age.

From a later period there are portraits by **Reynolds** and **George Dance**, some 18thC English furniture and a fine study of *Mares and Foals by the River at Euston* by George Stubbs.

Constable's Country

The Stour Valley in East Anglia is the only part of England that has come to be known by the name of one artist: John Constable (1776–1837), perhaps England's most popular painter. Constable's associations with the area regularly attract large numbers of tourists, and today the valley seems to reflect all that is conventionally pretty in English scenery (an impression reinforced by the predominantly elderly and retired population, and an abundance of antique shops and tea rooms). But the art of Constable in its day was revolutionary enough, and little appreciated by the artist's contemporaries.

In Constable's time landscape painting was only just beginning to be recognized as a serious art form. As such, it had to express noble and heroic qualities that were supposedly only to be found in particular types of scenery, especially the Classical landscape of Italy, spectacular (or "sublime") mountainous districts as in the Alps or North Wales, and gentler "picturesque" and Romantically beautiful areas such as the Wye Valley.

The ordinary, heavily agricultural Stour Valley did not meet any of these visual requirements. There were artists, such as members of the Norwich school, who painted plain scenery, but these were mainly concerned with attracting an exclusively local patronage. Constable despised the idea of being a merely topographical artist of this kind, just as he reacted against the rather artificial conventions of the more ambitious landscapists of his day. The landscapes that he painted had a deeply personal and lifelong significance for Constable.

A LIFE-LONG OBSESSION

Constable was born in East Bergholt in 1776, the second son of Golding Constable of East Bergholt House. Of this house, which stood on the E side of Church Street, there survives only a utility wing, now divided into cottages. Attached to the property were 30 acres of arable and pasture land, and these provided the subject of Constable's two finest paintings to be seen in the area: *Golding Constable's Flower Garden* and *Golding Constable's Kitchen Garden* (Christchurch Museum in IPSWICH).

Golding Constable came from a long line of Suffolk and Essex yeomen, and was the proprietor of two watermills on the Stour, at Flatford and Dedham. As a youth Constable worked with his father on the river, and thus acquired a familiarity with the workings of locks and mills which was later to inform his many paintings of the Stour. After spending much of his time painting and sketching in the area with a local amateur artist, John Dunthorne, Constable persuaded his father in 1798 to let him enter the Royal Academy in London. His student days over, Constable acquired a small property at East Bergholt for use as a studio. There he would spend long periods in the summer months, while continuing to live for the greater part of the year in London. The inheritance which he received on the death of his father in 1816 enabled him to marry, after a seven-year courtship, Maria Bicknell, the granddaughter of the local rector.

Thereafter Constable spent less time in Suffolk, his last long stay here being in the summer of 1817. Yet, on the basis of earlier sketches and memories, he continued to paint the valley in an increasingly monumental way, culminating with a series of six-foot canvases exhibited between 1819 and 1825. The obsessive nature of his art now began to be apparent, and the artist wrote in 1821: "I associate my 'careless boyhood' with all that lies on the banks of the Stour." For all their realism, the paintings of Constable's middle and old age express an increasingly intense nostalgia for his childhood.

THEMES *and* LANDMARKS

In common with a very different painter, Cézanne, Constable used to return repeatedly to the same landscape motifs. The church at Dedham features in the background of many of his general views of the Stour Valley, seeming to symbolize God's beneficent presence in the agricultural landscape. Constable was a deeply devout man, and painted several altarpieces in churches of the area, including St Michael's at Brantham and St James's at Nayland.

The most visited of Constable's sites is Flatford Mill, which outwardly has changed little since Constable's day. The most ambitious of his paintings of the actual mill is simply called ***Flatford Mill*** (Tate Gallery, 1817).

Downriver from the mill is an old cottage which, in Constable's day, belonged to a local farmer, Willy Lotts. This now rather over-prettified house occurs in numerous paintings, but most notably in ***The Haywain*** of 1821 (National Gallery, London), the best known of the artist's "six-footers". In keeping with his concern to represent the "working landscape", Constable omitted in this picture a row of trees on the far side of the river so that he could show labourers at work in the fields.

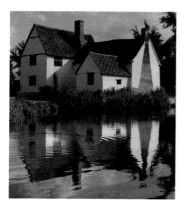
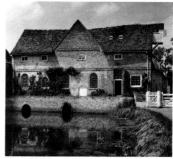

Two of Constable's favourite landscape motifs at Flatford Mill: Willy Lotts' cottage (left), and the Mill itself (above)

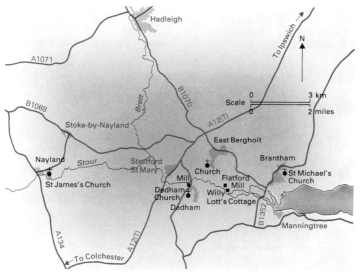

FELBRIGG HALL ⊞
Nr. Cromer, Norfolk Map D1

Tel. (026 375) 444
Open Apr – Oct Tues – Thurs, Sat, Sun
 2 – 6pm
Closed Mon, Fri Apr – Oct; Nov – Mar
🎫 ⌂ ⍟ ₽ 🏛 ☑ ⍦

Felbrigg Hall, by the Norfolk coast, is
substantially a Jacobean house of the
early 17thC although there are a number
of later additions. For over 300 years this
was the home of the Wyndham family,
whose collection of paintings, furniture
and porcelain is now on display. The
paintings are fairly diverse in character
and include family portraits by **Lely** and
Reynolds, some **17thC Dutch works**
and two good views of London by the
18thC topographical artist **Samuel Scott**.
In a separate room known as the Cabinet
and specially designed by **James Paine**
there are a number of Roman views, or
Vedute, by the Italian artist **Busiri** which
were acquired by William Wyndham
during the course of his Grand Tour.

The grounds, laid out by **Humphrey
Repton** in the early 19thC, enclose a late
Gothic church with several interesting
monuments by such sculptors as **Joseph
Nollekens** and **Grinling Gibbons**.

GREAT YARMOUTH
Norfolk Map E2

An important port at the mouth of the
Yare, Great Yarmouth also developed
from the late 18thC onwards as a popular
seaside resort. The town was much
damaged during World War II and has
now a rather ugly and forlorn seafront.
But the quay on the River Yare has
preserved its charming and strongly
Netherlandish character, and has many
fine old houses. Two of these are now
museums. **No. 4, South Quay** is a
merchant's house of 1596 re-fronted in
late Georgian times. Inside is some
intricate early 17thC **plasterwork** (most
notably in the drawing room) and various
domestic exhibits and items of **furniture**
mainly of the 16thC and 17thC.

The Tolhouse Museum
Tolhouse St
Tel. (0493) 58900
Open June – Sept Mon – Fri Sun
 10am – 1pm, 2 – 5.30pm; Oct – May
 Mon – Fri 10am – 1pm, 2 – 5.30pm
Closed Sat June – Sept; Sat, Sun Oct – May
🎫 🏛

The Tolhouse Museum is a much restored
flint-faced building dating back to the
13thC and used for many centuries as

Yarmouth's courthouse and jail.
Scattered among miscellaneous objects
related mainly to the town's history are
paintings by Norwich School artists of
Great Yarmouth subjects, including
works by **W. Hunt** and **Alfred Stannard**
and a large oil by **George Vincent** of a
Dutch fair on Yarmouth sands.

HOLKHAM HALL ⊞ ☆
Wells, Norfolk, Map C1

Tel. (0328) 710227
Open June, Sept Sun, Mon, Thurs
 1.30 – 5pm; July, Aug Sun, Mon, Wed,
 Thurs 1.30 – 5pm
Closed Tues, Wed, Fri, Sat June, Sept;
 Tues, Fri, Sat July, Aug; Oct – May
🎫 ⌂ ⍟ ₽ 🏛 ☑ ⍦

The huge Palladian mansion of Holkham
Hall in Norfolk is almost completely the
result of a collaboration between the
wealthy Thomas Coke, later 1st Earl of
Leicester, and his two advisors, Lord
Burlington and William Kent. Begun in
1720, the house was not finished until
after Coke's death in 1759 so he was
unable to see the final setting for the
collection of **paintings, tapestries** and
decorative arts he had assiduously
gathered all over Europe. From this hoard
it is the paintings which are the most
important, the portraits alone including
works by **Lely, Kneller, Batoni,
Gainsborough** and **Beechey**, as well as
the equestrian *Portrait of the Duc
d'Arenberg* by Van Dyck. In the
Landscape Room, however, the full
character of English 18thC taste comes to
the fore because Coke, in all, was able to
acquire seven works by **Claude** (including
Apollo Flaying Marsyas and *Perseus and
Medusa*★), three by **Poussin** and four by
Gaspard Dughet.

From the Italian school of the 17thC
there are works by **Annibale Carracci,
Guido Reni** and **Luca Giordano**, while
Rubens' *Return of the Holy Family* is the
finest of the northern pictures. There is
also a famous copy after Michelangelo's
cartoon for *The Battle of Cascina*, the
fresco conceived in rivalry with Leonardo
in the Great Council Chamber at
Florence, which, since the destruction of
the original, has become the principal
example of this hugely influential design.

The interior at Holkham is principally
noted for the designs of **William Kent**.
He was responsible for most of the
furniture as well as the fittings, and it is
fortunate that so much of his work is
retained in the location and setting for
which it was designed, alongside a range
of decorative items, **carpets** and
tapestries.

ICKWORTH ⌂
Nr. Bury St Edmunds, Suffolk
Map C3

Tel. (028 488) 270
Open Apr – Oct Tues – Sun 1.30 – 6pm
Closed Mon Apr – Oct; Nov – Mar
🖼 🛏 🅿 🌿

From the time when it was first planned
in the late 18thC, the grandiose and very
ambitious house at Ickworth was
intended as a showcase for the collection
of **paintings**, **sculpture**, **furniture** and
silver assembled by Frederick Augustus
Hervey, 4th Earl of Bristol and Bishop of
Derry. Much of this was stranded in Italy
and lost in the French invasion of 1798,
but the surviving family collection was
more than enough to fill this house with
an impressive range of treasures.
Flaxman's dynamic *Fury of Athamas* in
the hall provides an appropriate
introduction and thereafter one is drawn
through a series of rooms spanning the
taste of the 18thC and 19thC. Family
portraits, including works by
Gainsborough, **Hoppner**, **Lawrence** and
Angelica Kauffmann, are hung
throughout but it is the unusual items,
such as the 4th Earl's portrait by **Elizabeth
Vigée-Lebrun**, that are the most
memorable. The collection also contains
two interesting conversation pieces, *The
Family of the 3rd Earl* by Gravelot and
The Holland House Group by Hogarth,
but the finest work is undoubtedly the
*Portrait of the Infante Balthasar
Carlos* ★, son of Philip IV of Spain, by
Velazquez.

 The **furniture** and **porcelain** at
Ickworth are equally diverse, the French
18thC pieces being the finest, but the
clearest indication of the family's
continued interest in fine craftsmanship
is best demonstrated in the **silver**
collection displayed in the dining room
and W corridor. Many of the pieces are
outstanding examples of the 18thC
Rococo produced by continental
silversmiths working in London, notably
Paul de Lamerie, **Simon le Sage** and
Frederick Kandler.

IPSWICH
Suffolk Map D4

Ipswich, the county town of Suffolk, is a
busy port and industrial center. It has
various interesting old monuments (one
of the finest being the 16thC **Ancient
House**, the main front of which is an
outstanding example of the East Anglian
art of **pageting**, or decorative plastering).
But, to a far greater extent than

NORWICH, the place suffers from a lack of
unity and the presence of too many
characterless modern buildings.

Christchurch Mansion and Wolsey
Art Gallery ☆
Christchurch Park
Tel. (0473) 53246
*Open Mon – Sat 10am – 5pm; Sun
 2.30 – 4.30pm*
🖼 🛍 ☑ 🌿 ⚒

The works of art belonging to Ipswich
Corporation are divided between three
places. Some **17thC portraits** and a series
of **naval battles** painted in the 18thC by
the obscure Dominic Serres are hung in
the Town Hall; other works can be seen
in temporary displays in an art gallery
attached to the museum buildings in the
high street. But the greater part of the
collection, including most of its finest
works, are generally on view in
Christchurch Mansion, a heavily
restored and altered house dating back to
the 16thC and standing in the town's
large and delightful public park. Here,
the main attractions are paintings by East
Anglia's two most celebrated artists,
Gainsborough and **Constable**.
Gainsborough lived in Ipswich from
1752 – 9, after having failed to secure a
living as a portraitist in his native
Sudbury. The portraits by him are of local
sitters and show his development from a
stiff early manner (for example, his
Portrait of John Sparrowe) to the
seemingly effortless ease in handling of
paint and composition which he
achieved by the end of his stay in Ipswich
and later made him famous (note in
particular the marvellous half-length
portrait of *Mrs Samuel Kilderbee* ★ and
the portrait of *William Wellerston of
Finborough Hall* ★, who is shown in a
relaxed pose holding a flute). The works
by Constable include a portrait of his
father, Golding Constable, and two
luminous, outstanding **landscapes** ★★ of
his father's flower and kitchen garden at
East Bergholt in Suffolk.

 The museum has many interesting
examples of less famous works by other
artists from the 18thC right up to the
present day, including three by the East
Anglian horse painter, **Alfred
Munnings**; an amusingly absurd
Victorian history painting by the Hon.
John Collier (*A Glass of Wine with
Cesare Borgia*); works by the **Camden
Town School** artists Gore, Ginner,
Gilman and Bevan (many of which were
from the collection of Bevan's son, an
East Anglian resident); and a fine
abstract canvas by **Roger Hilton**. Of
particular note is a charming canvas by
Wilson Steer, *Knucklebones*,

Walberswick, ★ (1888); in later life Steer rarely achieved the vivid colour and spontaneous handling of paint that are the hallmark of this and the other works he painted during his various stays at the Norwich coast artists' colony of Walberswick during the 1880s.

KIMBOLTON CASTLE
Nr. Huntingdon, Cambridgeshire Map A3

Tel: (048084) 505
Open Mid-July – Aug Sun 2 – 6pm
Closed Sept – early July; mid-July – Aug, Mon – Sat
📷 🏛 ♨

Kimbolton is a quiet and particularly attractive small town which to many visitors might seem an appropriate setting for some novel of traditional English country life, with its beautiful old houses lining the wide high street, its fine medieval spired church, and its large castle, situated in spacious grounds.

Kimbolton Castle, which is now used as a school, is a medieval mansion and was the last home of Catherine of Aragon, Henry VIII's unfortunate first wife. But it was completely remodelled after its purchase by the 1st Earl of Manchester in 1621. Further remodelling, by **Vanbrugh**, took place after part of the building had collapsed in 1707. At the time of the collapse the owner, the 4th Earl and later 1st Duke of Manchester, was serving as Queen Anne's ambassador in Venice. When he returned to England the following year he brought back with him two young and very promising Venetian decorators, **Marco Ricci** and **G.A. Pellegrini**. Pellegrini was commissioned to execute the **decorative paintings** that are now the most important features of the castle's interior; these were begun in 1710 and finished shortly afterwards. Pellegrini worked in the **chapel** of the house and on the **ceiling** of the so-called Catherine of Aragon Room, but his most important works were on the walls of the staircase well where he painted two large scenes of the ***Triumph of Caesar.*** These were clearly influenced by Mantegna's ***Triumphs*** in Hampton Court Palace in *LONDON*, and were intended to flatter William III, who is seen in the ceiling painting above being carried by putti; and welcomed by trumpeting Fame. Pellegrini, despite the reputation and numerous commissions that he received in his lifetime, was apt to be an uneven and slapdash painter, and there is something particularly silly about his attempts at a heroic style in Kimbolton.

More suited to his lightweight talents was the **panel** on the upper landing of the staircase, showing with extremely vivacious handling of paint and colour three figures playing instruments, and a fourth handing over a bone to a dog.

KING'S LYNN
Norfolk Map C1

Situated on the River Ouse, 2 miles from where it reaches the sea, King's Lynn is a busy port and market town with a remarkable range of 14thC to early 19thC buildings. One of the finest of these is the **Guildhall**, an early 15thC structure chequered in flint and stone, and situated on the Saturday marketplace around which are some of the town's finest streets. The treasury of this building contains the **city regalia**, which includes the earliest surviving piece of English medieval secular plate, the 13thC ***King John's Cup***.

The Lynn Museum
(above the Bus Station)
Open Mon – Sat 10am – 5pm
Closed Sun
📷 ☑

The Lynn Museum is a pleasantly displayed collection of items mainly of local interest, among which are some fine **glasses** and **pottery**, and minor **oils, watercolours** and **prints** of local subjects.

LONG MELFORD CHURCH
Long Melford, Suffolk Map D4

The stateliest of Suffolk's "wool villages", Long Melford has a magnificent group of **half-timbered 15thC and 16thC houses**, many of which lie in the exceptionally long and attractive High Street. The large, airy 15thC church of the Holy Trinity is rich in **monuments** and **statuary**. But it is particularly notable for the 15thC **stained glass** ★ in the great East Window, which, miraculously, was unharmed in the 16thC and 17thC when most of the other glass in the church was destroyed; the subject is the Virgin seated on a decorated throne and holding the body of Christ crowned with thorns.

NORWICH
Norfolk Map D2

Norwich, the regional capital of East Anglia, was already a town of importance by the time of the Conquest. Between 1294 – 1320 the place was encircled by a

wall comparable in length to that of London. Remarkably, it was still almost wholly contained within this wall by 1800 and, moreover, had managed till then to retain a predominantly medieval appearance despite its expansion and prosperity. The town's sudden rise as an arts center in the early years of the 19thC coincided, ironically, with a temporary decline in its fortunes brought about by England's war with France (1793–1815). In 1803 a Norwich Society was formed with the intention of meeting regularly to discuss matters concerning art and to mount annual exhibitions during the August assizes. This laid the foundations of the so-called Norwich School, today the best known of 19thC Britain's regional schools of painting. By far its greatest associates were the landscapists John Crome and John Sell Cotman.

Numerous medieval monuments survive in Norwich today, including such a large number of churches that many of them have had to be deconsecrated. However, most of the picturesquely decaying medieval quarters that the Norwich School painters loved to represent have either gone or else been so tidied up that they are sometimes difficult to recognize. The chief surviving monuments of Norwich's medieval past are the **cathedral** and the **castle**, both of which date mainly from the 12thC. Among the various works of art kept in the cathedral is, in the S transept, an **effigy** of 1100, reputedly of Bishop Losinga and one of the earliest such effigies in the country.

In the chapels of St Luke and St Saviour are some rare surviving examples of **medieval East Anglian paintings**: these are respectively some 14thC panels from St Michael-at-Plea and a fascinating **retable**, probably presented as a thanks offering after the suppression of the Peasant Revolt of 1381 (the rebels had briefly occupied Norwich). The treasury, in the Choir, displays a collection of **ecclesiastical silver** loaned by Norfolk churches, and has traces of medieval painting on its ceiling.

Norwich Castle Museum and Art Gallery ☆

Tel. (0603) 611277 ext. 279
Open Mon–Sat 10am–5pm; Sun 2–5pm
🎟 ♿ 🏛 ☑ 🅿

The castle—the exterior of which, was refaced in the early 19thC with blank Norman arcading—is one of the finest surviving examples of **Norman military architecture** apart from the Tower of London. The building now partly houses the town's museum.

Only shortly before becoming a

museum in 1894 the castle had been serving (since 1220) as the county jail. Its dark Piranesi-like interior still retains something of the atmosphere of a prison, and morbidly inclined visitors can even go on a guided tour of the dungeons, where they will be shown death masks of murderers hanged at the castle gates between 1820–50. The main hall of the castle displays a selection of objects mainly of historic interest; the most remarkable and unintentionally sinister among these are two 15thC **dragon heads** (one a parody of the other) once used in civic processions. But the bulk of the museum's collections are shown in a dull modern extension to the castle in the form of a rotunda, and include a large natural history section, a number of archaeological items, such as an elaborately decorated **ceremonial Roman helmet** of the 3rdC AD, and a large group of **ceramics** ranging from Italian and Renaissance majolica to works by modern ceramicists such as **Lucy Rie**.

But the special feature of the castle and museum is its enormous collection of **paintings and watercolours by the Norwich School**. The great majority of these were donated by two members of the Colman family (of mustard fame); an earlier member of the family had been a considerable patron of these artists. Pride of place naturally goes to **Crome** and **Cotman**, after whom two of the galleries are named. Among the finest paintings by Crome are the very fresh and spontaneous oil sketch of the nearby beauty spot, *Postwick Grove* ★; a luminous study of one of Norwich's former picturesquely decayed riverside areas (*Back of the New Mills* ★), and the dark and melodramatic oil *Ruins of Carrow Abbey*, which can still be seen in the grounds of the Colman factory. Cotman was generally a more subtle artist than Crome, just as he was also a more sensitive and unstable personality. There are various striking oils by him in the museum, including *Old Houses at Garleston* ★ and the highly simplified composition, *Boats on Cromer Beach*. It was essentially in his watercolours that Cotman fully revealed his gifts for reducing nature to strikingly simple and delicate patterns. Many of these works have a pronounced modern character, which is partly why they were not always appreciated by Cotman's contemporaries, who prefered a more detailed and less structured approach. As with all the museum's watercolours, only a relatively small selection of those by Cotman are on show at any one time: generally chosen is one or more of the celebrated watercolours that Cotman

executed around Greta Bridge, which is now in County Durham.

In its time the Norwich School was principally appreciated locally, and for the simple reason that these artists painted sites well known to their patrons. Much to the chagrin of Cotman – who was by far the most ambitious of this group – the Norwich School was scarcely recognized in London. Today the critical fortune of these artists has been reversed completely and they now enjoy praise that at times seems ludicrously excessive. Apart from Cotman and Crome, much of the work of the Norwich School artists (most notably **John Thirtle, Robert Ladbrook, Henry Ninham, James Stark, Joseph Stannard, Revd E. Daniel, George Vincent** and **Henry Bright**) represents one of the more tedious areas of British art, being little more than a third-rate imitation of 17thC Dutch landscape painting (much of which is bad enough in itself). As you walk around the museum, you rapidly begin to tire of the endless placid green landscapes filled with ruminating cows.

Fortunately, not all the museum's art holdings are of Norwich School artists. There is an early 16thC triptych (the *Ashwellthorpe Triptych*) by a Flemish artist identified as the Master of the Legend of the Magdalene which is interesting for featuring portraits of two Norfolk donors. Among the other noteworthy paintings are a portrait by **Rubens** of an elderly man, a small genre scene by **G.B. Tiepolo** (of "a charlatan"), an *Annunciation* by **Burne-Jones**, and several highly popular paintings by the East Anglian horse painter, **Sir Alfred Munnings** (the best of which are *Sunny June* and *Gravel Pit in Suffolk*). On the first floor of the museum is a small and rather depressing collection of works mainly by modern British artists, ranging from a **Sickert** to a **Michael Andrews** (an interesting if not particularly beautiful painting showing, in a rather grotesque manner, a reception held in Norwich Castle on the eve of the installation of the post of Chancellor of the University of East Anglia). Perhaps the finest of the modern works is a late, highly Expressionist painting of Rhondda by **David Bomberg**, painted in 1954 when he had long been forgotten as an artist.

Sainsbury Centre for Visual Arts ☆
University of East Anglia
Tel. (0603) 56060
Open Tues – Sun noon – 5pm
Closed Mon
🖾 � ☑ ⠇⠇
The Sainsbury Centre is at the W corner of the University of East Anglia's

campus, which was established on the outskirts of Norwich in 1961. The modern concrete university buildings, designed by Sir Denys Lasdun, have already begun to show their age. The ziggurat-shaped residence blocks, once praised for their modernity, now seem more like penal institutions, and considerable agility is required to descend the steep staircases. After crossing the bleak campus, it is a relief to reach the **Sainsbury Centre**, the creation of Foster Associates.

Not only is this not a concrete building (its principal materials are steel and glass) but it is also a delightfully uncompromising structure, and as such is very different in spirit from the typically British half-hearted attempt at modernism represented by UEA's other buildings. Its shape has often been compared to an aircraft hangar and it is one of those buildings in which the architect seems to have gone out of his way to devise structural elements the main function of which is that they can be exposed. Moreover, its shape provokes certain practical difficulties that have been of particular concern to the university's art, history and music departments, which the building also houses: the administrative staff sit in wide open spaces suffering from agoraphobia, while the lecturers are forced to give seminars in cramped windowless cubicles that become so hot that their doors have to be kept permanently open. Nonetheless, as an art gallery the Sainsbury Centre is magnificent, indeed one of the most tastefully and imaginatively displayed in Britain.

A small section at one of the glass sides of the building puts on **temporary exhibitions** often of relevance to the permanent collection. It is also here that the university shows its collection of 20thC non-figurative art, which includes work in a wide variety of media (including three-dimensional workings and reconstructions) by such artists, architects and designers as **Sonia** and **Robert Delaunay, Bomberg, Tatlin, Le Corbusier, Ben Nicholson, Auguste Herbert, Frank Stella, Sol LeWitt** and **Jesus Raphael Soto**. The brilliance of the display lends a certain eloquence to the generally rather minor works on show. The main exhibiting space, in the middle of the gallery, includes objects from the Hansen collection of **Art Nouveau**, but is mainly taken up by a changing selection from the superb art collection of the Sainsbury family(who are also responsible for having had the gallery built).

The Sainsbury collection is a very diverse one, but it is particularly strong on **"primitive" art** (including pre-Columbian, African tribal, Pacific Islands, American, Indian and Eskimo objects) and **contemporary art**. In addition, there are marvellous examples of **ancient Egyptian, Greek and Roman art** (note especially a large group of **Greek Cycladic sculptures**), and **medieval and oriental art**. The main strengths within the modern collection are the works of **Francis Bacon, Henry Moore, Giacometti, Hans Coper** and the young English sculptor, **John Davies**. The latter artist, who specializes in rather sinister grey-painted casts of human figures, manages to combine extreme realism with an other-worldly dimension: His *Two Figures*, *Pick-a-back*★★ (1977–80) (which perhaps takes its formal inspiration from Bernini's famous *Aeneas and Anchises* in Rome) is one of the most moving and profound examples of contemporary British sculpture.

No attempt is made to arrange the Sainsbury collection in any chronological way, yet the display succeeds in giving a remarkable unity to the diverse whole. It does this by seeking out correspondences between the art of different periods. So you will find a pot by **Hans Coper** placed near a Greek Cycladic pot, and an early sculpture of a *Mother and Child* by **Henry Moore** almost alongside a pre-Columbian idol.

St Peter Hungate Church Museum
Princes St
Tel. (0603) 611277 ext. 296
Open Mon–Sat 10am–5pm
Closed Sun
ⓞ 🏛

The 15thC Church of St Peter Hungate, at the top of Norwich's most picturesque street, **Elm Hill**, was converted in 1936 into a small museum of **ecclesiastical art**. The church itself retains a number of fine **stained glass** windows of the 15th and 16thC. Among the many miscellaneous items in the showcase in the nave are the beautifully illuminated **Wyclif Bible** (c.1380) and some particularly fine 16thC Flemish **carved limewood panels**.

Strangers' Hall
Charing Cross
Tel. (0603) 611277 ext. 275
Open Mon–Sat 10am–5pm
Closed Sun
ⓞ 🏛

Strangers' Hall is a large rambling merchant's house of medieval origins, the rooms of which have been attractively furnished in different styles ranging from early Tudor to late Victorian.

PETERBOROUGH
Cambridgeshire Map B2

Peterborough is an industrial town surrounded by dull, flat country. However, it retains various attractive old buildings, many from the Georgian and Regency periods. The early 15thC Church of St John the Baptist has inside an interesting Neoclassical monument by **John Flaxman** (1826) showing a mourning Grecian beside a tall pedestal. The glory of Peterborough is of course its **cathedral**, the spectacular Gothic façade of which, comprising three enormously tall, deeply recessed arches, shields one of the most perfectly preserved Norman naves in the country. The carefully restored 13thC **wooden ceiling** of the nave is richly decorated with **paintings**.

Peterborough Museum and Art Gallery
Priestgate
Tel. (0733) 43329
Open May–Sept Tues–Sat 10am–5pm;
Oct–Apr Tues–Sat noon–5pm
Closed Sun Mon
ⓞ 🏛 ☑

The Peterborough Museum and Art Gallery is situated in a large, handsome Regency house. The collections are mainly historical and archaeological, and include some interesting **carved bonework** and **straw marquetry** executed by prisoners from the Napoleonic wars who were held in the town's Norman Cross Barracks. The small art gallery contains English **glass** and **pottery**.

RANWORTH CHURCH
Ranworth, Norfolk Map E2

The mainly Perpendicular **Church of St Helen** in the village of Ranworth has a battlemented W tower which you can climb in order to see wonderful views of the surrounding Norfolk Broads. The church's **painted rood screen** ★ of 1485, portraying the twelve Apostles, is probably the work of Flemish or German artists and one of the finest such screens in Britain. Also of interest is a **carved lectern** (c.1500) and the **Sarum Antiphoner**, a beautiful illuminated manuscript of 1400, viewable on request.

SOUTHEND-ON-SEA
Essex Map D5

Southend-on-Sea, a resort at the mouth of the Thames, was once very popular

with London families. Today, however, it appears to be favoured by leather-jacketed motorcyclists, who come here for the plethora of amusement arcades and fast-food stores.

Beecroft Art Gallery
Station Rd
Westcliff-on-Sea
Tel. (0702) 42878
Open Mon – Thurs 9.30am – 1pm,
* 2 – 5.30pm; Fri 9.30am – 1pm, 2 – 5pm*
Closed Sat, Sun
☒

The Beecroft Art Gallery is situated in an ugly suburban district of the town and is housed in an equally unappealing converted suburban residence. In this unlikely setting can be found numerous paintings. These include unremarkable **16thC – 18thC Dutch**, **Flemish** and **Italian works** by minor artists, a scattering of French and German paintings (including a landscape by **Harpignies**) and a large group of **British paintings**, **watercolours** and **drawings** from the 16thC up to the present day (among these is an oil landscape by **Constable** and three oils by the successful East Anglian painter of this century, **Edward Seago**). In addition, the museum houses the **Thorpe Smith Collection** of paintings, prints and drawings, which is intended as a comprehensive pictorial record of Southend-on-Sea.

SUDBURY
Suffolk Map D4

Once an important wool town, Sudbury is a pleasant place with various **half-timbered old houses**. It owes much of its reputation to having been the birthplace of **Thomas Gainsborough**, who is commemorated by a statue on Market Hill, and whose childhood home on what is now Gainsborough Street is the town's major attraction.

Gainsborough's House
46 Gainsborough St
Tel. (0787) 72958
Open Tues – Sat 10am – 12.30pm, 2 – 5pm;
* Sun 2 – 5pm*
Closed Mon
☒ 🏛 ♿

Gainsborough's father, a local wool weaver and the son of the town's chief constable, acquired this property in 1722. It then comprised two modest houses of Tudor origin; the father joined them together and added the elegant Georgian façade that you see today. The house is now an attractive museum, with **18thC furnishings** and some mainly minor works by **Gainsborough** from various stages in his career. An art center, which accommodates exhibitions of contemporary art, is attached to the house.

DEVELOPMENT *of* BRITISH *and* IRISH ART

British and Irish art, long isolated from the traffic in ideas and images that flowed between the Continental schools, had some advantages in the early periods when outside influences could be combined with indigenous traditions. Celtic art freely adopted and transformed Roman motifs, as in the illuminated manuscripts produced in Ireland and the North during the early Middle Ages, balancing descriptive elements with an extreme form of abstract design. Later, the Winchester school of illuminators and the East Anglian painters of the 14thC Luttrell Psalter provided further examples of sophistication. But the crowning achievement of this whole society came with the Gothic cathedrals throughout the country. Less orthodox than their French counterparts, the masons at Lincoln, Wells, Canterbury and Exeter were at their best in the deployment of rich masses of stonework. Sculptors often concentrated on carving tomb effigies, and in the area around Nottingham alabaster pieces were produced that found their way to all the religious houses of northern Europe and beyond.

The triumph of the Reformation in the early 16thC made Henry VIII the supreme head of the church, and religious themes, which had dominated earlier art, became suspect. Portraiture or "face-painting" came to assume a pre-eminent position, being perhaps the only area untainted by idolatry. At the same time, Henry's reign saw the beginning of an acceptance of Renaissance ideals in painting and the other arts.

In 1532 the great German painter Hans Holbein settled in London to become one of the principal painters to the king. Among other achievements Holbein brought miniature painting to a level of accomplishment that developed still further under later monarchs at the hands of Nicholas Hilliard and Samuel Cooper. But his greatest triumph was the creation of a portrait style that perfectly charts the types and individuals of the Tudor court, leading to a pattern of court patronage that was to continue till the 18thC. In the absence of a native school of painting, successive monarchs brought over foreign masters such as Eworth, Mor, Mytens and Lely to depict their families and courtiers. With Van Dyck, however, Charles I achieved something exceptional, and after his arrival in 1632 the Flemish master proceeded to create some of the greatest regal portraits of any age. Among British artists of the time, only William Dobson (who may have been Van Dyck's assistant) managed to transcend the naive virtues of an artistic backwater and succeeded in fashioning sophisticated art. On the restoration of Charles II, the Dutch-born artist Lely revived the sensual Baroque manner in his portraits and, in the next generation, a German, Sir Godfrey Kneller, introduced a simpler, more direct style.

ART *in the* 18TH CENTURY

Foreign artists continued to dominate the visual arts in England into the 18thC. The illusionistic, high-flown decorations that constituted the most important commissions for artists of the Baroque and Rococo period were almost all entrusted to foreigners such as Antonio Verrio, Louis Laguerre, Gianantonio Pellegrini, Jacopo Amigoni and Sebastiano Ricci. The only English artist capable of producing successful large-scale decorations was Sir James Thornhill, who in 1712 disappointed all his foreign colleagues by winning the prestigious commission to decorate the inner dome of St Paul's Cathedral in London. Thornhill's victory was cause for great optimism

among British artists, but in practical terms it was to have little consequence.

British painting of the first half of the 18thC was generally of a humble kind, and, as in the previous century, took mainly the form of portraiture. A new type of portrait evolved in which the subjects were not seen as heroic figures surrounded by swirling drapery but simply as landowners in the context of their property and family. One of the leading early practitioners of this type of portrait – which came to be known as a "conversation piece" – was Arthur Devis, whose doll-like figures and naive (but sometimes charming) attempts at characterization are an indication of the provincialism of British art at this time. William Hogarth began his career with conversation pieces, but soon started to challenge the idea that the British artist was not as capable as his foreign colleagues of doing ambitious figurative works. His attempts at creating canvases in an Italian Baroque manner, such as his altarpiece at St Mary Redcliffe in Bristol, cannot be said to be wholly successful. His greatest achievement came with his bitingly satirical scenes – that were always intended to be engraved – of contemporary life.

The establishment of the Royal Academy in London in 1768 vastly improved the stature of the British artist and at the same time gave him what he had previously so greatly lacked – an important institution where he could exhibit his works. But British patrons' insistence on having representations of themselves meant that many outstanding 18thC artists, including Reynolds, Ramsay, Romney, Raeburn, Sir Thomas Lawrence, Joseph Wright of Derby and Gainsborough, worked principally as portraitists; and even in this field there was strong competition from foreigners such as the German Zoffany. Within the constraints of portraiture, British artists now attempted to be as varied and imaginative as possible. Under the influence largely of Reynolds they made the subjects of their portraits adopt the poses found in famous works of art such as the **Apollo Belvedere**, or dress up in sometimes ludicrous guises, ranging from simple country girls to Greek goddesses. In addition to the portraits that were his livelihood, Joseph Wright of Derby painted dramatically composed canvases expressing his fascination with science, haunting moonlight effects, and themes of mortality. George Stubbs, though not as original as Wright, also broke through the dull conventions of British art at this time to create works of imaginative power.

LANDSCAPE ART *in* BRITAIN

Imaginative landscape painting in the late 18thC and early 19thC found no more support than did so-called "history" painting; and just as history painters maintained themselves through portraiture, so landscapists worked principally as topographical artists, executing views of famous buildings and beauty spots or property owned by their patrons. This is particularly ironical in view of the enormous admiration of English collectors for the Classical landscape tradition as represented above all by the French painter active in 17thC Italy, Claude Lorrain. The British in the 18thC not only made numerous purchases of Claude's paintings, but also based the arrangement of their gardens of this period, such as Stourhead in Wiltshire, on his works. Yet the "father of British landscape painting", Richard Wilson, who saw the landscape both of Italy and of his native Wales through the eyes of Claude, was greatly neglected in his time, dying in 1782 of drink and poverty.

The greatest British landscapists in the wake of Wilson were all strong individualists, from Thomas Jones, who painted open-air oil sketches of an immediacy and freshness that makes them almost modern in spirit, to Constable, in many ways that most revolutionary British artist of the early

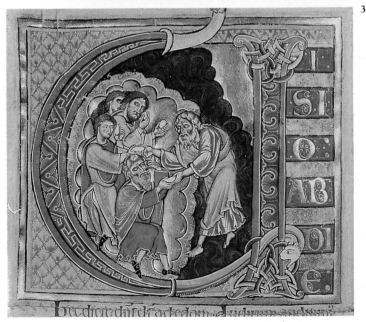

1 *Anon.*, **Muiredach's Cross**, *10thC, Monasterboice, Ireland*

2 *Anon.*, **Edward II** *(head), 14thC, Gloucester Cathedral*

3 *Anon.*, **Winchester Bible**, *("**Obadiah**"), 12thC, Winchester Cathedral Library*

1 *Nicholas Hilliard,* **Alice Brandon, Mrs Hilliard***, 1578, London, Victoria & Albert Museum*

2 *Hans Holbein,* **Christina of Denmark, Duchess of Milan***, 1538, London, National Gallery*

3 *Hans Eworth,* **Sir John Luttrell***, 1550, London, Courtauld Institute Galleries*

1 *Jacopo Amigoni,* **Mercury Presenting the Head of Argus**, *c.1732, Moor Park, Hertfordshire*

2 *Anthony Van Dyck,* **Philip, 4th Earl of Pembroke & his Family,** *after 1630, Wilton House, Wiltshire*

3 *Claude Lorrain,* **Harbour Scene**, *1635, Bowhill, Borders; Scotland*

1 *Joshua Reynolds,* **Charles Coote, 1st Earl of Bellamont,** *1764-5, Dublin, National Gallery of Ireland*

2 *Richard Wilson,* **Snowdon from Llyn Nantle,** *before 1774, Liverpool, Walker Art Gallery*

3 *William Hogarth,* **Marriage à la Mode II: Shortly after the Marriage,** *c. 1743, London, National Gallery*

4 *Pompeo Batoni,* **Sir Watkin Williams-Wyn, Thomas Apperley & Capt. Edward Hamilton,** *1768, Cardiff, National Museum of Wales*

5

4

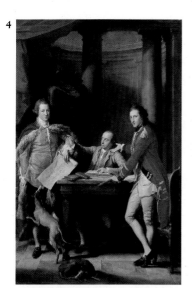

5 *Thomas Gainsborough,* **Mary, Countess Howe**, *c. 1760, London, Kenwood House*

6 *Canaletto,* **Whitehall and the Privy Garden from Richmond House**, *1746–7, Goodwood House, Sussex*

6

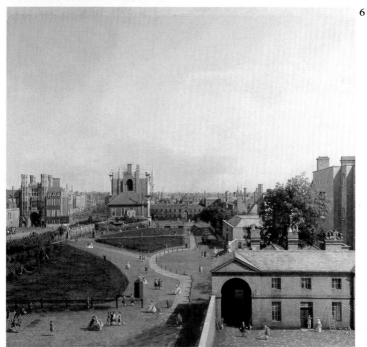

1

2

3

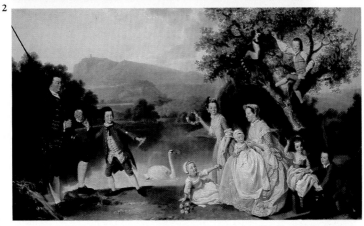

1 *James Barry,* **The Death of Adonis,** *c.1775, Dublin, Nat. Gall. Ireland*

2 *Johann Zoffany,* **John, 3rd Duke of Atholl & Family,** *1765-7, Blair Castle, Tayside; Scotland*

3 *Thomas Jones,* **Buildings in Naples,** *1782, Cardiff, Nat. Mus. Wales*

4 *Joseph Wright of Derby,* **Miravan opening the Tomb of his Ancestors,** *1772, Derby Art Gallery*

5 *George Stubbs,* **Horse Frightened by a Lion,** *1770, Liverpool, Walker Art Gallery*

6 *William Blake,* **God Judging Adam,** *1795, London, Tate Gallery*

1 *Henry Raeburn,* **Colonel Alastair Macdonell of Glengarry**, *c.1812, Edinburgh, National Gallery of Scotland*

2 *Thomas Lawrence,* **The Masters Pattisson**, *1811-17, Polesden Lacey, Surrey*

3 *J.M.W. Turner,* **Pope's Villa at Twickenham**, *between 1814-26, Sudeley Castle, Gloucestershire*

4 *John Sell Cotman,* **Yarmouth Bridge looking towards Breydon**, *c.1823-5, Norwich Castle Museum*

5 *Richard Parkes Bonington,* **Fisherfolk on the Coast of Normandy**, *1827, Nottingham Castle Museum*

6 *John Constable,* **Golding Constable's Kitchen Garden**, *1815, Ipswich Museum*

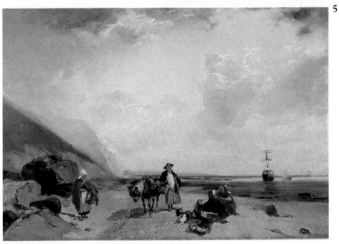

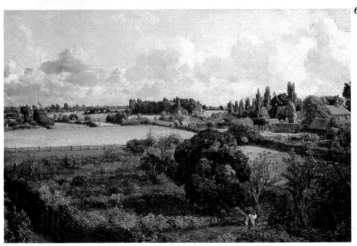

1 *John Martin,* **Sadak in Search of the Waters of Oblivion,** *1812, Southampton Art Gallery*

2 *Francis Danby,* **View in Leigh Woods,** *c.1822, Bristol Museum & Art Gallery*

3 *William Dyce,* **Titian's First Essay in Colour,** *1856-7, Aberdeen Art Gallery; Scotland*

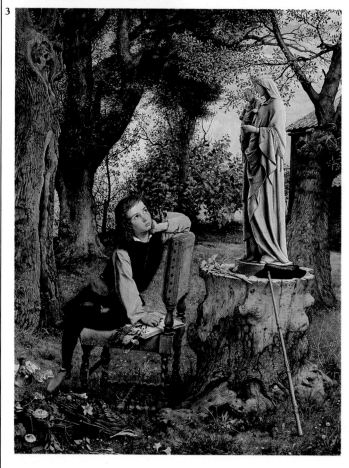

4

4 *Lawrence Alma-Tadema,* **94° in the Shade**, *1876, Cambridge, Fitzwilliam Museum*

5 *Edward Burne-Jones,* **Laus Veneris**, *1873-8, Newcastle upon Tyne, Laing Art Gallery*

6 *William Holman Hunt,* **The Children's Holiday (Mrs Fairbairn & Children)**, *1864-5, Torquay, Torre Abbey*

5

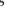

6

2 *Walter Osborne, **Cherry Ripe**, 1889, Belfast, Ulster Museum*

3 *John Lavery, **Loch Katrine**, 1913, Edinburgh, Gallery of Modern Art*

4 *Philip Wilson Steer, **Children Paddling, Walberswick**, 1894, Cambridge, Fitzwilliam Museum*

5 *Spencer Gore, **Harold Gilman's House at Letchworth**, c.1912, Leicester Museum & Art Gallery*

6 *James Dickson Innes, **Cathedral at Elne**, 1911, Cardiff, Nat. Mus. Wales*

1 *James Abbott McNeill Whistler, **Red and Black: the Fan**, 1891-4, Glasgow, Hunterian Art Gallery*

4

5

6

1

1 *Harry Clarke,* **Stained Glass Window**
 *(det.), 1915-17, Honan Collegiate
 Chapel, Cork, Ireland*

2 *Jack Yeats,* **Communicating with
 Prisoners**, *1924, Sligo Museum,
 Ireland*

3 *Alfred Gilbert,* **Memorial to Queen
 Alexandra**, *1928-32, London,
 Marlborough Gate*

4

4 Stanley Spencer, **Convoy of Wounded Arriving at Beaufort Hospital Gates**, *1927, Sandham Memorial Chapel, Burghclere, Hampshire*

5 *Eric Ravilious,* **Tennis** *(det.), c.1932, Bristol Museum & Art Gallery*

6 *Paul Nash,* **The Menin Road***, 1919, London, Imperial War Museum*

5

6

1 *John Davies, **Two Figures (Pick-a-Back)**, 1977-80, Norwich, Sainsbury Centre for the Visual Arts*

2 *Henry Moore, **King and Queen**, 1952-3. Glenkiln, Dumfries & Galloway; Scotland*

3 *David Hockney, **My Parents and Myself**, 1975, London, Tate Gallery*

19thC, and little recognized during his lifetime. The freshness of his vision seems to have been more appreciated in France than in Britain. Cotman, another major British landscapist of this period, is associated with the Norwich school of painters. Though forced to practise as a topographical artist, he gave his landscape views a simplicity of form and colour largely incomprehensible to his contemporaries.

The art of Turner was also deeply rooted in the British topographical tradition, yet it transformed this tradition almost beyond recognition. His genius was appreciated by his contemporaries far more than was that of Constable and Cotman, perhaps because of the strong literary element inherent in his paintings.

Turner was sometimes considered insane by his contemporaries, especially as his mother had died in this condition. There were many other artists of the time whose work suggested madness, the best known of whom was John Martin, referred to as "Mad Martin", who painted visionary apocalyptic scenes. Francis Danby painted similar works, but was perhaps more successful in his small, hauntingly still views of the Bristol Gorge that, for all their realism, have an other-worldly quality. Related to the streak of "madness" in British art is a strong element of mysticism. William Blake is a quintessentially English phenomenon, an artist who was more literary than visual, and who illustrated his own poems with engravings of a mystical intensity and a degree of imagination unfortunately beyond his technical powers. Blake had an enormous influence on the landscapist, Samuel Palmer, who in the 1820s and 1830s painted at Shoreham in Kent visionary landscapes that stand out completely from their period.

The ART of the VICTORIANS

Victorian art has begun to be widely appreciated again, following a long period of neglect. Opportunities for the artist in the Victorian age were actually far greater then than they had ever been in the past. The rise of middle-class patronage freed the artist from the need to make a living by having to paint portraits of the aristocracy; imaginative landscape painting had achieved full acceptance; and tastes in art had broadened considerably.

The early Victorian painter who perhaps most sums up the richness of this period is William Dyce, who painted scenes from Classical mythology, medieval-style murals, and minutely observed landscapes, influenced by the "truth to nature" ideals of the Pre-Raphaelites. The latter, who were formed in 1848, represent the most talented single group of artists England has produced. Yet what is perhaps most remarkable about them is their extraordinary variety. They attracted public attention at first through their realism; but in the later manifestation of the movement, represented above all by the later works of Rossetti, and the art of Burne-Jones, this had given way to fantasy and mysticism.

Later Victorian art is characterized by its great range of moods, from the sublime to the ridiculous. Artists of the so-called "Victorian High Renaissance" included Lord Leighton, Albert Moore, G.F. Watts and the sculptor Alfred Gilbert, while often Alma-Tadema, who also specialized in Classical scenes, gave these the same anecdotal qualities that he imparted to his representations of the contemporary world.

An INTERNATIONAL DIMENSION

Until the late 19thC British art had remained remarkably insular. Few of its artists had trained abroad, and almost all its greatest painters had been

individualists whose art is difficult to relate to mainstream European tendencies. Then, from about the 1870s onwards, it took on a more international dimension. British art began to be far more widely recognized abroad, with artists such as Burne-Jones having an enormous influence on European symbolists, and William Morris gaining international recognition for the Arts and Crafts Movement. In addition it became an accepted practice for British artists to spend a period abroad, most notably in France.

A feeling of dissatisfaction with their own native artistic institutions characterized artists returning from France in the late 19thC. In 1885 the new wave of British artists formed the New English Art Club (N.E.A.C.) as an alternative exhibiting institution to the Royal Academy. At the same time, artist colonies on the lines of those in France were set up all over the country, the most important ones being in Newlyn and St Ives on the tip of Cornwall. The fascination with old-fashioned rural communities that accompanied the development of artists' colonies was a reflection both of a widespread "back to nature" movement and also of the intense mood of nationalism that affected Europe generally in the late 19thC and early 20thC. This new regional pride within Britain and Ireland led to a renaissance of both Scottish and Irish art. Scotland's "Glasgow Boys", who included Sir John Lavery, Sir James Guthrie and George Henry, were internationally praised, as was Charles Rennie Mackintosh, who helped turn Glasgow into one of the most revolutionary centers of architecture and design in Europe. Irish art of this period was not as outstanding as its nationalist literature, but it could boast such fascinating painters as Walter Osborne and Jack Yeats, as well as craftsmen such as the stained-glass designer Harry Clarke.

English art from the 1880s was for a time further divided, not only between the Royal Academy and the N.E.A.C., but also between two strongly opposed factions within the N.E.A.C. itself. Most of the British artists who had studied in France had been influenced above all by the example of the French painter of traditional rural life, Bastien-Lepage; but an enlightened few had taken an interest in the then little appreciated art of the French Impressionists. These included Wilson Steer and Sickert, who worked under the aegis of Whistler, an American painter active in England. Sickert's Camden Town school associates such as Harold Gilman, Robert Bevan and Spencer Gore were among the main British artists included in the highly controversial and influential Post-Impressionist Exhibition organized by Roger Fry at the Grafton Galleries in London in 1910–11.

Viewed in terms of its main artistic movements, 20thC British art can seem parochial. Only the Vorticists, who were active in the second decade of the century, had any great power and originality. The painters whom Fry was particularly associated with, the Bloomsbury group (most notably Duncan Grant and Vanessa Bell) were merely poor imitators of contemporary French art. British abstract art achieved a certain distinction, if also blandness, in the work of Ben Nicholson, Henry Moore and Barbara Hepworth; but became in the 1950s little more than a pastiche of American art. However, figurative art has brought out the best in British art in recent years, and Britain can at least claim to have produced some of Europe's main contemporary figurative artists, from Francis Bacon to David Hockney and the remarkable sculptor John Davies. Yet perhaps the most interesting of all British artists this century, have been such individuals as J.D. Innes, Stanley Spencer, Eric Ravilious, Paul Nash and Ian Hamilton Finlay.

WESTERN ENGLAND

Other areas of provincial Britain may be wealthier in art treasures than the West Country, but none has played such an important role in the history of British art. Among the great attractions of the region from the 18thC onwards were the many vestiges of its prehistoric past, above all the stone circles at Avebury and Stonehenge in Wiltshire. There is something primeval about the appearance of much of the landscape in Western England, notably Dartmoor in Devon and the NW tip of the Cornish peninsula, both of which have wild expanses of moorland interspersed with rocky outcrops.

The artistic history of the region begins properly with the 18thC and early 19thC. A number of the leading British portraitists and history painters of this period were born in the West Country: John Opie came from Cornwall; and Thomas Hudson, Reynolds, Northcote, Benjamin Robert Haydon and Charles Lock Eastlake were all from Devon. More interestingly, large numbers of artists from elsewhere in Britain came to visit and even settle in the region, a phenomenon that was to intensify in later years. STONEHENGE was a major draw for artists, and developed into one of the most visited Romantic sites in Europe.

However, the first important art center in the West Country was the fashionable spa town of BATH, which after London provided the greatest opportunities in Britain for society portraitists such as Gainsborough. At the beginning of the 19thC, major artistic activity in the region shifted to nearby BRISTOL, where there grew up one of Britain's most interesting provincial schools of painting. The Irishman Francis Danby was the principal member of this school, which found its chief source of inspiration in the wooded Severn Gorge, poetically referred to as the "regions of Elysium".

ARTISTS' COLONIES

In the last quarter of the 19thC the Cotswolds, an area just to the E of Bath, came to be seen in a similarly idyllic way by members of the Arts and Crafts movement, for whom its little stone villages set among verdant hills represented all the values in traditional English art and life that they were attempting to revive. Other painters of this period were also obsessed by the West Country's old-fashioned rural communities, but preferred the rugged countryside of Cornwall's western tip to the cosy Cotswolds. However, this area suddenly became the artistic Mecca of Britain not least because of the similarities between it and what was then Europe's most fashionable artists' resort – Brittany. Like Brittany, Cornwall was admired for its "primitive" qualities, the grey, primeval aspect of its landscape, the harsh lives of its fisherfolk, and its Celtic folklore and traditions. The most popular artists' colonies in Brittany – Pont-Aven and Concarneau – were even situated in a part of the region called La Cornouaille, which is Breton for Cornwall.

Britain's two main equivalents of these Breton colonies, the Cornish villages of NEWLYN and ST IVES, developed out of the nostalgia that many artists felt for their time spent in Brittany. Newlyn, the "English Concarneau", was favoured principally by English figurative painters, whereas St Ives had a broader and more international appeal, attracting in addition to English artists the numerous American and Scandinavian painters who had been to Brittany. St Ives, unlike Newlyn, also lived on as an artists' colony well into this century. At the outbreak of World War II some prominent members of the artistic avant-garde of Hampstead in London moved here, most notably Adrian Stokes, Ben Nicholson, Barbara Hepworth and Naum Gabo; and in the 1950s there came the so-called "Middle Generation", British painters such as Patrick Heron, Bryan Wynter, Roger

Hilton and Peter Lanyon. These artists helped to turn the colony into a focus of Abstract art sufficiently important to inspire visits from a number of the leading Americans associated with this movement, including the critic Clement Greenberg, and Mark Rothko, Larry Rivers and Mark Tobey.

Many St Ives artists were invited to teach in the 1950s in the newly opened Bath Academy of Art at CORSHAM COURT – between Bath and Chippenham – which soon developed into one of the country's liveliest and most influential art schools. Then the Cotswolds came once again to be infiltrated by artists, many of whom had connections with Corsham, such as William Scott, Howard Hodgkin and Joe Tilson. The area's traditionally English appeal has also inspired the sentimental, shortlived, but much publicized group of painters known as the Ruralists. The West Country generally has maintained a widespread appeal among artists throughout this century. Paul Nash worked all over the region, encouraged in the Surrealist elements in his landscape paintings by such prehistoric sites as AVEBURY; but above all he loved Dorset, finding in it a strange and enigmatic quality exemplified in the seaside town of Swanage, which fascinated him with its combination of hideous "Purbeck-Wesleyan-Gothic" buildings and superb scenery. Stonehenge came to be admired for its qualities as abstract sculpture by Henry Moore, Barbara Hepworth and others; and the more primitive elements in the West Country landscape have continued to exert a fascination for one of our best-known "conceptual" artists, Richard Long.

Sadly, the importance of the region to British art is only partially reflected in the holdings of its museums. You will see portraits by Opie in Cornwall's county town of Truro, works by Devonshire's galaxy of 18thC and early 19thC painters in Exeter and Plymouth, society portraits by Gainsborough in Bath, and Arts and Crafts objects in Cheltenham. But none of these museums is of outstanding interest. Moreover, comparatively few of

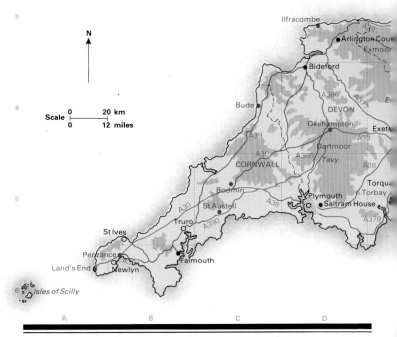

the countless paintings inspired by Cornwall from the late 19thC onwards
have been preserved in the county. The one major gallery in Western
England is in BRISTOL, and it should be your starting point for exploring this
region's art because its collections include works by almost all the main artists
to have worked here from the 18thC to the present day. Neither should you
miss – though its treasures have no close regional connection – the
extraordinary Russell-Cotes Museum in BOURNEMOUTH, a monument to late
Victorian and Edwardian opulence almost unrivalled in the whole country.
Yet ultimately the pleasures of an artistic tour of Western England derive
principally from seeing the places where its artists have worked. Bath is one of
Britain's most attractive towns; the Severn Gorge has changed remarkably
little since the Bristol school painted here; the Cotswolds, for all their
tourism, can still be seen to have idyllic qualities; and St Ives, has maintained
the lively and international character that it has had since its earliest days as
an artists' colony.

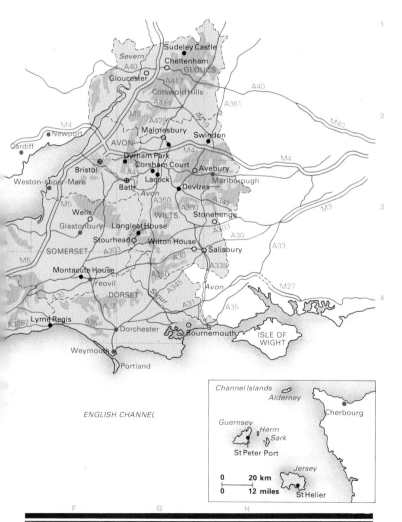

ARLINGTON COURT ⊞
Barnstaple, Devon Map D3

Tel. (027182) 296
Open Apr to late Oct Sun–Fri 11am–6pm
Closed Sat
▨ ◗ ☑ ❦
This is a Regency house (1822) set in a beautiful park. Its treasures include collections of model ships and pewter snuff-boxes, and an intriguing watercolour of extremely complex subject-matter by **William Blake**, entitled *The Circle of the Life of Man*. This was discovered in the 1940s on top of a cupboard in the house.

AVEBURY
Wiltshire Map G3

The 17thC writer and antiquarian John Aubrey wrote of the **Neolithic stone circle** of Avebury, "It surpasseth Stonehenge as a cathedral doth a parish church." The place had a similar impact on one of Britain's leading landscape artists this century, **Paul Nash**, who first came here in 1933, and was inspired to paint some of the most mysterious and powerful works of his career, such as the *Equivalents for the Megaliths* in the Tate Gallery in *LONDON*. Yet despite these isolated instances of strong individual enthusiasm, the site has never caught the public imagination in the same way as has Stonehenge, which has not only attracted more tourists but also inspired more paintings. Avebury is immensely bigger, and stands at the center of a whole complex of Neolithic monuments of c. 3,000–2,000BC. It is also a much more pleasant place to visit than Stonehenge, as its greater size helps to disperse the tourists who come here.

A short distance NW of Avebury is **Windmill Hill**, the top of which shows the remains of three concentric lines of earth works, vestiges of one of the oldest sites of the New Stone Age in Britain. Another and better known site in the vicinity is **Silbury Hill**, a huge, mysterious man-made cone jutting out from the landscape, constructed with enormous skill about 4,500 years ago.

Alexander Keiller Museum
Tel. (06723) 250
Open mid-Jan to Nov Mon–Sat
9.20am–6.30pm, Sun 9.20am–noon;
Dec to mid-Jan Mon–Sat 9.20am–4pm
Closed Sun Dec to mid-Jan
▨ ⬳
At the gates of a 16thC mansion in Avebury village is a museum named after the man responsible for important excavations at Avebury before World War II, Alexander Keiller. It contains pottery and other objects of the Neolithic and Bronze Ages found during excavations in the area of Avebury.

BATH
Avon Map G3

Bath is perhaps England's most attractive town, and makes an immediate impact on any visitor. It consists of numerous elegant 18thC and early 19thC houses and terraces built round a bend of the River Avon and extending on all sides up the slopes of wooded hills. What is more, these old houses lead almost directly to open countryside, and there is none of the characterless, sprawling suburbia that you see around many British towns.

Originally known as Aquae Sulis (the waters of Sul, a local Celtic deity), Bath was established in about AD54 by the Romans, who exploited its rich mineral springs to create one of the foremost bath systems in western Europe. **The Roman baths** were used from the 1stC to the 4thC, after which they fell into disrepair and were covered up; they were only rediscovered in 1879, and are now among the most important Roman remains in Britain. From the Middle Ages onwards the town became a focus of the cloth trade, but until the 18thC it is said that the living conditions of the place were squalid. The major monument from this period is the late 15thC **Abbey Church**, situated in a delightful and traffic-free square; among the building's most interesting features are **carvings** of angels on the W front.

The Bath that you see today is essentially a creation of the 18thC, when the town developed as Britain's most fashionable spa and – under the guidance of its Master of Ceremonies, Beau Nash – became the playground of England's high society. The architects mainly responsible for rebuilding the town at this period were the two John Woods, father and son; they were supported by Ralph Allan, the wealthy owner of the quarries at Combe Down, which provided the warm-toned Bath stone used for most of the buildings. The younger John Wood's masterpiece is the monumental **Royal Crescent**, an enormous segment of an ellipse overlooking Royal Victoria Park. No. 1 of this terrace has been recently opened to the public, and you can now see its beautifully restored **interior**, furnished as it might have been in the 18thC. The two major public buildings of 18thC Bath are the **Grand Pump Room**

and the **Assembly Rooms**. The former, rebuilt in 1795, is in the same square as the Abbey, and has an enormous main room where you can still experience the life of an 18thC aristocrat either by taking the evil-tasting waters or else, more pleasurably, by sipping the most elegantly served tea. The Assembly Rooms, which were built by the younger Wood, were at the heart of 18thC Bath's night life. Today the ball room and state rooms house The MUSEUM OF COSTUME.

Museum of Costume
Assembly Rooms
Tel. (0225) 61111
Open Apr–Oct Mon–Sat 9.30am–6pm,
Sun 10am–6pm, Nov–Mar Mon–Sat
10am–5pm, Sun 11am–5pm
🚗 🏛

The beautifully restored and furnished 18thC **interior** of this museum makes a wonderful setting for one of the finest collections of costumes in Europe. These range in date from the late 16thC to the present day and include such miscellaneous items as Byron's Albanian dress (1809), "patriotic corsets" of World War I, and even a suit once owned by the present director of the Victoria and Albert Museum, Sir Roy Strong.

Victoria Art Gallery
Bridge St
Tel. (0225) 61111 ext. 418
Open Mon–Fri 10am–6pm, Sat
10am–5pm
Closed Sun
🚗 🍴 🏛 📷

This is the town's municipal gallery, and was built in the late 19thC as an extension of the 18thC Guildhall. A library now occupies its ground floor, so there is relatively little space to show its collections. Virtually the only paintings on permanent display are on the grand and rather sombre staircase. They are all by British artists of the late 19thC and early 20thC, and include a small portrait of a girl with a red hat by Watts (*By the Sea*), a characteristically sentimental and mannered painting by the Scottish artist Hornel (*Playmates*), and an impressive *Portrait of a Youth* by Stanley Spencer's brother, Gilbert. The main gallery on the first floor shows rotating exhibitions of works from the museum's collections, as well as frequent touring exhibitions, but the gallery's finest Old Master painting, a 15thC Flemish *Adoration of the Magi* attributed to Hugo van der Goes, is usually on display. The rest of the fine art collection is principally devoted to British art from the early 19thC onwards. Here you can see several works, including *The Blind*

Fiddler, by the most successful painter working in Bath at the beginning of the last century, the now relatively little-known landscapist and genre painter, **Thomas Barker** of Bath. His son, Thomas Jones Barker, was also a painter, and the gallery has his award-winning *The Bride of Death* (1839).

Many leading British painters of this century have visited Bath and have donated works to the gallery, including not only **Gilbert Spencer**, but also **William Roberts**, **John Nash**, **Matthew Smith** and **Frank Brangwyn**. The gallery also has several Bath works by the most famous artist associated with the town this century, the Camden Town School painter **Walter Sickert**, who spent the summers of 1916–18 here, and from 1937 resided permanently at St George's Hill House (plaque) at Bathampton.

Holburne of Menstrie Museum
Great Pulteney St
Tel. (0225) 66669
Open Tues–Sat 11am–5pm, Sun
2.30–6pm
Closed Mon Dec–Jan
🚗 🍴 💷 🍴 🏛 📷

Leaving the Victoria Art Gallery and crossing the charming Pulteney Bridge, lined with shops and designed by **Robert Adam**, you come to the exceptionally long and elegant Pulteney Street, which comprises two almost unbroken terraces; at the end of these, and dominating the vista, is the Holburne of Menstrie Museum. This late 18thC building, formerly the Sydney Hotel, was converted early this century by Sir Reginald Blomfield to accommodate the fine and applied arts collections assembled originally by an early 19thC connoisseur, Sir Thomas William Holburne. The collections concentrate principally on the 17thC and 18thC, and most of the paintings are displayed in a large room on the second floor. They include a bizarre *Temptation of St Anthony* by the obscure 17thC Dutch artist van de Venne, vivid *capricci* by the 18thC Italian view painters, **Panini** and **Guardi**, and numerous 18thC British portraits of varying quality. Among the finest of these are three works by **Allan Ramsay** (all of members of the Sargent family), a portrait by Raeburn of *Thomas Mure*, and a marvellous **conversation piece** ★ by **Zoffany** showing the Reverend Robert Cotes Threlwall and his family in the grounds of his house at Redbourne Hall in Lincolnshire. Here you can also see two female portraits by **Thomas Gainsborough**, who came to Bath from his native Suffolk in about 1759, and remained here until 1774; it

was here that he established his reputation as one of the leading artists of his day. The finest picture by Gainsborough in the museum, a full-length portrait of **Dr Rice Charlton**, now hangs on the staircase of the museum, and was painted during the artist's early years in Bath. The subject, a prominent figure in Bath medical circles in the 1760s and 1770s, was the Gainsborough family physician as well as a good friend of the artist.

The main room of the museum, on the first floor and overlooking Pulteney Street, has a few paintings, including a pastel by the 18thC Swiss artist Liotard of **John Nelthorpe** in Turkish robes, and two recent and slightly incongruous acquisitions, a watercolour by Turner of **Pembroke Castle** and a fine oil landscape by the 19thC French artist, **Harpignies**. But the outstanding exhibits in this room – and indeed the pride of the whole museum – are the collections of **ceramics** ★ and, above all, of **silver** ★. The ceramics range from 16thC Italian majolica to 18thC Meissen ware, while the silver collection includes an enormous variety of objects, from tea caddies to sauce boats, by many of the leading Dutch, German and English silversmiths from the mid 16thC to the early 19thC.

The refurbished ground floor of the museum has since 1977 housed the **Crafts Study Centre**, the main intention of which is to collect and make more widely known the work of 20thC craftsmen active in Britain. The objects in its permanent collection, and the tastefully simple way in which they are displayed, could hardly form a greater contrast to the ornate sumptuousness characteristic of the museum's upper floor. The most impressive of these objects are again undoubtedly the ceramics. Here you can see one of the largest public collections in England of the work of **Bernard Leach**, and there are also various works by Leach's lifelong Japanese friend, **Shoji Hamada** (all made while staying with Leach in ST IVES in the early 1920s), as well as some stoneware made in Africa by Leach's most famous pupil, **Michael Cardew**. Both Leach and Cardew were the leading potters responsible for the revival of slipware, a very simple and inexpensive type of pottery that had once been produced by peasant potters, and in fact the museum has an 18thC English slipware bowl that looks almost indistinguishable from the adjacent works by Leach. Other leading ceramicists represented here include **Lucie Rie** (noted for her exceptionally light and delicate works) and **Hans Coper**.

American Museum in Britain
Claverton Manor, nr. Bath
Tel. (0225) 60503
Open Apr – Oct Mon – Sat 2 – 5pm;
Nov – Mar (by appointment only)
🔲 ⬅ ▣ 🏛 ☑ 🌱

On top of Bathwick Hill, which rises behind the HOLBURNE OF MENSTRIE MUSEUM, is Bath's modern university, from where beautiful views can be had of the town. Going down the hill on the other side you come immediately to open countryside, and, after about ten minutes' walk you will reach Claverton Manor, built in the early 19thC. Since 1959 this has housed the American Museum, the first of only two museums in Europe devoted to America (the other is in La Rochelle in France). This lively and very well presented museum consists essentially of a series of authentically furnished rooms from all over the United States (but in particular from New England), with items ranging in date from the 16thC to the mid 19thC. The Early Colonial Room contains furniture owned by some of the Pilgrim Fathers; an 18thC bedroom has walls and furniture stencilled with naive patterns by journeyman craftsmen; the Shaker Room possesses beautifully simple chairs that can be supported on wall pegs while the floor is being cleaned (the Shakers believed that cleanliness was next to godliness); in the New York Grecian-style apartment there are curtains suspended from crescent moons; and the 19thC New Orleans bedroom seems to come straight out of the film, *Gone with the Wind*. You should not miss the museum's wonderful collection of **patchwork quilts** ★, which are displayed in a room with a traditional stencilled floor. The museum as a whole provides an excellent opportunity to study the evolution of American decorative styles, and how European styles were adapted to meet American tastes, such as the incorporation of corn-in-the-cob motifs into 18thC French wallpaper, or the placing of a huge peanut in the center of a rococo cartouche on top of an 18thC wardrobe (an ideal gift perhaps for Jimmy Carter). In the beautiful grounds of the museum are a reconstruction of George Washington's garden at Mount Vernon, a semi-circular gallery devoted to American Folk Art and a cafeteria specializing in American foods.

BIDEFORD
Devon Map D4

Situated on the estuary of the River Torridge, Bideford was an extremely

active port and mercantile center from the 16thC–18thC. Today the port functions only in the most limited capacity, though the visitor strolling along the pleasant tree-shaded quay might occasionally be surprised by the sight of an occasional small ship from the Baltic. The town has various other attractions besides the quay, in particular a 15thC bridge (widened in 1925), some fine 17thC houses and a small art gallery.

Burton Art Gallery
Victoria Park, Kingsley Rd
Tel. (02372) 6711 ext. 275
Open Mon–Fri 10am–1pm, 2–5pm; Sat 9.45am–12.45pm
Closed Sun
🔲 ⛄ ☑ ❧

The Burton Gallery was built in 1951 on the instigation of Thomas Burton – a wealthy businessman and lay preacher – and Hubert Coop, a collector and watercolourist. Their aim was to create a gallery to exhibit their collection of paintings and antiques, and also to commemorate the untimely death of Thomas Burton's daughter Mary.

Apart from the works donated to it by Burton and Coop, the gallery has attracted other loans and donations; recently it has also received various archaeological items and other bits and pieces that once made up the now defunct Bideford local museum. A good part of the painting collection is taken up by Coop's own **watercolours**, which are technically proficient, if rather unexciting works. The rest of the paintings are also of middling quality, though important artists such as **Reynolds**, **Opie**, **Clausen** and **Alfred Munnings** are represented, and there is an excellent portrait by Sir John Lavery of *Aubrey Hunt*.

BOURNEMOUTH
Dorset Map G4

Described by Thomas Hardy as a "Mediterranean lounging-place on the English Channel", Bournemouth is the closest English equivalent to such chic resorts of France's Côte d'Azur as Cannes. Until the 1840s the place consisted of little more than a few holiday houses on an expanse of wild moorland, but it then began to develop rapidly as a resort. The first of many pines was then planted that today help to give the place its slightly exotic Mediterranean character. Unlike Britain's other leading south coast resort, Brighton (see *SOUTH EAST ENGLAND*), Bournemouth has relatively few important surviving

buildings of the 19thC. Instead, there are countless blocks of luxurious modern flats greatly favoured by retired people from London.

Rothesay Museum
8 Bath Rd
Tel. (0202) 21009
Open Mon–Sat 9.30am–5pm
Closed Sun
🔲

The Rothesay Museum was originally in a Victorian building adjoining an earlier home of Sir Merton and Lady Russell-Cotes, but this was pulled down in 1971 to make way for a parking lot and bridge. At present, it has a temporary home in a depressing modern building on an isolated and rather dilapidated site that overlooks the parking lot. It is crammed with a strange variety of objects ranging from **Italian Renaissance majolica** to largely indifferent Victorian and other paintings. One of the rooms on its first floor houses the British Typewriter Museum.

Russell-Cotes Art Gallery and Museum ☆
East Cliff
Tel. (0202) 21009
Open Mon–Sat 10.30am–5pm
Closed Sun
🔲 🍴 🏛 ☑ ⋯ ♨

The Russell-Cotes Art Gallery and Museum is certainly the greatest survival of Bournemouth's past. Originally the house of Sir Merton and Lady Russell-Cotes, it was built in 1894 – the year of Sir Merton's term of office as mayor of Bournemouth – on a beautiful hilltop site, and in the style of an Italian Riviera villa. The house was opened to the public on the death of Russell-Cotes's widow in 1922 and its interior has remained virtually unchanged since that time.

The museum is one of the most enchanting of any in the British provinces. Memories you may have of drab and depressing Victorian interiors will fade away completely in this Aladdin's Cave of a place. Immediately on entering the house you find yourself in a sumptuously decorated main hall, dominated by an ornamental mosaic fish pond with fountain. The sense of wonder that this hall inspires is maintained by the other rooms in the house, each one of which is filled with a seemingly endless treasury of **paintings, statuettes, furniture** and other curiosities. It comes as no surprise to find that the controversial British film director, Ken Russell, known for his rich if somewhat self-indulgent imagination, filmed here many of the scenes in *Valentino*, which

starred the ballet-dancer Nureyev. The museum exhibits stills from the film.

This is one of those museums where the art object plays a completely subordinate role to its setting. Nonetheless, a closer look at the confusion of objects that surround you will reveal numerous fascinating Victorian works of art. These include oil landscapes by Turner (*St Michael's Mount, Cornwall*), John Brett (*Land's End, Cornwall*), and Atkinson Grimshaw (the superlative *An Autumn Idyll* ★), *A Highland Flood* by Landseer, and a version of Frith's famous *Ramsgate Sands* in the Tate Gallery in *LONDON*. But Russell-Cotes's particular predilection as a collector seems above all to have been for the erotic and the exotic. Thus you will come across a nude *Captive Andromeda* (a sort of Victorian bondage picture) by Arthur Hill, a *Venus Verticordia* (1869) by D.G. Rossetti, various nudes by Etty (the most finished being *The Dawn of Love*), and countless other paintings of naked mythological figures and scantily dressed oriental slaves. The climax comes at the top of the main stairs, where two bronze female nudes (*Day* and *Night*) appear to block your way to the first floor gallery.

Russell-Cotes's favourite Victorian painter was, appropriately, the specialist in sensual mythological and oriental scenes, **Edwin Long**. A gallery built onto the house in 1920 contains the largest collection of Long's work in existence. These enormous canvases include one showing Xerxes creating his ideal nude by choosing to portray the most perfect parts of all the most beautiful women of Alexandria; it is said that Long's wife posed for all the nude women in the picture, which was recently the subject of a knife attack by a demented attendant. Another painting by Long in the gallery – one of three works on the theme of Jephtha's vow – inspired, when first exhibited, the following comment in *Punch* Magazine: "It's long, it's the longest painting on show. But is it art?"

BRISTOL
Avon Map F3

Bristol, a city port on the Avon, has been a thriving trading and commercial city since the 13thC. Badly damaged during World War II, it is now a town rather lacking in unity, with extremely pleasant 17thC, 18thC and early 19thC houses and terraces alongside much characterless modern development. The mainly 14thC **church of St Mary Redcliffe** is the finest of its surviving old monuments, a

magnificent Perpendicular structure described by Queen Elizabeth I as "the fairest, the goodliest and most famous parish church in England". Unfortunately its impact is marred today by its position on a traffic island in the middle of an especially ugly rebuilt urban area. By far the most attractive part of present-day Bristol is Clifton, which developed as a prosperous residential area in the 18thC. This is a high-lying area with a well-preserved 18thC atmosphere and a magnificent situation overlooking the deep and wooded Avon Gorge. On the other side of the gorge from Clifton (and crossed over by means of Brunel's famous **Suspension Bridge** of 1864) is beautiful parkland incorporating Leigh Woods, Nightingale Valley and Stapleton Glen. These places have changed remarkably little since the early 19thC, when they were renowned beauty spots painted by all the city's leading artists, one of whom, the Rev. John Eagles, even compared Leigh Woods to the "regions of Elysium".

Bristol City Museum and Art Gallery ☆
Queens Rd
Tel. (0272) 299771
Open Mon – Sat 10am – 5pm
Closed Sun
🔟 ▯

The Bristol City Museum and Art Gallery was built at around the same time as the adjoining main university buildings, in the first decade of this century. At one stage it was hoped that the art gallery would be housed in a building of its own, but this proved financially impossible. However, despite all the resulting problems caused by lack of space, the museum manages to display its diverse collections remarkably well. Paradoxically, the place is almost more fun to visit for being so crammed: there is something for everyone to enjoy, and surprises are to be had at every corner. The entrance hall has a carnival character, with a gaudily painted bookstall, Chinese festival dragons over one of the doors, and an old biplane suspended in the air. Sharing the space with such disreputable company are three of the finest **Assyrian reliefs** ★ to be found outside the British Museum, taken from the palace of Ashurnasipal II at Nimrod. Elsewhere on the ground floor are further archaeological finds (of more local interest) as well as a natural history collection featuring a tropical aquarium. The first floor is taken up by a geology collection, a temporary exhibition gallery and a "Schools Activities Room". You will find the bulk of the museum's fine

and applied art collections on the second floor. Two of the strongest features of these collections are the magnificent holdings of **oriental art** (donated mainly by F.P.M. Schiller), and of 15th–20thC **ceramics**. The painting collection is also a good one, being both diverse in its scope and containing works of generally high quality. The earliest outstanding paintings among the foreign school holdings are a panel of the *Crucifixion and Lamentation* by the 14thC Florentine artist Taddeo Gaddi, and a *Descent of Christ into Limbo* ★ by the Venetian early Renaissance painter, **Giovanni Bellini**: this last work has the harshly intense quality characteristic of the art of Bellini's older North Italian contemporary, Andrea Mantegna, and indeed might well be a lost work by Mantegna.

Among the paintings of foreign schools in the museum are some 17thC Dutch and Flemish works, most notably a *Nativity* by Jordaens. More impressive are the 17thC and 18thC French and Italian paintings, which include good works by Philippe de Champaigne (*Verger Abbé de St Ciran*), Le Brun (*The Brazen Serpent*), Pietro da Cortona (*Laban Seeking His Idols*), G. Battista Crespi (a dramatic and agitated **Flight into Egypt**) Sofonisba Anguiscola (a marvellous portrait of *Three Children* ★), Francesco Solimena (*A Knight of the Order of St Januarius*) Francesco Trevisani (*Christ Supported by Angels*) and G.B. Pittoni (*Winter*).

The French 19thC paintings are also a strong point of the museum, with **Delacroix, Courbet, Boudin, Renoir, Seurat** and **Vuillard** all represented, though by minor works. Perhaps the greatest surprise among the French pictures of this period is a charming, vividly painted oil by **Eva Gonzalès** featuring her sister on a donkey.

The gallery's holdings of British art include, among the earliest works, an intriguing portrait of a woman (c.1610) attributed to **William Larkin**, a striking battle scene by de Loutherbourg (*The Cutting Out of the French Corvette* ★) described by a contemporary as "the highly celebrated chef-d'oeuvre of Loutherbourg", and some good portraits by one of the most famous artists to have been born in Bristol, **Thomas Lawrence**.

It was not until the early 19thC that Bristol came to have an artistic life of its own. The most outstanding artist of the so-called "Bristol School" (this term seems to have been first coined in 1826 by the Rev. John Eagles), was the Irish painter **Francis Danby**, who settled in Bristol in 1817. One of his works which

you can see in the gallery is a very romanticized view of *Conway Castle*, which clearly shows the artist's great admiration for Claude Lorrain. Other works by Danby are in a room specially devoted to the Bristol School. Danby reveals a more original side to his art in these works, landscapes all done in the Avon Gorge (the greatest are *Boy Sailing a Little Boat* ★, *Near Stapleton* ★, *View of the Avon Gorge* ★, and *View of Blaise Castle, Belgade* ★). These fine pictures are characterized both by a precise yet intensely vivid handling of paint and colour, and also by a quality of haunting stillness. Danby also painted in a sensationalist manner reminiscent of the art of the Newcastle visionary painter, John Martin. The gallery has no examples of these, but instead has similar works by another Bristol painter, **Samuel Colman**, most notably *The Destruction of Pharaoh's Host*. This small, strange work combines an almost abstract treatment of composition and colour with the most disturbing and precise detailing. The third important Bristol painter of the 19thC was **William Muller**. Although born in Bristol and based in the town all his life, Muller is best remembered today for his oriental scenes, of which the gallery has several examples, including a version of *The Avenue of Sphinxes at Luxor – Moonlight*.

Apart from the paintings by Danby and the odd canvas by Colman and Muller, the work of the Bristol artists cannot be said to be very exciting, comprising mainly indifferent topographical views. By and large the gallery's other 19thC British paintings are more enjoyable, even if this pleasure is derived not from their intrinsic artistic quality but rather from seeming so amusingly "kitsch" to present-day tastes. High points include an Egyptian landscape by **David Roberts** which could almost be a film set by Cecil B. De Mille, a much-reproduced "tear-jerker" by Tissot of a parting couple (*Les Adieux*), a highly erotic painting by Lord Leighton of a mermaid pressing her breasts against a naked young man, a large painting by Burne-Jones (*The Briar Rose*) showing a number of women in various stages of lassitude, and a particularly awful and unintentionally amusing late work by Millais (*The Bride of Lammermoor*), looking like an illustration from an old-fashioned children's adventure book.

Of generally greater aesthetic interest are the gallery's remarkably extensive holdings of British 20thC art. A large number of leading British artists of this period are represented here by truly excellent works. Among these are a

marvellous *Nude* ★ by Spencer Gore, a characteristically original landscape by Gauguin's friend **Roderic O'Conor** (this is one of the few surviving paintings of this mysterious reclusive artist), and a most colourful painting by Winifred Nicholson, *The Artist's Children at the Isle of Wight*). More striking still is *Tennis* ★, 1932–4, by **Eric Ravilious**, an artist generally regarded as a pleasant if rather lightweight illustrator, who deserves much greater recognition. This large ambitious work manages subtly to instil into such an apparently innocent scene as a game of tennis on an English summer afternoon an atmosphere of lurking menace and sexual tension. Details such as a young girl walking out of the court, or another girl skipping over a lawn, somehow manage to hold a deeper, more sinister significance.

Many of the other recent British artists with works in the gallery have some West Country connection. The short-lived **Christopher Wood**, whose family came from Wiltshire, was one of the most promising of these artists, and you can see here a characteristically childlike landscape painted by him at Venice. Less well known is the Surrealist painter **John Armstrong**, who lived in Lamorna Cove in Cornwall between 1947 and 1955, and of whose work the gallery has three rather haunting examples. **William Scott**, a painter known especially for his subtly coloured and very abstracted rendering of still-lifes, worked in his youth at Mousehole in Cornwall, and had a house near the Bath Academy of Art at CORSHAM in Wiltshire, where he was senior painting master in the 1950s. One of his still-lifes is in the gallery, as well as an excellent semi-nude of a **Breton Girl** ★, painted in 1939 when he was briefly at the then unfashionable artists' colony at Pont-Aven. **Peter Lanyon**, who lectured frequently at Corsham while Scott was there, was a more untidy and emotionally violent artist than Scott, and also unlike him developed a completely abstract manner (see, for instance, the gallery's *High Moor*). Lanyon has the distinction of being the only important abstract artist working in the Cornish town of St Ives who was Cornish-born. In more recent times, the West Country has been the base of the now happily defunct **Brotherhood of Ruralists**, a group of unashamedly sentimental artists working in the English tradition of poetic landscape painting. By far the finest of these artists is **Peter Blake**, who in recent times has been strongly criticized for having wasted his brilliant technical gifts on such precious "Ruralist" works as the

gallery's *Owl and the Pussy Cat*. Another former "Ruralist" is **David Inshaw**, whose minutely detailed and rather lifeless work in the gallery (it has a typically silly Ruralist title, *Our Days were a Joy and our Paths through Flowers*) strives very selfconsciously to achieve a disquieting, mysterious quality similar to that conveyed so effortlessly by Ravilious in *Tennis*. An artist of more robust talent than Inshaw is **Richard Long**, who lives in Bristol and is one of England's leading conceptual artists. Long has a rather romantic fascination with the primeval elements in a landscape and has been inspired by various West Country landmarks, such as the ithyphallic Cerne Abbas Giant in Dorset, the bleak moorland of Dartmoor, and the Avon Gorge (from which he has extracted and arranged driftwood). One of his West Country works is in the gallery: a photograph entitled *84 Filed Stones placed by the source of the River Avon, 84 miles from the source of the Mouth* (1978).

St Nicholas Church Museum
St Nicholas St
Tel. (0272) 299771
Open Mon–Sat 10am–5pm
Closed Sun
� 🏛

St Nicholas' church is a 14thC church reconstructed in the 18thC. It has now been converted into a museum displaying a miscellaneous collection of objects, including **archaeological finds**, **church plate** and **vestments**, and **topographical watercolours** of Bristol. There is also a large and famous **altarpiece** ★ (1755–6) by **William Hogarth**, originally painted for the high altar of St Mary Redcliffe, and then transferred to the BRISTOL CITY MUSEUM AND ART GALLERY, where it hung until very recently. It depicts *The Ascension*, flanked by *The Sealing of the Tomb* and *The Three Magi at the Tomb*. You may not find this an attractive work, but it is nonetheless interesting in that it is one of the few large-scale works painted for an English church during the 18thC. Moreover it reveals a completely different side to Hogarth, an artist who today is known principally for his down-to-earth satirical scenes of everyday English life. Here he is shown trying to rival the grand Baroque manner of 17thC and 18thC Italian artists; in so doing, he was probably – if unconsciously – expressing his resentment towards the then commonly held attitude that English artists were not as capable as their Italian counterparts of producing ambitious figurative works on a large scale.

CHELTENHAM
Gloucestershire Map G1

Before 1700 Cheltenham was a typical Cotswold stone village, but in 1716 a mineral spring was discovered here, supposedly traced through observation of the habits of some particularly healthy pigeons (a pigeon is incorporated into the town's crest). However that may be, Cheltenham soon developed into one of Britain's most fashionable spa towns, and numerous elegant **Regency terraces** and houses were built here.

Cheltenham Museum and Art Gallery
Clarence St, Cheltenham
Tel. (0242) 37431
Open Mon–Sat 10am–5.30pm
Closed Sun
[icons]
The Cheltenham Museum and Art Gallery is a cluttered but attractive place, with **furniture, silver** and other applied art objects jumbled together with a relatively large and good **painting collection**. Numerous information panels provide helpful information, even if they may seem at times rather over-optimistic in their attributions of pictures. The holdings of Old Master paintings occupy the ground floor, and come mainly from the collection of the Baron de Ferrières. De Ferrières was of Dutch extraction, and most of the pictures that he owned were of the **Dutch** and **Flemish 17thC schools**. There are etchings by **Rembrandt**, a landscape by Koekkoek (*The Coming Storm*), a good genre scene by Gabriel Metsu (*Man and Woman at Wine*), and some works of dubious authenticity by Jan Steen and Ostade. Other works in this department include a fine portrait of *Mrs Bowler* by Thomas Hudson and two extensive **bird's-eye views** (c.1720) of the country around Dixon Manor: these slightly naive paintings by an anonymous artist are particularly interesting for their numerous tiny details of rural life.

As you walk up the museum's main staircase, take note of a curious drawing of a seated figure by the eccentric writer and illustrator, Mervyn Peake. At the top of the staircase you can see other fine works by 20thC British artists, most notably *Devastation* (1940) by Graham Sutherland, *St Pancras* by Paul Nash, and an oil study by Stanley Spencer entitled *Village Gossip*. The artist described this last work, painted in 1939 while Spencer was staying with friends in Gloucestershire, as representing an "old couple witnessing the coming of God in the sky while they stand in the garden taking in the clothes".

Elsewhere on the first floor are canvases by **William Rothenstein** painted in and around Far Oakridge, the Cotswold village which he moved to in 1912 and set up an idyllic home. More interesting are some applied art objects testifying to the importance of the Cotswolds in the Arts and Crafts movement of the late 19thC. These include a wallpaper design by **William Morris** and some magnificent **furniture** and **metalwork** by **Charles Ashbee**, who in 1896 established an experimental Arts and Crafts community in the Cotswold village of Chipping Camden (pp.126–7).

CORSHAM COURT
Chippenham, Wiltshire Map G3
Tel. (0249) 712214
Open June–Sept Tues–Thurs, Sat, Sun 2–6pm; mid-Jan to May, Oct to mid-Dec 2–4pm
Closed Mon, Fri
[icons]
Corsham Court is an Elizabethan manor acquired by Paul Methuen in 1777 to house a collection of pictures inherited from his cousin. Methuen called in **"Capability" Brown** (who is better known as a landscape gardener) to make various alterations to the house, including the addition of a picture gallery, and **John Nash** added another gallery in 1800. The painting collection at Corsham is renowned, and boasts some outstanding works, such as an *Annunciation* ★ by Fillippo Lippi, a *St John the Baptist* by Andrea del Sarto, *The Pandolfini Cartoon* by Correggio, and portraits by **Gainsborough**, **Reynolds** and **Romney**. However, the impact of these works is lessened by the proximity of numerous indifferent and dubiously attributed pictures.

Since 1946 part of the building has housed the Bath Academy of Art. In the early years of its existence this art school was one of the liveliest in Britain: the heads of the painting and sculpture departments respectively were William Scott and Kenneth Armitage, and among the many distinguished artists who came to teach here at this time were the St Ives abstract artists, Peter Lanyon, Terry Frost and Bryan Wynter. You may find it hard to imagine that this genteel, elegant and traditionally English house, crammed with Old Master pictures and set in luscious lawns where peacocks strut, provided the setting where many of the ideas behind the English artistic avant-garde of the 1950s were disseminated.

The Arts and Crafts movement in the Cotswolds

In the early 1930s, the writer J. B. Priestley went on a tour of England in search of his country's most characteristic qualities. He found his ideal England in the Cotswolds, which he described as "the most English and least spoiled of all our countryside". To this day it retains much of its charm.

It is perhaps not surprising that such a quintessentially English area played an important part in an artistic movement that reacted strongly against the encroaching urbanization of the late 19thC and early 20thC. This, the Arts and Crafts movement, derived its intellectual outlook first and foremost from the Romantic socialist ideals of the art critic and writer John Ruskin, and the designer, poet and political theorist William Morris. In 1861 Morris, horrified by the "state of complete degradation" of the applied arts in Britain, set up a firm which began by producing embroideries, and then turned to wallpapers, stained glass, printed and woven textiles, carpets, rugs, tapestries and furniture. Both his and Ruskin's passionate interest in the Middle Ages, and their belief that craft objects of the finest quality should be made available to the widest number of people, inspired also the creation of numerous medieval-style guilds.

A desire for the "simple life" in the country was central to this whole movement, and Morris's 16thC gabled stone cottage at **Kelmscott** (see *THE MIDLANDS*) came to be seen as the ideal English home. It was featured in Morris's socialist parable, *News from Nowhere* (1891), which expressed a vision of a future England as a "garden where nothing is wasted and nothing is spoilt, with the necessary dwellings, sheds and workshops scattered up and down the country, all trim and neat and pretty." This book, which was printed by Morris's newly founded Kelmscott Press, had a frontispiece showing the house that was designed by Charles Gore, a Birmingham artist strongly influenced by Morris.

In 1904 Gore moved to the village of **Painswick** in the Cotswolds, by which date many other leading members of the Arts and Crafts movement had settled in this part of the country. Among these was Ernest Gimson, who was particularly known for his elegant and beautifully worked furniture, and who set up a workshop in the Cotswolds in 1895. Another was William Richard Lethaby, who practised both as an architect and a designer, but is best known for his influence on others, especially after 1900 when he became Professor of Design at the Royal College of Art in London, and vigorously preached the message of William Morris.

CHIPPING CAMDEN

But the most important member of the movement to come to the Cotswolds was Charles Robert Ashbee. Ashbee, who trained as an architect, had an influential meeting with Morris after a lecture given by him in 1886 under the auspices of the Socialist League in Hammersmith. Two years later, aged 25, he founded the Guild and School of Handicraft at Whitechapel in the East End of London. For this he designed furniture in a lighter version of the Morris style, and also silver and metalwork in a style which, much to his annoyance, was often called Art Nouveau.

With the expiry of the lease at his East End property, Ashbee decided to move the Guild to the country. After much searching he stumbled on **Chipping Camden**. This Cotswold village, which had been a prosperous wool village up to the 17thC, had gone through a subsequent decline in fortune,

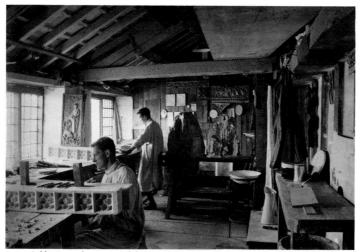

Ashbee's woodcarving workshop at Chipping Camden: a contemporary photograph

and was then an almost forgotten place with many old abandoned houses. Ashbee had written a romance for the Guild entitled *From Whitechapel to Camelot*. He now began to see this as prophetic, for this untouched medieval village did indeed seem like "Camelot".

Moving in with Ashbee into the village were 50 craftsmen and their families (some 150 people in all), who set about converting and restoring the dilapidated cottages. The reaction of the villagers to this invasion was naturally one of suspicion, though by this stage the Cotswolders were becoming used to having rather unorthodox people in their midst. At nearby **Whiteway**, for example, there was one of the more extreme of the various "back-to-nature" Tolstoyan communities that had sprung up all around Europe and in America in the 1880s and 1890s. This particular community comprised people of many different nationalities who lived in crude buildings, participated in the hay-making and bread-baking, and dabbled in anarchism, communism, nudism and free love. Ashbee and his followers, though they made their own clothes and beer, were rather horrified by the primitive life-style of their Whiteway neighbours. The only really eccentric aspect of Ashbee's brand of utopianism was his belief in "homogenic love", according to which all sexual urges were transformed into the purer love of comradeship.

The first summer at Chipping Camden was a highly successful one, and a spirit of optimism prevailed. Leading associates of the Arts and Crafts movement, such as Walter Crane and William de Morgan, came to visit the Guild, much work was done, and a swimming pool was even planned to encourage "homogenic love". Like so many experimental communities, however, Ashbee's was shortly to disintegrate as a result of financial pressures, sexual tensions and the onset of middle age among its members. Moreover, by 1910 disillusionment was to be felt generally with the Arts and Crafts movement, which despite its socialist ideals only managed to produce a few sensitively designed but exclusive objects for a privileged minority. In that same year Ashbee wrote: "modern civilization rests on machinery and no system for the encouragement in the endowment and the teaching of the arts can be sound that does not recognize this."

DEVIZES
Wiltshire Map G3

Once an important cloth-making town, and now a large corn market, Devizes is a pleasant place with three fine medieval churches, some 16thC monuments, and numerous attractive 18thC buildings. Thomas Lawrence, the well-known portraitist, was here as a child, the son of the landlord of the now heavily restored Bear Hotel. As a boy Lawrence was a famous prodigy who would sketch the portraits of the many distinguished guests staying at his father's inn on their way from London to Bath; the influential contacts that he made in this way proved useful when he later established himself in BATH as a fashionable society portraitist. One of the bars in the Bear Hotel is now called the Lawrence Room.

Devizes Museum
41 Long St
Tel. (0380) 2765
Open Apr – Oct Tues – Sat 11am – 1pm,
2 – 5pm; Nov – Mar Tues – Sat
11am – 1pm, 2 – 4pm
Closed Sun, Mon
🖼 ƒ 🕮 🏛 ☑ ⸬

The Devizes Museum occupies an attractive 18thC house, and contains important prehistoric collections and various other well-displayed items of mainly archaeological and local interest. A picture gallery with a stained glass window by **John Piper** has recently been added to the museum, which puts on temporary exhibitions mainly derived from its extensive collections of topographical **watercolours** and **prints**. These include numerous views of STONEHENGE, notably an excellent watercolour by **Copley Fielding**.

DYRHAM PARK 🏠
Nr. Chippenham, Avon Map G3

Tel. (027582) 2501
Open Apr – May, Oct Mon – Wed,
Sat – Sun 2 – 6pm; June – Sept
Mon – Thurs, Sat – Sun 2 – 6pm
Closed Apr – May, Oct Thurs – Fri;
June – Sept Fri
🖼 🚂 🕮 ▯

Tucked away in a steep and narrow valley, Dyrham Park was originally a Tudor house belonging to the Wynter family. In 1681 the wealthy Mary Wynter married a hardworking employee of the king, William Blathwayt, who after her death, five years later, proceeded to rebuild her family home. The major part of this rebuilding took place between 1700 and 1704, when Blathwayt used his contacts in the royal service to commission a royal architect, William Talman, and craftsmen in the service of King William III. As a result, the interior of Dyrham Park has a restrained and very Dutch character, and in fact Blathwayt had also spent much time in Holland when secretary of state to William III, and had brought back from there various Dutch objects and works of art. There is blue and white **Delft ware** throughout the house (note particularly the pyramid tulip-holders) and a collection of minor Dutch paintings, including bird pictures by **Hondecoeter**, as well as two fascinating perspective paintings by **Hoogstradten** that were greatly admired by the diarist Samuel Pepys (a close friend of Blathwayt). Among the other paintings in the house, acquired by subsequent Blathwayts, are a *Peasant Woman and Boy* by **Murillo**, and a specially commissioned copy of this work by **Gainsborough**.

EXETER
Devon Map E4

Exeter, the administrative capital of Devon, and a cathedral and university city, is one of Britain's oldest towns, founded by the Romans in the 1stC AD. From the Middle Ages onwards it was an important cloth-manufacturing and trading city, and also a busy port, having the earliest ship canal in England (opened in 1563). In 1942 much of its old quarter was destroyed by bombing, though miraculously its **14thC cathedral** and surrounding close survived intact. The cathedral, which is the only one in England to have towers on its transepts, has fine **14thC figures** on its west façade, and, inside, magnificent **rib vaulting** as well as a beautifully carved **14thC choir screen** and **bishop's throne**. Various fine houses of medieval and later date surround the close. Some have been converted into shops, including one (formerly called Mol's Coffee Shop but now an art shop) that is said to have been frequented by the famous Elizabethan sea captains, Raleigh and Drake.

Guildhall
High St
Tel. (0392) 56724
Open Mon – Sat 10am – 5.30pm
Closed Sun
🔲

The dull, heavily restored 19thC façade of the Guildhall shields a delightful 15thC hall, with a fine wooden-panelled **ceiling**, and a number of old portraits

(loaned from the art gallery), including works by Lely (*General Monk*), and the Exeter-born **Thomas Hudson** (*George II*).

Royal Albert Memorial Museum and Art Gallery
Queen St
Tel. (0392) 56724
Open Tues–Sat 10am–1pm, 2–5.15pm
Closed Sun, Mon
🎟️ 🏛️ ▯

On the death of Prince Albert in 1861, Sir Stafford Northcote, the Member of Parliament for Devon, proposed to commemorate him in Exeter by establishing a group of educational institutions similar to those founded by the Prince in London. His idea was accepted, and by 1870 a building containing arts and science schools, a public library and a museum, had been constructed. The interior of the latter has recently been excellently restored and repainted, and provides a pleasant setting for the museum's art collections.

The principal gallery contains mainly 18th and 19thC oil paintings by Devon artists. The leading Exeter-born painters of this period were the portraitists **Thomas Hudson** (the teacher of Sir Joshua Reynolds) and **Francis Hayman** (who is thought to have begun his career as a scene painter in Drury Lane). The finest of Hudson's portraits here is of *Anne, Countess of Dumfries* (1763), a work which the artist once said was the best thing that he had ever done. Hayman is represented only by an attributed *Self-Portrait at the Easel*. Hudson and Hayman in fact spent most of their lives in London, but Exeter's other two main artists, the landscapists **Francis Towne** and **John Abbot White** (Towne's pupil) lived and worked almost entirely in their native city, where White also continued to practise as a surgeon. Both were topographical artists who worked principally in watercolour, but also executed a few oil paintings.

The main gallery contains works by four famous Plymouth-born portrait and history painters – **Reynolds, Eastlake, Northcote** and **Benjamin Robert Haydon**. These include **portraits** by Reynolds, an Italian landscape and a portrait entitled *Contemplation* by Eastlake, Northcote's large and striking *Entry of Richard and Bolingbroke* ★ (intended for Boydell's collection of scenes from Shakespeare), and one of the grandest and most ludicrous works by Haydon to be seen in any public gallery, *Curtius Leaping to the Gulf*, which shows Curtius plunging downwards on horseback as if on a fairground carousel.

Works by other 18thC and 19thC British artists in the gallery include beautiful landscapes by Wright of Derby (*Lake Nemi*) and Richard Wilson (*Llyn Peris and Dolbadarn Castle, North Wales*); a vivid and very Rubensian oil sketch by Etty of *Perseus and Andromeda*; and a famous painting by Frith, *The Fair Toxopholites* ★ which is a portrait of the artist's three daughters, Alice, Fanny and Louisa, engaged in archery.

Among the gallery's holdings of late 19thC British art you can see an interior by Stanhope Forbes (*22 January, 1901, Reading the News of the Queen's Death in a Cornish Cottage*) and various works by **Sickert** and his Camden Town school associates, **Gilman, Gore, Ginner** and **Bevan**. The works by Ginner and Bevan are both of the same subject – a farm called Applehayes in Devon's Blackdown Hills. Various members of the Camden Town school visited this farm in the second decade of the century at the invitation of Harold B. Harrison, a retired rancher from Argentina who in old age enrolled himself at the Slade School of Art in London.

FALMOUTH
Cornwall Map B6

Falmouth, a magnificently situated but architecturally dull port and seaside resort, has on the southern side of its peninsula some large 19thC and 20thC hotels and villas. Its port (which has greatly declined in importance since the mid-19thC), shopping and commercial quarters lie on the northern side.

Falmouth Art Gallery
The Moor
Tel. (0326) 313863
Open Mon–Fri 10am–1pm, 2–4.30pm
Closed Sat, Sun and between Christmas and
* New Year*
🎟️ 🏛️ ▯ ✅ ▯ ✒️

The art gallery occupies a small upstairs room in a late 19thC building on the N side of the town. The gallery's holdings – of which only a small selection can be seen at any one time – are strongest in late 19thC and early 20thC British paintings. Most of these were presented to the gallery by a South African, Edward de Pass, the owner of a house (Cliffe House) in Falmouth, which he regarded as his true home. De Pass donated further works of art to other British institutions, including the National Gallery in London, and museums in Bristol, Cambridge and Plymouth. Among the works he gave to Falmouth are a painting of a peasant girl (1881) by the

Glaswegian artist **Arthur Melville**, a landscape (*A Summer Day*) by the once highly fashionable Sir John Arnesby Brown, three works by Burne-Jones (*The Masque of Cupid*, studies for **The Law of Love**) and a full-size **oil study ★** by John Waterhouse for his celebrated *Lady of Shallot* in the Leeds City Art Gallery (see *NORTHERN ENGLAND*).

Virtually the only artists represented in the gallery with any strong West Country connection are two associates of the Newlyn School, **Hereward Hayes Tresidder** and **Henry Scott Tuke**. The former was a pupil of the Newlyn artist Stanhope Forbes and is represented in the gallery by his painting *Man in a Ruff*, which was one of a number incorporating fancy costume accessories.

Tuke, by far the more important painter of the two, was born in Yorkshire, but came to Falmouth as a child. He studied at the Slade Art School in London, as well as in Florence and Paris (where the internationally renowned French painter of peasant genre scenes, Jules Bastien-Lepage, complimented him on two of his works). After moving back to England in 1883, he lived for two years in NEWLYN before settling permanently in Falmouth. There he became friends with de Pass and in later life acquired an old ship which he used both as a home and studio. Tuke is one of the great colourists of late 19thC British art. However, his preferred subject-matter – lithe and generally naked boys in a sunny setting (Falmouth fortunately claims to have the most temperate climate of any British resort) – might not be to everyone's taste. The Falmouth Gallery has several paintings by him, including an especially vivid oil study of *Boys Bathing* and sunny, Impressionistic watercolour views of two of his favourite haunts on the Continent, *Genoa* and *St Tropez ★*.

GLOUCESTER
Gloucestershire Map G2

Gloucester was originally a Roman town, and its four main thoroughfares still follow the Roman plan, forming a cross at the middle of the city. Today it is an active inland port and commercial center with much unattractive modern development.

Gloucester's principal interest for tourists is its **cathedral,★★**, one of the finest in England. The nave of this building is predominantly Norman (11thC – 12thC), but the choir was remodelled in the 14thC, following the interment here of the murdered King Edward II, whose body had earlier been refused burial at Bristol and at Malmesbury. The new king, Edward III, set about making a cult of his father's memory, and Gloucester soon became a focus of miracles and pilgrimage. **Edward II's tomb ★★**, executed in alabaster shortly after 1330 by London court sculptors, is one of the great treasures of English medieval art. Particularly fine is the sensitive and slightly effeminate head of the king, which is not a portrait but rather an idealized image of saintliness.

The cathedral's magnificent **cloisters** were built at the same time as the renovation of the choir and contain the earliest fan-vaulting in England; this vaulting was later the source of inspiration for the roofs of Henry VII's Chapel in Westminster Abbey (*see LONDON*) and parts of St George's Chapel in Windsor (*see SOUTH-EAST ENGLAND*). At the end of the choir is the 15thC **Lady Chapel**, a masterpiece of intricately decorated late Gothic architecture, and the last of the work carried out before the completion of the cathedral.

City Museum and Art Gallery
Brunswick Rd
Tel. (0452) 24131
Open Mon – Sat 10am – 5pm
Closed Sun
🎫 💀 ☑ ▒

The Gloucester Museum and Art Gallery is principally of interest for its archaeological collections, which include numerous Roman and early British finds. Look in particular for the two **Romano-British tombstones** of the 1stC AD, and the exquisitely ornamented **bronze mirror** of the same date, executed by a native British artist.

A room on the museum's first floor puts on exhibitions culled from the small fine arts collection, which includes some rather indifferent **17thC Dutch landscapes**, and a modest representation of **British art** from the 18thC to the present day (including minor works by **Gainsborough, Sickert, William Rothenstein, Edward Burra** and **John Tunnard**). In an adjoining room devoted mainly to local pottery and costumes, and 17thC – 18thC English furniture, you can see two of the most interesting works of art in the museum: a bronze entitled *The Beast* (1956) by Lynn Chadwick, who lives in Lypiatt Park in Gloucestershire; and an outstanding **tombstone ★** by **Eric Gill**, who spent the last years of his life in the Cotswolds. This work, showing a naked woman pushing herself upwards between two graves, combines sensuality and mysticism in a way typical of Gill's art at its best.

LACOCK
Wiltshire Map G3

The village of Lacock is a showpiece among English villages, having perfectly preserved its 15thC–18thC appearance. Its various attractions include picturesque twisting streets, half-timbered buildings, an old village cross, and a fine **Perpendicular** (15thC) church.

Lacock Abbey
Open Apr to late Oct Mon, Wed–Sun 2–6pm
Closed Tues, Good Friday, Nov–Mar
🎦 🎫 🏛 ☑ ♨

The 13thC abbey at Lacock was transformed for use as a mansion in the mid-16thC following Henry VIII's dissolution of the monasteries. The building was altered in a Neo-Gothic style in 1753, and had further changes made to it in the early 19thC. It was here that, between 1839 and 1841, Henry Fox Talbot carried out his pioneering experiments in photography. One of his so-called Talbotypes is on show in the house (others can be seen in the village museum).

Fox Talbot Museum of Photography
Lacock
Tel. (024973) 459
Open Mar–Oct Mon–Sun 11am–6pm
Closed Nov–Feb
🎦 ☑

This excellently laid out museum was opened in 1975 in a 16thC barn in the village. In addition to Talbot's camera and Talbotypes, there is an audio-visual presentation on him and his work, and a room for exhibitions devoted to photography in general.

LONGLEAT HOUSE 🏰
Warminster, Wiltshire Map G3

Tel. (09853) 551
Open Apr–Oct Mon–Sun 10am–6pm.
Nov–Mar Mon–Sun 10am–4pm
🎦 ➳ ✗ 🎫 🏛 ☑ ♨ ⚏

Longleat, erected between 1559 and 1580, is one of England's most famous Elizabethan houses. The exterior is particularly impressive, and looks today very much as it did when first built. The interior, however, underwent considerable alteration in the 19thC; one of the rooms was even redesigned at this time in an Italian Renaissance style by imported Italian craftsmen. Apart from a large group of sporting pictures by the 18thC artist **John Wooton**, the paintings

of interest in the house are all family portraits. These include the ubiquitous works by **Lely** and the School of Van Dyck; but there are also some fine works by later artists, such as **G.F. Watts** (a brooding, romantic portrait of **Frances de Vesci**, wife of the 4th Marquess of Bath), **Orpen**, and, most recently of all, **Graham Sutherland**.

LYME REGIS
Dorset Map F4

Beautifully situated in a wide, cliff-lined bay, Lyme Regis was a medieval port and cloth town, but from the mid-18thC onwards it became one of the first seaside resorts in the south-west. It was particularly favoured by the Regency society of Bath, including the novelist Jane Austen, who described the town in her last novel *Persuasion* (1817). It is still a charming and much-visited place, with steep old streets and a strong Regency character. A little to the W of the town center is the old harbour known as the **Cobb**, the scene of Louisa Musgrove's accident in *Persuasion* and the place where the heroine of John Fowles's novel, *The French Lieutenant's Woman* (recently filmed in Lyme Regis), used to take her solitary strolls.

The Lyme Regis Museum
Bridge St
Tel. (02974) 3370
Open Apr–Oct Mon–Sat 10.30am–1pm, 2.30–5pm Sun noon–5pm
Closed Nov–Apr
🎦 ➳ 🎫 ☑

This small and pleasantly old-fashioned museum overlooks the sea and will principally interest palaeontologists (there is a large collection of fossils from Lyme Regis's famous Undercliff), as well as those who wish to catch a glimpse of the distinguished curator, the novelist John Fowles. Fowles has written two short publications on Lyme Regis that are on sale here (signed copies available). However, the museum also has on its first floor some pleasant, locally made **18thC lace**, a most delicately engraved modern glass on a revolving stand by **Laurence Whistler**, and a case containing memorabilia relating to the brief stay in Lyme Regis of a distant ancestor of Whistler, the late 19thC American painter, **James McNeill Whistler**. J.M. Whistler spent the autumn of 1895 in the town, staying in a first-floor room at the Red Lion Hotel and working in a studio a few doors away up Broad Street (now a carpenter's shop, behind a tobacconist). Among the paintings that he produced

here were two portraits (both in the Museum of Fine Arts, Boston) of the local blacksmith (***Master Smith of Lyme***) and the small daughter of the town's mayor (***Little Rose of Lyme***).

MALMESBURY CHURCH
Malmesbury, Wiltshire Map G2

The main monument of this attractive old town on the River Avon is its former **abbey church**, a 12thC building with 14thC additions. After the Reformation only the nave of the church survived, and this became the parish church of St Mary. In a lunette on the W wall porch of the church is some of the finest **Romanesque sculpture ★★** in England. This depicts the Apostles, who are shown in animated postures and with powerfully carved drapery patterns. One of the Apostles lowers his head, seemingly to make way for the angel which the artist has ingeniously tried to squeeze into the upper part of the lunette.

MONTACUTE HOUSE ⌂
Yeovil, Somerset Map F4

Tel. (0935) 82389
Open Apr – Oct Mon, Wed – Sun
12.30 – 6pm
Closed Tues Apr – Oct; Nov – Mar
🔲 ⸹ ⛟ 🅿 🐾

Montacute is a splendid Elizabethan mansion built for Sir Edward Phelips, a successful and ambitious lawyer who later became Master of the Rolls. Built in 1598, it is conspicuous for its extensive glass windows, a characteristic feature of houses of this period; however, few other houses have heraldic **stained glass** of the quality that you will see in Montacute's Great Parlour and Great Hall. The interior of the house has otherwise been refurnished in relatively recent times, and is now hung with some excellent **tapestries** (most notably a 15thC piece from Tournai of an armed and mounted knight). Two charming **needlework panels** from the 18thC show figures strolling around a formal garden, and there is a selection of Tudor and Jacobean **portraits** (mainly of decorative value) on loan from the National Portrait Gallery in *LONDON*.

NEWLYN
Cornwall Map B6

For much of the 19thC Newlyn remained a picturesque but notoriously dirty fishing village, despite its proximity to the

fashionable seaside resort of Penzance. Then from the 1880s onwards large numbers of artists came to work and even to settle here, attracted to it both by its backward, old-fashioned character (one artist wrote that the place was far enough from Penzance to be "quite primitive and suitable for artistic purposes"), and by its resemblance to the grey stone fishing villages and towns of Brittany, such as Concarneau, that were then among the most popular artists' haunts of Europe. The leading artist of the Newlyn school, Stanhope Forbes, wrote soon after arriving in the village in 1884 that it was like an "English Concarneau", and indeed the place is today twinned with the Breton town. Newlyn is now virtually a suburb of Penzance, but it retains a quiet and very individual character, and moreover, is still dominated by its fishing industry. The oldest and least spoilt part of it begins at the point where the coastal road from Penzance crosses a small river and starts to climb. Behind this road are steep, narrow streets lined with stone-walled and grey-tiled fishermen's cottages. From the top there is a beautiful view of **Penzance Bay** and the church-topped promontory known as **St Michael's Mount**.

Newlyn Art Gallery
New Rd Map 00
Tel. (0736) 3715
Open Mon – Sat 10am – 5pm
Closed Sun
🔲 ⸹ ⛟ 🅿 ☑ 🐾 ⸬

The Newlyn Gallery is in the lower, more modern part of the village, an area of Victorian villas and small hotels. It was built in 1895, essentially as an exhibiting place for the **Newlyn artists** then at the height of their popularity. Previously these artists had on certain days opened their studios to the public, but the numbers of people wanting to come to these so-called "private views" had apparently begun to be almost unmanageable. The Newlyn Gallery must have seemed at the time a large and rather ugly intrusion on the Newlyn skyline. Today it stands as a sad reminder of the fame which these artists once enjoyed. Fortunately the interior has been cheerfully modernized, and forms a pleasant setting for the exhibitions, generally of local interest, that are put on here. The small and rarely shown permanent collection contains only a few paintings by the village's 19thC painters, including one by Stanhope Forbes's Canadian wife, **Elizabeth Armstrong**. To see a far larger collection of Newlyn School pictures you should visit the nearby **Queen's Hotel** off the promenade

between Newlyn and **Penzance**. The staircase, hall, corridors and public rooms of this building are crammed with late 19th and early 20thC **paintings** and **watercolours** by Newlyn artists.

PLYMOUTH
Devon Map D5

Plymouth has played a major role in British maritime history ever since the 16thC, when it became the base of the English navy. It was here – on the elevated esplanade with extensive lawns known as the Hoe – that Sir Francis Drake was interrupted in his game of bowls on hearing the news of the advance of the Spanish Armada (1588). Just over 30 years later the Pilgrim Fathers embarked on the *Mayflower* from the Hoe on their way to America. Then, in 1689, William of Orange decided to build the Royal Dockyard on the nearby marshes that were to become Devonport. Plymouth's naval importance led to the town being severely damaged in World War II. The little that survived of the Plymouth known to Drake and the Pilgrim Fathers (a handful of Tudor and Jacobean houses, most notably the **Old Custom House**), is to be found in and around the small and now rather chic quayside area known as the Barbican.

City Museum and Art Gallery
Drake Circus
Tel. (0705) 668000 ext. 4378
Open Mon–Fri 10am–6pm, Sat 10am–5pm
Closed Sun
📷 🎪

The ponderous classical-style building (1956) that houses the town's library, museum and art gallery is a typical example of the lack of adventurousness in British post-war civic architecture. The architect's efforts seem to have been directed almost entirely to the creation of would-be grandiose effects to the visual exclusion of practical details. Thus the only toilets that can be used by the museum visitor are situated on the outside of the building. More seriously, the building's massive façade shields an interior that leaves remarkably little space for the display of the museum's fine art holdings, which can thus be never more than partially shown.

On loan to the gallery is a collection of **17thC portraits** amassed by the 1st Earl of Clarendon (who was Lord Chancellor to Charles II) for the adornment of his London home. The collection contains works by **Van Dyck** and **Sir Peter Lely**.

An extraordinary succession of leading British portrait and history painters came from Plymouth, and the gallery's 18thC and 19thC holdings display their work to interesting effect. The most famous of these artists was **Sir Joshua Reynolds**, the son of the Reverend Samuel Reynolds, Master of the Grammar School at nearby Plympton (this beautiful building is still standing, although the original schoolmaster's house was rebuilt in 1971). Reynolds was apprenticed in London to the Exeter-born portraitist, Thomas Hudson. When he completed his training he set up his own portrait practice in what is now the Plymouth suburb of Devonport, but then returned to London, where he later became the first President of the Royal Academy, and the author of some celebrated discourses on art. Among the works by him in the museum are early **portraits** of his sister and father, and a later portrait (1777) of the Plymouth art collector, ***Charles Rogers***. Rogers' collection, which incorporated an earlier one brought together by William Townson, later formed the basis of the so-called Cottonian Collection, which was presented to Plymouth in 1953 and is now in the possession of the art gallery: it is particularly rich in 17thC–18thC **Old Master drawings** and **prints**.

Plymouth's other main artists were Reynolds' pupil **James Northcote** (whose work at the gallery includes a fine self-portrait), **Benjamin Robert Haydon**, and Haydon's pupil and later director of the National Gallery in London, **Charles Lock Eastlake**. Of these artists, Haydon is undoubtedly the best represented in the gallery, having two characteristically large and over-ambitious canvases, *The Black Prince Thanking Lord James Audley for his Gallantry in the Battle of Poitiers* and *The Maid of Saragossa*. Haydon enjoyed early success as an artist; but his ambitions far outstripped his talents, and his later life was characterized by growing mental instability and an acute sense of injustice towards himself. His increasingly depressing career, which culminated in suicide, is recorded in his voluminous published diaries. The diary entry describing *The Maid of Saragossa* (which deals with the besieging of Saragossa by the French forces in 1808–9) is typically melodramatic in tone: "Painted two hours, finished musket and bayonet. The musket fell down. I did not see it, an ran my foot against it, and the bayonet (half an inch) cut into my left foot. It bled copiously. As I wanted blood, I painted away on the ground of my Saragossa while the surgeon was coming. Never lose an opportunity!"

The gallery has a large collection of **British paintings** from the late 19thC up to the present day. Included in these is an important group of Camden Town school paintings (note in particular Spencer Gore's portrait of his wife entitled *Woman in a Hat*, and Malcolm Drummond's evocative winter scene, *Queen Anne Mansions*), and various works by artists of the 1950s based in ST IVES and the West Country, such as **Terry Frost**, **Patrick Heron**, **Bryan Wynter**, **Michael Canney** and **Karl Weshke**. Perhaps the most popular of the later British paintings is *Fish Sale on a Cornish Beach* ★ by the mainstay of the NEWLYN colony of artists, **Stanhope Forbes**. Exhibited with enormous success at the Royal Academy in London in 1885, it was the first work both to establish Forbes' reputation as an artist and to draw public attention to the group of artists working in Newlyn. It is a life-sized painting which – following the practice of the Newlyn artists – was executed completely out-of-doors. When planning the painting in the summer of 1884, Forbes wrote, "Painting out of doors in England is no joke and the picture will be a long weary job." In December of that year he recorded a typical day's work: "I sallied forth to have another go at the large picture. I got blown about and rained upon, my model fainted, etc."

ST HELIER
Jersey, Channel Islands

The island of Jersey – which like the other Channel Islands has belonged to England since 1066 – is now essentially a tax haven infested with golf courses and pretentious houses for the newly rich. Its capital, the port of St Helier, is a much-prettified place where expensive yachts line the harbour. The exiled French writer Victor Hugo lived here briefly before going on to Guernsey. Another famous resident of the town was **John Everett Millais** who, though born in Southampton, spent much of his childhood here, and always styled himself a Jerseyman.

Barreau Art Gallery, Jersey Museum
9 Pier Rd Tel. (0534) 75940
Open Mon – Sat 10am – 5pm
Closed Sun
📷 �🏛

The Jersey Museum, a converted 19thC house, contains a room known as the Barreau Art Gallery. Its best-known paintings are all late works by **Millais**,

most notably a sickly-sweet portrait of one of his daughters, Alice, entitled *The Picture of Health*. A finer work by Millais is owned by the States of Jersey, and you can generally see it in the St Helier leisure center known as **Fort Regent**. This is the Jersey actress, *Lily Langtree*, who is also commemorated by various items in the Barreau Art Gallery, including a portrait by **Poynter**.

ST IVES
Cornwall Map B5

St Ives is impressively situated on a hill which slopes down to form a long promontory, narrow in the middle and ending in a mound largely bare of houses once known as "the Island". The N side of this promontory has a beautiful sandy beach, and on the S side is the town's still lively harbour. The place was a little-visited fishing town until 1877, when the railway line from London to Penzance was extended to reach it. Soon afterwards it began to attract large numbers of artists and wealthy tourists who at first stayed in the upper and more genteel part of the town. However, the artists invariably chose as their studios converted fishing-lofts in the lower town (known as Downalong), which was an extremely poor, dirty but picturesque fisherman's quarter. Unlike the artists of nearby NEWLYN, the St Ives artists were a remarkably international group, comprising many Americans, Scandinavians and even Russians. Also in contrast to Newlyn, St Ives lived on as an artists' colony well into this century, attracting in the 1940s and 1950s numerous leading abstract artists. St Ives continues to be an exceptionally popular summer resort, but the serious artists who once came here have now been replaced by amateur watercolourists, potters and owners of antique shops, many of whom have rather over-prettified houses in Downalong. For all this, St Ives is still a delightful and lively place to visit, with a more international character than any other small town in Britain.

The Barbara Hepworth Museum
Barnoon Hill
Tel. (0736) 796226
Open Mon – Sat Apr – June, Sept
 10am – 5.30pm; July – Aug
 10am – 6.30pm; Oct – Mar
 10am – 4.30pm; Sun July – Aug
 2 – 6.30pm
Closed Sun Sept – June
📷 🚶 ⚲ 🏛 ☑ ☙ 🌱

Barbara Hepworth was one of the many artists based in Hampstead, London in

the 1930s who moved to St Ives at the outbreak of World War II. In 1949 she bought Trewyn Studios – where the museum devoted to her is now situated – and lived there permanently after 1951 when her marriage to the painter Ben Nicholson was dissolved; she later acquired the neighbouring Palais de Danse to use as an additional studio. She died in a fire at Trewyn Studios in 1975, after falling asleep with a lighted cigarette. The building and its delightful walled garden with exotic plants and trees has been little altered since her death, and is generously filled with her **sculptures**. It must be admitted, however, that these works, seen in such profusion, begin to seem almost excessively tasteful and decorative.

Penwith Galleries
Downalong
Open Tues – Sat 10am – 1pm, 2.30 – 5pm
Closed Sun, Mon
🎨 🏛 ☑ ⫶
In the late 1940s growing tensions between the traditionally-minded and the avant-garde artists in St Ives led to the creation of the Penwith Society of Arts in Cornwall, which was intended as an exhibiting institution for the latter group, "the modernists". In 1961 the Society moved into a converted pilchard-packing factory in the heart of Downalong, a site later considerably expanded by the acquisition of neighbouring buildings.

It was originally intended that one gallery should put on commercial and temporary exhibitions, and that the other should display the nucleus of a permanent collection of work by the leading artists based in St Ives from the 1940s onward, such as **Ben Nicholson**, **Barbara Hepworth**, **Patrick Heron**, **Bryan Wynter**, **Peter Lanyon** and **Roger Hilton**. Unfortunately this so-called "permanent" collection is rarely shown.

ST PETER PORT
Guernsey, Channel Islands
The island of Guernsey is a more human and affable place than its neighbour Jersey. Its capital, St Peter Port, has narrow, picturesque streets lined with attractive 19thC houses.

Guernsey Museum and Art Gallery
Candy Gdns, St Peter Port
Tel. (0481) 26518
Open 10.30am – 5.30pm
🎨 ▯
The newly opened Guernsey Museum provides a tasteful modern setting for the

display of items mainly relating to the island's history. There are numerous topographical works by Guernsey artists, as well as an Impressionist painting by **Renoir**. This was one of a number of landscapes Renoir produced during a visit to the island in September 1883 (another is in the National Gallery in *LONDON*). Renoir was delighted by the place, and he wrote to a friend in Paris: "I am here on a charming beach completely different from our Norman beaches . . . it seems more like a landscape by Watteau than something real."

Hauteville House
Open Apr – Oct Mon – Sat 10.30am – 4pm;
Nov – Mar 10.20am (one tour only)
Closed Sun
🎨 🏛 🎨
The French writer **Victor Hugo** lived in this dark and rather ramshackle building during most of his years of exile in the Channel Islands, moving here from Jersey in 1855, and staying until 1870, when he was able to return to France. As well as being a writer, Hugo produced some freely executed wash **drawings** that resemble the Rorschach blots of an extremely disturbed mental patient, and make use of chance effects. Hauteville House has examples of these, in addition to various memorabilia chronicling Hugo's stay on the island.

SALISBURY
Wiltshire Map H3
Salisbury is a particularly attractive market town, built on a medieval grid plan but containing fine old houses from many periods. Its chief monument is its **cathedral** ★, whose enormously tall 14thC spire you can see from miles away. The rest of the building was built as a whole in the 13thC, thus making it one of the most homogeneous medieval cathedrals in Britain. Its architecture is far more striking than its furnishings, though it does have some fine **stained-glass windows**, and an excellent **14thC brass** to Bishop Wyville, who is shown standing in a castle. The spacious cathedral close features some elegant 15thC – 18thC houses, one of which, **Mompesson House** (1701), is open to the public, and contains splendid plasterwork and a good collection of 18thC English drinking glasses.

The most famous artist associated with Salisbury is **John Constable**, who first came here in 1811 to visit the bishop (previously the rector of a village near Constable's native East Bergholt in Suffolk). Constable painted the

cathedral several times, including once from the meadows across the River Avon, (National Gallery, *LONDON*) and, on another occasion, from the bishop's gardens in the close (Victoria and Albert Museum, *LONDON*). The bishop is reported to have liked the latter work "all but the clouds", and to have wished the artist had created a sunnier picture.

In the village cemetery of Broadchalke, about 5 miles SW of Salisbury, you can see a simple but moving headstone by **Eric Gill** marking the grave of one of this century's most promising British artists, **Christopher Wood**. Wood died aged 29 at Salisbury Station in strange circumstances. His mother and sister, who had gone to meet him there, found him in an agitated state, claiming that he was being followed by some strange Algerians. Shortly afterwards he fell under a moving train. In his pocket were found these scribbles: "Are they positive?" and "Throwing away is not big enough proof."

Salisbury and South Wiltshire Museum
The King's House, 65 The Close
Tel. (0722) 332151
Open May, Sept Mon – Sat
* 10.30am – 5pm; Sun 2 – 5pm; Oct – Apr*
* Mon – Sat 10.30am – 4pm*
Closed Sun, Oct – June
🕱

This museum has good archaeological collections (including a **Roman mosaic pavement** from Downton), some charming reconstructed **interiors** of Old Salisbury, and substantial holdings of local pottery, porcelain, and prints.

SALTRAM HOUSE 🏠
Plymouth, Devon Map D5
Tel. (0752) 336546
Open Apr – Oct Tues – Sun 12.30 – 6pm
Closed Mon; Nov – Mar
🕱 🔊 📖 🏛

Saltram House was built in the early 17thC, but then completely remodelled in the following century. The finest rooms in the house are the dining room and the saloon, which were designed by **Robert Adam** and incorporate in their exquisitely stuccoed ceilings roundels by **Antonio Zucchi**. There are numerous 17thC and 18thC paintings (including a **Murillo**, various **Dutch landscapes** and Italian Baroque works of often questionable attribution). These were bought mainly on the advice of Sir Joshua Reynolds, a great friend of the owners of the house. The pride of the collection are 14 works by **Reynolds** himself.

STONEHENGE
Wiltshire, Map H3
Open mid – Mar to mid – Oct
* 9.30am – 6.30pm; mid – Oct to*
* mid – Mar 9.30 – 4pm*
🕱 🔊 📖 🌱

This circular group of hewn standing stones from the Early Bronze Age (c. 1800 – 1400BC), possibly a temple to the sun, is one of the most famous prehistoric sites in the world, and one of Britain's greatest tourist attractions. With its mysterious, monumental qualities and impressively isolated position on a great plain, it had been a source of inspiration to artists and writers long before the 18thC Irish writer Edmund Burke used Stonehenge as a major example of the "sublime" in his *Philosophical Enquiry into the Origin of the Sublime and Beautiful*. It was probably Burke's enthusiasm for the place that induced his protegé, the Irish painter **James Barry**, to include Stonehenge-like structures in his *King Lear Weeping over the Dead Cordelia* (Tate Gallery).

By the early 19thC Stonehenge had become one of the main Romantic pilgrimage places in Europe. Among the most famous works painted of the place at this time were some watercolours by **John Constable** (one of the finest of these, dated 1836, is in the Victoria and Albert Museum in *LONDON*). This century Stonehenge came to be admired also for its purely formal qualities, and was an object of veneration to Britain's pioneering abstract artists such as Henry Moore and Barbara Hepworth. Today it is difficult to be so excited by this group of stones; the vast crowds of tourists, the wire netting covering some stones, the Department of the Environment's statutory green fence encircling the site, the nearby souvenir kiosk and underground toilet complex, may suppress all thoughts of the "sublime".

STOURHEAD HOUSE 🏠 ☆
Stourton, nr. Mere, Wiltshire
Map G3
Open Apr and Oct, Mon, Wed, Sat, Sun
* 2 – 6pm (or dusk) May – Sept*
* Mon – Thurs, Sat, Sun 2 – 6pm (or*
* dusk)*
Closed May – Sept Fri; Tues, Thurs, Fri,
* Apr and Oct; Fri May – Sept; Nov – Mar*
🕱 🔊 🏛 🌱

Stourhead, which is approached from the charming village of Stourton, is a magnificent Palladian structure, built mainly between 1720 and 1724 by Colin

Campbell for Henry Hoare. It was one of the first great houses to be built in the Georgian style. The interior, though badly damaged by fire in 1902, has been well restored and contains numerous paintings. These are mainly of the 17thC and 18thC, and include works by **Gaspard Dughet**, **Vernet** and **Mengs**. The Italian School is particularly well represented with leading 18thC artists such as **Sebastiano Ricci**, **Conca**, **Cigoli**, **Zuccarelli**, **Canaletto** and **Pompeo Batoni**, together with some disputable attributions to earlier masters such as **Andrea del Sarto**, **Francesco Bassano**, and **Caravaggio**.

Yet it is not really the pictures, nor even the house, that makes a visit to Stourhead such an unforgettable experience. Here, essentially, is one of the finest landscape gardens of 18thC Europe. Designed and laid out by Henry Hoare, it has as its focus a beautiful lake. In contrast with the formal gardens of earlier periods that you can see in England, Stourhead glories in its artful irregularity, and as such encapsulates the then highly fashionable concept of the "picturesque". As you walk around the lake, new "pictures" are constantly being formed. Statues appear and disappear, grottoes give way to rustic motifs, and what is at one moment a Temple of Flora becomes at the next a Pantheon copied from the Pantheon of Rome. The main formal inspiration for the garden was the work of the then highly popular classical landscape painters, **Claude Lorrain** and **Gaspard Dughet**; and indeed, despite the English climate, you sometimes have an uncanny sensation of actually being in one of their paintings.

SUDELEY CASTLE 🏰
Winchcombe, Gloucestershire
Map G1
Tel. (0242) 602308
Open Mar–Oct noon–5.30pm
Closed Nov–Feb
🏰 ⚓ 🏛 ⛪ 🏛 🚻 ☑ 🌱

Originally a 12thC castle, Sudeley was rebuilt *c.*1450, and the following century became the home of Catherine Parr, the sixth queen of Henry VIII. During the Civil War Charles I made the castle his headquarters, and as a result it was besieged and largely dismantled. In 1858 **Sir Gilbert Scott** reconstructed it, incorporating into his designs parts of the 15thC structure.

The castle's small but outstanding painting collection was mainly gathered in relatively recent times. One room has a fine landscape by **Claude**, a female

portrait by Greuze entitled **Innocence**, and a wonderful early work by Turner of **Pope's Villa at Twickenham** ★. This painting, which is suffused with a quiet melancholy, was intended to commemorate the recent demolition of the building; at the same time the artist wrote a poem, *On the Demolition of Pope's House at Twickenham*, which emphasized how the memory of even so famous a man as Pope could be effaced through the vagaries of taste. The castle's other major paintings are all in the last room to be visited on the guided tour. Here you can see an oil sketch by Rubens of **The Miracle of St Francis of Paola**, a landscape by Ruisdael (**The Water Mill**), a fine **Self-Portrait** ★ by Reynolds, and an important large landscape by Constable (**The Lock** ★), that was exhibited at the Royal Academy in 1824.

SWINDON
Wiltshire Map H2

The small market town now known as Old Swindon was absorbed in the 19thC by a much larger urban complex that developed as a major engineering location of the Victorian railway age. This dull conglomerate again expanded rapidly after World War II.

Museum and Art Gallery
Bath Rd
Tel. (0793) 26161 ext. 3169
Open Mon–Sat 10am–6pm, Sun 2–5pm
🅿 🚻

This characterless modern building is potentially the finest small museum devoted to contemporary art in Britain; for, quite amazingly, it contains, through the bequest of the Vorticist painter **David Bomberg**, work by almost all the leading British artists of this century. It is thus very hard to understand or forgive Swindon Council for allowing only one small room for the display of this collection. Worse still, even this room is usually occupied by mediocre touring exhibitions, which means that you can see only a tiny fraction of the collection that can be shown at any one time, and that only three or four times a year.

TORQUAY
Devon Map E5

Devon's smartest and liveliest seaside resort, Torquay enjoys a pleasant climate, being protected from the winds on three sides. Thanks to the warm waters of the Gulf Stream it even boasts palm trees and tropical gardens.

Torre Abbey Mansion
King's Drive
Tel. (0803) 23593
Open Mar–Oct 10am–1pm, 2–5pm;
Nov–Feb by appointment
🖼 🔄 🛢 🅿

This is a heavily restored 17thC–18thC house built around the ruins of a medieval abbey. Inside is a badly displayed collection of mainly indifferent paintings and watercolours, together with other items of local interest.

However, in this unlikely setting you will find a Pre-Raphaelite masterpiece, Holman Hunt's *The Children's Holiday* ★★ This strange, haunting, minutely naturalistic work is a portrait of a Mrs Fairburn and her five children.

TRURO
Cornwall Map B5

Truro, Cornwall's only cathedral city, is considered the capital of Cornwall. Today it is mainly an administrative center and market town, as its port – once famous for its export of mineral ore – has long been superseded in importance by that of Falmouth. It is a pleasant place with some elegant 18thC streets and houses that bear witness to the time when the town was very popular with rich merchants. The cathedral, which incorporates the old church of St Mary, was designed at the end of the 19thC.

County Museum and Art Gallery
River St
Tel. (0872) 72205
Open Mon–Sat 9am–1pm, 2–5pm
Closed Sun
🖼 🛢 ☑

The Royal Institution for Cornwall was founded in 1818 for "the promotion of knowledge in natural history, archaeology, ethnology and the fine and industrial arts, especially in relation to Cornwall". This institution has always sponsored the museum, which has occupied its present spacious premises since 1919, and is the finest in Cornwall. A room on the ground floor contains most of the applied art holdings, which feature a group of **17thC silver spoons** made in Truro, **Japanese ivories and lacquer work**, and excellent collections of **pewter, porcelain and pottery**, including pots by Bernard Leach. The rest of this floor is devoted principally to archaeology, local history and geology. You should not miss the room with items relating to the local iron and copper industries, for this contains one of the finest paintings in the museum, a double portrait by **John Opie** of 1786 entitled *A Gentleman and a Miner: Captain Morcom of Polperro Mine, St Agnes, showing a Specimen of Copper ore to Thomas Daniell of Truro* ★.

Opie, Cornwall's best-known painter, was born in 1761 near Truro, in the hamlet of Mithian just outside St Agnes (the house of his birth is now called "Harmony Cot" and is marked with a plaque). His father was a St Agnes mineworker who apprenticed his son to a local wheelwright until his precocious talent for drawing was discovered by the Truro writer, Dr John Wolcot. Wolcot arranged for Opie to paint portraits of local gentry and then, in 1781, took him to London. Here Opie's working-class manner and strong Cornish accent were the source of much amusement, but he was also immediately recognized as an artistic prodigy, and came to be known as the "Cornish wonder".

The staircase leading to the first floor gallery has on one of its walls a much-reproduced 17thC portrait of **Arthur Payne** by the 17thC artist **Sir Godfrey Kneller**. Payne, who grew to be seven feet two inches tall, was known as the "Cornish Giant"; the work was commissioned from Kneller by Charles II.

Facing each other on either side of the gallery are two large rooms devoted to the fine art collections. One has on almost permanent display an impressive collection of **drawings** donated to the gallery by Edward de Pass (see FALMOUTH), including works by **Rembrandt, Callot, Van Dyck, Claude, Hogarth, Boucher, Géricault** and **Augustus John**. The other room shows the bulk of the gallery's holdings of paintings, which are mainly of the English 18thC, 19thC and early 20thC schools. Here you can see various other portraits by **Opie**, among which is an excellent self-portrait, and a powerful, disturbing portrait of *Sir David Wilkie* ★ showing the Scottish painter with a troubled expression as he holds his hand to his mouth. Apart from a dark oil sketch by **Hogarth** for one of the scenes of his *Marriage à la Mode* series (in the National Gallery in LONDON) and a roundel by Sargent entitled *The Archers*, the most impressive of this room's remaining works are all by NEWLYN School artists. There are two paintings by the mainstay of the Newlyn group, Stanhope Forbes (*Lighting-Up Time* and *Against Regatta Day*), *A Steady Drizzle, Penzance* by Norman Garstin (painter of the much reproduced *The Rain it Raineth Every Day* in the collection of the Penzance Charter Trustees), and a most striking work entitled *Weaving the Chain of Roses* by

Frank Bramley, the author of the Tate Gallery's famous *A Hopeless Dawn* (see *LONDON*.

WELLS CATHEDRAL ☆
City Centre, beside Market Pl Map F3
Tel. (0749) 74483
🏛

Wells, a quiet old town with a haunting atmosphere, has a magnificent **cathedral** built principally between the 12thC and 14thC. Its most striking feature is its wide tiered façade, which in its **sculptural decoration ★★** rivals that of Reims and Amiens cathedrals. It originally comprised 400 figures, but many of these have been destroyed either by the weather or 17thC iconoclasm, and only a few traces of the original polychrome colouring can be seen. Among the finest surviving scenes, look for the **Virgin and Child** in the typanum of the main portal and, in the niche above, the **Coronation of the Virgin**. All the sculptures were carved by local craftsmen, working from the 12thC to the 13thC. The main decorations inside are the elaborate **carvings** of the capitals in the nave and transept, some of which are said to refer to the miraculous toothache cures for which the 13thC tomb of Bishop William Bytton II became famous.

WILTON HOUSE 🏦 ☆
Wilton, Wiltshire Map G3
Tel. (0722) 743115
Open Apr to early Oct Tues – Sat
 11am – 6pm, Sun 1 – 6pm
Closed Mon
🖼 🚬 🛏 💷 🏛 ☑ 🌿 ⚒

Wilton is a small town with an impressive parish church designed in 1844 by **T.H. Wyatt** in an Italian Romanesque style, and richly decorated with marble and mosaics as well as 12th – 16thC **stained glass**. The first place in England to manufacture carpets, Wilton remains world famous for its carpets to this day. The industry was strongly encouraged by the town's most important family, the Earls of Pembroke, one of whom even went so far as to smuggle in highly skilled French weavers concealed in a wine barrel. Today you can still visit the Royal Wilton Factory, a charmingly housed and old-fashioned institution. However, the town's greatest attraction is the seat of the Earls of Pembroke, Wilton House.

Wilton House is one of the most important of England's country houses. Built originally in the mid 16thC, perhaps to designs supplied by the painter

Hans Holbein, it was redesigned after a fire in 1647 by England's most renowned early 17thC architect, **Inigo Jones** and his son-in-law **John Webb**. Further alterations in a Gothic style were made by **James Wyatt** in 1801. The house is full of literary associations: Shakespeare is said to have acted in *As You Like It* in the Great Hall (where you can see an 18thC statue of him by Scheemakers), Marlowe, Spenser and Ben Jonson were frequent visitors, and Sir Philip Sidney (whose sister was married to the Second Earl), wrote here his *Arcadia*, which is illustrated in the **ceiling decoration** of the Single Cube Room. The collection of paintings in the house is outstanding and in addition to family portraits by **Van Dyck**, **Reynolds** and **Lawrence** features important works by Ribera (*Democritus* ★), Luca Giordano (a painting of the *Conversion of St Paul* incorporated in the ceiling of the Corner Room), Sassoferrato (*Madonna*), **Rembrandt** (an early portrait of his mother), Honthorst (*Prince Rupert*) and **Richard Wilson** (a Claude-like view of Wilton House).

The single most remarkable feature of the house is the **Double Cube Room**, which was designed by Inigo Jones and completed by John Webb in c. 1653. This room, which has retained all its original furnishings, is one of the most spectacular and best preserved 17thC interiors in England. The ceiling is decorated by canvases depicting the legend of Perseus, supposedly by the 17thC Flemish painter **Thomas de Critz**. The walls are of pine, painted white and elaborately decorated with gilded swags of fruit, flowers, foliage and other ornamentation. With the exception of one studio piece, all the paintings in the room are by **Van Dyck**, and indeed constitute the greatest single collection of this artist's work to be found anywhere. They were painted in London c. 1635 – 6 and then moved to Wilton after the completion of the Double Cube Room, which was designed specially to house them. Among these works, look for a *Portrait* ★ of Charles II, James II and Princess Mary as children, and a portrait of their father **Charles I ★**. Here you can also see Van Dyck's largest canvas, an enormous group portrait featuring members of the *Family of Philip, 4th Earl of Pembroke* ★. This painting is a wonderful combination of realistic observation and theatrical magnificence. After visiting the house, you should walk around the beautiful grounds, where you can see a 16thC pavilion known as the **"Holbein Pavilion"** and an **18thC bridge** spanning the River Nadder.

The MIDLANDS

Like northern England, the Midlands is artistically one of the richest areas of Britain. Yet tourism is heavily concentrated on just a very small part of it, the counties of Oxfordshire and Warwickshire. The attractions of OXFORD itself lie in its combination of architectural beauty and outstanding art treasures. In the Ashmolean Museum it has one of the finest, as well as the oldest, public museums in the country. Warwickshire has no such important art center, though it has extremely pleasant small towns and scenery, and boasts another of Britain's major tourist places, STRATFORD-UPON-AVON which, in addition to its associations with Shakespeare, has a small but fascinating art gallery. This has, in addition to numerous depictions of Shakespeare himself, many portraits of famous actors, from Garrick onwards.

INDUSTRIAL TOWNS *and* CATHEDRAL CITIES
North and E of Warwickshire you reach the flat, heavily built-up and industrialized country that characterizes the greater part of the Midlands. Numerous major British artists, including David Cox, Richard Parkes

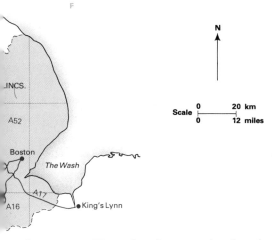

Bonington, and Burne-Jones have come from here though few have remained, the main exception being Joseph Wright of Derby. Artistic travellers to the industrial Midlands will probably wish to devote most of their time to seeing the area's more conventionally attractive places such as the charming cathedral towns of Lichfield and LINCOLN, or the important country houses, such as BELVOIR, ALTHORP and BOUGHTON, that are situated in quiet rural enclaves.

It would be a shame, however, if you were to miss the area's major museums, all of which are to be found in towns not known for their great beauty. BIRMINGHAM has both the Barber Institute of Fine Art – one of the most representative small art galleries in Britain – and a municipal gallery famed for its holdings of David Cox and the Pre-Raphaelites; impressive collections of the works of Bonington and Joseph Wright can be seen in NOTTINGHAM and DERBY; and at LEICESTER you will find the largest group of German Expressionist works to be seen in any British gallery.

At the western confines of the Midlands you will come once again into beautiful countryside. Though difficult to imagine today, the wooded and hilly area to the W of Birmingham is the traditional birthplace of the Industrial Revolution; at COALBROOKDALE, quietly nestling in a gorge formed by the River Itten, you will find a small art gallery tracing the effects of this revolution on the Romantic generation of British artists. This early industrial site was an attraction for travelling artists from the mid 18thC onwards. Its combination of Romantic scenery with spectacular industrial workings attracted as many as 50 to the area between 1750 and 1830; the dramatic light effects created by lime kilns and iron works provided subjects for Turner, Cotman, Sandby and, most sensationally, de Loutherbourg (*Coalbrookdale by Night*, Science Museum, London). Apart from the remains of the ironworks you can still see the celebrated and much-painted Iron Bridge, the world's first, built over the Severn by Abraham Darby III in 1779.

To the N of Derby, which has a fine gallery featuring works by its most famous artist son, Joseph Wright, you will come to the Peak District which has some of the best scenery you will see anywhere in the country. At the heart of this is the "Palace of the Peak", Chatsworth House, the huge Palladian residence of the Duke of Devonshire. The wealth of art treasures here includes some of the finest paintings and drawings in England. The park and gardens offer beautiful views of the surrounding countryside.

ALTHORP 🏛
Nr. Northampton Map D4

Tel. (060-125) 209
*Open Jan – July Sept – Dec Tues – Thurs Sat
Sun 2.30 – 5.30pm; Aug Mon Tues
Thurs – Sun 2.30 – 6pm
Closed Mon Fri Jan – July Sept – Dec;
Wed Aug*
🖼 🍴 📷 ▣ ♿

Originally a 16thC house, Althorp owes
its present rather forbidding appearance
to late 18thC remodelling. Much of the
popularity which the place now enjoys is
due to its being the family home of the
Princess of Wales, Lady Diana. Yet the
house does also have an outstanding
collection of paintings, the nucleus of
which was assembled by Robert Spencer,
2nd Earl of Sunderland, in the late
17thC. You will see some impressive
works from the **Italian Baroque**,
including two large and dramatic
landscapes by **Salvator Rosa**, an
allegorical study by **Guido Reni** entitled
Liberality and Modesty, and scenes by
Reni's pupil, **Guido Cagnacci**, of
Lucretia and Cleopatra. The statutory
family portraits by **Van Dyck**,
Gainsborough and **Reynolds** are of
particularly high quality (note especially
the latter's portrait of ***Georgiana,
Countess Spencer ★***).

BELVOIR CASTLE 🏛
Belvoir, Leicestershire Map D2

Tel. (0476) 870262
*Open Apr – Sept Tues – Thurs Sat
noon – 6pm; Sun noon – 7pm; early Oct
Sun 2 – 6pm
Closed Mon Fri Apr – Sept; Mon – Sat early
Oct; mid Oct – mid Mar*
🖼 🍴 ▣

Belvoir Castle (pronounced Beever)
derives its name from the extensive views
to be had as a result of its splendid
ridgetop position. Originally a medieval
castle, then a mid 17thC house in a
Classical style, the castellated structure
that you see today is principally a Gothic
fantasy made for the 5th Duke of Rutland
in the early 19thC by **James Wyatt**.
Much of Wyatt's interior was destroyed
by a fire in 1816, and the duke's wife took
it upon herself to re-create it with the aid
of her cousin-in-law, the Rev Sir John
Thornton, and Wyatville's son
Benjamin. The interior decoration,
which includes rooms in a variety of styles
ranging from Gothic (inspired by Lincoln
Cathedral) to French Rococo, is in
varying taste. The picture gallery boasts
miniatures by **Hilliard** and **Oliver**, a

splendid portrait of **Henry VIII**
attributed to Holbein, and five canvases
from the celebrated series of paintings by
Poussin representing the ***Seven
Sacraments ★★*** (of the other two
paintings in the series, one was lost in the
1816 fire, and the other is now in the
National Gallery of Art in Washington).
They were commissioned from Poussin in
the late 1630s by his most important
Italian patron, Cassiano del Pozzo, who
was Secretary to Cardinal Francesco
Barberini, and a man with a passionate
enthusiasm for classical archaeology. The
Sacraments series reflects his and
Poussin's great interest in the history of
the early church, and includes many
details inspired by the 17thC finds from
the Roman Catacombs.

BIRMINGHAM
West Midlands, Map C3

Birmingham has been a comparatively
small town for much of its history, but it
rapidly expanded after the late 18thC
thanks to the abundant supplies of coal,
iron and wood in the vicinity. Today
Birmingham is Britain's second-largest
town and the leading center in the
country of the metalwork industry. An
architecturally undistinguished place, it
has lost even the strong Victorian
character that lends interest to many of
Britain's northern industrial towns.
Perhaps the most striking of its buildings
is its **early 19thC Town Hall**, which
takes the form of a Classical temple
modelled on that of Castor and Pollux in
Rome; but its distinctive qualities are
slightly marred by its being in the heart of
an area which seems an unplanned
jumble of old and new. Two churches, **St
Martin's** and the cathedral church of **St
Philip**, contain stained glass windows by
the Pre-Raphaelite painter **Burne-Jones**,
the town's most famous native artist.

Barber Institute of Fine Arts ☆
The University, Birmingham
Tel. (021) 472 0962
*Open Mon – Fri 10am – 5pm, Sat
10am – 1pm
Closed Sun*
📷 ▣ ☑

Birmingham's second major art gallery
belongs to the town's university and is
situated with the other university
buildings in the quiet, elegant suburban
district of Edgbaston. The Barber
Institute of Fine Arts runs the gallery,
which was founded in 1932 by Dame
Martha Barber in memory of her husband
to promote the study of the fine arts and
music at the university. She provided

funds for the erection of a building to house it (this was opened in 1939) and to purchase "works of art or beauty of exceptional and outstanding merit comprising pictures painted not later than the end of the 19thC". The institute's collection ranks with that of the Courtauld Institute in *LONDON* as the finest of any British university. In common with the Courtauld Institute, the gallery is also a very enjoyable place to visit; it is of manageable proportions, and displays its paintings as though in a private collection, offering a comfortable, relaxed setting alongside period furniture, sculpture and applied art objects. Its secluded situation affords the added advantage that it is little visited, and you may enjoy background music from the university's nearby music department.

The Barber Institute's painting collection, though relatively small (about 50 works) has examples of the art of almost all the major European schools. The Italian holdings range in date from 1320 – a fine *St John the Evangelist* ★ by Simone Martini to the large 18thC *Regatta on the Grand Canal of Venice* by the Venetian view painter Guardi. Here you will also see three particularly fine Venetian Renaissance works, two of which are by **Giovanni Bellini** (a charming **portrait of a boy** and a small *St Jerome in the Wilderness* ★ with a beautiful landscape background). The other, by **Cima**, is a powerful, stark representation of the *Crucifixion* featuring in the background scenes of the presentation to the people and Christ's agony in the garden.

The Flemish 15thC does not appear in the collection, but don't miss a superb **early 16thC work** ★ by Jan Gossart (called **Mabuse**), a Flemish painter much influenced by contemporary Italian art. This amusingly portrays Hercules holding a phallic club in one hand and with the other embracing the naked Deianira, whose legs are entwined with his. In many ways the outstanding painting in the whole collection is Rubens' *Landscape near Malines* ★★, a landscape (without figures) of such freshness and spontaneity that from a distance it could almost be mistaken for a painting by Constable. Among the many works by Rubens' Dutch contemporaries are some fine landscapes by **Jan van de Cappelle**, **Jan van Goyen**, **Jacob Ruisdael** and **Cuyp**. Pride of place, however, must go to **Rembrandt's** majestic half-length study of an *Old Woman* ★ and an uncharacteristically sombre portrait by Frans Hals of a *Man Holding a Skull* ★.

The **Spanish** and **French** 17thC schools are represented respectively by Murillo's large *Marriage Feast at Cana* and a painting by **Poussin** inspired by Tasso's *Jerusalemme Liberata*, *Tancred and Erminia*. This relatively early work by the artist, revealing a sensual treatment of light and colour, was once owned by the English Baroque artist Sir James Thornhill. The gallery's French holdings take you into the 18thC and 19thC, with works by **Watteau**, **Lancret**, **Ingres**, **Delacroix**, **Rousseau**, **Daubigny**, **Corot**, **Courbet** and **Boudin**. They culminate in a marvellous group of **Impressionist** and **Post-Impressionist paintings** ★, among which is **Manet's** portrait of the successful society portraitist Carolus-Duran, Monet's *Church at Varangville* (one of a series), Degas's *Jockeys Before the Race* ★, and Gauguin's *Landscape at Pont-Aven* ★ and *Bathers in Tahiti* ★.

The English works are as wide-ranging as the French, beginning with a portrait miniature by the early 17thC artist **Isaac Oliver**, and ending with the *The Eldorado, Paris* by the leading Camden Town painter **Sickert**. In between you will find one of **Gainsborough's** most important landscapes, *The Harvest Wagon* ★. Gainsborough developed a particular affection for the horse that appears in the picture, and wanted to buy it from its owner (a man called Wiltshire who often transported the artist's canvases from Bath to London, and who is featured here as the driver of the wagon). Wiltshire gave the horse to him as a gift and in return Gainsborough presented him with the painting, saying, "Because I think this is one of my best compositions I send it to a gentleman who has vastly contributed to my happiness." Other British works in the collection include excellent landscapes by Richard Wilson (*The River Dee near Easton Hall*), Turner (*The Sun Rising through Vapour* ★) and Constable (*The Glebe Farm*). Finally there is **Whistler's** outstanding study of two girls in white, *Symphony in White No. 3* ★.

Birmingham Museum and Art Gallery ✩✩
Chamberlain Square
Tel. (021) 235 2834
Open Mon – Sat 10am – 5pm, Sun 2 – 5pm
◉ 🛍 ☑ ✓

The Birmingham City Museum and Art Gallery overlooks the Town Hall and is housed in the upper rooms of the Council House, a late 19thC structure in a Renaissance style. The interior is rather like the area outside – an unwholesome mixture of modern and Victorian, and in a constant state of flux thanks in this case

to the frequent rearrangement of the collections. As you walk up the grand staircase leading to the museum be sure to take a look at the charming frescoed scenes of Birmingham life by the Edwardian painter **Joseph Edward Southall**, some of whose other works you will be able to see at a later stage.

At the top of the stairs you will find yourself in a large round room hung with tall and mainly unmemorable 18thC and 19thC English works. If you turn right from here you will find yourself in a large gallery displaying the museum's applied art collections, which include magnificent textiles by **William Morris** and ceramic tiles by **William de Morgan**. Coming back to the round room and turning right again you will soon reach the museum's book shop and an information kiosk.

Beyond this is a small collection of Oriental art (note in particular a fine earthenware tomb figure of a horse from the **T'ang dynasty**), and a stunning collection of jewellery donated by Mrs Hull Grundy. After this come the rooms devoted to paintings (a sequence only interrupted by a room containing a large collection of silver); and at the end of the building are the museum's natural history and archaeological sections, the latter being particularly strong in its holdings of **ancient Egyptian**, **Peruvian** and **Cypriot** art treasures.

The earliest important paintings in the collection date from the 15thC. Two are of the Flemish schools, a *Nativity* by **Memling** featuring a delightful glimpse of a Flemish town in the background, and *The Man of Sorrow* ★ by **Petrus Christus**, a tiny work with the most minutely observed detail such as the filigree halo which the Christ figure is wearing. The Italian Renaissance is represented principally by a dramatic *Ascent of the Holy Ghost* by **Botticelli**, a small, dark and moving *Dead Christ* by the Venetian painter **Cima** and the glowing *Madonna and Child Enthroned with St Peter and St Paul and a Donor* by **Giovanni Bellini**. Italian paintings dominate the museum's 17thC collections, and include masterpieces by three of the leading painters of this period. The Florentine painter **Carl Dolci** is often dismissed today as a painter of almost repellently sweet Madonnas and penitent Magdalenes, but this opinion has to be revised in the light of *St Andrew Praying before his Execution* ★, a work combining minutely realistic detail with a composition of great monumentality and power. Guercino's *Erminia and the Sheperds* ★ (the subject is taken from Tasso's *Jerusalemme*

Liberata), belongs to the earlier and more impressive half of this artist's career, and is notable for its dramatic and irrational use of light. But perhaps the most immediately attractive of these works is *The Rest on the Flight into Egypt* ★ by the follower of Caravaggio, **Orazio Gentileschi**. This is a wonderfully intimate portrayal of the scene, showing the Holy Family against the background of a ruinous wall with the Christ child at the Virgin's breast and a coarsely featured Joseph lying back in an ungainly, somnolent stupor.

You will also see three fine Italian paintings of the 18thC. One, *The Rape of Europa* by the Venetian painter **Zuccarelli**, is a pretty, decorative composition that reduces this dramatic scene from Ovid almost to a minor anecdotal detail in the background. The other two paintings are both views of *Warwick Castle* ★ by Zuccaro's Venetian contemporary **Canaletto**. When you see these splendid works you may find it difficult to understand why the English were so disappointed by artists' representations of their country (there was even a suggestion that the Canaletto who came to England was an impostor). The 18thC collections also feature a small, charmingly sensual work by Boucher (*Jupiter Disguised as Diana Surprises Callisto* ★), a portrait by **Ramsay** in shimmering purples and silvers of *May Atkin* ★ and two entertaining theatrical scenes by **Zoffany**. Belonging to the 18thC, though remarkably modern in spirit, are two of the Welsh painter **Thomas Jones's** small-scale landscapes in oil on paper: one is of a hilltop near Naples, and the other portrays his country estate at *Penkerrig* ★ in Wales.

The 19thC French holdings are very impressive. Girodet's *Death of Hippolytus*, showing the Roman soldier who refused to renounce Christianity being torn apart by horses in a landscape of wild mountains and gushing torrents, is a typically sensational work of the Romantic movement. As for **Delacroix**, the greatest and best known of the French Romantic painters, you can see a quiet and intimate side to his work with his superlative portrait of *Madame Simon* ★ sitting pensively in a Parisian bourgeois interior. The leading Parisian portrait painter of the mid 19thC, **Thomas Couture**, is represented by an excellent portrait of the sculptor *Antoine Etex*. Couture's Realist contemporary **Courbet** is also displayed, but by a rather coarse nude study for a painting (*Venus and Psyche*), which inspired the Turkish ambassador in Paris, Khalil Bey, to commission the artist to paint a sequel

called **Afterwards** (this later became a celebrated pornographic piece, **The Sleepers**, in the Grand Palais in Paris). A large and striking landscape by **Harpignies**, a view of Etretat in Normandy by **Jongkind**, and generally minor works by **Fantin-Latour** and the **Impressionists** bring the French 19thC to a close. The one outstanding work by a French Impressionist artist – indeed one of the great paintings in the whole museum – is Degas's **Roman Beggar Woman** ★★, which was painted very early in the artist's career, long before the birth of Impressionism. Though the composition is extremely simple, the attention to detail is meticulous and the observation of colour has a quite extraordinary subtlety.

For all that the museum has to offer in the way of foreign painting, it is the **English 19thC works** that constitute the place's greatest attraction. **David Cox**, Birmingham's greatest artist of the first half of the 19thC, was also one of England's leading landscapists of this period, and you will find here the largest collection of his works to be seen anywhere. Cox was principally a watercolourist, though he also took up oil painting later in life, achieving in oil the same broad and atmospheric effect that characterizes his watercolours. Two of his finest works in the museum are the small, vividly painted oil, **All Saints Church, Hastings** ★ and **Rhyl Sands** ★, a large composition consisting mainly of sea and sky, and brilliantly portraying the exhilarating freshness of a windy day.

The museum has not only one of the finest groups of **Pre-Raphaelite paintings** in Britain, but also the most extensive collection of **Pre-Raphaelite drawings** in the country. Apart from the later associate of the movement, **Burne-Jones**, none of the Pre-Raphaelites had any strong Birmingham connections. Their works are in such abundance here simply because Birmingham patrons supported them before they became widely popular elsewhere. For this reason, too, some of their finest works to be seen here date from the time when their art was still the subject of enormous controversy. Holman Hunt's **Two Gentleman of Verona** ★ was so sharply criticized when first exhibited in 1851 that Ruskin wrote to *The Times* in its defence: "Further examination of this picture has even raised the estimate I had previously formed of its marvellous truth in detail and splendour in colour." Of a slightly later date is Hunt's **The Finding of the Saviour in the Temple** (1854–60), which was a work resulting from the trip he had made to the Holy Land with the intention of painting a biblical subject in its original setting. A more humorous work conceived on the same trip was the **Lantern maker's Courtship** (1854–61), for which Millais had offered to pose as the Englishman in the background.

The most famous painting by **Millais** in the museum is **The Blind Girl** ★ (1856). Though the subject might seem cloyingly sentimental to contemporary tastes, you can at least appreciate (unlike the subject of the picture) the magnificent landscape background with double rainbow, painted at Winchelsea in Sussex. In the same artist's **Waiting**, the narrative content has happily been reduced to a minimum, and you can observe without distraction the Pre-Raphaelites' skill in rendering the most lifelike naturalistic effects. Perhaps the two greatest Pre-Raphaelite landscapes in the museum are Ford Madox Brown's **An English Autumn Afternoon** ★ (1852–4) and **Walton-on-the Naze** ★. The former is an oval composition painted from the artist's lodgings in Hampstead, and looking towards Highgate; the artist's use of extreme foreshortening and the gesture of the young man in the foreground as he points out the view to his sweetheart, seem to draw the viewer right into the landscape. **Walton-on-the-Naze** is a small, jewel-like work which manages to combine, like the other painting, minute observation with an almost mystical breadth of vision. Brown's **Pretty Baa-Lambs** (1851–9) also has stunning pictorial qualities, but the work's title and the rather repellent faces of the foreground figures put this work beyond most people's appreciation. Far finer is his **The Last of England** ★ (1852–5), one of the most reproduced of all Pre-Raphaelite images. The artist wrote that this painting "treats of the great emigration movement which attained its culminating point in 1852". He chose to portray an educated middle-class couple leaving England, because "the educated are bound to this country by quite other ties than the illiterate man, whose chief consideration is found in food and physical comfort." The couple represented are the artist and his wife, but the picture was inspired by the Pre-Raphaelite sculptor Thomas Woolner and his wife, both of whom set off for Australia in 1852 but returned shortly afterwards.

Rossetti (of whom there is a splendid pastel portrait by **Hunt**) is the Pre-Raphaelite painter least well represented in the museum. His best work here is the **Beata Beatrice** of 1877, a fine but depressing painting inspired by the

memory of his wife Elizabeth Siddal, who had committed suicide in 1862. The art of **Burne-Jones**, like that of Rossetti, had little of the naturalism or social realism you can see in Hunt, Millais or Madox Brown, but instead embodied many of the escapist elements inherent in the movement. Of his numerous works here the best known is his series of panels of *Cupid and Psyche*. Based on William Morris's *Earthly Paradise*, these were painted for the dining room of a London house. Well-known paintings by artists in the circle of the Pre-Raphaelites include Henry Wallis's *The Stone Breaker* (a work combining poetry and social realism) and Arthur Hughes's *The Long Engagement*, showing a sexually frustrated man being consoled by his chaste but equally miserable fiancée with the questionable sentiment (expressed in a quotation which appeared alongside the painting when first exhibited): "For how myght ever sweetnesse have been known/To hym that never tasted bitternesse?"

The museum's remaining holdings of British art include William Langley's "*Never Morning Wore to Evening but some Heart did Break*." Langley was a Newlyn artist (see *WESTERN ENGLAND*) whose work Tolstoy singled out for special praise for its moral qualities and social realism. The picture at Birmingham is one of many that the artist did of Newlyn fisherwomen mourning for their menfolk killed at sea (his most famous picture on this theme is *Hopeless Dawn* in the Tate Gallery, *LONDON*). The most important artist active in Birmingham in the late Victorian and Edwardian periods was **Edward Southall** and you can see his **frescoes** on the museum's staircase. However, these are not characteristic of the artist in that they depict a contemporary subject inspired by Birmingham, whereas Southall normally escaped into the past in his art, and was indeed the leading figure in a group that attempted to revive the style and technique of the early Italian painters. A fine work of his here is the colourful and decorative *New Lamps for Old*.

Among the high points of the museum's representative collection of **20thC British art** are a delightfully simple oil study by **J.D. Innes** of a *Landscape near Collioure* ★; a student work by **Gertler** of his lively Jewish family at play in their East End home; and a great example by Paul Nash (*Landscape of the Moon's First Quarter* ★) of the many works he painted at Boar's Hill in Oxfordshire, looking towards Wittenham Clumps, a group of trees with a mystical significance for him.

BLENHEIM PALACE 🏛
Woodstock, Oxfordshire Map C5
Tel. (0993) 811325
Open mid Mar–Oct Mon–Sun
11am–6pm
Closed Nov–mid Mar
🖼 🚗 ✗ 🍴 🅿 🏛 ♿

One of the grandest palaces of Europe, Blenheim Palace was built in the early 18thC as a gift from the nation to honour the military achievements of John Churchill, 1st Duke of Marlborough. It was later named after the scene of his most famous victory over the forces of Louis XIV. The design of the house, one of the great masterpieces of English Baroque architecture, was entrusted to **Sir John Vanbrugh**, who, however, quarrelled with the duchess before the place was completed, and was replaced by **Nicholas Hawksmoor**. Today Blenheim is one of the group of English country houses referred to as "the magnificent seven", but its fame can mean that a visit here requires considerable patience. After waiting interminably outside the building you may find yourself hurried through the interior in a crowded tour group, and you may leave with tired feet and a general impression of magnificence, but little else. The decoration of the interior was the work of many of the leading artists and craftsmen of the early 18thC, and you will catch glimpses of elaborate ceiling and wall paintings by **Louis Laguerre** and **Sir James Thornhill**, a plethora of carvings by **Grinling Gibbons**, and a fine set of **Brussels tapestries** portraying the duke's victories.

An altogether more relaxing experience is to wander around the superb gardens belonging to the palace. Below one of the terraces of the house is a beautiful formal garden with parterres, ponds and fountains by the French garden designer **Achille du Chêne**, who was in the tradition of Le Nôtre. Beyond this stretch grounds laid out at a later date and in a completely different style by **Capability Brown**. They are typical of the English Picturesque style, with an enormous serpentine lake, and a purposefully asymmetrical arrangement of trees, woods and lawns.

BOUGHTON HOUSE 🏛
Kettering, Northamptonshire Map D3
Tel. (0536) 82248
Open early Apr, Aug–mid Sept
Mon–Thurs Sat Sun 2–6pm; Sun
(Aug only) 12.30–6pm; mid Sept–Oct

Wed, Thurs, Sat, Sun 2–6pm
Closed Fri early Apr, Aug–mid Sept; Mon,
Tues, Fri mid Sept–Oct; Nov–Mar,
June, July
🖼 ⚬ 📖 🕮 ♨

Situated in the middle of an enormous flat estate punctuated by lakes and wide, interminably long avenues of trees, Boughton is one of Britain's largest houses, being built up around no less than seven courtyards. It is sometimes called an English Versailles, and for once such a simile is not entirely inappropriate. The northern front of the house, with its arcaded ground floor and mansard roof, resembles a 17thC French château, and might well have been designed by a French architect. The man who commissioned it, Ralph, 1st Duke of Montague, had in fact twice been ambassador at the court of Louis XIV and had developed a great enthusiasm for French art and architecture. The house which the duke inherited and so radically transformed in the 1690s had originally been a 15thC monastery, to which a manor house and various wings had been added after 1530 when it had been acquired by Sir Edward Montague. Behind the N front you will see a number of buildings which, though refaced in the late 17thC, have a characteristically Tudor appearance.

The interior decoration of the house has remained virtually untouched since the time of the 1st duke, and bears many of the traces of his taste, with magnificent French furniture, murals and ceiling paintings by the French Baroque painter **Louis Chéron**, and flowerpieces over the doors in the little hall by an artist, **Jean-Baptiste Monnoyer**, who had worked under Lebrun at Versailles. The house contains numerous other treasures, among which you can see an early *Adoration of the Shepherds* by El Greco, a charmingly intimate study of *A Young Man in a Plumed Hat* by Annibale Carracci, a *St John the Baptist* by Murillo, and various 17thC Dutch landscapes. The dining room is hung with 40 small oil sketches which **Van Dyck** painted for his famous set of engraved portraits, the *Iconography* (published in 1641), which was intended as a record of the most distinguished men of his time.

Outstanding among the many family portraits in the house, and prominently displayed on an easel in the Great Hall, is a portrait of the *Marquis of Monthermer* ★ (great-grandson of the 1st duke) by **Pompeo Batoni**. Depicting the marquis with a guitar and a score of music, the artist has managed to combine Baroque grandeur with lively informality and penetrating characterization.

BUSCOT PARK 🏠 ☆
Nr. Faringdon, Oxfordshire Map C5
Tel. (0367) 20786
Open Apr–Sept Wed–Fri Sat Sun 2–6pm
Closed Mon Tues Apr–Sept; Oct–Mar

🖼 ⚬ 📖 📖 ♨

Buscot is a showpiece village owned by the National Trust which occupies a narrow and willow-lined stretch of the Thames. Buscot Park, a late 18thC Adam-style house, was considerably altered and added to in the 19thC and then restored to something approximating its original state in the 1930s by the 2nd Lord Faringdon. The remarkable **art collection** that you can see inside was largely assembled by the 2nd Lord's predecessor, a financier who acquired the house in the late 19thC. Among the earlier paintings are some minor **15th–16thC Italian works**, and a fine **Murillo** which was removed from a Spanish church during the Peninsula War (*Faith Presenting the Eucharist*), a landscape by **Gainsborough** in an unusual technique using watercolours to simulate oil, and a portrait and mythological scene by **Reynolds**. The most memorable of the pre-19thC holdings is a **portrait** ★ by **Rembrandt** of a man thought to be Clement de Jongh, who was a great collector of Rembrandt's graphic art (three examples of which can also be seen in the house).

The climax of a visit to Buscot is to be seen in the Saloon, where the decorated gilt wood panelling incorporates the celebrated series of canvases, *The Briar Rose* ★★ by the Pre-Raphaelite painter **Edward Burne-Jones**. Portraying the story of the Sleeping Beauty, these encapsulate the more vivid extremes of the late Victorian dream world, and may seem to overshadow the many other fine pictures in the house by English artists of this period, such as **Rossetti**, **Madox Brown** and **G.F. Watts**.

CHATSWORTH HOUSE 🏠 ☆
Bakewell, Derbyshire Map C2
Tel. (024688) 2204
Open Apr–Oct Mon–Sun
* 11.30am–4.30pm*
Closed Nov–Mar
🖼 ⚬ 𝕏 📖 📖 🕮 ♨

Situated in a hilly wooded valley overlooking the River Derwent, Chatsworth is one of England's greatest country houses. Originally built by **William Talman** for the 1st Duke of Devonshire between 1687–1707, the

house underwent later alterations in the 1820s. The architect responsible was **Jeffry Wyatville**, who built the Orangery and an extension on the NE side of the house, incorporating a ballroom as well as picture and sculpture galleries. The 6th duke, who was responsible for this work, also employed his friend and employee **Joseph Paxton** (the future architect of the Crystal Palace in London) to lay out the spectacular gardens that you can see today, which include magnificent waterworks, most notably a fountain which throws a water jet 276ft high. The part of the house designed by Talman contains some of the finest **Baroque interior decorations** in England, with elaborate ceilings and wall paintings by **Verrio** and **Laguerre**, wrought-iron works by **Tijou**, and extensive carvings in wood and alabaster by **Samuel Watson**.

In addition to splendid furniture and other objects of applied art, the house boasts one of the best private **collections of paintings and drawings** in England, much of which was built up by the 2nd duke. Unfortunately, only a very small selection of the paintings are on public view in the house at any one time, and the drawing collection (with important holdings of **Raphael**, **Inigo Jones**, **Claude**, **Rubens**, **Van Dyck** and **Rembrandt**) can only be seen by scholars after written application to the librarian. Most of the paintings on display in the rooms to which the public are admitted are family portraits by such artists as **Van Dyck**, **Hudson**, **Gainsborough**, **Zoffany**, **Reynolds**, **Batoni** and **Landseer**. The other paintings in the collection (not necessarily on open view) include two portraits by **Hals**; a magnificent portrait attributed to **Velazquez** of a *Lady in a Mantilla* ★ (a version of a painting in the Wallace Collection, *LONDON*); a landscape by **Claude**; an outstanding early work by **Poussin** painted under the influence of the vivid colour and sensual handling of paint of the great Venetian masters of the Renaissance (*The Shepherd's Arcadia* ★); two works by **Rembrandt** (*Portrait of an Old Man* ★ and *Uzziah Stricken by Leprosy*), and an impressive group of canvases by **Lucian Freud**.

COVENTRY
West Midlands Map C4

Coventry's development as a town stems essentially from the time when Leofric, Earl of Mercia, founded the Benedictine priory here in 1043. Leofric's wife Godiva is supposed to have ridden naked through Coventry in an attempt to obtain relief

for the townspeople from the taxes levied by her husband. The earliest version of this famous story dates from 1188, since when it has been subject to many embellishments, including, in the late 17thC, the addition of "Peeping Tom", a man who was struck blind after taking a forbidden glimpse of the naked Godiva on her journey. The keen interest taken by the people of Coventry in their audacious benefactress has long been reflected in the Godiva procession held at regular intervals from 1678.

Coventry suffered one of the worst air raids of World War II, and was largely destroyed. Of its magnificent 14thC cathedral, only a shell remains. The new building that rose in its stead in the early 1950s was designed by **Basil Spence** (who was later knighted) and makes Coventry today one of the most visited places of the Midlands. It is indeed one of the finest examples of this century's ecclesiastical architecture and one of the few memorable British buildings of recent years. On the S side of its rosy sandstone exterior is an enormous sculptured group of *St Michael the Archangel* by Epstein. The W front, symbolically joined by a canopy to the ruins of the old cathedral, is almost all taken up by an enormous glass window with intricate and expressive figures engraved by **John Hutton**. On entering the interior you have the impression of an extremely light and spacious structure. To the right is the **Baptistry Window**, which extends from the ground floor to the ceiling and has stained glass by **John Piper** and **Patrick Reyntiens**. The E end of the interior is dominated by **Graham Sutherland's** vast tapestry of *Christ in Glory* ★, the largest tapestry in existence woven in a single piece, and one of the few modern examples of religious art to have a genuinely awe-inspiring appeal. Sutherland was engaged in designing it between 1952 and 1957.

Herbert Art Gallery and Museum
Jordan Well
Tel. (0203) 25555 Ext. 2315
Open Mon – Sat 10am – 6pm; Sun 2 – 5pm
🖼 📖 ⚏ ♿

The Herbert Museum and Art Gallery is a modern building near the cathedral. On permanent display on its first floor is a large series of studies for **Sutherland's cathedral tapestry**: these powerful, agitated studies in different media are particularly interesting for the light they throw on the artist's constantly changing ideas for the masterly final work. The other rooms are mainly used for loan exhibitions of contemporary art, but you can generally see a selection of the

gallery's small but impressive permanent collection of **20thC British paintings and sculptures**. Among these are works by **Robert Bevan**, **Stanley Spencer**, **Matthew Smith**, **L.S. Lowry**, **Ben Nicholson**, and **Paul Nash**, and a most expressively painted landscape by Bomberg, *Evening Cornwall* ★ (1947).

You should also take a look around the museum's ground floor, where you will find various ceramics, paintings and watercolours incorporated within an imaginative display devoted to **Coventry history**. One room contains various 18thC and 19thC topographical views of Warwickshire. Rather more interesting than this is a room displaying a number of the museum's painted representations of the Lady Godiva story. The earliest of these is a curious **late 16thC work** by an anonymous artist (thought to be Flemish) with a background that suggests ancient Rome rather than Coventry. Of greater artistic interest is Sir Edwin Landseer's *Lady Godiva's Prayer* ★. As you might expect from this well-known painter of animals, particular attention has been paid to Godiva's horse, who is shown viewing with curiosity an excited dog. Godiva herself is portrayed as a typically virtuous Victorian heroine, and is suitably accompanied by an elderly handmaiden who joins her in prayer. Rather different in spirit is *Lady Godiva's Ride* by the late 19thC artist, the Hon. **John Collier**, which features a very young and attractive girl. The gallery also has some charmingly naive studies of the Godiva procession by the local 19thC artist, **David Gee**.

DERBY
Derbyshire Map C2

Derby is an industrial town on the River Derwent. In the 18thC it was the scene of a thriving porcelain industry, and England's first successful silk mill was established here. The town's rapid growth in the 19thC came about principally through its development as the seat of the most important railway works in Britain.

Derby Museum and Art Gallery ☆
The Strand
Tel. (0332) 31111
Open Tues–Sat 10am–5pm
Closed Mon, Sun
[icons]

The Derby Museum and Art Gallery is devoted mainly to local industries, and you will see here much **Derby porcelain**, and numerous models of trains. Within this unpromising setting, you will also

come across the largest collection of works to be seen anywhere of one of Britain's most outstanding and original artists, **Joseph Wright of Derby**. Wright, the son of an attorney, was born in the town at 28 Irongate in 1734 (the site, now No 34, is marked with a plaque). After an initial training in London he returned to Derby, where he was to work intermittently until his death in 1797. Throughout his life Wright supported himself by doing local portraits, and one of these in the museum is *Sarah Carver and her Daughter* (1769–70), a painting remarkable for its unidealized rendering of the sitters' features.

However, the idea of being simply a provincial portraitist did not appeal to him, and from the mid 1760s he began exhibiting subject paintings in a dramatic style at the Society of Artists in London. The two most famous of these paintings, and indeed the works by which he is best known, are the museum's *A Philosopher Lecturing on the Orrery* (c.1764–6) and *An Experiment on a Bird in the Air Pump* (1768) in the Tate Gallery, *LONDON*. In these works he combined his interest in science with a dramatic chiaroscuro inspired by 17thC artists. Many of his friends in Derby were scientists, including Erasmus Darwin (see Wright's **portrait** in the museum), and Peter Perez Burdett, a surveyor and mathematician (who appears on the left of the *Orrery* picture).

Both Darwin and Burdett belonged to a group of Midlands intellectuals known as the Lunar Society, who met on or near the date of the full moon so that they could ride home by moonlight. This society organized lectures in Derby, including, in 1762, a series given by a Scottish scientist, James Ferguson, who is known to have used an orrery (a mechanical model of the solar system) in his demonstrations. Wright's portrayal of the scientific world, for all its realism and attention to detail, remains a deeply romantic one. The museum's *Alchemist in Search of the Philosopher's Stone Discovers Phosphorus* ★ was influenced by a French treatise on chemistry that Wright had read in an English translation (1771) by a Lunar Society member, James Keir. But despite such a sober and serious source, Wright represents the scientist as a mad bearded old man working at night in a ghoulish, Gothic setting.

The romantic side to Wright's art is illustrated in particular by his obsession with mortality, as for instance *Hermit Studying Anatomy* ★, which again is set at night and shows a long-haired old man in a cave contemplating the bones of a skeleton. A similarly morbid note even

characterizes his first major attempt at rendering Classical subject matter, **Miravan Opening the Tomb of his Ancestors ★★** (1772). The unusual story which Wright chose to portray concerns an avaricious young nobleman who opens the tomb of his ancestors in the hope of finding the treasure mentioned in an inscription on the tomb. He finds instead only bones and dust, the promised treasure being merely the eternal rest of death. Wright depicts Miravan reeling from the shock of the discovery in yet another dark and dramatically lit setting. You can see the artist's passion for haunting nocturnal effects in most of his landscapes, the first important example of which is the **Earth-Stopper on the Banks of the Derwent ★**, showing in its right hand corner a solitary man blocking up the den ("earth") of a fox.

Soon after painting this Wright went to Italy, where his interest in antiquity intensified. He was there to witness the eruption of Vesuvius in October 1774, an event which drew many artists to Naples. Wright's interest was characteristically both artistic and scientific, and he at once sent details to his friend at the Lunar Society, John Whiteman the geologist. The artist's powerful **gouache study** of Vesuvius in the museum was the precursor of a series of paintings on this subject that would preoccupy him for another 20 years. Returning to England in 1775, Wright attempted unsuccessfully to take over the portrait practice recently vacated by Gainsborough in Bath; he was back in Derby by 1777.

One of Wright's most famous subject pictures of his later years is the **Indian Widow** (1785), which was probably inspired by Adair's *History of the American Indians* and features the heroine outlined against a violent and strangely glowing sky, with an erupting volcano on one side and a turbulent sea on the other. His preoccupation with themes of mortality increased with age, as did his interest in landscape painting. The outstanding picture of this period is the **Landscape with Rainbow ★** (c.1794–5), a dark and disturbing work with, in its left foreground, a tiny figure of a man hurrying his cart to escape from the storm, a symbol perhaps of the feelings of the by now ageing and sick artist at the approach to death.

DUDLEY
West Midlands Map B3

A major historic center of the iron industry, Dudley now commands some of the most extensive views to be had of the vast urban industrial sprawl that stretches from Birmingham to Wolverhampton. At the top of the wooded hill dominating the town are the impressive ruins of a **medieval castle**. You can reach this from the site of Dudley's other main attraction – its zoo – by a chairlift that passes over the heads of bewildered llamas.

Dudley Museum and Art Gallery
St. James's Rd
Tel. (0384) 55433
Open Mon–Sat 10am–5pm
Closed Sun
📷 ♿

This old-fashioned late 19thC museum has a small permanent collection of 19th–20thC British art, including works by leading British painters such as **Brangwyn, Benjamin Leader, Paul Nash** and **Nevinson**. Of particular interest are its holdings of the little-known Dudley artist, **Percy Shakespeare**, who showed brilliant promise during the 1930s but was killed in World War II before obtaining more than local recognition. He specialized in simplified figurative scenes with a strong surreal and humorous character, most notably his masterpiece, **The Bird House, Dudley Zoo ★**.

Unfortunately, the space available for showing pictures in the museum is small and generally taken up by touring exhibitions, often of mediocre contemporary art. However, a room on the top floor of the building has recently been made the permanent home of the **Brooke Robinson Museum**. Brooke Robinson was an industrialist and politician who, when he died in 1911, left £30,000 to build a museum in memory of his first wife and her father. After several years of legal complications his will was altered by a special Act of Parliament so that his money could be used to help build the rather strange Tudor-style town hall you can see opposite the Dudley Museum. A room in the town hall was set aside for Robinson's art collections, but they remained virtually unseen until they were transferred to the Dudley Museum.

The collection consists of a few **18thC Dutch flower pieces**, many **Victorian portraits** by minor artists, a few pieces of **Sèvres porcelain** and several examples of the black, inlaid **papier mâché furniture** that was made in Birmingham and Wolverhampton in the 19thC. None of these items have any great individual value but, displayed as they are in a Victorian skylighted room with potted plants, they have a certain nostalgic appeal.

DUDMASTON HOUSE ⌂
Quatt, Bridgnorth, Shropshire Map B3
Open Apr – Sept Wed, Sun 2.30 – 6pm
Closed Mon Tues Thurs – Sat Apr – Sept;
Oct – Mar
🖼 🅿 🏛 ♿

Occupying particularly beautiful wooded
grounds with views down to a large lake,
Dudmaston was built c. 1695 – 1701 and
partially remodelled in the 1820s. Inside
the house you will find British and
Continental **furniture** and, in the
library, some pleasant **18thC flower
pieces**. However, the interest of the
interior lies principally in the collections
assembled by the diplomat Sir George
Labouchère and his wife Rachel. These
include some outstanding **Chinese
porcelain** of the Sung and Ming periods,
and a large collection of 18thC and
19thC **topographical watercolours**,
many of which were bought as reminders
of places where Sir George served in the
diplomatic service. Another of these
collections comprises works by **botanical
artists**, ranging from the great masters of
the 18thC, such as **Ehret, Redouté,
Reinagle** and **Fitch**, to this century's
John Nash, under whom Rachel
Labouchère studied botanical art at
Flatford Mill in Suffolk.

But what makes Dudmaston special
among English country houses, indeed
almost unique, is its extensive collection
of **contemporary art**. Among the earliest
of these works are **drawings** by the minor
Impressionists **Maximilien Luce** and
Armand Guillaumin, and the Fauves,
Matisse and **Albert Marquet**. A bronze
medal by **Hans Arp**, an etching by
Kandinsky and a charming pastel by
Sonia Delaunay entitled *Flamenco
Dancers* serve as early examples of
abstract art, which is the great strength
of the collection.

George Labouchère's first purchases of
contemporary art were by British artists
associated with Abstraction, such as
**Henry Moore, Barbara Hepworth, Ben
Nicholson, Kenneth Armitage, Lynn
Chadwick** and **Alan Davie**. Then he
began acquiring works by French and
American Abstract artists of the 1950s,
including **Soulages, Serge Poliakoff,
Vasarély, Marin, Tobey** and **Sam
Francis**. At the same time, he developed
a great interest in the work of the avant-
garde artists with whom he came into
contact when ambassador to Belgium
from 1955 – 60 and to Spain from
1960 – 66. Spanish abstract art, which is
characterized by a violent expressiveness
and a sober use of greys and blacks, is
particularly well represented, with works

by such artists as **L. Muñoz, P. Serrano,
M. Millares** and **O. Rivera**, who deserve
to be better known outside their own
country, as well as two important works
by the leading Catalan artist of recent
times, A. Tàpies, *Composition* (1961)
and *Painting with Newspaper* ★ (1964).

HAGLEY HALL ⌂
*Nr. Stourbridge, West Midlands
Map B4*
Tel. (0562) 882408
*Open Apr May Sat Sun; June – early Sept
Mon – Sun 12.30 – 5pm*
Closed Mon – Fri Apr May; mid Sept – Mar
🖼 🍴 🅿 🏛 ♿

Hagley is a rather grand 18thC mansion
in the Palladian style designed by
Sanderson Miller, an architect and
gardener generally associated with the
early Gothic Revival. This house,
however, has a rich diversity of styles, the
sober façade giving way to a flamboyant
Rococo interior with elaborate
plasterwork by **Vassalli**. Most of the
contents, including furniture, tapestries
and porcelain, are also from the 18thC as
are the bulk of the paintings with
portraits by **Batoni, Van Loo, Ramsay,
Wilson, Reynolds** and **West**, and some
decorative landscapes by **Zuccarelli** and
Cipriani. There are also some earlier
pictures such as the genre scene *The
Misers* by **Van Rymerswaele** and, given
pride of place, two works by **Van Dyck**; a
Portrait of the 2nd Earl of Carlisle and,
less predictably, a *Descent from the
Cross*.

IRONBRIDGE
Shropshire Map B3

You may find it difficult to believe today
that the quiet wooded gorge in which the
village of Ironbridge is situated can claim
to be the birthplace of the Industrial
Revolution. The iron bridge that spans
the River Severn at this point was the
first of its kind; Abraham Darby III
designed it in 1779 at his grandfather's
pioneering iron foundry at nearby
Coalbrookdale. The stretch of river
between Ironbridge and Coalbrookdale is
now occupied by an exciting museum
complex dedicated to the history of this
important early industrial site.

Ironbridge Gorge Museum
Tel. (095 245) 3522
Open Mon – Sun 10am – 6pm
The Coach House Gallery, within the
Ironbridge Gorge Museum complex,
mounts well displayed and informative

exhibitions culled principally from the museum's extensive collection of works of **fine and applied art** relating to Ironbridge. This area was enormously popular with British artists of the Romantic generation, who often stopped here on their way from London to North Wales to admire its combination of luscious scenery and spectacular industrial workings. The most famous painting to have been inspired by the place was de Loutherbourg's *Coalbrookdale by Night*, now in the Science Museum in *LONDON*. Few other works of this time convey so brilliantly the sense of excitement and terror which the region inspired at a time when people were not accustomed to seeing the dramatic light effects created by industrial lime kilns and ironworks.

The museum's holdings are more modest, comprising mainly **18thC and 19thC graphic work** of more historical than artistic interest.

KELMSCOTT
Oxfordshire Map C5

The well-kept village of Kelmscott, with its gabled stone houses, is one of the most important places associated with the poet, painter, craftsman and socialist visionary, **William Morris**, who lived at the Manor and is buried in the village churchyard. You can see his tree-shaded grave there with its simple stone carved by his associate **Philip Webb**.

Kelmscott Manor
Open Apr–Sept 1st Wed each month
 11am–1pm, 2–5pm
Closed Oct–Mar
🎦 🏛 ♿
William Morris and his Pre-Raphaelite friend **Dante Gabriel Rossetti** took the joint tenancy of this typical late 16thC Cotswold stone house in 1871. Rossetti came here principally to be near his favourite model, Morris's beautiful wife Jane. His interest in her eventually caused tensions between the two men, and Rossetti discontinued his visits after 1876. The Manor's exterior features as the frontispiece of Morris' utopian novel, *News from Nowhere* (see p.126). The interior contains **memorabilia** relating to him and is furnished with many items designed by Morris and his associates.

KETTERING
Northamptonshire Map D4

Kettering is like a small version of **NORTHAMPTON**, both in its general lack

of distinction and in its renown as a shoemaking center. Its liveliest part is arranged round a large market square, where markets are held three times a week. Near to this is the SIR ALFRED EAST GALLERY.

Alfred East Art Gallery
Sheep St
Tel. (0536) 85215
Open Mon–Wed Fri Sat 10am–5pm
Closed Thurs Sun
📷 ♿
The Sir Alfred East Gallery is a small early 20thC building in a Classical style attached to the town library. It is named after a late 19thC landscapist, whose large bequest of **paintings and watercolours** to his native town formed the basis of the gallery. This was opened in 1913, but East was too ill to attend the ceremony. He died shortly afterwards and his body lay in state in the library. To judge by his dull, extremely conventional works on display here, consisting mainly of equally uninspired Midlands scenery, it is difficult to understand why he was rated so highly in his day.

A more interesting local artist was East's contemporary **T.C. Gotch**, a leading member of the **Newlyn school** (see *WESTERN ENGLAND*). Gotch was known for his soft-featured representations of children and young women, whom he invariably portrayed in a decorative or symbolical setting. Typical examples of these are the gallery's *Death of the Bride* and *The Bow*, showing, respectively, one young woman surrounded by flowers and another holding a sword. There are numerous other works by him here in different media, perhaps the most appealing of which are a series of free and very spontaneous **watercolours** done mainly in and around Newlyn.

Up to 1953 the gallery's holdings were almost exclusively of a local nature; but since then it has adopted a policy of acquiring works by 20thC British artists such as **Stanley Spencer**, **Mark Gertler**, **Vanessa Bell**, **Wyndham Lewis**, **Ivon Hitchens** and **Alan Davie**. As space is extremely limited, little of the permanent collection is on view at any one time.

LEAMINGTON SPA
Warwickshire Map C4

Royal Leamington Spa, one of the most elegant small towns in the Midlands, retains many of its fine terraces and parades dating from its heyday as a spa resort in the late 18thC and early 19thC.

Leamington Spa Art Gallery
Avenue Rd
Tel. (0926) 26559
Open Mon – Sat 10am – 12.45pm, 2 – 5pm,
 (Thurs evening 6 – 8pm)
Closed Sun
▨ ☑

The Leamington Museum and Art
Gallery is situated slightly outside the
town center and is therefore unlikely to
attract as many visitors to the town as it
should. Opened in 1928 but in spirit
belonging firmly to the 19thC, it
encapsulates many of the more delightful
if ephemeral features of a small provincial
museum. It has collections of **pottery**,
porcelain, **glass** and **paintings**,
interspersed with such diverse objects as
an old doll's house, a reconstruction of a
Sedan chair, a case of butterflies and an
Egyptian mummy case of c.550BC.
Connoisseurs of the eccentric will
appreciate the pair of glasses worn by an
18thC postman and a lethal looking
penknife containing 366 blades.

As you would expect, the museum has
a number of paintings by local 19thC
artists, most notably **Thomas Baker**,
whose dubious talents nonetheless earned
him the epithet "Landscape Baker".
However, the gallery rightly prides itself
on having many paintings by artists with
no local connections. Admittedly, the
17thC Dutch and Flemish paintings seem
to bear rather dubious attributions (the
main exception is an excellent *Self-
portrait by Candlelight* ★ by G.
Schalken), but the English 20thC is
admirably represented, with works
ranging from a pleasant portrait of a *Girl
in a Red Hat* by the Edwardian painter
Clausen, to Abstract paintings by
contemporary artists such as **Terry Frost**
and **Peter Lanyon**.

LEICESTER
Leicestershire Map D3

Before the Romans established their
township of Ratae here, Leicester was a
Celtic settlement. The massively built
Jewry Wall testifies to the Roman
occupation, but you tend to forget
Leicester's long history when confronted
with the largely modern industrial town
of today. The place has something of a
reputation for grimness, though it is
perhaps worth pointing out that by far the
ugliest of its modern buildings are those
belonging to its university. There are in
fact some very pleasant areas in the
town's central part, most notably around
the quiet and shaded **New Walk**, a
pedestrian street laid out in Regency
times.

Leicestershire Museum and Art Gallery ☆
New Walk
Tel. (0533) 554100
Open Mon – Thurs Sat 10am – 5.30pm,
 Sun 2 – 5.30pm
Closed Fri
▨

The Museum and Art Gallery, situated
on the New Walk, occupies a porticoed
Classical building dating from the late
19thC. The largely modernized interior
has a slightly makeshift character, partly
a result of the museum's policy of
constantly loaning and rearranging its
pictures. These are shown mainly on the
first floor, though a large and imposing
ground floor room (easily missed by the
uninitiated visitor) displays a selection of
Victorian works. The early foreign
school holdings are not the museum's
strong point, but recently they have been
greatly enhanced by the acquisition of a
small panel by the 14thC Sienese artist
Lorenzo Monaco (*St John the Baptist
entering the Wilderness*) and a painting
of a *Choirboy* ★ singing by the light of a
candle by the 17thC French painter
Georges de la Tour. This last work,
shown to the public for the first time in
February 1984, was offered to the
museum in a rather poor state, and was
only fully recognized as by La Tour after it
had been brilliantly cleaned and restored
by the museum's senior art restorer,
Gillian Tait. La Tour's accepted oeuvre is
relatively small, and it is curious that two
of the most recent additions to it (this
and a painting now in the Preston Hall
Museum in Stockton, see NORTHERN
ENGLAND) were both at one time in
Leicestershire collections. Though not
one of his finest works, it has the formal
simplicity and serenity of mood which
make this artist so popular today.

The museum's first important **English
paintings** date from the 18thC and early
19thC and include a haunting moonlit
landscape by Joseph Wright of Derby
(*High Tor, Matlock* ★), a charming
study of a boy with a hoop by **John Opie**,
and a dark, commanding portrait by Sir
Thomas Lawrence of *William Brabazon*
★. You should also note a magnificent
painting by de Loutherbourg, showing
*Richard the Lionheart Conquering the
Saracens* ★. This exceedingly dramatic
work, with the figure of the hero acting as
the pivotal point of an agitated, smoke-
filled composition, was one of a series of
paintings commissioned from the leading
artists of the day to depict "the most
important events in British history". The
whole series was bought up in 1792 by the
miniature painter Robert Bowyer, who
eventually had the works engraved.

One of the most well-known figures in the British art world at this time was **Sir George Beaumont**, whose home from 1808 until his death in 1827 was at Coleorton Hall, about 15 miles NE of Leicester. Beaumont was an important patron and connoisseur, whose collection of Old Master paintings was instrumental in helping to set up the National Gallery in London. Although his views on art were firmly rooted in the 18thC (upholding as he did the Classical landscape tradition as represented by Claude and Richard Wilson), Beaumont took a close interest in such avant-garde early 19thC artists as John Constable: the latter's celebrated **Cenotaph** in the National Gallery in *LONDON* was painted from a monument that Beaumont had erected to his friend Sir Joshua Reynolds.

Beaumont was also an amateur painter and the many works here reveal him to have been a conventional and barely competent artist: the finest of these is the dramatic *Peel Castle in a Storm*, which shows a strong influence from the art of his friend Turner.

The museum boasts some splendid **High Victorian paintings**, including a reduced version of Frith's *The Railway Station*, Dyce's *The Meeting of Jacob and Rachel* ★, Watt's singularly dramatic *Orlando Pursuing the Fata Morgana* ★, and a large roundel by Lord Leighton of *Perseus on Pegasus Hastening to the Rescue of Andromeda*. Among the substantial holdings of British art from the late 19thC to the present day is a very fine group of **Camden Town school** paintings, most notably **Gore's** colourful study of **Harold Gilman's** extremely suburban house at *Letchworth* ★, and Bevan's *From the Artist's Window*, which shows the view from his house at 14 Adamson Road in Hampstead, London, a building previously owned by the KETTERING painter Sir Alfred East. Other British paintings of note are **Sir William Rothenstein's** updating of a subject very popular with Italian Renaissance painters, *The Toilet*; a portrait by Orpen of *Elizabeth Ann Ferrier* lying on a couch in a Spanish dress (the work is a clear homage to Manet); and an amusing study by **Spencer** of women bowing before a group of venerable bearded men in seedy overcoats, *Adoration of Old Men*.

The later foreign school works begin with Boudin's *Le Havre-Avant Port* and one of the Impressionist painter Degas' few rural scenes, *La Rentrée du Troupeau*, painted at a friend's country house at St-Valéry-sur-Somme in northern France. You will also find at Leicester a large collection of delicate **glassware** and related designs by the minor Fauve painter, **Maurice Marinot** whose work may be familiar – perhaps over-familiar – to visitors to French provincial museums. Marinot's works have been donated in large numbers to countless museums (including 4 in Britain alone).

An altogether more pleasant surprise is the museum's collection of **German Expressionist art**, the largest of its kind in Britain. The remarkable feature of this collection is that it began to be assembled during the 1940s, a time when few people in Britain took an interest in this art. The man responsible for initiating it was the then director of the museum, Trevor Thomas, who organized an exhibition of German Expressionist works in Leicester in 1948. In this he received the help of the local Free German League of Culture (an organization that looked after German artists and writer refugees), one of whose members, Tekla Hess, owned a number of Expressionist paintings. The museum purchased three key works from the exhibition, and received others through donations. Subsequently, Mrs Hess's son was released from internment to work for the museum, where he eventually became keeper of art.

The interest taken in German Expressionism by this museum is admirable but lack of adequate funding has restricted its holdings mainly to minor works, in particular **drawings** and **prints**. Three of the most important works were those purchased for the 1948 exhibition: Feininger's *Behind the Town Church* ★, Marc's *Red Woman* ★ and Nolde's watercolour, *Head with Red-Black Hair*. Another fine painting is Pechstein's *Coast Scene with Boats* ★, a work with a particularly yellow colouring much influenced by Van Gogh. But perhaps the most outstanding of all the German pictures is the portrait of *Carl Ludwig Elias* ★★ (1899) by an artist who was a precursor of the Expressionists, **Lovis Corinth**. This powerful study in grey and black owes something to the art of the French painter Manet, but is unmistakably German in its disturbing undertones.

LINCOLN
Lincolnshire Map E1

Situated in dull landscape, and surrounded by extensive industry, the town of Lincoln itself comes as a magnificent surprise, for it is built on a steep hill and capped by one of Britain's finest **medieval cathedrals** ★★. Work on

the cathedral was begun in the 11thC, but a fire followed by an earthquake in the next century led to extensive rebuilding in the 13thC. The W façade, the main block of which dates from Norman times, is famous for its sculptures: above the richly moulded central doorway are bands of **carved panels** ★ (c.1145) of Old and New Testament scenes, apparently influenced by those at the Cathedral of Modena in northern Italy. Another fascinating example of sculpture of this date is the representation of the Last Judgement on the tympanum of the **Judgement Porch** ★ on the S side of the cathedral. Among the more striking features of the unusually wide interior are the beautiful mid 13thC **stained glass** windows in the Great and W transepts, and the elaborately carved late 14thC **bench ends** and **misericords** of the magnificent **choir stalls** ★.

Usher Gallery
Lindum Road
Tel. (0522) 27980
Open Mon–Sat 10am–5.30pm, Sun 2–5pm
▓ ▨ ▥

The Usher Art Gallery is a 1920s Palladian-style structure within sight of the cathedral. It was the gift to the town of James Ward Usher, a jeweller and art lover who was at one time Sheriff of Lincoln. His personal collection consists of jewelled **watches** dating mainly from the 17thC, French and historical **portrait miniatures**, **mementoes** of Nelson and Napoleon, and **Sèvres, Meissen and English porcelain**; this is permanently on show in the Usher Room, together with a large collection of 18thC English **silver**.

The crowded gallery features numerous fine examples of local **Regency porcelain**, and an extensive collection of paintings, ranging from two panels of *St Mary Magdalene and St Catherine of Alexandria* by the 16thC Lombard painter, **Gaudenzio Ferrari**, to work by contemporary British artists such as **Bryan Wynter** and **Ruskin Spear**. Its strong point is the work of local painters, the most famous of whom was the leading early 19thC watercolourist, **Peter De Wint**. De Wint, who was born in Stone in Staffordshire in 1784, came to know Lincoln through an artist friend, William Hilton, whose parents lived in the town and whose sister De Wint later married. In 1814 De Wint and his wife bought a house near the cathedral on the corner of Drury Lane and Union Road (now marked with a plaque). The museum has numerous examples of his watercolours and also some of his few oil paintings, including a number of local views.

The late Victorian painter, **Charles Shannon**, the son of a Lincolnshire vicar, is represented in the museum by some portraits and a rather sensual nude. Shannon, one of the leading painters associated with the Aesthetic movement in late 19thC British art, lived for most of his life with the Beardsley-like illustrator Charles Rickets in an extravagantly decorated house in Chelsea in London.

A curious and little-known local painter of this same period was **William Tom Warrener**, who was born in Lincoln in 1861 and studied at the local art school before moving to Paris. In Paris he became friendly with Toulouse-Lautrec and achieved lasting fame through being the subject of Lautrec's famous poster, *The Englishman at the Folies-Bergère* (the study for this is in the Metropolitan Museum, New York). You can see in the museum the actual hat and gloves that feature in this picture, together with some works by Warrener himself, most notably *Le Lavoir* and a charming **oil painting** of the popular artists' colony on the outskirts of the Fountainbleau Forest, Grez-sur-Loing. Another room in the museum is devoted to Lincoln's most famous literary son, the poet Alfred Lord Tennyson.

NORTHAMPTON
Northamptonshire Map D4

Northampton is a sprawling county town best known for its shoemaking industry, which was established in the Middle Ages and achieved particular prominence after being called on to provide shoes for all of Cromwell's army. Amid much non-descript 19thC and 20thC architecture, you can see two important medieval buildings: the late Norman parish church of **St Peter** and the church of **St Sepulchre**, one of England's four round churches dating from the Norman period and modelled on the church of the Holy Sepulchre in Jerusalem.

Central Museum and Art Gallery
Guildhall Rd
Tel. (0604) 34881
Open Mon–Sat 10am–6pm
Closed Sun
▓

The Northampton Museum and Art Gallery occupies a late 19thC building erected on the basement of the old county jail. This architecturally uninspiring place contains on its ground floor a crowded, old-fashioned display of what claims to be the largest collection of shoes and boots in the world, with examples ranging from Roman times to

the late 19thC. Around the walls of this room you can see a selection from the museum's holdings of **prints**, **drawings** and **oil paintings** relating to the history of shoemaking. Among these is a small painting of a travelling cobbler attributed to the Dutch artist active in 17thC Rome, **Jan Miel**, an oil by **David Teniers the Younger** of a shoemaker in his shop and a drawing by **Rowlandson** entitled *The Cobbler's Cure for a Scolding Wife*.

Upstairs you will find a room devoted to local archaeology and crafts and 2 small, cramped rooms that contain the art gallery. In addition to paintings you will see an **Egyptian seated statue** of 2340BC, various **Oriental items**, and a tiny collection of **silver**. The paintings, which come as a pleasant surprise, include a number of **Flemish** and **Dutch works**, most notably a fine *Madonna and Child* attributed to the early 16thC Flemish artist **Adriaen Ysenbrandt**, and a curious satirical painting by David Teniers, *Cats in a Monkey's Barber Shop*. The Italian Renaissance is represented by a **marriage chest** of c.1470 decorated with panels thought to be by Sienese artists in the circle of **Francesco di Giorgio** and **Nerocci di Landi**. Three of these amusingly naive panels portray Ovid's story of Hippomenes, who ran a race against Atalanta in order to win her hand. The other Italian paintings are almost all of the 18thC. Two of the finest are a view of *St Mark's Square* by Guardi and a *Venus and Cupid* by the Venetian decorative painter, **G.A. Pellegrini**.

NOTTINGHAM
Nottinghamshire Map D2

Nottingham achieves visual distinction among the main industrial towns of the Midlands by virtue of its **castle**, which stands impressively behind the city center on a tall bluff of sandstone. At one time the most important fortress in the Midlands, the original castle was built shortly after the Norman Conquest and was used in the Middle Ages as a royal residence. But its history has been a troubled one, and, now owned by Nottingham Corporation, it still retains on the outside a battered, unloved appearance. The castle houses Nottingham's museum and art gallery.

Nottingham Castle Museum ☆
Tel. (0602) 411881
Open Apr–Sept Mon–Sun
 10am–5.45pm; Oct–Mar Mon–Sun
 10am–4.45pm
🄫 ☑ ⛶ ♿
The Castle Museum and Art Gallery used

to be scarcely less depressing than the passageways and dungeons within the rock on which it stands. Even today it has not entirely lost its morgue-like character, yet admirable attempts are being made to liven the place up, not least by putting on extremely imaginative exhibitions, as, for example, a major show recently of women's art.

The ground floor displays most of the museum's archaeological and ethnographic holdings, as well as a collection of mainly English **18thC silver**, and **English ceramics** from the Middle Ages to the present day. A small room off the half-landing between the ground floor and first floor is taken up by **Classical pots**, **votive terracottas** and fragments of **statues** from the Temple of Diana at Nemi near Rome; these were excavated in 1885 by John Savile Lumley, the British ambassador in Rome, whose ancestral home was Rufford Abbey near Nottingham. The earliest works of art that you will see on the first floor are some **medieval alabaster carvings** made in Nottingham. The town was famed for such carvings from the mid 14thC until 1550, when their manufacture was banned by an Act of Parliament.

Most of the museum's paintings on show are housed in the Long Gallery adjoining the alabaster display. The earliest important work here is *The Christ Child Learning to Walk* ★ by the 16thC Ferrarese **Dosso Dossi**, a small jewel-like painting that lay unnoticed in the museum's reserve collection until very recently. But the outstanding Old Master painting in the museum is LeBrun's **Hercules and Diomedes** ★★, which illustrates the legend of Hercules' taming of the man-eating horses of Diomedes by killing their master and feeding them his flesh. Painted when the artist was only 21, it reveals a vigour of handling and composition that is in marked contrast to the arid Classicism of LeBrun's later years, when he was the arbiter of taste at the court of Louis XIV.

The remaining 17thC paintings in the Long Gallery are of little interest, comprising largely indifferent **Dutch and Flemish works**. The monotony of the 18thC holdings is relieved only by two paintings by **Richard Wilson**, a replica of his view of *Snowdon from Llyn Nantle* in the Walker Art Gallery in Liverpool (see *NORTHERN ENGLAND*) and another painting of *Llyn Nantle* ★ from a different viewpoint and in cloudier conditions.

At the end of the Long Gallery you reach the **19thC paintings**, and here the museum livens up again with some marvellous late **Victorian subject**

pictures, including Laslett Pott's *Mary Queen of Scots Led to her Execution* and Marcus Stone's *In Love*, which shows a man in an 18thC costume staring pensively over a table at an insipid-looking girl doing some sewing. Alongside these Victorian paintings are foreign works of this period in a similarly absurd vein, most notably Gioacchino Pagliey's softly pornographic *The Naiads*, which shows two naked women, one of whom lies on her back playing with some fluttering seagulls in a pose clearly derived from Courbet's *Woman with a Parrot* in the Grand Palais in Paris.

Amusing though these works are, the visitor to the museum will probably prefer to remember the paintings displayed in the room beyond, which is devoted to Nottingham's greatest artist son, **Richard Parkes Bonington**. Bonington was born in Arnold, 3 miles to the N of Nottingham, in 1802 (the High Street is marked by a plaque). Most of his short life (he died aged only 25) was spent in Paris, where his family moved in 1818; for a while he shared a studio with his friend and admirer Delacroix. He is known principally as a landscapist, though he also painted historical paintings reminiscent of some of those of Delacroix, including the museum's *Quentin Durrant at Liège*. His landscapes are generally small in size and notable for their remarkable freshness and lively handling of paint; an excellent example at Nottingham is *Fisherfolk on the Coast of Normandy* ★. In the same room you will also find **drawings** and **watercolours** by him (note the vividly coloured *Castelbarco Tomb, Verona* ★), and an oil sketch by **Delacroix** of *Tam O'Shanter*, painted while he was sharing the studio with Bonington.

The museum also has a representative selection of **20thC British art**, though at present only a tiny selection of this is on display, mainly on the walls of the principal staircase. However, another room on the first floor will soon be displaying a further selection from the museum's 20thC holdings. Among the works of this period are paintings by two of Nottingham's leading painters in the early years of this century, **Sir William Nicholson** and **Dame Laura Knight**.

OXFORD
Oxfordshire Map D5

Oxford claims to be the seat of the oldest university in the world after the Sorbonne in Paris, and has a skyline of towers, domes and spires that is perhaps the most beautiful of any English town. The university was certainly in existence by the 12thC, but its exact origins are not known, and it has even been suggested (rather implausibly) that it might have been formed as a result of the expulsion of foreign students from Paris. In contrast to Cambridge, the university buildings here are scattered throughout the town, which is itself a lively place. One of the most famous of these buildings is the **Sheldonian Theatre**, which was designed by **Sir Christopher Wren** in the 1660s as a place where the university's public ceremonies could be held. The flat, semi-circular **ceiling** inside was decorated by **Robert Straeter** with an allegory of *Truth descending on the Arts and Sciences*. This Baroque work, clumsy and heavy-handed though it is, has the distinction of being the most important large-scale decorative painting executed by an English artist before Thornhill.

Another prominent Oxford monument is the **Bodleian Library** (generally referred to by students as the "Bod"). Founded in 1662 by Sir Thomas Bodley, it incorporates an earlier structure (with a magnificent large **15thC painted wooden ceiling**), which once contained the library of Duke Humphrey, the youngest brother of Henry V. In the New Bodleian, an early 20thC structure joined to the old building by an underground passage, is the **Upper Exhibition Room**, which shows a selection of some of the Library's most interesting **books** and **manuscripts**. These include various illuminated **Books of Hours**; Caedmon's metrical translation of Genesis in Old English (c.1000) with outlined **drawings** of the **Winchester School**; Persian illuminated **manuscripts**; and Caxton's *Mirror of the World* (1481), the first illustrated book printed in England.

The college richest in art treasures is undoubtedly **Christ Church** (see below), but a number of other interesting works of art can be seen in the other colleges. You should not fail to pay a visit to **Jesus College**, which has portraits attributed to Zuccaro (*Elizabeth I*), Van Dyck (*Charles I*) and Lely (*Charles II*). It also has a splendid portrait by the Pre-Raphaelite painter **Holman Hunt** of the *Reverend J.D. Jenkins in New College Cloisters* ★. A more famous painting by Hunt is his *Light of the World* ★, which hangs in the specially built side chapel attached to the S side of **Keble College Chapel**. To paint this picture, which shows Christ standing in a rural setting at night holding a lantern, the artist constructed a straw hut in an orchard, where he would go and work at midnight.

William Morris and **Edward Burne-Jones**, two later associates of the Pre-Raphaelites, were theology students at Exeter College before turning to art after seeing a work by **Millais** in a private collection (*The Return of the Dove to the Ark*, now in the ASHMOLEAN MUSEUM). But the Pre-Raphaelite who was to have the greatest influence on the development of their art was in fact **Dante Gabriel Rossetti**, to whom they were introduced at Oxford while still undergraduates. Their first artistic endeavour was to assist **Rossetti** in the decoration of the **New Debating Hall** (now the library) of the Oxford Union. The **murals** they painted there represent incidents from Malory's *Le Morte d'Arthur* (1470), but they were executed in an amateurish technique and have now faded almost to the point of invisibility. However, you can see some splendid **tapestries** by these artists, hung in the Victorian chapel of Exeter College.

Not least among the art treasures of the Oxford colleges are a series of humorous drawings by the writer and caricaturist **Max Beerbohm**, which are kept in the Beerbohm Room in **Merton College**. Beerbohm's days at Oxford inspired, of course, his famous novel *Zuleika Dobson* (1911), which tells of the havoc wrought on the undergraduates by the arrival of the beautiful heroine.

The Ashmolean Museum ☆☆
Beaumont St
Tel. (0865) 512651
Open Tues – Sat 10am – 4pm, Sun 2 – 4pm
Closed Mon
🅿 👜 🏛

The Ashmolean Museum originated in a large collection of miscellaneous items, mainly of scientific rather than artistic interest, that was presented to the university in 1675 by Elias Ashmole (referred to in his time as "the great virtuoso and curioso"). The building that was made to house this gift was opened in 1683 and was the first truly public museum in Britain. Its collections rapidly expanded, particularly in the field of archaeology, and eventually were incorporated into the present Classical-style building, which was designed by **C.R. Cockerell** and erected between 1839 and 1845.

Up to this date the museum's fine art holdings were relatively slight, but they increased significantly after 1850. Lack of space soon led to the transfer of much of the scientific part of the collection elsewhere, and numerous structural additions have been made to Cockerell's building. The Ashmolean Museum today is a most confusing, stuffy and old-fashioned place, and a visit here is heavy going. In complete contrast to the Fitzwilliam Museum at Cambridge, (see *EAST ANGLIA* section), it has more of the character of a didactic institution rather than that of a museum where art can simply be enjoyed. But its collections are among the finest in Britain.

The museum is dominated by its archaeological holdings, which take up much of the 2 main floors of the building. On the ground floor you will see in the Randolph Gallery an extensive collection of **Greek, Hellenistic** and **Roman sculptures** mainly assembled by Thomas Howard, Earl of Arundel. Arundel, a leading figure at the court of Charles I, was one of the most enlightened patrons of the arts in 17thC England, and a man with an extraordinary range of cultural interests.

At the end of the Randolph Gallery you come into a series of rooms devoted to ancient Egyptian finds, among which is the impressive **Shrine of Taharqa from Kawa** (7thC BC), adorned with **bas-reliefs** and with wall paintings from Tell el Amarna. A room beyond these houses a collection of **18thC Worcester porcelain**. Returning to the Randolph Gallery, and turning to your left, you will reach the small medieval room, where the principal treasure is the **Alfred Jewel ★** of the 9thC AD: this is an exquisite object comprising a small cloisonné enamel encased in an intricately decorated gold mount attached to an animal-headed socket; it bears the inscription "Alfred had me made" and is presumed to have belonged to Alfred the Great (849–99).

The remaining rooms on the ground floor are taken up by the collections of the Department of Eastern Art, which include excellent examples of **Gandhara sculpture** from India, **Chinese bronzes**, **ceramics** and **pottery tomb figurines**, and **Japanese** and **Persian ceramics**. If you walk to the first floor by way of the main staircase you will find yourself in the Founder's Room, which has **portraits** of Elias Ashmole, and of John Tradescant the Elder and his son. The Tradescants followed the Renaissance example of forming what the Germans called a *Wunderkamner*, or a collection featuring a miscellaneous range of curiosities. Adjoining the Founder's Room is a room that gives some idea of the character of the Tradescants' *Wunderkamner*, which has some very strange objects indeed, including Guy Fawkes' lantern.

Beyond this are the remaining archaeological rooms of the museum, with finds from Sir Arthur Evans' excavations at **Knossos** in Crete, some

marvellous black- and red-figure **Greek vases**, and a renowned collection of **Anglo-Saxon antiquities**.

Finally, you come to the main fine and applied art section of the museum. This is particularly famous for its holdings of **14thC** and **15thC Italian art**, much of it donated to the museum in the 19thC by the Hon. William Fox-Strangways. Fox-Strangways formed his collection while on diplomatic service in Italy in the first half of the 19thC, and was unusual among English connoisseurs for taking an interest in this early period in Italian art. The most famous painting acquired by him was Paolo Uccello's *The Hunt* ★★ (c.1469). Showing hunters and hounds all converging on a central point in a forest, it is a magnificent illustration of Uccello's obsession with perspective.

Next to *The Hunt* is another masterpiece of the Florentine 15thC, Piero di Cosimo's *Forest Fire* ★★. According to Vasari, Piero di Cosimo led a hermit-like existence, despising the behaviour of civilized society and living exclusively on a diet of hard-boiled eggs cooked in advance in large numbers. He apparently far preferred the company of animals to that of human beings.

Among the many other Italian Renaissance paintings in the collection, special mention should be made of the Virgin and Child (*The Tallard Madonna* ★) by **Giorgione**, showing the unfinished campanile of St Mark's in Venice in the background; a powerful *Resurrection* by **Tintoretto**, probably intended as a study for a ceiling painting; a splendid portrait of *Don Garzia de Medici* ★ by **Bronzino**; and (one of the great rarities in the collection) an unfinished grisaille of *The Return of the Holy Family from Egypt* ★ by **Michelangelo**. Shown alongside Italian paintings of this period are some wonderful Italian **Renaissance bronzes**, including a delightful *Pan* ★ by Andrea Briosco (known as **Riccio**).

Later Italian art is not so well represented in the museum, but you can nonetheless see a fine group of works by 18thC Venetian artists. These include a most vividly painted **study** ★ by G.B. **Tiepolo** of a woman in green holding a parrot; Canaletto's *View of Dolo on the Brenta* ★, (an early work painted with that same freshness and simplicity that you will find in his *Stonemason's Yard* in the National Gallery in *LONDON*); and Guardi's *Pope Pius VI Blessing the Multitudes in the Campo SS Giovanni e Paolo* ★.

Outstanding among the other pre-19thC foreign school holdings is **Claude Lorrain's** landscape showing *Ascanius shooting the stag of Sylvia* ★★. Executed in 1682, the year of Claude's death, it is an intensely lyrical canvas painted, like all the great works of his old age, in a range of colours comprising the subtlest shades of blue, green and silvery grey.

Three rooms on the building's second floor show the museum's collection of **17thC** and **18thC Flemish**, **Dutch** and **British** art. This is generally disappointing, though you will see some impressive oil sketches by **Rubens** and **Van Dyck**, a lively *A Man Playing the Bagpipes* (1624) by Terbrugghen, and two characteristically serene **landscapes** by **Richard Wilson**. Returning back to the first floor, you should proceed to the room containing the museum's large group of **Pre-Raphaelite works**, all of which were donated by Thomas Combe (look for the fine portrait of him here by **Millais**). A devout churchman, Combe was known as "the Early Christian" because of his deep involvement with the Oxford Movement, a Victorian religious group. In its nostalgia for medieval Christianity the Oxford Movement had a clear tie of sympathy with Pre-Raphaelitism. The most important Pre-Raphaelite paintings in Combe's collection were of religious subjects, including Holman Hunt's *A Converted British Family Sheltering a Christian Missionary from the Persecution of Druids* ★ (1849–50), which was intended as a pendant to Millais' *Carpenter Shop* now in the Tate Gallery in *LONDON*.

For the models of his converted British, Hunt was led to Battersea Field in London in search of gypsies "of a proper savage brownness" but for the head of the missionary he used his friend and colleague Rossetti. The work did not meet with quite the same degree of hostility as did Millais' *The Carpenter's Shop*, but nonetheless its subject matter, emphasizing the artist's interest in monasticism, was anathema to conventional Protestant critics. Charles Collins' *Convent Thoughts* ★ (1850–1), painted in Combe's garden, was also a highly controversial work and was accused of "Popery". The picture's carved gilt frame featuring lilies was designed by **Millais**, whose finest work in the museum is *The Return of the Dove to The Ark* ★, the painting that had such an impact on the young Burne-Jones and William Morris.

The museum's later 19thC holdings are particularly notable for their **French Impressionist paintings**, among which are several works by **Pissarro** in a Pointillist style and **Toulouse-Lautrec's** very expressive *La Toilette* ★, showing the back view of a woman fastening her

hair before a mirror. British art from the late 19thC onwards is represented principally by some fine **Camden Town school** works, including Sickert's *The Lady in the Gondola* and one of **Harold Gilman's** studies of his housekeeper, *Interior with Mrs Mounter* ★.

Finally, it should be said that the museum has one of the finest **print rooms** ★ in the country, with large groups of works by **Raphael**, **Michelangelo**, **Claude**, **Samuel Palmer**, **Turner** and **Ruskin**.

Christ Church Picture Gallery
(By Canterbury Gate)
Tel. (0865) 242102
Open Mon – Sun 10.30am – 1pm, 2 – 4pm
📷 ☑

Christ Church Picture Gallery has a relatively large collection of paintings, principally from **Italian 14thC – 18thC schools**, beautifully displayed in a quiet modern setting. It has to be admitted, however, that many of these paintings are dull and minor works. The one truly memorable early painting in the collection is not an Italian work, but a fragment of a *Lamentation* ★ presumed to be by the 15thC Flemish artist **Hugo van de Goes**. Showing the head of the Virgin and of St John, with tears welling from the Virgin's sore red eyes, it is an almost painful representation of grief by an artist who was known to be a depressive.

The later holdings of Christ Church are particularly strong in paintings by the great Bolognese artists of the 17thC, including a *St John the Baptist* by **Guercino**, two landscapes by **Domenichino**, and a remarkable group of works by **Annibale Carracci**. One of these shows the Virgin and Child in the clouds floating over Bologna, and was owned by the English Baroque painter Sir James Thornhill. The others are all genre scenes, most notably the large *Butcher's Shop* ★, which might represent members of the artist's family (his uncle was a butcher). Flemish art of the 17thC is represented principally by some works by **Van Dyck**, painted while still heavily under the influence of his teacher Rubens: *The Continence of Scipio* and three monochrome **oil sketches**. A darkened room displays a changing selection from the gallery's large collection of **Old Master drawings**, which are again mainly Italian and of academic rather than general interest.

You should not leave Christ Church without looking inside the **16thC hall**, which has some outstanding portraits ranging from the 16thC to the 19thC, with works by **Kneller**, **Lawrence**, **Romney**, **Millais** (*Gladstone*),

Herkomer (*Lewis Carroll*), **Watts** and **Orpen**.

Museum of Modern Art
Pembroke St
Tel. (0865) 722733
Open Tues – Sat 10am – 5pm, Sun 2 – 5pm
Closed Mon
📷 🛏 📽 ☑ ⠶

Although the Museum of Modern Art does not have a permanent collection, it regularly displays outstanding loan exhibitions, generally of contemporary art, in its spacious, well-modernized premises. The museum is run by one of England's youngest and most dynamic directors, David Elliott, and has contributed much to a wider appreciation of aspects of modern art.

RAGLEY HALL 🏛
Alcester
Warwickshire Map C4

Tel. (0789) 762090
Open Apr – Sept Tues – Thurs Sat Sun
Closed Mon Fri Apr – Sept; Oct – Mar
📷 ☕ 📽

Ragley Hall, the Warwickshire home of the Marquess of Hertford, was begun in 1680 by Robert Hooke but it was the later architects **James**, **Gibbs** and **Wyatt** who were responsible for its most impressive features. Gibbs in particular conceived the magnificent **Great Hall**, rising the whole height of the building, and began the elaborate plasterwork designs which have proliferated throughout the interior. The house is furnished with a selection of **Chippendale** and **Sheraton pieces** and furthermore there is some interesting English **porcelain** and ormolu. The collection of paintings includes some excellent family portraits by **Wissing**, **Dahl**, **Kneller**, **Ramsay** and **Reynolds**, the last of whom is represented by a pensive *Portrait of Horace Walpole* in the library. There is also a group of fine 17thC Dutch pictures, including *The Raising of Lazarus* by **Cornelius van Haarlem** and a *Holy Family* by **Cornelius Schut**, and from the following century there is an *Italian Landscape* by the French painter **C.J. Vernet**. Of the other British works **Wootton's** equestrian pieces are quite attractive and there is a good small scene by **Morland** in the study. Bringing the collection up to date, the hall by the North Staircase contains a large picture entitled *Defeat of the Spanish Armada* by the Welsh artist **Ceri Richards** and on the South Staircase there is an exotic decorative mural of *The Temptation* by **Graham Rust**.

SOUTHWELL MINSTER
Southwell, Nottinghamshire Map D2

Southwell, one of Nottinghamshire's most attractive small towns, is a quiet, seldom visited place with Georgian houses and a famous 17thC inn (The Saracen's Head), where Charles I lodged in 1646 immediately prior to his arrest. The main reason for a visit here is the town's magnificent **minster ★**. This church, which was begun in 1108, is virtually unique in Britain for retaining its three **Norman towers**. Its impressively spacious interior features a Norman nave divided from a 13thC choir by an elaborately carved mid **14thC screen** comprising 289 small figures.

The most celebrated feature of the interior is its **chapter house**, a light, airy structure built (at the end of the 13thC) without any central supporting pier. The extraordinarily naturalistic **carvings ★** on the doorways and the interior arcading are among the finest from 13thC England. They represent a staggering variety of foliage, so realistically represented that it can all be firmly identified. Sometimes the artists have entertained themselves by placing among the leaves little people and animals.

STAMFORD
Lincolnshire Map E3

Stamford is one of the richest small towns in England for **architectural monuments**. There are many fine structures dating from the Middle Ages (for example, **Brazenose Gateway**), but the appearance of Stamford today is due principally to building work carried out in the 17thC and 18thC, when the town became a very desirable place owing to its proximity to the Great North Road.

Burghley House
Stamford
Tel. (0780) 52451
Open Apr–Sept Tues–Thurs Sat 11am–5pm, Sun 2–5pm
Closed Mon Fri Apr–Sept; Oct–Mar
🏛 🚗 🏛 ☑ 🖭

Burghley House, situated 1¼ miles SE of Stamford in the middle of a spacious park, is a magnificent Elizabethan building erected by Lord Burghley in 1560–87. The interior of the house was extensively redecorated in the late 17thC, and among its many impressive features it boasts numerous late 17thC painted decorations by **Antonio Verrio**. The finest of these are in the **Heaven Room**, the walls and ceilings of which are

completely covered with some of the most dazzlingly illusionistic works to be seen in England. You will also find numerous other art treasures of a more modest kind, including carvings attributed to **Grinling Gibbons**, and portraits by **Holbein** and **Van Dyck**.

STOKE-ON-TRENT
Staffordshire Map B2

Stoke-on-Trent is a major center of the national pottery industry, and in fact consists of a series of interlinked small towns known as the Potteries. These were only unified into one city at the beginning of this century, and form the basis for the "Five Towns" of Arnold Bennett's novels. Due to the area's abundance of fire clay and a long tradition of the potter's craft, the ceramics industry has flourished here for hundreds of years, but its fame dates particularly from the 18thC when **Josiah Wedgwood** established a factory here which he called Etruria, to be closely followed by other leading manufacturers of fine porcelain such as **Minton**, **Mason** and **Spode**.

City Museum and Art Gallery
Broad St
Hanley
Tel. (0782) 29611 ext. 2173
Open Mon–Sat 10.30am–5pm
Closed Sun
🖼 🗗

The opening of this museum in 1979 was an attempt to display a representative collection of all aspects of Staffordshire pottery. This has been done, although in many cases greater emphasis has been placed on rather flashy effects than on clarity and information. There is a good selection of **English pottery**, **porcelain** and **slipware** from the 18thC to the present day and, to accompany it, an equally interesting range of **Continental**, **Oriental** and **South American pieces**.

The rest of the museum is similarly weighted towards the decorative arts with large **glass**, **silver** and **costume** displays but there are a reasonable number of **British 20thC paintings** and **sculptures**. This collection includes works by **Brangwyn**, **Sickert**, **Steer** and **Lowry**, as well as an interesting *Portrait of Stephen Spender* by Wyndham Lewis, but an active programme of temporary exhibitions restricts the space available for such works. There is also a good collection of English **watercolours** from the 18thC and 19thC, and a group of unusual but artistically valueless views of the area by **Arnold Bennett**.

Art and industry

The Connoisseur, H. H. La Thangue, Bradford

The rise of industry in the 18thC, and the spirit of scientific enquiry that
accompanied it, led to a major shift in the intellectual life of Britain. The
most progressive currents of thought no longer arose exclusively in the
capital; scientific, philosophical and cultural societies grew up in the main
industrial towns, providing an intellectual focus for the new wealthy
industrial class, many of whose members were Nonconformists and therefore
excluded from the official culture of the old landed establishment.

In the 19thC industrial patronage of the arts came almost to supersede
that of the aristocracy. Moreover, whereas the aristocracy wished to preserve
the pictures they amassed for future members of their family, the
industrialists were far more public-spirited, being anxious to repay by way of
gifts of pictures the towns whose industries had made them wealthy. Their
munificence was largely responsible for the abundance of well-endowed art
galleries that you will find in the Midlands and North of England.

One of the main impacts of technological progress on the arts was in the
field of industrial design, as is illustrated by the changes in the manufacture of
pottery in Staffordshire in the 18thC. Until well into the 18thC the typical
Stafford product was a heavy red or brown slipware, which was characterized
by its bold criss-cross patterns, naively drawn figures and crude lettering.
Then the Wedgwood family, in an attempt to compete with more elegant
foreign products, began seeking for improved materials, techniques and
standards of design, which in turn led to mass production and an industrial
division of labour. Leading British artists such as John Flaxman, George
Stubbs and Joseph Wright now came to be employed by the Wedgwoods as
designers. "Peasant art" had thus come to be replaced by high quality
"industrial design"; and it was not until a much later period that the
traditional artist craftsman was to come into his own again.

The INDUSTRIAL LANDSCAPE
The influence of the industrial environment on the artist is an altogether
more complex issue. Horror at the destruction of the countryside and at the
rather infernal aspect of the new factories and foundries was accompanied in

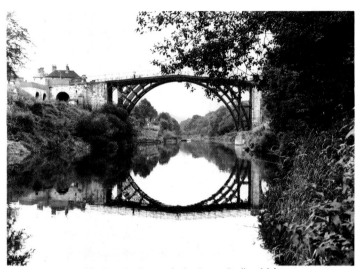

The Iron Bridge, *Ironbridge Gorge, Coalbrookdale*

the 18thC by a general sense of exhilaration, featuring pride in the national achievement and a feeling that industry would bring unalloyed benefits to the poor. Such a contradictory attitude was exemplified in the writings of the poet Anna Seward, the "Swan of Lichfield" who in one poem was able to praise Birmingham as "the growing London of the Mercia Realm", while at the same time decrying the iron foundries and kilns at Coalbrookdale for driving out the "pearly-wristed Naiads" who inhabited the gorge.

The Coalbrookdale industries, though they violated pastoral beauty, nonetheless caught the imagination of painters more than any other site of the Industrial Revolution. Indeed the iron workings lent the "tinge of terror" necessary to turn the beautiful gorge into a landscape of the "sublime". The most depicted monument at Coalbrookdale was the Iron Bridge, which was completed in 1780 and was the first of its kind in the world. The countless pictures of it, which took the form of drawings, watercolours, prints, panoramas, medals, reproductions in porcelain, and so on, were greatly encouraged by its proprietors, who were anxious to promote it as one of the great wonders of the modern age. Interest in the site continued until the 1820s, after which virtually no pictures of it appeared until about 1950, when the site became a place of pilgrimage for lovers of industrial archaeology.

When the horrifying and exhilarating elements of industry gave way in the 19thC to mere drabness, the industrial landscape generally began to lose its attraction for artists, and was rarely painted again. The countless important artists whom the Midlands and North of England have produced have very often settled outside the region at an early stage in their careers, and if they have worked here have generally turned their back on the drearier elements of their environment: thus the main artistic group active in Birmingham in the late 19thC, the Tempera Revival, escaped into the world of 15thC Italy. One of the few 20thC painters to have explored England's industrial landscape was a Frenchman based in Manchester, Adolph Valette, who gave it a mysterious, poetic element by shrouding it in twilight or fog. Another was Valette's pupil, L.S. Lowry, who, virtually alone among English painters, attempted to capture something of the life in the industrial towns.

STRATFORD-UPON-AVON
Warwickshire Map C4

The popularity of Stratford-upon-Avon, now one of England's major tourist attractions, dates from after 1769, when the actor David Garrick started a festival in honour of William Shakespeare, who was born here in 1564. The town is a pleasant enough place, attractively situated on the River Avon, and with fine **Georgian houses** in addition to its celebrated half-timbered **Tudor cottages**, some of which (most notably **Shakespeare's birthplace**) have been converted into museums. Yet it has the character now of a holy shrine, and a visit here can sometimes be more of an obligation than a pleasure.

Royal Shakespeare Theatre Memorial Gallery
Open Mon – Sat 10am – 1pm, 2 – 6pm;
 Apr – Nov Sun 2 – 6pm
Closed Sun Dec – Mar
🎭 ▥

The most enjoyable part of any visit to Stratford-upon-Avon generally involves taking in a production at the Royal Shakespeare Company's theatre on the banks of the River Avon. Their first theatre here, opened in 1879, was burnt down in 1926 and replaced by the present rather ungainly structure in the 1930s. However, the original library and art gallery have survived.

The small art gallery, adorned in one of its rooms with stained glass windows, is a charming and fascinating place. As you would expect, it contains numerous portraits of the Bard himself, ranging from the earliest representations of him to the 18thC artist **Angelica Kauffmann's** bizarre *Ideal Portrait of Shakespeare*, and a cartoon for a portrait by the Pre-Raphaelite **Ford Madox Brown**. There are also countless **portraits of actors and actresses** from the time of David Garrick up to the present day. Among the most interesting of them are those showing the subjects in their better-known Shakespearian roles, a genre of painting that was at its height in the late 18thC and early 19thC (note, for example, **Daniel Maclise's** portrait of *Miss Priscilla as Ariel* and Northcote's *Miss Betty as Hamlet*).

From this period also date the finest works in the museum – painted representations of **scenes from Shakespeare's plays**. Many of these were commissioned by the entrepreneur and later Lord Mayor of London, John Boydell, for a Shakespeare gallery opened in 1789 in Pall Mall in London. This enterprise, which eventually resulted in a famous series of engravings, involved almost all of the leading artists active in Britain in the late 18thC, and produced some of the most imaginative subject pictures painted during this period. One of the artists closely associated with Boydell's gallery was the Swiss-born **Fuseli**, who was particularly responsive to the darker and more fantastical aspects of Shakespeare's plays. Among these the gallery has a most powerful portrayal of the witches in *Macbeth* (*The Weird Sisters★*). Characteristically, that specialist in turbulent scenes of naval battles and other scenes of war, **de Loutherbourg**, painted for Boydell an enormous work (originally twice its size) of the *Shipwreck in the Tempest★*. Other high points of the museum are the painted Shakespearian scenes by **Reynolds**, **Opie**, **Francis Wheatley**, **Romney** and **Northcote**.

UPTON HOUSE 🏛 ☆
Edge Hill
Warwickshire Map C4

Tel. (029587) 266
Open Apr – Sept Mon – Thurs; selected
 weekends (ring for further info) 2 – 6pm
Closed Fri Apr – Sept; Oct – Mar
🎭 🛏 ▥ 🏛

Upton House is a late 17thC mansion with a modern interior adapted to use as a museum. The collection of fine and applied art displayed here was largely assembled by the 2nd Viscount Bearsted, who presented it to the National Trust shortly before his death in 1948. It is now one of the finest collections possessed by the Trust. Among its applied art objects are **Brussels tapestries**, **Sèvres porcelain**, **Chelsea figurines**, and much **18thC furniture**.

The painting collection features examples of the art of all the major European schools, with particularly impressive holdings of early Netherlandish art, including works by **Rogier van der Weyden**, **Hugo van der Goes**, **Memlinc** and **Dieric Bouts**. Especially unusual for an English private collection are the paintings by **Bosch** and **Bruegel**: the former is represented by a version of the famous *Adoration of the Magi★* in the Prado Museum in Madrid, and the latter by an exquisite grisaille panel of the *Death of the Virgin★*.

Among the Italian Renaissance works are a *Madonna and Child* by Filippo Lippi, *St John the Baptist* by Carlo Crivelli, *The Wise and Foolish Virgins* by Tintoretto, and a portrait by **Lorenzo Lotto** and **Parmigianino**. Of this same

period there are a number of important French paintings, most notably a miniature of *St Michael* ★ taken from Fouquet's *Book of Hours for Étienne Chevalier*, and **portraits** attributed to **Jean Clouet** and **Corneille de Lyon**; while of the 16thC Spanish school there is an outstanding *Stripping of Christ* ★ by El Greco, a small version of the well-known work in Toledo Cathedral.

The 17thC holdings possess a brilliant sketch by **Rubens** of *Judas Maccabaeus Praying for the Dead* ★ (the finished picture is in the museum at Nantes in France), but are strongest in **17thC Dutch art**, with numerous works by **Jan Steen**, **Jan van Goyen** and **Jacob van Ruisdael**, and three small early paintings by **Rembrandt** (look especially for the portrait of the *Young Woman* ★ and *The High Priest at the Altar* ★). There are two paintings attributed to **Goya**, one of which is a portrait of his teacher Bayeu; a mythological scene by **Boucher**; a number of **Greuze's** "pin-ups" of young scantily dressed girls in hypocritically pious attitudes; and marvellous small **works** ★ by the Venetian 18thC painters **Canalettto**, **Guardi** and **Tiepolo**.

The remainder of the 18thC collection is taken up by a large and impressive group of English works, including portraits by **Reynolds**, **Romney**, **Lawrence** and **Raeburn**; a beautiful landscape by **Gainsborough** (*Crossing the Ford*); and **Hogarth's** *Morning and Night*.

WALSALL
West Midlands Map B3

An industrial town once known exclusively for the manufacture of leather, Walsall distinguishes itself from many other towns in the vast urban conglomerate in which it is situated by its large number of fine parks, in particular its enormous **arboretum**.

Museum and Art Gallery ☆
Lichfield St
Tel. (0922) 21244 ext. 3124
Open Mon – Fri 10am – 6pm, Sat
 10am – 4.45pm
Closed Sun
🖾 ⏦
The Walsall Art Gallery, a large room above the town library, will overwhelm unsuspecting visitors with the extraordinary range and quality of its collection. No other gallery in Britain of comparable size can claim works of art by so many famous artists. Its riches are due principally to the bequest made in 1973 of a collection formed by Lady Kathleen

Epstein (née Garman, the wife of the famous sculptor, Sir Jacob Epstein) and an American sculptress friend, Sally Ryan.

Before 1973 the gallery's holdings were principally of 19thC British art (including works by **Crome**, **Cox**, **Thomas Barker**, **Frith** and **Maclise**), though there was also a small group of works by the 19thC Dutch painters **Joszef Israels** and **Barend Cornelis Koekkoek**. The Garman-Ryan bequest provided the gallery with numerous **archaeological** and **ethnographic items** (from such diverse areas as Greece, Egypt, the Middle East, China, Africa, South America and Polynesia); **medieval carvings** and **manuscripts**; and **graphic works** by Old Masters such as **Dürer**, **Rembrandt**, **Callot**, and **Watteau**. But the most outstanding feature of the bequest was its collection of **19thC** and **20thC art**, both British and European.

Among the paintings are portraits of Chateaubriand by **Girodet**; nudes by **Etty** and **Géricault**; a study of a man reading by **Corot**; a portrait by **Degas** of his sister Marguerite; landscapes by **Constable**, **Monet**, **Renoir** and **Bonnard**; and three marvellous **oils** ★ by the contemporary British artist **Lucian Freud**. You will also see sculptures by **Rodin**, **Degas** and **Gaudier-Brzeska**, in addition to many works in this medium by **Jacob Epstein** and **Sally Ryan**. And the list of artists represented by watercolours and drawings is almost endless: **Turner**, **Delacroix**, **Millet**, **Ruskin**, **Burne-Jones**, **Puvis de Chavannes**, **Rossetti**, **Manet**, **Monet**, **Rodin**, **Pissarro**, **Vuillard**, **Van Gogh**, **Whistler**, **Augustus John**, **Modigliani** and **Matthew Smith**, to name but a few.

WARWICK
Warwickshire Map C4

Warwick is a particularly attractive county town, which, though largely destroyed by a fire in 1694, retains many half-timbered medieval and Tudor houses, most notably **Lord Leycester's Hospital**, a charming group of 14th – 15thC buildings originally belonging to religious guilds and turned by the Earl of Leicester in 1571 into an asylum for "twelve poor brethren".

Warwick Castle
Tel. (0926) 45421
Open Mar – Oct Mon – Sun
 10am – 5.30pm; Nov – Feb Mon – Sun
 10am – 4.30pm
🖾 ⚔ 🗡 ⏦ 🏛 ⚘
Warwick Castle, one of the few medieval fortresses in England that is still

inhabited, stands on the S side of the town, overlooking the Avon and in beautiful, extensive grounds.

In the Great Hall and in the Armoury Passage you will see some superbly ornate **16th** and **17thC armour**; and elsewhere you will find a beautiful inlaid **Venetian table** of the 16thC, a **clock** that belonged to Marie Antoinette, and portraits by **Cranach** (*Sibylla of Cleves*), **Holbein**, **Rubens** (*Loyola*), **Van Dyck** (*Charles I, Stafford and Prince Rupert*), and **Carolus-Duran** (*Frances, Countess of Warwick*).

WESTON PARK 🏠
Nr. Shifnal
Shropshire Map B3

Tel. (095276) 207
Open Apr May Sept Sat 1–5.30pm; June, Aug Tues–Thurs Sat 1–5.30pm
Closed Mon–Fri Sun Apr May Sept; Mon Fri June, Aug; Oct–Mar
🎫 🍴 ♿ 🏛

The red-brick mansion of Weston Park is unusual in the fact that it may have been designed by a woman, **Elizabeth Mytton**, during the reign of Charles II. Since then it has undergone many modifications but the original character of the house has to some extent been preserved, the black and white stone floors of the Marble Hall and the salons being one of its more distinctive features. The interior as a whole is well appointed with English and French furniture, **Gobelins, Aubusson** and **Soho tapestries, porcelain** from the major English factories as well as from Europe and China and a number of curiosities such as a stuffed parrot.

Throughout the house there is a magnificent collection of portraits, beginning with **Holbein's *Sir George Carew*** in the Breakfast Room and including works by virtually all the leading English portraitists between the 16thC and the 19thC. **Lely, Wissing, Wright, Kneller, Reynolds, Gainsborough, Romney** and **Hoppner** are all represented, as is **Van Dyck** with an elegant half length of *Sir Thomas Hanmer* in the dining room. Of the other English pictures, there is an interesting conversation piece of Lord Bradford's family, *Homage to Handel*, (c.1779) by **R.E. Pine**, an artist who later left England to seek a better living in America, and in the Entrance Hall there are some sporting pictures, including a painting of *Two Horses* by George **Stubbs**. Besides these, there are a few foreign works by **Storck, Brouwer, Castiglione** and **Vernet**.

WIGHTWICK MANOR 🏠
Nr Wolverhampton, Warwickshire
Map B3

Tel. (0902) 761108
Open Jan, Mar–Dec Thurs Sat 2.30–5.30pm
Closed Mon–Wed Fri Sun Jan, Mar–Dec; Feb
🎫 🍴 ♿ 🏛

A visit to this late 19thC house would be the perfect conclusion to a day partly spent looking at the **Pre-Raphaelite paintings** in the City Museum and Art Gallery in nearby BIRMINGHAM. The house was designed by two architects (Messrs Gray & Ould of Liverpool) who were strongly under the influence of **William Morris**; and the spirit of Morris is prevalent in the furnishings, decorations and painting collection. The pictures are all by the Pre-Raphaelites and their associates, including works by **Ford Madox Brown, D.G. Rossetti, Elizabeth Siddal** (a self-portrait), **Burne-Jones, Holman Hunt, Christina Rossetti** and **Millais**.

WOLVERHAMPTON
West Midlands Map B3

Known as the "Capital of the Black Country", the large industrial town of Wolverhampton presents a somewhat battered, desolate character. However, its central area contains numerous proud, imposing **Victorian buildings**, including the art gallery. This adjoins a major medieval survival, the charming 13th–15thC red-stone **Church of St Peter**.

Central Art Gallery
Lichfield St
Tel. (0902) 24549
Open Mon–Sat 10am–6pm
Closed Sun
🎫 ♿ 🏛 ☑

The monumental Classical-style building housing the art gallery was built in 1884, and its proportions give a rather misleading impression of the extent and quality of its holdings. The staircase leading up to the first floor is hung with minor works by Edwardian artists such as **Brangwyn, William Nicholson, Alfred Munnings** and **William Strang**. On the first floor rooms you will see paintings of varying quality by 18thC English artists, including a portrait by **Raeburn** of *William Fairlie of Fairlie*, two forgettable works by **Gainsborough**, and a version of **Zoffany's** amusing theatrical painting, *Garrick as Sir John Brute in*

Vanbrugh's The Provok'd Wife (see the South Bank Art Centre in *LONDON*).

The large brashly painted landscape by **Richard Wilson** has a certain curiosity value, as it portrays the *Niagara Falls*, which the artist only knew from engravings. The English artist active in 18thC Dublin, **Francis Wheatley**, is represented by a charming small **roundel** of a young man embracing his sweetheart with one hand and with the other donating money to a beggar (*Love and Charity*). But pride of place in the 18thC collection must be given to **Fuseli's** *The Apotheosis of Penelope Boothby*, not one of this artist's most sensitively painted works but having nonetheless a characteristic imaginative power.

The **19thC British holdings** include a most impressive and finely detailed example of one of the Irish painter **Francis Danby's** fantasy pieces (*The Shipwreck* ★); a portrait of a Spanish woman with a mandolin by **John Phillip** ("Phillip of Spain"), and a portrait by **Landseer** of the young *Queen Victoria* in Windsor Park, looming imperiously on horseback above a dead deer which is in the process of being torn apart by dogs. Among the various late Victorian subject pictures in the gallery are a scene set in ancient Roman baths by Poynter (*The Champion Swimmer*) and a painting by **Orchardson** of a world-weary nun talking to novices (*The Story of a Life*).

Of particular popular appeal today, and the subject of numerous calendars and greeting cards, are the paintings by the locally born **F.D. Hardy**. Hardy lived from 1854 until his death in 1911 in the picturesque Kent village of Cranbrook, where he became the mainstay of the so-called Cranbrook Colony, a group of artists specializing in interior scenes of rural life in a style that owes much to 17thC Dutch paintings. One of the finest of Hardy's many oils in Wolverhampton is *The Clergyman's Visit*, which shows a clergyman reading the Bible to an old couple in a simple, minutely observed interior.

In the gallery's ground floor there is an excellent small collection of **Oriental applied art**, and a number of well modernized rooms displaying **20thC British** and **American art**. The gallery has concentrated its purchasing funds on this field, and in so doing has given the museum as a whole its lively and imaginative character. The two latest important modern purchases have been of Stanley Spencer's *Chestnuts* and Paul Nash's *Souldern Pond*; but the emphasis of the modern collection is on much more recent work, in particular **Pop art** and **Photo-Realism**. You will find works by

Richard Hamilton (*Adonis in Y-Front*); **Andy Warhol** (silkscreen prints on canvas of *Jackie Kennedy* and a *Campbell's Soup Tin*); a parody by **Lichtenstein** of Cubism (*Purist Painting with Bottles*); and a 24ft-long print by **Rosenquist** (*F-111*), featuring among its many lurid images of modern life a disgusting close-up of tinned spaghetti and a photograph of the young Shirley Temple with her head in a hairdryer. Towering over the collection, both visually and metaphorically, is **Nicholas Munro's** entertaining sculpture, *Maquette for King Kong*★, a study for an enormous civic monument that was sadly never executed.

WORCESTER
Hereford and Worcester Map B4

In character Worcester has much in common with the towns of the nearby Welsh Marches, being a quiet pleasant place with a remarkable series of 15thC and 16thC **half-timbered houses**, in addition to many other fine old monuments. Its **cathedral**, which overlooks the River Severn, has a beautiful **Norman crypt** and an outstanding early **13thC choir**. Worcester is renowned for its **porcelain** industry, which was initiated in the mid 18thC by a local citizen, Dr Wall, who developed a substitute for china clay.

City Museum and Art Gallery
Foregate St.
Tel. (0905) 25371
Open Mon–Fri 9.30am–6pm, Sat 9.30–5pm
Closed Sun
🗀 ♿

The Worcester City Museum and Art Gallery is a crammed, late 19thC institution devoted mainly to local history and archaeology. Lack of space and the exhibiting demands made by local art societies mean that little of its permanent fine art collection is ever on show. This collection – the greater part of which was donated by Charles Wheeler Lea – includes a substantial number of watercolours by the Birmingham artist **David Cox** (including views of Worcester); a characteristically erotic and slightly absurd work by the Victorian subject painter, the **Hon. John Collier** (*Clytemnestra*); and an excellent large oil by the leading Newlyn school artist, Stanhope Forbes (*Chadding on Mount's Bay*★). The most famous Worcester-born painter was the Victorian landscapist **Benjamin Leader**, of whom the museum has 7 oils.

WALES & THE MARCHES

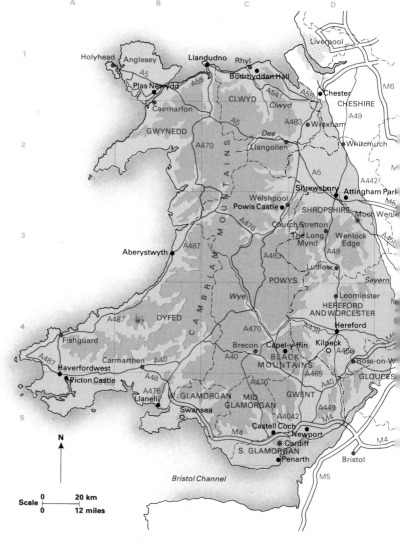

Although dominated by England for many centuries, Wales has clung tenaciously to its own language, and often gives the impression of being a separate country. All road signs, and even the museum catalogues, are written in both languages, and if you stray off the beaten track you may find yourself in villages where Welsh is spoken in preference to English. The Welsh genius has traditionally been for poetry and music, but unfortunately the same talent is not seen in Welsh architecture: towns and villages generally present a depressing red-brick aspect, and the numerous Congregational chapels scattered around the region exemplify ecclesiastical architecture at its least imaginative. In contrast, the natural scenery of Wales is quite superb with its wild mountains, lakes and rugged coastline, providing an inspiration to British landscape artists from the 18thC to the 20thC.

The WELSH VISUAL TRADITION

In the visual arts, as in architecture, Wales has had a very poor tradition. However, the painters it has produced are of outstanding interest. One of the first of these was Richard Wilson, Britain's leading 18thC landscape artist. Wilson spent much time in Italy and painted landscapes in an Italianate style, but he was one of the first passionate enthusiasts of Welsh scenery, and is said to have remarked that everything a landscape painter could want was to be found in the region. His contemporary Thomas Jones, though less well known, also reveals a remarkable originality and freshness in the small oil sketches that he painted both of Italian subjects and of his estate at Pencerrig near Builth Wells, Powys.

Equally original, and deserving of far greater recognition, is the early 20thC Welsh artist J.D. Innes, who developed an obsession with the northern Welsh mountain of Arenig Fawr near Blaenau Ffestiniog, Gwynedd. Innes' friend Augustus John was a far more renowned artist in his time, but the brilliant promise that he showed at the start of his career was never fully realized. The fame that John once enjoyed distracted attention from his sister Gwen John, who is now coming to be seen as one of Britain's subtlest and most interesting woman artists. Another Welshman who deserves particular attention is David Jones, who was both a poet and a watercolourist, and who worked briefly with the English craftsman Eric Gill at the remote and beautiful monastery of CAPEL-Y-FFIN, Powys.

The art galleries of Wales are unfortunately concentrated almost entirely in the ugly area in the S of the region. The finest is the National Gallery of Wales at CARDIFF, which not only has a remarkable group of works by leading Welsh artists but also extensive foreign holdings, including the largest collection of French Impressionist works to be seen outside London. If you travel W of Cardiff, stopping at the small but fascinating gallery of SWANSEA, you will finally leave industrial Wales and reach the Pembrokeshire peninsula. This hauntingly attractive area made a deep impression on one of Britain's leading 20thC artists, Graham Sutherland, whose fascination with the place is commemorated by an excellent gallery in PICTON CASTLE near Haverfordwest, Dyfed. But the most painted and visited part of Wales has always been the northern part of the region, in particular the mountainous area of Snowdonia. Here you will be able to see some of the most beautiful and influential sites in the development of Romantic landscape painting.

THE MARCHES

The boundary between England and Wales has fluctuated in the past, and this section of the *Guide* includes the English border area known as the Marches – the western parts of the present counties of Cheshire, Shropshire, and Hereford & Worcestershire. Here again you will see magnificent scenery, much of it celebrated by the poet A.E. Housman in *A Shropshire Lad*, and, though you will not come across any art gallery of significance, there are many towns and villages of exceptional architectural beauty, culminating in the Shropshire town of Ludlow, which has maintained almost intact its elegant 15thC – 18thC appearance.

Dividing South Wales from England is the Wye Valley, one of Britain's most popular sites for artists during the Romantic era. Whereas wild, mountainous Snowdonia embodied concepts of the "Sublime" ("beauty tinged with terror"), this winding wooded valley had a gentler appeal, and was advocated as a perfect example of the "Picturesque". Its finest feature is perhaps Tintern Abbey, which inspired many Romantic artists.

Artists in North Wales

In the late 18thC and early 19thC the Lake District in Cumbria tended to attract literary figures, but artists were drawn to the mountainous regions of northern Wales. One of the first and most important of these was Richard Wilson, a native of the region. Wilson was born in Penegoes, Powys, in 1714, where you can see a plaque to him in the churchyard wall. He died, an impoverished alcoholic, at Colomenly Hall near Mold, Cheshire, in 1782, and is buried in Mold churchyard. Another early painter in North Wales was an Irishman, the landscapist George Barret, who did much work here in the 1760s. However, the fashion for painting in the region did not become widespread until the 1770s, reaching its zenith during the period of the Napoleonic blockade, when the mountains of Snowdonia provided an alternative to the inaccessible Alps.

Artists who came to North Wales frequently toured the region for a period of several weeks in the company of a patron, who was generally an amateur artist himself. In 1771 the topographic artist Paul Sandby went on such a tour with Sir Watkin Williams-Wynn, a very important patron whose family home was at Wynnstay near Ruabon, Clwyd. The sketches that Sandby made at that time formed the basis for an influential series of aquatints, published in 1776 and entitled *Views in North Wales, Being Part of a Tour through that Fertile and Romantic Country.* Later tours of the same kind included those of Julius Caesar Ibbetson with the Hon. Robert Fulke Greville in 1792, and Thomas Rowlandson with Henry Wigstead in 1797.

ROMANTIC SITES *of* NORTH WALES

Snowdon and Cader Idris, Wales's two largest mountains, were among the sites most favoured by artist travellers. Of the many paintings that they inspired, the two most memorable are perhaps those of Richard Wilson. His celebrated painting of **Snowdon** that you can see in the Walker Art Gallery, Liverpool (see **NORTHERN ENGLAND**) was painted in the early 1760s from the W side of Llyn Nantle, looking eastwards. For all its Classical heroic grandeur, the painting is a remarkably accurate representation of the actual scene. His depiction of **Cader Idris** (Tate Gallery, **LONDON**) painted c. 1765–7, shows Llyn-y-Cam, a volcanic lake near the top of the mountain, and, as with the Snowdon picture, turns the scene into a paradise of primitive simplicity.

Barret's North Wales views are far less familiar than Wilson's, but they have a similarly grand and noble quality. His favourite site was Llanberis Lake on the northern side of Snowdon, a scene painted by many artists (including Turner), not only for its natural beauty but also because of the ruined and historic castle of Dolbadarn that rises above it.

To the S of Snowdon you will see another of the great Romantic sites of Wales, the pass of Aberglaslyn. Ibbetson's **Phaeton in a Thunderstorm** (Leeds City Art Galleries, **NORTHERN ENGLAND**) records an exciting moment here when the horses taking him and his patron Greville on their 1792 tour stampeded. The artist averted catastrophe by jamming a rock against the back wheel of the carriage to act as a brake.

Other much painted Welsh sites of the period include the splendidly preserved coastal castles of Conway, Caernarfon and Harlech. Among these, Conway had the added advantage of being near Benarth, a mansion belonging to one of Britain's most influential patrons, Sir George Beaumont, who was known for his lavish hospitality. Cotman and Girtin, the leading watercolourists of the day, were both guests here at the same time in 1801. Almost all the leading Romantic British landscapists painted these castles, the most unusual interpretation being by John Martin, an artist known best

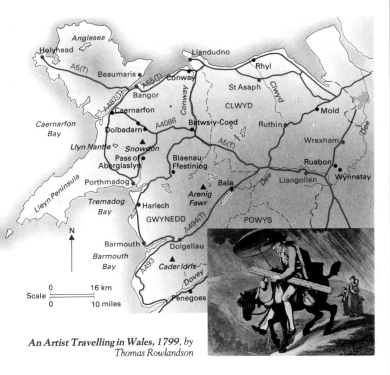

An Artist Travelling in Wales, 1799, by
Thomas Rowlandson

for his fantastical biblical scenes. Martin featured Harlech Castle in the
background of his otherwise imaginary **The Bard** (Laing Art Gallery,
Newcastle upon Tyne, *NORTHERN ENGLAND*).

VICTORIAN HAUNTS

In Victorian times the village of Betws-y-Coed, to the E of Snowdon, became
a popular resort for artists and tourists, as indeed it still is. The man largely
responsible for this was the watercolourist David Cox, who came here from
his Birmingham home almost every summer between 1844 and 1856. Cox
brought such fame to the village that the modest inn where he stayed had to
be pulled down in 1861 to make way for a large hotel, the Royal Oak. This is
still standing, and you can see the sign Cox painted for it in its bar. Cox is also
known for his associations with the North Wales coastal resort of Rhyl.

In the early years of this century J.D. Innes, the highly original Welsh
artist, produced some outstanding paintings of North Wales, following a tour
of the region in 1910. Innes discovered a hospitable inn at Rhydd-y-Fen, in
the middle of the spectacularly desolate but little painted moorland between
Bala and Blaenau Ffestiniog. Falling in love with the area, he returned again
in 1911 and 1912, encouraging his Welsh friend and colleague Augustus John
to accompany him on these later occasions. Innes drew his inspiration from
the place's most prominent landmark, the gaunt and treeless mountain of
Arenig Fawr. Though by now suffering from advanced tuberculosis, he made
arduous treks over the moors in a constant search for new angles from which
to paint the mountain. In 1912 he even placed under the cairn on its summit a
casket of love letters written to him by Euphemia Lamb, a girl who marked
both his and numerous other lives.

ABERYSTWYTH
Dyfed, Wales Map B3

Hemmed in by mountains and sea, Aberystwyth is an attractively situated but architecturally dull seaside resort and university town. The University College of Wales was founded here in 1872.

Aberystwyth Arts Centre Gallery
Penglais
Tel. (0970) 4277
Open Jan – mid May, July – Dec Mon – Sat
* 10am – 5pm*
Closed late May – late June
🖼 ⬇ 📖 🄿 ▦

The Aberystwyth Arts Centre Gallery is housed in one of the dull modern buildings on Penglais Hill. It has a collection of Welsh ceramics and folk art, oriental *netsuke* and English ceramics and glassware. Part of this collection is on permanent show, but the place acts essentially as an exhibiting institution.

The National Library of Wales
Penglais
Tel. (0970) 3816
Open Mon – Fri 9.30am – 6pm, Sat
* 9.30am – 5pm*
Closed Sun
🖼 ⬇ 📖 ▦

The National Library of Wales, a monumental example of late 19thC classicism, occupies a prominent position on Penglais Hill and has magnificent views. The Gregynog Gallery and the Central Hall put on exhibitions selected from the library's holdings, which include in addition to books a large collection of topographical prints, watercolours and drawings, mostly relating to Wales: among these are a set of over 50 drawings made by **Thomas Rowlandson** on a tour of Wales in 1797, and etchings by **Augustus John**.

ATTINGHAM PARK ▦
Nr. Shrewsbury, Shropshire Map D3
Tel. (074377) 203
Open Apr – Sept Mon, Wed, Sat, Sun
* 2 – 6pm; Oct Sat, Sun 2 – 6pm*
Closed Nov – Apr
🄰 ⬇ 🄿 🏛 ☙

Attingham Park was built in 1785 by George Steuart. It has a magnificent **drawing room** with a stuccoed ceiling strongly influenced by the designs of Robert Adam, superlative Italian and French Empire **furniture**, and paintings by **Angelica Kauffmann**, **Thomas Lawrence** and others. In 1807 the renowned architect **John Nash** built the

picture gallery attached to the house. This is one of the first English buildings to make extensive use of iron and glass, and moreover the earliest surviving example of a roof-lit picture gallery. The paintings displayed here are rather less interesting than their setting; the names of the frames are impressive (e.g. Rubens, Caravaggio, Giordano, Domenichino, Sebastiano del Piombo and Holbein), but the pictures are in fact almost all bad school copies, or contemporary and later imitations.

BODRHYDDAN HALL, ▦
Nr. Rhyl, Clwyd, Wales Map C1
Open June – Sept Tues, Thurs 2 – 5.30pm
Closed Oct – May
🄰 🄿 🏛 ☙

This is essentially a 17thC house with 18thC and 19thC additions. It has a good **porcelain collection** (mainly Chinese 18thC) and some excellent **portraits**, including two by the French early 18thC artist de Troy (the *Duc d'Anjou* and the *Duc de Berry*), one by Reynolds (*Dr Shipley*), and another by Hogarth (*Mrs Shipley*).

CAPEL-Y-FFIN ▦
Powys, Wales Map C4
🏛 ☑

Capel-y-ffin is a secluded monastery in the wild, beautiful and still relatively unspoilt Vale of Ewyas high up in the Black Mountains. The place was founded in the 1860s by a controversial Anglican preacher, Father Ignatius, who had wanted to revive the Benedictine monastic lifestyle in the Church of England. However, his ambitious plans for Capel-y-ffin were defeated by the place's remote position and harsh climatic conditions; by the time of his death in 1908, only three monks remained in the monastery, and these decided to join a more successful community on Caldy Island near Tenby.

The monastery lay abandoned until 1923 when the distinguished sculptor, calligrapher and wood-engraver, **Eric Gill**, decided that it would be an ideal new base for the experimental self-sufficient group of craftsmen that he had founded at Ditchling in Sussex. This community (or "guild" as Gill called it) remained in Capel-y-ffin only until 1928. Nonetheless, the few years that Gill spent here were key ones in his life, and he looked back on them afterwards with increasing nostalgia. The only associate

of Gill's at Capel-y-ffin of any comparable talent was the poet and watercolourist, **David Jones**. Jones proved inept in the practical life of the community; he was a hopeless carpenter and made such unfortunate mistakes as trying to light a fire with a bundle of candles, but he produced here some of the earliest of his outstanding delicate and mysterious watercolours (now in various galleries including CARDIFF), and was inspired by the place to include numerous references to it in his epic poem, *In Parenthesis*.

Today the monastery at Capel-y-ffin is a private residence, but you are allowed to see the small **chapel** that Gill and his friends built to replace the enormous one begun and then abandoned by Father Ignatius. The striking simplicity of Gill's building is epitomized by the **altar** – a stone slab mounted on bricks, on top of which is a **tabernacle** painted by Jones.

CARDIFF
South Glamorgan, Wales Map C5

Cardiff, the capital of Wales since 1956, was little more than a village in 1800. Its subsequent rapid development arose largely from its situation as a major port for the handling of coal and iron. In 1905 it was given the status of a city, and in 1922 its boundaries were extended to include Llandaff with its cathedral. **Llandaff Cathedral**, which was begun in the 12thC, has had an especially disturbed history. After the 14thC the building was neglected and left to decay for nearly 300 years; in the 17thC Cromwell's soldiers used the nave as a tavern and the font as a pig trough. The building was drastically restored in the 18thC, and again in the 19thC. Then in World War II it was damaged by bombing, and has since been extensively rebuilt.

The 14thC nave is now divided from the choir by a hideous concrete arch supporting a cylindrical organ case decorated with 64 19thC figures from the old choir stalls, and an enormous aluminium figure of Christ by **Jacob Epstein**. The stained glass window behind the high altar is by **John Piper**. The most attractive feature of the interior is a triptych (*The Seed of David*) in the chapel of the 53rd (Welsh) Infantry Division. This is the work of the Pre-Raphaelite painter **D.G. Rossetti**, who used as models for it his friends Swinburne, Burne-Jones, William Morris and Morris's wife. Rossetti's wife, Elizabeth Siddal, a source of inspiration to many of the Pre-Raphaelites, was the

model for the figures in the six porcelain panels designed by **Burne-Jones** for the W organ case.

Cardiff Castle 🏛
Castle St
Tel. (0222) 31033
Open Mar–Apr, Oct 10am–4pm, May–Sept 10am–5pm, Nov–Feb 11am–3pm
Closed occasionally for special events

The finest architectural monument in Cardiff itself is the **Castle**, which was built in the 12thC and substantially added to in subsequent centuries. Inside, in the Banqueting Hall, are **murals** of c.1428 depicting the life of Richard of Gloucester. But the interior is worth visiting principally for the additions of the eccentric 19thC architect, **William Burges**, which comprise rooms in the Gothic, Arab and Classical Greek idioms. The **Arab room** is particularly exciting, taking the form of a harem with trellissed windows, and covered in gold, lapis lazuli and other ornamentation, much of it the work of specially imported Arab craftsmen.

S of the Castle lies the city's main shopping district (a rather dull area), and to the N is Cathays Park, the civic center of the city, composed of enormous white stone buildings (the earliest of which, the Town Hall, was opened in 1905) set along broad avenues and interspersed by gardens, fountains and occasional monumental statues. The effect is somewhat reminiscent of the most pompous extremes of Soviet town planning.

National Museum of Wales ☆ ☆
Cathays Rd
Tel. (0222) 397951
Open Mon–Sat 10am–5pm, Sun 2.30–5pm

The National Museum of Wales is in one of Cathays Park's grandiose civic buildings. Founded in 1907, its declared intention was "to teach the world about Wales and the Welsh people about their own fatherland." But it is much more than this, for it shows the Welsh achievement against a wider cultural background, and indeed has one of Britain's best collections of foreign paintings. The building consists of a pair of two-storied wings flanking a monumental marble hall which displays the larger pieces from the museum's sculpture collections (including four works by **Rodin**).

The museum's collections are for the most part excellently laid out, and are devoted not only to art and archaeology but also to industry and the sciences. The archaeological collection, situated on the first and second floors of the left wing, has one fascinating room containing 23 **inscribed Welsh stones** of the early Christian period, arranged in a stepped circular setting. Other archaeological treasures of a later date include the beautifully ornamented 13thC **Dolgellau Chalice** and **Paten** (which are among the earliest examples of church plate in Britain) and an exquisite **14thC French diptych ★** found in Llandaff.

The main painting collections take up the first floor of the museum's right wing and are arranged in a roughly chronological sequence. This sequence is interrupted by some large **tapestry cartoons** attributed to **Rubens**, and hung in a darkened room. These recent and highly controversial acquisitions are undoubtedly interesting 17thC Flemish works, but it is generally thought that they are not by Rubens at all, but by some lesser follower. However, the present keeper of paintings at the museum, Peter Canon-Brookes, continues to insist on their authenticity, and has gone to the extent of spending a considerable sum of money on the extremely theatrical semi-circular setting for their display. This room is at present closed.

The gallery's other holdings of foreign school paintings before the 19thC are small but impressively wide-ranging. Among the earliest works you can see paintings by the 15thC Italian masters, **Piero di Cosimo** (a small mythological scene on loan from Count Labia), **Giovanni Bellini** and **Mantegna**. Of the 16thC paintings special mention should be made of a pair of portraits by the Haarlem-born **Martin van Heemskerk** of a man and woman seen against classical ruins in Rome, and a large, dynamic altarpiece, **The Virgin and Child with SS Francis and Lucy ★** (1583), by Bronzino's closest pupil **Allessandro Allori**.

The 17thC is especially well represented, with excellent portraits by Francesco Albani (**Andrea Calvi ★**) Justus Sustermans (**Grand Duke Ferdinand II of Tuscany ★**) and Rembrandt (**Catrina Hoogstaet ★** 1657), landscapes by **Cuyp**, **Van Goyen**, **Jacob van Ruisdael** and **Claude Lorrain**, and a powerful **St Jerome in the Desert** by **Ribera**. But the outstanding work of this period is perhaps **Poussin's The Body of Phocion Carried Out of Athens ★★** (1648). This is one of a pair of paintings – the other is now on loan to the Walker

Art Gallery, Liverpool (see *NORTHERN ENGLAND*) – taken from Plutarch's account of the unjust condemnation to death of the Stoic hero Phocion. As in many of Poussin's works from the 1640s onwards, the figures are subordinated to the landscape, which is given a quality of great solemnity, each form being rendered with extreme clarity in an overall composition of almost mathematical lucidity.

When you come to the gallery's holdings of 18thC art, the foreign school paintings (which include works by the Venetians, **G.D. Tiepolo**, **Pittoni** and **Canaletto**) begin to be overshadowed by the works of British, and, in particular, Welsh artists. This was the period when most of Britain's leading artists and connoisseurs spent a significant period of their lives in Italy, above all in Rome, and some of the finest of the gallery's 18thC paintings, including Wright of Derby's **Lake Albano ★**, and various paintings by the Welsh artists **Richard Wilson** and **Thomas Jones**, were in fact painted in Italy. Wilson is one of Wales's best-known painters, and is often referred to as "the father of British landscape painting". He lived in Italy 1750–57, and when he returned to Britain painted the local landscape in an idyllic, Italianate manner (see for instance, the gallery's luminous **Penn Ponds, Richmond Park** and **Caernarvon Castle**). Thomas Jones, a pupil of Wilson, lived in Italy between 1776 and 1783, and has given account of his years there in his highly spirited memoirs (published in 1948). He appears to have been one of the first British artists to have done numerous oil sketches out of doors, and the ones owned by the gallery, which are all of Italian subjects, have a remarkably fresh and life-like quality. The **Buildings of Naples ★** (April, 1781) is particularly impressive in its rendering of subtleties of tone and texture as observed on a plain, whitewashed and slightly decrepit foreground wall, and could almost be the work of a present-day artist. In 1787 Jones inherited his father's estate at Pencerrig near Builth Wells, and gave up full-time painting in order to run it. The gallery has an amusing **portrait** of him and his family at Pencerrig in 1797, painted by the obscure Italian painter **Francesco Renaldi**.

Other foreign school portraits in the gallery with Welsh subjects include a 1752 portrait by **Mengs** of Richard Wilson, and a large and very lively **Group Portrait ★** executed in Rome in 1768 by **Pompeo Batoni** and featuring one of Wales's most important 18thC patrons, Sir Watkin Williams-Wynn. Williams-

Wynn accompanied the topographical artist Paul Sandby on his famous tour of northern Wales in 1771 which was to lead to the very influential publication, *Views in North Wales, being Part of a Tour through that Fertile and Romantic Country (1776)*.

The most popular section of the gallery is undoubtedly that devoted to **French 19thC painting**, and in particular to the Impressionists. The gallery's renowned 19thC French collections – perhaps the most extensive in Britain outside London – was almost entirely due to the bequest of two remarkable women, Gwendoline and Margaret Davies. The unmarried daughters of a wealthy industrialist, they began to form a joint collection of pictures in 1908, acting largely on the advice of Hugh Blaker, the brother of their governess. Blaker was an eccentric dilettante who tried his hand at painting, dealing, writing and acting, and who held very outspoken views on art. For a while he was the controversial curator of the Holborne of Menstrie Museum in Bath (see **WESTERN ENGLAND**). In 1920 the sisters bought Gregynog Hall in Powys (formerly Montgomeryshire), with the intention of turning it into an artist's retreat, but they abandoned this plan in 1929, when they themselves moved into the house. Thereafter they virtually ceased to collect, although Margaret Davies – who had briefly attended the Slade Art School in London as an external pupil – made some further purchases in her old age.

Although the most outstanding works in their collection were all of the French 19thC, they also acquired a large number of other paintings, most notably by 19thC and 20thC artists. Their first purchases were all very conventional, and included a painting by the immensely popular French realist, Meissonier (*A Game of Piquet*), and works by **Millet**, **Corot**, **Constable** and **Turner**. Then from about 1912 they began to acquire a large number of Impressionist and Post-Impressionist pictures. The Davies sisters were at first virtually alone in their dedication to collecting the works of these artists, even though Roger Fry's celebrated Post-Impressionist Exhibition, held at the Grafton Galleries in London in 1910 had made the British public more widely aware and appreciative of their works.

The most striking of the earlier French pictures in the Davies collection are the various landscapes by **Corot** and the paintings by **Millet**, especially the unfinished *Peasant's Family* and the very powerful late landscape, *The Gust of Wind* ★. The Davies sisters also amassed one of the largest groups of oil paintings by **Honoré Daumier** to be seen anywhere; among these, look for the haunting *Les Noctambules* ★, which shows two men walking across a bridge in Paris at night. Virtually all the leading French Impressionists and Post-Impressionists are represented in the Davies collection. There are three paintings by **Manet**, including an oil of Argenteuil, and a striking oil sketch of a dead animal thought variously by art historians to be either a rabbit or a hare. Among the other Impressionist works are two bronze statuettes of dancers by **Degas**, a Paris snow scene by **Pissarro**, a late landscape (1891) by **Sisley** painted from the interior of his house at Moret-sur-Loing, a most expressively painted oil study by **Berthe Morisot** of a woman and her child in the grass at Bargival (1882), and a delightful full-length portrait of a woman in blue by Renoir, *La Parisienne* (1874), of which Signac wrote in 1895: "The tricks of colour are admirably recorded. And it is simple, it is beautiful, and it is fresh. One would think that this picture painted twenty years ago had only left the studio today." Above all there is a large and outstanding **group of paintings** ★ by **Monet**, including views of Venice and London, one of his Rouen Cathedral series, and three of the many near-abstract paintings that he executed in his old age of the waterlily pond in his garden at Giverny. But the highpoints of the Davies's Post-Impressionist pictures are three **oils** ★ by Cézanne – *Mountain seen from L'Estaque* (1878–1880), *Landscape in Provence* (c. 1880) and *Still-Life with Teapot* (c. 1899) – and a most unusual canvas by van Gogh of rain falling at *Auvers* ★, painted in the same month that he committed suicide.

The gallery's holdings of 20thC art include works by leading foreign artists such as **Max Ernst**, **Archipenko**, **Morandi**, **Erich Heckel** (a powerful Expressionist landscape of 1909) **Kokoshka** (an excellent view of Waterloo Bridge), and **Matisse** (a bronze head of *Mariette*). However, this department is far stronger in British paintings, a significant number of which were donated by the Davies sisters. Here the works by Welsh artists are naturally of particular interest. **Augustus John**, perhaps the most famous of these artists, was one of the dominant figures of the British art world in the early years of this century. His reputation as an artist was undoubtedly enhanced by his notoriously Bohemian lifestyle: he sported colourful, outrageous clothes, had affairs with countless women, drank heavily, and was obsessively interested in the lives of

gypsies. His remarkable facility as a painter and draughtsman led to a certain laziness and slickness in his later work, but in his early years it resulted in paintings and drawings of astonishing freshness. One of the finest of his works in the gallery is a colourful painting of his wife **Dorelia** ⋆ dressed in her homemade gypsy-style clothes and standing in their garden at Alderney Manor in Dorset; but a later work by him, a portrait of the leading Welsh poet **Dylan Thomas**, is also very impressive.

John's sister Gwen received far less recognition than her brother during her lifetime, living in considerable financial hardship in Paris (where she posed for and became infatuated with Rodin). Her art is the complete opposite of his, having a quiet, intimate and very introspective quality which has a far greater appeal to present-day sensibilities than the brash fluency of Augustus John's art. Many of her works, such as the gallery's superlative **Girl in a Blue Dress** ⋆, are subtly coloured studies of women against almost monochromatic backgrounds.

Perhaps the least known of Wales's important 20thC artists is the landscapist **J.D. Innes**, a great friend of Augustus John whom he first met at the Slade Art School in London. Innes spent much time in France, staying three summers at Collioure in Roussillon, where he painted the marvellous **Cathedral at Elne** ⋆ (1911) and **Canigou in Snow** (1911). The artist subsequently transferred his virtual obsession with the snow-capped peak of Canigou to the treeless mountain of Arenig Fawr in North Wales, and this feature, like Mount Canigou, inspired many of the finest works of his short career (he died aged only 27). Innes was undoubtedly inspired by Japanese prints of Mount Fuji, but the work of the Fauve artists (who were also closely associated with Collioure) may have influenced him less than is supposed. Ultimately his small colourful landscapes with their boldly decorative patterning and free, fragmented use of paint, are the work of a completely independent genius. As Augustus John once said of him: "He is an entirely original chap and that's saying a lot."

Morland Lewis, a less talented artist than Innes, though nonetheless an interesting one who deserves more recognition, was a Welsh follower of Sickert; he is represented here by one of his many views of Laugharne, the village where Dylan Thomas wrote *Under Milk Wood*: like the best of his few surviving paintings it is characterized by its great simplicity of form and tonal subtlety.

CASTELL COCH ⌂
Tongwynlais, South Glamorgan, Wales Map C5
Open mid-Mar to mid-Oct Mon – Sun
9.30am – 6.30pm; mid-Oct to mid-Mar
Mon – Sat 9.30am – 4pm, Sun 2 – 4pm
⌂ ⬥ ✗ ℹ ⛫ ☑ ❧

High on a hill and surrounded by trees stands Castell Coch, the masterpiece of one of 19thC Britain's most eccentric architects, **William Burges**. This building was originally a 13thC castle which later fell into ruins. In 1872, when its owner, the 3rd Marquis of Bute, asked Burges to make plans for its reconstruction, virtually only the foundations still remained. The building that Burges designed was an amalgam of various medieval castles (including those of L'Aigle and Chillon in Switzerland), with sundry imaginary touches of his own, such as the picturesque but implausibly high pointed roofs on the towers. Burges took great delight in fitting out the castle as for war, and included such features as a working drawbridge as well as slits and holes in the walls from which boiling oil could be poured. The interior of the building is no less fantastical than the exterior; the mural decorations, stained glass windows and other fittings all take their inspiration from medieval example but combine to create a fantasy that is unmistakably Victorian.

CHESTER
Cheshire Map D1

Chester is a well preserved medieval town on the site of an earlier Roman settlement known as Deva. Both periods are very much in evidence. The partly excavated **Roman amphitheatre** is one of the largest in the country, and you can visit several Roman buildings such as the Praetorium or military headquarters. From the medieval period, the city walls are virtually intact and several streets retain their distinctive **timbered houses** cut through by continuous arcades known as "rows". The largely Gothic cathedral has some notable 14thC **carved choir stalls** complete with elaborate canopies and misericords.

Grosvenor Museum
Grosvenor St
Tel. (0244) 21616
Open Mon – Sat 10am – 5pm, Sun 2 – 5.30pm
◉ ⌂ ❧

The principal concern of the Grosvenor

Museum is the Roman period of Chester and its surrounding area. Chester was the garrison town of the 20th Legion, and therefore one of the major Roman towns in Britain, but its military purpose emphasized that it was still essentially an outpost of the empire. Like most provincial communities, it has yielded art objects that carry the mark of the Imperial style but the craftsmanship of merely local tradesmen. The works on display therefore, including a large series of carved and inscribed **gravestones** of soldiers in Agricola's 20th Legion, as well as the usual pottery and jewelry, are primarily of historical interest alone. This is further reflected in the models and dioramas of life in Roman Britain.

HAVERFORDWEST
Dyfed, Wales Map A5

Haverfordwest is a dull market town in the middle of a part of Pembrokeshire (now called Dyfed) which has always considered itself as an enclave of England in Wales. Apart from the 13thC–15thC **church of St Mary's**, and the remains of the originally 13thC **castle**, the town has few old buildings of note. The leading Welsh painter **Augustus John**, born in 1878 when his family were staying at nearby Tenby, spent much of his childhood here; his family home was at no. 7 Victoria Place (a plaque to him has been wrongly affixed to no. 5). His eldest sister, **Gwen John**, herself a remarkable painter, was born in this house in 1876.

The Castle Museum and Art Gallery
Tel. (0437) 3708
Open Apr–Sept Mon–Sat
 10am–5.30pm; Oct–Mar Tues–Sat
 11am–4pm
Closed Sun
🖼 � 🏛 📽 ⸬

The town's heavily restored castle houses a museum devoted mainly to local history. Sadly its small art collection (which is only partially shown), has no works by Augustus or Gwen John, or indeed by the two other significant artists who have worked in Pembrokeshire in recent times, John Piper and Graham Sutherland. Instead it mainly has works by locally active artists of equally local importance, such as the painter Ray Howard Jones. Its most interesting art treasures are undoubtedly the small group of Expressionist paintings (in particular *Low Tide at Newport*) by the German artist **Frederick Könekamp**. Könekamp was born in Germany in 1897 and worked initially as a mathematician and

philosopher. He took up painting when in exile in Switzerland after 1933, and continued to paint after moving to Wales in 1949. Here he lived until his death in 1977, a virtual recluse in an isolated cottage halfway up Carn Ingli in northern Pembrokeshire. His work has recently gained some recognition in Germany and Switzerland, but it remains almost completely unknown in Britain.

HEREFORD
Hereford & Worcs Map D4

Most of medieval Hereford was demolished in the 18thC in an attempt to clear the town of some of its notoriously dirty and unhealthy areas. Further extensive sanitization occurred in the 19thC, and this helped to create the pleasant, prosperous but rather insipid town of today. Hereford's main monument is its **cathedral**, which was built between the 12thC and 16thC, but was considerably altered in later periods. Among its many treasures are some fine 14thC **misericords** with carved animals, a famous **medieval map** of the world (the Mappamundi) in the Choir Aisle, and, in the S transept, an early 16thC **triptych** of the South German School.

Churchill Gardens Museum/Brian Hatton Gallery
Venn's Lane
Tel. (0432) 267409
Open Apr–Oct Tues–Sun 2–5pm;
 Nov–Mar Tues–Sat 2–5pm
Closed Mon, Sun Nov–Mar
🖼 � 🏛 📽 ⸬ ⸬

The Churchill Gardens Museum is in an early 20thC building on a hilltop residential district. The main feature of its collections are its early costumes. Attached to it is the small Brian Hatton Memorial Gallery, which was opened in 1975. **Hatton**, who was born in Hereford in 1887, developed an extraordinary proficiency as a draughtsman by the time he was only 13. When Hatton was 16, the painter G.F. Watts thought that he might "become the greatest artist England has had" and that "nothing but serious accident bars his way to the highest place". Unfortunately, this serious accident did indeed occur: Hatton was killed in Egypt in World War I thirteen days after writing home to his parents: "One only has to take reasonable precautions and lie down behind a few inches of sand hill to be quite safe from any bullet." However, it is doubtful whether Hatton would have developed as a great artist. His works here are competent but unimaginative.

Hereford City Museum and Art Gallery

Broad St
Tel. (0432) 268121 ext. 207
Open Apr–Sept Tues, Wed, Fri
10am–6pm, Thurs, Sat 10am–5pm;
Oct–Mar Tues, Wed, Fri 10am–6pm,
Thurs 10am–5pm, Sat 10am–4pm
Closed Mon, Sun
◻️⋯

The pictures that hang on the staircase walls of this late 19thC building include a painting by the obscure Victorian artist **John Davis** showing Rembrandt at work on the *Night Watch*, and a vintage "kitchen sink" painting by John Bratby of the social-realist writers *Jeremy and Nell Sandford* (1957), which features such deliberately unremarkable details as a box containing packets of Stork margarine. The rest of the museum's art collections are shown on the first floor, where lack of space allows only a small fraction to be displayed at any one time. These collections include not only local glass, pottery and silver, but also watercolours by some of the important English topographical artists who have worked in and around Hereford, including **Turner**, **Girtin**, **Joshua Cristall** and **John Varley**. You can usually see on show some watercolours by the greatest artist closely associated with Hereford, **David Cox**, who came here from London in 1814 to teach drawing twice a week in a ladies' school run by a Miss Croucher. Cox was attracted to the job because it provided easy access from Hereford to favourite sites in the Wye Valley and North Wales.

KILPECK CHURCH
Hereford & Worcs Map D4

The remote and secluded early 12thC church of Kilpeck has some of the finest **carvings ★** of this period in England. The exterior has a most intricately carved s doorway featuring a **tympanum** with a stylized **Tree of Life** bearing grapes, shafts with snakelike monsters twined round other figures, and an **outer arch** filled with further fantastical and strangely contorted creatures. Running around the whole of the outside of the building is what is called a corbel table, a series of projecting blocks placed under the eaves of the roof. Most of these blocks retain their lively and humorous **carvings** of human figures, although some of these carvings were considered too erotic in detail for the Victorians, who had them removed. There is nevertheless an outstanding example of a Sheila-ne-gig, a carved female figure

with genitals exposed. More carvings are to be found inside the church, especially on the **chancel arch** and in the apse. Interestingly, none of the Kilpeck carvings appear to derive their forms from Norman art, but instead seem to have more in common with sculpture to be found in St James's Cathedral at Santiago de Compostela in Spain.

LLANDUDNO
Gwynedd, Wales Map C1

Llandudno was little more than a village until 1850, after which date it developed into a major seaside resort. It is still Wales's largest and classiest resort, but in spirit the place seems still to have remained in the 19thC.

Mostyn Art Gallery
12 Vaughan St
Tel. (0492) 79201
Open during exhibitions Apr–Sept
Tues–Sat 11am–6pm; Oct–Mar
11am–5pm
Closed Sun, Mon
◻️⬚🅿️☑️⋯

The recently opened Mostyn Art Gallery, housed in a late 19thC building in the middle of the town, represents an attempt to instil some form of active cultural life into Llandudno. The gallery does not have a permanent collection, but instead puts on imaginative exhibitions devoted mainly to contemporary Welsh art, including the work of such avant-garde artists working in North Wales as the sculptor and conceptual artist **David Nash**.

Rapallo House Museum and Art Gallery
Fferm Bach Rd, Craig-y-Don
Tel. (0492) 76517
Open Apr, Sept–Nov Mon–Fri
10am–12.45pm, 2–4pm; May–Aug
Mon–Fri 10am–12.45pm, 2–5pm
Closed Sat, Sun; Dec–Mar
🖼️⋯✗⬚☑️✿

The Rapallo Museum and Art Gallery is situated in a quiet, dignified residential area a mile from the town's center. It is affiliated to the National Museum of Wales, but promotes itself so discreetly that those who enter the very suburban Tudor-style building in which it is housed may well fear that they have inadvertently stumbled into someone's private house. Because so few people come to this place, plans have recently been proposed to close it down. While it cannot be claimed that such a closure would seriously affect Britain's artistic

heritage, the country would nonetheless lose a museum of quite considerable charm. The gallery remains very much as it was when left to the town by its original owner, Francis Edward Chardon, a wealthy amateur artist and collector who retired to Llandudno in the early 1920s. Chardon was of French-Italian extraction (his mother's family name was Rapallo), and he had spent a good period of his life in Italy, where he studied pastel drawing and watercolour painting under the Neapolitan artist, Giuseppe Casciaro. His house is choc-à-bloc with indifferent **Victorian pastels** and **watercolours** (mainly by him), and furniture, porcelain and objects of this date in varying taste.

LLANELLI
Dyfed, Wales Map B5

Llanelli developed in the 19thC as an industrial town known especially for its manufacturing of tin plate and shipping of coal. Both these industries have now greatly declined and, although important steelworks have grown up in their stead, the town bears the stamp of a place whose great age of prosperity belongs essentially to the past.

Parc Howard and Art Gallery
Tel. (05542) 3538
Open Mar – Nov Mon – Sat 10am – 7pm,
* Sun 2 – 6pm*
Closed Dec – Feb
🔲 ✈ 📠 🐌

Parc Howard is a beautiful park with a slightly abandoned air, situated on top of a hill in a quiet Victorian residential district; it was presented to Llanelli by the town's first mayor, Sir Stafford Howard. In its middle is a late 19thC building housing the town's main art gallery. The interior of this is dark and the atmosphere is strongly Victorian, but a group of brash, amateurish oil paintings by recent local artists adds a modern and somewhat jarring note.

Apart from these, the museum has exhibits relating to the local tinplate industry, and a small but surprisingly good collection of **19thC and early 20thC British painting**. This includes a very dark interior (*The Little Smithy*) by the Newlyn School artist Stanhope Forbes, an Alpine scene (*Prayer Walk*) by Hubert Herkomer and a landscape (*Barmouth Estuary*) by Christopher Williams. The Welsh school is represented by Frank Brangwyn's *The Masque*, a group of paintings by the eccentric Swansea artist **Evan Walters** (including a straightforward

"monofocal" version of the *Cockle Woman* in the Glyn Vivian Gallery in SWANSEA), and a now rather damaged landscape of Llanelli by the town's greatest artist son, **J.D. Innes**, who was born in Greenfield Villas, Murray Street in 1887. Before going in 1906 to the Slade Art School in London (where he became a close friend of his great native contemporary, Augustus John) he studied at the Carmarthen art school. It was probably the principal of this school, Harold James, who encouraged him to execute a series of views of Carmarthen and Llanelli early in 1906. The most ambitious of these was the **oil** now in Parc Howard Gallery, painted from Furnace Quarry, which was not far from his parents' home at 47 Old Road (now Orchard Croft). A **watercolour** for this work, giving a greater indication of Innes's later development as an outstanding colourist, is also owned by the town. This is kept with other early Innes watercolours and works by minor local artists in the **Public Library Gallery** in the middle of Llanelli.

NEWPORT
Gwent, Wales Map D5

Newport expanded rapidly after 1801 to become the principal coal port of South Wales, as well as the focus of massive iron and steel production. Today most of the 19thC town has been pulled down to make way for characterless modern development.

Newport Museum and Art Gallery
John Frost Square
Tel. (0633) 840064
Open Mon – Thurs 10am – 5.30pm, Fri
* 10am – 4.30pm, Sat 9.30am – 4pm*
Closed Sun
🔲 🍴 🛍 📠 ☑ ⋮⋮

The Newport Art Gallery is situated high up in a building overlooking the central square of the town's shopping area, but it makes the most of its unpromising position and pathetically slender resources. The small room that you see on entering the gallery generally shows modern prints, pots and other objects by **contemporary Welsh artists**, while the large room behind is always taken up with touring exhibitions. The gallery's most attractive feature is its pleasantly and thoughtfully laid out back room, which shows items of local interest such as Victorian samplers and charming postcards of old Newport, as well as a modest collection of British oil paintings, watercolours, prints and drawings, including minor works by **Richard Doyle**

(the eccentric father of the creator of Sherlock Holmes), **Augustus John**, **Stanhope Forbes**, **Stanley Spencer**, and **Laura Knight**.

PENARTH
South Glamorgan, Wales Map C5

Now little more than a suburb of Cardiff, Penarth faces Cardiff Docks from across the small bay known as the Penarth Flats. Since the 19thC it has been a modest seaside resort, and was visited by the Impressionist painter Alfred Sisley in 1897. Sisley was enchanted by the place, his only complaint being that the weather was too hot; the landscapes that he painted here were among the last works of his life.

Turner House 🏛
Tel. (0222) 708870
Open Tues–Sat 11am–12.45pm, 2–5pm;
Sun 2–5pm
Closed Mon
📷 💷 🏛 ☑ ⃞

Turner House Art Gallery was built in 1888 by a local industrialist, James Pyke Thompson to put on public display a large group of works of art owned by him. These were later bequeathed to the National Museum of Wales at CARDIFF, which now administers the house and arranges various exhibitions of works in its collections.

PICTON CASTLE/GRAHAM SUTHERLAND GALLERY 🏛
Haverfordwest, Dyfed, Wales
Map A5
Open Tues–Sat 10.30am–5.30pm
Closed Sun, Mon
📷 ⬛ 𝑓 💷 🏛 ☑ ⬧ ⬩

Picton Castle is an early 14thC building with 19thC additions. Since 1976 the Graham Sutherland Gallery, a branch of the National Museum of Wales, has occupied a small section of it.

The English painter Graham Sutherland was greatly influenced by the landscape of Pembrokeshire (now Dyfed). Coming to the region in 1934, he immediately became obsessed by it and returned regularly until 1945. During those years he painted landscapes that are perhaps among the most haunting, mysterious and original works of his career. After 1945 he considered, wrongly, that he had exhausted the mood of the place, and did not come back to Pembrokeshire until 1960. But then he returned regularly every summer until his death in 1980, staying at various places

throughout the region, including Lleithyr Farm near St David's (where there is a fig tree which appears in many of his paintings), the seaside towns of Solva and Milford Haven, and Picton Castle itself, where he was good friends with the owners, the Hon. Haming Phillips and his wife Lady Marion.

In old age Sutherland began to feel that he should repay the debt which he owed to Pembrokeshire, and presented to the region a **collection** of his works. Picton Castle became, as a result of the Phillips's suggestion, the site of this collection. In his introduction to the catalogue, the artist expresses his opinion that "work done in a certain area is seen perhaps best in that area". All the 15 oil paintings and over 100 watercolours, gouaches, drawings and lithographs in the collection are in some way related to Pembrokeshire.

The majority of the graphic works date from his first and most interesting Pembrokeshire period. The oils, however, with the exception of *Estuary with Rocks*, were all executed towards the end of his life, when he painted in a slicker and less spontaneous manner.

PLAS NEWYDD 🏛
Isle of Anglesey, Gwynedd, Wales
Map B1
Tel. (024886) 714795
Open Apr, Sept–Oct Sun–Fri 2–5pm,
May–Aug noon-5pm
Closed Sat; Nov–Mar
⬛ ⬧ 💷 ⬩

This late 18thC Gothic-style house by **James Wyatt** enjoys superb views over the Menai Straits and towards the mountains of Snowdonia. Some rooms are decorated in a conventionally classical style, but the music room (built on the site of the 16thC great hall) and the entrance are Georgian Gothic. More recently, the walls of the dining room have been extensively decorated in an extremely lively trompe-l'oeil style by the 20thC English artist, **Rex Whistler**.

POWIS CASTLE
Welshpool, Powys, Wales Map C3

Open Easter, May–June, Sept Wed–Sun
1–6pm; July–Aug Tues–Sun 1–6pm
Closed Mon, Tues, May–June, Sept; Mon
July–Aug; Oct–Apr
⬛ ⬧ 𝑓 💷 🏛 ⬩

Built originally in the 13thC-14thC, Powis Castle still looks as if it belongs to that date, but the building was in fact reconstructed in the 17thC at the same

time that its magnificent surrounding formal gardens were laid out. Inside are some fine portraits (mainly of the family) by **Gainsborough**, **Kneller**, **Batoni**, and the Irish artist **Hugh Douglas Hamilton**.

SHREWSBURY
Shropshire Map D3

Occupying a peninsula of rising ground formed by a loop in the River Severn, Shrewsbury (usually pronounced "Shrowsbury") came into being in the 5thC AD when the inhabitants of Wroxeter (the large Roman city of Viroconium) were looking for a more easily defended place to live following the departure of the Roman legions from their town. Shrewsbury is one of the best-preserved medieval towns in England, and has numerous monuments from this period. One of these is the **Church of St Mary**, the main body of which was built c. 1200. Inside you can see some outstanding 14thC–16thC **stained-glass windows**, among which are 19 panels of the life of St Bernard, executed by the **Master of St Severin of Cologne** and originating from the German abbey of Altenburg. One of the most attractive features of Shrewsbury is the large number of **half-timbered houses** dating from the Tudor and Elizabethan periods, when the town enjoyed great prosperity through its trade in wool and flax with the Welsh.

Clive House
College Hill
Tel. (0743) 54811
Open Mon–Sat 10am–5pm
Closed Sun
🄾 🕭 🏛 ⚓

Clive House is a mainly 18thC building with 15thC fragments. Lord Clive (of India), a native of Shrewsbury who played a leading part in the British campaigns in India, stayed here in 1762 when he was mayor of Shrewsbury. The house provides an elegant and extremely pleasant setting for the museum, which contains a modest collection of miscellaneous objects, including **17th C church silver**, local Coalport and Caughley **ceramics**, and a painting by **Zoffany**.

Rowley's House Museum
Baker St
Tel. (0743) 61196
Open Mon–Sat 10am–5pm
Closed Sun
🄾 🕭 🏛 ☑

Rowley's House Museum occupies a

16thC half-timbered warehouse, the interior of which has been marvellously preserved. It is devoted principally to finds from the **Roman town of Viroconium**: one of the finest treasures here is a large, exquisitely ornamented silver **mirror**, probably from an Italian workshop of the 2ndC AD.

SWANSEA
West Glamorgan, Wales Map B5

Swansea was the largest port in Wales by 1700, and also became in the same century a major focus for the smelting of copper. The trade of the port continued to increase significantly after the opening of the Swansea Canal in 1798, and at the same time the town's industries rapidly expanded to include not only the smelting and refining of a variety of ores and metals besides copper, but also the manufacture of porcelain. In 1918 the first oil refinery in Britain was opened near here.

Glyn Vivian Gallery and Museum
Alexandra Rd
Tel. (0792) 55006
Open Mon–Sat 10.30am–5.30pm
Closed Sun
🄾 🕭 🕭 🚻

The Glyn Vivian Art Gallery stands just behind the central area at a point where Swansea rises up a hill in a series of often perilously steep streets lined with low Victorian houses. It was built in the early years of this century, at a time when the principal of the city's art school was trying to establish this institution as one of the most important in the country. The construction of the gallery was largely paid for by a gift of £10,000 from a local copper manufacturer, Richard Glyn Vivian, who also presented to the place his own collection of **paintings**, **china** and **objets d'art**. The ground floor of this pleasantly old-fashioned gallery displays the nucleus of the Glyn Vivian donation, which includes a fine collection of 19thC **Swansea pottery** (known for its simplicity of form and delicacy of painted decoration), and some generally indifferent Old Master paintings such as a *Susanna and the Elders* attributed to **Guido Reni**, and a copy of Correggio's *Madonna della Scodella* attributed to **Mengs**.
 The high point of the gallery's painting collection consists of its holdings of British art from the late 19thC onwards. This is shown mainly on the first floor, and includes good examples of paintings and watercolours by English artists such as **Ginner**,

Mathew Smith, **Mark Gertler** (*The Artist's Mother*), **William Roberts**, **Paul Nash** and **Stanley Spencer** (*Marriage at Cana*). Numerous leading Welsh artists are represented, including **J.D. Innes**, **Augustus John** (most notably by one of his few Welsh landscapes – a view of Arenig painted when staying in North Wales with Innes), **Morland Lewis** and the rather heavy-handed but none the less highly successful contemporary landscapist **Kyffin Williams**. Of particular interest are the two rooms devoted to Swansea's greatest artist sons, **Evan Walters** and **Ceri Richards**. The former, who is now little-known outside Wales, experienced a brief moment of national recognition with his first London show in 1926, when he was promoted (quite inaccurately) as the poor son of a Welsh miner who had had no formal training as an artist. The show made him an overnight success, and led to his moving from Swansea to London, where he began to mix in sophisticated artistic circles. However, his work soon started to go out of fashion. From 1936, after spending one evening sitting cross-legged gazing into the fire, he began to devote himself obsessively to the problems of rendering double vision in art. Unfortunately he could not impress upon others the importance of these artistic experiments. He returned permanently to Wales in 1939, and thereafter led an even more isolated life. It is indicative of his lack of commercial sucess in the latter half of his career that he bequeathed over **400 canvases** to the Glyn Vivian Gallery. The small selection of these that are shown in the gallery proves that he had a remarkable though wayward talent. In his early sober style you can see such boldly handled canvases as *A Welsh Miner* (1926–30), while his experimental canvases include the *Cockle Woman*, now one the most popular paintings in the gallery. This illustrates Walters' wonderful ability to give life to a portrait, although it must also be said that its attempt at rendering double vision makes it look like a cross between a half-hearted Futurist canvas and a colour television set in the process of being focused.

Ceri Richards is perhaps Wales' best-known artist of recent times, and though his work is often inspired by Welsh subjects, he spent most of his working life in London. Two of the finest of the small

selection of his works in the gallery are *The Pianist* and the *Portrait of The Artist's Father*.

Guildhall/Brangwyn Hall
South Guildhall Road
📷 🔫 ☑ ♿

The Guildhall stands in a rather isolated position about one mile to the W of the city center; it was opened in 1934. On the walls of the Assembly Hall are hung **Sir Frank Brangwyn's** 16 **Empire Panels**, which were originally intended to complete the decoration of the Royal Gallery in the Palace of Westminster in London, and to serve as a memorial to the peers and relatives of peers who had been killed in World War I. Brangwyn was offered the commission in 1924, and began work on it with tremendous enthusiasm. He even suggested that the existing paintings in the Royal Gallery (which he found dark and depressing) should be whitewashed to enable him to carry out an even more grandiose decorative scheme. At first he planned to commemorate the war victims by showing them amid scenes of great horror; but he then decided that such subject-matter was too gruesome, and instead depicted scenes illustrating the wealth and beauty for which these men had died. In designing the panels he made use of hundreds of sketches that he had executed in the course of his many exotic travels. He also did numerous drawings of the animals in the London Zoo.

The panels, which took seven years to complete, were considered by the artist to be the culminating works of his career. Unfortunately, the lords at Westminster thought differently and rejected them, considering that they were more suited for a night-club decoration than for a war memorial. After some difficulty in finding a permanent home for them, Swansea Council, whose new Guildhall was then in the process of being built, offered to make the necessary adjustments to the Assembly Hall of their building in order to accommodate them.

In addition, the Guildhall now displays (mainly in the corridors around the hall) many of the **cartoons** and preparatory **drawings** for the panels. These smaller works show Brangwyn's talents at their best, and are executed with a vigour worthy of the artists whose influence was always paramount in his work – Peter Paul Rubens.

NORTHERN ENGLAND

From the southern edges of Lancashire and Yorkshire to the borders of
Scotland, the section of the *Guide* covering northern England comprises a
large and diverse part of the country, and one which affords the greatest
contrasts. Topographically it takes in two enormously popular scenic areas –
the Lake District to the W and the Peak District in the middle – which are
both National Parks, and also the bleak, sparsely populated moorland regions
of Yorkshire, Cumbria and Northumberland. These landscapes of striking
beauty contrast strongly with the major industrial regions around Leeds,
Manchester and Sheffield, the ports of Tyneside and Merseyside, and the
industrial canals of Shropshire and Staffordshire where the first Industrial
Revolution began (and where traces of it can still be seen).

VARIETY *and* IDENTITY
Now divided into the new counties of North Yorkshire, West Yorkshire and
Humberside, the old county of Yorkshire still has a very strong regional
identity going back at least to the medieval Wars of the Roses. It is a huge
tract of land in the NE, traditionally divided into its three "ridings" (which
correspond roughly with the new administrative groupings) and contains, in
addition to heavily industrialized areas, enormous open landscapes
interrupted only by sheep and abandoned buildings. Here, in addition to
massive industrial workings – now often sadly dilapidated – you will see some
of the greatest medieval monuments in the country, as well as the ancient
county town of YORK itself, with its recently opened Viking museum and its
magnificent Minster (which is still the seat of an archbishop – the second
figure in the English ecclesiastical hierarchy). Leeds, on the other hand, owes
much of its artistic heritage to the patronage of 19thC manufacturers.
 Alongside it, to the W, lies the county of Lancashire, Yorkshire's historic
rival separated by the bleak mountain chain of the Pennines. Throughout the
19thC Lancashire had the highest population and greatest concentration of
industry in such cities as Manchester, Blackburn, Oldham and Bolton. The
damp climate encouraged cotton manufacturing, an immensely important
trade that spawned countless mills and factories in the southern reaches of the
county, and these are still in evidence despite the severe decline of the
industry in recent decades. Wealthy 19thC manufacturers and mill-owners
endowed their towns with collections of art, and you will be pleasantly
surprised at the quality of some of the galleries, such as ACCRINGTON or BURY,
in otherwise unprepossessing towns. MANCHESTER itself has of course been a
center of cultural activity since the mid 19thC.

URBAN AREAS *and* RURAL HINTERLANDS
Of the other regions in this section of the *Guide*, Durham is perhaps the most
unusual, combining as it does a great medieval heritage (you should not miss
the superb cathedral and castle of the county town of DURHAM itself) with a
landscape marked by coalfields and pit workings. Like many other regions,
Durham has been radically altered in recent years as a result of local
government reorganization – a process that has not only cut across the
ancient county boundaries, but has also proved in many cases confusing and
impractical. Cumbria, for example, in the extreme NW of the region, is the
result of an amalgamation of Westmorland and Cumberland stretching from
the Lakes to Hadrian's Wall, while conurbations at the great river estuaries
have been isolated to create Humberside, Merseyside, Cleveland, and Tyne
& Wear. These urban areas are now separated from the inner rural
hinterlands for which they were once the main focus.

NORTHERN ARTISTS

In general, the northern areas of England have little pictorial tradition to speak of, although the rise of the "Picturesque" tour in the 18thC made areas such as the Lakes and the Peak District, as well as the ruined abbeys of Yorkshire, popular sketching grounds for the connoisseur and traveller. Here the landscape offered the prospect of alternately wild and pastoral scenery in accordance with the prototypes seen in the art of Claude and Salvator Rosa and diligently amassed by British collectors abroad. Turner and Girtin, the greatest exponents of the topographical watercolour, supplied the same market, and both these artists worked regularly in northern England, monastic ruins being a particularly popular subject.

In the region of Merseyside, however, several local artists were encouraged to develop their own styles, following the establishment of the Liverpool Academy, although even in its greatest phase in the mid 19thC this was chiefly notable for a provincial version of Pre-Raphaelitism as interpreted by W.L. Windus. Since then, the numerous artists who began

their careers in northern England have clearly followed a well-trodden path to the art schools and galleries of London, only to claim later that their northern backgrounds served to toughen their characters and impart a particular flavour to their work. Henry Moore would not be the first to attribute his direct and down-to-earth approach to his Yorkshire childhood, and more recently David Hockney has made frequent autobiographical references to his Bradford origins. But it is of course hard to assess how far such factors have been instrumental in conditioning these and other artists' styles or methods.

The SALFORD painter L.S. Lowry (1887–1976) appears as a curious exception to this trend. Lowry is the only artist of any importance to have used the stark industrial and urban landscapes of the region as the basis for his art. By so doing, he has managed to avoid being drawn into any displays of northern chauvinism, but his chosen method of depicting the street life of Manchester and Salford in a simple, naive manner (he had very little formal training) has by now itself become something of a cliché, and his artistic ability does not always justify his undoubted popularity.

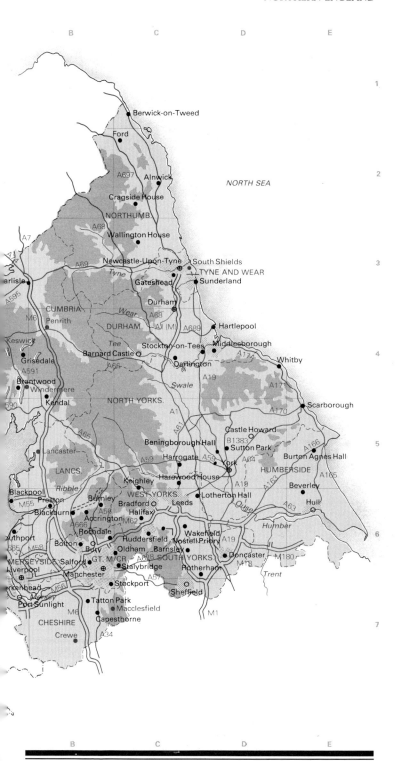

B C D E

1

Berwick-on-Tweed

Ford

2

NORTH SEA

A697 Alnwick

Cragside House

NORTHUMB.

A68 Wallington House

A7

A69 Newcastle-Upon-Tyne South Shields

Tyne TYNE AND WEAR

3

arlisle

A595 Gateshead Sunderland

CUMBRIA Durham

M6 Penrith Wear A68

DURHAM A1 (M) A689 Hartlepool

Keswick Tee Stockton-on-Tees Middlesborough

Griesdale Barnard Castle Darlington A171 Whitby

4

A591 A66 Swale A19

Brantwood Windermere

590 Kendal NORTH YORKS. A170 A171 Scarborough

A1

A65 Castle Howard

Lancaster A61 Beningborough Hall B1383 A166

5

LANCS. Harrogate A59 Sutton Park Burton Agnes Hall

Keighley York A64 A165

Ribble Harewood House HUMBERSIDE

Blackpool Burnley WEST YORKS. A19 A163 Beverley

M55 Preston Bradford Leeds Lotherton Hall

Blackburn Halifax Ouse A63 Hull

A666 Accrington M62 Humber

uthport Rochdale Huddersfield Wakefield

6

365 M58 Bolton Bury Oldham Barnsley Nostell Priory A19

MERSEYSIDE Salford GT. M/CR. Doncaster M180

Liverpool Manchester Stalybridge SOUTH YORKS. M18

rkenhead A628 Rotherham Trent

Mersey Stockport A57

Port Sunlight Tatton Park Sheffield

M6 Macclesfield M1

CHESHIRE Capesthorne

7

Crewe A34

B C D E

ACCRINGTON
Lancashire Map B6

Like most of the towns in this area of Lancashire, Accrington near Blackburn has strong links with the cotton weaving and spinning industry.

Haworth Art Gallery ☆
Haworth Park
Tel. (0254) 33782
Open Mon – Thurs Sat Sun 2 – 5pm
Closed Fri
📷 🏛 ☑ ♨

The Haworth Art Gallery in Accrington is one of the finest small galleries in northern England; the care that has been taken to display the works to their best advantage makes the place a real pleasure to visit.

The gallery was set up as a result of the bequest of Miss Haworth, who in 1920 presented the attractive Edwardian house and gardens, as well as a collection of paintings, to the town. This collection was largely made up of **English watercolours**, including works by **Prout**, **Cox**, **Copley Fielding** and **Birket Foster**, and it has been enhanced by similar works by **De Wint**, **Cristall** and **Thomas Barker** of Bath. Paul Sandby's *Old Castle and Cascade* is the earliest and most important work in this section. Of the oils, C.J. Vernet's *The Tempest* is a particularly good example of this French artist's dramatic seascapes, but there are several good 19thC British works. J.F. Herring's *My Ladye's Palfrey* and J.J. Hill's *Exterior of an Irish Cabin* demonstrate the strong anecdotal element in much Victorian art, while Edward Frere's *The Laundress* is a simple genre scene with sensitive handling of light.

Less predictably, the Haworth Art Gallery also contains an outstanding collection of "Favrile" or iridescent **glassware ★** by the great American designer **Louis Comfort Tiffany**. This was presented to the town by Joseph Briggs, a native of Accrington who had joined Tiffany's firm in the late 19thC and eventually rose to the position of art director and assistant manager. While in America he had been able to gather a collection of some of the finest **Art Nouveau vases**, many of which are now on display and which constitute the most important group of these works in Europe. One of the most striking items was in fact designed by Briggs himself, a glass mosaic exhibition piece entitled *Sulphur Crested Cockatoos* with the vivid iridescent colouring associated with Tiffany's products.

ALNWICK
Northumberland Map C2

The small market town of Alnwick in Northumberland has preserved much of its rural charm although its popularity in the summer can lead to overcrowding. There are numerous interesting buildings apart from the **castle**, home of the Percy earls of Northumberland.

Alnwick Castle ☆
Tel. (0665) 602722
Open May – Sept Mon – Fri Sun 1 – 5pm
Closed Sat May – Sept; Oct – Apr
📷 🏛

Despite its martial appearance, Alnwick Castle, the principal seat of the Percy family, is largely the result of an extensive restoration in the 18thC and 19thC by, among others, Robert Adam. Behind the ancient and warlike exterior, complete with barbican and towers, the residential parts are elegantly fitted out with marble, stucco and damask which, with the fine **furniture** and **porcelain**, provides an elaborate setting for the superb collection of paintings.

The **Venetian pictures** are the most important with works by **Titian** (*The Bishop of Armagnac with his Secretary ★*), Tintoretto, **Palma Vecchio** and **Canaletto** (*View of Northumberland House ★*), but the **English portraits** are equally outstanding, including Dobson's *Portrait of the Artist with Sir Charles Cotterell and an Elderly Man ★* (otherwise known as *Three Cavaliers*), Van Dyck's *10th Earl of Northumberland ★* and other family portraits by **Reynolds**, **Gainsborough**, **Cosway** and **Dance**. A later work, Turner's *Temple of Aegina ★*, hangs in the Red Drawing Room, and throughout the castle there are various **ancient and medieval antiquities**.

BARNARD CASTLE
Co. Durham Map C4

Barnard Castle on the River Tees is famous for the BOWES MUSEUM, but there are other attractions such as the original castle built in the 12thC.

The Bowes Museum ☆
Tel. (0833) 37139
Open Mar – Oct Mon – Sat 10am – 5.30pm,
* Sun 2 – 5pm; Nov – Feb Mon – Sat*
* 10am – 4pm, Sun 2 – 4pm*
📷 ♨ ▣

The Bowes Museum would be an unusual institution in any city, but to come across it in a quiet country town like Barnard

Castle is doubly surprising. It was built in the 1870s to accommodate and display the huge collection of fine and decorative arts that John Bowes and his French wife, Josephine, had amassed over the previous 30 years. Neither of the two principals lived to see the building completed and opened to the public but, seemingly, their intentions for the arrangement of the museum's interior were carried out. That would certainly explain the rather faded and often cluttered displays but this can have its own charm, and from the moment you enter the building, to be confronted by a silver swan that moves to the accompaniment of music, it is clear that this is an exceptional museum.

The largest single area of the collection is devoted to **French paintings** and applied arts of the 18thC (a reflection, perhaps, of Mrs Bowes' taste). **Tapestries, furniture, porcelain, glass, jewellery** and **silverware** are all found in such abundance that only a part of the collection can be displayed, but the most attractive rooms are those in which a period interior has been re-created to suggest the inter-relationship of different items. In the heart of this, the paintings include a beautiful pastoral scene by Boucher, *Landscape with a Watermill* ★, a tiny *Landscape with Two Figures* ★ by Fragonard, portraits by **Largillière** and **Van Loo**, architectural fantasies by **Hubert Robert**, and a number of sporting and animal studies by **Oudry** and **Desportes**. Of a slightly later date there is a *Portrait of Napoleon* by Girodet and a *Portrait of Charles X* by Gérard, while among their contemporary artists the Bowes favoured **Courbet** (seen here with a *View from Ornans* ★) **Boudin** and **Fantin-Latour**.

If the French works are the most numerous, the **Spanish paintings** in the great hall are undoubtedly the chief glory of the collection. El Greco's *Tears of St Peter* ★ is the finest, a tragic work from the 1590s which, like many others, was acquired in 1862 from the collection of the Spanish connoisseur, the Conde de Quinto. There are also some **15thC panels** and an impressive selection of 17thC pictures, including *St Eustochium* by Juan Valdes Leal, *The Immaculate Conception* and *The Agony in the Garden* by Jose Antolinez, *Belshazzar's Feast* by Juan Carrena di Miranda and a striking *Portrait of Queen Mariana of Austria* ★, widow of Philip IV, in a nun's habit, by El Greco's pupil **Luis Tristan**. Goya, the principal figure of the Romantic era in Spain, is represented by two works, a portrait of the lawyer *Melendez Valdes* and a rather bleak, despairing picture of *The Interior*

of a Prison, which is painted on tin.

The Italian paintings cover a similarly wide range, beginning with **Sassetta's** predella panel from the 1420s, *The Miracle of the Holy Sacrament*, and ending in the 18thC with two recently purchased Venetian views by **Canaletto**: *A Carnival Regatta on the Grand Canal* and *The Bucintoro returning to the Molo after the Ceremony of Wedding the Adriatic*. Between those dates there are works by Primaticcio (*The Rape of Helen*), Luca Giordano (*The Triumph of Judith*) and Solimena (*The Birth of John the Baptist*), but the finest work in this section is Tiepolo's *The Harnessing of the Horses of the Sun* ★, a sketch for the lost ceiling decoration of the Archinti Palace in Milan.

Of the other European schools only the Netherlandish artists are present in any strength, a 15thC *Crucifixion* by the Delft painter known as the **Master of the Virgo inter Virgines** being one of the most interesting works. Thereafter you will find some good 17thC paintings by **van Heemskerk** and **Nicolaes Maes**, and a fine *View on the Rhine* by Herman Saftleven, an artist who frequently worked in Germany. As regards German artists, there is a picture of *St Jerome and the Lion* by Hans Schaufflein, a pupil of Dürer, although this could hardly be described as important. German art did not find much favour outside its native country in the 19thC and this may account for the relative shortage of significant pictures at Barnard Castle. What is less expected, however, is a similar shortage of English paintings in a collection of this size. Apart from a small group of 18thC portraits by **Hudson, Ramsay** and **Reynolds**, the most interesting picture, given this location, is a small topographical view of the original *Barnard Castle* by the watercolourist **Thomas Girtin**.

BARNSLEY
South Yorkshire Map C6

In the heart of a coal-mining district of South Yorkshire, Barnsley has often been regarded as the epitome of the northern industrial town. Yet it does have several unusual features on closer inspection.

Cannon Hall Art Gallery and Museum
Tel. (0226) 790270
Open Mon–Sat 10.30am–5pm, Sun 2.30–5pm
📷 🏛 ❧

This 18thC house, situated in its own parkland some 5 miles out of the town,

was acquired by the Barnsley authorities in 1951 from the Spencer family and turned into a country house museum. The original contents had been dispersed, but these have been replaced by some **17thC–18thC English furniture**, and the building now displays an impressive collection of **glassware** from Roman times to the present day. The small collection of pictures includes some English portraits by **Lely**, **Wright** and **Highmore**, as well as a range of 19thC and 20thC works by such artists as **Ruskin**, **Sickert** and **Hitchens**. To this has been added the **William Harvey Collection** (formerly the National Loan Collection) of **17thC Dutch paintings**, the finest of which are the river scenes by **Cuyp** and **Berchem**, *The Ponte Molle near Rome* by Jan Asselyn and the genre scenes of **Ostade**, **Teniers** and **Metsu**. The **decorative paintings** on the ballroom fireplace were executed by **Roddam Spencer Stanhope**, a member of the family who was associated with the Pre-Raphaelites in the later 19thC.

Cooper Gallery
Church St
Tel. (0226) 42905
Open Tues 1–5.30pm, Wed–Sun
* 10am–6.30pm*
Closed Mon
The Cooper Gallery occupies an old school building in the center of Barnsley and its modest scale gives it an unobtrusive aspect. It was first opened in 1914, following Samuel Cooper's gift of the building and a large number of paintings "to provide a public art gallery for Barnsley". This original collection was largely made up of British and European pictures of the 19thC including works by **Isabey** (*Hurricane before St Malo*), **Gérôme**, **Jongkind** and the **Barbizon painters**, but there are a few **17thC Dutch landscapes** and genre scenes. Since then the gallery has built up an enviable collection of **British watercolours** with examples of all the major exponents of this art, and a number of 20thC British drawings including works by **Augustus John** and **Paul Nash**.

BENINGBOROUGH HALL ▥
Nr. York
North Yorkshire Map D5

Tel. (0904) 470715
Open Apr–Oct Tues–Thurs Sat Sun
* noon–6pm*
Closed Mon Fri Apr–Oct; Nov–Mar
▨ ▣ ▥ ⚐
When the National Trust acquired Beningborough Hall in 1957 this early

18thC Baroque house was in a state of considerable disrepair. Since then an extensive programme of renovations has restored the excellent **woodcarving** on the cornices and overmantles (much of it by a local craftsman, **William Thornton** of York), and installed a range of good **17thC and 18thC English furniture**; the house also contains a remarkable collection of **Oriental porcelain**. What is more, the National Portrait Gallery has collaborated on the whole project, lending a series of **English portraits** from the late 17thC and 18thC, which are now hung throughout the house and in a new gallery on the top floor. Most of the leading English portraitists of the period are represented, including Reynolds (*Joseph Gibbs* and *Admiral Edward Boscawen*) and Gainsborough (*Admiral Edward "Grog" Vernon*), but the most notable works are those by **Sir Godfrey Kneller**, including a very early painting, *James Vernon*, and a number of half-lengths from the series of portraits of members of the learned **Kit Cat Club**.

BERWICK-ON-TWEED
Northumberland Map C1
As a border town between England and Scotland Berwick suffered repeatedly from sieges and bombardments, the 16thC walls being a reminder of this precarious history. In more settled times, however, the port thrived until the arrival of the railways, and since then Berwick has maintained its position as the market town of the region.

Berwick-on-Tweed Museum and Art Gallery
32 Marygate
Tel. (0289) 307320
Open June–Sept Mon–Fri 10am–1pm,
* 2–5pm, Sat 9am–noon*
Closed Sun June–Sept; Oct–May
▣
The Berwick gallery beside the library is chiefly notable for a collection of paintings presented to the town in 1949 by Sir William Burrell, who lived in the nearby Hutton Castle during the latter part of his life. In common with Burrell's larger and more famous collection in Glasgow (see *SCOTLAND*), the finest pictures are drawn from the French school of the 19thC and include Géricault's *Wounded Cavalry Officer*, Daubigny's view of *Cap Gris Nez*, Degas' *Danseuses Russes* and George Michel's *Windmill*, as well as other works by **Boudin, Bonvin, Fantin-Latour** and the Dutch artist of the Hague School, **Anton Mauve**. The gallery also possesses a

number of 18thC portraits by **Hudson**, **Ramsay** and **Raeburn**, and a *Group of Peasants* attributed to the **Le Nains**. There are also some local **antiquities** and **ceramics**.

BEVERLEY
Humberside Map E6

The market town of Beverley has been able to maintain its traditional "county" atmosphere through the preservation of so many of its early buildings. Chief among these is the superb **13thC–15thC Minster★**, a large Gothic church with twin towers and double transepts whose scale and decoration are the equal of many cathedrals. In the choir there are some excellent **carved stalls** and **misericords**, and the 14thC **Percy Tomb★** beside the altar is one of the finest of its type in England. Other buildings of note include the 15thC **Church of St Mary** and the **North Bar**, a remnant of the original town gates.

Beverley Art Gallery and Museum
Champney Rd
Tel. (0482) 882255
Open Mon–Wed 10am–5.30pm, Thurs 10am–noon, Fri 10am–5.30pm, Sat 10am–4pm
Closed Sun
🖼 ☑ ♿

The quiet top-lit rooms of the Beverley Art Gallery above the public library have a relaxed air that is now uncommon in British museums. As such they provide a perfect setting for the work of **Fred Elwell** (1870–1958), a local-born painter who specialized in scenes of Edwardian country life. Despite plans to convert the main gallery into a local heritage center, Elwell's idyllic and frankly nostalgic pictures, such as *Elevenses*, *Maids with Pigeons* and *The Last Cab*, will continue to be shown.

Elwell's wife **Mary Elwell** was also a painter, and her *Interior, Bar House* hangs alongside a number of watercolours (from the original Champney Bequest) by such artists as **Arthur Hughes**, **Helen Allingham** and **William Russell Flint**.

BIRKENHEAD
Merseyside Map A7

Birkenhead, on the W bank of the River Mersey opposite Liverpool, was developed in the 19thC through the establishment of docks (which were amalgamated with those of Liverpool in 1858), and important shipbuilding and engineering works.

Williamson Art Gallery
Slatey Rd
Tel. (051) 652-4177
Open Mon–Wed Fri Sat 10am–5pm, Thurs 10am–9pm, Sun 2–5pm
🖼 ☑ ♿

The Williamson Art Gallery, a one-storeyed Classical-style building situated in a quiet suburban district of the town, was built in the 1920s with money donated by John Williamson, a director of the Cunard Steamship Company Ltd, and his son Patrick Williamson. The interior is old-fashioned in character, but spaciously proportioned and pleasant to walk around. In addition to paintings, it has items of historical interest, some **ancient Cypriot pots**, extensive holdings of **ceramics** and **glass** (in particular 18thC and 19thC British works), and a surprisingly good Oriental collection, which includes **Chinese** and **Japanese porcelain**, and a few **Japanese bronzes**.

The bulk of the painting collection is of **18thC–20thC British watercolours**, a selection of which is displayed in three of the museum's rooms. A further room shows canvases by the 19thC Liverpool School painters (most notably the animal and landscape painter **William Huggens** and the still-life painter **George Lance**), and another is devoted to Birkenhead's greatest native artist, **Philip Wilson Steer**. Steer was born in 1860 at 39 Grange Mount, Birkenhead (his birthplace, now marked by a plaque, is recorded in a painting in the museum by **K.M. Hume**). He was a founder member of the New English Art Club, an exhibiting institution set up in 1885 in opposition to the by then reactionary Royal Academy. Steer was an enormous enthusiast for contemporary French art, and his finest paintings show a vividness in the handling of paint and colour that is characteristic of the work of the French Impressionists. The museum has drawings and watercolours by him, and 22 of his oil paintings. The latter include a *Self-Portrait* as a young man, a *landscape* done at the artists' colony at Walberswick in Norfolk, two **nudes**, numerous **portraits** (including a vividly coloured one of a *Girl in a Muslin Dress Lying on a Sofa★*) and many of his later landscapes, which were generally of conventionally beautiful countryside, painted in a rather slapdash style.

BLACKBURN
Lancashire Map B6

Blackburn is the principal cotton-weaving center of Lancashire. It was the birthplace of James Hargreaves, inventor

of the Spinning Jenny, and played an important role in the Industrial Revolution. The cotton industry is now in decline but the mills are still in evidence and the **Lewis Textile Museum** (in Exchange St) records many aspects of their history.

Blackburn Museum and Art Gallery
Library St
Tel. (0254) 667130
Open Mon – Fri 9.30am – 6pm, Sat
9.30am – 5pm
Closed Sun
◙

The entrance to the Blackburn Museum and Art Gallery is flanked by two tile and mosaic murals, *Science and Labour* and *Painting and Poetry*, which clearly identify the Victorian character of the building and of the collection itself. Inside, the ground floor is devoted to local history and archaeology, while the upper galleries contain the bulk of the **painting collection**. There are a few paintings in the lower sections, such as **Kneller's** full-length *Portrait of Mary II* in the Regimental Rooms or the attractive *Portrait of Mrs Healey* by Vladimir Sherwood at the door, but the collection begins in earnest with some late 19thC and early 20thC works on the stairs. La Thangue's *Ligurian Arbetus*, a landscape free from the normally cloying sentiment of this artist's work, Cursiter's *Roberta* and Gilbert Spencer's *Wooded Landscape* are probably the most interesting.

The first gallery is devoted to **English watercolours** between the 18thC and 20thC, and includes works by **Rowlandson, Cotman, Varley, De Wint, Bonington, Lewis** and **Russell Flint**. David Cox's *Crossing Lancashire Sands* is one of the finest, the subject itself being appropriate for this northern museum. Beyond this, the main gallery contains most of the oil paintings and, despite the presence of a few portraits by **Reynolds, Romney** and **Lawrence**, it is clearly a Victorian selection. The finest are J.F. Herring's *Nanny*, (a picture of a goat), Linnell's large landscape *Hesperus*, Henry O'Neil's *Opera Box*, and a group of High Victorian works, including Albert Moore's *The Loves of the Winds and the Seasons*, Long's *Diana or Christ* and *Cherries* by Lord Leighton.

There is also a display of Lancashire **glass** and **ceramics** of the 19thC, but the museum is particularly rich in two unexpected areas: **Japanese prints** and **European coins**. The former have been shown in temporary exhibitions in the past but the coin collection is about to be given a full permanent display.

BLACKPOOL
Lancashire Map A6

Since the late 19thC Blackpool has been so popular as working-class England's foremost coastal resort that its very name is now a byword for seaside commercial development and a range of elaborate entertainments. The tower, the piers, the "illuminations" and a series of amusement parks, draw millions of visitors from the North each year.

Grundy Art Gallery
Queen St
Tel. (0253) 23977
Open Mon – Sat 10am – 5pm
Closed Sun
◙

Surprisingly for a town not readily associated with the fine arts, Blackpool's Grundy Art Gallery, founded in 1911, has an interesting small collection of **19thC** and **20thC British pictures**. The earlier works are mainly landscapes and views such as Thomas Creswick's *Bolton Abbey*, *The Woodland Forest* by John Linnell and *Rouen Cathedral* by the Scottish traveller and topographical artist, **David Roberts**. Atkinson Grimshaw's *Five Views of Old Liverpool* could be classed in the same category, but the 20thC paintings have a different mood. Look for Augustus John's *Portrait of Air Mechanic Shaw* (the pseudonym adopted by the writer T.E. Lawrence), and works by **Harold** and **Laura Knight**.

BOLTON
Greater Manchester MapB6

A large steam engine designed to drive a cotton loom stands in the middle of Bolton's bustling pedestrian district, testifying to the source of the town's enormous propriety in the 19thC. Nearby is a monumental civic complex, comprising a massive late 19thC town hall in a Classical style, and a matching crescent built in the 1930s. Part of this houses the museum and art gallery.

Bolton Museum and Art Gallery
Le Mans Crescent
Tel. (0204) 22311 ext. 379
Open Mon Tues Thurs Fri
9.30am – 5.30pm, Sat 10am – 5pm
Closed Wed Sun
◙

Bolton's Art Gallery, though founded in 1890, did not benefit from the large

Victorian benefactions that endowed other northern museums with so many of their greatest art treasures. Its collection has been largely built up this century with limited funds, and concentrates mainly on **watercolours**. Three rooms of the gallery are always taken up with a selection from the museum's watercolour collection, which is particularly strong on **British 18thC** and **20thC works**. The nucleus of the museum's small oil painting collection, which is only occasionally shown, comprises works by British artists of the early years of this century, and was the gift of a Bolton mill-owner, Frank Hindley Smith, who was a close friend of Maynard Keynes and other members of the Bloomsbury circle. It includes an excellent canvas (*The Wash*) by the Vorticist painter, **William Roberts**, and numerous works by Bloomsbury artists such as **Duncan Grant**, **Roger Fry** and **Vanessa Bell**; of particular note is the latter's *View in Garden**, which was painted in her house at Charleston in Sussex. In the gallery's main hall you can generally see a group of 20thC British sculptures, including works by **Henry Moore**, **Epstein**, **Paolozzi**, **Elizabeth Frink** and **Lynn Chadwick**.

BRADFORD
West Yorkshire Map C6

Bradford, a leading wool-manufacturing and engineering town, has a predominantly grey, Victorian appearance. For all this, it is an exceptionally lively place with a strongly cosmopolitan character and an enterprising, progressive spirit. It can boast an impressive number of social and cultural achievements, ranging from its establishment of England's first nursery school and municipal hospital, to its opening of England's first important museum devoted to film and photography.

Cartwright Hall ☆
Tel. (0274) 493313
Open Apr–Sept Tues–Sun 10am–6pm;
Oct–Mar Tues–Sun 10am–5pm
Closed Mon

Cartwright Hall, a monumental neo-Baroque structure opened in 1904, was a gift to Bradford from Lord Masham and stands on the site of his old home. Bearing the name of the reputed inventor of the power loom, Edmund Cartwright (1743–1823), it occupies an extensive public park in an elegant part of Bradford once favoured by wealthy Victorians.

Its art collections, which are pleasantly displayed in both Edwardian and modernized rooms, boast a small number of foreign works, most notably a group of **16thC–18thC Italian paintings**. Among these are *The Holy Family with St John the Baptist* attributed to Vasari, *The Flight into Egypt* by Guido Reni and *St Gregory the Great* by Corrado Giaquinto. You will also find some Classical landscapes attributed to the 17thC Flemish painters **Paul Bril** and **Swanevelt**; *St Peter by Candlelight* by the enigmatic Dutch artist of this period, **Godfried Schalken**; *Maria at Moulines* by the Swiss-born 18thC painter **Angelica Kauffmann**; and works by **Fantin-Latour** and Gauguin's follower, **Maxime Maufra**. There are various British 18thC and early 19thC works, including an oil sketch by **James Ward** for his famous *Gordale Scar* in the Tate Gallery (see *LONDON*); *The Edge of the Forest* by John Crome; and Ford Madox Brown's *Wycliffe Reading his Translation of the Bible to John of Gaunt*.

But the real strength of the collection is its very representative selection of **British art** from the **late 19thC** up to the **present day**. The Bradford industrialists of the late Victorian and Edwardian periods were exceptionally enlightened in their artistic patronage, and many leading members of the New English Art Club in London (the progressive exhibiting institution set up in 1885 as an alternative to the Royal Academy) including **George Clausen** and **Henry Herbert La Thangue**, found support here. One of the finest private art collections in the city at that time was owned by Abraham Mitchell, who is portrayed in a superlative portrait by La Thangue (*The Connoisseur**) staring, magnifying glass in hand, at one of his acquisitions.

Bradford's leading native artist of this period was **William Rothenstein**, who was born in 1872 of a wealthy Jewish family involved in the wool trade and living near Cartwright Hall. Rothenstein became one of the best-known figures in the Edwardian art world and the director of the Royal College of Art in London. However, his particular talent seems to have been in making influential friends, and his gifts as a painter were uneven. The museum has several of his works, including a view of the old quarry at nearby Hawksworth and a group of portraits featuring the artist's wife, Alice Knewstub and her sister Grace (who was the wife of the painter William Orpen).

Perhaps Bradford's greatest claim to artistic fame is as the birthplace of the

most popular British artist today, **David Hockney**. He was brought up in the rather more modest residential district of Eccleshill, and after becoming, in the words of one of his teachers, "an almost legendary figure of fun" at Bradford Grammar School, joined the Bradford School of Art. In 1959 he entered the Royal College of Art in London, and while still a student began making a considerable name for himself. His enormous popularity may partly be accounted for by his much promoted and endearingly humorous personality, and his adoption of a colourful and simple figurative style. He is principally represented in the museum by a marvellous *Double Portrait* ★★ of his mother seated next to his flamboyantly eccentric father.

The museum's collections of present-day art have been considerably enhanced by the **International Print Biennale**, which has been held at Bradford since 1968 and has come to attract artists from all over the world. Many of these prints have been acquired by the museum, and an impressive selection of them is generally on show.

National Museum of Photography, Film and Television
Prince's View
Tel. (0274) 727488
Open Tues–Sat noon–8pm, Sun 2.30–6pm
Closed Mon
📷 ☑ ⬚

This is the first important museum of its kind in Britain, and is administered by the Science Museum in *LONDON*. It is housed in a former cinema, adjoining the town's most famous theatre, and its modernized split-level interior provides an exciting space for the display of items relating to the technical processes of film and photography. As with the Science Museum, you are encouraged to press buttons to activate many of the objects. Particularly enjoyable is the booth where you can make a video of yourself. The museum also has galleries putting on temporary photographic exhibitions.

BRANTWOOD 🏛
Coniston, Cumbria Map A4
Tel. (096 64) 396
Open Apr–Oct Mon–Fri Sun 11am–5.30pm
Closed Sat Apr–Oct; Nov–Mar
🐚 🚗 🍴 🏛 ♨ ⛏

Brantwood, beautifully situated overlooking Lake Coniston in extensive, wooded and rocky grounds, was originally

a relatively modest late 18thC house. This was considerably enlarged in the 1830s, and again after 1872 when it was acquired by Victorian England's most influential writer on art, **John Ruskin**. One of Ruskin's first changes was to build a small turret room, entered from his bedroom, affording a magnificent view over the surrounding lake and mountain scenery. But his interior decoration was rather less felicitous, and visitors to Brantwood today who find the interior to be rather heavy and depressing in its overall effect might be consoled by the knowledge that this opinion was shared by a number of Ruskin's guests, who were surprised at the lack of taste shown by such an eminent art critic.

While he lived there Ruskin's house was crammed to capacity with works by himself and distinguished contemporary artists: in his bedroom hung part of his famous collection of Turner's watercolours, which was later donated to the Ashmolean Museum in Oxford (see *MIDLANDS*). Today, you can still see here a large number of Ruskin's own minutely detailed **watercolours and drawings** , but the other works are mainly by minor artists associated with him such as **W.G. Collingwood**, **Arthur Severn** and **Stacey Marks**. The major exception is a large **Burne-Jones cartoon**, hanging in the drawing room, which was the design for a stained glass window executed by Morris's Company for the English church in Berlin. Brantwood remained Ruskin's principal home until his death in 1900, his last years being clouded by madness and senility. He is buried in the churchyard at **Coniston**.

BURNLEY
Lancashire Map B6

Burnley is one of the traditional industrial centers of Lancashire with mining, engineering and weaving concerns active in the neighbourhood. Weaving is the theme at the nearby Jacobean house of **Gawthorpe Hall**, which has one of the finest **textile collections** in the country.

Towneley Hall Art Gallery and Museum
Tel. (0282) 24213
Open Mon–Fri 10am–5.30pm, Sun noon–5pm
Closed Sat
📷 ⬛ 🏛

Burnley's civic art gallery is located at Towneley Hall, a 14thC house with considerable later modifications, whose surrounding park has now been turned

over to playing fields. The Towneley family, who lived there for some 500 years, is perhaps best known for the great 18thC collector and connoisseur, Charles Towneley. The portrait by **Zoffany** in the main gallery depicts him surrounded by his antique sculptures and engaged in conversation with his friends. But his famous collection was dispersed at the beginning of the 19thC, the Classical pieces forming the basis of the Greek and Roman departments of the British Museum (see *LONDON*). The principal item surviving at the Hall is the elaborate **Towneley Altarpiece**, a Netherlandish wood sculpture with the upper part dating from the early 16thC.

The interior of Towneley Hall is still in the course of restoration, but several rooms have retained their fittings and you can see some early views of the house by such artists as **George Barret** and **Turner**. Otherwise, the main picture galleries are on the upper floor, the first of which has a large number of **English watercolours** of the 18thC–19thC from the Edward Stocks Massey Bequest. **Prout**, **Towne**, **Cotman**, **Cox** and **De Wint** are all represented, but the finest are George Barret's *Ancient Italy* and *The Foro Romana* by Dance. With the exception of Zoffany's *Portrait of Charles Towneley*, the most notable oil paintings in the adjacent gallery are all Victorian, Burne-Jones's *Wood Nymphs*, Alma-Tadema's *The Picture Gallery* and Long's Egyptian scene, *The Gods and their Makers*, being the most interesting.

Throughout the house, which also has **ceramic displays**, reconstructed kitchens and a regimental museum, there are further miscellaneous paintings by such artists as **Herring**, **Troyon** and **John Bratby**, while the outbuildings contain a **craft museum** and a restored ice house.

BURTON AGNES HALL 🏛
Nr. Bridlington, Humberside Map E5

Tel. (026289) 324
Open Apr–Oct Mon–Fri 1.45–5pm, Sun 1.45–6pm
Closed Sat Apr–Oct; Nov–Mar
📷 🍴 🏛

Burton Agnes Hall is an attractive red-brick house from the early 17thC designed by **Robert Smythson**, the greatest architect of the Elizabethan period. In addition to its impressive façade and gatehouse, Burton Agnes Hall's interior has much to offer. On entering it, you will be almost immediately aware of the rich and exuberantly decorative **plasterwork**,

panelling and **friezes** that are found throughout. This decoration is at its finest in the Great Hall, where there is a carved oak screen depicting the *Twelve Tribes of Israel* and an overmantle of *The Wise and Foolish Virgins*, but there is also an unusual *Dance of Death* over the fireplace in the Drawing Room.

The collection of paintings is also remarkable for a house of this type. There is a good portrait of *The Three Misses Griffiths* by the 17thC Dutch artist **Gheeraerts** and a number of good 18thC British portraits by **Reynolds**, **Gainsborough**, **Kneller** and **Cotes**. But the house's greatest attraction is a collection of **French paintings** of the late 19thC and early 20thC, including works by **Pissarro, Renoir, Gauguin, Cézanne, Matisse, Rouault** and **Vlaminck**, which are divided between the small garden gallery and the upper drawing room. If this alone were not sufficient to make Burton Agnes Hall into something exceptional, there is also a good range of European **porcelain** and some **Oriental ceramics** supplemented by **lacquer screens** in the Chinese Room.

BURY
Greater Manchester Map B6

Bury, an industrial town known for paper-making, dyeing, engineering works and the manufacture of woollen yarn, was the birthplace of one of Britain's greatest prime ministers, Sir Robert Peel.

Bury Art Gallery ☆
Moss St.
Tel. (061) 761-4021
Open Mon–Fri 10am–6pm, Sat 10am–5pm
Closed Sun
📷 🏛 📋

The collection of **paintings** and **watches** belonging to Bury Art Gallery was built up principally by a 19thC industrialist Thomas Wrigley, a leading figure in the local paper trade and the author of a pamphlet advocating compulsory education. In 1897, the year of the Queen Victoria's Diamond Jubilee, his collection was donated by his children to the town, on condition that a suitable building was erected to house it. The museum, an imposing Classical-style structure, was opened in 1901. Its rather depressing interior, with drab, greyish-green walls, seems to have changed little over the years, and though temporary exhibitions are put on here, the place is dominated by Wrigley's collection.

This collection is devoted exclusively to **19thC British art**, and includes fine

paintings by Constable (*Hampstead Heath*) and David Cox (*A Breezy Day: going to the Hayfield*), as well as a superb Turner, *Calais Sands, Low Water, Poissards (or Fisherwomen) collecting Bait★*. This painting comprises a flat foreground, relieved in its monotony only by the bending fisherwomen and the brilliant light reflected on it from the rising sun. It was described in the *Morning Chronicle* of 3 May 1830 as "literally nothing in labour, but extraordinary in art."

Impressive though this Turner is, perhaps the most lasting memory of a visit to the museum is the collection of Victorian subject paintings. Among these are the Scottish painter **John Faed's** illustration of a traditional Border ballad (*The Cruel Sister*), **Daniel Maclise's** portrait of a pair of lovers in a medieval setting (*A Student*), **Alfred Elmore's** study of a young pretty nun having second thoughts about her choice of vocation (*The Novice*), and **Frederick Goodall's** ludicrous though in its time much reproduced picture of Charles I and his family enjoying a Thames boating party (*The Happier Days of Charles I*). Outstanding among these pictures is Sir Edwin Landseer's *Random Shot★*, portraying a snowy Highland scene, tinged by the red of the evening sun and by the blood of an accidentally killed roe, whose fawn is trying unsuccessfully to get milk from her udder. This work was originally intended for Prince Albert, but he found it too painful to live with. A masterpiece of a later date is Sir George Clausen's *Spring Morning, Haverstock Hill ★* (1882), a most beautifully painted and enigmatic work, featuring a child being led by a pensive woman who has just bought a bunch of flowers.

CAPESTHORNE HALL 🏛
Nr. Macclesfield, Cheshire Map B7
Open Apr Sun 2–5pm; May, June Wed Sat Sun 2–5pm; July–Sept Tues–Thurs Sat Sun 2–5pm
Closed Mon–Sat Apr; Mon Tues Thurs Fri May June; Mon Fri July–Sept; Oct–Mar
🎨 🍴 🅿 🏛 ♿

Capesthorne has a fairly diverse, asymmetrical exterior, reflecting the fact that it was built over several generations in the 18thC and 19thC. The interior is similarly varied, particularly in its contents. The furniture, for example, includes some **Ceylonese pieces** in ebony that were brought here in 1830 by Sir Edward Barnes, and several European items that were designed in an Oriental

style to give the rooms an exotic flavour.

The finest of the paintings is a vivid landscape of **The River Manzanares**, just N of Madrid, attributed to the Spanish 17thC artist **Murillo**, and there are some 18thC Venetian scenes, including a view of the **Grand Canal** uncertainly linked to **Canaletto**. Besides these, there are a number of English portraits of the 18thC and 19thC, including one of **Jean-Jacques Rousseau** by Alan Ramsay, painted when the French philosopher visited Edinburgh in 1766, and a selection of miscellaneous works amid the decorative arts in the dining room. Otherwise, the most interesting room is the **Sculpture Gallery**, which contains a bust of *Charles James Fox* by **Nollekens** as well as some antique works.

CARLISLE
Cumbria Map B3

Carlisle, the county town of Cumbria, was an important military city during Roman times owing to its proximity to **Hadrian's Wall** (the structure erected by the Romans in the 2ndC AD as the frontier of their empire), and continued its role as a border fortress up to the 18thC. But despite its long history it today presents a rather characterless, largely modern aspect.

Carlisle Museum and Art Gallery
Tullie House
Castle St
Tel. (0228) 34781
Open Apr–Sept Mon–Sat 9am–7pm; Oct–Mar Mon–Sat 9am–5pm; June–Aug Sun 2.30–5pm
Closed Sun Sept–May
📷 🏛

The Carlisle Museum and Art Gallery occupies the beautiful late 17thC Tullie House. You will find here some interesting **Roman objects** (including delicate **Romano-British jewellery** of the 1st/2ndC and a curious stone **statuette** of a god) and much **18thC English porcelain**. There is also a large collection of **19thC–20thC British paintings**, among which are several drawings and watercolours by **Samuel Palmer**, and an extensive group of rather minor works by the **Pre-Raphaelites** and their associates. Here you can also see work by an interesting and undeservedly neglected local artist of the mid 19thC, **William James Blacklock**, who did strangely linear, dream-like views of landscapes with medieval architecture.

The gallery's holdings of British art from the late 19thC are especially comprehensive, partly owing to the

generous bequest made by the poet George Bottomley (a friend of many artists, including **Paul Nash**, of whom the museum has several works), and partly owing to a scheme begun in 1933 whereby important figures in the art world advised Carlisle on the purchase of works by modern British artists. The first and most important of these advisers was **Sir William Rothenstein**, who acquired at little cost to the gallery a most impressive collection, including works by **Lucien Pissarro**, **Sir William Nicholson**, **Augustus John**, **Orpen**, **Wyndham Lewis**, **Eric Kennington**, **Stanley Spencer**, **Edward Bawden** and Rothenstein himself. The gallery also has some of the simple, brilliantly coloured still-lifes, portraits and landscapes by **Winifred Nicholson**, who was married to Ben Nicholson during the 1920s and lived for most of her life at the farm of Bankshead near Carlisle.

CASTLE HOWARD 🏛
York, North Yorkshire Map D5
Tel. (065 384) 333
Open late Mar – Oct Mon – Sun
11.30am – 5pm
Closed Nov – mid Mar
🚗 🍴 🛍 🅿 🏛 ♿

In recent years Castle Howard has achieved international fame as the setting for the television dramatization of Evelyn Waugh's *Brideshead Revisited*, but it has always been known as one of the pre-eminent country houses in Britain and the building which launched Vanbrugh's architectural career. In fact **Vanbrugh** was little more than an inspired amateur when commissioned to undertake the project in 1699 and was certainly fortunate in having **Hawksmoor** to assist him. Although it is described as a "house", Castle Howard is truly palatial both in scale and in the handling of the colossal orders on the façade; a feature repeated in the stone-paved Great Hall and surmounted by **Pellegrini's** restored murals, *Phaethon and his Chariot*, in the dome.

In keeping with these surroundings, the contents of the house are similarly superb with a fine collection of **porcelain**, **Soho tapestries**, **Oriental rugs**, **bronzes** and **Italian**, **French** and **English furniture**. Family portraits are everywhere, including works by **Lely**, **Kneller**, **Reynolds**, **Gainsborough**, **Wheatley** and **Romney**, but the best works are undoubtedly those by **Van Dyck** and **Holbein** (*Henry VIII* and *The 3rd Duke of Norfolk*) in the Long Gallery. **Gainsborough** is further

represented by one of his most attractive "fancy pictures", *The Girl with Pigs* in the Music Room, which once belonged to Sir Joshua Reynolds.

In the Orleans Room there are a number of Old Master paintings, which were acquired from the sale of the Duke of Orleans' collection. The most important is Rubens' **Herodias and Salome with the Head of John the Baptist** but there is an interesting picture of **A Music Master** by the Roman Baroque painter **Domenico Feti** and three landscapes by **Gaspard Dughet**, Poussin's pupil and brother-in-law. As regards the **sculpture**, there is a fine bust attributed to **Bernini** as well as an attractive Graeco-Roman figure of **Ceres**, which is only the most notable of the large collection of **Greek, Roman and Egyptian antiquities**.

CRAGSIDE HOUSE 🏛
Rothbury, Northumberland Map C2
Tel. (0669) 20333
Open Apr – Sept Tues – Sun 1 – 6pm; Oct
Wed Sat Sun 2 – 5pm
Closed Mon Apr – Sept; Mon Tues Thurs
Fri Oct; Nov – Mar
🚗 🅿 🏛 ♿

When the industrialist William Armstrong called in **Norman Shaw** to extend the hunting lodge at Cragside in 1869, it is doubtful whether he anticipated a major undertaking. In the event, however, this Arts and Crafts architect was encouraged to increase his plans and over the next 16 years he built a huge mansion in lofty romantic grounds.

For the interior at Cragside other **Arts and Crafts designers** were employed, and many of the rooms have original **Morris wallpaper**. There is also stained glass by **Rossetti**, tiles and pottery by **William de Morgan** and, in the large drawing room, an inglenook designed by **W.R. Lethaby**. Unfortunately, Armstrong was uncritical in his own purchases and he introduced some less interesting late Victorian furniture that has diluted the overall effect.

Most of the original paintings at Cragside were sold after Armstrong's death in 1900, but the remainder have been supplemented with a series of paintings by **de Morgan** in the library.

DARLINGTON
Co. Durham Map C4

The opening of the historic Stockton to Darlington Railway in 1825 was the key to Darlington's expansion as an

engineering and steelworking center over
the next 150 years. As a result, parts of
the town have a strong Victorian flavour
but there are surviving traces of its earlier
history, notably in the 13thC **church of
St Cuthbert**, which has some interesting
carving on the **rood screen** and **stalls**.

Darlington Art Gallery
Tubwell Row
Tel. (0325) 463795
Open Mon – Wed 10am – 1pm, 2 – 6pm,
Thurs 10am – 1pm, Fri 10am – 1pm,
2 – 5.30pm
Closed Sun
🔲
The single large gallery alongside the
public library is the only space available
for displaying works of art in Darlington,
with the result that it is generally taken
up with temporary exhibitions of local
interest. Darlington does, however,
possess a municipal collection, which
consists largely of 20thC British art and
includes works by **Brangwyn**, **Prunella
Clough**, **Epstein**, **Spencer Gore** and
Graham Sutherland, but unfortunately
this is not displayed very often.

DONCASTER
South Yorkshire Map D6

Doncaster stands apart from the more
industrial areas of South Yorkshire, and
despite its coal and engineering interests
it has something of the atmosphere of a
market town. It has been a horse racing
center for over 350 years and the oldest
classic race in the calendar, the St Leger,
is still run there in the second week of
September.

Doncaster Museum and Art Gallery
Chequer Rd
Tel. (0302) 62095/60814
Open Mon – Thurs Sat 10am – 5pm, Sun
2 – 5pm
Closed Fri
🔲 ☑
At first glance, Doncaster Museum
seems, like many galleries in the North,
to be devoted to local history and
technology. Those departments fill the
ground floor of the modern building. On
the upper floor, however, there are
displays of **decorative arts**, and in a group
of 4 galleries to the rear, a very good
collection of **British** and **European
paintings** from the 16thC to the 20thC.
Some of these paintings have been
loaned from the National Gallery in
LONDON, and many others originate from
the extraordinary collection which has
been built up by the British Railways
Pension Fund, one of the main artistic

advisers to which is the director of the
National Gallery, Sir Michael Levey.
Well displayed in a setting enhanced by
16thC and **17thC silverware and
enamels** is a selection of 17thC Dutch
pictures including landscapes by **van
Goyen**, **Cuyp**, **Ruisdael** and **Hobbema**, a
still-life by **Jan Fyt**, an interesting
Classical subject, *Alexander and
Diogenes*, by **Teniers** and a striking
Portrait of a Man by **Bartholomeus van
der Helst**. In the 18thC room portraits by
Vigée-Lebrun and **G.D. Tiepolo** (a lively
group portrait ★ of his family, including
his artist brother, Lorenzo) as well as
some vedute (views) are complemented
by pieces of contemporary **French
furniture**.
 The British room has a wider range
covering the period between the 18thC
and 20thC with paintings by **Hoppner**,
Roberts, **Alfred Stevens** (a *Self-
Portrait*) and **Lavery**, and there are more
works by **Nash**, **Lowry**, **Sutherland** and
Moore among the ceramics, glass, silver
and jewellery displays in the main gallery.
One section devoted to **horse racing** in
the area has several pictures by the 19thC
animal painter **J.F. Herring**, and along
the wall there is a series of pen-and-ink
studies by the humorist **George du
Maurier** for **cartoons** in *Punch* magazine.

DOUGLAS
Isle of Man

The Isle of Man, of which Douglas is the
capital, is situated halfway between
Britain and Ireland and, though it is part
of the United Kingdom, it has its own
separate constitution administered by the
picturesquely titled Court of Tynwald.
Douglas is pleasantly situated on a wide
bay backed by hills, but like many of the
island's other resorts, becomes
overcrowded in the summer months and
bears throughout the year the
unattractive marks of major tourist
development.

The Manx Museum
Tel. (0624) 5522
Open Mon – Sat 10am – 5pm
Closed Sun
🔲
The Manx Museum, set back on a high
terrace about a mile from the promenade,
occupies a late Victorian hospital to
which various additions were made when
the building became a museum in 1922. It
is devoted exclusively to the history,
natural history and art of the Isle of Man,
with interesting archaeological exhibits
dating principally from the early
Christian and Viking periods. These

include a well-known Celtic relief stone
carving known as the **Calf of Man
Crucifixion** (8thC), and some splendid
jewellery from a Viking boat grave.

The museum's fine art holdings are of
marginal interest. You will see three
portraits by **Romney** of members of the
Taubman family (a local merchant
family), and numerous **19thC views** of
the island by local topographical
painters, one of the better known of
whom was **John Millar Nicholson**, a
protegé of Ruskin's who went to Venice
and afterwards painted views of the island
with a rather Venetian colouring. The
one Manx artist to achieve major
national recognition was the Art
Nouveau designer, **Archibald Knox**, who
is known principally for his work for
Liberty's Store in London. The museum
possesses a number of decorative designs,
pewter and silverware by him, as well as a
group of his little-known **oil paintings**.

DURHAM
Co. Durham Map C3

Durham has one of the most spectacular
sites of any town in Britain, a loop in the
River Wear forming the steep peninsula
that is crowned by the magnificent
Norman cathedral ★★ and **castle**. Begun
in 1093, this cathedral is the largest and
finest example of Romanesque
architecture in England and its interior is
distinguished both by its noble
proportions and the incised zigzag
patterns of the columns. The **Galilee**, or
vestibule at the W end, is outstanding,
while the **Chapel of the Nine Altars** and
the altar screen in the choir, have some
fine **13thC** and **14thC** carvings. In the
undercroft there is a **treasury** with some
medieval manuscripts and **church plate**,
as well as the **7thC wooden coffin** in
which St Cuthbert's body was carried
throughout northern England until it was
finally laid to rest here in 995.

The town itself has a large number of
well-preserved early buildings, many of
which are now occupied by the
university, while another aspect of
Durham's history is indicated by the coal
mines that equally characterize the area.

**Durham University Oriental
Museum/Gulbenkian Museum ☆**
Elvet Hill
Tel. (0385) 66711
*Open Mon–Fri 9.30am–1pm, 2.15–5pm,
Sat 9.30am–noon, 2.15–5pm, Sun
2.15–5pm*
🎦 🏛 ☑
Durham University's Museum of
Oriental Art is not easy to locate, situated

as it is among the halls of residence
outside the town. The journey, however,
is well worthwhile because this large and
remarkably wide-ranging museum is
definitely one of the most interesting
repositories of Oriental art in Britain. It is
housed in a spacious modern building in
which a curious system of stepped floors
descends through three separate levels
crammed with display cases. In fact the
sheer quantity of objects on display is
slightly bewildering and would perhaps
benefit from pruning to focus attention
on some of the finer pieces.

Virtually all the periods and cultures
of the East are represented, the Chinese
and Indian works being perhaps the most
notable. There is, for example, an
extensive display of **Chinese pottery and
porcelain ★** from the earliest times to the
present century, a large collection of
carvings in jade and other precious stones
and, in a separate room, a complete
Chinese bed made for an English
merchant in the mid 19thC. The balcony
is lined with a series of carved **teak panels**
from a Burmese palace of the early 18thC
and below it a selection of **Gandhara
Buddha figures ★** is laid out in display
cases. A small Egyptian room with a
painted mummy case and some small
sculptures contains the collection
acquired from ALNWICK CASTLE, but the
range of **Japanese**, **Korean**, **Tibetan** and
Islamic works defies any simple
description. It is an extraordinary
museum to come across in a medieval
town of northern England.

FORD
Northumberland Map C2

The village of Ford overlooks the field of
the 16thC battle of Flodden, and has an
ancient appearance; but this is in fact due
to development in the 18thC and 19thC.
However, it is an attractive place with a
water-driven mill still in operation.

The Lady Waterford Hall
🎦 🏛
The old schoolhouse at Ford is the scene
of one of the most interesting and single-
minded attempts on the part of an
amateur artist to link the stories from the
Bible with the life of a small community.
Using the village children and their
parents as models, **Louisa, the
Marchioness of Waterford**, painted a
series of **murals** around the interior of the
hall in the 1860s and 1870s, depicting
those biblical subjects connected with
childhood, and providing a
Northumbrian setting for such subjects as
The Finding of Moses.

Northern Monasteries

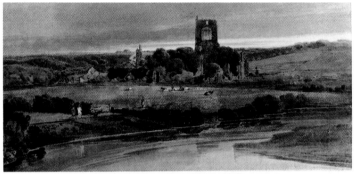

Girtin, **Kirkstall Abbey, Yorkshire**, *c.1800, watercolour*

When Walter Espec, lord of Helmsley, founded an abbey at Rievaulx in 1132 he was furthering the cause of a new order, the White Monks or Cistercians who had already made a huge impact on the monastic life of Europe. Bernard of Clairvaux, the founder of the order, had reintroduced a simple, pious existence withdrawn from the traffic of everyday life, with a special emphasis on hard work as an accompaniment to spiritual devotions. The North of England must have seemed perfectly suited to this aim, and the valleys of Yorkshire in particular offered remoteness and seclusion as well as a challenge to improve the yield of the land for food and profit.

Espec was not alone. There were many noblemen as well as merchants and even rich clerics ready to endow the new foundations with lands and money, thus storing up merit for their own spiritual wellbeing. But the North had the further attraction of being the scene for some of the most momentous events in the early Christian church. Lindisfarne, or Holy Island as it came to be known, was the base for Aidan's mission to convert the pagans of Northumbria in the 7thC, and it was in the first monastery here under Cuthbert that the great gospel book now in the British Museum was produced. Monks from Lindisfarne later carried Cuthbert's sacred remains to DURHAM, over which the great Norman cathedral was built in the 12thC.

These early Christian establishments had also been great centers of learning in a period noted for its ignorance. The Venerable Bede wrote his *Ecclesiastical History of England* in the monastery at Wearmouth and Jarrow while Alcuin, the greatest scholar and reformer at the court of Charlemagne, began his studies at the cloister school of YORK. It was also at a northern abbey, Whitby, that the historic Synod of 633 resolved the dispute between the two early churches of Celtic and Roman Christianity.

FOUNDATIONS *and* RUINS

Most of these early establishments suffered over the following centuries as a result of Viking raids, but the memory, or at least the reputation, of the great figures ensured a continuation of monastic life in the region. This was certainly in the mind of Aildred, the great abbot of Rievaulx in the mid 12thC, when he embarked on the ambitious building programme in the Rye Valley, creating in the large abbey church one of the masterpieces of early Gothic architecture in England. Fountains, also in Yorkshire, had a similar dramatic expansion after its foundation in 1132.

From these two great foundations many daughter houses were created, Byland and Jervaulx being only the largest of a constellation of priories and

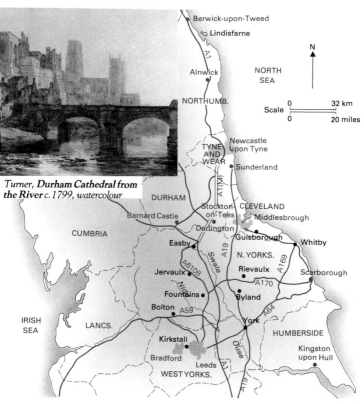

Berwick-upon-Tweed
Lindisfarne
Alnwick
NORTHUMB.
NORTH SEA

N

Scale
0 — 32 km
0 — 20 miles

Newcastle upon Tyne
TYNE AND WEAR
Sunderland

*Turner, **Durham Cathedral from the River** c. 1799, watercolour*

DURHAM
Barnard Castle
Stockton-on-Tees
Darlington
CLEVELAND
Middlesbrough
Guisborough
Whitby
CUMBRIA
Easby
N. YORKS.
Jervaulx
Rievaulx
Scarborough
Fountains
Byland
Bolton
A59
York
IRISH SEA
LANCS.
Kirkstall
HUMBERSIDE
Bradford
Leeds
WEST YORKS.
Kingston upon Hull

abbeys throughout Yorkshire and the North. Kirkstall near Leeds is one of the best preserved, the simplicity of its lines perfectly reflecting the principles of Cistercian life, while the remains of Easby on the River Swale is one of the most attractive. All these abbeys were very successful, managing their land and flocks efficiently and attracting large numbers of lay brothers, but the great period of monastic building was over by the mid 14thC. The Black Death and the repeated incursions of the Scots cut deeply into their resources, with the result that many foundations had fallen into serious decline before Henry VIII began his persecutions. The old establishments were then stripped of their treasures and used as quarries for building the manor houses of the new owners.

For generations the ruins lay unnoticed until in the 18thC there was a rise in antiquarian interest and what was known as the "Picturesque Tour". Gilpin wrote in 1792 that the Picturesque eye sought "the elegant relics of ancient architecture; the ruined tower, the Gothic arch, the remains of castles and abbeys", echoing the sentiments of many travellers who had already clambered over the remains of Fountains, Rievaulx, Easby and the like. These people provided a market for topographical watercolours, Turner making several sketching trips to the North while the buildings at Guisborough, Bolton and Kirkstall provided the subject of some of Girtin's greatest pictures. Ruins in a landscape may seem like a poor end to the great monastic foundations but it has created a taste for scenic views that is almost as powerful today as it originally was in the 18thC.

GATESHEAD
Tyne and Wear Map C3

The industrial town of Gateshead is opposite NEWCASTLE on the S bank of the Tyne.

Shipley Art Gallery
Prince Consort Road South
Tel. (0632) 771495
Open Mon – Fri 10am – 5.30pm, Sat
10am – 4.30pm, Sun 2 – 5pm
🔲
This art gallery, housed in its own building complete with sculpted figures representing the Arts and the Sciences on the façade, was opened to the public in 1917 after a large sum of money and a collection of pictures were bequeathed by a local solicitor, J.A.D. Shipley. The collection is fairly diverse, but its most remarkable feature is the large group of 16thC and 17thC Netherlandish paintings, including works by **Lastman**, **Teniers** and **Terbrugghen** (*Pilate washing his Hands*). A dramatically lit *Adoration of the Shepherds* is particularly interesting, being the finest known work by **Benjamin Gerritsz**, the uncle of Aelbert Cuyp, but for sheer visual impact you are more likely to remember three Mannerist pictures: Hendrick van Balen's *Moses Striking the Rock*, Joachim Wttewael's *Temptation of Adam and Eve*, and *Diana and her Companions* ascribed to Abraham Janssens.

Among the other European works there is a crude but expressive **16thC German altarpiece** with scenes from the life of Christ, but the principal remaining area in the collection is **British art** of the 18thC and 19thC. Lambert's *Classical Landscape* is one of the earliest, and this is followed by the works of **Crome**, **Linnell**, **Varley** and **Atkinson Grimshaw**. There are a few genre paintings by **Wilkie** and **Redgrave**, two pictures by **Millais** (*Meditation* and a scene from *As You Like it*), and, reflecting his associations with the area, a dramatic townscape entitled *The Fire, Edinburgh* by **John Martin**.

GRISEDALE
Cumbria Map A4

Scattered around Grisedale Forest are some interesting **wooden sculptures** by young British artists. The presence of these works here is the result of an unusual scheme devised by the Arts Council in collaboration with the Forestry Commission whereby artists are appointed for a period of residence in the forest. One of those chosen was the Welsh sculptor **David Nash**, who diverted a stream to create here an intriguing **wooden waterway**. Details of the exact location of this and other works can be had from the Forestry Office.

HALIFAX
West Yorkshire Map C6

Situated in the Hebble Valley of West Yorkshire, Halifax was one of the principal centers of the 19thC textile industry whose mills would seem to be a universal feature of the surrounding landscape. **Piece Hall**, the 18thC cloth market, has recently been reopened as a museum of textile machinery, and the nearby **Shibden Hall**, a 15thC half-timbered house, now contains the **West Yorkshire Folk Museum**.

Bankfield Museum and Art Gallery
Akroyd Park
Tel. (0422) 54823/52334
Open Mon – Sat 10am – 5pm, Sun
2.30 – 5pm
🔲 ☑ :::
The Bankfield Museum brings together a curious miscellany of different local interests. In addition to two regimental museums, a natural history section, an extensive toy collection, and a period costume display with European and Oriental exhibits are on show here.

The building itself, a Renaissance-style house erected by Edward Akroyd in the 1860s, is rather unusual and from certain viewpoints appears to be in some disrepair. There is, however, a very attractive exhibition area in the narrow Marble Gallery, where the paintings from the collection are displayed. Again, this is generally used for temporary exhibitions of such local artists as **William Holt**, **Henry Sykes** and the 19thC father and son **John** and **Joshua Horner**. There is also a small display of **Japanese ceramics**, **lacquer** and **prints**.

HAREWOOD HOUSE 🏛
Nr. Leeds, West Yorkshire Map C5

Tel. (0532) 886225
Open Feb, Mar Tues – Thurs Sun
11am – dusk; Apr – Oct Mon – Sun
11am – dusk; Nov Tues – Thurs Sun
11am – dusk
Closed Mon Fri Sat Feb, Mar, Nov; Jan,
Dec
🔳 🐾 🍴 🏛 ♿
Harewood is largely the result of a collaboration between **John Carr** of York

and the young **Robert Adam** and, despite some later alterations, the success of their original scheme is still apparent. The interior is particularly beautiful; in the Music Room, for example, Adam made use of the various talents of the stuccoist **Joseph Rose**, the painters **Angelica Kauffmann** and **Antonio Zucchi**, and the furniture-maker **Thomas Chippendale** to create a harmonious setting in the finest 18thC taste.

The Lascelles family, for whom it was built, were keen collectors and throughout the 18thC and 19thC acquired some fine **Continental** and **Oriental** porcelain. The 6th Earl, however, was primarily interested in Old Master paintings and assembled an excellent group of Venetian works by **Titian**, **Tintoretto** and **Veronese**, which are now hung in the Green and Rose Drawing Rooms. You should not miss El Greco's genre scene, sometimes known as *Fabula* ★, which is one of the most intriguing and attractive paintings in the gallery. Throughout the house there is also a fine selection of family portraits by **Reynolds** (*Lady Worsley*), **Gainsborough**, **Romney** and **Lawrence**, and, as if to underline the royal connections of the family, a portrait of *Charlotte, Lady Canning* that was commissioned by Queen Victoria.

HARROGATE
North Yorkshire Map C5

In the 19thC Harrogate was one of the most popular spa resorts in England, attracting large numbers of people to take the waters. The various baths and pump houses are still in evidence, and one of them now houses a museum of local history.

Harrogate Art Gallery
Library Buildings
Victoria Ave
Tel. (0423) 503340
Open Mon – Fri 10am – 5pm, Sat
 10am – 4pm
Closed Sun
ⓞ
In the Harrogate Art Gallery, which occupies the upper floor of the library building, a small selection of English 19thC and 20thC pictures is generally on display. Of these the **Victorian paintings** are the most interesting. They include Atkinson Grimshaw's *Silver Moonlight* and a group of works by the popular genre painter **William Powell Frith**, who spent most of his childhood in Harrogate. Appropriately, his *The Birthday Party* is the finest painting in the gallery.

HARTLEPOOL
Cleveland Map D4

Hartlepool, on the coast just N of the Tees estuary, was the site of an important Saxon settlement in the 7thC with an early convent dedicated to St Hieu. All trace of this has now disappeared, and the principal focus of the town is the port with its shipping interests, recorded in a museum overlooking the docks.

Gray Art Gallery and Museum
Clarence Rd.
Tel. (0429) 68916
Open Mon – Sat 10am – 5.30pm, Sun
 3 – 5pm
ⓞ
The Gray Art Gallery and Museum occupies a large two-storey house in West Hartlepool, bequeathed to the town by the shipbuilder Sir William Gray in 1921. The collection is limited but lively, and you can see some unusual and interesting items on display. Among the local and natural history sections on the ground floor, for example, there is a collection of **Oriental antiquities**, including **Buddha figures, Indian dolls, Hindu metal figurines** and a suit of 1 7thC **Japanese armour**, while nearby, on the stairs, is a display of **Japanese ivory and lacquer netsukes** ★ that is one of the finest outside London.

Gray's original bequest included a collection of **English 19thC paintings** and these are now exhibited, along with more recent acquisitions, in the newly appointed galleries on the upper floor. The finest works are by the Victorian painters **Maclise** (*Sleeping Beauty*) **Farquarson** and **Clarkson Stanfield**, but the town's maritime interests are reflected in a series of **shipping scenes and seascapes** by the local painters **Carmichael**, **Chambers** and **Henry**. There is also an attractive village scene by Stanhope Forbes, *Gala Day at Newlyn*, and two large and rather melodramatic allegories by another local artist, **F.J. Shields**.

HUDDERSFIELD
West Yorkshire Map C6

Huddersfield, the main town of the newly created Kirklees district, was one of the main "cloth towns" of Yorkshire, a fact celebrated in the **Tolson Memorial Museum** and the remains of the 18thC **Cloth Hall** in Ravensknowle Park. Despite modern redevelopment, it remains one of the most attractive of Yorkshire's industrial towns.

Huddersfield Art Gallery

Princess Alexandra Walk
Tel. (0484) 21356
Open Mon – Fri 10am – 6pm, Sat
* 10am – 4pm*
Closed Sun
🖭

The Huddersfield Art Gallery occupies the top floor of the municipal library, a simple stone building surrounded by the gradually encroaching shops of a new pedestrian precinct. Approaching the gallery from the stairs, you are confronted by a large copy in oils of Leonardo's *Last Supper* and, on the landing, some British 20thC sculptures by **Epstein**, **Moore** and **Phillip King**. Moore's *Fallen Warrior* is the most interesting of these and was adapted from Classical Greek pedimental figures including some from a 5thC BC temple at Aegina. The painting collection, shown in the 6 galleries around the building, is dominated by 20thC British works. Sickert's *View of Ramsgate*, Harold Gilman's *Interior* (otherwise known as *Tea in the Bedsitter*), Spencer's *The Garden at Cookham Rise* and Bacon's *Figure Study II* are probably the finest, but there are also works by **Ginner**, **Duncan Grant**, **Matthew Smith**, **Bomberg** and **Christopher Wood**.

HULL
Humberside Map E6

The city of Kingston upon Hull has been a seaport since the 13thC when it was deliberately planned for the purpose by Edward I. To this day the port dominates the town.

The Ferens Art Gallery

Queen Victoria Sq
Tel. (0482) 223111 ext. 2750
Open Mon – Sat 10am – 5pm; Sun
* 2.30 – 4.30pm*
🖭 💻 🏛 ☑

The Ferens Art Gallery occupies a rather severe Neoclassical building on Victoria Square, which in itself contributes much to the overall character of the place. The sculptures in the central court, include Barbara Hepworth's marble *Icon II* and Paolozzi's *Frog II*, which are placed near an elaborate fund-raising contraption, *The 3000 Volt Moneybox* by Ken Gray. As regards the paintings, the **17thC Dutch** and **Flemish works** are probably the strongest in the collection and they are well displayed in the first gallery to the left. Hals's *Portrait of a Young Woman* is the finest, being a particularly sensitive rendering by this leading Haarlem artist, and there are similarly

interesting paintings by Teniers (*A Man Holding a Glass*), Barent Fabritius (*The Expulsion of Hagar*) and Jan van Bylert (*Vertumnus and Pomona*), as well as landscapes by **Van Goyen**, **Ruisdael** and **Abraham Pether**. A small roundel of *A Bishop Saint* by the 15thC Florentine artist **Bartolommeo di Giovanni** is the earliest of the Italian paintings and also one of the finest here.

The other Continental schools are not represented in the same quantity, but you will see some good individual works such as Ribera's *Portrait of a Philosopher*, an anonymous *Portrait of a Man* from 16thC Augsburg, and two very attractive French paintings, Philippe de Champaigne's *Annunciation* ★ and a vivid *Portrait of a Young Woman* by an unknown early 19thC painter working in a style similar to Girodet or Gerard. The remaining pictures are mostly British and cover the period between the 17thC and 20thC. Dobson's *Portrait of a Musician* is one of the earliest, and there are other portraits by **Hogarth**, **Devis** and **Hoppner**, landscapes by **Wilson** and **Constable**, and a good range of **Victorian** pictures. This gallery has also been able to build up a representative selection of British 20thC art, with works by **Spencer**, **Sickert**, **Gore**, **Gilman**, **Wyndham Lewis** and **Augustus John**, as well as the more recent painters such as **Riley**, **Hockney** and **Peter Blake**. But it is the unusual pieces, such as Gerald Brockhurst's fascinating *By the Hills*, that stand out.

In the upper gallery there is a very good selection of marine paintings, including many by the Hull artist **John Ward**, notably his masterpiece, *The Return of the William Lee* ★ (1839).

KEIGHLEY
West Yorkshire Map C5

Keighley a manufacturing town, lies close to Haworth and the wild, beautiful moors associated with the Brontë family.

Cliffe Castle Museum and Art Gallery

Tel. (0535) 64184
Open Apr – Sept Tues – Sun 10am – 6pm;
* Oct – Mar Tues – Sun 10am – 5pm*
Closed Mon
🖭 🏛

When Henry Butterfield, a local cloth manufacturer, came to rebuild Cliffe Castle in the 1880s, his tastes ran to continental styles and he brought in French craftsmen to design and decorate the interior. This is now the setting for a range of **French furniture** from the

18thC and 19thC, which has been loaned by the Victoria and Albert Museum in LONDON. The rest of the museum is devoted mainly to local history with reconstructions of craft workshops, but you will find a few paintings, such as Etty's *Bathers* and a flower piece by **Fantin-Latour**, from Cartwright Hall in BRADFORD.

KENDAL
Cumbria Map B4

Kendal, known as the "auld grey town" because of its many grey limestone buildings, is an attractive small town lying in a bend of the River Kent. It is famous for its associations with the leading 18thC English artist **George Romney**, who practised as a portraitist here until 1762, returning at the end of his life when he was suffering from melancholia and bouts of insanity. He stayed in what is now the Romney House Hotel, overlooking the Kent on Milnthorpe Road. Portraits by him can be seen in the **Mayor's Parlour** of the town hall and in the ABBOT HALL ART GALLERY.

Abbot Hall Art Gallery
Tel. (0539) 22464
Open Mon–Fri 10.30am–5.30pm, Sat
Sun 2–5pm
📷 🏛 ✅ ☕ ♿

The Abbot Hall Art Gallery was opened in 1962 in a well-restored mid 18thC country mansion surrounded by gardens. Here you will see 6 oil paintings by **Romney**, including especially an early **portrait** (1761) of his brother James holding a candle (the inspiration for this surely comes from works of the *Caravaggisti*, 17thC followers of Caravaggio) and a splendid group portrait, dating from the artist's maturity, of **The Gower Family★** (1776–7): this depicts Lady Gower and her children in long flowing robes dancing as in a Classical frieze to the accompaniment of a tambourine.

There is much else to enjoy in the museum, including fine **18thC furniture, silver, porcelain** and **glassware**, and an excellent collection of **British 18thC** and **19thC watercolours**, among which is a beautiful detailed study by **Cotman** of *Norwich Market Place★* and a dramatic Turner, *The Passage of Mount St Gothard★*. But perhaps the most unexpected feature of the gallery is its good and extensive collection of **contemporary art**. Within this collection, which is mostly of British art, you will probably be surprised to find a small group of works by the German

Dadaist **Kurt Schwitters**. Schwitters, one of the most original artists of this century, came to England in the 1930s to escape Nazi persecution and eventually ended up in the nearby Lake District town of Ambleside, where he lived until his death in 1948. His major work of this late period is a large three-dimensional abstract assemblage known as a *Merzbau*, which is now in the Hatton Gallery in NEWCASTLE UPON TYNE. The Abbot Hall has three rather more modest Abstract works in this vein (including *YMCA Flag, Ambleside*), and three works which few would be able to recognize as Schwitters' because they are conventional **portrait** and **still-life studies**. His abstract art was largely incomprehensible to the people of Ambleside, and these last works were to a certain extent concessions to local taste; they are also a surprising expression of the fact that this leading member of the avant-garde, known for his flouting of bourgeois values, was prepared even to join the local art society as a gesture of goodwill to the town.

LEEDS
South Yorkshire Map C6

Leeds is one of the largest and busiest industrial cities in northern England, the mainstay of which has been the textile trade (although this has been declining in recent decades). However, the 19thC also saw the rise of commercial and engineering interests and left the strongest mark on the city's appearance, the huge **town hall** of 1858 being both the embodiment of Leeds's civic pride and its most impressive landmark.

City Art Gallery ☆
Municipal Buildings
Headrow
Tel. (0532) 462495
Open Mon Tues Thurs Fri 10am–6pm;
Wed Sat 10am–4pm; Sun 2-5pm
📷 ♿ ✅

Following a closure for several years the City Art Gallery was reopened in 1982 with a new character and appearance. The Old Master paintings have been packed off to TEMPLE NEWSAM HOUSE and the collection in this, the main gallery, is almost entirely drawn from **British art of the 19thC and 20thC**. In some respects this makes reasonable sense because that was the area in which the collection was always strongest, and the present arrangement allows a wider cross-section of British art to be displayed. The Leeds gallery was also strongly identified with civic and commercial patronage, and this

has now been further emphasized: the names of the principal benefactors are proclaimed over each doorway, while minor support is recorded by means of an inscription on the steps of the main staircase, making you constantly aware of the benefactor responsible for your enjoyment.

The main focus of the gallery is immediately evident, as the entrance hall has a number of 20thC paintings and sculptures by such figues as **Lowry, Pasmore, Yeats, Sutherland** and **Ben Nicholson**. The most important works in this area are the two paintings by **Stanley Spencer,** *Family Group, Hilda, Unity and Dolls* and *Gardens in the Pound, Cookham*. Leading on from this, the Arnold and Marjorie Ziff Gallery has a selection of Victorian paintings including works by **Holman Hunt, Inchbold, Etty, Tissot, Leighton, Waterhouse** and **Tuke**, although on the whole this is less impressive than many other northern collections. Lady Butler's *Scotland For Ever, (The Charge of the Scots Greys at Waterloo)*, was for many years the most famous and popular painting in the gallery, but the appeal of Napoleonic military achievements has somewhat diminished in the present century. Apart from this, the locally born painter **Atkinson Grimshaw**, who specialized in moonlit street scenes, is well represented, notably by *Nighfall down the Thames* and *Tree Shadows on the Park Wall, Roundhay*.

In the adjacent gallery, sponsored by Bernard and Lucy Lyons, there is a display of British art of the 1950s, promoting the frequently indifferent work of such artists as **Ceri Richards, William Scott, Alan Davie** and **Terry Frost**, although there are some attractions such as Bacon's *Painting, 1950*. The historical sequence of the collection is resumed on the stairs and on the upper floor, where you can see some of the finest examples of **British early 20thC art**. This display is large enough to have examples of the work of virtually every painter of note, including especially Gertler's *Still Life*, Sickert's *St Marks, Venice* and *The New Bedford*, Spencer's *Christ's Entry into Jerusalem* and Wyndham Lewis' *Praxitela*.

You will also see a good group of pictures by the Camden Town school, notably one of **Gilman's** studies of his housekeeper, *Mrs Mounter*, and *Portrait of S.F. Gore*. Of greater local interest are some works by **Jacob Kramer**, whose *Day of Atonement* makes typical use of Vorticist motifs for a Jewish subject. A further range of pictures from the same period can be found in the Sam Wilson Bequest, dominated by the 5 large panels

by **Brangwyn** depicting scenes from British industry. These were submitted to the Venice Biennale of 1905.

The remaining galleries on the upper floor continue the survey of British art up to the present day with works by **John Walker** and **Richard Long**, but there is one room devoted to **late 19thC and 20thC French painting** that offers a pleasant change. Several examples of the **Barbizon School** hang alongside some English landscapes by **Constable, Crome** and **Cotman**, as well as **Courbet's** sketch for *Les Demoiselles du Village*, a *Portrait of Mme Maitre* by Fantin-Latour, and a range of later works by **Sisley, Bonnard, Signac, Derain** and **Marquet**. Among these works is an unusual early painting by Picabia, *Notre-Dame in the Sun* (1906), using an Impressionist manner. The same room contains Joseph Beuys' *He Came Bringing Tallow*, a recent acquisition in which the German artist celebrates the life-preserving qualities of mutton fat (a recurrent and semi-mystical feature in the work of this artist).

The Leeds gallery has always possessed a good collection of **19thC and 20thC sculpture**, as can be seen from the works by **Arp, Calder, Gilbert, Paolozzi** and **Barry Flanagan** distributed throughout the building; but the opening of a new extension, the Moore Sculpture Gallery, greatly increases their holdings in this area. The new rooms also afford the opportunity to celebrate Yorkshire's greatest modern artist, **Henry Moore**, and there are other facilities in the form of a library and archive designed to encourage the study of sculpture as a whole. As you might expect, Henry Moore's *Reclining Figure* of 1929 figures prominently here but there are also several other 20thC pieces by **Hepworth, Epstein** and **Gaudier-Brzeska**, as well as a painting by **Ivon Hitchens** depicting Moore at work in his Hampstead studio.

Leeds has a superb collection of **English watercolours ★**. Here you can see examples of the work of all the leading painters in this medium, although the group of landscape studies by **Cotman** is generally considered most important. Inevitably, however, these are not all on general display.

Temple Newsam House
Leeds
Tel. (0532) 647321
Open Tues – Sun 10.30am – 4.30pm
Closed Mon
🖼 🍴 🏛 ☑ ♿
Temple Newsam is a large 16thC – 17thC house which the Leeds City Council acquired in 1922, and converted into a

museum and outpost of the CITY ART GALLERY. The grounds contain sculptures, and even the car park is marked by a large **Hepworth** bronze, while the 3 wings of the house look onto a *Reclining Figure* by Henry Moore in the courtyard.

In the past Temple Newsam was noted for its collection of **European and Oriental decorative arts**, in which it has some excellent **English furniture** and **porcelain**. The finest individual items are probably the marquetry library table by **Thomas Chippendale** and the **Chelsea** "Gold Anchor" tea and coffee service, but it is the combination of the setting with the quality of the pieces themselves that is most attractive. The reorganization of the city collections has meant that the house also now contains many of the Old Master paintings, such as Vasari's *Temptation of St Jerome*, Giordano's *Triumph of David* and Stomer's *Adoration of the Shepherds*, which were originally hung in the CITY ART GALLERY. These can be seen alongside other works, including Wilson's *Classical Landscape* and family portraits by **Reynolds** and **Gainsborough** (a full-length *Portrait of Lady Hartford*).

LIVERPOOL
Merseyside Map A6

Liverpool, one of Europe's greatest Atlantic seaports, is also one of the most exciting modern cities in Britain. Ever since the 1960s it has been the scene of some of the liveliest manifestations of rock culture, and there is a brisk tourist trade concentrating mainly on places associated with the Beatles, such as the Cellar Club, Strawberry Fields and Penny Lane. But what is immediately impressive about Liverpool is the scale and quality of its 19thC and 20thC architecture, in which respect the city can almost be likened to a miniature version of Chicago. Among these buildings are the **Royal Liver Building** of 1910, which looms over the docks and is surmounted by representations of the legendary "Liver" birds, and the **Anglican Cathedral**, a 20thC Gothic-style structure claiming to be the largest church in the world after St Peter's in Rome. The **Catholic Cathedral** of Christ the King was also planned on a monumental scale, as you can see by the enormous crypt that the Edwardian architect **Sir Edwin Lutyens** laid out. On top of this, however, there now rises a more modest, almost comical structure built in the 1960s and known as the "tea cosy" by irreverent Liverpudlians. This is nonetheless one of the finest examples in Britain of post-war ecclesiastical architecture, with a light, airy interior flooded by colours from **John Piper's** and **Patrick Reyntiens'** superlative **stained glass windows**.

Of all Liverpool's buildings, however, you may find **St George's Hall** the most impressive with its Corinthian columns. This serves both as law court and concert hall, and is to 19thC Classical architecture what Manchester Town Hall is to Gothic. Sadly, it has to be said that the image of civic magnificence presented by such buildings today is a particularly ironic one, in that with the decline of the docks, unemployment in the city is quite exceptionally high, and areas almost adjoining the center have a derelict, abandoned character.

Sudley Art Gallery
Mossley Hill Rd
Open Mon – Sat 10am – 5pm; Sun 2-5pm
Situated in the semi-rural suburban district of Mossley Hill, Sudley is an elegant early 19thC house which once belonged to the Victorian shipping magnate, George Holt. Holt's daughter Emma presented the house, together with her father's large collection of British art, to the City of Liverpool in 1944. The attraction in visiting this gallery derives from seeing mainly **19thC works of art** in an appropriate, relaxing setting, which still has the character of a private residence. Almost all the paintings are shown in small rooms on the ground floor, including the gallery's small holdings of 18thC art, which comprise unremarkable portraits by **Gainsborough, Reynolds, Romney, Lawrence** and **Raeburn**. Many of the great 19thC British artists are represented, though not by any outstanding work; and what good paintings there are tend to lose their impact through being surrounded by much that is mediocre.

Among the museum's numerous landscape paintings, look out for **Copley Fielding's** dramatically lit and Rembrandt-like *Broadwater Sussex*, **Bonington's** exquisitely subtle *Fishing Boats in a Calm* ★, and a large group of paintings by **Turner**. Of particular interest is William Dyce's *The Garden of Gethsemane*★, which shows the small figure of Jesus wandering through a minutely observed landscape that is clearly based on the artist's native Scotland. There are several paintings by **Pre-Raphaelite artists**, most notably a small study by Holman Hunt for *The*

Finding of the Saviour in the Temple now in the Birmingham City Art Gallery (see *MIDLANDS*) and a late painting by **Millais** depicting Swift's heroine *Vanessa*. You will also see various Classical-style works by the artists of the so-called Victorian High Renaissance, including Alma-Tadema's *A Bacchante*, and two fine paintings by Lord Leighton, *Weaving the Wreath* and *Study: At a Reading Desk* (which portrays the child actor, Connie Gilchrist, who was also the model for Whistler's *The Gold Girl* in the Metropolitan Museum in New York). Of the various Victorian genre pictures, Henry Stacey Marks' *A Treatise on Parrots* (showing a man at a desk classifying a group of stuffed parrots) has considerable curiosity value. Upstairs are some **Chinese ivories**, **Hindu prayer scrolls**, a **Victorian doll's house**, and two evocative if rather conventional **landscapes** by Auguste Bonheur, brother of the famous animal painter, Rosa Bonheur.

University of Liverpool Art Gallery
3 Abercrombie Sq
Tel. (051) 709-6022
Open Wed Fri noon – 4pm
Closed Mon Tues Thurs Sat Sun Jan – July,
 Sept – Dec; Aug
⬜🖼

The University of Liverpool has a large art collection, much of which, in particular the contemporary paintings and prints, is distributed around the university's various departments. However, you can see a substantial part of it in the art gallery which takes up most of a small Regency house. You will find here a very representative collection of **early English porcelain**, some fine **silver** (notably a highly intricate **candelabra** of 1836 – 37), **English period furniture**, a selection from the university's holdings of **18thC** and **19thC British watercolours**, and a varied group of **oil paintings**. Among the earliest of these are some genre paintings by **George Morland** and his lesser known contemporary **William Redmore Bigg**, a striking oil by **Turner** of the *Eruption of Mt Soufflier*★, and some fine bird and animal studies by the American ornithologist **Audubon**, who came to Liverpool on his visit to England in the 1820s to find a publisher for his *Birds of America*. Of the late 19thC, there are 4 cartoons by **Burne-Jones** for windows in the cathedral of St Giles in Edinburgh.

Pride of the 20thC holdings are some portraits by **Augustus John** painted for the now defunct University Club. John was invited to teach at the university's School of Applied Arts in 1901, and during the two years that he spent there he succeeded in antagonizing the more traditional elements within Liverpool's art establishment through his bravura style of painting and his flamboyant, unconventional behaviour. John's portrait of his friend, the Professor of Ancient History **John MacDonald Mackay**★ (1902), is a wonderfully energetic work dating from the time when the artist's powers were at their height. It was to have been awarded a gold medal at the International Exhibition at St Louis in America in 1904, but the President of the Royal Academy and the English members of the exhibition jury, alarmed that such an honour should be given to so young and controversial a figure, threatened in retaliation to withdraw the whole British section.

More recent work in the gallery includes Lucian Freud's *Paddington Interior*, which features a portrait of his friend, the photographer Harry Diamond.

Walker Art Gallery ☆☆
Tel. (051) 227-5234 ext. 2064
Open Mon – Sat 10am – 5pm; Sun 2-5pm
⬜🔽☑🏚

The Walker Art Gallery, a Classical-style building near St George's Hall, was opened in 1877. Today it is one of the finest of Britain's galleries, even though its paintings tend to be displayed in rooms with a grey, musty atmosphere. The gallery's holdings of early Italian and northern Renaissance art are renowned. One of the Italian masterpieces of this time is *Christ Discovered in the Temple*★ by the 14thC Sienese artist **Simone Martini**. This exquisite, glowingly coloured small work deals with the rarely painted subject in a most human way: a stubborn-looking Christ child is being reprimanded by his parents with gestures that indicate how anxiously they have been while looking for him. Another small work, though of a completely different character, is a harrowing *Pietà* by the late 15thC Ferrarese artist, **Ercole de'Roberti** where the realistically painted body of Christ has a linear expressiveness that is still medieval in spirit.

Among the early Netherlandish pictures, look out for **Jan Mostaert's** portrait of a praying *Young Man*★ (1520) against a beautiful landscape background featuring the legend of St Hubert, and Joos van Cleeve's *Virgin and Child with Angels*★, which has marvellous still-life details of a symbolical significance (the grapes and goblet on the table can be seen as prefigurations of the Crucifixion, and the cherries and peaches as the fruits of heaven). German Renaissance art is

represented principally by Cranach's *The Nymph of the Fountain*★, a type of recumbent female that had recently been popularized by the Venetian artists Giorgione and Titian: the inscription on the fountain reads "I am resting, the nymph of the sacred spring. Do not awaken me", but her half-opened eyes glance beckoningly at the spectator, indicating that she would perhaps welcome a distraction.

The gallery also has outstanding 17thC and 18thC foreign holdings which include a youthful *Self-Portrait*★ by **Rembrandt**, (1630); a hauntingly simple and enigmatic *Magdalene*★ by **Paulus Bor**; a characteristically exuberant *Virgin and Child with SS Elizabeth and The Child Baptist*★ by Rubens; and a famous self-portrait by **Mengs**, showing himself alongside a painted study of antique sculptures. You will also find numerous fine 17thC Italian paintings, including Salvator Rosa's violently painted *Landscape with Hermit*★ and a powerful *Rape of Europa*★ by the idiosyncratic Neapolitan contemporary of Caravaggio, **Pietri Cavallino**. But pride of place must be given to two works painted by foreign artists active in 17thC Rome: Elsheimer's *Apollo and Coronis*★★ and Poussin's *Landscape with the Ashes of Phocion*★★.

The early 17thC German painter **Elsheimer**, though he lived only until the age of 32, had an enormous influence on the development of landscape painting through his skill in capturing luminous sun and moonlight effects; his paintings are usually minutely executed on copper, and the figures are small in relation to the background. At Liverpool you can see, within a luscious, verdant landscape, his painting of the naked Coronis awaiting seduction by Apollo.

Poussin's painting here is a pendant to a work now in the National Gallery of Wales and Cardiff (see WALES): the pair depict the collecting of the ashes of the Stoic hero Phocion by his widow after his unjust condemnation. At this stage in his career landscape had come to dominate the figurative elements in Poussin's painting, and the whole is invested with extraordinary solemnity. The city of Megara, represented in the background of the Liverpool painting, is reduced to the simplest geometrical forms, and you feel that even the smallest details are so well thought out and placed that they cannot be removed without detriment to the composition.

The museum's English holdings rival the foreign ones from the 18C onwards, and Hogarth's *David Garrick as Richard II*★ is one of the most impressive of the theatrical paintings that were so much in vogue in 18thC England. David Garrick, a close friend of Hogarth's, portrays Richard III waking up in terror after the ghosts of all those he has killed have come to visit him in the night. The gallery has also one of the most famous British landscape paintings of this period, Richard Wilson's *Snowdon from Llyn Nantle*★★, a work which despite its Classical appearance is a fairly realistic portrayal of the actual view. Stubbs's celebrated *Horse Frightened by a Lion*★★ is also here, a painting epitomizing romantic notions of the sublime. Less well known, but equally exciting, is **Joseph Wright of Derby's** large, almost apocalyptic portrayal of a firework display at the *Castel Sant Angelo in Rome*★.

The 19thC British holdings include many works by the Liverpool school of painters (most notably **Richard Ansdell, William Huggins** and **William Davis**), but these are mainly conventional landscapes and animal and hunting scenes, and are of little interest. The gallery has relatively few important early 19thC British paintings, but in compensation it is crammed with masterpieces both familiar and unfamiliar dating from the second half of the century. The main **Pre-Raphaelite** painting is Millais' *Isabella*★, which was the first picture the artists painted after he formed the Pre-Raphaelite brotherhood with William Holman Hunt and Dante Gabriel Rosetti, and is characterized by its painstaking realism. Among the many very lifelike figures seated around the table is Rossetti, who is shown downing a glass of wine. Your attention will probably also be caught, if for no better reason than the work's size, by Burne-Jones's *Sposa de Libano*, which illustrates a verse from the Song of Solomon where Solomon calls upon the north and south winds.

The Aesthetic movement of the late 19thC is also represented by one of **Albert Moore's** more masterly compositions, *A Summer Night*★, which features four partially draped women in a beautifully detailed decorative setting with a view of the sea by night in the background. The gallery also owns two once highly popular Victorian history paintings, **William Frederick Yeames's** Civil War scene, "*And When Did You Last See Your Father?*" and Poynter's *Faithful until Death*, a study of a Roman centurion in the middle of a scene of death and destruction caused by the eruption of Vesuvius.

Among the contemporary genre paintings is an important early work by

Stanhope Forbes, the luminous *A Street in Brittany* ★ (1881), painted just before the artist settled in Newlyn in Cornwall (see *WESTERN ENGLAND*), and Herkomer's dark and grotesque study of demented old women, *Eventide – A Scene in the Westminster Union, 1878* ★, the composition of which had a great influence on Van Gogh's *Interior at Arles* in The Jeu de Paume in Paris.

The museum's late 19thC holdings are small but choice, with an almost monochromatic oil by Degas of a *Woman Ironing* ★, a marvellously subtle small oil sketch by Seurat of *White Houses at Ville d'Avray* ★, and one of Cézanne's dark, crude but powerful early paintings, *The Murder* ★. There is also an outstanding example of Italian Symbolist painting, Giovanni Segantini's *The Punishment of Luxury* ★, which is painted in a minutely stippled technique and features two floating women against a spectacular Alpine landscape.

The large representative collection of 20thC British art counts among its high points the Camden Town painter Harold Gilman's best-known portrait of his depressed-looking housekeeper, *Mrs Mounter* ★, and one of the contemporary figurative painter Lucian Freud's finest early works, *Interior at Paddington* ★ (1951), which is set in the artist's former London studio overlooking the Regent's Canal, and shows a tensely posed man in a dirty raincoat staring at a large potted palm. The collection extends right up to the present day, with works by artists such as Hockney and Patrick Caulfield.

However, the modernized section of the museum which shows these more recent examples of British art is taken up in autumn and winter by the major biennial exhibitions of contemporary art organized on alternative years by Peter Moores and his brother John Moores: one exhibition comprises a selection made by a well-known figure in the art world of what he or she considers as the best of contemporary British art, while the other is arranged as an open competition, the prize winners of which have frequently gone on to achieve subsequent international fame.

LOTHERTON HALL
Aberford, nr. Leeds Map C6

Open Tues – Sun 10.30am – 6.15pm
Closed Mon
▓ ✿

Lotherton Hall was for generations the home of the Gascoigne family, who presented it to the City of Leeds in 1968.

It is a largely Edwardian house, although its origins go back to the 18thC, and the exterior is unimpressive, but the contents, and particularly the ceramics and costumes, are remarkably diverse. Of the furniture, the work of the High Victorian designers Burges, Pugin and Gimson is probably the most interesting, and it is complemented by a large collection of European and Oriental ceramics which extends as far as the 20thC studio potter Bernard Leach and his followers.

The Gascoigne family were also noted art collectors, particularly in the 18thC and early 19thC when they acquired a number of pieces by English sculptors working in Rome. During the same period Batoni painted a portrait of the 8th Baronet on the Grand Tour, and a painting of *The Irish House of Commons*, a vivid piece of 18thC reportage by Francis Wheatley, also came into the collection at this time.

MANCHESTER
Greater Manchester Map B6

Manchester is at the heart of one of the most densely populated areas of Europe. The city's origins date back to Roman times, but the Manchester of today is essentially a creation of the 19thC, when the city became established as the capital of the great cotton-manufacturing district of SE Lancashire. Rapid industrial and commercial expansion in the early years of the 19thC inevitably led to serious overcrowding and appalling poverty, which in turn resulted in numerous strikes and riots culminating, in 1819, in the notorious mass meeting known as Peterloo, in which 11 people were killed and hundreds injured after troops rode into the crowds with slashing sabres. Against this background Manchester became an important center of English radicalism. The *Manchester Guardian* was founded in 1821 to support constitutional reform; and to this day the newspaper retains its reputation as one of the most liberal of the major dailies.

Manchester has been one of the most culturally active cities in Britain since the mid 19thC. In 1857, it was the scene of a celebrated exhibition entitled "Art Treasures of the United Kingdom", which attracted visitors from all over Europe, and in the following year Charles Hallé established a city orchestra that was soon one of the finest in Britain. Today the city also boasts a major theatre: this, the Royal Exchange, is an extraordinary circular construction made of steel tubes

which stands like an invading spaceship within the main hall of the enormous 19thC Cotton Exchange building. Soon the city will also have a major arts center, featuring a gallery for temporary exhibitions of contemporary art, and a branch of the National Film Theatre.

Architecturally Manchester is far more diffuse than Liverpool, and as a result the city makes a less immediate visual impact. Nonetheless, it has some outstanding 19thC buildings, the most important of which is undoubtedly its **Town Hall**, which was designed in a Gothic style by Alfred Waterhouse in 1867 and completed in 1876. The walls of its great hall are covered with 12 strange, expressive **murals★** by the Pre-Raphaelite painter **Ford Madox Brown**: painted in 1879–93, the year of the artist's death, they illustrate scenes from Manchester's history with particular emphasis on the roles played by Christianity, commerce and the textile industry. Near the Town Hall is a magnificent Grecian-style building designed by **James Barry** in 1824. Originally the Manchester Institute for the Promotion of Literature, Society and the Arts, this became after 1882 the **Manchester City Art Gallery**.

The City Art Gallery ★★
Mosley St
Tel. (061) 236-9422
Open Mon–Sat 10am–6pm Closed Sun
🏧 📖 🏛 ☑️

The Manchester City Art Gallery was until recently notorious for being a singularly drab and uncared for museum. But its present director, Timothy Clifford, has done an enormous amount in a short period of time to enliven the place, repainting the once grey-green walls in startling colours such as deep crimson, rearranging the collections in a more rational manner, and making numerous major purchases. The character of the museum is still very old-fashioned, evoking Victorian opulence in a very pleasant way with paintings hung close together in rooms adorned also with sculptures, exotic applied art objects, potted palms and other plants.

The nucleus of the museum's archaeological and applied art holdings is diplayed in a series of rooms on the museum's ground floor. These include numerous **Egyptian bronzes**; a magnificent group of **red-figure and black-figure Greek** and **Hellenistic vases** once belonging to the leading Victorian scholar, F.T. Palgrave; 69 **Chinese cloisonné enamels**; an enormous collection of **English earthenware** from the Roman period up to the early 19thC;

and much **English 18thC silver**. Interspersed among these are many minor **17thC Dutch paintings**, and a group of small Venetian views of principally decorative interest by the 18thC Venetian artist **Francesco Guardi**.

The bulk of the gallery's painting collection is displayed on the first floor, beginning with a strange, powerful work by the obscure early 17thC English artist, John Souch, *Thomas Ashton at the Deathbed of his Wife* (1635). The wife, who died in childbirth, is seen both as a corpse, and also as she was when alive, seated at the foot of the bed. Such a representation is medieval in spirit, and very old-fashioned for this date.

The greatest foreign paintings in the collection date principally from the 17thC and 18thC and are by Italian artists. These include a late work by Guido Reni (*St Catherine*); a sensually painted *St John the Baptist★* by Reni's Roman contemporary **G.B. Gaulli** in a beautiful 18thC frame designed by **William Kent**; two large German views by the 18thC Venetian follower of Canaletto, **Bellotto**; and a flamboyant portrait by **Pompeo Batoni** of *Sir Gregory Page-Turner*, who is shown on his Grand Tour in a pose loosely imitative of the Apollo Belvedere and against a background of the Colosseum. In the same room as these two works you can also see a brilliantly realistic bust of *Monsignor Antonio Cerri★* by Algardi, Italy's leading Baroque sculptor after Bernini.

French art of the Baroque and Rococo periods is represented by a slightly disappointing work by Claude, *Landscape with the Adoration of the Golden Calf*; an oil sketch of *Apollo and Phaethon with the Seasons* by La Fosse for the ceiling of Montague House in London (the house was destroyed in the early 19thC to make way for the British Museum); a fine landscape by Boucher (*Le Galant Pêcheur★*); and a splendid erotic painting by Fragonard (*The Sacrifice of the Rose★*), representing Cupid igniting with a torch a symbolic rose laid on a sacrificial altar, next to which is an ecstatic woman.

The gallery has some important **18thC English works**, most notably Gainsborough's *A Peasant Girl Gathering Faggots in a Wood★*; a portrait by **Reynolds** of the military leader *Lord Cathcart*, who proudly displays the black silk patch that he wore to hide a scar received after being shot in the face at the battle of Fontenoy in Flanders; and—the largest picture in the whole collection—James Barry's majestic and recently cleaned *The Birth of Pandora★*. This shows Pandora brought before the

gods on Mount Olympus, immediately prior to being sent to earth, where she disobediently opened the box given to her as a gift from Jupiter and released evil into the world.

The rest of the gallery is dominated by its celebrated holdings of **19thC British art.** Among the earliest work are various paintings characteristically featuring buxom female nudes by **Etty,** an impressionistically painted *Rhyl Sands* ★ by **David Cox** (which from a distance could almost be mistaken for a work by Boudin), a small panel entitled *The Bright Clouds* ★ by **Samuel Palmer** dating from his mystical Shoreham period, and a view of Hampstead Heath by **Constable.** Especially striking is a group of canvases by **Turner,** in particular his enormous *Thomson's Aeolian Harp* ★ (1809). In the foreground of this work you will see a tomb inscribed with the name Thomson, a reference to the poet James Thomson who published *An Ode on Aeolus' Harp* in 1748. Although the painting has completely the character of one of Claude's views of the Roman Campagna, the scene is in fact of Richmond near London, where Thomson lived.

The most popular room in the museum is the one devoted to the **Pre-Raphaelites** and their associates. In addition to paintings, you will find here a superb writing desk in pseudo-medieval style by **William Burges,** an architect and designer much admired by Morris, Rossetti and Burne-Jones; ceramic tiles by Morris's follower **William de Morgan;** and personal memorabilia relating to **Holman Hunt,** including his glasses and palette. Above these memorabilia is Hunt's early masterpiece, *The Hireling Shepherd* ★ (1851). The artist's initial intentions in painting this work were to portray "not Dresden China bergers [sic] but a real shepherd and a real shepherdess, and a landscape in full sunlight with all the colour of luscious summer". Many of the work's minutely observed details also have a symbolical significance, and the artist later wrote that, by showing a shepherd taking more interest in the shepherdess than in his flock, he intended a veiled criticism of the contemporary Church, which neglected its pastoral duty, the care of souls, for useless theological debate.

Also brimming with symbolism is **Ford Madox Brown's** substantial *Work* ★, which was inspired by the sight of roadworkers digging for drains in Heath Street, Hampstead. This is a complex allegory of the virtues of work: the social message is reinforced by the presence in the right-hand corner of

portraits of Thomas Carlyle (the writer on social issues) and the Rev. F.D. Maurice, the pioneer of education for the poor. Less complex in its symbolism and more direct in its appeal is Millais' *Autumn Leaves* ★, a twilight evocation of the transience of beauty.

Another painting much liked today is J.W. Waterhouse's *Hylas and the Nymphs* ★. This large, sensual work depicts a young man about to be pulled to his death by beautiful nymphs in a waterlily pond, and has been the inspiration for numerous modern advertisements for bath oils and similar products.

A small room adjoining the Pre-Raphaelite room contains the museum's collection of late 19thC French works, including a fine *Self-Portrait* ★ by **Fantin-Latour,** a beautiful terracotta of *A Woman Reading* ★ by **Dalou,** and a group of not especially interesting works by **Pissarro, Sisley, Renoir** and **Gauguin.** The last room of the museum and the main staircase gallery are lined with late Victorian paintings. Here you will see a famous painting by **Maclise** of a naked woman rising from the sea in moonlight (*The Origins of the Harp* ★); Peter Graham's *A Spate in the Highlands*, a most realistic and powerful landscape by an artist who did more than any other painter to popularize this part of Scotland in Victorian England; a painting by **Herkomer** of a poor family by a roadside (*Hard Times* ★); high-society genre scenes by **Tissot** (*The Convalescent* and *The Concert*); and a massive painting by **Watts** of *The Good Samaritan*, presented by the artist to the citizens of Manchester as an expression of his admiration for Thomas Wright, a Manchester foundry worker who devoted his life to prison visiting and the rehabilitation of discharged convicts.

Above all, your attention will be caught by the numerous scenes set in ancient Rome and Greece, most notably Alma-Tadema's *Silver Favourite* ★ (three Roman ladies idling in brilliant sunshine by a marble pool), and Lord Leighton's *The Captive Andromeda* ★, one of the artist's largest and most masterly compositions.

The Gallery of Modern Art
Athenaeum, Princess St
Tel. (061) 236-9422
Open Mon – Sat 10am – 6pm Closed Sun
🔲 🏛 ⌷⌷

The Athenaeum, designed in 1826 by Sir Charles Barry in the style of a 16thC Italian Palazzo, houses on its ground floor the misleadingly named Gallery of Modern Art. This place serves principally

as the venue for temporary exhibitions organized by the CITY ART GALLERY which is situated immediately behind: a major exhibition of the English 20thC painter **Henry Lamb** (a friend and associate of Stanley Spencer) is planned for 1984, and also an exhibition of the French Rococo painter **François Boucher**.

When not used for such exhibitions the gallery shows a selection of the City Art Gallery's impressive holdings of **20thC art**. These holdings are largely of British art, with works by **Orpen** (the celebrated *Homage to Manet* ★ of 1909), Wyndham Lewis (*Portrait of the Artist as the Painter Raphael*, 1921), Ben Nicholson (a still-life entitled *Au Chat Botté*), Lucian Freud (*Girl with Beret*), Francis Bacon (portrait of *Henrietta Moraes on a Blue Couch*) and David Hockney (a coloured crayon drawing of *Celia*, 1973). The few foreign paintings, include Léger's *Painting*, (1926), and Max Ernst's *La Ville Petrifié*.

Fletcher Moss Museum
Wilmslow Rd, Didsbury
Tel. (061) 236-9422
Opening times subject to alteration
🎫 🏛 ❦
Originally a simple two-storeyed cottage called the Old Parsonage, this delightful small building in beautiful verdant grounds, was altered in 1834 in a Gothic style. Later it passed to Alderman Fletcher, a well-known author and campaigner for the conservation of old Manchester. The house has recently been restored by the Manchester City Art Gallery to its early 19thC appearance, and displays exhibits relating to the city.

Among these are paintings by the highly original late 19thC artist, **Adolphe Valette**, who was born and brought up in France, and came to Manchester in 1876 to work in a printing firm. Taking up painting in 1905, he became one of the first artists to attempt to portray the spirit of industrial Manchester, specializing in Whistlerian canvases with small, isolated figures set against a foggy gloom (see, for example the haunting *Under Windsor Bridge on the Irwell* ★). Alongside these works are paintings by Valette's most famous pupil, the popular naive painter **L.S. Lowry** (see SALFORD).

The Gallery of English Costume
Platt Hall, Platt Fields, Rusholme
Tel. (061) 224-5217
Open Apr – Sept Tues – Fri 10am – 6pm
Closed Mon Sat Sun Apr – Sept; Oct – Mar
🎫 🏛
This attractive Palladian house of the

mid 18thC, though plain on the outside, has a playful **rococo interior**. In the dining room, fitted into the delicate plasterwork above the chimneypiece, is a beautiful landscape painting, *A Summer Evening* ★ (1764), commissioned by the original owner of the house from **Richard Wilson**.

Whitworth Art Gallery ☆
Oxford Rd
Tel. (061) 273-4865
Open Mon – Wed Fri Sat 10am – 5pm,
Thurs 10am – 9pm
Closed Sun
🎫 ♿ ✅ 🖼
The Whitworth Art Gallery, situated in the slightly desolate part of the city occupied by Manchester's university buildings, was founded in the 1850s as a posthumous memorial to the engineer, Sir Joseph Whitworth. It was intended to be "a source of perpetual gratification to the people of Manchester, and at the same time a permanent influence of the highest character in the direction of technical education and of the cultivation of taste and knowledge of the arts of painting, sculpture and architecture." After a rather uneasy financial history, it was handed over in 1958 to the university, and its drab interior was duly transformed into the pleasantly modern gallery of today.

Its collections are various, and include **textiles** ranging in date from Egyptian times up to the present day, and celebrated holdings of **wallpapers**. You will also see a few Old Master 19thC paintings, most notably a superb portrait by **Sir Thomas Lawrence** of one of the leading 18thC antiquarians and collectors, *Richard Payne Knight* ★, and the final version of Watts's *Love and Death* ★, which was exhibited at the Manchester Royal Jubilee Exhibition of 1887 and subsequently offered by the artist as a gift to the Whitworth Committee.

But what makes this gallery such a special place is its collection of **drawings, prints and watercolours** ★, which is one of the finest in Britain. Moreover, unlike most other such collections, a very large quantity from it is always on show. Each selection is frequently changed, and exhibitions are put on devoted to particular aspects of the collection. Its greatest strength is its holdings of British watercolours and drawings: almost all the major British artists from the 18thC up to the present day are represented by important examples of their graphic art.

Another aspect of the Whitworth gallery needs emphasizing, and that is its dedication to contemporary art. Here you

can often see temporary exhibitions of the work of some of this country's most interesting living artists, and it was here that David Hockney had his first public museum showing in Britain. In addition, the gallery has built up a superb collection not only of graphic works but also **paintings** and **sculptures** by contemporary British artists. Given its relatively limited financial resources, the judicious choice of these works has been exemplary. Recent purchases include a portrait of the painter *Lucian Freud* by **Francis Bacon**, a good example of one of **Peter Blake's** interpretations of the Pop Art idiom (*Got a Girl*, 1961), an outstanding *Self-Portrait* by **Auerbach**, and a glowing red *Interior at Oak Wood Court* ★ by **Howard Hodgkin**, considered by the artist to be one of his finest works.

MIDDLESBROUGH
Cleveland Map D4

If you approach Middlesbrough from the N you cannot fail to be impressed by the huge steel framework of the Transporter Bridge, one of the largest of its kind in the world, which supports the main roadway across the River Tees into the town.

Middlesbrough Art Gallery
Linthorpe Rd, Middlesbrough
Tel. (0642) 247445
Open Mon – Sat 10am – 6pm
Closed Sun
▣☑

The Middlesbrough Art Gallery occupies a well-appointed house near the town center in which the rooms have been sensitively converted to create a series of good exhibition galleries. The civic collection is surprisingly well stocked with British 20thC art, including works by **Frank Auerbach**, **Edward Burra**, **Frink**, **Gaudier-Brzeska**, **Hitchens**, **Lowry**, **Pasmore**, **William Scott** and **Stanley Spencer**. There are also some good drawings of the same period, but it is somewhat disappointing to find that the permanent collection is only occasionally displayed, the space being more often devoted to temporary touring exhibitions.

NEWCASTLE UPON TYNE
Tyne and Wear Map C3

The coal-mining and industrial city of Newcastle upon Tyne is the principal town of north-eastern England. Despite considerable redevelopment in recent years there are still many early buildings, such as the 13thC – 15thC **cathedral** and the even earlier **castle** as well as the handsome 19thC city center. Grey Street (1835 – 9) is one of the finest in Europe, and Central Station is a masterpiece of its kind. But the most characteristic and striking feature of the area is to be seen in the series of contrasted bridges across the River Tyne. **Thomas Bewick**, the father of British wood engraving, worked in Newcastle for most of his life; examples of his work can be seen in the **Hancock Museum of Natural History** beside the university. There is also a fine **Museum of Antiquities** with items ranging from Romano–British sculpture to 9thC Runic inscriptions. Altogether a fascinating place.

The Laing Art Gallery ☆
Higham Pl
Tel. (0632) 327734
Open Mon – Fri 10am – 5.30pm; Sat
* 10am – 4.30pm; Sun 2.30 – 5.30pm*
▣❑▥▦

Newcastle's celebrated painter, **John Martin**, receives considerable prominence at the Laing Art Gallery; a series of his visionary melodramas are the first works that you encounter in the entrance hall. Of these *Belshazzar's Feast* and *The Destruction of Sodom and Gomorrah* are quite typical, serving up a liberal helping of fire and brimstone, but *The Bard*★, despite its absurdities, is probably Martin's most interesting picture. Nearby is a bronze *Seated Woman* by Henry Moore, but the main galleries on the ground floor are devoted to a large collection of **silverware, glass, ceramics** and other **applied arts**. Many of the pieces are from Newcastle itself, notably the glass which has been produced on Tyneside since the 17thC, and you should also look for the room with a large stained glass window designed by **Burne-Jones** which was originally in the now demolished church of St Cuthbert.

When it was originally set up in 1904 there was no permanent collection at the Laing, nor was there an initial bequest to start it on its way. This has meant that all the works now on display have been acquired over the last 80 years and, although this period has provided much in the field of the applied arts, the painting collection has many obvious deficiencies. There are only a few European paintings, Karel Dujardin's *Travellers taking Refreshments outside an Inn*, Pannini's *Interior of the Pantheon* and Gauguin's *Breton Shepherdess* being perhaps the finest, but you can see a representative selection of **18thC – 20thC British pictures**. These are hung in the galleries on the

upper floor. Portraits by **Hudson, Batoni, Wright, Ramsay** (*James Adam*, brother of Robert), **Reynolds** (*Mrs Elizabeth Riddell*) and **Zoffany** predominate in the early rooms, and there are some good landscapes by **Wilson, Gainsborough** and **Constable**.

But it is with the Victorian period that the collection comes into its own. Here you will find a comprehensive range covering virtually all aspects of British art in the mid to late 19thC, among which the most interesting works are *King Alfred in the Camp of the Danes* by Daniel Maclise, Landseer's gory *Otter Hunt*, *Love in Idleness* by Alma-Tadema, *The Catapult* by Sir Edward Poynter, and a fine night scene by **Atkinson Grimshaw**. The Pre-Raphaelite paintings are particularly notable with works by **Rossetti, Deverell** and **William Bell Scott**; but you should not miss Holman Hunt's *Isabella and the Pot of Basil* ★ and Burne-Jones' sumptuous *Laus Veneris* ★.

As regards the collection of **20thC art** many of the leading British painters are represented, though only rarely by works of any great distinction. Stanley Spencer's *The Dustman*, Orpen's unusual *Self-Portrait*, an interior entitled *19 Fitzroy Street* by Malcolm Drummond, and *Dusk* by Sir George Clausen are exceptional here, and the gallery also possesses a good collection of **modern prints**. Alongside this the Laing has been able to gather a number of interesting paintings by local artists such as **T.M. Richardson** and **J.W. Carmichael**. These are now hung on the stairway and indicate a lively interest in the visual arts during the last century.

The Laing also possesses a fine collection of **English watercolours** ★ by such artists as **Towne, Cozens, Cox** and **De Wint**, some of which are usually on display. The collection of Japanese woodblock prints and other Oriental works of art, which were presented to the gallery in 1919 by A.H. Higginbottom, can be seen on request, although advance notice is advisable.

The Greek Museum

Percy Building, The Quadrangle, The University of Newcastle upon Tyne
Tel. (0632) 328511 ext. 3966
Open Mon – Fri 10am – 4.30pm
Closed Sat Sun

This museum on the first floor of the University Classics building has a small collection of **ancient Greek arms, armour** and **painted pottery**, with is laid out in a very clear and attractive manner. The **Attic vases** from the red, black, and

white-figure periods are perhaps the most important but there are two very fine Greek helmets as well.

The Hatton Gallery

The Quadrangle, The University of Newcastle upon Tyne
Tel. (0632) 328511 ext. 2053
Open Mon – Fri 10am – 5pm; Sat (during term) 10am – 4pm

Newcastle University has a small but very good collection of paintings, including a number of **Italian works** from the period between the 14thC and the 17thC. Of these Domenichino's *Descent from the Cross*, Palma Giovane's *St Mark*, Procaccini's *The Drunkenness of Noah*, and *Soldiers and Peasants in a Landscape* by Salvator Rosa are probably the most important. There is also a fine work by the 17thC French landscapist **Gaspard Dughet**.

British 20thC pictures by **Roberts, Bomberg** and **Bacon** are not generally on display because the gallery is largely devoted to temporary exhibitions. There is, however, one work by the German Dadaist Kurt Schwitters, the *Elterwater Merz* ★ construction, which can always be seen. This was assembled by Schwitters in a barn near KENDAL in Cumbria just before his death in 1948, and the whole wall was later acquired by the university in 1965. Schwitters used torn-up paper and street debris in making the assemblages he called *merz*, the aim being "to combine art and non-art" in typically Dadaist style.

NOSTELL PRIORY 🏠
Nr. Wakefield Map C6

Tel. (0924) 863892
Open Apr – June, Sept, Oct Thurs Sat noon – 6pm; July, Aug Mon – Thurs Sat noon – 5pm, Sun 11am – 5pm
Closed Mon – Wed Fri Apr – June, Sept, Oct; Fri July, Aug; Nov – Mar

As its name suggests, Nostell Priory has monastic origins stretching back to the 12thC, but after the dissolution of the monasteries in 1539 it was acquired by the Winn family who rebuilt on the site. the present house was designed in the 18thC by **James Paine** and **Robert Adam** who were also responsible for much of the interior. Adam in fact went so far as to design some of the furniture which was made up by **Thomas Chippendale**, and it was the Scottish architect's principal decorator, **Anthonio Zucchi**, who painted the roundels in the Dining Room and the Classical landscapes that enliven the Saloon and Tapestry Room.

Nostell has a fine collection of **ceramics** and **paintings**, which far exceed the normal fare of similar houses. There is, for example, an extensive range of **antique pottery** and **Chinese porcelain**, while the paintings include a number of **family portraits**, a landscape by **Claude** and a Shakespearean subject, *The Tempest*, by **Hogarth**. The house also contains the finest surviving copy of a famous lost work by **Holbein**, the large group portrait of *Sir Thomas More and his Family*. The original was Holbein's first major work on his arrival in England in 1526, and this version is still a facinating insight into the life of the great humanist who was later executed by Henry VIII.

OLDHAM
Greater Manchester Map C6

Oldham, another of Lancashire's cotton towns which enjoyed great prosperity in the 19thC, thanks to the textile industry, is an architecturally undistinguished place set on a hill. Numerous derelict mill buildings testify to its former industrial achievement.

Oldham Art Gallery
Union St
Tel. (061) 678-4651
Open Mon 10am – 7pm; Tues 10am – 1pm,
* Wed – Fri 10am – 7pm; Sat 10am – 4pm*
Closed Sun
📷 ⬚

The Oldham Art Gallery is an early 20thC building with a strong old-fashioned character despite partial modernization. A selection is generally on show of the museum's large and impressive collection of **18thC** and **19thC English watercolours**, by artists such as **Sandby**, **Cozens**, **Girtin**, **Turner**, **Constable**, **Prout** and **Cox**. The main room of the museum is taken up by generally unmemorable Victorian and Edwardian paintings, including a Capri scene by **F.W. Jackson** (see ROCHDALE), *In the Dublin Mountains* by Orpen, and a particularly hideous allegorical painting by Val Prinsep ponderously entitled *At the First Touch of Winter, Summer Fades Away*.

Strangely, the museum rarely seems to show its works by the town's most famous artist son, **William Stott of Oldham**. Stott was a late 19thC outdoors painter much influenced by the art of contemporary French painters and of Whistler: his most famous work is his large and hauntingly tranquil *The Ferry* (in a private collection), a portrayal of the riverside gardens of the village of Grez-sur-Loing near Barbizon; but he also did some strange symbolical works in a very simplified, enigmatic style, including the museum's magnificent large roundel, *Venus Born of the Sea Foam★* (1887). Stott died in 1900 on a sea crossing to Belfast, thus inspiring one of Whistler's many cutting quips, "So he died at sea, where he always was," a reference to Stott's uncertain direction as an artist. Stott is frequently confused with his Rochdale contemporary **Edward Stott** (no relation), another outdoors painter, of whom the museum has several works, most notably a painting also called *The Ferry★*, which is set in the West Sussex village of Amberley where the artist lived from 1889.

The museum has a small collection of **20th British art** displayed in a small room often used for infants' art classes: one of the most interesting works here is a painting, several inches deep in pigment, by Frank Auerbach entitled *E.O.W. on her Blue Eiderdown★*. Also here is **Epstein's** bust of *Winston Churchill*.

PORT SUNLIGHT
Merseyside Map A7

Port Sunlight is a model town built between 1888 – 1914 by the 1st Viscount Leverhulme for the employees of his soap factory. Leverhulme, born William Hesketh Lever in Bolton in 1851, worked initially in his father's wholesale grocery business before making a vast fortune through Sunlight Soap. His success in the soap trade was due largely to his perception of the enormous benefits to be had from good packaging, advertising and promotion. Later he branched out to many other products and projects, which eventually formed the basis of the multi-national company Unilever.

Port Sunlight is an extraordinary place, comprising cottage-like domestic buildings arranged in an overall scheme redolent of Utopianism and megalomania, with wide, tree-lined avenues, sometimes broken by rows of fountains, radiating from a monumental Classical-style building totally out of scale with the surrounding architecture. That this structure should be an art gallery is characteristic of Leverhulme's Victorian belief in the elevating power of art and the need to bring a spiritual dimension into the lives of working people. It is also characteristic of him that he should not include in his model town a place where his employees could indulge in the less spiritual but nonetheless more popular activity of drinking alcohol.

The Lady Lever Art Gallery ☆
Tel. (051) 645-3623
Open Mon – Sat 10am – 5pm; Sun 2-5pm
📷 🏛 ☑

The Lady Lever Gallery was opened in 1922 as a memorial to the 1st Viscount Leverhulme's wife, who had died in 1913, the year before the foundation stone of the museum had been laid. Though dating from the first quarter of this century, the museum is essentially a monument to Victorian taste. Even those who greatly dislike such taste can hardly fail to take at least an amused interest in the pompous opulence of its interior, and th absurdity of the subject matter of many of the pictures here. Moreover, it is by no means just a repository of Victorian paintings and sculptures, but reflects other areas of High Victorian interest that might have a wider appeal. Thus you will see magnificent **18thC English furniture**, much **17thC – 18thC Chinese porcelain**, and one of the finest collections of 18thC and early 19thC **Wedgwood vases**, **bowls** and **statuettes** to be found anywhere. When Leverhulme began collecting paintings in the 1880s, a revival of interest was already well under way in 18thC British art, and you will find in the museum fine examples of the art of the leading masters of this period, including a *Landscape with Diana and Callisto* by **Richard Wilson**, a half-length portrait by **Gainsborough**, and two excellent full-length portraits by **Reynolds**.

With the major exception of a large oil sketch by John Constable (*Cottage at East Bergholt*), the remaining paintings in the collection are all of the High Victorian era, and principally subject pictures. At least two of these were bought with the intention of advertising Sunlight Soap. Thus, John Bacon's *The Wedding Morning*, which shows a bride, surrounded by female assistants and onlookers, carefully adjusting her wedding dress, drew from Leverhulme the comment that it was "only a moderate picture but very suitable for a soap advertisement". Another such picture was **Frith's** portrait of a pretty young girl proudly holding a new frock. The artist intended this, probably in a slightly mocking way, to be a painting proclaiming the vanity of human adornment, as he exhibited it with the title "*Vanitas Vanitatum, Omnia Vanitas*". For Leverhulme, however, the work displayed the virtues of cleanliness and Sunlight Soap, and much to the artist's annoyance he had it engraved as an advertisement for his product while it was still on exhibition at the Royal Academy. Another artist who objected

to Leverhulme's commercial attitude towards art was **Briton Riviere**, whose study of a poacher in prison being consoled by his dog (*Fidelity*), was at one time going to be reproduced as a colour poster to be given out in exchange for a certain number of Lever Brothers' soap wrappers. In this case Leverhulme gave in to the artist's wish not to have his work used in this way, but he still maintained his belief that pictures "must have a good effect in raising the artistic taste of the cottager".

Many of the other High Victorian paintings in the museum deserve singling out, and not simply for historical reasons. There are some major works by **Pre-Raphaelite painters**, most notably **Holman Hunt's** famous symbolical study of a dejected-looking goat, painted in the Holy Land in appropriately hard and dangerous conditions (*The Scapegoat*★); **Millais'** much-represented tear-jerker of a young woman trying to prevent her soldier sweetheart from going off to probable death (*The Black Brunswicker*★); a large, sinister painting by **Burne-Jones** of *The Beguiling of Merlin*; and a portrait by **Rossetti** of his friend Alexa Wilding entitled *The Blessed Damozel*.

One of the finest of the historical genre scenes at Port Sunlight is Orchardson's *St Helena 1816 – Napoleon Dictating to Count Las Cases the Account of his Campaigns*, a painting acquired by Leverhulme because of his interest in Napoleon whom he saw as a man like himself committed to welfare and benevolence. Among the contemporary genre paintings are **Edward Gregory's** lively study of the Henley Regatta (*Bolton's Lock, Sunday Afternoon*★), and Herkomer's *Sunday at Chelsea Hospital*★, which is an interesting example of a Realist approach to death, having as its subject a large group of Chelsea pensioners attending chapel, one of whom suddenly realizes that the pulse of his companion has just stopped.

The more escapist side to Victorian art is represented by some superb Classical scenes by artists of the so-called "Victorian High Renaissance", including a lusciously coloured roundel of three languorous women (*Garden of the Hesperides*★) by **Lord Leighton**, one of Lever's favourite artists. In this same category is a famous and especially blatant example of Victorian pornography, Alma-Tadema's *In the Tepidarium*★, which portrays a naked recumbent woman holding in one hand a feather and in the other a suggestively-shaped object (in fact a strigil used for

scraping the skin after soaping and oiling it), which points in the direction of her half-open mouth. This work was originally acquired by Leverhulme's rival in soap-making, Pears Brothers, who were probably intending to use it as an advertisement, but then on further reflection might have worried about its impropriety.

PRESTON
Lancashire Map B6

Preston is an ugly industrial town with an elegant late Georgian district. It was the birthplace of Richard Arkwright in 1732, the pioneering cotton entrepreneur who set up the first water-powered spinning factories.

Harris Museum and Art Gallery
Market Sq
Tel. (0772) 58248
Open Mon–Fri 10am–5pm
Closed Sat Sun
📷 📖 ♿

The building housing Preston's library, museum and art gallery was built in the late 19thC through the bequest of a native of Preston, Edward Robert Harris. It is a large and pompous Classical-style structure rising behind some splendidly elaborate public toilets. The museum section, situated above the library, contains historical and archaeological items, as well as **porcelain**, **glass**, **costumes**, and a large collection of 18th and 19thC scent bottles.

The gallery is housed in a grim, rather tatty series of rooms on the top floor. Among its attractions are works by the **Devis family** of artists, the most famous member of whom, **Arthur Devis**, was born in Preston in 1711. Active as a portraitist and painter of "conversation pieces", Devis enjoyed local patronage at first, but moved to London when he was 30. His works, of which the museum has several characteristic examples, feature doll-like figures with sweetly smiling faces. They have a certain naive charm, and enjoyed enormous popularity – due perhaps in part to the general backwardness of English art at this time. The gallery has also extensive holdings of **19thC** and **20thC British art**, including a large and powerful work by Francis Danby (*Pharaoh and his Hosts overwhelmed in the Red Sea* ★); a painting by Landseer of *A Puppy Teasing a Frog*; minor works by late Victorian artists such as **Augustus Egg**, **Frith**, **Watts** and **Atkinson Grimshaw**; a group of **Camden Town School** paintings; landscapes by **John Piper**, **Stanley**

Spencer and **Paul Nash**; and an early enigmatic *Still-life with Urchin* by the contemporary painter **Lucian Freud**.

ROCHDALE
Greater Manchester Map B6

Rochdale's industrial prosperity was based up to the end of the 18thC on wool, and later on cotton. The site of the first stirrings of the Cooperative movement with the thrifty "Rochdale Pioneers" in the mid 19thC, modern Rochdale is an unhappy blend of old and new buildings, but is pleasantly situated at the foot of the Pennines.

Rochdale Art Gallery
Esplanade
Tel. (0706) 47474 ext. 764
Open Mon–Sat 10am–5pm; Sun 2.30–5pm
📷 💬

The Rochdale Art Gallery, occupying an early 20thC building slightly outside the town center, has a large collection of **19thC** and **20thC British art**. However, the gallery's policy is to fill the relatively plentiful space here with rapidly changing exhibitions of the work of living artists; and selections from the permanent collection are only put on show occasionally.

Of the local artists represented here, one of the most interesting was **F.W. Jackson**, a late 19thC outdoor painter much influenced by contemporary French art, and an associate of the artists' colony at Staithes on the N Yorkshire coast. Like so many so-called Realist artists of his generation, Jackson had a nostalgic obsession with traditional rural lifestyles, as is illustrated by three of his finest works in the museum, *Rush-Bearing at Middleton*, and two scenes of an old man at a loom, *The Old Weaver* and *The Last of the Handloom Weavers*. On the wall of the gallery's staircase you will see a painting by the modern British figurative artist, **Anthony Green**, the specialist in scenes of seamy surburban sex painted within shaped, illusionistic canvases. Entitled *Our Tent: The 14th Wedding Anniversary*, it portrays the artist himself in an intimate position with his wife.

ROTHERHAM
South Yorkshire Map D6

Whichever way you approach Rotherham, you cannot fail to recognize the blighting effects of the coal and steel industries on the surrounding landscape,

but the city center itself has suffered just as badly at the hands of recent town planning policies.

Clifton Park Museum
Clifton Park
Tel. (0709) 2121 ext. 3569/3519
Open Apr–Sept Mon–Thurs Sat
 10am–6pm; Sun 2.30–5pm; Oct–Mar
 Mon–Thurs Sat 10am–5pm, Sun
 2.30–4.30pm
Closed Fri
📷 �: 🏛 ☑

The house of Clifton Park was probably built by the Yorkshire architect **John Carr** who was responsible for many buildings in northern England during the later 18thC. Now a museum, it contains good period **furniture**, displays of **local archaeology** and **Roman antiquities**, some **19thC** and **20thC paintings**, and a range of **decorative arts**. The most important of these is the collection of **Rockingham pottery** and **porcelain**, which was produced during the early 19thC at the nearby factory at Swinton.

SALFORD
Greater Manchester Map B6

Salford is a cotton-spinning town that to all intents and purposes is part of Manchester, being separated from it only by the narrow River Irwell. The gloomy, urban industrial landscape of the area can be best appreciated from the terrace of the town's **Peel Park**, a view that in fact inspired L.S. Lowry's ***The Pond*** (1950) in the Tate Gallery in *LONDON*.

Salford Museum and Art Gallery
The Crescent, Peel Park
Tel. (061) 736-2649
Open Mon–Fri 10am–5pm; Sun 2-5pm
Closed Sat
📷 🏛 🚶

The Salford Museum and Art Gallery is housed in an imposing building adjacent to Peel Park. It contains some minor **18thC** and **19thC British paintings** (for example, a portrait by **John Hoppner** of ***William Beckford*** and a portrait after Thomas Lawrence of the Italian sculptor ***Antonio Canova***) donated by the locally born 19thC art dealer, Thomas Agnew. But its attraction lies principally in its extensive holdings of the works of one of the most popular and overrated British artists of this century, **L.S. Lowry**.

Lowry lived all his life in different parts of the Greater Manchester area, and his reputation is based on his grey, naively painted industrial scenes populated with stick-like figures. The popularity of these clumsy, depressing

works was enhanced by the image that the media projected of the artist, portraying him as a solitary but affable man who became charmingly eccentric in old age. In fact for much of his life Lowry worked as a tax collector, but this was never given much emphasis. The Salford Museum gives you a full opportunity to study the development of his art. Perhaps the finest of his works here are his very early ones, some of which were done during evening classes at the Salford School of Art, which constituted his main artistic education. These early works (for example his **portrait** of his father of 1910 and a **self-portrait** of 1925), at least reveal a technical competence which later gradually declined as his fame grew.

SCARBOROUGH
North Yorkshire Map E5

Scarborough was one of the earliest seaside resorts, sea bathing having begun there in the 18thC, and the mineral waters were known from even earlier. The beaches are overlooked by an impressive ruined **castle**, which last saw action in World War I when the town was bombarded by a German squadron, and in the "old town" there are several interesting buildings such as the medieval church of St Mary, and the 19thC church of St Martin, which is splendidly decorated by leading **Pre-Raphaelites**.

The Crescent Art Gallery
The Crescent
Tel. (0723) 74753
📷 ☑

Scarborough's art gallery occupies two floors of a Victorian house, and, has an interesting collection with a very distinctive flavour. Here you can see a number of views of the area, some by **Henry Strange** and **H.B. Carter** who were both associated with the town's own school of art in the late 19thC and early 20thC, and there are also works by **Lord Leighton**, who was born in the town (look for an unusual biblical subject, ***Jezebel and Ahab***). Another locally based artist was **Atkinson Grimshaw**, who divided his time between Leeds and a house on the coast, and painted several muted evening scenes such as ***Scarborough Lights*** (1878).

The bulk of the paintings, however, were presented to the gallery by Tom Laughton, brother of the famous actor Charles Laughton, whose family were wealthy hoteliers in the area. Tom Laughton died in 1984 but he had taken a great interest in the arrangement of the

rooms, intending them to be a tribute or dedication to each of his four wives. For this reason it still has a strong personal identity. The earliest picture is a portrait rather dubiously attributed to **Van Dyck** but there are some good English paintings of the early 20thC by **Edward Bawden** and **Eric Ravilious**, and a vivid *Portrait of Vera Cunningham* by Matthew Smith. Laughton was a particular admirer of the Polish artist **Ruszkowski** whose work he acquired in huge numbers, and from this collection he presented 9 pictures to the Crescent Gallery.

Next door to the gallery is **Woodend**, the former home of the **Sitwell** family. Here you can see a collection of memorabilia and photographs belonging to Sir George and his three children, **Edith, Osbert** and **Sacheverell Sitwell**, as well as a few paintings by **John Piper**.

SHEFFIELD
South Yorkshire Map C7

Sheffield, the largest town in Yorkshire, is chiefly noted for its steel industry and for the production of "Sheffield plate" and cutlery. The huge sheds of the steelworks along the valley of the Don are a prominent feature of the urban landscape, but you will find some earlier and more attractive buildings in the central part, such as the **cathedral** (begun 14thC) and the **Cutlers' Hall**.

Sheffield's civic art collection is very large, numbering in all some 5,000 items, and in order to show a wider selection of works than would normally be possible the curators pursue a policy of regular temporary exhibitions and rehanging. This often means that paintings or sculptures you might expect to see have been put in storage to be replaced by others, or works previously held in one of the two galleries have been transferred to the other. For this reason there is no definite pattern to the contents or the arrangement of Sheffield's galleries, although they tend to be more suited to certain areas of the collection overall, and this governs the selection.

Graves Art Gallery ☆
Surrey St
Tel. (0742) 734781
Open Mon–Sat 10am–8pm, Sun 2–5pm
🔲🚻 ▣ ☑⁞⁞⁞

Despite its unpromising entrance from the street, the Graves Art Gallery, on the top floor of the library building, has one of the most attractive suites of galleries in Britain. It was founded in 1934 following a gift of money and paintings from Dr J.G. Graves, and is to some extent the town's principal gallery containing the main collection of **European Old Master paintings** and works from the late 19thC and 20thC.

The earliest works are found in the Italian school, including some **15thC panels**, but the later pictures such as the *Death of St Francis* by Lodovico Carracci, *The Mocking of Christ* by Procaccini, *The Adultress before Christ* by Pittoni and *The Arts* by G.D. Tiepolo are perhaps more interesting. The collection also has a few Spanish paintings, notably *The Infant Christ Asleep on the Cross* by Murillo and a group of **17thC Dutch works**. The landscapes of **Pynacker, Jan van Goyen, Ruisdael** and **Hobbema** are probably the best known of these, but there are also portraits by **Miereveld** and **Hanneman**, and some handsome genre scenes by **Teniers**.

In the later period Matisse's Fauvist study, *La Femme au Peignoir*★, is probably the most important of a number of French works, but a recent loan of some beautiful **late 19thC paintings**★ by **Pissarro, Monet, Boudin, Sisley, Gauguin** and **Bonnard** has greatly enhanced this area of the collection. You can also see **British artists** of the same period in greater numbers, and there are good examples of the work of Lavery (*The Harbour at S. Jean de Luz*), Sickert (*Portrait of a Man seated on a Chair*), Steer (*Chepstow Castle*) and both Augustus and Gwen John, the latter's *A Corner of the Artist's Room in Paris*★ being one of her finest paintings. The Camden Town group are best seen in two interiors, Gilman's *Eating House* and Malcolm Drummond's *The Artist's Desk*, while Rothenstein's *Sheffield Buffer Girls* obviously has a local significance. Of the remaining works from this period two of the finest are Spencer's *Helter Skelter* and Nevinson's *Bombed City*, but the collection maintains its interest in British 20thC art right up to the present day, and you can see a number of recent pictures by such artists as **Allen Jones, Hockney** and **Kitaj**.

In the heart of this, the Graves has two galleries with a completely different character. Gallery 3 contains a miscellaneous group of **antique, Oriental, Islamic** and **African** objects, which is in itself an interesting contrast to the paintings in the other rooms, while a further gallery displays the Grice Collection of **Chinese ivory carvings**. Well displayed and remarkable for their detailing, they include several memorable pieces, such as a head of *Kuan Yin*, a 17thC figure entitled *The*

Immortal Lan Ts'ai Ho, and a later figure of *Liu Po-Wen*.

Mappin Art Gallery
Weston Pk
Tel. (0742) 26281/754091
Open Jan–May, Sept–Dec Mon–Sat
* 10am–5pm, Sun 2-5pm; June–Aug*
* Mon–Sat 10am–8pm, Sun 2-5pm*
📷 🏛 ❧

Weston Park, which contains the Mappin Art Gallery, has a number of interesting monuments and sculptures in its grounds. Caro's **Lock** (1962) has a clear connection with the gallery, but there is also a **carved stone column** in memory of Godfrey Sykes, a local sculptor who was responsible for the decoration of the South Kensington Museum until his death in 1866.

The Mappin gallery itself is a simple Neoclassical building with a series of spacious rooms containing a permanent collection largely made up of **18thC** and **19thC British art**. In the first room to the right you will see a fairly settled display of **landscapes** from the Georgian period. **Samuel Scott**, **Wheatley** and **Constable** are each represented, although the most impressive works are **Marlow's** view of *The Pont Du Gard, Nimes* and **Turner's** Claude-inspired *Festival of the Vintage at Macon*. Some smaller pictures are equally interesting: Ibbetson's *The Storm* and David Cox's *Crossing the Heath* being the finest.

The Victorian paintings constitute the largest single group, many of the works having entered the collection with the Graves and the Mappin bequests. There are a number of Napoleonic military scenes by **E. Crofts**, but the most important pictures are Pettie's *Drumhead Court Martial*, Frith's *The Toilet*, Collinson's *At the Bazaar* and Burne-Jones's *The Hours*, as well as some later, more prosaic, scenes by **Edward Stott** and **Legros**. **Sargent**, the leading society portraitist of the late 19thC and early 20thC, is seen to good effect in a group portrait entitled *The Misses Vickers*.

Sheffield City Museum
Weston Park
Tel. (0742) 27226
Open Mon–Sat 10am–5pm; Sun
* 11am–5pm*
📷 🏛 ❧ ⬚

This museum, which shares the building with the Mappin Art Gallery, has a good collection of **decorative arts** from the 18thC and 19thC. The principal displays are understandably devoted to **cutlery, table settings and Sheffield plate** but there is also some English **porcelain** and

ceramics, an archaeology room with **Egyptian**, **Celtic** and **Saxon antiquities**, and a number of elaborate timepieces. In the middle of this, and for no apparent reason, there is a curious life-size and lifelike pair of *Japanese Wrestlers* carved in wood by **Hannanuma** (*c.*1890).

SOUTHPORT
Merseyside Map A6

Southport is an elegant seaside resort which was much favoured by wealthy industrialists in the 19thC. It has a charming main thoroughfare, **Lord Street**, which is lined with trees and attractive Victorian buildings.

Atkinson Art Gallery and Library
Lord St
Tel. (0704) 33133 ext. 129
Open Mon–Wed, Fri 10am–5pm;
* Thurs–Sat 10am–1pm*
Closed Sun
📷 🏛

The Atkinson Art Gallery and Library, prominently situated on Lord Street in front of a fountain pool, was erected in the late 1870s in a composite Italian Classico-Baroque style. The recently renovated art gallery shows a selection of the gallery's permanent collection.

This collection mainly comprises **18thC** and **19thC British watercolours**, **Victorian landscapes** and **genre paintings**, and a small group of **20thC British works**. Important artists such as **Etty**, **Cox**, **Crome**, **F.D. Hardy**, **Mulready**, **David Roberts**, **Watts**, **Brangwyn**, **Sickert**, **Laura Knight** and **Henry Moore** are represented, but largely by very minor works. You may find more enjoyment in some of the **genre scenes** by little-known Victorian artists, for example, James Haylar's portrayal of a humble country wedding, *Happy is the Bride the Sun Shines on* (1890).

STALYBRIDGE
Greater Manchester Map C6

A small manufacturing town on the River Tame, Stalybridge had its heyday in the 19thC, when it was one of the first towns to employ steam power in the mills.

The Astley Cheetham Art Gallery
Trinity St
Tel. (061) 338-2708
Open Tues–Fri 1–8pm; Sat 9am–4pm
Closed Sun
📷 ⬚ 📖

The Astley Cheetham Library and Art Gallery, opened in 1901, was the gift to

Stalybridge of J.F. Cheetham, the husband of Beatrice Emma Astley and a member of a well-known local cotton family. The pleasantly arranged art gallery, comprising a recently restored room above the library, shows its small permanent collection only occasionally during the year. The gallery particularly prides itself on its **early Italian works**, most notably two late 14thC Florentine pictures: a *Madonna and Child with Angels and Saints* by the Master of the Strauss Madonna, and a *Madonna and Child with adoring Angels* by Jacopo di Cionne and Workshop.

However, some visitors might find more exciting and unexpected the small landscape entitled *Near Rouen* ★★ by the early 19thC English artist **Richard Parkes Bonington**. This exquisite and vividly painted work, showing a church outlined against an extensive, brilliantly lit view of the Seine Valley, must surely be one of the finest paintings by this artist to be seen anywhere.

STOCKPORT
Greater Manchester Map B7

The skyline of this otherwise drab industrial town is dominated by its spectacular 100-ft high Victorian viaduct, supposedly much admired by the 19thC illustrator of infernal scenes and urban squalor, **Gustave Doré**.

War Memorial Art Gallery
Wellington Road South
Tel. (061) 480-9433
Open Mon – Fri noon – 5pm; Sat
* 10am – 4pm*
Closed Sun
🖼 🏛 ☑

In the 1920s a Classical-style building with a Corinthian portico was erected with the strange dual function of commemorating the dead from World War I and housing an art gallery. The war memorial aspect is undoubtedly this gallery's most impressive feature, and you may feel genuine emotion as you walk into its marbled shrine on the ground floor, which is almost bare save for a memorial by **G. Ledward**.

The gallery's permanent collection is shown only occasionally on the floor above. It comprises a mediocre group of **19thC** and **early 20thC British paintings**, including a copy of Raphael's *Madonna della Sedia*, Barbizon-inspired landscapes by the "Manchester School" artist **Anderson Hague**, John Phillip's *The Castanet Player*, Benjamin Leader's landscape entitled *Mountain Solitude*, and Lowry's *Crowther Street, Stockport*.

STOCKTON-ON-TEES
Cleveland Map C4

An industrial town with dilapidated ironworks and shipyards. Stockton is said to have the widest high street in England. The town possesses an elegant parish church, completed in 1712, but there is no truth in the claim that Sir Christopher Wren had any part in the design. Stockton was the birthplace of the furniture maker Thomas Sheraton (1751 – 1806).

Preston Hall Museum
Yarm Rd
Open Mon – Sat 10am – 6pm; Sun 2-6pm
🖼 🏛 ☑ ☙

This pleasant museum, occupying a 19thC house in a large park, is devoted principally to **Victoriana**, including dolls and a charming reconstruction of a street and a period room. Incongruously, you will also find in this museum an outstanding 17thC French painting, *The Dice Players* ★★ by **Georges de la Tour**. This is kept in a locked room of its own, into which an attendant will take you. On entering this you might well feel that you are in a shrine, for the work is spotlit behind a barrier which prevents you from getting closer than a few feet from the painting. Although full appreciation is difficult under these circumstances, this is nonetheless an excellent genre painting by an artist whose genuine works are rare; this one, which is signed, was only discovered recently.

SUNDERLAND
Tyne & Wear Map C3

The industrial town and port of Sunderland at the mouth of the River Wear is in the heart of a region noted for its early Christian associations. The Venerable Bede (c.673 – 735) spent virtually all of his life in the monastic houses of the area and there are still fragmentary remains of many of the early medieval buildings.

Museum and Art Gallery
Borough Rd
Tel. (0783) 41235
Open Mon – Fri 10am – 5.30pm; Sat
* 10am – 4pm; Sun 2-5pm*
🖼

The Sunderland Museum and Art Gallery appears to place greater emphasis on local history than the visual arts. Accordingly, there is a very good display of local wildlife and geology on the ground floor of the library, while the bulk

of the art collection is kept in storage. There are, however, a few contemporary pictures by **Allen Jones**, **Hockney** and **L.S. Lowry** on the stairs, and two large paintings by the local-born artist **Clarkson Stanfield** (*The Castle of Ischia* and *Lago di Garda*), which serve to stimulate interest in the collection overall.

SUTTON PARK 🏛
Sutton-on-the-Forest, North Yorkshire Map D5

*Open May–Oct Tues Thurs Sun 2-6pm;
 Wed (by appointment only)*
Closed Mon Fri Sat May–Oct; Nov–Apr
🎨 🚗 🅿 🏛 ☑ ♿

The red-brick Georgian house of Sutton Park in North Yorkshire has preserved much of its early character despite some additions to **Thomas Atkinson's** original design. The gardens, for example, have only recently been reorganized according to their original form, but the interior retains the beautiful **plasterwork** of **Cortese** in several rooms. The furniture is not original, but it is quite in keeping with the surroundings, as are many of the **18thC family portraits** by such artists as **Kneller** and **Hayman**. Those apart, the most interesting pictures are a *View of the Thames* by **Samuel Scott** and a *Self-Portrait* by the American painter **Benjamin West**, who succeeded Sir Joshua Reynolds as the President of the Royal Academy. The most striking feature of the house, however, is the ensemble of decoration in each room, in which an excellent collection of **British**, **European** and **Oriental porcelain** is justifiably given pride of place.

TATTON PARK 🏛
Knutsford, Cheshire Map B7

Tel. (0565) 3155
*Open Apr–mid May, Sept Mon–Sun 1-
 4pm; Mid May–Aug Mon–Sun 1-5pm;
 Nov–Mar Sun 1-4pm*
Closed Mon–Sat, Nov–Mar
🎨 🚗 🅿 🏛 ♿

Tatton Park is an elegant Neoclassical mansion designed by **Samuel Wyatt** at the end of the 18thC. For the interior Wyatt was assisted by his nephew, Lewis, who was responsible for the restrained entrance hall that now houses a small group of **Italian Renaissance chests**. Following this, many of the rooms have been very well preserved, retaining much of the original furniture commissioned by Wyatt from the Lancaster-based cabinet-maker **Gillow**.

There is also some good English **porcelain**, an outstanding **library** and a good collection of **pictures** and works of art.

The first work to be seen is in the entrance hall, a *Portrait of the Duke of Mantua* by his court painter **Frans Pourbus** (1569–1622) but this, and all the other works for that matter, are overshadowed by Van Dyck's *Martyrdom of St Stephen* ★ (in the drawing room), painted in the early 1620s when the artist was in Italy. Nearby there are two 18thC Venetian views by **Canaletto**, a striking *Portrait of Samuel Egerton* by the Italian Bartolomeo Nazzari and, in the music room, a landscape by **Gaspard Dughet**. Further on, the elaborately decorated dining room contains a collection of 19thC family portraits by **Beechey**, **Lawrence** and **Herkomer**, and this room also reveals the personality of the last owner of Tatton Park, the 4th Lord Egerton, who has left his mark with a number of game trophies and early vehicles, recalling the sporting activities that he no doubt pursued in the extensive park.

WAKEFIELD
West Yorkshire Map C6

The county town of the West Riding (West Yorkshire) was an important weaving center long before the Industrial Revolution, during which it underwent the process of industrialization common to most northern cities. However, it has managed to preserve something of its earlier heritage, notably the **cathedral**, which dates from the late 15thC, and the **Bridge Chapel**, which is even older (though largely reconstructed in the 19thC).

Wakefield Art Gallery
Tel. (0924) 370211 ext. 8031
*Open Mon–Sat 10.30am–12.30pm,
 1.30–5pm; Sun 2.30–5pm*
🔲 🏛 ♿ 🚻 ♿

The city art gallery occupies a late Victorian house at the edge of the town in which the domestic character of the rooms is further emphasized by the original decorative fittings. You should not be misled, however, into regarding the collection as a merely provincial display, because the first room alone contains a very good 16thC Venetian painting (*Noah and his Family building the Ark*) by Jacopo Bassano, and two 17thC Dutch works: an unusual scene of *Poultry in a Farmyard* attributed to **Cuyp** and a sea piece by **Jan Claes Rietschool**.

Thereafter, British pictures represent the bulk of the collection and there are fine examples of the work of **Reinagle**, **Atkinson Grimshaw**, **J.J. Tissot** (*On the Thames*) **Sickert**, **Ginner** (*Pond Square*), **Gilman** (*Self-Portrait*), **Matthew Smith** and **Duncan Grant**.

The sculptress **Barbara Hepworth** was born in Wakefield and there is a representative selection of her work on display, such as *Mask* (1928), *Kneeling Figure* (1932) and *Two Figures* (1968, in the garden), as well as that of her contemporaries **Henry Moore** (*Reclining Figures* of 1936 and 1961) and **Ben Nicholson** (*Piquet* 1936). Following on from this, the gallery maintains a lively interest in the finest contemporary British art, and it is a refreshing surprise to find pictures by **John Walker** and **Keith Milow** in the upper rooms where there is also a programme of temporary exhibitions.

WALLINGTON HOUSE 🏛
Cambo, Northumberland Map C3

Tel. (067 074) 283
Open Apr–Sept Mon Wed–Sun 1-6pm;
 Oct Wed Sat Sun 2-5pm
Closed Tues Apr–Sept; Mon Tues Thurs
 Fri Oct; Nov–Mar
🎫 🅿 🏛 ❦

Wallington, near the charming estate village of Cambo in Northumberland, is a 17thC house although later periods have left a greater mark on its appearance. In the 18thC it was largely remodelled and the interior decorated with elaborate **Rococo stuccowork**, and in 1855, on Ruskin's advice, Lady Pauline Trevelyan commissioned the Pre-Raphaelite painter **William Bell Scott** to paint a series of **8 murals** on the history of Northumberland for the covered courtyard. The most famous of these is *Iron and Coal* and *The Building of Hadrian's Wall*, but they are all of interest if only because the figures are generally portraits of the Trevelyan family and friends. **Ruskin** himself participated in the project, painting some of the decorative passages around the main scenes.

The contents of the house are notable for the superb collection of **European** and **Oriental porcelain**, particularly the Bow figurines and early Meissen pieces, but there is also a good collection of paintings, including family portraits by **Reynolds** (a full-length of *Sir Walter Calverley Blacket*), **Gainsborough** (*Mrs Hudson*), **Romney** and **Hoppner**. There are also some noteworthy 19thC works by **Turner**, **Cox**, **Burne-Jones** and **William Bell Scott**.

WHITBY
North Yorkshire Map D4

Whitby is a picturesque fishing village at the mouth of the River Esk in North Yorkshire. The town contains a fine church with interesting **18thC fittings**, but the principal monument in the area is the ruined **Whitby Abbey**, one of the chief monastic centers of the early church.

Pannett Art Gallery and Museum
Pannett Park
Opening times not available
📷 ❦

The Pannet Art Gallery (as well as the museum and the park) was the creation of Alderman Pannett who at his death in 1920 bequeathed a sum of money for the building and a collection of **19thC pictures**. The oil paintings are uniformly dull, but there is a good small collection of English topographical **watercolours**, including works by **Girtin**, **Turner**, **Constable**, **Bonington**, **Cox** and **De Wint**.

YORK
North Yorkshire Map D5

York, one of the best-preserved medieval cities in Europe, is most unusual in the extent to which its **original walls** have survived. Within this virtually complete perimeter the old city is still clearly evident in numerous **half-timbered buildings**, such as the street known as **The Shambles**, and in a series of late **medieval churches**. In the N corner of the city stands the **Minster★★**, the largest and one of the greatest medieval buildings in Britain, and the seat of the archbishop of York. Built between the 13thC and the 15thC, it has examples of all periods of English Gothic design; an extensive renovation programme which lasted for most of the 1970s, has restored the exterior and interior to a near-perfect condition.

The early sculpture on the Minster is of little interest when compared to many similar cathedrals, but this is more than compensated for by the **stained glass ★★**, which is without equal in Britain and includes some of the largest and earliest pieces in existence. The most famous window is the **five-lighted lancet ★** in the N transept, known as the "Five Sisters", which is a masterpiece in grisaille from the 13thC. There is also an elaborately carved **rood screen** from the 15thC and a number of interesting monuments throughout the choir; the main church

treasures, including the 8thC *Horn of Ulf* and some miscellaneous **silver**, are displayed in a special museum in the undercroft.

York has been settled by various groups since before Roman times and the surviving traces of each period have given rise to an impressive array of museums, ranging from the **Yorkshire Museum** of Roman and medieval antiquities to the **National Railway Museum**, the largest of its kind in the world, and the new **Viking Museum**. Nor should you miss the **Castle Museum** in the former Women's Prison beside the castle, which is an excellent folk museum based on the collections of Dr. J.L. Kirk.

York City Art Gallery ☆
Exhibition Sq
Tel. (0904) 23839
Open Mon–Sat 10am–5pm; Sun 2.30–5pm
🎨 🛍 ☑ ⚒

The York Art Gallery, near the Minster, was built in 1879 as a local exhibition center, but soon afterwards was acquired by the town along with the nucleus of its collection of pictures. In its early years this remained of primarily local interest, but in 1955 F.D. Lycett Green presented over 100 **Old Master paintings**, which now constitute the most important aspect of the collection.

These are displayed in the large central gallery, beginning with an important group of Italian Renaissance paintings, the most interesting of which are two panels by **Bernardo Fungai**, of scenes from the *Life of St Clement*; *The Man with a Book* attributed to **Parmigianino**; two panels depicting *St Bridget of Sweden* and *St Anthony Abbot* by the mid 16thC Florentine painter **Tommaso Manzuolo**; and other works by **Guido Reni**, **Agostino Carracci**, **Luca Giordano** and **Procaccini**. Domenichino's *Portrait of Monsignor Agucchi*★ is a particularly interesting work, not merely because of its considerable merits as a painting but also because the sitter was one of the leading art theorists in 17thC Rome.

In the same gallery you will see some early **German** and **Flemish paintings**, the finest of which are Jan van Scorel's

Portrait of a Man, but again it is the 17thC which is best represented among all the Northern European schools, with still-lifes by **van Beyeren** and **van Streek** and an unusually large landscape by **van Goyen**. There is also an interesting collection of 18thC pictures by such artists as **Guardi**, **Watteau**, **Bellotto** and **Greuze**, although the most attractive work, even in this company, is Vernet's *Sporting Contest on the Tiber*.

In the three galleries to the left you will find British school paintings displayed in a chronological sequence, from Van Dyck's *Portrait of Albert de Ligne* (c.1630) to Reynolds' *Portrait of Captain John Foote* in Indian costume. Between these two fine works there are other portraits by **Lely** and **Gower**, landscapes by **Marlow**, **Gainsborough**, **Towne** and **de Louther bourg**, and an unusual history painting by Sawrey Gilpin, *The Election of Darius*, in which his craft as an animal painter is put to good use. The last of those galleries is devoted to **William Etty**, (1787–1849) the academic painter noted for his nude studies, who was born in York. *The Toilet of Venus*★ and *Venus and Cupid*★ are typical examples of his voluptuous Rubensian manner, but there are also a few portraits on display and a view of *The Monk Bar*.

On the upper floor there are two further galleries of **19thC** and **20thC paintings** in which British artists again predominate. The Burton Bequest alone consists of a number of **Victorian genre scenes** by such artists as **Faed** and **Phillip**, and there are other works by **John Martin**, **Danby**, **Watts** and **Whistler**. **Albert Moore**, an associate of Whistler, was also a native of York and he is represented by a large *Venus*★, *Kingcups* and *The End of a Sofa*. Alongside these there are a few 19thC French pictures by **Boudin**, **Courbet**, **Fantin-Latour** and the **Barbizon School**, but as the collection moves into the 20thC it is almost exclusively British. Virtually all the leading painters are represented, at least in the period before 1940, although **Stanley Spencer's** *Deposition* and *Rolling away of the Stone*, a single work divided like an early altarpiece, is from his last years, c.1956.

SCOTLAND

Few people will be unfamiliar with the popular image of Scotland, the land of "the mountain and the flood", of Robbie Burns and the Loch Ness monster, and a host of other motifs. The Scots themselves have been assiduous in promoting this mythology, but in fact it bears little relation to the country and the people.

An independent country until voluntary union with England came about in 1603, when the two kingdoms were joined (followed by the union of the two parliaments about a century later), Scotland has retained many separate institutions such as its courts and legal system. However, Scottish culture itself is not unified: at the time of the Union, Highlanders and Lowlanders spoke different languages, wore different styles of clothing, and formed quite different societies.

HIGHLANDS *and* LOWLANDS

The Lowlands and the E coast of Scotland of that time were very European in outlook, supporting a network of universities that were generally older and more democratic than those in England, and producing many leading natural scientists, philosophers and engineers. The Lowlands' greatest period was in the 18thC and early 19thC, the so-called Scottish Enlightenment, when figures such as David Hume, Francis Jeffrey and Henry Raeburn made EDINBURGH the principal, if not the only, significant cultural center outside London. Other Lowland regions with their own distinctive characters also flourished, such as the Borders region with its strong literary tradition and great natural beauty. In the 19thC a further element was introduced with the rise of GLASGOW, as a result of 19thC industrial and mercantile expansion, to become the "second city of Empire".

The landscape of Scotland has also been one of the country's most famous features, particularly that of the Highlands. But although this region is celebrated for its remote and spectacular scenery, very few paintings of note have developed from it – perhaps because imagination rather than direct experience has created its popular image. As early as 1508 the Italian artist Pintoricchio painted a fresco at Siena showing an ostensibly Scottish landscape with many salient features of later views: mountains, lochs and a brooding atmosphere. Later, the Highland identity has been overlaid by MacPherson's pseudo-epic of *Ossian*, Walter Scott's Romantic ideals of the Highland clans, Queen Victoria's blend of the wild and the domestic at Balmoral and, in the present century, a tourist trade fostering spurious notions of "tartany".

CONTINENTAL CONNECTIONS

Painters have done little more than repeat these conceptions, at least in the 19thC when there was scarcely an artist who was not touched in some way by Scott's imagery. Yet this period saw many Scottish artists turning to themes that were more widely pursued in Europe. William McTaggart, for example, painted in a style based on his experience of the W coast Mull of Kintyre, which nevertheless finds its closest parallel in the art of the Impressionists. The Glasgow school found their sources in contemporary Dutch and French work. C.R. Mackintosh was readily accepted by the Vienna Secession. The Colourists turned to Scottish scenes with a rich palette and a freedom of handling that obviously links their work with that of Matisse.

Such innovative attitudes have been conspicuously lacking among most recent Scottish artists. But, ironically, Scottish galleries showing contemporary and earlier art are better now than they have ever been.

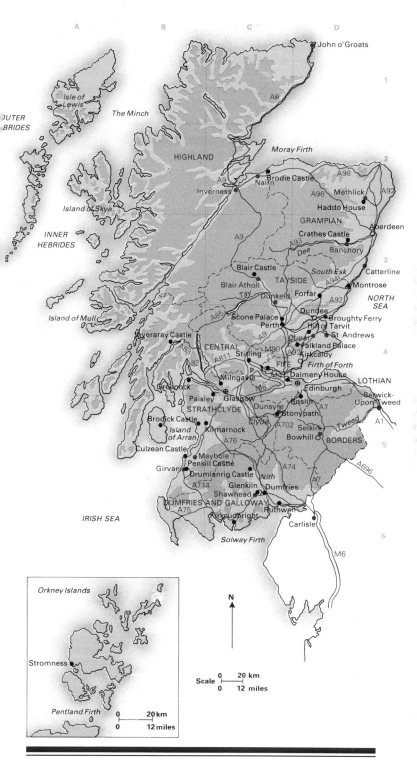

ABERDEEN
Grampian Map D3

Aberdeen, known today as Europe's North Sea oil capital, is a forbidding place. Its old buildings (most of which date from the 19thC) are austerely decorated, and virtually all are built of granite, thus earning the city its nickname of the "granite city". The leading Aberdonian architect of the last century, Archibald Simpson (1790–1847), was responsible for most of the city's massive and grimly impressive Neoclassical buildings, including the **Marischal College**, once the largest granite building in the world after the Escorial in Spain.

The part of the city known as Old Aberdeen was in fact a separate town until 1891, and is no more ancient than "New Aberdeen". It is a quiet district with a number of 18thC houses, virtually all now belonging to the University. The city's cathedral, **St Machar's**, is also here, although only a few stones of the original Norman building survive, the rest having been constructed mainly in the 15thC.

Aberdeen Art Gallery ☆
Schoolhill
Tel. (0224) 646333
Open Mon – Wed Fri Sat 10am – 5pm;
* Thurs 10am – 8pm; Sun 2 – 5pm*
🖾 🗪 🛍 💶 ☑ ⋯ ♿

The Aberdeen Art Gallery, which is housed in a late 19thC classical-style building, is the third major art gallery in Scotland. When the gallery was built in 1885, it was used simply for large exhibitions by local artists and industrial exhibitions. Then, in 1900, a local collector called Alexander MacDonald presented to the gallery his own extensive art collection as well as a sum of money for the purchase of other works of art. MacDonald had made his money from the smoothing and polishing of granite, an idea that came to him after he had seen some examples of ancient Egyptian granite work in the British Museum in London: his interests as a collector were principally in the work of his Victorian contemporaries, a number of whom he lavishly entertained at his Kepplestone home near Aberdeen. The gallery's holdings grew rapidly in size, and new additions had to be made to the building in 1905 and 1925. Recently the interior has been beautifully modernized, and is now one of the finest in Britain. Few other art galleries in Great Britain are so pleasant or relaxing to walk around; the works of art are tastefully and spaciously displayed, and there is a delightful main hall where you can sit and watch the water from a central fountain play over a sculpture by **Barbara Hepworth**.

The holdings of pre-19thC art are the collection's weakest aspect. There is only one work of the 17thC, a self-portrait by **George Jamesone**, who was one of Aberdeen's most important native artists. The 18thC collection features a fine portrait of Miss Janet Shairp by **Ramsay**, and some rather indifferent works by **Raeburn**, **Wilson** and **Hogarth**. The holdings of 19thC British art are by contrast of consistently high quality. The two leading Aberdonian artists of this period were **William Dyce** (who was born at 48 Marischal St), and **John Phillip** (whose birthplace, at 15 Skene Square, is commemorated by a plaque). The former achieved national recognition through such major commissions as the decoration of the Houses of Parliament in *LONDON*. His immense versatility as an artist is exemplified in the many works by him (only partially displayed) in the Aberdeen Art Gallery. These include mythological and biblical scenes, designs for frescoes (including one of his panels in the House of Lords), portraits and landscapes. The two best known works by him here are *Titian's First Essay in Colour* ★ (1856–7) and *A Scene in Arran* ★ (1859); both were originally in the collection of his father-in-law James Brand, and are rendered in a meticulously detailed technique reminiscent of the Pre-Raphaelites. The former work shows the boy Titian in an unmistakably British landscape, with flowers in one hand and staring up at the sky; it still has immense popular appeal today, as you can see from the numerous reproductions on sale in the gallery's shop. *A Scene in Arran* has the same haunting quality as Dyce's celebrated *Pegwell Bay* in the Tate Gallery in *LONDON* (also once in the collection of James Brand, and painted in the same year). It records a family holiday that Dyce had taken that year on the Scottish island of Arran. The other 19thC Aberdonian artist, John Phillip, worked for much of his life as a portraitist in Aberdeen; but he is now best known for the exotic Spanish scenes that earned him the nickname of "Phillip of Spain". Two fine examples of these in the gallery are his *Maja Bonita* and the *Early Career of Murillo*.

The gallery's holdings of Victorian painting also include Alexander MacDonald's collection of **91 portraits** of the leading British artists of his time (these are now framed in groups on movable panels); the idea for this series came when the renowned John Everett Millais stayed with MacDonald in 1880,

and, at the latter's suggestion, was painted by the Aberdonian portraitist and painter, George Reid. This collection features portraits and self-portraits by a most impressive range of artists working in Britain, from the illustrator **Randolph Caldecott** to **G.F. Watts** and **W.P. Frith**; there are even some works by renowned foreign artists of the day, most notably the French peasant genre painter, **Jules Breton**, and the Hague School painter, **Josef Israels**. One contemporary believed that the collection represented "all the greatest in the world of art"; however, you will see that virtually all the artists were successful academicians and, with the possible exception of **John Singer Sargent**, all the more experimental and now generally better-known artists are not represented.

In addition to a self-portrait in the MacDonald portrait collection, **Millais** has two other canvases in the gallery, *The Convalescent* (1875) and *Bright Eyes* (1877); both belong to the artist's late and now less popular period, which is characterized by numerous slickly painted and mawkishly sentimental representations of children, of which these two works at Aberdeen are typical. You can see more impressive examples of late Victorian art in the four works portraying scenes of rural life (a type of subject matter that enjoyed extreme popularity in Britain at this time): *The Ploughman* by La Thangue, *Ploughing* by Sir George Clausen, *Our Village* by Sir Hubert Herkomer (which shows the village square near the artist's home in Bushey, Surrey) and the *Goose Girl* a well-known painting executed in the artist colony in Cockburnspath by the mainstay of the colony and leading Glasgow School painter, **Sir James Guthrie**. The gallery has also what is now perhaps the most famous of all the Glasgow School paintings, Sir John Lavery's *The Tennis Party* ★. The artist's extremely delicate treatment of figures and colours, and his depiction of a sunny, carefree atmosphere are in marked contrast to his soberly realistic and earthy *Goose Girl*. The latter was painted just outside Glasgow, at Cartbank on the Cathcart Estate, where Lavery and his Glasgow School friends, Guthrie, Melville and Walton, used to play tennis at weekends.

The gallery's holdings of French 19thC art are less impressive than those of British art, but nonetheless contain pleasant landscapes by **Theodore Rousseau**, **Boudin**, **Renoir** and **Pissarro**, still-lifes by **Fantin-Latour** (who was enormously popular in Scotland), a

sculpture by **Rodin** and oils by **Vlaminck**, **Toulouse-Lautrec** and **Vuillard**. Two foreign artists who had an especially strong influence on British late 19thC art were **Josef Israels** and, above all, the French peasant genre painter, **Jules Bastien-Lepage**. The former, who visited Aberdeen in 1870, is represented in the gallery by *The Errand* and *The Sleepers*, two typical examples of his Rembrandtesque interior genre scenes. Of Bastien-Lepage's work, the gallery has the small but superlative *Going to School* ★ (1882), which was painted in the artist's home village of Damvilliers in Normandy, where he painted almost all his best-known works.

The Aberdeen Art Gallery is one of the finest places in Britain to study the development of modern British art from the **Camden Town School** up to the present day. Among the many paintings of this period worth singling out are Augustus John's luminous *The Blue Pool* ★ (painted on Wareham Heath near Poole in Dorset); John's sister, Gwen's characteristically subtle *Seated Girl Holding Piece of Sewing* ★ Christopher Wood's *Cornish Fisherman, St. Ives* and Paul Nash's *Wood on the Downs* ★. Of more local interest are the Scottish painter **Joan Eardley's** freely painted coastal scenes from the wild and beautiful nearby village of Catterline, where she spent much of her life (and arranged for her ashes to be scattered on the beach). Recent British sculpture is well represented by such works as Anthony Caro's *Footprints* (a large free-standing animal-like form), and the highly amusing *The Infant St George* by George Fullard (a sculpted collage with objects such as golf clubs and wooden blinds).

The gallery has an outstanding print room, featuring mainly British works ranging from topographical watercolours by **Girtin** to figure drawings by **Augustus John**; an extremely large selection of these are always on show. There is in addition the **James McBey Print Room** and **Art Library**.

Provost Skene's House
Guestrow (off Broad St)
Tel. (0224) 641086
Open Mon–Sat 10am–5pm
Closed Sun
🖼 ⚓ 🅿 🏛

Provost Skene's house is the oldest surviving domestic house in Aberdeen, part of it dating back to as early as 1545. It has now been turned into a museum; each of its rooms, which range in date from the Cromwellian to the Victorian periods, has furniture and works of applied art appropriate to its setting. The **chapel**

contains a series of crude but fascinating **early 17thC religious panels** painted on the ceiling; they owe their excellent state of preservation to the fact that they were hidden under plaster for 300 years.

BLAIR CASTLE
Blair Atholl, Tayside Map C3

Tel. (079681) 355
Open Apr Mon 10am–5pm, Sun 2–5pm; May–early Oct Mon–Sat 10am–5pm, Sun 2–5pm
Closed early Oct–Mar
🏰 🅿 🏛 ⚘

Blair Castle, originally a 13thC fortress, was turned into a plain Georgian mansion house in the 18thC. Then, in the Victorian era, when the Scottish baronial style of architecture became fashionable, an attempt was made to restore it to its former medieval appearance with the addition of turrets, towers and crow-stepped gables. The Atholl family, who own it, were the most important Highland patrons of the arts; and the grounds of Blair Castle and of their now destroyed house at nearby **Dunkeld**, were the first areas of the Highlands to be popular with tourists and extensively painted. The grounds of Dunkeld, called the **Hermitage** (and now owned by the National Trust of Scotland), include a most beautiful stretch of the River Bran. In the early 19thC the Duke of Atholl had a hermitage built overlooking the River Bran at the point where it forms a spectacular waterfall, the Black Lyn Fall; nearby he also had constructed an **"Ossianic Cave"**, in which were inscribed fragments of Macpherson's then highly fashionable poem about the mythical Celtic hero, Ossian. Both these follies survive and form part of an itinerary devised by the local Forestry Commission.

Blair Castle is exceptionally rich in 16thC–18thC furniture and applied art: in particular a set of **Brussels tapestries** made for Charles I, and a magnificent collection of **Sèvres porcelain** displayed in 18thC Chippendale and Sheraton cabinets. Among the family portraits are fine portraits by **Zoffany, Lawrence, Hoppner, Landseer** and **James Guthrie**: most charming of all is a delightful **"conversation piece ★"** by Zoffany of the 3rd Duke of Atholl and his family in the grounds of their former house at Dunkeld, and a **portrait** by Sir Edwin Landseer of the Hon. James C. P. Murray playing with a doe under the watchful eye of a favourite family retainer, the fisherman John McMillan. Of considerable historical interest are four

paintings by the Scottish landscapist **Charles Steuart** incorporated into the walls of the beautifully stuccoed 18thC dining room; these are among the first known Scottish landscapes and represent the four main scenic attractions in the Atholl estates: the Black Lyn Fall, the ruins of Dunkeld Abbey, and the lower and upper falls of the River Bran (the last two sites are both in the grounds of Blair Castle).

BOWHILL 🏛 ☆
Nr. Selkirk, Borders Map D5

Tel. (0750) 20732
Open May–June Sept Mon Wed Sat 12.30–5pm, Sun 2–6pm; July–Aug Mon–Thurs Sat 12.30–5pm, Sun 2–6pm
Closed Oct–Apr
🏰 🍴 🅿 ⚘

Although it has a pleasant lakeside position, Bowhill is a rather ugly early 19thC building. However, like the Duke of Buccleuch's other two properties that are open to the public, DRUMLANRIG CASTLE in Galloway and Boughton House in Northamptonshire, (see *MIDLANDS*), it is filled with important art treasures, including a painting ascribed to **Leonardo**. Two fine works by Claude (both dating from the 1630s) are *The Landscape with the Judgement of Paris* ★ (the artist's first painting with a mythological subject), and the *Harbour Scene* ★ (the first of his many paintings in which a view of a harbour is framed by tall, arched classical buildings). The latter is also the first example in European art of a subject that was to be very popular with later painters, for instance Turner. The other great paintings at Bowhill date mainly from the 18thC, as do most of the furniture, porcelain and other applied art objects that surround them. One room, called the Italian Room, has excellent canal scenes by **Guardi, Canaletto** and other contemporary Italian view painters such as **Marieschi, Panini** and **Antonio Joli**. Bowhill also has some outstanding family portraits. Four of these feature members of the family of the 3rd Duke of Buccleuch, who is shown in a fine portrait by **Gainsborough** with his arms around a dog. A dynamic full-length portrait by **Reynolds** depicts his wife, Elizabeth Duchess of Montagu, together with their daughter Lady Mary Scott, and Reynolds also painted their two other children, Charles Earl of Dalkeith and Caroline Scott, later Marchioness of Queensberry. While he was engaged on the picture of Charles – which is now called *The Pink Boy* – Charles's small

sister, Caroline, came into the room dressed in her winter clothes, and Reynolds was so enchanted by her appearance that he insisted on painting her in this dress. The resulting work, now called **Winter ★** is one of Reynolds' most famous child portraits. Finally mention should be made of **Raeburn's** famous portrait of *Sir Walter Scott* (1808) sitting pensively with a book in a romantic landscape setting. Scott's visits to Bowhill are also commemorated in a collection that includes his plaid and a manuscript of the *Lay of the Last Minstrel*.

BRODICK CASTLE ⊞
Isle of Arran, Strathclyde Map B5

Tel. (0770) 2202
Open Apr Mon Wed, Sat 1–5pm;
May–Sept Mon–Sun 1–5pm
Closed Oct–Mar
◪ ➤ ▯ 🏛 ⚘

The present castle at Brodick dates from the mid 16thC when the Baron Hamilton rebuilt an earlier fortified house on the site. Over the next three centuries further alterations and additions were made but it still retains its original stark and simple appearance.

The contents of the castle owe something to the family's connection with the immensely wealthy and eccentric William Beckford, part of whose estate of Fonthill, Berkshire, was inherited by the Dukes of Hamilton. Turner's watercolour of *Fonthill* emphasizes this link, but it is only a small part of a painting collection that includes works by **Teniers, Fragonard, Rowlandson** and **Gainsborough**. Clouet's portrait of the *Duc d'Alençon* is perhaps the most interesting, having once been in the collection of Charles I.

In the area of the decorative arts however, Brodick does suggest something of Beckford's eclecticism and range. There is French and Italian furniture from the 18th and 19thC in the drawing room and English 18thC furniture in the boudoir. Throughout the house you can see a selection of silverware and porcelain from all the leading English and European factories.

BRODIE CASTLE ⊞
Nr. Nairn Moray Map C2

Tel. (03094) 371
Open May–Sept Mon–Sat 11am–6pm,
Sun 2–6pm
Closed Oct–Apr
◪ ➤ ▯ 🏛 ☑ ⚘

The 16thC fortified house at the heart of

Brodie Castle recalls the building's feudal past, although the interior and extensions have subsequently been fitted out for a more elegant life style. This is perhaps most obvious in the ornamental plasterwork **ceilings** dating from the 17thC and 18thC, as well as in a wide range of furniture, fabrics and other decorative arts. There are also a number of paintings, the finest of which is a group portrait of *The Family of William Brodie of Brodie* by John Opie, c. 1804, and some **17thC Dutch works**. These represent the typical inheritance of an old landed family in Britain, but in the early 20thC a number of modern pictures were acquired, covering a range between **William McTaggart** and **Raoul Dufy**, and this gives the collection its distinctive character.

CRATHES CASTLE ⊞
Banchory, Grampian Map D3

Tel. (03302) 525
Open May–Sept Mon–Sat 11am–6pm,
Sun 2–6pm
Closed Oct–Apr
◪ ➤ 𝒳 ▯ ▯ 🏛 ☑ ⚘

Crathes is a 16thC tower house next to a delightful 18thC formal garden with ancient yew hedges. The house has on its second and third floors some of the best-preserved Jacobean **ceiling paintings** in Scotland – crude but spirited allegorical works with intriguing inscriptions like "As a dog turneth to his own vomit, so the foole returneth to his own foolishness."

CULZEAN CASTLE, ⊞
Maybole, Strathclyde Map B5

Tel. (0655) 269
Open Apr–Sept Mon–Sun 10am–6pm;
Oct Mon–Sun 10am–4pm
Closed Nov–Mar
◪ ➤ ▯ 🏛 ⚘

Culzean Castle has the finest position of any country house in Britain, being perched on a cliff rising sharply above the sea. The castle was originally a relatively modest medieval structure; but in the 1770s the 9th Earl of Cassilis called in the great **Robert Adam** to extend the building considerably, and Adam devised a massive sham Gothic addition, complete with turrets and crenellations.

The fortress-like exterior contrasts with the elegance of the Georgian rooms inside. The **oval saloon** is one of Adam's most masterly creations, for the architect has made full use of the castle's beautiful setting by inserting into one side of this

room a series of tall French windows that allow the widest possible views of the sea below; the blues and greys of the sea and sky combine with the delicate pastel-coloured stucco of the room's ceiling to create an almost dream-like environment.

The paintings that you will see within the castle unfortunately do not match the quality of the building's architecture and decoration. There is a good portrait of the 10th Earl of Cassilis by **Pompeo Batoni**, a pleasant seascape by **van de Velde** and, in the first drawing room, a ceiling roundel by **Antonio Zucchi**. But the finest works are undoubtedly two views of Culzean by **Alexander Nasmyth**. These succeed in showing the building in the way that Robert Adam must surely have intended: as the "enchanted castle" that you can see in many of the paintings of Claude Lorrain.

DRUMLANRIG CASTLE ⌘
Thornhill, Dumfries and
Galloway Map C5
Tel. (0848) 30248
Open Apr Sat 12.30–5pm; Sun 2–6pm;
May Mon Wed Thurs Sat 12.30–5pm,
Sun 2–6pm; June–late Aug
Mon–Thurs, Sat 11am–5pm, Sun
2–6pm
Closed Mon–Fri Apr; Tues Fri May; Fri
June–late Aug; late Aug–Mar
🖼 ➡ 🅿 ⏶ ♿

Standing in the middle of attractive grounds crossed by the tree-lined River Neith, Drumlanrig Castle is an early 17thC building which was substantially rebuilt to the designs of Sir William Bruce between 1676 and 1689. The cost of this rebuilding almost bankrupted the 17th Duke of Queensberry, who commissioned it, but the result is one of the most magnificent examples of 17thC architecture in Scotland. Since 1810, Drumlanrig has been the property of the Dukes of Buccleuch, and like the other two major properties owned by this family, **BOWHILL** in the BORDERS and Boughton House in Northamptonshire, (see *MIDLANDS*), has a superlative collection of art treasures. Among the many fine family portraits are works by **Lely**, **Ramsay**, **Kneller** and **Hudson**. In the Serving Room is a curious series of early 19thC genre portraits of members of the Buccleuch household by the Glaswegian painter **John Ainslie**. The portrait of the cook, Joseph Florence, (depicted in front of a table of food and pointing to a provisions list) was greatly admired by Sir Walter Scott. Some of the

best foreign school paintings are to be found in the staircase hall, and include portraits by Holbein (*Sir Nicholas Carew* ★), Joos van Cleve, Mabuse and Clouet (*Francis I*), and a *Virgin and Child* by Murillo. There are more foreign paintings in the Boudoir, including Dutch 17thC works by **Teniers**, **Ostade**, **Jakob van Ruisdael**, **Aert van der Neer**, and **Albert Cuyp**, and a pair of charming pastoral scenes by the 18thC Venetian artist, **Zuccharelli**. The morning room has four excellent watercolours of Windsor Castle by **Paul Sandby**. But the greatest treasure of the house is in the ante-room; it is a portrait by Rembrandt, signed and dated 1655, of an *Old Woman Reading* ★★, and the setting allows you plenty of room to admire the powerful simplicity of composition that Rembrandt was able to achieve in his old age.

DUMFRIES
Dumfries and Galloway Map C6

Dumfries, the largest town in SW Scotland, is a clean, prosperous market town and center of light industry. Although it lacks any truly distinctive character, it has a pleasant riverside position and a number of interesting old monuments, most notably the extensive ruins of the 13thC **Caerlaverock Castle**, destroyed in 1640.

Gracefield Arts Centre
28 Edinburgh Rd
Tel. (0387) 52301/63822
Open Apr–Sept Mon–Sat 10am–1pm,
2–5pm, Sun 2–5pm; Oct–Mar
Mon–Sun 2–5pm
The Gracefield Arts Centre is now so poorly funded that it cannot even afford to be listed in the annual handbook, *Museums and Art Galleries of Great Britain and Ireland*. Yet it is the only public art gallery in the SW of Scotland, and contains a surprisingly large number of good pictures. It was built in 1951 in celebration of the Festival of Britain, and since then has amassed a modest but wide-ranging collection of British art from the late 19thC onwards, in addition to three etchings by **Rembrandt**. Most of the leading Scottish artists of this period are represented here (generally, it must be said, by rather slight works), as well as some well-known artists from elsewhere in Britain, most notably **Dame Laura Knight**, **Sir Frank Brangwyn**, **Mark Gertler** and **Sir George Clausen**. Pride of the collection are a small head of an old woman by the local **Thomas Faed**, and a peasant genre scene with a rather

silly title by Clausen, "*And We have the Payne and Trevely, Reyne and Wynde in the Felles*".

DUNDEE
Tayside Map D4

Dundee, when approached from the impressively long bridges that span what the notoriously awful Dundee poet, William McGonagall, described as the "silvery, silvery Tay", seems almost beautiful. These early impressions, unfortunately, soon prove to be delusory. Although the city's history dates back to Roman times hardly a single monument survives from before the 19thC, when the city developed as a major industrial center thanks principally to the manufacturing of jute fibre exported by the East India Company. Fires and wars destroyed most of the town's early monuments, including the parish church of St Mary's (of which only the steeple remains); but sheer philistinism has been responsible for the destruction of many other buildings, including, unforgivably, that of William Adam's masterly 18thC Town Hall.

Central Museum and Art Gallery
Albert Square
Tel. (0382) 27643
Open Mon–Sat 10am–5.30pm
Closed Sun
🖼 ✗ ⬛ ⬛ ⠿ ⚓

In 1862 it was decided that a memorial building for the promotion of literature, science and art, should be erected in the center of Dundee, to be called the Albert Institute. The architect chosen for this was Sir Gilbert Scott, who described his design as a "13th or 14th century secular style with the addition of Scottish features, peculiar in that country to the 16th century, though in reality derived from the French style of the 13th and 14th centuries". The Art Gallery and Museum occupy two slightly later extensions of this pompous and eclectic building. The interior has been recently renovated, but the display of objects is crammed and unimaginative. Lack of space allows only a small selection of the gallery's good and reasonably extensive picture collection to be shown at any one time. This includes a few foreign school paintings, most notably an early 16thC Venetian *Sacra Conversazione* with an especially obscure attribution to the studio of Bonifazio de' Pitati, a *Sacrifice of Abraham* plausibly ascribed to the 17thC Neapolitan follower of Caravaggio, G.B. Caracciolo, some indifferent Dutch 17thC still-lifes, a

Rest on the Flight to Egypt by Pompeo Batoni, and an attractive harbour scene by **Boudin**.

The holdings of English art are far more impressive, and include a vast collection of the graphic works of **Sir Frank Brangwyn**, 61 pencil drawings by the topographical artist **David Cox**, *Dante's Dream* by Dante Gabriel Rossetti (a smaller version of an oil painting dated 1871 in the Walker Art Gallery in Liverpool), a sickly-sweet but finely painted late portrait by Millais called *Puss in Boots* (the subject is one of the artist's daughters) and landscapes by **Sickert**, **Steer** and **Stanley Spencer**. Perhaps the most striking of the English pictures is the *Poppy Field* ★ (1905) by Sir Alfred Munnings; this vigorously painted and vividly coloured canvas is an early work of the artist, who later described it as "the first real go I had at a large outside painting, trying to see colour . . .". Not surprisingly, the greatest number of works in the gallery are of the Scottish school, and indeed the gallery's recent purchases have been almost exclusively of Scottish 19th and 20thC paintings. Among the high points of the Scottish collection are two **Spanish Scenes**★ by **John Phillip** ("Phillip of Spain"), a large outdoor genre scene by Thomas Faed (*The Visit of the Patron and Patroness of the Village School*), a highly realistic landscape by the Glasgow School painter **Joseph Crawhall**, an exquisitely coloured still-life by the "Scottish Matisse", **F.C.B. Cadell**, and an abstract painting of 1928–30 (*Ode to the West Wind* ★) by the unfairly neglected **William Johnstone**.

Dundee itself cannot be said to have produced much great art, although at the turn of the 19thC it was briefly the home of two of Scotland's greatest symbolist and art nouveau artists, **John Duncan** (who was born in the city) and **George Dutch Davidson**. The gallery has a number of works by the former and almost the entire surviving oeuvre (which is full of morbid symbolism) by Davidson, who died in Dundee at the age of 24. The town can also boast an artist whose work (though not his name) is known to millions: **Dudley Watkins**, the original illustrator of the comic magazine, the *Beano*. A vast number of the original illustrations for this are owned by the gallery, but sadly they are rarely shown.

Orchar Art Gallery
Closed until further notice
Contact Tourist Board (0382) 27723 for information

By far the most attractive part of Dundee

is the outlying residential suburb of Broughty Ferry, which in the 19thC was a very wealthy district favoured by the "jute princes" and other industrialists. Today the place has a sad but dignified Victorian character. The Orchar Art Gallery occupies a late 19thC house – to which a gallery was attached at the back in 1936 – overlooking the mouth of the River Tay. It once displayed the magnificent and extensive collection of **19thC British pictures** donated to the town by Samuel Orchar. Apparently as an economy measure the Dundee Council have recently closed the gallery down, and put the pictures in storage in the Dundee Art Gallery. This unpardonably short-sighted act has deprived Scotland of one of its greatest collections, and one moreover which was hung in the most appropriate and atmospheric of settings. This collection includes works by **Turner**, **Millais**, **Cox** and **Whistler** (36 etchings), and by such now increasingly fashionable Victorian artists as **Copley Fielding** and **Birket Foster**. Above all, it contains an almost unrivalled group of paintings by Scott Lauder's pupils such as **McTaggart**, **Chalmers**, the **Faed brothers** and **Orchardson**. An Orchar Art Gallery Action Group has recently been formed, and it is to be hoped that they will succeed in having the gallery reopened.

EDINBURGH
Lothian Map D4

Despite its overwhelming popularity as a tourist center, and the somewhat hackneyed routine of its annual Military Tattoo, Edinburgh remains one of the most distinctive and diverse cities in Britain. Its history corresponds to the curious landscape that it occupies. The ancient settlement around the volcanic rock where the castle now stands evolved into a medieval town of "closes" and "courts" that witnessed many famous events; while the elegant Georgian development to the N encompasses some of **Robert Adam's** greatest urban architecture. This so-called New Town saw the development of the Scottish Enlightenment with such figures as David Hume and Francis Jeffrey, and also the creation of the Royal Scottish Academy – initially the instrument of a Scottish school, but more recently a static organization which, like the Edinburgh College of Art, has been responsible for little that is new or exciting.

Edinburgh also acts as the administrative, religious and legal capital of Scotland, giving a superficial impression of mannered affectation to many people who do not know the city. But few visitors see the other side of Edinburgh: the port of Leith, the public bars, the dilapidated housing estates, or the massed ranks of supporters cheering a football team that shares its name with one of Walter Scott's most famous novels, *Heart of Midlothian* (the name of the old town prison).

Edinburgh City Art Centre
1–4 Market St
Tel. (031) 225-1131
Open Mon – Sat 10am – 5pm
Closed Sun
⊠ ▥ ▯ ⸬

The presence of the national museums and art galleries in Edinburgh serves to emphasize the relative poverty of the city's own art collection.

Apart from the numerous views of the city, most of which are of topographical interest only, the bulk of the collection concentrates on the late 19thC and early 20thC. These are the works purchased by a benevolent organization known as the Scottish Modern Arts Association, who presented a large number of paintings to the city in 1964. This group consists of six pictures by **William McTaggart**, including the lively seascape *Jovie's Neuk*; two by **J.Q. Pringle**; a good portrait of *James Pryde* by H.J. Gunn; and other works from the Glasgow School and the Scottish Colourists that are among the finest in the collection. Since 1961, the gallery has also had funds from a bequest to increase its stock, and from this has acquired a number of 20thC Scottish paintings, notably two good oils by **J.D. Fergusson** and several contemporary works. Nevertheless, the collection remains limited, and the four large galleries of the art center are usually either closed or taken up with various touring exhibitions.

The Fruitmarket Gallery
29 Market St
Tel. (031) 226-5781
Open Mon – Sat 10am – 5.30pm
Closed Sun
⊠ ▥ ▯ ▥ ⸬

Originally the site of the Edinburgh fruit market, and later converted into a complex of art galleries and workshops under the auspices of the Scottish Arts Council, this contemporary art gallery is now run by an independent organization. There is no permanent collection, but the gallery is committed to showing the finest of British and international contemporary art, which it does in a series of major exhibitions throughout the year.

National Gallery of Scotland ☆☆
The Mound, Princes St
Tel. (031) 556-8921
Open Mon–Sat 10am–5pm, Sun 2–5pm
⊡ 𝍖 ⟐ 🏛 ☑ ⠿

"The finest small picture gallery in Europe" is the unattributed quotation that the National Gallery of Scotland authorities use in their publicity; a claim that might invite dismissal but does contain considerable truth. For this gallery has collections large enough to offer a wide range of works from all the principal European schools, and yet is small enough not to exhaust the visitor with an array that cannot possibly be digested. More important, there is the added attraction of a number of truly outstanding works whose quality is only enhanced when seen in this setting.

The origins of the National Gallery lie in the Royal Institution or, more properly, the Institution for the Encouragement of the Fine Arts in Scotland, which by the 1820s had begun purchasing examples of the work of leading European artists. During the same period the Royal Scottish Academy was set up, and this too acquired paintings for study and exhibition. But there was generally felt to be some rivalry between the two organizations, especially since they shared the same impressive neo-classical building overlooking Princes Street. By 1850, the need for a new gallery was recognized and another imposing structure grew up immediately behind the first.

The National Gallery of Scotland was opened to the public in 1859 with the basis of its collection on display and since then it has steadily added to these paintings through purchases and bequests. It has also benefited greatly from extended loans, particularly from the Duke of Sutherland whose pictures include those by **Raphael**, **Titian**, **Rembrandt** and **Poussin**; in many respects the greatest pictures in the gallery. The collection has been greatly strengthened by several excellent post-war acquisitions such as paintings by **Velazquez**, **Saenredam**, **Elsheimer** and **Giulio Romano**.

The European paintings commence in **Room 7** (the opposite end of the building from the main entrance) and, altogether, there are 23 spacious galleries on three levels. Each room is devoted to a particular period or school.

Room 7 contains the early Italian works beginning with a selection of 13thC and 14thC domestic altarpieces and Lorenzo Monaco's *Madonna and Child* (c. 1420), which was also the central panel of a triptych. The most important 15thC work is the so-called *Ruskin Madonna* ★ by the Florentine master **Verrocchio**. Three works by **Raphael** hang alongside these paintings, two of which, *The Holy Family with a Palm Tree* ★ and the *Bridgewater Madonna* ★ are from the master's hand, although the latter has been badly altered. A similar *Madonna* by Raphael's principal assistant, **Giulio Romano** rounds off this Renaissance group.

Venetian pictures feature in the following room and are dominated by an excellent group of five paintings by **Titian** spanning the range of his career. The *Three Ages of Man* ★★ is an outstanding example of the lyrical romantic style introduced by Titian and Giorgione in the early years of the 16thC, while the two mythologies, *Diana and Actaeon* ★★ and *Diana and Callisto* ★★ (painted around 1560 for Philip II of Spain) belong to the artist's mature expressive manner.

The small **Room 9** is devoted to the two wings of an altarpiece painted by the Netherlandish artist, **Hugo van der Goes**. Known as the *Trinity Panels* ★ after the Edinburgh church where they originally hung, these large works depict James III of Scotland and his queen, Margaret of Denmark, with their patron saints on one side (the heads of the royal family were painted in by a local painter after the panels had arrived from Holland) and Sir Edward Bonkill, who commissioned the work in adoration of the Trinity on the other.

Of the Italian pictures in **Room 10** a dull *Deposition* by **Tintoretto** is easily overshadowed by a vivid *Adoration of the Magi* from the less well known Venetian **Jacopo Bassano**. Spanish pictures are introduced in the same room with three works by **El Greco**; *Fabula*, the most unusual, depicts two men and a monkey illuminated by the glow from an ember. Velazquez's *Old Woman Cooking Eggs* ★ of 1618 is an example of the "Bodegon" or kitchen scenes which the artist treated in his early career.

Room 11 with Northern pictures from the 16thC, has works by **Cranach**, **Holbein**, **Clouet** and **Gerard David** and a good *Portrait of a Man* ★ (c. 1520) by **Quentin Massys**. Flemish art of the 17thC follows on in the next room and includes work by **Terbrugghen** and **Rubens**, as well as a large group portrait of *The Lomellini Family* by **Van Dyck**. *Christ in the House of Martha and Mary* by **Vermeer** (c. 1655) is an unusual picture; it may be his earliest painting, as well as his only biblical subject.

Room 13 has a selection of pictures by artists who were active in 17thC Rome;

Poussin, Claude, Domenichino, Guido Reni and Paul Bril, but the most interesting and rare are the two paintings by the German-born artist Adam Elsheimer, *The Stoning of St Stephen* and *Il Contento* ★.

Room 14, up one flight of stairs, contains the Reserve Collection (generally on display) and Room 15, again on the ground floor, introduces a selection of the finest Scottish paintings from the 18th and 19thC. Ramsay's delicate portrait of *Mrs Bruce of Arnot* (c.1765) is followed by Raeburn's famous *Reverend Robert Walker Skating on Duddingston Loch*, ★ a picture which has no real parallel anywhere. Wilkie's successful genre scenes are also represented in *Pitlessie Fair*, painted in 1804 when the artist was only 19, and *The Letter of Introduction*, and there are other works by Dyce, Noel Paton, McCulloch and Guthrie.

The 17thC Dutch school is well-represented in Room 16 with landscapes by Ruisdael, van Goyen, Cuyp and Hobbema. The genre painters Terborch, De Hoogh, Both and Dou are included as is Pieter Saenredam's recently acquired masterpiece, *Interior of St Bavo's Church (Grote Kerk) at Haarlem* ★. Of the figurative painters there is Lievens' *Portrait of a Young Man* ★ (c.1630) and three interesting works (from five in the collection overall) by Rembrandt: the early *Young Woman with Flowers in her Hair* ★ (1634), a *Self-Portrait* ★ (1657) and the often disputed, but nonetheless moving *Woman in Bed* ★ (c.1645) – possibly a portrait of the artist's mistress.

Room 17 brings together various artists who worked in 18thC Rome such as Pompeo Batoni, Guardi, Gavin Hamilton, Goya and Alan Ramsay. This disparate group suggests something of the diversity of the 18thC, as do the remaining pictures of particular note. Bernardo Bellotto's view of *The Ponte delle Navi, Verona* ★ demonstrates the full potential of this type of painting while Tiepolo's flamboyant *Finding of Moses* is an elaborate and sophisticated pastiche of the great age of Venetian art in the 16thC. Raeburn's dramatic *Portrait of Col. Alastair Macdonnell of Glengarry* ★ (c.1811) introduces the highlights of the British school in the following room. Among southern portraits, Gainsborough's rather flashy *Hon. Mrs Graham* ★ stands out; his two landscapes provide an interesting preamble to the large *Dedham Vale* ★ (1828) by Constable. There is no work by Turner which can rival this powerful scene, but the latter's *Somer Hill* is a vivid portrait of a country house, and there are good

landscapes by Bonington, Cotman and Crome.

The French school between the 17th and 19thC, displayed in the five rooms on the first floor, opens with a series of pictures by Poussin which can readily be considered as the culmination of this artist's career. *The Seven Sacraments* ★★ were painted in 1644–8 for Fréart de Chantelou who wanted copies of an earlier set commissioned by the artist's friend, Cassiano dal Pozzo. Typically, Pousin redesigned the whole series to produce scenes which far surpass their models and place the Seven Sacraments in their historical context: ancient Rome, the source of the classical tradition, and the Christian church. Following this there are a number of French 18thC pictures including works by Boucher, Greuze, Pater and Lancret. Two very different pictures which are particularly notable are Chardin's *Vase of Flowers* ★★, the only surviving flower piece by this master of still-life and the *Fêtes Venitiennes* ★★, one of the finest of this unusual Rococo type which Watteau perfected. By comparison, the early 19thC pictures have little to offer, but the collection has a good group of mid-century naturalist works by artists such as Courbet, Corot, Boudin, Daubigny and Bastien-Lepage ★. All the principal Impressionists are represented by works of great quality; Degas' *Portrait of Diego Martelli* ★ (1879), Renoir's *La Promenade* (1870), Pissarro's *Kitchen Garden at the Hermitage, Pontoise* (1874) and Monet's *Poplars on the Epte* ★ (1890) are merely a few examples. Whatever the strength here however, the Post-Impressionist collection is even more remarkable. Pre-eminent among works by Cézanne, Seurat, Van Gogh, Bonnard and Vuillard is a group of three pictures by Gauguin including the exotic *Martinique Landscape* ★ of 1887 and the seminal *Vision after the Sermon* ★★ of the following year. Considering the paucity of French works in British collections this is certainly one of the most important in the country.

The National Gallery of Scotland, not surprisingly, also houses the principal collection of Scottish art, and this is displayed in Rooms 1 to 5, part of the new wing in the basement of the gallery. The 18th and early 19thC paintings are the main strengths of this collection and there are works by all the leading figures of the Scottish school such as Ramsay, Raeburn, David Allan, Wilkie, William Dyce, Rev John Thomson, David Scott, Noel Paton, John Philip, Orchardson, Pettie and Guthrie. One artist worth singling out for particular attention

however is **William McTaggart**. His loose, atmospheric seascapes find their nearest parallel in the work of Monet, although his palette and handling remained true to his experience of the Scottish coast.

Finally, the new extension on the lower floor also has a **prints** and **drawings gallery** in which items from the main collection can be displayed. The range of this collection is too large to indicate briefly, spanning as it does most periods and schools, but it is worth mentioning that the Vaughan Bequest of watercolours by **J.M.W. Turner** is exhibited in January of each year when the light is weakest; a precaution which has ensured the survival of the artist's brilliant colour.

The Royal Scottish Museum ☆
Chambers St
Tel (031) 225-7534
Open Mon–Sat 10am–5pm, Sun 2–5pm
☒ ☜ ☗ ☎ ✓ ☷

In contrast to its dull façade, the interior of the Royal Scottish Museum is one of the finest surviving examples of High Victorian design: a celebration of 19thC industrial technology deploying cast iron columns in a light soaring structure reminiscent of a Gothic cathedral. The building houses the national collections of Ethnography, Natural Sciences and Technology – much of it therefore outside the scope of this guide – but it also has a collection of sculpture and decorative arts drawn from various parts of the world.

Oriental sculpture is displayed in the powerful setting of the main hall. Here, amid exotic plants and ponds full of goldfish, there is a voluptuous sandstone figure of **Surasundari ★** from 11thC India and an 18thC **Japanese Temple Lantern** in bronze. There are also works in stone, wood and bronze from most of the eastern civilizations and a number of seated Buddha figures, including two immense bronzes from 18thC Japan.

The rest of the ground floor is devoted to Technology, Evolution, Birds and Mammals (as is much of the first floor), but the balcony surrounding the main hall contains **Classical**, **Byzantine** and **Medieval sculpture** and **decorative arts**. The small Classical section has no more than a few cases, but these contain several interesting pieces such as the Hellenistic bronze figure of **Poseidon**, c. 200BC, and a striking 2ndC Roman **Portrait Head ★**. You should also look for the Greek vases, particularly a black-figure lekythos by the so-called **Edinburgh Painter**, and an attractive mummy portrait of **A Young Woman**

from Roman Egypt. The Medieval section has several ecclesiastical treasures such as reliquaries, monstrances, enamels and alabasters, but the most impressive works are the 15th–18thC **German wood sculptures**, including a number of individual figures in limewood.

There is a large amount of British and European silverware from the 16th–18thC on the opposite balcony and, leading off from this, a very good costume and textile display. You then reach the Egyptian department, where a large part of the display is educational, with models and reconstructions, but there is also a fair selection of **decorated mummy cases**, **funerary items**, **jewellery** and **sculpture** including a **Bronze Head** from Aegis, which was once the prow of a sacred boat (c. 400BC), and an attractive limestone relief of **Nectanebo II**, the last native pharaoh who was driven out of Egypt by the Persians in 341BC.

The Oriental department on the second floor has a Burmese **Standing Buddha** at one end and a glazed earthenware **Statue of Wei-t-o** from China (c. 1600) at the other. Following the circuit of the balcony between these two pieces you will see examples of the ceramics and metalwork of the various ancient cultures including China, Japan, Korea, Indonesia, Cambodia, Tibet, Persia and Turkey. Leading off this area there is also an international survey of pottery and porcelain spanning the 3,500 years between the **Minoan civilization** and the studio potters of the **early 20thC**.

On the same floor, but to the W of the main hall, the Ethnography section has some interesting and attractive items, most of which are drawn from tribal Africa, North America and the Pacific. The most striking piece is the red and yellow **feather cloak** of a Hawaiian chief, but there are carved clubs and paddles from the Marquesas, various masks and fetishes from Africa and a small but very good group of bronzes from **Benin**.

Scottish National Gallery of Modern Art ☆
Belford Rd
Tel. (031) 332-0227
Open Mon–Sat 10am–5pm, Sun 2–5pm
☒ ☜ ☗ ✓ ☙ ☷

The gallery was opened in 1960 at Inverleith House, an 18thC building in the Botanical Gardens. From the beginning this was intended as no more than a temporary lodging because the rooms were relatively small and unsuitable for much contemporary art. However, 24 years elapsed before new and more appropriate accommodation was found. The new building in the

remodelled John Watson's School is much larger and more spacious, with 12 galleries on two floors.

The need for more space was particularly pressing because the collection has grown from its initial small group of Scottish and European pictures to its present size of almost 3,000 pieces, some of which are particularly notable. The aim from the beginning was to acquire a representative selection of the finest and most important 20thC art and, although this cannot quite be claimed for the present collection, all the major movements are represented – often by works of reasonable quality.

German Expressionists are amongst the most notable, with good pictures by **Kirchner**, **Nolde** and **Jawlensky**, as well as an interesting precursor in Hodler's *Lake Thun* of 1910. There are also some interesting Russian works by **Larionov**, **Goncharova** and **Popova**. Of the early 20thC artists working in France you will see pictures by **Matisse** and **Derain**, Cubist *Still-Lifes* by Braque and Picasso, and a good *Woman and Still-Life* of 1921 by Léger. Surrealist works include Magritte's *Black Flag*, Ernst's *Great Lover* and Giacometti's bronze *Woman with her Throat Cut*.

The gallery has found it difficult to obtain good American pictures of the post-war period (Lichtenstein's *In the Car* being the exception), but there is a range of good British paintings and sculpture, from Wyndham Lewis' *The Reading of Ovid (Tyros)* to Kitaj's *If Not, Not* and Richard Long's *Stone Line*.

As you might expect, the gallery maintains a commitment to modern Scottish painting, in which it has the most comprehensive collection. Outstanding among the earlier works is *Loch Katrine* ★ Lavery's study of his wife painting out-doors under a parasol. Among living artists Ian Hamilton Finlay's *Et in Arcadia Ego*, a poetic analogy between the classical tradition in art and the military imagery of the 20thC, should not be missed.

The Scottish National Museum of Antiquities
Queen St
Tel. (031) 556-8921
Open Mon–Sat 10am–5pm, Sun 2–5pm
🔲 💷 🏛

The Scottish National Museum of Antiquities is primarily an archaeological museum with exhibits which deal more with everyday life than the fine or decorative arts of earlier cultures. There are, however, some items of interest such as the fragments of **Roman monuments**

and **armour**, the **Celtic and Norse crafts** (mainly metalwork and jewellery) and the **Pictish carvings**. The historical gallery on the ground floor also has a small **textile** and **costume** display.

Scottish National Portrait Gallery
Queen St
Tel. (031) 556-8921
Open Mon–Sat 10am–5pm, Sun 2–5pm
🔲 💷 🏛 🔅

The Scottish National Portrait Gallery and the NATIONAL MUSEUM OF ANTIQUITIES both share the same building, a grandiose Victorian version of a Venetian Gothic Palazzo that is far from ideal for either institution. The position is further aggravated by the general inflexibility of the layout, with the result that, despite the decorative scheme of historical murals in the entrance hall, the interior as a whole is uncongenial and dull. The portrait gallery has made a considerable, if not completely successful, effort to improve this lack of intimacy by installing screens, and a major programme of renovation has recently begun which will surely improve matters.

Since the principal purpose of a portrait gallery is to record the appearance of famous people from various walks of life, it often happens that the quality of the painting is of secondary importance. The Scottish National Portrait Gallery is unusual in this respect, for many good pictures have found their way into the collection, either by accident or design, making a visit to the gallery more than just a jaunt through Scottish history and folklore.

Of the royal and aristocratic portraits, look for the pair by Lely of *James II* and his wife the *Duchess of York*; *Lord Darnley*, second husband of Mary Queen of Scots by Eworth; *James VI and I* by Bronckhorst; and *Robert Kerr, 1st Earl of Ancram* by Jan Lievens. But the finest pictures in the gallery are Dobson's allegory of military greatness depicting *Charles II* ★ as a boy, and Gainsborough's glittering portrait of *John Campbell, Duke of Argyll* ★ in his robes of office. The Jacobite section has appropriately bland depictions of a largely unlikeable group of figures, but the portrait of *Flora McDonald*, the woman who came to the Young Pretender's aid after his defeat at Culloden, is an interesting early work by **Richard Wilson**. Other works in this section are of interest for their gruesome subjects. An *Anamorphic Portrait of a Woman*, often thought to be Mary Queen of Scots, juxtaposes her face with a skull, and *The Execution of Charles I* by Weesop, subtitled "an Eye Witness",

records the details of the event right down to the mourners' dipping of handkerchiefs in the blood.

Most of the notable Scottish writers and politicians are represented, including Burns, Scott, Stevenson, Gladstone and Earl Haig and again there are a few particularly interesting works. **Lavery's** fitting portrait of a wasted *James Maxton MP* is unlike his normal refined manner, while **Ramsay's** portrait of his friend *David Hume* is typical of the artist's sensitive later style. Nicholson's *James Barrie* and Alexander Moffat's bleak *Norman McCaig* are also notable.

Expressive portraits such as these are more common among artists, and there is a special display mainly of self-portraits on the stairway including works by **Medina**, **Allan**, **Runciman**, **McTaggart**, **Peploe** and **Duncan Grant**.

The second floor gallery has the studies for James Guthrie's large group portrait, *Some Statesmen of the Great War* and a selection of portraits depicting the Scottish intelligentsia of the 18thC. Paintings by **Raeburn**, **Ramsay**, **Reynolds** and **Romney** are the most important here, and Raeburn's earthy portrayal of *Neil Gow*, the blind fiddler, is probably the finest.

In recent years the Portrait Gallery has been collecting early examples of photography, an area where the Scots were particularly active. **Hill** and **Adamson**, two of the great pioneers, and a number of others are well represented.

The Talbot Rice Arts Centre
Old College, South Bridge
Tel. (031) 667-1011
Open Mon – Sat 10am – 5pm
Closed Sun
▨ ▢ ⋒ ⫶⫶
The Talbot Rice Arts Centre is the main art gallery of the University of Edinburgh, holding part of the University's collection of painting and sculpture, but, unfortunately, it does not compare favourably with its counterpart in GLASGOW (the Hunterian). The gallery is housed in the Old Quadrangle designed by **Robert Adam** and later modified by **William Playfair**, but its striking architectural setting proves too powerful for the paintings within the impressive Neoclassical interior.

Most of the pictures on display come from the Torrie collection of mainly Italian and Dutch works from the 17thC. The Dutch pictures are the finer with a landscape by **Pynacker**, a shipping scene by **van de Velde** and a group of *Bowlers* by **Teniers** being the most interesting. There is also a good self-portrait, *The Blue Shirt*, by the 20thC Scottish painter

James Cowie painted near the end of his life.

Beyond the Playfair Room there is a large modern gallery which displays temporary exhibitions throughout most of the year.

FALKLAND PALACE
Fife Map D4

Tel. (03375) 397
Open Apr – Oct Mon – Sat 10am – 6pm,
 Sun 2 – 6pm
Closed Nov – Mar
▨ ⋒ ⫯
Falkland Palace in Fife was begun in the 16thC by James IV more as a royal residence than a state palace. Built in the Renaissance style favoured by the cultured interests of the court, the architect **James Hamilton**, the king's cousin, used several French craftsmen on the building. Much of the palace was burnt down by Cromwell's troops in 1654 but the surviving parts have been restored.

Only two rooms are furnished and open to the public; the **chapel** with its **painted ceiling** decoration from the 17thC and the reconstructed **King's Bedchamber**, complete with the 17thC so-called "Golden Bed of Brahan" and a number of Flemish **tapestries**. There is also a 16thC Venetian painting of *The Marriage of St Catherine*. The principal attraction of the palace, however, are the gardens which have a strong period flavour and include the ancient Royal Tennis Court.

FORFAR
Tayside Map D3

To all Scots the name of Forfar is synonymous with the popular meat pie known as a "bridie". A visit to this town can be recommended to those who wish to savour this Scottish delicacy.

Forfar Museum and Art Gallery
Public Library Meffan Institute, High St
Tel. (0307) 65101
Open by arrangement Mon – Wed Fri
 9am – 7pm; Thurs Sat 9am – 5pm
Closed Sun
▨ ⫰
The impressively named Forfar Museum and Art Gallery is in fact just a small room cluttered with uninteresting miscellanea above the town library (from where the key to the place should be collected). Unfortunately the museum does not have the space to show its collection of works by the late 19thC

artist, **J.W. Herald**. Herald, who was born in Forfar and lived in nearby Montrose, was an evocative painter of urban landscapes and interiors, who deserves greater recognition.

GLASGOW
Strathclyde Map C4

Once known as the "Second City of Empire" Glasgow's expansion to this role was very sudden, for it grew from a modest town into an industrial metropolis in little more than the last quarter of the 19thC. The city is therefore predominantly Victorian, with typically grandiose and pretentious buildings, although the steady erosion of its heavy industries and wealth has left some areas with a starkness and monumentality that many people describe as "character".

In matters concerning the arts Glasgow was overshadowed by Edinburgh until the late 19thC, when the city's dramatic economic prosperity was reflected in a corresponding interest in painting, architecture and design. Between 1880 and 1914 it is fair to say that Glasgow became one of the liveliest artistic centers in Europe.

The Burrell Collection ☆
2060 Pollokshaws Rd, Pollok Country Park
Tel. (041) 649-7151
Open Mon–Sat 10am–5pm, Sun 2–5pm
🖼 🚗 🏛 🅿 🏧 ☑ ♿

The Burrell Collection is a highly unusual phenomenon among modern British collections. Burrell created his enormous fortune from ships, selling the last of his fleets to the British government during World War I at an immense profit. Thereafter he devoted the rest of his life to collecting paintings, sculpture, ceramics, tapestries and oriental antiquities. At first he seems merely to have followed his own interests which needed no specific direction. By the 1930s, however, he began to plan for the whole collection to be brought together in a museum, and therefore sought to round it off, giving the collection a range and scale substantial enough to achieve this object. In 1944, the whole collection (some 8,000 items) was presented to the City of Glasgow on the understanding that a suitable building would be found to house it.

The collection's reputation increased over the years while it lay in secret storage, acquiring a near legendary status before it had even been seen in public. Then at last, in 1983, after years of deliberation, the Burrell Collection was

opened in its new custom-built gallery in Pollok Country Park to the S of the city.

With such preparations, it is especially pleasing to see that the new gallery is a success in almost every respect. The building strikes an unusual balance between modern and traditional design; particularly relevant in this case because several of the most important pieces are medieval architectural fragments such as the two **16thC portals** from Hornby Castle which are incorporated into the structure. Furthermore, the nature of the objects required that novel display techniques had to be used for everything to be seen properly, as well as protected. This is most notable in the first corridor to the right, where **stained glass** has been hung on frames against the exterior windows, allowing the works to be seen through natural light.

The main part of the museum leads off a large central courtyard in which there are sculptures by Rodin, notably *The Age of Bronze*, and the large **Warwick Vase ★**, a Roman ceremonial urn in marble dating from the 2ndC. Proceeding through the **Hornby Castle portal ★** you first encounter the Egyptian section, containing a late period basalt *Head of a Goddess* and a case for a mummified ibis. Following this the classical antiquities include a number of **Attic vases** and **sculpture fragments** as well as an interesting 6thC BC **Corinthian bronze helmet** before you enter the **Oriental section**, one of the largest areas in the collection overall. Burrell bought widely in the field of Eastern arts and crafts, with the result that the display contains a large amount of ceramics, prints, jade, bronzes, carpets, textiles and sculptures. The Chinese works, for example, include **porcelain** from most dynasties, ancient **funerary bronzes**, a number of **earthenware figures** such as the lifesized seated figure of a *Lohan* ★ from the Ming dynasty, **tiles**, **carved jade pieces** and some **arms** and **armour**, and there are equivalent selections of **Japanese**, **Persian** and **Turkish treasures**.

The **medieval section** is the other area of great strength and diversity within the collection. Ceramics, tapestries, ecclesiastical treasures, metalwork, silverware, stained glass, sculpture in stone and wood, misericords, ivories, alabasters and enamels are all on display and in some cases, particularly the 15thC German tapestry, *The Pursuit of Fidelity* ★ or the 12thC *Prophet Jeremiah* ★ window from St-Denis, the pieces are of outstanding quality.

Following this main gallery through its constantly traversing passages you

eventually reach the painting collection, which begins with a series of late medieval and early Renaissance panels such as Memling's *Virgin of the Annunciation* (c.1465), Veneziano's *Judgment of Paris*, Bellini's *Madonna and Child* and Cranach's unusual *Stag Hunt* of 1529. The second group consists predominantly of French paintings of the 18th and 19thC, beginning with a *Still Life* by Chardin, although the bulk of the works date from the later 19thC. Apart from the pictures by **Géricault, Delacroix, Daubigny, Boudin, Courbet, Daumier** and **Millet**, you should not miss Manet's *The Ham* ★, Cézanne's *Château at Medan* ★ and Degas' *The Rehearsal* ★★ for particular enjoyment; the last-mentioned being perhaps Degas' finest painting in Britain. The succeeding room has a number of **prints** and **drawings** on display, as well as some **paintings** by 19thC Dutch artists of the Hague School, but the painting collection also occupies the **Period Rooms** running parallel to the

main picture gallery, which attempt to combine various items of furniture and decoration from a particular period. The Elizabethan Room, for example, has a tapestry, an elaborately carved fireplace, the **Kimberley Throne** and a good, stern portrait of **William Cecil, Lord Burghley** by Gheeraerts, while the 17thC–18thC Room is dominated by portraits: a *Self-Portrait* ★ by Rembrandt, *Jacob Trip* by Nicolaes Maes, a rather poor *Mrs Ann Lloyd* by Hogarth, and a sensitive *Miss McCartney* by Raeburn.

The final three rooms are reconstructions of the interior of Burrell's own house at Hutton Castle near Berwick-on-Tweed, which give you an idea of the way in which he laid out his treasures. In comparison with the main collection itself, these are relatively uninteresting, but if you have not already seen enough there is a small reserve collection of four rooms on the first floor which have more classical, oriental and medieval pieces on display.

The Burrell Collection contains many magnificent works of art, of which the following is a selection:
1 *The Hornby Castle Portal*, Anon., 16thC
2 *The Warwick Vase*, Anon., 2nd C AD

3 *A Lohan*, Anon., 1485
4 *The Prophet Jeremiah*, Anon., mid 12thC
5 *The Pursuit of Fidelity*, Anon., c.1475–1500
6 *Portrait of the Artist,* Rembrandt van Rijn, 1632
7 *Chateau of Médan*, P. Cezanne, 1880
8 *The Rehearsal*, H.G.E. Degas, 1877(?)
9 *The Ham*, E. Manet, c.1880

The Glasgow style

The unprecedented flowering of the arts and crafts in Glasgow during the last two decades of the 19thC is a phenomenon that has defied any simple explanation. Glasgow was certainly then an expanding city, indeed one of the powerhouses of the British Empire, but so were Manchester, Liverpool and Birmingham, where there was no equivalent reaction in the visual arts. Furthermore, Glasgow had only shown a faltering interest in the arts up to that time. This attitude was probably to the advantage of younger Scottish artists like Lavery, Guthrie, Walton and Roche, who were able to adopt a more eclectic and wide-ranging approach than a traditional environment would perhaps have allowed. Lavery, for example, had trained in Paris as well as in London, and during trips to artists' colonies like Grez and Barbizon he had seen the more naturalistic art of Bastien-Lepage and his contemporaries. In fact almost all of the young painters, the so-called "Glasgow Boys" who met in the early 1880s at W.Y. Macgregor's studio in Bath Street, had at least travelled to the Continent.

The Glasgow Boys were equally admiring of Whistler's work, and it was partly as a result of their campaign that Whistler's portrait of Carlyle, **Arrangement in Grey and Black II**, was purchased for the city (the first of this artist's pictures to enter a public collection). Many of the younger painters took to Whistler's *Japonisme*, and both George Henry and E.A. Hornel actually visited Japan in 1893, producing a series of vivid pictures.

MACKINTOSH *and his* CIRCLE

In 1890 the young architect and designer Charles Rennie Mackintosh received his first commission to design a house in Glasgow's Springburn district. Hardly an important monument in itself, this house nevertheless marks the beginning of an immense outpouring of architectural designs, interiors, furniture, graphics, jewellery and metalwork over the next 20 years. Mackintosh's career reached an early climax in 1897 when he won the competition for the new Glasgow School of Art overlooking Sauchiehall Street. His designs were strikingly original, combining the languid decorative motifs of Art Nouveau and the solid rectilinear masses of the emerging modern movement. This must be considered as perhaps the most significant building of its period anywhere, and not since the time of Vanbrugh had an architect established the nature of his personality so quickly. At the same time Mackintosh designed a series of tearooms throughout the city for a Miss Cranston, public buildings such as the Martyr's Public School, and a series of houses, the finest of which are Hill House in Helensburgh and his own residence at Southpark Avenue (now reconstructed in the Hunterian Art Gallery, Glasgow). These perfectly illustrate the simplicity of his work and the harmony of each room with its contents – qualities which appealed in particular to the designers of the so-called Vienna Secession.

But Mackintosh was not alone; apart from his immediate circle (known collectively as The Four) other architect designers such as E.A. Taylor and George Walton were active in much the same field, although none came close to the elegance and clarity that characterizes Mackintosh's work. Among a number of decorative designers trained in Glasgow at this time, only Jessie M. King achieved anything like his sophistication.

Few could approach the remarkable originality and assurance of Mackintosh, but even he could not maintain this level for long. He nonetheless recognized the requirements necessary even in the most lighthearted designs, as he recorded in a famous inscription of 1901: "There is hope in honest error, none in the icy perfections of the mere stylist."

THE·THREW·HER·WET·HAIR·BACKWARD·FROM·HER·BROW

Jessie M. King, **Illustration** *to* **The Defence of Guinevere**, *William Morris (Hunterian Gallery, Glasgow)*

C. R. Mackintosh, (below) **Bedroom** *(reconstruction), Hunterian Gallery, Glasgow: (bottom)* **Glasgow School of Art**

Glasgow City Art Gallery and Museum ☆
Kelvingrove
Tel. (041) 334-1134
Open Mon – Sat 10am – 5pm, Sun 2 – 5pm
🖾 ⚫ 🏛 🔲 ☑ ♿ ⬚

The elaborate sandstone building of Glasgow Art Gallery and Museum, situated at the edge of Kelvingrove Park, is a typical product of that combination of civic pride and cultural improvement which gripped many of the major industrial cities at the end of the last century. This institution was opened in 1902, the year after Queen Victoria's death, and like many others the collection was intended to be comprehensive, covering a wide range of interests. Accordingly, the ground floor galleries deal with such varied subjects as geology, wildlife, history and archaeology, and there are some impressive items such as the **Chinese and Japanese armour** in the Oriental and Ethnography Room. The first floor is devoted to the fine and decorative arts, and the area around the central hall and organ displays selected items from the collection of western European **ceramics, glass, silver, jewellery** and **furniture**. In one corner there is a special display of the work of **Charles Rennie Mackintosh** and his associates, **Herbert McNair** and the sisters **Margaret** and **Frances Macdonald**, otherwise known as "The Four". The rest of the first floor is taken up by the painting galleries, split into two sections: British one side and European the other.

The European paintings open with the Italian School between the 15th and 18thC, with works by **Bellini, Pesellino, Correggio, Domenichino** and **Guardi**. The most notable are a well-preserved tondo of *The Madonna, Child and St John with Angels* by Filippino Lippi, a much disputed painting attributed to Giorgione of *The Adulteress Brought Before Christ* and three very good and typically wild landscape settings by **Salvator Rosa**. There is also an unusual depiction of *Salome with the Head of John the Baptist* by Carlo Dolci which has a portrait-like observation of the dancer's features and, from a small group of Spanish works, a powerful *St Peter Repentant* by Ribera.

In the Flemish room the finest work is actually French, *St Maurice and a Donor* ★ by the Master of Moulins, and there are works by **Rubens** and **Van Dyck** before you reach the Dutch school, the strongest area in the collection overall. Many of the leading 17thC landscape, still-life and genre painters, including **Cuyp, van Goyen, Hobbema, van de Velde, Ostade** and **Kalf**, are represented

in this room, and from this impressive selection two landscapes by **Ruisdael** ★ and two works by Rembrandt (*The Flayed Ox* and *The Man in Armour* ★) stand out for particular attention. As an example of later Dutch art there are a few pictures nearby from the late 19thC Hague School specializing in naturalistic renderings of landscape similar to contemporary French art.

The two French rooms following this, span the period between the 17th and 20thC, beginning with Simon Vouet's allegory of *The Four Seasons*, but it is not until the mid 19thC that there is any great strength. Thereafter you will see works by **Delacroix, Courbet, Boudin, Fantin-Latour** and **Le Sidaner** as well as the principal Impressionists and Post-Impressionists. Millet's *Going to Work* ★ and two paintings by Pissarro, the early *Tow Path* (1864) and the late *Tuileries* (1901) are very good, but Van Gogh's portrait of the Glasgow art dealer *Alexander Reid* ★ is the most memorable. The 20thC pictures on display are also concentrated in the early decades with Derain's view of the Thames, *Blackfriars* ★ (1906), being the finest of a group of Fauvist works. The most famous picture, however, Salvador Dali's slick *Christ of St John of the Cross*, hangs on its own in the corridor beside the area used for temporary print and drawing exhibitions.

The British collection on the opposite side of the building covers the period between the 17th and 20thC and has a strong Scottish flavour. Gallery I, for example, has good portraits by **Ramsay** and **Raeburn**, as well as a conversation piece attributed to **Zoffany** and several interesting landscapes such as *The First Steamboat on the Clyde* by the Glasgow artist John Knox. Gallery II, covering the 19thC, has works by **Turner, Constable** and the **Pre-Raphaelites** as well as several Scottish artists (**Dyce, McTaggart** and **Noel Paton**). Gallery III has a selection of pictures by contemporary artists, while Gallery IV concentrates on the principal figures of the late 19th and early 20thC. The "Glasgow School" and the "Colourists" are well represented but it is perhaps worth singling out the work of **George Henry** whose collaborative pictures with E.A. Hornel, *The Druids* and *The Star of the East*, are both on display, as are several other paintings such as the ambitious *Galloway Landscape* ★ (1889) and the *Japanese Lady with a Fan*. A number of the artists included in this room took their lead from Whistler, so it is appropriate that his magisterial and well-observed *Portrait of Thomas Carlyle: Arrangement in Grey*

and Black No.2 ★ should be given pride of place at the end of the outer corridor where its muted tones can be properly appreciated.

Hunterian Art Gallery ☆
University of Glasgow
82 Hillhead St
Tel. (041) 339-885 ext. 7431
Open Mon–Fri 10am–5pm, Sat
 9.30am–1pm
Closed Sun
📷 🎒 (for Mackintosh House)
🗺 ⛪ ☑ ⫶⫶⫶ 🍴

Opened in 1980 in an appropriately flexible building, the new Hunterian Art Gallery brings together for the first time the considerable collection of paintings, sculpture and prints belonging to the University of Glasgow. The nucleus of the collection was the bequest of William Hunter, a former student of the university and a famous physician who worked as a teacher of anatomy in the Royal Academy in London. This association no doubt encouraged his interest in art and he was able to assemble a good collection of 17thC paintings, the most important of which are Rembrandt's small **Entombment**, Rubens' *Head of an Old Man* and a large **landscape** by the Dutch artist Philips de Koninck. Hunter also acquired paintings of his own time, notably the three works by Chardin, *The Scullery Maid*, *The Cellar Boy* and *A Lady Taking Tea* ★ and he commissioned a good portrait of himself from **Alan Ramsay**. His classes in the Royal Academy brought him into contact with **George Stubbs**, an artist with a particular interest in anatomy, who painted the three studies of wild and exotic animals, *The Nylghau*, *The Moose* and *The Blackbuck*. Around this important bequest the university has been able to gather a number of other English 18thC–20thC works, including portraits by **Hudson**, **Reynolds**, **Romney**, **Raeburn** and **Lawrence**, as well as a view of *Ladye Place* by **Turner**.

The second principal area at the Hunterian is the **Whistler collection** ★ of paintings, drawings, pastels, prints, furniture and ceramics, indeed the complete contents of the artist's studio, which were bequeathed to the university by his sister-in-law, Miss Rosalind Birnie Philip. Whistler had several links with Glasgow, the city museum being the first public gallery to purchase one of his works; and in 1903, when he was still largely outside the British art establishment, the University of Glasgow conferred on him an honorary degree. It is fitting, therefore, that the university should possess the largest collection of Whistler material anywhere, including 80 of his oil paintings covering such areas as portraiture, townscapes, evening scenes (known as **Nocturnes**) and several unfinished "Harmonies" and "Arrangements", many of which are on permanent display. There is also a cabinet designed by **E.W. Godwin** which Whistler decorated for the Paris Universal Exhibition of 1878, and a screen entitled *Blue and Silver* depicting one of his most effective motifs, the Old Battersea Bridge.

The university also possesses the largest collection of furniture, drawings and objets d'art by the Scottish architect and designer, **Charles Rennie Mackintosh** ★. You can see this in a separate wing from the main gallery, designed to reconstitute several complete rooms and thereby set off much of the architect's own furniture in the integrated settings for which they were conceived.

With such strengths in those three areas it is to the credit of the university that it has continued to expand the collection. The Hunterian has several good French late 19thC pictures by artists such as **Pissarro**, **Boudin**, **Corot** and **Fantin-Latour**, and also maintains a commitment to Scottish art of the 19th–20thC. It is perhaps an indication of the gallery's status that such modern artists as **Richard Hamilton**, **R.B. Kitaj** and **Bridget Riley** have donated works to the collection, thus reflecting favourably on the progressive policy overall. To mark the opening of the new gallery, the large metal doors which form the entrance to the main part of the collection were commissioned from the sculptor, **Eduardo Paolozzi**.

Finally, mention must be made of the Hunterian **print collection** ★ which is the largest in Scotland, and one of the largest and most comprehensive in Britain. Beginning with the classic early works of **Schongauer** and **Mantegna** and continually expanding to take in recent contemporary works, the collection is particularly rich in **Italian prints** of the 16thC and 17thC, and has a number of exceptional items such as the only print made by **Pieter Breugel the Elder**. These are displayed in a series of changing exhibitions in the print gallery on the first floor.

Pollok House
2060 Pollokshaws Rd
Tel. (041) 632-0274
Open Mon–Sat 10am–5pm, Sun 2–5pm
📷 🚗 🗺 🅿 ⛪ ♿

With the opening of the Burrell Collection in the Pollok estate more

people will almost certainly visit Pollok House than was ever the case before. Pollok House remains a furnished 18thC house which, considering its scale, has a modest interior of mainly small rooms. Its most remarkable feature is the collection of paintings assembled by Sir William Stirling-Maxwell, whose early taste for Spanish art led to the acquisition of works by **El Greco**, **Murillo**, **Alonso Cano**, **Alonso Sanchez Coello** and **Goya**. El Greco's *Woman in a Fur Wrap* ★, often thought to depict the artist's mistress, is the most important picture, but Murillo's *Madonna and Child with St John – "La Serrana"* is notable, as are several portraits by Sanchez Coello. The rest of the collection is diverse, including works by such artists as **Jan Both**, **Gaspard Dughet**, **A.R. Mengs**, **Hogarth** and **Nasmyth**, as well as a curious group of paintings by **William Blake**, executed in a tempera technique.

GLENKILN
Shawhead, nr. Dumfries, Dumfries and Galloway Map C6

On privately owned land, but visible from the tiny road that passes through this bleak stretch of countryside, stands Henry Moore's celebrated sculptural group, *The King and Queen* ★. Nearer the road are to be found other important sculptures, including – very appropriately for the setting – Rodin's *St John the Baptist Preaching in the Wilderness*.

GREENOCK
Strathclyde Map B4

Situated on the Clyde next to the port of Glasgow, Greenock is an important ship-building town. It is not an attractive place, with bleak moorland behind, industrial pollution above and an all-pervading atmosphere of Victorian gloom.

The McLean Museum
9 Union St, West End
Tel. (0475) 23741
Open Mon–Fri 10am–5pm, Sat 10am–1pm, 2–5pm
Closed Sun

The main body of The McLean Museum and Art Gallery was built in 1876 and houses a rather dingy and neglected collection of objects of local interest, relating particularly to Greenock's greatest son, the steam-engine pioneer, James Watt. The art gallery is housed in a modern addition to this building

constructed in 1958. It owes its remarkably good collection of paintings and watercolours to a 1917 bequest made by Stuart Anderson Caird, a local shipowner who was also the brother of the Principal and Vice-Chancellor of Glasgow University. Caird left both his own collection and a sum of money to the museum to set up a trust fund to purchase other works of art. The holdings of this gallery are of consistently high quality and there is a most informative catalogue. The landscape painting tentatively labelled Claude Lorrain may be a most optimistic attribution; but there are many genuine surprises to be had, such as the oil sketch by **Corot**, the Bordeaux scene by **Boudin** and a portrait by **Lord Leighton** of his daughter, Yasmeenah. But above all, there is the rich and varied collection of 19th and 20thC Scottish art, with such artists represented as **Paton**, **Orchardson**, **Guthrie**, **W.H. Hornel**, **Gillies**, **Melville**, **Russel Flint** and **Anne Redpath**. Particularly good are McTaggart's *The Wind Among the Grass* ★ and F.C. Cadell's luscious still-life, *Crême de Menthe* ★.

HADDO HOUSE ⌂
Nr. Methlick, Grampian Map D2

Tel. (06515) 440
Open May–Sept Mon–Sun 2–6pm
Closed Oct–Apr

The paintings and furniture at Haddo House are very closely linked to the Gordon family, who from the 18thC have held the title of Earl of Aberdeen as well as Lord Haddo. The 2nd Earl had both political and theatrical ambitions, and acquired a number of portraits of eminent public figures as well as a portrait of the actor *Kemble* by **Lawrence**. His own **portrait** by the same artist is a very striking work. In the drawing room you can see several pictures with a wider appeal, including some 17thC **Dutch landscapes** and a version of *David and Goliath* by the 17thC Roman painter **Domenichino**.

HILL OF TARVIT ⌂
Nr. Cupar, Fife Map D4

Open May–Sept Mon–Thurs Sat Sun 2–6pm.
Closed May–Sept Fri; Oct–Apr

The Hill of Tarvit marks the site of a small mansion built in 1696. In 1904 the

property was acquired by F. M. Sharp, who, needing more space to display his fine collection of paintings, furniture and porcelain, called in the distinguished Edwardian architect, **Sir Robert Lorimer**, to have a larger house built. Most guidebooks prefer to describe the present building misleadingly as a remodelled 17thC house rather than as a completely Edwardian structure. Yet the fact of its being Edwardian does not make the place less interesting: indeed, one of its great attractions is the excellent preservation of its Edwardian interior, even to the extent of having kept some of its old vacuum cleaners. Its other alluring features are its magnificent hilltop setting and small but choice collection of paintings. Many of the finest of these are in the ground floor library, and include a superlative late **Ramsay portrait** of a *Mrs Mure of Caldwell* ★, two portraits by **Raeburn**, and a good still-life by **Fantin-Latour**. Elsewhere in the house is another still-life by Latour, an interior genre scene by **Francis Wheatley** and a pleasant landscape convincingly attributed to **Salomon Ruisdael**.

INVERARAY CASTLE
Strathclyde Map B4

Tel. (0499) 2203
Open Apr–June, Sept–mid-Oct
Mon–Thurs, Sat 10am–1pm, 2–6pm,
Sun 2–6pm; July–Aug Mon–Sat
10am–6pm, Sun 2–6pm
Closed Fri Apr–June, Sept; mid-Oct–Mar
🐾 🚗 ♿ 🏨 🏛 ♿ 🚻

The small town of Inveraray is one of the most beautiful and most visited places in the W of Scotland; an excellently preserved 18thC town magnificently situated at the point where the River Aray meets Loch Fyne. Originally it occupied the site now taken by Inveraray Castle; but in the early 18thC the 3rd Duke of Argyll decided to relocate it to make way for a new castle, replacing the original 16thC building.

The castle, which is still the seat of the Argylls and thus of Scotland's largest clan, the Campbells, lies hidden from the town about one mile to the S. The wooded and mountainous site is most impressive, and the castle is one of the earliest examples in Britain of Gothic Revival architecture. However, the interior – which was entirely gutted in a disastrous fire in 1975 – is disappointing, having neither the attractions of a cosy family home nor of an interesting museum. The best of the largely indifferent pictures are the portraits by **Gainsborough, Pompeo Batoni**,

Reynolds, Ramsay, Hoppner and **Opie** (note in particular a picture by Opie showing the 6th Duke of Argyll as a boy sketching a piece of sculpture).

KILMARNOCK
Strathclyde Map C5

Kilmarnock is an architecturally undistinguished town known principally for its wide range of industries.

Dick Institute Museum and Art Gallery
Elmbank Avenue
Tel. (0563) 26401
Open May–Sept Mon, Tues, Thurs, Fri,
Sun 10am–8pm, Wed, Sat
10am–5pm; Oct–Apr 10am–5pm
📷 ✓

The Dick Institute is a large 19thC neo-classical building with a library and a number of well displayed collections devoted to such varied subjects as ethnology, archaeology and basket-hilted swords. It also houses, on the ground floor, a small gallery which shows a modest selection from the Institute's excellent painting collection. This collection includes important works by major Scottish artists such as **Raeburn** (a delightful portrait of *Mrs Menzies*), **D.Y. Cameron** and **Hornel**. The gallery's outstanding works are by two of the leading classical artists working in Britain in the late 19thC, **Sir Lawrence Alma-Tadema**, and **Lord Leighton**. The former is represented by the minutely detailed *An Audience with Agrippa* ★ and the latter by the large, erotic and slightly bizarre canvas entitled *Greek Girls Playing Ball* ★; this unusual composition shows two girls in contorted poses and diaphanous drapery against an expansive Greek landscape of sea and mountains. The gallery possesses one powerful, Picasso-inspired work (*Women in Ireland*) by **Robert Colquhoun** (1912–62), who was born in Kilmarnock and attended art school in the town. Colquhoun, and his inseparable companion **Robert MacBryde**, were in recent times regarded as two of Scotland's best-known artists, though their reputations may well have been enhanced by their notoriously unconventional private lives.

KIRKCALDY
Fife Map D4

Kirkcaldy, a sea port with few architectural features, is an industrial

town whose finest attributes are its views over the Firth of Forth and the extensive, well-kept parks bequeathed to the town by native industrialists. Its industrial boom in the last century was due principally to Michael Nairn, originally a weaver of ships' sails who later devised a floor cloth that came to be known as linoleum. Kirkcaldy still remains the linoleum capital of the world.

Kirkcaldy Museum and Art Gallery
War Memorial Grounds
Tel. (0592) 260732
Open Mon – Sat 11am – 5pm, Sun 2 – 5pm
🅿 🚗 🍴 ☑ ♿ ⌕ ♨

The Kirkcaldy Museum and Art Gallery, together with its surrounding garden, was built in the 1920s to commemorate those who fell in World War I; the benefactor was John Nairn of the linoleum family. The ground floor of this old-fashioned museum is crammed with items of local interest, including the very popular but tastelessly decorated local pottery known as **Wemyss Ware**. In contrast the painting collection, which is on the first floor, is one of the finest in Scotland. Most of the paintings were from the collection of John W. Blyth and were not acquired by the town until 1964. One of Blyth's great interests as a collector was the work of **Sickert** and his **Camden Town School** associates. There are six paintings by Sickert, most notably one from a well-known series of pictures of a naked woman on a bed with a rather bored-looking man beside her. The works in this series were originally called the **Camden Town Murder**, but this title was later changed to **What Shall We do for the Rent?** The main works by Sickert's circle are three paintings by **Harold Gilman** and four by **Spencer Gore**; of these Gore's **Gravel Pit** and **Garden** (which bears a certain resemblance to one of Monet's paintings of his garden at Giverny) are the most impressive. But undoubtedly the greatest strength of the collection are the **Scottish paintings**, which include examples of the work of all the well-known Scottish artists from **Raeburn** (who is represented by a fine portrait of *Sir James Stevenson Barnes*) up to recent figures such as **Joan Eardley** and **Anne Redpath**. Blyth particularly admired the works of the **Glasgow Boys** (a good example of which is George Henry's **Lady with the Goldfish ★**) and of **William McTaggart** and **Samuel Peploe**. McTaggart was one of the most original artists working in Britain in the late 19thC and the Kirkcaldy Gallery has the largest collection of his works (28 oils and three watercolours) to be seen outside Edinburgh. His remarkably bold and

innovative technique is seen at its best in the landscapes, **Broken Weather, Port Seaton ★** and *White Surf ★* which in their proto-abstract handling of paint and colour could almost be works by a recent artist. The least attractive aspect of McTaggart's art to present-day tastes is its sentimental incorporation of smiling and implausibly red-faced children, as in **Consider the Lilies**. Larger still than the group of McTaggart paintings in the gallery is that of the works of Samuel Peploe, who was one of the so-called Scottish colourists, and is considered as one of the main exponents of Post-Impressionism in Scotland. The size of the Peploe collection in Kirkcaldy is admittedly a mixed blessing. His countless still-lifes and views of Iona (his favourite part of Scotland) are sometimes pleasant when seen individually, but together begin to seem simply tired, academic and coldly coloured imitations of the work of Cezanne. Among the non-Scottish works in the gallery are **Adam and Eve Entertaining the Angel Gabriel** by the visionary Newcastle artist, **John Martin**, a fin-de-siècle fantasy, **Dolce Far Niente** by **Alfred Waterhouse**, and a beautifully simple silver-toned still-life by **Sir William Nicholson**, **Sheffield Plate**.

KIRKCUDBRIGHT
Dumfries and Galloway Map C6

Kirkcudbright (pronounced Kercoobree) is a quiet and beautiful old town at the head of the Dee Estuary. A number of its streets have not been widened or changed since the 17thC and 18thC. The town's picturesque qualities and unspoilt character contributed towards making it an important artists' colony towards the end of the 19thC. The most famous artists associated with the place were the Glasgow School painters **E. A. Hornel** (who lived here for much of his life) and **George Henry**. Other artists who worked here include the Art Nouveau illustrator **Jessica King** and her painter husband **E. A. Taylor**; a plaque to them at 46 High Street marks their former house, with its charming green gate in the style of Mackintosh, and tiny alley leading on to one of the many delightful courtyards and gardens backing on to the Dee. The town's artistic reputation was given added notoriety with the publication of Dorothy Sayers' *Five Red Herrings*, which deals with a murder in the artist's colony.

Broughton House
High St
Tel. (0557) 30437

*Open Apr – Sept Mon – Sat 11am – 1pm,
2 – 5pm; Oct – Apr Tues Thurs 2 – 5pm
Closed Sun Apr – Sept; Mon Wed Fri – Sun
Oct – Apr*

The fine 18thC Broughton House,
bought by the painter **E.A. Hornel** in
1901, is now a museum to him. Hornel
had lived in Kirkcudbright for much of
his childhood; and it was here, in 1883,
that he had met the painting companion
of his early years, George Henry. By the
time Hornel bought Broughton House,
he had achieved immense success as an
artist, but his work had also begun to
suffer a decline in quality. His later
paintings are endless variations of a
formula he had achieved earlier in his
career: prettily coloured, impasto-laden
and highly decorative canvases generally
featuring smiling girls. Japan had a great
influence on the style and subject matter
of his art; he paid an influential visit to
this country with Henry in 1893 – 4, and
went there again in later life in the course
of his various tours around Asia.
Although Hornel's paintings might not
be to everyone's taste, Broughton House
(which displays a large number of them,
including the large **Memories of
Mandalay**) is well worth a visit for its
pleasantly faded, old-fashioned
character. The artist's living quarters, full
of curious personal memorabilia, have
been well preserved, as has his studio,
which even features a waxwork model of
the artist at work on one of Hornel's
incomplete canvases. Other art objects
include various old samplers, a gouache
by Sir Alfred Munnings (**The Winner**,
1915), and an oil by George Henry
(**Vegetable Garden**). Not to be
overlooked, there is the artist's beautiful
garden, designed by him in a Japanese
style with wonderful views over the Dee.

MILNGAVIE
Strathclyde Map C4

Milngavie, a modern town which is now
essentially a Glasgow suburb, has
buildings that encapsulate all that is dull
and unimaginative in British post-war
architecture.

Lillie Art Gallery
*Station Rd
Tel. (041) 956 2351
Open Tues – Fri 11am – 5pm, 7 – 9pm, Sat
Sun 2 – 5pm
Closed Mon*

The Lillie Art Gallery forms part of the
featureless 1950s style Town Hall. Much
of its space is taken up by temporary

exhibitions generally of little more than
local interest. But it also possesses an
ever-expanding collection of the works of
well-known contemporary Scottish
artists such as **Joan Eardley** and **Alan
Davie**.

MONTROSE
Tayside Map D3

Montrose is a spacious, elegant town with
an impressive position at the mouth of
the River South Esk, alongside the
enormous Montrose basin. It has long
been a thriving holiday resort and was
once very popular with country gentry,
many of whom had residences here.
Recently it has experienced a financial
boom through its proximity to the North
Sea oil rigs and fields.

Montrose Museum
*Panmure Place
Tel. (0674) 3232
Open Apr – Sept Mon – Sat
10.30am – 1pm, 2 – 5pm, Sun
(July – Aug) 2 – 5pm; Oct – Mar
Mon – Fri 2 – 5pm, Sat 10.30am – 1pm,
2 – 5pm
Closed Sun Sept – June*

The Montrose Museum is in one of the
quietest and most attractive parts of the
town. Its varied collection is mainly of
local interest, but is pleasantly displayed.
The principal treasure is the **Inchablaoch
Pictish Stone**, which has crude but
expressive carvings showing traces of
Christian influence. In addition there are
two early copies of paintings by **Bruegel**,
an attractive late 19thC watercolour by
the local artist, **James Herald**, and a
powerful bronze bust of the modern
Scottish poet, Hugh MacDiarmid, by
Montrose's most famous native son,
William Lamb (1893 – 1951).
If you are interested in Lamb's work
you should ask one of the museum staff to
take you to his nearby **studio**, which has
now been turned into a **memorial
museum**. Lamb was trained as a sculptor
principally at the École des Beaux-Arts in
Paris. After his training there he
undertook a 3,000-mile bicycle tour of
France and Italy before settling down, in
1924, to a reasonably uneventful life in
Montrose. In 1932 he was invited to
sculpt the heads of the Royal Family and
thereafter was reasonably successful as a
sculptor of celebrities and society people.
However, his favourite subject always
remained the local fisherfolk, whom he
rendered in a vigorously simplified and
naturalistic style. Unfortunately, his
studio has not been kept in its original

state, but has instead been transformed into a rather characterless place displaying a wide variety of his sculptures, with a section devoted to explaining his working methods.

PAISLEY
Strathclyde Map C4

Paisley, now Scotland's fifth largest town, has a long history that dates back to Roman times. However, few of the town's pre-19thC monuments survive today, with the notable exception of the heavily restored **15thC–16thC abbey church**, which originally formed part of a Cluniac monastery founded here in 1163. The town's character is still much like it was in the 19thC when Paisley's thread and shawl-weaving industries brought a period of great prosperity. The "Paisley shawls", woven in cotton or silk, were inspired by designs taken from Indian and Turkish shawls brought back during the Napoleonic Wars; the "Paisley Pattern" is still much copied in other textiles.

Museum and Art Galleries
High St
Tel. (041) 889-3151
Open Mon–Sat 10am–5pm
Closed Sun
🖾 𝄖 ⼞ ☑ ⸬
The Paisley Museum and Art Galleries are housed in a Victorian-style (now much expanded) building given to the town by the Coats, a leading thread-manufacturing family, who also gave the town the splendid Thomas Coats Memorial Baptist Church. The museum's interior has been extensively modernized and the tremendous amount of love and civic pride that has gone into the display of its collections is an example for other provincial British museums. The most popular feature of the museum is its collection of over 800 **Paisley shawls**, and you can see a wonderful selection of these in a beautifully laid out room with excellent information panels and full-scale model looms.

The **painting collection**, also of high quality, is shown in the most recently modernized part of the museum. It has good holdings of 19thC French art, including still-lifes by **Courbet** and **Fantin-Latour**, and landscapes by **Le Sidaner**, **Diaz**, **Corot** (*Foggy Morning at Ville-de-Avray*) and **Boudin**. The majority of these were amassed by a local 19thC collector, James Fulton, whose daughters, Eva and Alice, were the subject of two good portraits by **Sir John Lavery** in the gallery. Other Scottish School painters well-represented in the

gallery include **Ramsay**, **Scott Lauder**, **Wilkie** and **Joan Eardley**.

In addition, the museum has the largest collection in Scotland of **ceramics**; indeed, much of the institution's purchasing funds are devoted to increasing this collection. Most of the leading potters who have worked in Britain in recent times have works featured in this collection, including **Bernard Leach** and **Shoji Hamada**; lack of space, and a wish to show these ceramics in as pleasant and spacious an environment as possible, has meant that only a fraction of this collection can be seen at any one time.

PENKILL CASTLE ⊞
Girvan, Strathclyde Map B5

Tel. (046587) 261
Open Easter and Hols 11am–2pm;
* May–Sept (by appointment)*
Closed Oct–Apr
🖾
Penkill Castle in Ayrshire was the 19thC home of the Boyd family, friends and patrons of the Pre-Raphaelites, many of whom spent long periods of time there. Rossetti in particular wrote some of his finest poems at Penkill in the 1860s, and his friend **William Bell Scott** was employed, along with several others, to decorate the interior in the rather fanciful medieval style favoured by the group. Unfortunately, most of this work was later dispersed, but the new owner, a Canadian with a taste for Pre-Raphaelite art and design, has set about restoring the interior and acquiring many original pieces. Eventually it is intended that Penkill will be both a museum and a workshop for practising artists.

PERTH
Tayside Map C4

A county town on the River Tay, Perth has a beautiful situation and some interesting 18thC and 19thC buildings.

Perth Museum and Art Gallery
George St
Tel. (0738) 32488
Open Mon–Sat 10am–1pm, 2–5pm
Closed Sun
🖾 ⌁ ⼞ 𝄖 ☑ ⸬
The recent local government reorganization has prompted greater civic interest in the Perth museum, with the result that its miscellaneous collection of fine and decorative arts, ship models, stuffed salmon and the like is now well laid out and enjoyable to visit. In fact the

museum is fairly old, tracing its origins back to the 1820s, but it was not until the present century that the bulk of the pictures were assembled. Several important bequests make up this, notably those by R. Hay Robertson and Robert Brough, but the painter and etcher D. Y. Cameron also left a considerable collection of paintings, furniture and ceramics to the gallery.

The collection has a number of European paintings such as *St Andrew* by the 17thC Spanish artist **Ribera** and a *Still-Life* by **De Heem**, but by far the largest group is Scottish. **Runciman's** curious *Portrait of the Earl of Buchan* was the first to enter the museum collection, and this has been followed by the works of **Raeburn, Millais** and members of the Glasgow School. One particularly memorable picture is Horatio McCulloch's powerful and romantic Highland landscape, *Loch Katrine*, (1866). Of the 20thC pictures, again Scottish artists predominate but *Circus Matinée* by Laura Knight is an interesting work depicting a suggestive scene by means of an oddly dull technique.

ROSLIN
Lothian Map D5

A village on the River Esk some 10 miles (16km) s of Edinburgh, Roslin's picturesque setting, ruined castle and Gothic chapel made it popular with travellers during the 18th and 19thC.

St Matthew Chapel
🔲 ☕

The **decorative stone carving** which covers almost every exterior part of the small episcopal chapel of St Matthew, begun in the mid-15thC, makes it something of a curiosity in late medieval Scotland. So complex and elaborate is this ornamentation that many people have looked to the late Gothic sculpture of Spain and Portugal as the possible source, but as yet no clear explanation has been put forward. The interior is equally decorative and surprisingly tall, with much of the **sculpture** concentrated on the piers, one of which has become famous as the '**Prentice Pillar**, so-named from an apocryphal story that the virtuoso apprentice who carved it was murdered by his jealous master.

RUTHWELL CHURCH
Dumfries and Galloway Map C6

The village church of Ruthwell has an **apse** specially built to display an 18ft high **preaching cross** dating from the 7thC. This is one of the best preserved runic crosses to survive from the Anglo-Saxon period – the other is in Bewcastle in Cumberland (see *NORTHERN ENGLAND*) – as well as one of the major monuments of Dark Age Europe. On one side, Mary Magdalene is portrayed washing Christ's feet, and on the other, Christ is worshipped by animals. The handling of these figures displays some Classical influence. Inscribed in runes on the margins of the figures (the longest runic inscription in Great Britain) are portions of the earliest poem in the English language, *The Dream of the Rood*. The sides of the cross have intricate carvings of vinescrolls, birds and beasts.

SCONE PALACE
Perth, Tayside Map C4
Tel. (0738) 52300
Open Apr to mid-Oct Mon – Sat
 10am – 6pm, Sun 2 – 6pm (July – Aug
 11am – 6pm)
Closed mid-Oct to Mar
🔲 ☕ 🍴 ♿ 🏛 ☑ ☙ ⫶⫶⫶

The present early 19thC palace at Scone (pronounced Skoon) marks the site of an abbey and palace that played a key role in Scottish history. It was here in 843 that King Kenneth I brought the "Stone of Destiny" on which the Scottish kings were crowned. In 1296, the English King Edward I took the stone to Westminster Abbey to form part of the chair that is still used in English coronation ceremonies.

The present building is an austere, fortress-like structure set in vast and attractive grounds. It has a number of fine works of art, including good family portraits by **Zoffany** and **Reynolds**. The library and dining room have an interesting **bust of Homer** by the young **Bernini** (this was acquired by the 1st Earl of Mansfield, who is shown in a nearby 18thC portrait proudly displaying it), as well as bookcases now covered with an impressive array of Meissen, Sèvres, Ludwigsburg, Chelsea, Derby and Worcester porcelain. The dining room has a fascinating collection of 17thC, 18thC and 19thC ivory statuettes from Bavaria, Flanders, Italy and France. These were for the most part gathered by the 4th Earl of Mansfield.

STIRLING
Central Map C4

Stirling is an ancient and royal town grouped round the spectacular **castle**

which once controlled the main thoroughfare to the Highlands. It was here at Bannockburn, now an anonymous suburb, that the Scots under Robert the Bruce defeated an English army in 1314 to establish their independence. The new university outside the town has a small art gallery which contains a collection of mostly **20thC paintings** and **sculpture**, including a bequest of works by **J.D. Fergusson**.

Stirling Castle

Open May, Sept–Oct Mon–Sat
9.30am–6pm, Sun 11am–6pm
June–Aug Mon–Sat 9.30am–7pm;
Sun 11am–6pm; Nov–Apr Mon–Sat
9.30am–5.05pm, Sun 12.30–4.20pm
🎫 🍴 🎧 🏛 ☑

Stirling Castle stands on a great basalt rock some 250ft high, and is the dominant landmark of the Forth plain. This austere bastion where lions were once kept contains a royal palace (built mainly by James V) which is one of the most important early Renaissance buildings in Britain. The sculpted decoration on its façade includes **classical figures and ornamentation** ★ of the early 16thC, and represents one of the earliest attempts in Britain to imitate Italian Renaissance art. It has been suggested that Italian craftsmen were responsible for this work, but the overall effect is so bizarre and unorthodox that it is more likely to be the work of indigenous artists using pattern books. Inside are 31 magnificent **16thC wooden roundels** ★ of heads in the classical style; these originally formed part of an extensive ceiling decoration.

Stirling-Smith Art Gallery and Museum

7 Baker St
Tel. (0786) 71917
Open Mon–Sun 2–5 pm
🎫 🍴 🎧 ∷

This museum, founded as a result of a donation to the town, is housed in a spacious building with several large galleries. However, in common with many ambitious civic projects of the late 19thC, it has fared less well since its inauguration, and the steady deterioration of the fabric forced the whole museum to close. A major renovation programme is currently in progress, but only one room is open to the public. This shows a selection of items from the collection, which includes a substantial number of paintings, mostly Scottish works from the 19thC, but also a number of French and English pictures of note.

STONYPATH 🏨 ★
Little Sparta, Dunsyre, Strathclyde
Map C5
Tel. (Dunsyre) 252
Open by appointment only
📷 𝄞 (by the artist himself) 🎧 ☑ ☙ ∷ 🌾

On the side of a small road leading through the wild vale of Dunsyre you will see a signboard with an inscription from the ancient Greek philosopher Heraclitus: "The way up is the same as the way down." This marks the beginning of a rough upward track that will lead you through two farm gates and eventually deposit you outside a small and undistinguished grey stone building. You have now entered Little Sparta, and in front of you lies the extraordinary artistic creation of Stonypath.

This is the domain of **Ian Hamilton Finlay**, one of the most original artists working in Europe today. Finlay was initially a straightforward writer who became, in the early 1960s, one of the leading exponents of concrete poetry, a type of poetry that uses the visual form of words to convey meaning, often arranging them into significant patterns. Later he began to translate these poems into works of fine art, for which purpose he employed calligraphers, stone carvers, potters, medallists, and even specialists in neon lighting. When he moved to Stonypath in 1967, he and his wife Sue began to create a garden in which these "poems" would form an integral part.

A small mountain stream was used to create two lakes, one of them (Lochan Ech) being big enough for Finlay to sail his dinghy on. All over the surrounding land you will see "poems" in the form of **sundials, commemorative slabs, columns, paving stones**, and so on. The garden continues to this day to be enriched and expanded by Finlay and his wife. Essentially it is a modern version of the great classical gardens of the past, and in common with these places is the expression of a personal philosophy. Finlay feels that the classical tradition has a continuing validity today, and moreover that a garden should not be simply a pleasant decorative arrangement but rather a challenging and almost a subversive force.

Military imagery abounds at Stonypath. There are battleships, gun emplacements, fighter planes, camouflaged tanks, and signs in the undergrowth such as *"Achtung Minen!"*. In using these images Finlay is partly referring to the classical concept of *Et Ego in Arcadia* ("I too in Arcady", an allusion to the omnipresence of death in even the

most idyllic surroundings). He is also responding perversely towards what he refers to as the passive or "pebble" tradition in British art, represented above all by the tasteful organic forms of Henry Moore and Barbara Hepworth, that is so often found in other British gardens. Next to Lochan Ech Finlay has placed a polished and rounded grey stone that from a distance might even be a product of the "pebble" school, but a closer view in the context of the adjoining lake clearly shows that it is intended to be the head of a nuclear submarine. Finlay also believes that classicism is the manifestation of a revolutionary ethos, and that his garden can be seen to have a political significance: recently he has found great inspiration in the French Revolution, and in particular in the uncompromising social views of St-Just.

Stonypath is an extremely enjoyable place to visit. In the tradition of the "picturesque" gardens of the 18thC such as Stourhead in Wiltshire (see *WESTERN ENGLAND*), it is a garden full of surprises and contrasts, and manages to entertain as well as to stimulate thought. Visual puns and other jokes abound: for instance, a headstone placed next to a birch tree has the slogan "Bring back the birch"; a real clump of grass resembling an Albrecht Dürer watercolour has Dürer's monogram placed next to it; a tortoise carries the words "Panzer Division" engraved in gothic lettering on its shell; and birds land on a bird tray in the form of an aircraft carrier. To complete your visit to Stonypath, look inside the garden temple, a simple stone building with classical columns painted onto it. Here you will see a changing selection of Finlay's works arranged in a quiet and contemplative setting.

It is strange that the greatness of Finlay's achievement at Stonypath has been far more generously acknowledged outside than within Scotland itself. Finlay sees the garden as representing a cultural oasis in the middle of a country that is both literally and metaphorically bleak. He refers to the region where he lives as "Strathclyde, the Infernal Region", and indeed has recently been waging a war with the Strathclyde Regional Council, who have rather pettily insisted that the building which forms the garden temple is in fact a commercial art gallery and therefore subject to tax. Far from being grateful to Finlay for bringing so much international attention to this part of Scotland, the Council seems almost to have gone out of its way to antagonize and prevent him from working. Matters came to a head on 4 Feb 1983 when Finlay's continued

refusal to pay the demanded tax or rates led the Council to attempt seizure of some of his works in the temple. Thanks to considerable press coverage of the event, and the support of a cultural militia group called the St-Just Vigilantes, the day was gloriously won by Finlay. This event has become known as the "Battle of Little Sparta", and is soon to be commemorated by an incised stone monument placed near one of the relics of the battle. However, the war continues.

STROMNESS
Orkney Map Orkney Islands

Stromness is a picturesque seaport in the remote island of Orkney.

The Pier Art Centre
Victoria St
Tel. (0856) 850209
Open Tue–Sat 10.30am–12.30pm,
1.30–5pm; Sun 2–5pm
Closed Mon
🖾 🛥 🕭 ☑ 🔲

The Pier Art Centre in Stromness is a remarkable place to find in this distant part of Britain. Opened in 1979 in a converted warehouse overlooking the sea, it has two well-equipped modern galleries displaying a series of temporary exhibitions as well as a workshop and library in another house alongside. Its most notable feature, however, is the collection of **20thC paintings** and **sculpture** donated by Margaret Gardiner, who has long had associations with Orkney. The collection has a distinctive character because Margaret Gardiner was a friend and supporter of the younger artists who gathered in St Ives (see *WESTERN ENGLAND*) at the other end of the country during the 1940s and 1950s.

The two principal figures, **Barbara Hepworth** and **Ben Nicolson**, are well represented, each by a series of works, and to fully define their range of interests there are also works by the Russian Constructivist **Naum Gabo (*Linear Construction No. 1*)**, as well as the Cornish Primitive painter **Alfred Wallis**. Of the younger group of artists who gathered round Hepworth and Nicolson there are also pictures by **Peter Lanyon, Terry Frost, Patrick Heron, Roger Hilton** and **Alan Davie**, as well as such related figures as **Eduardo Paolozzi, William Scott** and **Julius Bissier**. In general one can say that this collection charts a distinct area in British art between the 1930s and 1960s, and does so in a compact group of small-scale works that are of consistently high quality.

IRELAND

A visit to Ireland is like a trip back in time. The appearance of the country seems scarcely to reflect the remarkable improvement in Ireland's economy in recent decades, and you are struck by how old-fashioned everything is, from the telephone kiosks to the road signs, and by the somewhat shabby appearance of many of the towns. In fact the Irish Tourist Board capitalizes on this pleasantly decrepit image in their promotion of what they call "the real Ireland", but romantic notions of the country are often reinforced by a knowledge of its extensive literature.

IRISH ART

Whereas Irish literature is justly celebrated, Irish art has received relatively little attention outside the country. Undoubtedly the most distinctive monuments of Irish art, and the ones most likely to appeal to the imagination, are those of the Celtic and early medieval periods. A number of these can be seen in their original locations and derive much of their power from the unspoilt beauty of their settings, such as the Turoe Stone at LOUGHREA or the figures at WHITE ISLAND. Irish art later came to be a provincial reflection of that of London, where most of its best artists, such as James Barry, Francis Danby, John Foley and Daniel Maclise, were forced to go. Unlike Scotland, Ireland was not voluntarily united with England and in fact the Union had an adverse affect on Dublin and on the Irish gentry. As the political, cultural and economic focus shifted to London, so did Ireland's elites, and after them, in search of patronage and success, went the painters and the craftsmen. Meanwhile, many aristocratic estates and fine Georgian mansions fell into disrepair, due to absentee landlords.

The IRISH REVIVAL

Only in the late 19thC and early 20thC, with the upsurge of nationalism that accompanied the "Irish Revival", did Irish art really come into its own again. This revival started primarily as a literary movement, though it encompassed all aspects of Irish life (even sport) and set out to prove the existence and vitality of native cultural traditions, as opposed to imported British ones. It was led largely by such well-known literary figures as William Butler Yeats, Lady Gregory and John Millington Synge, who were the leading lights behind the foundation of the formative Abbey Theatre. Other famous Irish writers of this Celtic Twilight era (though not necessarily sharers of that movement's preoccupations) were George Bernard Shaw, Oscar Wilde, "A.E." Russell, James Stephens and George Moore. And, of course, this pantheon was later joined by James Joyce and Sean O'Casey.

In parallel with this literary upsurge, Irish artists began to spend more of their time in their own country, and to interest themselves more with Irish themes. These artists, who included William Osborne, Charles Lamb, Sarah Purser, Sean Keating, Harry Clarke and Jack Yeats, shared with their better-known literary contemporaries the fascination with those areas of Irish art and life that had been unsullied by English influence. They loved the forms and spirit of Celtic art, and the landscape and people of the Gaeltacht, the Gaelic-speaking districts of Ireland.

The CHARM of IRISH MUSEUMS

The most important of Ireland's museums are unquestionably in DUBLIN, where the National Museum has unrivalled holdings of Celtic and early medieval art, and the adjoining National Gallery of Art possesses collections of an international stature. After these comes the Ulster Museum in BELFAST

Fine Homebuilding
Subscribe and Save

☐ 1 year (7 issues) for just $34.
Save almost $15 off the newsstand price.

Send no money now. We will bill you later.

PLEASE PRINT: FR107 Z Y X W T S R

NAME

ADDRESS APT. #

CITY

STATE ZIP

I am 1. ☐ a professional builder 2. ☐ a homeowner 3. ☐ an architect 4. ☐ other
☐ Please do not make my name available to other companies.

Outside the U.S. $41/yr. (U.S. funds; Canadian residents: GST included.) Offer ends 5/31/98.

Taunton
MAGAZINES
for fellow enthusiasts

BUSINESS REPLY MAIL
FIRST-CLASS MAIL PERMIT NO. 6 NEWTOWN CT

POSTAGE WILL BE PAID BY ADDRESSEE

Fine Homebuilding®

63 S MAIN ST
PO BOX 5507
NEWTOWN CT 06470-9873

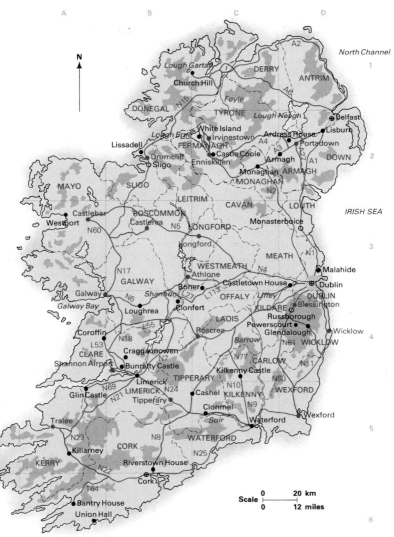

which is among the best displayed in the country, though it is relatively neglected by visitors due to the present political circumstances. Few of Ireland's other museums are of major importance, and often have a ramshackle, run-down character. Yet, apart from the opportunity they offer of getting to know the many fascinating aspects of Ireland's artistic history, they have a friendly charm that is often lacking in the generally better organized, and certainly better funded, provincial museums in Britain.

The same holds true of Ireland's country houses, which invariably delight through their informality and slightly faded air, and are thankfully free of the commercialization that you often find in England's major stately homes. If you attempt to visit all the museums and houses mentioned in this section, you will incidentally see the most beautiful parts of the country, and find that many of the places, such as BANTRY HOUSE, WESTPORT HOUSE and the Glebe Gallery in CHURCH HILL, are worth a visit just for their sites.

ARDRESS HOUSE ⌂
C. Armagh, N. Ireland Map D2

Tel. (0762) 851236
Open Apr – Sept Mon – Thurs Sat Sun
* 2 – 6pm*
Closed Fri; Oct – Mar
📷 ⑭

Originally a 17thC farmhouse, Ardress
House was completely remodelled in the
1770s by its owner, the Dublin architect
George Enson. This century the house
fell into disrepair and it was nearly
derelict when the National Trust for
Northern Ireland acquired it in 1960.
Now magnificently restored, the interior
is notable for its delicate **Georgian
plasterwork** by the renowned Dublin
plasterers, the Stapletons. The dining
room displays a collection of **paintings** on
loan from Lord Castle Stewart. These are
mainly minor works of **Italian**, **Flemish**
and **British Schools** of the 16thC-18thC, and
include an interesting *Portrait of a
Man* attributed to the Bolognese artist,
Passarotti.

ARMAGH
Co. Armagh, N. Ireland Map D2

Armagh, the ancient capital of Ulster
and site of St Patrick's church, is the
ecclesiastical capital of Ireland and the
seat of both Catholic and Protestant
archbishoprics. It is also one of the most
attractive of Northern Ireland's towns.
The Catholic cathedral, situated just
outside the town's center in the middle of
a large park, is an early 19thC structure
which impresses principally by its size.
More modestly proportioned is the
Protestant cathedral, a reconstructed
Gothic building containing the ancient
Celtic **Tandragee Idol**. It stands on top of
the town's main hill, a quiet area
intersected by steep streets lined with old
houses. To the S of it lies the Mall, a long
oval green around which are elegant
18thC and early 19thC buildings some of
which, sadly, are now shielded with wire
netting.

The County Museum
The Mall East
Open Mon – Sat 10am – 1pm, 2 – 5pm
Closed Sun
📷 ⑭ ♿

The Armagh Museum is in the Mall in an
early 19thC neoclassical building with an
Ionic façade. The building, originally a
school, was converted into a museum in
1937. Its interior has a drab 1930s
character and is far less impressive than
the exterior. The museum has always

been predominantly educational in its
function and is dedicated principally to
Armagh County. The collection is the
largest in Northern Ireland outside
Belfast. However, it can only be partially
shown (frequent touring exhibitions take
up much of the limited space available for
display), and is of mediocre quality. The
artists represented are almost all local,
including **J.S. Sleator** (a successful but
now little-known pupil of Orpen) and
John Luke (a recent artist specializing in
luminous simplified landscapes with a
slightly surreal character). The most
important of these artists is **George
Russell** (invariably known as **A.E.**), who
was born in the neighbouring small town
of Lurgan in 1867. A.E. was a major
figure in the Irish Revival, but spread his
many talents perhaps a bit too thinly.
Today he is best remembered for his
writings on social and literary matters,
and for his active involvement in the
theosophical movement (a Western
interpretation of oriental mysticism); but
he was also a painter who found particular
inspiration in the landscape of Donegal,
which he regarded as the spiritual heart of
Ireland. A great admirer of Corot and
Monticelli, he painted in a free and
rather slapdash manner (many of his
works have suffered considerable
technical deterioration), and was very
decorative and repetitive in his
compositions. The writer George Moore,
who had first admired his works, later
referred to him as the "Donegal dauber".
Among the works by him in the Armagh
Museum are a crude self-portrait and a
rather finer Donegal landscape with two
girls on a beach. The museum also has his
spectacles and palette.

BANTRY HOUSE ⌂
Co. Cork, Rep. of Ireland Map A6

Tel. (027) 50047
Open May – Sept Mon – Sun 9am – 8pm;
* Oct – Apr Mon – Sun 9am – 6pm*
📷 🅿 ⑭ ♿

A pleasant small town on one of Ireland's
most famous bays, Bantry has a
magnificent **18thC house** set in
Italianate gardens directly overlooking
the bay. The house dates largely from
1740, though the S front was constructed
a century later. Part of its charm today
lies in its slightly dilapidated character.
Weeds grow out of the masonry, and the
white painted Corinthian capitals on the
façade, like the classical statuary in the
garden, seem to have crumbled away as if
they were made of icing sugar. The ornate
interior has a haunting atmosphere
enhanced by the sounds of Tchaikovsky,

Beethoven and other classical composers being played on an old-fashioned gramophone. There is a large painting by **Snyders** with figures by a follower of Rubens, and prints by **Piranesi** and **G.B. Tiepolo.** But the main artistic attraction of the interior is the superb **18thC furniture** and **tapestries,** collected mainly by the 2nd Earl of Bantry on trips to the Continent in the early 19thC, and displayed in many cases in the exact positions chosen for them over 120 years ago. High points of the collection include **Aubusson tapestries** said to have been ordered by Louis XV for the marriage of the Dauphin to Marie Antoinette, and a **work-table** and pair of **bookcases** that may have once belonged to her and come from the Petit Trianon at Versailles.

BELFAST
Co. Antrim, N. Ireland Map D2

Belfast, the second city of Ireland, developed in the 19thC as a major port and industrial center with world famous shipbuilding yards. Its industrial expansion led to the disappearance of most of its old buildings, and there would have been little to attract tourists here even before the present Troubles. Today the city's central section will appeal only to those with a rather perverse fascination with grimness; it includes not only monumentally ugly civic buildings such as the early 20thC City Hall, but also a hotel (the Europa) with sandbags up to the second floor, much wire netting and derelict buildings, and an enormous pedestrian precinct, at which you are liable to be searched on entering. Under these circumstances you may feel like taking a drink at the **Crown Liquor Saloon** on Great Victoria Street. As well as being a licensed premises managed by Bass Charrington, this is also, curiously enough, a property owned by the National Trust of Northern Ireland; it is a magnificently restored **19thC bar** with **tiling, glasswork** and **carving** carried out by Italian craftsmen.

Arts Council of Northern Ireland Gallery
Bedford St
Tel. (0232) 244222
Open Tues – Sat 10am – 6pm
Closed Mon, Sun
🖼 ☑ 🎨 🏧 ⌂
The Arts Council of Northern Ireland Gallery is responsible for the principal artistic attractions within the city. It puts on regularly changing exhibitions, often of works from its own extensive collection of Ulster art since 1945.

Ulster Folk and Transport Museum ☆
Cultra Manor, Holywood
Tel. (02317) 5411
Open Mon – Sat 11am – 6pm; June – Sept
 Sun 2 – 6pm
Closed Sun Oct – May
🖼 🅿 🏛 ☑ 🌺 ⌂
The Ulster Folk and Transport Museum takes up a large hilly park 2 miles beyond the residential district of Holywood and 8 miles from the center of Belfast in the direction of Bangor. It is one of the most enjoyable museums in the British Isles. Throughout the park there are **reconstructions of traditional Irish dwellings,** the interiors of which can be seen. A beautiful modern building – surely one of the most successful examples of recent museum architecture in Europe – houses charming examples of **local crafts** and industries. At present there is also shown here a small selection of **paintings, watercolours** and **drawings** of Ulster life by **William Conor** (see the ULSTER MUSEUM), as well as various memorabilia connected with him, including his famous "wee black hat". Eventually these and many more of Conor's works will be moved to the 19thC Cultra Manor-house itself, which is at the center of the park and is in the process of being meticulously and lovingly restored.

Ulster Museum ☆
Botanic Gardens
Tel. (0232) 668251
Open Mon – Fri 10am – 5pm; Sat 1 – 5pm;
 Sun 2 – 5pm
🖼 🎨 ☑ 🌺 ⌂
Belfast's two principal museums – two of the finest in the whole of Ireland – are both outside the center. Since 1929 the Ulster Museum has occupied a site in the attractive Botanic Gardens in the heart of the city's university quarter. It once filled a pompous 1920s building, but now it is all contained in an excellent modern extension opened in 1972. This is an exceptionally lively and welcoming museum, whose collections are for the most part displayed with an unusual degree of taste and imagination.

Among the collections are numerous items of historical and natural historical interest, and a particularly splendid display of industrial archaeology, including three **working waterwheels.** The collection of antiquities, perhaps the best in Ireland outside the National Museum in DUBLIN, features numerous Celtic objects such as **bracelets, pots,** and **stone crosses** all shown in an impressively darkened series of rooms. The art collections, which take up the upper floors of the building, include a

large and very fine collection of **jewelry** donated by Mrs Anne Hull-Grundy. The holdings of **Old Master paintings** in the museum are small and unremarkable, comprising mainly 16 – 18thC Italian and Flemish pictures of obscure authorship. Far more impressive are the museum's **19th and 20thC paintings**, a great many of which are naturally by Irish and in particular Ulster artists. The most famous artist Belfast has produced was **Sir John Lavery**, who was born in North Queen Street (where his father owned a spirit store) in 1856. Lavery spent much of his childhood in Scotland, where he later became one of the most important of the "Glasgow Boys", a group of artists who painted out of doors and were strongly influenced by the grey naturalism of contemporary French painters such as Bastien-Lepage; in late life Lavery was active as a highly successful society portraitist based mainly in London. Although a Belfast Catholic, it was typical of his amenable attitude towards Irish politics that he painted *The Orangemen's Annual 12th of July Procession in Woodhouse Street, Portadown*★. This is one of his finest Irish works and the most colourful of his paintings in the Ulster Museum, although it is rarely shown. Other works by him in the museum include a **self-portrait** in a roundel (an allusion to Murillo's self-portrait in the National Gallery in LONDON) and two fine large canvases, *Under the Cherry Tree* and *My Studio Window*. Lavery's contemporary, the landscapist **Paul Henry**, was also born in Belfast, but like Lavery he spent little time in his native city. In 1896 he decided to leave, depressed and shaken by an outbreak of violence during a nationalist procession in which he had taken part, principally to be near a militant girl, Mary McCracken, with whom he was then in love. Paul Henry is known for his simple, decorative and subtly coloured landscapes of the west of Ireland, a fine example of which is the sensitive *Dawn, Killarney Harbour* in the museum. **William Conor**, who was born in Belfast in 1881, was the most important artist to have regularly painted the city. His works are particularly interesting for their portrayal of Belfast working-class life at the turn of the century, despite the increasing nostalgia with which he painted these subjects and the lack of concession to changing social conditions he showed right until his death in 1968. The museum has several works by him, including *The Jaunting Car*; but the largest collection of his works in the city is in the ULSTER FOLK MUSEUM.

Other Irish paintings include a superlative example of one of **Walter Osborne's** evocative portrayals of Dublin's slum life in the late 19thC, *Cherry Ripe*★ (c. 1889), and an excellent early work by **Jack Yeats**, *Riverside long ago*★, a typically nostalgic evocation of the Sligo that he had known as a child. Here you can also see and enjoy the largest group of works in any public museum by the fascinating late 19thC artist **Roderic O'Conor**. The most artistically important period in O'Conor's life was spent in Pont-Aven in Brittany where he became close friends with Gauguin. During this period he evolved an exceptionally original style of painting, which his Pont-Aven contemporary Mortimer Menpes would have characterized as "Stripist": two Pont-Aven paintings by him in the museum are by far the most important of his works here, in particular the brilliantly coloured *Field of Corn, Pont-Aven*★ (1892). In later life O'Conor lapsed into obscurity in Paris, and was portrayed as the failed artist Clutton in Somerset Maugham's *Of Human Bondage*.

Ireland's most successful living artist, **Louis Le Brocquy**, is also well represented in the museum. A striking study of a *Woman in White* (1945) is in a conventional naturalistic style with strong overtones of the work of Whistler, though its overall light tonality and extreme subtlety point to the Minimalist, almost completely white, canvases of his later years, such as the museum's recumbent *Nude* (1958).

The most renowned feature of the museum's art collections are the holdings of **contemporary art**. These are displayed on the building's top floor, from the windows of which you can see Belfast at its best, in that much of the ugliness of the place is out of sight and you can fully appreciate the beauty of its natural position in between steep hills and the sea. There is a whole room dedicated to the two greatest Ulster artists of recent times, **William Scott** and his friend the figurative sculptor **F.E. McWilliam**, (both of whom spent much of their lives in England). The numerous canvases by Scott are mainly of relatively recently date and of abstract inspiration, while the **sculptures** by McWilliam include a portrait of Scott and various examples of his important series entitled *Women of Belfast*, which depict women caught in bomb blasts. The museum also has a wide selection of British contemporary art, including works by Pasmore, **Colquhoun, Bacon, Hepworth, Caro, Peter Lanyon, John Hoyland** and **Peter**

Phillips. However, what is especially remarkable about the contemporary holdings is its number of major works by leading American and other non-British artists, such as **Sam Francis, Helen Frankenthaler, Kenneth Noland, J.R. Soto** and **Karel Appel**.

BOHER CHURCH
Co. Offaly, Rep. of Ireland Map C3

The Catholic church at Boher preserves the **Shrine of St Manchan ★**, a wooden box adorned with metal work and cloisonné enamel, probably made at Clonmacnoise c. 1130 for the Abbey of Lemanaghan. The metalwork is one of the finest products to have survived the great revival in this art in 12thC Ireland.

BUNRATTY CASTLE ▥
Co. Clare, Rep. of Ireland Map B4

Tel. (061) 61511
Open Mon–Sun 9.30am–5pm
▨ ▥ ☑ ❧

The 15thC Bunratty Castle is likely to be the first Irish monument to be seen by visitors arriving in the country from Shannon airport. The interior has been recently restored to its medieval glory and contains one of the finest collections of **14thC–17thC furniture** and fittings to be seen in Ireland. It provides a perfect setting for the medieval banquets that draw so many tourists here in the summer months. Beside the castle is a folk park with the **reconstructions of traditional country houses** from County Clare, all furnished with antiques that were in everyday use a 100 years ago.

CASHEL
Co. Tipperary, Rep. of Ireland Map C5

Rising dramatically behind the small town of Cashel is an enormous rock, on top of which is one of the most famous of Ireland's medieval sites. The rock, originally a fortification of the 4thC kings of Munster, was a provincial capital for a century after the coronation of the celebrated Brian Ború in AD 977. From the 6thC onwards Cashel also served as an important ecclesiastical center. A cathedral was built here in the 12thC, to be superseded the following century by the present structure which, after a turbulent history, was abandoned in the mid 18thC, and is now a most impressive ruin. The ruined **cathedral** and the cluster of monuments that surround it are reached through the 15thC **Hall of the Vicars Choral**, which has now been turned into a small but well displayed museum of historical and archaeological items relating to Cashel. Adjoining the cathedral is **Cormac's Chapel★**, the most remarkable Romanesque church in Ireland. The **stonework** on the exterior and interior of the church is profusely decorated: inside on the W wall you can also see a fascinating **12thC tomb** with a complex interlacing of serpent motifs influenced by contemporary Scandinavian art. From the Rock you can enjoy wonderful views of the town and surrounding countryside, including other ruined medieval monuments in the vicinity.

CASTLE COOLE ▥
Co. Fermanagh, N. Ireland Map C2

Tel. (0365) 22690
Open Apr–Sept Mon–Thurs Sat Sun 2–6pm
Closed Fri; Oct–Mar
▨ ▥ ☑ ❧

Situated in extensive grounds with a lovely lake, the Palladian house of Castle Coole (built in 1790–6 for the 1st Earl of Belmore) is perhaps the grandest and finest country house in Northern Ireland. Inside are portraits of George III and Queen Charlotte by **Ramsay**; but the interior is worth visiting mainly for the superlative **Georgian plasterwork** (by Joseph Rose), **fireplaces** (by Richard Westmacott) and **furniture**, which was designed by the architect of the house, James Wyatt.

CASTLETOWN HOUSE ▥
Celbridge, Co. Kildare, Rep. of Ireland Map D3

Tel. (01) 288 252
Open Jan–Mar Sun 2–5pm; Apr–Sept Wed, Sat, Sun 2pm–6pm
Closed Mon–Sat Jan–Mar; Mon, Tues, Thurs, Fri Apr–Sept; Oct–Dec
▨ ▥

Built in 1722–32 by Alessandro Galilei and Sir Edward Lovett Pearce, Castleton is Ireland's largest and most influential 18thC house. Now the headquarters of the Irish Georgian Society, it has a splendid **interior** with many striking features, including a staircase with mid 18thC **plasterwork** by the **Francini** brothers and a long gallery decorated in a Pompeian manner, and featuring a fine portrait of "Squire" Thomas Conolly by **Mengs**, the Neoclassical painter.

CHURCH HILL
Glebe Gallery, Co. Donegal, Rep. of Ireland Map C1

Tel. (Through operator) Church Hill 7
Open Apr–Sept Mon–Sat 9.30am–6pm;
Sun noon–6pm
Closed Oct–Mar
☎ ❧ ⚲

The Glebe Gallery occupies an isolated site overlooking the wild and beautiful Lough Gartan, and is one of the most attractively situated art galleries in Europe. It comprises the collection of the English artist, **Derek Hill**, who has lived for many years in this remote part of Donegal. Hill is a conventional portraitist and landscapist, some of whose most famous works (including one in the Ulster Museum in BELFAST) were painted on Donegal's Tory Island, where he has a studio for use in the summer. He has also spent much time in Italy, having once been a student and friend of the famous American connoisseur Bernard Berenson at I Tatti near Florence, as well as the director of the British School in Rome. At present only a small changing selection from his collection can be seen, but this is excellently displayed in a superbly converted stable block. The authorities have plans to display much of the rest of the collection in the adjoining late 18thC red-painted house where Hill once used to live. The collection comprises numerous though generally rather slight works by 20thC British and Irish artists, including Derek Hill and notably, **Roderic O'Conor**. One of the artists featured is **John Dixon**, a Tory Island "primitive" who took up painting after he had watched Hill at work and had been presented by the artist with a box of paints. Hill's great interest in Islamic art (he is the author of a book on the subject) is reflected in various charming **Islamic tiles, pots** and other objects. A **Madonna** after Bellini and several works by modern Italian artists (including **Modigliani**, **Morandi**, **Annigoni**, and **Simone**) testify to his time in Italy. Finally, British 19thC art and craftsmanship is represented by **Wemyss ware**, **William Morris** wallpaper and hangings, and paintings by **Constable**, **Bonington**, **Sickert** and **Steer**. After a visit to the house, you should wander around the delightful grounds (picnics are allowed).

CLONFERT CATHEDRAL
Co. Galway, Rep. of Ireland Map B4

The ruined cathedral in the hamlet of Clonfert marks the site of a Benedictine monastery founded about 560 by St Brendan the Navigator. Its greatest feature is its **12thC West Doorway**, the most important surviving example of Irish Romanesque decoration, which features a striking variety of motifs from bizarre animal and human heads to elaborate foliage.

CLONMEL
Co. Tipperary, Rep. of Ireland Map C5

Clonmel is a lively small town with attractive old warehouses lining the River Suir, and a main street arched over by an early 19thC **turreted gate**. This marks the site of one of the town's four medieval gates.

County Museum and Art Gallery
Parnell St
Tel. (051) 75823
Open (Ring above number for information)
The county museum and art gallery is situated above the town's library in a modest but handsome late 19thC building. The museum deals mainly with local 19thC and 20thC history, and includes a letter from the Irish-born Duke of Wellington acknowledging the receipt of a case of whiskey from a local merchant. The tiny art gallery comprises about 50 minor paintings by 19thC and early 20thC Irish artists from **William Conor** to **William Leech**.

CORK
Co. Cork, Rep. of Ireland Map B6

The Republic of Ireland's second largest city, Cork occupies an island on the River Lee and extends up the steep banks on either side of the river. Much of its architecture reflects its prosperity during the 18thC and early 19thC, when it became noted for its glass manufacture. However the town suffered greatly during the Anglo-Irish War (1919–21), when much of its main section was set alight by the "Black and Tans". Like many Irish towns, its charm derives from its slightly seedy, old-fashioned character, but few of its monuments are worth singling out.

Cork Public Museum
Fitzgerald Park
Tel. (021) 20679
Open Mon–Fri 11am–1pm, 2.15–5pm,
Sun 3–5pm
Closed Sat
📷 🏛

Just S of the university is the riverside Fitzgerald Park, in the middle of which is

a simple white Georgian building housing the Cork Public Museum. This has mainly items of historical interest, in particular relating to the history of the town during the Troubles of the 1920s, but it also has good examples of local **pottery**, lace and, above all, **glass**.

Crawford Municipal Art Gallery
Emmet Place
Tel. (021) 965033
Open Mon – Fri 10am – 5pm; Sat
9am – 1pm
Closed Sun
回 ☑ ⸬

The building housing the gallery was constructed early this century as an extension to the Custom House of 1724, and also contains the **Cork Academy of Art**. It has all the character of a rambling old-fashioned art school, which accounts for much of its fascination and charm, and makes up for the rather moderate standard of many of the works on display. To the left immediately on entering you will see an enormous hall filled with plaster casts and 19thC Irish and British paintings of generally low quality. Little attempt has been made at labelling, and even the paintings by well-known artists, such as **Sir John Lavery**, often seem to be in a state of serious decay. The finest works are *The Beguinage* by the largely Cornish-based artist, Norman Gastin, a *Grez Scene* by the obscure **W.S. Barry**, and *The Vineyard* by the Welsh artist **Brangwyn**. Here you can also see two portraits by **H. Jones Thaddeus**, a very successful portraitist in his time known today (if at all) principally for his lively memoirs, *Recollections of a Court Painter*.

Walking out of the main gallery and into the staircase well, you come across works of a rather higher quality, including *The Revolutionary* by Orpen, a small evocative interior by Orpen's contemporary William Leech (*The Barber's Shop*) and the excellent *Falconer*★ by one of Cork's greatest artist sons, the 19thC painter **Daniel Maclise**. The other major Cork-born artist was the 18thC portraitist and history painter **James Barry** who, like Maclise, spent the most important part of his life in England. The main work by Barry in the museum – a full-length *Portrait of a Man* ★ in allegorical guise – hangs on the staircase and is certainly the museum's one truly excellent painting, although unfortunately it is now in a very dark state and is hung in such a way that it can hardly be seen at all. Before proceeding upstairs you should take a quick look at the **Cork Room** (do not be deterred by the kitchen-like appearance of the place), for here you will see an interesting

18thC view of the city by Barry's contemporary **Nathanial Grogan**, and other works by local artists, including Maclise. The first floor galleries – which are often taken over by temporary exhibitions – show more 18th and 19thC works by Irish artists, as well as the gallery's foreign school paintings, including dubious attributions to Sebastiano del Piombo and Teniers, and 13 paintings of the **French Barbizon School** bequeathed to the gallery by Sir Alfred Chester Beatty. The second floor galleries feature slight works (mainly **watercolours** and **drawings**) by British and Irish artists of the late 19thC and early 20thC, poor examples of the graphic art of leading foreign school painters such as **Rouault**, **Miró** and **Picasso**, and an undistinguished collection of contemporary Irish art.

The Honan Collegiate Chapel ☆
University of Cork
The university is on the E edge of the town. Inside the precinct is the Honan Collegiate Chapel, a rather ugly church built in 1915 in a bastard Irish Romanesque Revival style. But you will find a visit to this place amply worthwhile simply to see the **stained-glass windows** ★★ by the most important of Ireland's many 19thC – 20thC craftsmen in this medium, **Harry Clarke**. Clarke, who is also known as the author of decorative Art Nouveau illustrations reminiscent of the work of Aubrey Beardsley, was associated with *An Túr Gloine* (the Glass Tower), the influential stained-glass workshop founded in Dublin in 1903 by the painter Sarah Purser. The 1915 windows at Cork were Clarke's first commission in stained glass, and immediately brought him fame. They are distinguished from the other windows in the chapel (some of which are by **Sarah Purser**) by the depth and richness of their colouring.

COROFIN
Co. Clare, Rep. of Ireland Map A4
Corofin is an architecturally unremarkable but pleasantly situated village lying between Lough Atedaun and Lough Inchiquin.

Clare Heritage Centre Museum
Tel. (065) 27632
Open mid-Mar – Oct Mon – Sat
10am – 5pm; Sun noon – 5pm
Closed Nov – early Mar
▨ ▯

The Clare Heritage Centre occupies **St Catherine's Church** in Corofin, and was

opened in 1982. At present it is devoted principally to archaeology, and among other items includes an interesting early medieval **Martyrdom of St Sebastian**, once part of a door jamb in the nearby church of Kilvoydane. However, the authorities plan in the near future to bring together a selection of the work of **Sir Frederick Burton**, who was born at Adelphi House nearby. Burton was active at first as a miniaturist and watercolourist in Dublin, but later became more interested in art history than in painting, and in 1874 was appointed Director of the National Gallery in London.

CRAGGAUNOWEN PROJECT
Quin, Co. Clare, Rep. of Ireland
Map B4

Tel. (061) 72178
Open Apr–Oct Mon–Sun 9.30am–5pm
Closed Nov–Mar
🏛 🅿 ✅ 🏧 ⚲

At the bottom of a hill in the middle of bleak countryside 15 miles to the NW of Limerick stands a fortified house built around 1550 by John McSheeda McNamara. In 1965 this building was acquired by the late collector and art historian John Hunt. Inside, on the ground floor, is a small part of his collection of **medieval** and **Renaissance antiquities**, the bulk of which is on show at the National Institute for Higher Education at Plassey near LIMERICK. The objects in the castle are mainly Irish of the 14thC and 15thC, and are of relatively little interest, though they are well displayed in an environment with an evocative medieval atmosphere. You should not miss a tour of the grounds, in which Hunt attempted to recreate **ancient habitations** of the Irish people. In the slightly sinister lake outside the castle is an Irish **ring fort**, and in the middle of a nearby wood is a **crannog**, or lake dwelling, of the late Bronze Age; inside these reconstructed habitation compounds can be seen replicas of furniture of the period. There is even a replica of the *Brendan*, the **6thC boat** in which Tim Severin and his crew recently attempted to prove that St Brendan the Navigator could have crossed the Atlantic and reached North America.

DUBLIN
Co. Dublin, Rep. of Ireland Map D3

Ireland's capital city is beautifully situated at the head of Dublin Bay. To the N you can see the hilly promontory of Howth and to the S the headland of Dalkey, at the edge of the Wicklow Mountains. Through the middle runs the River Liffey. The most striking feature of Dublin's architecture is the predominance of 18thC buildings, in particular the series of elegant **Georgian terraces** such as those surrounding Fitzwilliam Square and Merrion Square. Sadly, the superficial elegance of much of Dublin does not always bear close examination. The central section of the city has in the last decade been considerably tidied up, but important buildings remain in a terrible state of repair, and a layer of grime hangs over many of the Georgian houses in the outlying districts. To some however, this seediness is part of Dublin's charm.

Dublin's importance as a city dates from the 18thC, when the population more than trebled. But it was only from about 1740 that the city began to flourish as a cultural center. In 1746 the Dublin Society's schools were set up, and they were soon to attract virtually every important artist born in Ireland during the next 100 years – including James Barry and John Henry Foley.

But perhaps the most exciting and creative period was the late 19thC, when growing nationalism and a desire for independence inspired the "Irish Revival". Not only were writers such as Synge and W. B. Yeats associated with this movement but also a number of leading artists, such as Sean Keating, Sarah Purser, W. J. Leech, Estella Solomons, Harry Clarke, and Jack Yeats, brother of the poet. The latter, the best-known Irish painter of recent times, spent much of his life in Dublin (there is a plaque to him at 18 Fitzwilliam Sq, his last residence). His works, more than those of any other painter, are fired with the bustling vitality of Dublin life.

You may find that the best introduction to art in Dublin is to be had by walking in the streets and visiting the churches rather than by spending time in museums. In this way you will certainly see the finest examples of sculpture in the city. Dublin's two **medieval cathedrals**, Christ Church and St Patrick's, in the Liberties section of the city and no more than a stone's throw of each other, are rich in **medieval** and **18thC sculpture**. St Patrick's has the famous epitaph of its one-time Dean, Jonathan Swift, a fine statue of the Marquess of Buckingham by **Edward Smyth** (1788) and a **17thC tomb** to the memory of the wife of Richard Boyle, "Great" Earl of Cork.

City Hall on Cork Hill near Dublin Castle is a notable building of the 1760s designed by **Thomas Cooley** (1740–84). Once known as the Royal Exchange, its

impressive domed and colonnaded rotunda houses a gallery of **monumental statuary**, including *Charles Lucas* by Edward Smyth (1772) and three works by Ireland's leading neoclassical sculptor, **John Hogan** (1800–58) portraying *Daniel O'Connell*, *Thomas Davis* and *Thomas Drummond*. More recent sculpture can be found in Dublin's parks, particularly **St Stephen's Green**, where there are works by such contemporaries as **Henry Moore**, **Edward Delaney** and others. An interesting if somewhat over-elaborate piece by **Oisin Kelly** dominates the National Garden of Remembrance (Parnell Sq.) and portrays the Celtic legend of the *Children of Lir* (1971).

The Abbey Theatre
Marlborough St
🎫 ▣ 🏛
Founded in 1904 by Lord Gregory and W.B. Yeats, the Abbey Theatre has since its inception ranked as Ireland's leading theatre. The new Abbey, designed by Michael Scott to replace its predecessor (burnt out in 1951) was opened in 1966. The walls of the vestibule and bar area are a veritable gallery of who was who in the Irish literary world of the first half of the 20thC. Among these, **portraits** by John B. Yeats (1839–1922) are of particular interest.

The Bank of Ireland
2 College Green, Dublin
Tel. (0001) 776801
Open (During banking hours)
🎫 🏛
This beautiful building was Ireland's Parliament House until the Union of 1801. It is now the Bank of Ireland. The original House of Commons has been completely remodelled and the only chamber that survives is the House of Lords (1729–39), designed, as was the building, by Sir Edward Lovett Pearce (1699–1733). This contains a magnificent Dublin glass **chandelier** and two **tapestries** of 1733 by John Van Beaver celebrating William of Orange's victory at the Battle of the Boyne in 1690.

The Bank of Ireland Exhibition Hall
Head Office, Lower Baggot St
Tel. (0001) 785744
Open Mon–Fri 10am–5pm
Closed Sat Sun
🎫 ☑ ▦
The Bank of Ireland's modern headquarters on Baggot St houses an impressive collection of **contemporary Irish art**, some of which is always on view.

Chester Beatty Library and Gallery of Oriental Art
20 Shrewsbury Rd
Tel. (0001) 692 386
Open Tues–Fri 10am–1pm, 2.30–5.15pm; Sat 2.30–5.15pm
Closed Mon Sun
🎫 🎭 ☑
In the 1950s Sir Alfred Chester Beatty, an American millionaire who settled in Dublin, bequeathed to the Irish nation his fine collection of **Western manuscripts** and **bindings**, **Persian miniatures** and **Korans**, and **Chinese and Japanese handscrolls**. This very personal collection is housed in two galleries in a quiet suburban setting within the unofficial diplomatic quarter of Dublin. The original gallery, built in 1957, houses the Western collection, while a new gallery, opened in 1975, houses the rest.

Under-utilized and poorly attended, the Chester Beatty offers a fascinating excursion through the history of **book art** from ancient Egypt to 19thC Japan. Alfred Chester Beatty spent over 40 years collecting books and manuscripts of all kinds, particularly choice examples of Asian origin. In the Library and Oriental Gallery you can pore over the wonderful **miniatures** with little or no interference from fellow visitors. The collection includes more than 100 **Babylonian clay tablets**; and **Egyptian and Greek papyri**, the earliest dating from c.1160BC. There are also some 4thC **Syrian manuscripts** and a rich collection of **Bibles** and **Christian tracts**. The **Coëtivy Book of Hours ★**, the masterpiece by the "Bedford Master", is a splendid 15thC treasure. In the new gallery you can admire a superb collection of 14 **Chinese imperial jade books ★** dating from the 17thC, one of which has 50 sheets. There are also Japanese carved *inro* and *netsuke*, as well as *Ukioy-e* prints and a rare collection of *Narae-hon*, which were popular Japanese picture books of the 17th–19thC. The upstairs gallery in the new building exhibits the extensive Islamic collection and the Chinese handscrolls. The former includes a manuscript of Omar Khayyám.

Dublin Castle
Tel. (01) 777129
Open Mon–Fri 10am–12.15pm, 2–5pm; Sat, Sun 2–5pm
🎫 ✗ 🏛
The original castle dates from the 13thC with various additions in later centuries, but the bulk of the present building was constructed in the 18thC; it is this area that is open to the public. The lavish State Apartments were built as ceremonial rooms for the British administration when Dublin Castle was

the citadel of imperial authority in Ireland. The largest of these rooms is St Patrick's Hall, formerly the State Ballroom, and now the venue for the inauguration of the presidents of the Republic. The **ceiling paintings**, which commemorate the Union of the Kingdoms of Great Britain and Ireland in 1801, were painted by an Italian, **Vincent Waldré**.

The other State Rooms have been beautifully restored and display a rich collection of 18thC Irish and English **landscape**, **portrait** and **genre paintings**, among which you should not miss Matthew William Peters' *The Gamesters* (c.1788). The walls and ceilings of the apartments are rich with examples of **stuccowork** by some of the leading decorators of the time.

Hugh Lane Gallery of Modern Art ☆
Charlemont House,
Parnell Square
Tel. (0001) 741 903
Open Tues – Sat 9.30am – 6pm; Sun
11am – 5pm
Closed Mon
[icons]

Hugh Lane was a generous benefactor to the National Gallery of Ireland, but it is for the creation of Dublin's Modern Art Gallery in the early years of this century that he is especially remembered. And so it was only right that in 1979 the Dublin Corporation, which runs this gallery, should have decided to rename the collection (formerly known as the Municipal Gallery of Modern Art) in his honour. The gallery has been situated in **Charlemont House**, an 18thC town house, since about 1930. Prior to that the modern collection had been housed by Lane in Harcourt St. Although beautifully kept, Charlemont House still has the air of a town house, and its modest-sized rooms are not suited to the hanging of many contemporary works. The modern art of Lane's day was still of a manageable size, but his collection has now become academic, and the works that have been collected since World War II do not succeed in breaking out of the constraints imposed by their limited surroundings. As a pleasant building in which to walk around and, as in all Dublin museums, be unaffected by crowds, it has a definite charm. But the Hugh Lane Gallery is not so much a museum of international contemporary art as a collection of **20thC Irish art** juxtaposed with Lane's earlier superb collection of **19thC French paintings**.

These paintings were, of course, "modern" in Lane's day, when he offered them to Dublin on condition that a gallery be built to house them. When the city did not respond positively Lane retaliated by bequeathing the paintings to London. Tragically, he drowned when the *Lusitania* was torpedoed in 1915, but before embarking he added an unwitnessed codicil to his will re-bequeathing the collection of **19thC Masters** to Dublin. For years a protracted battle went on between the two cities, until at last a new agreement was reached in 1979, and the pictures can now be satisfactorily viewed in both the Dublin Gallery and in the National Gallery in *LONDON*.

The paintings have been divided into three categories. First, there is the supreme masterpiece of the collection (according to the advisory committee), Renoir's *The Umbrellas* ★ (c.1883), which is in Dublin from 1979 – 86 and will then go to London for 7 years. Second, there are 8 masterpieces by **Degas, Daumier, Puvis de Chavannes** and **Ingres**, which are in London until 1993. Third, there are the 30 major works presently on show in Dublin, which include Manet's portrait of his student *Eva Gonzales* ★ (1869 – 70), Courbet's *Snowstorm* ★, a Monet *View of Vetheuil*, a Morisot, and a **Boudin**, as well as pieces by **Puvis de Chavannes, Fantin-Latour** and **Gérôme**.

Despite this superb collection, the Hugh Lane Gallery appears to suffer from funding problems, thus preventing the people of Dublin from enjoying a properly representative view of 20thC art, or even a thorough viewing of the gallery's existing holdings. The gallery owns a large collection of civic and official **portraits** dating back to the 18thC, as well as a rich collection of **19thC British paintings**, but few of these are now hung due to lack of space. They include two important works by **Constable**, as well as works by **Edward Burne-Jones, Albert Moore, G.F. Watts** and **Augustus John**.

An exhibition of **early 20thC Irish art** is nearly always on display. Represented are such Post-Impressionists as **W.J. Leech, Roderic O'Conor** and **John Lavery**. Numerous works by **Jack Yeats** are also usually on show. To your left as you enter the main rooms of the gallery is a splendid display of stained glass by the Irish artist **Harry Clarke** (1889 – 1931), an illustrator and fantasist of great charm and imagination. Various other early 20thC artists, such as **Paul Henry** (famous for his views of the West of Ireland) and **Sean Keating**, are also well represented. Keating's vigorous portrayals of Irish peasants (*Men of the West*, c.1917) convey some of the

romantic picturesqueness which can be associated with the Irish Literary Revival and the struggle for independence. The central rooms of the gallery house the rather depressing post-war Irish collections. The best work here is **Le Brocquy's** series of heads of Irish literary figures, such as *Yeats*, *Joyce* and *Beckett*, all executed in a hauntingly Minimalist style.

National Gallery of Ireland ☆ ☆
Merrion Square (West)
Tel. (0001) 767571
Open Mon – Wed Fri Sat 10am – 6pm;
* Thurs 10am – 9pm; Sun 2 – 5pm*
📷 ♿ 🅿 🏛

Plans to create a national collection of art were first discussed in the 1760s but nothing came of them until the 1850s, when a testimonial fund was set up to commemorate the public services of William Dargan, a railway entrepreneur and organizer of Dublin's Great Industrial Exhibition in 1853. Eventually, an Act of Parliament of 1854 provided for the establishment of a National Gallery, which opened its doors in 1864 in a building by **Francis Fowke** (1823–65), who was also architect of Edinburgh's Royal Scottish Museum and the Victoria & Albert Museum in London.

As you look at the building today, Fowke's design is the three-bay (blind) construction to the left. The central area and the rooms behind were built in 1903 to accommodate a very large bequest of the Dowager Countess of Milltown, while the blind façade to the far right is a late 1960s extension. Like its sister institutions surrounding Leinster House, the National Gallery is state-funded.

On entering the gallery you pass the main desk in front of which are some circular plaster casts of an 18thC stucco series that originally decorated a Dublin house (they are by **Michael Stapleton**, who died in 1801). To the left of the entrance hall is the first of the original rooms of the 1860s gallery. This splendidly ostentatious room houses an eclectic collection of large-size paintings, including the well-known Daniel MacLise *Marriage of Aoife and Strongbow* (c. 1854), which describes the marriage alliance effected by the notorious Dermot MacMurrough between his daughter and the leader of the invading Normans in 1170. At the other end of the room is the entrance to the collection of the religious paintings, which are displayed in a church-shaped room. In the "apse" are some fascinating **Romanesque frescoes** from a small chapel near Avignon; while in the "side chapel" are numerous early **Italian**

paintings and **Russian and Greek icons**: apart from a fine **Fra Angelico predella ★** (c. 1438–40) portraying a miraculous event in the lives of SS Cosmas and Damian, few of these works are worth singling out. If you then retrace your steps and mount the grand staircase you come to the great Baroque room with the gallery's collection of **Italian 16thC** and **17thC paintings**. This collection is generally regarded as one of the great strengths of the museum, although many of the large-scale works here by such important artists as **Giulio Procaccini**, **Veronese**, **Gentileschi**, **Bernardo Strozzi**, **Mattia Pretti** and **Carlo Maratta** do not show these masters at their best. The great exceptions to this are two dark and agitated canvases (*The Last Supper* and *The Multiplication of Loaves and Fishes*) from a series of 8 commissioned from the 17thC Bolognese artist **Lanfranco** for the chapel of the Blessed Sacrament in San Paolo Fuori le Mure in Rome. All 8 canvases – which are among the most important works in oil in Lanfranco's career – were acquired in the early 19thC by Napoleon's brother-in-law Cardinal Fesch. After the latter's death they were dispersed and the two in the National Gallery – the finest and largest in the series – were the first purchases made by this institution. Also of interest are two large and characteristically freely handled canvases (*Susanna and the Elders* and *Bathsheba spied on by King David ★*) by the prolific and rather uneven 18thC Venetian decorative painter, **G.A. Pellegrini**. Although both the paintings are of religious subjects their tone is light-weight and extremely sensual. Climbing more stairs, you pass through four rooms of smaller Italian paintings that take you from 15thC Florence to 18thC Rome. Of particular importance is the large, exquisitely tranquil *Pieta ★* by **Perugino** (1490s), a superlative small portrait by Batoni of the *1st Earl of Milltown ★* and a pleasant sketch of an allegory of the Immaculate Conception attributed to **G.B. Tiepolo** although more likely to be the work of his son.

Leaving the original gallery, you descend a rather narrow stairway and enter the rich **English collection**. Considering Ireland's excessively close historical relationship with England it is not surprising that the gallery should have a large selection of English landscape and portrait paintings. All periods are represented, though the 18thC does tend to dominate. **Reynolds'** wonderful *Charles Coote, 1st Earl of Bellamont ★★* (1773), an Irish subject, is one of the finest paintings by this artist to

be seen in any public collection; the foppishness of the pose and the extraordinary plumed hat of the sitter makes this an outstanding study of bloated egoism. Also by Reynolds, though of more historical than artistic interest, is an amusing parody of Raphael's *School of Athens*. Other 18thC English works include a strange self-portrait by **Hoppner** showing himself in profile holding a fish, and a magnificent portrait by Lawrence of *Lady Elizabeth Foster* ★.

The Spanish collection, which leads from the English rooms, is small but choice. Of particular note is a painting by Zurbarán of *St Rufina* ★, a *Vision of St Francis* by El Greco, and a small and extremely mysterious work by Goya, *The Dreamer* ★. From here you enter the Flemish collection, which is housed in a large room suitable for viewing the gallery's various **Rubens** paintings and three large **Jordaens**, the most interesting of which is *The Church Triumphant*.

From Flanders you move into the Netherlands, which is represented mainly by indifferent 17thC works; but here you can also see one of the gallery's most popular paintings: the small, yet astonishingly penetrating *Rest on the Flight into Egypt* ★★ by Rembrandt (1647).

From here you can descend to the ground floor. From the end of 1984 all the important paintings of leading Irish sitters from the Irish National Portrait Gallery (see MALAHIDE CASTLE) will be hung on the staircase well of the 1960s extension; At present only the late 19thC and 20thC portraits are hung here, including many by **John Yeats** (father of the poet William and the painter Jack), depicting figures associated with the Irish Revival. On the ground floor are to be found the recently rehung French rooms; the blue of the sculpture pedestals and the red of the security roping give these rooms a rather obvious Gallic flavour. The most impressive of the early French works are a group of mainly religious canvases by **Poussin**, ranging from a dark and dramatic *Lamentation* ★, in which a stormy landscape expresses the mood of the painting, to a much more rational and serenely classical composition, *The Holy Family* ★. Among the 18thC and early 19thC French School you will see a fine painting of animals by **Oudry** (on loan to the gallery), a luminous full-length portrait by Gérard of *Julie Bonaparte, Queen of Naples*, and one of the earliest paintings (*The Funeral of Patroclus*) by Gérard's teacher, **Jacques Louis David**, which is executed in a very Rococo style. The later 19thC and early 20thC French

paintings are not outstanding, with minor works by **Barbizon School artists, Courbet** and the **Impressionists**.

The Irish rooms run parallel to the French, and you enter them through the bookshop. This series of octagonally shaped rooms was built in 1902 to house the Milltown Collection, which has now been incorporated into the various national collections. Unfortunately the lighting in these rooms leaves much to be desired, and you may find difficulty in appreciating this display to the full.

Irish art has only received serious study in the last 10–15 years, and still remains largely unknown outside the country. Many of the greatest examples of Irish art can be seen here. Among the earliest works look for the powerful, Rembrandt-inspired *The Conjurer* (1775) by **Nathaniel Hone the Elder**; the delightfully uninhibited and naturalistic study of a courtesan called *Sylvia* by **Matthew Peters**; two paintings by Ireland's leading Neoclassical artist, Hugh Douglas Hamilton – the erotic *Cupid and Psyche in the Nuptial Bower* ★ and the recently acquired **double portrait** ★ of the eccentric Earl Bishop of Derry with his grand-daughter, Lady Caroline Crichton; a brilliant example of **Francis Danby's** "fantastical" manner, *The Opening of the Sixth Seal* ★ (in which he shows himself to be technically far superior to his English contemporary, John Martin); and two fine pieces by **James Barry** (a riveting *Self-Portrait* of 1803 and a dramatic *Venus and Adonis* ★).

Up till the late 19thC, almost all of Ireland's leading painters were forced to seek a living mainly outside the country, in particular in Italy and England. However, with the growing mood of nationalism at the end of the century, many Irish painters, generally after a period of training in France or Antwerp, began to return on a more permanent basis to their native country, or at least to paint scenes inspired by it. One such artist was the *plein air* painter, **Walter Osborne**, who today is best known for his evocative scenes of Dublin's slum life, a famous example of which, *St Patrick's Close* ★ is in the museum. Other painters strongly under his influence, and also closely associated with the Irish Revival, were **Sarah Purser** and **Estella Solomons** (both represented in the museum by various portraits).

Two of the most successful Irish painters at the turn of the century, **Sir John Lavery** and **Sir William Orpen**, were active principally as society portraitists in London, although both frequently returned to Ireland for short

periods. The gallery displays a large canvas by Lavery showing his wife and their daughters, and numerous works by Orpen, including the enormous allegorical work, *The Well of the Saints*; and the altogether more likeable *The Dead Ptarmigan*, a strange portrait of himself with a bird and holding a fish, undoubtedly inspired by a Hoppner *Self-Portrait* that is also in the gallery.

Standing apart from all these artists was the reclusive **Roderic O'Conor**, a friend and follower of Gauguin, who is represented here by a highly original study of Gauguin's one-time studio of *Lézaven at Pont-Aven★*. Jack Yeats is internationally by far the best known Irish painter this century, and he also has the closest association with Dublin. The museum displays several of his late works, in which the paint is used with a characteristic, sometimes excessive, ebullience. Altogether more impressive is a painting in his earlier, more soberly realistic manner, *The Liffey Swim★*, a composition of movement and power.

The National Gallery of Ireland contains numerous excellent paintings, among which the following are of great interest:

1 Jack Yeats, *The Liffey Swim*, c.1930
2 Roderic O'Conor, *Lezaven at Pont-Aven*, 1894
3 Walter Osborne, *St Patrick's Close*, 1887
4 James Barry, *Venus and Adonis*, c.1780

5 Francis Danby, *The Opening of the Sixth Seal*, 1828
6 Nicolas Poussin, *Lamentation*, mid 1650
7 Pietro Perugino, *Pietà*, 1513
8 Joshua Reynolds, *Charles Coote, 1st Earl of Bellamont*, 1773
9 Rembrandt van Rijn, *Rest on the Flight into Egypt*, 1647
10 Francisco de Goya, *The Dreamer*, c.1798
11 Francisco Zurbarán, *St Rufina*, c.1645

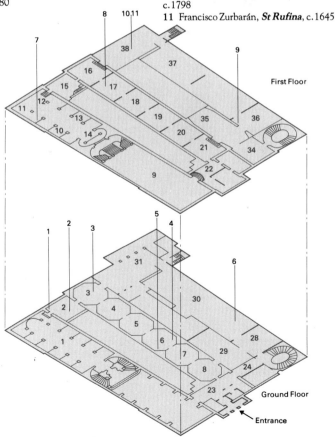

National Museum of Ireland ☆
Kildare St
Tel. (0001) 765521
Open Tues – Sat 10am – 5pm; Sun 2 – 5pm
Closed Mon
📷 🏛 ☑

Ireland must be one of the few countries in the world where the state parliament building is surrounded on all sides by four institutions of learning. In 1922, a year after the country had become independent, it was decided to purchase **Leinster House**, (which faces Kildare St and backs onto Merrion Sq) to act as a parliament house. Formerly the town house of the dukes of Leinster, this so-called prototype for the White House in Washington DC, had served from 1815 as the headquarters of the Royal Dublin Society (founded 1731). This body fostered interest in practical economics, agriculture and the training of artists, and its various collections eventually formed the basis for the national collections of **Old Master paintings**, **antiquities** and natural history, as well as a library. The National Library and the National Museum are matching buildings on either side of Leinster House and are entered only from Kildare St. Behind Leinster House and approached from Merrion Sq are the other by-products of the philanthropic Royal Dublin Society: the NATIONAL GALLERY OF IRELAND and the Natural History Museum (a division of the National Museum and commonly known as the "Animal" Museum). The National Library and the National Museum, designed by Sir Thomas Manly Deane (1851 – 1933), opened their doors to the public in 1890. Both buildings act as impressive 19thC sentinels to Richard Castle's mansion of 1745.

The National Museum, like the National Library, is arranged round a rotunda and has all the charm as well as the drawbacks of a late Victorian building. The mosaic floors and heavy marble columns give the museum an archaic atmosphere, and the main exhibition hall has lost little of its original appearance. In no other European museum can you find so many Celtic objects on display, and the antiquities section is physically and officially the heart of the museum. Here is a unique collection of early Irish **gold torcs**, **fibulae**, **lunulae**, finely tooled **brooches**, **crosiers** and heavy **shrines**, and around the walls you can view the impressively utilitarian **cauldrons** and **buckets** of the Bronze Age, all of which are well labelled and attractively arranged. The recent discovery of the so-called **"Derrynaflan Hoard"** (a collection of **ecclesiastical plate** dating from the 8th – 9thC) greatly increases our knowledge and appreciation of the golden age of early Irish craftsmanship. The Museum's most famous treasures include the **Tara Brooch ★**, and the magnificent **Ardagh Chalice ★** (both of which date from the early 8thC AD); other important items include the **Shrine of St Patrick's Bell** (1094 – 1105) and the majestic **Cross of Cong** (1123).

Other collections include the division on Irish military history, where, in a long room off the main hall, you can view a rather crowded display of **uniforms and objects** relating to Ireland's fight for independence between 1905 and 1921. It is worth pointing out that little attention is given to the Irish Civil War period of 1921 – 2. Upstairs, in the very limited space available, you can see a superb collection of **crystal**, **coins** and **silver**. The museum is so chronically short of space that much of the collection is permanently in storage. In recent years attempts have been made to exhibit some of the rich ethnographical, folk-life and 18thC collections. A semi-permanent exhibition of **Viking Dublin** is on show in the National Museum's Annex on **Merrion Row**, only two blocks away in the direction of St Stephen's Green.

Trinity College Library
Trinity College
Tel. (0001) 772941
Open during normal College hours
📷 ⚔ 🎪 🏛 ☑

Dublin boasts two large universities, Dublin University, or Trinity College, which is in the middle of the city, and University College, Dublin, which lies some three miles S of the city center. Trinity dates from the time of Elizabeth I and acted as the leading institute of Protestant learning in Ireland until well after the establishment of the Irish Free State. The Old Library houses not only **Roubiliac's** bust of Swift (1745) but also the famous *Book of Kells* ★★ (c. AD800). This is the most splendid of all the numerous illuminated gospel books produced by Irish monks, and you can see two volumes (of the four) in the Long Room on the second floor of the Old Library. One book is open at one of the lavish "carpet" pages, which act as introductions to the texts. A page of the other book is turned each day to reveal the text and show the calligraphic skill of the monks. Of the other important **manuscripts** on view (in glass cases) the earliest book is the exquisite *Book of Durrow* ★, a comparatively small manuscript of the Gospels and reputedly one of the most important documents in Europe to survive from the second half of

the 7thC. The gospel books are displayed within Benjamin Woodward and Thomas Deane II's Long Room (1860–2), beneath a **timber barrel vault** and surrounded by the soft brown and gold of the leather-bound volumes.

The Douglas Hyde Gallery
Arts Building,
Trinity College,
Nassan Street Gate
Tel. (0001) 772941
Open Mon–Sat 11am–5.30pm
Closed Sun
◙ ⃞
A few hundred yards from the OLD LIBRARY is the college's new **Arts Building**, which has an extensive gallery named after Ireland's first president. The gallery does not have a permanent collection but mounts interesting exhibitions that are well worth investigating.

GLENDALOUGH
Co. Wicklow, Rep. of Ireland
Map D4

The most renowned of Ireland's early monastic sites, Glendalough consists of a series of ruined medieval monuments in a small wooded valley with two lakes. It was supposedly founded as a monastery by St Kevin in the 6thC, though the present remains are mainly of the 10th–12thC. Among these is one of the best preserved **round towers** in Ireland, and a two-storeyed **oratory** known as St Kevin's Kitchen, which now contains a collection of **stone crosses** and other **carved stones** from the valley. The much visited monuments at Glendalough are now linked by paths, fences and sign posts that guide the visitor as if along an open "nature trail". As a result, the place somewhat lacks the mysterious unspoilt qualities so characteristic of many other early Irish sites.

GLIN CASTLE ▦
Co. Limerick, Rep. of Ireland
Map A5

Tel. (068) 34173
Open (By arrangement)
▥ ☑ ⅄
Glin Castle is a late 18thC building which in the 1820s was castellated and given a veneer of Gothic detailing; in the beautiful grounds overlooking the Shannon you can see some **Gothic Lodges** which further contribute to the toy-fort atmosphere of the property. Appropriately, this is the desmesne of the

magically-titled Knights of Glin – the present Knight, Desmond Fitzgerald, is an art historian and former keeper of furniture at the Victoria & Albert Museum in *LONDON*. The castle contains attractive Irish **furniture** and **stucco** work of the 18thC, a large collection of family **portraits** from the 18thC onwards and various 18th–20thC **Irish paintings** collected by the present Knight (the co-author of a book on Irish artists). These include **Orpen's** brilliantly coloured *On the Beach House*, ★ showing the artist's wife and daughter in an idyllic setting.

KILLARNEY
Co. Kerry, Rep. of Ireland Map A5

The lakes of Killarney have been one of Ireland's major tourist attractions since the 18thC, when they were painted by nearly all the major landscapists working in Ireland, including, most notably, **Jonathan Fisher** (for example his *Lower Lake Killarney*, National Gallery of Ireland, DUBLIN). The small town of Killarney, which is crammed with hotels, has itself little of interest, apart from its situation and a fine **Gothic Revival Cathedral** designed by A.W. Pugin and completed by the foremost Irish church architect of the 19thC, J.J. McCarthy. However, just outside the town, off the Bantry road, are the pleasant **15thC ruins** of Muckross Abbey; and about a mile beyond this is MUCKROSS HOUSE, a large mock Elizabethan manor of the early 19thC, situated in magnificent gardens overlooking the Lower Lake.

Muckross House National Folk Museum
Tel. (064) 31440
Open Mid Mar–June, Sept–Oct
 Mon–Sun 10am–7pm; July–Aug
 Mon–Sun 9am–9pm; Nov–Mar
 Tues–Sun 11am–5pm
Closed Mon Nov–Mar
▨ ⇔ ⅏ ⅄
The interior of the house comprises both a number of over-restored rooms sparingly decorated with heavy 19thC furniture, and also a set of plain brown rooms with simple displays of **photographs** and other documentation relating mainly to the **folk history** of Co. Kerry. There are engravings by **Jonathan Fisher** of the Killarney lakes, and 19thC and early 20thC portraits of varying quality, including two drawings by the American artist **John Singer Sargent**. These represent the two previous American owners of the house, the Vincents (who were largely responsible for laying out the gardens).

Celtic art in Ireland

"Lusty Man", Lough Erne, Fermanagh

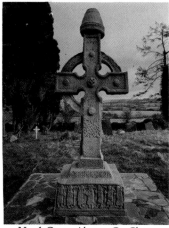

North Cross, Ahenny, Co. Clare

The Celtic peoples, who first arrived in Ireland c.600BC, have left their mark on Irish art and culture to a far greater extent than in Wales or Scotland. However, comparatively little of artistic interest has survived from the earlier period, apart from a few works such as the Tandragee Idol in ARMAGH CATHEDRAL or the Turoe Stone near LOUGHREA. The latter, a rounded stone covered in swirling tendrils, exemplifies the distinctively flowing Celtic decorative style known as La Tène, after a group of incised monuments found at a site in Switzerland. In its earlier phase this style adopted and then stylized Classical Greek motifs, such as the honeysuckle, and later introduced animal ornament; the use of tendril ornamentation dates from shortly before 300BC.

The La Tène style reached Ireland later than other parts of Celtic Europe, but it lingered on here long after the conversion of the country to Christianity in the 5thC, at a time when Celtic art elsewhere was being supplanted by Classically inspired naturalistic art disseminated throughout the Roman Empire. However, the Romans never occupied Ireland, which was therefore not subjected to the mass-produced wares left by Roman colonists wherever they went. Early Christian art in Ireland retains many of the decorative themes found in pre-Christian Celtic art.

The ART of the MONASTERIES

The major centers of early Christian Ireland were the large monastic settlements such as Glendalough and Clonmacnoise, which also trained and supported the country's artists and craftsmen. By the 7thC strong links had been established between these and similar settlements in Britain, most notably Iona in Scotland and Lindisfarne in Northumberland, where a blend of Celtic and Anglo-Saxon influences produced the illuminated *Lindisfarne Gospels* of c.700.

The first important Irish illuminated manuscript is the *Book of Durrow* of c.670–680 (Trinity College Library, DUBLIN). As in the Lindisfarne Gospels, a number of its pages are given over to pure ornamentation. These, the so-called "carpet pages", contain in addition to characteristically Celtic spirals and animal forms, interlaced bands of possible Coptic or eastern Mediterranean origin: this new decorative feature was to be very important for the later development of Irish art. Also at Trinity College is the best

Book of Kells, *Trinity Coll. Lib., Dublin* **Book of Durrow**, *Trinity Coll. Lib., Dublin*

known of Ireland's medieval treasures, the **Book of Kells** of c.800, which is a work of extreme eclecticism, featuring not only spirals and interlacing, but also elements derived from a wide variety of other European traditions.

Some of the finest products of Irish art of the Celtic Christian period were its metal objects, in particular the **Tara Brooch** and the **Ardagh Chalice**, both of which were executed c.700 and are now in the National Museum in DUBLIN. Like the manuscripts of this period, they are characterized by the extraordinary complexity and intricacy of their ornamental detailing. In the case of the Tara Brooch, the ornamentation is placed also where it would not have been seen except by the wearer. The Ardagh Chalice was only discovered in the last century by a boy digging for potatoes in a field where it had been hidden to save it from capture by the Vikings.

The HIGH CROSSES

Impressive though these works are, the Irish monuments most likely to have the greatest impact on the visitor are the carved stone high crosses that you can see even in some of the most remote parts of the countryside. These exist in greater numbers and in a better state of preservation than in any other European country. They have their origins in the pillar stones of before c.700, such as that at Kilnasagart in Armagh, which is a crudely engraved stone calling to mind the commemorative stones of pagan times. The first outstanding high crosses are those of Ahenny in Co. Clare, which were probably inspired by metalwork processional crosses, and are works of extreme ornamental complexity. At a later date, figurative scenes were added to the crosses, creating the so-called "scriptural crosses", the most celebrated of which is that of Muiredach of AD923 at MONASTERBOICE in Louth.

Although magnificent high crosses continued to be erected in the 10thC, Irish art generally went into a decline during this period largely owing to the devastation caused by repeated Viking raids. This decline was temporarily halted, however, in the late 11thC and early 12thC, when there was a great revival in metalwork: such objects of this period as the **Shrine of St Manchan** in Offaly and the **Cross of Cong** in the National Museum in DUBLIN display an ornamental inventiveness and complexity that compare well with the finest Celtic-inspired art of earlier times.

KILKENNY CASTLE ⌂
Co. Kilkenny, Rep. of Ireland Map C4
Tel. (056) 21450
Open Mid-June–Sept Mon–Sun
10am–7pm; Oct–early June Tues–Sat
10am–1pm, 2–5pm, Sun 2–5pm
Closed Mon Oct–early June
📷 ⊀ ⌂ ⊡

Kilkenny, one of Ireland's oldest and most charming towns, has numerous fine medieval and later monuments, including the largely **13thC cathedral** of St Canice and the **castle**, which was erected in the 13thC but whose present appearance is largely due to 18thC and 19thC alterations and additions.

Until 1967 the castle was the seat of the Butlers. Most of the Old Master paintings hung in the heavily restored interior of this building are in the long gallery and are 17thC–19thC **portraits** of members of the Butler family. Though these are for the most part rather dull, there is a good portrait by **Kneller** of James Butler, 2nd Duke of Ormonde. In the basement is a series of light and well modernized rooms containing the Butler Gallery. This is run by the Kilkenny Art Gallery Society, which shows selections from a small but excellent collection of modern Irish paintings (including works by **Louis Le Brocquy, Marie Swanzie, Evie Hone, Paul Henry** and **William Scott**), as well as temporary exhibitions devoted to living artists. Its progressive spirit is in keeping with the culturally active town of Kilkenny, which has recently begun to host a highly ambitious summer arts festival.

LIMERICK
Co. Limerick, Rep. of Ireland Map B4

An industrial port and the fourth largest city in Ireland, Limerick stands just above the beginning of the Shannon estuary. The old town is divided into three distinct areas. In the English town, which lies to the N of the confluence of the Abbey River and the Shannon, is the much altered 13thC **King John's Castle** and the **Cathedral of St Mary**, which was founded in 1172 but owes its present appearance largely to an extensive mid-19thC restoration. To the S of the narrow Abbey River is the Irish town. Here is the **Neo-Gothic Cathedral** of St John, the treasury of which has an outstanding gilded and enamelled **silver crosier** ★ of 1418. Immediately S of this is the attractive 18thC suburb of Newtown Pery, an area of elegant if now rather shabby **18thC terraces**.

Municipal Art Gallery
Pery Square
Tel. (061) 44668
Open Mon–Fri 10am–1pm, 2.30–8pm
Sat 10am–1pm
Closed Sun
⊡ ⊡

The Municipal Gallery occupies a large room at the back of the library. The paintings displayed here are frequently taken down to make way for touring exhibitions; but the friendly library staff are happy to produce any paintings on request. The collection is almost exclusively of **19thC** and **20thC Irish art**, and includes fairly good work by most of the leading Irish artists of this period. Among these is a well-known portrait by **Orpen** entitled *Man of the West*: the subject is Sean Keating, one of the painters associated with the Irish Revival who immersed himself the most fully in the life of the Connacht Gaeltacht (the Irish-speaking region in the west). Of greater artistic interest, and indeed the most remarkable work of the collection, is Jack Yeats' *The Chairplanes* ★. This is one of the best examples to be seen anywhere of the artist's late style with his turbulent handling of paint.

Plassey House (Hunt Collection)
The National Institute for Higher Education,
Plassey Technological Park
Tel. (061) 43644
Open Mar–Oct Mon–Fri 9.30am–5pm;
Sat, Sun 10am–5pm
Closed Nov–Feb
📷 ⊞

Just outside Limerick, off the Dublin Road, is the National Institute for Higher Education at Plassey. On the top floor of one of the large modern buildings that form part of the Institute you can see most of the Hunt Collection (the rest of it is shown at the **CRAGGAUNOWEN PROJECT**). The aim of the collection is to present aspects of Ireland's cultural heritage within a broader European context. The Irish items on show range from the **7thC–8thC crosses** with enamel inlay to a beautiful Galway **silver chalice** of the 17thC. In addition, there are numerous fine works from elsewhere in Europe, including **Greek pottery**, **13thC Limoges enamels**, and a 17thC **Mannerist statue** from Augsburg.

Kneafsey Gallery
The National Institute for Higher Education,
Plassey Technological Park
Tel. (061) 43644
Open Mon–Fri 9am–5pm; Sat Sun (By
arrangement only)
⊡ ⊞

The Kneafsey Gallery occupies one small

room in the old building of the PLASSEY INSTITUTE, which is attached to the modern part by a covered walkway. It contains the grandly titled "National Self-Portrait Collection", in fact a group of very undistinguished self-portraits by 20thC Irish artists, including **Sean Keating**, **William Conor**, **Louis Le Brocquy** and **Basil Blackshaw**.

LISBURN
Co. Down, N. Ireland Map D2

Lisburn is a small industrial town which was largely destroyed by fire in 1707. Its center is built around a hill, on top of which is a tall spired **cathedral**, reconstructed in 1708 in a style combining Gothic and Renaissance detailing. The town's other main landmark is the neighbouring market house assembly rooms, a much modified 17thC building which now houses the town's museum.

Lisburn Town Museum
Assembly Rooms,
Market Square
Tel. (08462) 72624
Open Tues–Fri 11am–4.45pm
Closed Mon Sat Sun

Lisburn Town Museum contains a modest, pleasantly displayed collection of objects of mainly local interest, including a number of watercolours by the rather sentimental 19thC Lisburn artist, **Samuel McCloy**.

LISSADELL
Co. Sligo, Rep. of Ireland Map B2
Tel. (071) 73150
Open May–Sept Mon–Sat 2pm–5.15pm
Closed Sun May–Sept; Oct–Apr

Lissadell, an early 19thC house in the middle of a large wood with views over Sligo Bay, has a haunting charm once recalled by W.B. Yeats: "The light of evening, Lissadell, great windows open to the south." It has always been the home of the Gore-Booths, one of whom, Constance, was a famous freedom fighter for Ireland, the first woman elected to the British House of Commons and a minister in the first independent Irish government. She began her career as a painter, and it was at art school in Paris that she met her future husband, Count Markievicz. A number of her **Impressionist-style canvases** can be seen in the house, together with a rather sentimental portrait of her and her poet

sister Eva as children by **Sarah Purser**. Her husband's works are also on show, most notably a series of amusing elongated **portraits** of members of the household painted, bizarrely, on the pilasters of the dining room. There are many other works of art in the house, including prints by **Gustave Doré**, and paintings by **Sir Frederick Burton** and **George Russell (A.E.)**. But ultimately it is the atmosphere of the place that makes a visit here so worthwhile, for its interior seems to have been untouched since the early years of the century.

LOUGHREA CATHEDRAL
Co. Galway, Rep. of Ireland Map B4

The small town of Loughrea has a ruined **Carmelite church** of 1300 and a rather ugly Catholic **cathedral** of 1897–1903. This latter building is worth visiting simply for its rich collection of modern Irish **ecclesiastical art**, including embroideries designed by **Jack Yeats** and stained glass windows by **A.E. Childe**, **Sarah Purser**, **Evie Hone** and others. Four miles NE of the town, at Bullaum, is the famous **Turoe Stone ★** which offers splendid abstract ornamentation of the late Iron Age.

MALAHIDE
Co. Dublin, Rep. of Ireland Map D3

Malahide is a small resort on the estuary of the Broad Meadow river. The late 19thC Barbizon School landscapist, **Nathaniel Hone**, lived just outside the village; and a plaque on the Malahide to Dublin road records his residence at the now much altered St Doolagh's Park.

Malahide Castle
Malahide, Co. Dublin
Tel. (01) 452655
Open Jan–Dec Mon–Fri 10am–12.45pm,
2–5pm; Apr–Oct Sat 11am–6pm,
Sun 2–6pm; Nov–Mar Sat Sun
2–5pm

Malahide Castle, to the SW of the village, was founded in the 12thC; but the building itself has been substantially altered over the centuries, particularly in the 18thC. The dark over-filled interior now contains numerous **family portraits** from the collection of the late Lord Talbot de Malahide, and a marvellous, though confusingly displayed and only temporary, selection of the more important early **portraits** previously hung in the National Portrait Gallery of the National Gallery in DUBLIN, including

works by **Ramsay**, **Hogarth**, **Romney** (the artist's wife), **Opie**, **Reynolds**, **Nathaniel Hone the Elder** (an excellent self-portrait), **Hugh Douglas Hamilton** and **William Osborne**.

MONAGHAN
Co. Monaghan, Rep. Of Ireland Map C2

A busy county town known for its shoe factories, Monaghan has an interesting pedimented **market house** of 1791–2, and an important **Gothic Revival building** of 1861–92. This, the cathedral of the Catholic diocese of Clogher, once contained the celebrated 13thC **Cross of Clogher**, which is now in the County Museum.

County Museum
The Courthouse
Tel. (047) 82211
Open Tues–Sat 10am–1pm, 2–5pm;
June–Aug Sun 2–6pm
Closed Mon; Sun Sept–May
◫ ☑
The Monaghan County Museum, housed in a former courthouse, has a recently renovated interior, and was awarded the Council of Europe Museum Prize in 1980, for its well displayed and informative local collections. These include **prehistoric pottery** and fine examples of the distinctive **19thC lace** produced in the locality. The museum's outstanding treasure is undoubtedly the 13thC **Cross of Clogher ★**, a magnificent oak cross covered with bronze and semi-precious metal featuring representations of ecclesiastics and saints.

MONASTERBOICE
Co. Louth, Rep. of Ireland Map D3

The graveyard at Monasterboice, in an isolated rural setting about two miles W of the main Drogheda–Belfast road, contains the ruins of a monastery founded in the 6thC by an obscure saint named Buithe which existed until 1122. The ruins comprise two **churches**, a **round tower**, and three **carved high crosses** of the 10thC, including the famous **Muiredach's Cross ★★**, one of the best preserved of such monuments in Ireland. The E and W faces of this cross show, on their central panels, Christ in Glory surrounded by good and bad souls, and the Crucifixion; underneath and above are panels, some unidentified, of Old and New Testament scenes; while along the sides and base are fascinating interlacing and vinescroll motifs, as well

as amusing representations of animals and hunters. Nearer the round tower is the **Tall Cross**, with similar though far more worn carvings; the third cross is near the NE corner of the graveyard.

POWERSCOURT ESTATE ⌂
Ennisbury, Co. Wicklow, Rep. of Ireland Map D4

Tel. (01) 863557
Open Apr–Oct Mon–Sun 10am–5.30pm
Closed Nov–Mar
▧ ☙
Powerscourt House, an imposing 18thC granite building, was gutted by fire in 1974, and its main block is now only a charred shell. Yet its **gardens**, originally laid out in the 18thC but radically transformed in the following century, remain among the most famous and visited in Europe. They are entered through magnificent **wrought-iron gates** (c.1770) brought here from the Cathedral of Bamberg in Bavaria. The most celebrated view of the gardens looks down a series of terraces to two rearing winged horses in front of a lake behind which, in the far distance, rises the distinctively shaped Sugar Loaf mountain. A walk of 4 miles through rhododendron bushes takes you to the Powerscourt Waterfall, the highest waterfall in the British Isles and one of the most popular Irish sites among writers and artists of the Romantic generation. The late 18thC philosopher, Edmund Burke, who popularized the concept of the "Sublime", was a great enthusiast for the place and may have first encouraged **George Barret** – Ireland's best known landscapist of this period – to paint here.

RIVERSTOWN HOUSE ⌂
Co. Cork, Rep. of Ireland Map B5

Tel. (021) 821205
Open May–Sept Thurs–Sun 2–6pm
Closed Mon–Wed May–Sept; Oct–Apr
▧ ☑
Riverstown House, 4 miles from Cork on the Dublin road, is an early 17thC house substantially added to in the mid 18thC by Dr Jemmet Browne, Bishop of Cork. It was Dr Browne who engaged the well-known Italian plasterers, the **Francini brothers** to work in the dining room of this externally plain and rather dull building. The figurative **stuccowork ★** on the walls and ceiling of this room (which makes use of a design that Poussin prepared for Cardinal Richelieu) is among the finest 18thC stuccoes to be seen in Ireland.

RUSSBOROUGH 🏢 ✩✩
Nr. Blessington, Co. Wicklow, Rep. of Ireland Map D4

Tel. (045) 65239
Open Apr – Oct Sun 2.30 – 6.30pm;
* June – Sept Wed 2.30 – 6.30pm;*
* July – Aug Sat 2.30 – 6.30pm*
Closed Mon – Sat Apr – May; Mon Tues
* Thurs June – Sept; Nov – Mar*
📷 🏛 ⚓

Russborough is an enormous Palladian house built in 1741 for the Earl of Milltown. It would be worth visiting simply for the magnificence of its architecture and its 18thC interior decoration, which includes outstanding **plasterwork** by the Francini brothers (most notably in the saloon), as well as Louis XVI chairs covered in **Gobelin tapestries**. Yet what really makes this house such a memorable place is its collection of paintings, founded at the beginning of this century by the uncle of the last owner, Sir Alfred Beit. This collection – which achieved notoriety in 1974 when it was the object of a politically-motivated robbery – is one of the finest privately formed art collections in Europe. It is not so much its size that makes it important, but rather the almost uniformly high quality of the works within it. The holdings of **17thC Dutch art** are especially strong, with famous works by Frans Hals (*The Lute Player*) and Vermeer (*Interior with Two Women* ✩), and an intriguing *Marriage at Cana* ✩ by Jan Steen: this last highly detailed work interprets the biblical scene in terms of amusing and perceptive vignettes drawn both from 17thC Dutch life and theatre. But perhaps the finest Dutch painting in the collection is Jacob Ruisdael's *Castle at Bentheim* ✩✩, not only one of his greatest works but also one of the supreme masterpieces of Dutch 17thC landscape painting, with a breadth and grandeur of composition that makes most other Dutch landscapes of this period seem merely decorative.

The other strong point of the collection is the **Spanish paintings**, which include a group of narrative religious canvases by **Murillo** ✩. These are painted with extreme vigour and realism, and contradict conventionally held notions that this artist is principally a painter of sickly sweet Madonnas. Then there is Velazquez's celebrated *Christ at Emmaus* ✩✩, a genre scene executed during his Seville period and including still-life details that are haunting in their simplicity, as well as an equally well-known half-length study of a *Maja* ✩ in black lace by **Goya**. Among the British

works are a much reproduced genre portrait by Gainsborough (*The Cottage Girl* ✩), a fine Bonington *Seascape* ✩ and a dramatic **double-portrait** ✩ by Raeburn (*Sir John and Lady Clark*) which was one of the first of this Scottish artist's works to make an impact in London. Finally, mention should be made of a beautiful copy by **John Singer Sargent** of a detail from Velazquez's *The Spinners* in the Prado, Madrid.

SLIGO
Co. Sligo, Rep. of Ireland Map B2

Sligo, a pleasantly situated but architecturally undistinguished market town joining Lough Gill to the sea, is famous above all for its associations with the Yeats family. The paternal great-grandfather of the poet **William Butler Yeats** and the painter **Jack Yeats** was a rector at the village of Drumcliff six miles to the N. His son William (later a curate at Moira in Co. Down) was brought up at Drumcliff and would often speak with great nostalgia about the area to his own son, **John Butler Yeats**. The latter, a lawyer who later became a painter, was a close friend of George Pollexfen, whose family had been settled in Sligo for a number of years. John Butler Yeats's longing for the ancestral Sligo area might have contributed to his friendship with George Pollexfen and his marriage to George's beautiful and much sought-after sister, Susan. His children by her, Jack and William Butler Yeats, spent much of their childhood in Sligo with their maternal grandparents, the Pollexfens, and at the now abandoned Elsinore house at nearby **Rosses Point**, where their great-uncle William Middleton lived. Anyone familiar with the poetry of William Butler Yeats (who is buried in **Drumcliff** churchyard) will recognize the names of many of the places and sites of the area, particularly that of the imposing and distinctively shaped mountain that rises to the NE, Ben Bulben. **Jack Yeats** was similarly inspired by the area around Sligo and Rosses Point in his paintings, though most of his later life was spent in London and Dublin.

Sligo County Museum and Art Gallery
Stephen St
Tel. (071) 5847
Open (during exhibitions) Mon – Fri
* 10am – 2pm; 3 – 5pm; Sat 10am – 1pm*
Closed Sun
📷 ♿

The Sligo County Museum is a small, old-fashioned place crammed with items

of local interest, including a large painting showing a scene in the life of a local heroine, the freedom fighter Constance Markievicz (see LISSADELL). As with the art gallery, the museum's most interesting items relate to the **Yeats family**, including first editions, letters, poems and broadsheets by **William Butler Yeats**, and a number of books illustrated by **Jack Yeats**.

The art gallery and local library are housed in a converted late 19thC church opposite the museum. Most of the works are shown in a simple room above the library, and consist principally of **oils**, **watercolours** and **drawings** by Jack Yeats. The two outstanding masterpieces are both early oils, *Communicating with Prisoners* ★ and *An Island Funeral* ★. In his later works, of which there are many examples here, Yeats became increasingly free in his handling of paint, with results that might not be to everyone's taste; indeed, there is a strong "hit-or-miss" element in these works. His father **John Butler Yeats** is represented in the museum by a superlative portrait of *William Butler Yeats* ★. There are various works by other leading Irish artists of this period in the museum, displayed both in the main room and in the entrance hall and staircase well. Among these are works by **Sir William Orpen**, **Paul Henry**, **Sean Keating**, **Evie Hone** and **Mary Swanzy**. One of the artists who comes off well in this company is **Estella Solomons**, a pupil of Orpen and Osborne who, like Jack Butler Yeats, achieved fame as a portraitist of most of the famous figures associated with the Irish Revival. The museum has a number of her vigorous portraits, including one of Jack Yeats in middle age, and another of a woman in a riding jacket (probably Kathleen Goodfellow). Estella Solomons' own striking features are recorded in a sensitive portrait by her close friend **Frances Beckett**, aunt of the playwright Samuel Beckett.

UNION HALL
Co. Cork, Rep. of Ireland Map A6

An exceptionally pretty village on a long narrow bay, Union Hall has a main street which was recently made the subject of one of a popular series of postcards called "The Real Ireland".

Ceim Hill Museum
Cappagh
Open Mon – Sun 9.30am – 7pm
🏛 ➤ ✗
This museum, in an isolated spot W of Union Hall in the Skibbereen direction,

is not strictly speaking a museum or an art gallery. But this highly eccentric place should not be missed by anyone with an interest in Irish culture. The position of the museum is superb, with views down to a ruined **medieval tower** and across to a long bay with distant islands. You may wonder what sort of museum you are going to see as you make your way along a muddy path in the direction of a ramshackle cottage surrounded by miscellaneous decaying items. But pull a dangling piece of wire next to a board with the word "museum" written on it by hand, and you will be greeted by the charming proprietor, Miss Theresa O'Mahony, and taken inside what was once her sitting room. Ceim Hill Museum is in fact her house which she has crammed to capacity with an extraordinary range of objects either inherited or found on her property. Handwritten signs – some even in French and German – explain what these items are. Many of the items are of archaeological and geological interest, but there are also fascinating if sometimes rather worn examples of **local folk art**, such as excellent **traditional needlework.** You can also see **caricatures** of local people by Miss O'Mahony herself and some battered **old prints** which, though of little artistic quality, are interesting indicators of popular taste in art about 100 years ago. This museum, so small and yet so full that you can hardly turn without touching something, might lack the clear presentation of a local historical museum, but unlike these places it has a heart-warming character, teaching you more about people than objects.

WATERFORD
Co. Waterford, Rep. of Ireland
Map C5

Waterford's history dates back to when Danish Vikings settled here perhaps as early as AD 853. However, few old monuments of note survive. One of the attractions is the **Waterford Glass Factory**: the town became famous for the manufacture of glass in the early 19thC and though the trade came virtually to an end by 1851 as a result of excise duty, it was revived in 1947.

Waterford Municipal Art Gallery
O'Connell St
Tel. (051) 3501
Open Mon Wed Fri 2 – 5.30pm, 7 – 9pm;
Tues Sat 11am – 1pm, 2 – 5.30pm
Closed Sun
🏛 🏛

An attractive 18thC town house,

originally the house of a city alderman, contains the town library, and, on the ground floor, the Waterford Art Gallery. This is a modest collection, mainly of works by 20thC Irish painters, including **Jack Yeats, Paul Henry, Manie Jellet, Evie Hone** and **Sean O'Sullivan**.

WESTPORT
Co. Mayo, Rep. of Ireland Map A3

Westport, both architecturally and in terms of its situation, is one of the most attractive of Ireland's west coast towns, preserving some of the elegance it must have shown when first laid out in 1780. It stands at the head of the wonderful **Clew Bay**, which is guarded at its entrance by Clare Island and bordered to the S by the mountain of **Croagh Patrick**.

Westport House
*Open Apr–mid May, mid Sept–mid Oct
2–6pm; mid May–mid Sept
10.30am–1.30pm
Closed mid-Oct to Mar*
🏰 🏛 ☑ ❧

Westport House, just to the W of the town, is an enchanted place. Its walls are overgrown with ivy and moss, and it stands in parkland with a river, lake and distant views over to the sea and Croagh Patrick. Built in 1730 (though enlarged in 1781) for the Marquess of Sligo, it boasts a splendid dining room with excellent **plasterwork** and a long gallery with family portraits by **Opie, Beechey** and **Reynolds**. The most interesting paintings in the house are in the hall and on the walls of the marble stairs leading to the first floor. These are by the Irish Romantic landscapist **James Arthur O'Connor**, who is much less known than his contemporary and compatriot Francis Danby for the simple reason that he worked principally in Ireland. Yet the works at Westport are in many ways comparable to Danby's landscapes, having similar qualities of haunting stillness and cool precision in the

handling of forms and colour. They are all of sites in and around Westport and were painted between 1818–19 when O'Connor was a guest at Westport House of the 2nd Marquess of Sligo. One of the most curious of these works indulges the Marquess's fondness for comparing local sites to famous places in Europe: it shows Clew Bay transformed to look like the Bay of Naples, with Clare Island as Capri and Croagh Patrick as Vesuvius.

WHITE ISLAND
*Lower Lough Erne, Co. Fermanagh,
N. Ireland Map C2*

The enormous and little-spoilt lake of Lough Erne, dotted with wooded islands, is one of the great beauty spots of Ulster. You follow the road from Ballyshannon to Enniskillen until you reach a border post where there is a camouflaged sentry box. Immediately beyond this, the road S to Enniskillen takes you on to **Boa Island**, at the northern end of which, a poorly marked sign leads you off to the right to a most remarkable site. This is **Caldragh Cemetery**, a place overgrown with moss and wild flowers. In the middle of this are two **statues ★** of Janus form (i.e. facing both ways), the smaller and less impressive of the two being known as the "Lusty Man". Both figures presumably represent pagan gods and were probably executed in the 5thC or 6thC AD; although crudely carved, they make a powerful impression on the spectator, particularly in the context of their wild setting. Other **stone figures** of later date (probably AD 7thC–9thC) were until very recently to be found on **White Island**, which can be reached by hiring a boat from the Aghinver Boat Hire, situated on the eastern coastal road to Enniskillen 3 miles S of Pettigo. The figures (including a **Sheila-na-gig**) were attached to the wall of a small **12thC ruined church**; they have now been replaced by copies (the originals are in the Ulster Museum in BELFAST).

BIOGRAPHIES

This selective list of artists mentioned in the *Guide* consists mainly of British and Irish artists, but includes a number from other countries whose work has been influential in Britain and Ireland.

Adam, Robert 1728–92
Scottish architect and designer, active with equal distinction in Scotland and England. He was one of the greatest architects of the 18thC and outstanding also as an interior decorator and designer of furniture. Often he employed painters such as Kauffmann and Zucchi to provide decorative panels for his interiors. His father **William** (1689–1748) and his brothers **John** (1721–92) and **James** (1732–94) were also architects.

Alma-Tadema, Sir Lawrence 1836–1912
Dutch-born painter who became a naturalized British citizen in 1873. He achieved immense success with his scenes of Greek and Roman domestic life – paintings that helped to fashion a popular vision of the ancient world later associated with Hollywood films.

Amigoni, Jacopo 1682–1752
Italian decorative painter who spent most of the 1730s in England. His style is light and colourful.

Bacon, Francis b.1909
Irish painter, one of the most original and distinctive of contemporary figurative artists. His paintings often show twisted and disturbed figures from a world of horrific fantasy.

Barry, James 1741–1806
Irish painter, a vigorous exponent of history painting in the Grand Manner.

Barret, George 1732?–84
Irish landscape painter who settled in London in 1767. His work is in a rather prosaic version of Richard Wilson's style.

Bastien-Lepage, Jules 1848–84
French painter, mainly of portraits and scenes of rural life, popular and influential in his lifetime among British as well as French artists.

Batoni, Pompeo 1708–87
Italian painter. He was the most successful portraitist in 18thC Rome and it was almost obligatory for distinguished visitors to sit for him. Many of his finest works are still to be found in English country houses in the collections of the descendants of the sitter.

Beardsley, Aubrey 1872–98
English illustrator, one of the key figures of Aestheticism. His style was very distinctive, conveying a menacing sense of decadence. Despite his early death from tuberculosis, his output was large.

Bellini, Giovanni c.1430–1516
The greatest Venetian painter of his day.

His brother **Gentile** (c.1429/30?–1507) and his father **Jacopo** (c.1400–70/71) were also painters.

Bevan, Robert 1865–1925
English painter. Although he was a founder member of the Camden Town group, his favourite subject was rural life rather than the city. He worked in France in the 1890s and his use of strong colour was influenced by Gauguin.

Bewick, Thomas 1753–1828
English wood engraver, active mainly in Newcastle upon Tyne, where he had a flourishing business. He revived the art of wood engraving, transforming it into an economical process for fine book illustration.

Blake, William 1757–1827
English painter, engraver and poet, one of the greatest figures of the Romantic period.

Bomberg, David 1890–1957
English painter and founder member of the Vorticist movement. Before World War I he was considered one of the most avant-garde British artists, but much of his later career was spent in relative obscurity.

Bonington, Richard Parkes 1802–28
English painter in oil and watercolour, active mainly in France. He is best known for his landscapes, but also painted genre scenes and romantic, medieval and oriental subjects. His brilliant, fluid technique was highly influential on French painters.

Boucher, François 1703–70
French painter of mythology, gallantry, landscape and portraits, one of the greatest of Rococo artists.

Boudin, Eugène 1824–98
French painter of seascapes and beach scenes. His spontaneous brushwork influenced the Impressionists.

Brangwyn, Sir Frank 1867–1956
Bruges-born British painter, etcher and designer. He is best known for his large-scale decorative schemes.

Bratby, John b.1928
English artist, active in various fields but best known as the most prominent member of the so-called "kitchen-sink" school of painters of everyday domestic life, at its peak in the 1950s.

Bronzino, Agnolo 1503–72
Florentine Mannerist painter. He is best known for his elegant and highly polished court portraits.

Brown, Ford Madox 1821–93
English painter of historical, literary, biblical and genre scenes, and

landscapes. He expressed his social beliefs in his work and was an important influence on the Pre-Raphaelites, although never a member of the Brotherhood.

Brown, Lancelot 1716–83
English architect and (much more important) landscape gardener, nicknamed "Capability Brown" because he is supposed to have told patrons that their estates had "great capabilities". He designed gardens for many of the greatest English country houses.

Bruegel (Brueghel), **Pieter the Elder** c.1525–69
The greatest Netherlandish painter of the 16thC. He is best known for his peasant scenes and landscapes, but he also painted moving religious works. His sons were painters: **Pieter Brueghel the Younger** (1564–1638) imitated his father's work; **Jan Brueghel** (1568–1625), a friend of Rubens often known as "Velvet Brueghel".

Burlington, Richard Boyle, 3rd Earl of 1694–1753
English architect and patron, the chief proponent of Palladianism through his buildings and his publishing activities.

Burne-Jones, Sir Edward Coley 1833–98
English painter, illustrator and designer, one of the leading lights of the second wave of Pre-Raphaelites that had a great vogue from the 1860s onwards. His favourite subjects were romantic legends and allegories.

Burne-Jones, *Portrait by his son Sir Philip, 1898, London, NPG*

Burra, Edward 1905–76
English painter, best known for his Surrealistic work of the 1930s.

Butler, Lady Elizabeth (Elizabeth Thompson) 1846–1933
English painter whose patriotic military scenes were once immensely popular.

Butler, Reg 1913–81
English sculptor. As a conscientious

objector in World War II he worked as a blacksmith, and his finest sculptures are semi-abstract pieces using iron-forging techniques.

Canaletto (Giovanni Antonio Canal) 1697–1768
The leading view-painter of the 18thC, active mainly in his native Venice where he acquired a great reputation among British visitors. He spent the decade 1746–56 largely in England and is best represented in English collections.

Canova, Antonio 1757–1822
Italian sculptor, one of the most celebrated Neoclassical artists. He was noted for his generous nature and had an immense influence on younger sculptors.

Caravaggio, Michelangelo Merisi da 1571–1610
The greatest Italian painter of the 17thC. His revolutionary style – characterized by bold, strongly lit, realistically painted figures emerging dramatically from dark shadow – was immensely influential throughout Europe.

Cézanne, Paul 1839–1906
French painter, one of the greatest artists of the 19thC and a key figure in the development of 20thC art. His declared aim was to make Impressionism into "something solid and durable, like the art of the museums" and his rigorous analysis of structure made him an inspiration to the pioneers of abstract art.

Chadwick, Lynn b.1914
British sculptor who uses various materials inventively in his work.

Champaigne, Philippe de 1602–74
The greatest French portraitist of the 17thC, also a distinguished painter of religious works.

Chantrey, Sir Francis 1781–1841
English Neoclassical sculptor. He created numerous impressive church monuments.

Chardin, Jean-Baptiste-Siméon 1699–1779
French painter of still-life and genre, one of the outstanding artists of the 18thC.

Cibber, Caius Gabriel 1630–1700
Danish-born sculptor who settled in England shortly before 1660. He had a successful workshop producing tombs, garden sculpture and pieces for architectural settings.

Clarke, Harry 1889–1931
Irish stained glass designer, one of the most original artists ever to work in the medium. He also worked as a book illustrator.

Claude Gellée called **Claude Lorrain** 1600–82
French painter, active in Rome for

almost all his career. He was the most famous exponent of ideal landscape and was enormously influential – in England his influence pervades landscape gardening as well as painting.

Clausen, Sir George 1852 – 1944
English painter. He was an original member of the New English Art Club and specialized in agricultural scenes strongly influenced by the *plein-air* realism of Bastien-Lepage.

Coldstream, Sir William b. 1908
British painter, co-founder with Pasmore of the Euston Road school. He has influenced many young British figurative painters through his work as a teacher.

Colquhoun, Robert 1914 – 62
Scottish painter, active mainly in London. He used stylizations derived from Cubism and the hard-edged portraits of Wyndham Lewis.

Constable, John 1776 – 1837
English landscape painter. He received limited recognition during his lifetime, but is now, with Turner, considered one of the most important landscape artists of the 19thC. Although admiring Gainsborough, Claude and the 17thC Dutch landscapists, he believed in studying directly from nature and his freshness of approach was highly influential, although initially more in France than in England.

Constable, *Self-portrait drawing,*
c. 1800, London, NPG

Cooper, Samuel 1609 – 72
English miniature painter. He was the most celebrated miniaturist of his day.

Cooper, Thomas Sidney 1803 – 1902
English painter of animal subjects. Almost all his pictures show sheep or cattle, and he had immense success with them. His work was shown every year at the Royal Academy from 1833 – 1902, a record for continuous exhibiting.

Copley, John Singleton 1738 – 1815
The greatest American painter of the 18thC, working in England from 1775. He made his reputation as a portraitist, but the most remarkable works he produced in England are his history paintings.

Corot, Jean-Baptiste-Camille 1796 – 1875
French landscape and figure painter. He is one of the most important artists in the history of landscape painting, as his unaffected, clearly lit scenes broke away from stereotypes and were a major influence on the next generation.

Correggio (Antonio Allegri) d. 1534
Italian painter, one of the most inventive artists of the High Renaissance. He is noted particularly for his subtle treatment of light and shade and his brilliant handling of erotic subjects.

Cotes, Francis 1726 – 70
English portraitist, best known for his pastels.

Cotman, John Sell 1782 – 1842
English landscape painter, one of the finest exponents of the classic watercolour technique and a leader of the Norwich school.

Courbet, Gustave 1819 – 77
French painter, the foremost exponent of Realism, who exerted an immense influence on 19thC art by his emphatic rejection of idealization.

Cox, David 1783 – 1859
English landscape painter, principally in watercolour, on which he published several treatises.

Cozens, Alexander c. 1717 – 86
English landscape draughtsman. His son **John Robert** (1752 – 97) was a landscape watercolourist and pioneered the Romantic representation of the Alps.

Cranach, Lucas the Elder 1472 – 1553
German painter and designer of woodcuts, one of the leading artists of the Northern Renaissance.

Crane, Walter 1845 – 1915
English painter, designer and book illustrator. He was associated with the Arts and Crafts movement.

Crome, John 1768 – 1821
English landscape painter and etcher, known as "Old Crome" to distinguish him from his son **John Crome** (1794 – 1842), also a painter. Old Crome was a founder member of the Norwich school, and his work owes much to the 17thC Dutch landscapists.

Cuyp, Aelbert 1620 – 91
One of the most famous Dutch landscape painters. His glowing effects of light and majestic power of composition bring him closer to Claude than any of his Dutch contemporaries. He had an enormous reputation in England in the 18thC and

19thC and is best represented in English collections.

Dadd, Richard 1819–87
English painter. He went mad and in 1843 murdered his father. For the rest of his life he was confined to asylums, where he executed allegorical and fairy pictures crowded with intricate detail.

Danby, Francis 1793–1861
Irish painter working mainly in Bristol and London. He is best known for his apocalyptic scenes in the manner of John Martin, but he also painted pastoral idylls.

Daumier, Honoré 1808–79
French painter, sculptor and lithographer, considered the father of modern caricature.

Davies John b. 1946
English sculptor. His work is highly distinctive, consisting of plaster figures of clothed men cast from the life; they evoke a powerful feeling of alienation.

Degas, Edgar 1834–1917
French painter and sculptor, one of the most popular of 19thC artists. Although he is a central figure in Impressionism, he differed from his colleagues in the stress he laid on drawing and in the fact that he did not paint outdoors.

Delacroix, Eugène 1798–1863
French painter, one of the greatest artists of the Romantic movement.

De Morgan, William 1839–1917
English ceramic designer, an associate of Morris and Burne-Jones and a powerful influence on the Arts and Crafts movement and Art Nouveau.

Devis, Arthur 1711–87
British portrait painter. He was a leading exponent of the conversation piece and was especially favoured by first-generation owners of property.

De Wint, Peter 1784–1844
English landscape painter of Dutch extraction, primarily a watercolourist.

Dobson, William 1610–46
The greatest English painter of the 17thC, almost exclusively a portraitist. All his portraits show royalist sitters; they are reminiscent of Van Dyck's works, but they are more robust in temperament.

Duccio di Buoninsegna a. 1278–1318
The greatest painter of the Sienese school.

Dughet, Gaspard (also called Gaspard Poussin) 1616–75
French landscape painter, draughtsman and etcher, active in Rome. His work was highly influential in the 18thC, especially on the development of the Picturesque in England.

Dürer, Albrecht 1471–1528
German painter, printmaker and writer on art, the greatest artist of the Northern Renaissance. His prints were enormously influential throughout Europe, and he was the first artist of such stature to express himself primarily through engraving.

Dyce, William 1806–64
Scottish painter. He worked in a bold, serious style influenced by Raphael, whose work he had studied in Italy. He transmitted his ideals to the Pre-Raphaelite brotherhood.

Eastlake, Sir Charles 1793–1865
English history and genre painter, art historian and arts administrator.

Egg, Augustus Leopold 1816–63
English painter of literary, historical and contemporary scenes.

Epstein, Sir Jacob 1880–1959
American-born British sculptor. He studied in Paris and his work before World War I paralleled the most avant-garde French art in its use of formal simplifications and awareness of primitive art.

Etty, William 1787–1849
English painter, celebrated for his paintings of the female nude.

Eworth, Hans c. 1520-after 1573
Flemish portrait painter, active mainly in England, where he was official portraitist to Mary I.

Eyck, Jan van d. 1441
The most renowned Netherlandish painter of the 15thC.

Fabritius, Carel 1622–54
Dutch painter, Rembrandt's finest pupil and probably the master of Vermeer.

Faed, Thomas 1826–1900
Scottish painter. He specialized in sentimental genre scenes.

Fantin-Latour, Henri 1836–1904
French painter and lithographer, one of the finest of all flower painters.

Finlay, Ian Hamilton b. 1925
Scottish artist. He is a poet as well as a sculptor and graphic artist, and his work – particularly his highly personal form of experimental art – explores the relationship between words and images.

Flaxman, John 1755–1826
English sculptor, illustrator and designer, one of the outstanding Neoclassical artists. He established an international reputation with his illustrations (1793) of Homer's *Iliad* and *Odyssey*.

Flint, Sir William Russell 1880–1969
English painter and graphic artist, remembered mainly for his mildly erotic watercolours of female nudes.

Foley, John Henry 1818–74
Irish sculptor. He was active mainly in England, where he was one of the leading

monumental sculptors of his period, contributing in particular many figures for the Albert Memorial.

Forbes, Stanhope 1857–1947
Irish-born painter, active chiefly in Cornwall, where he was a leading figure of the Newlyn school.

Fragonard, Jean-Honoré 1732–1806
French painter of mythology, gallantry and landscape, one of the quintessential Rococo artists.

Frampton, Sir George 1860–1928
Distinguished sculptor, best known for his *Peter Pan* statue. His son **Meredith** (b.1894) was a painter who achieved considerable acclaim in the interwar years with his vividly focused and impeccably finished works.

Freud, Lucian b.1922
German-born painter (the grandson of Sigmund Freud) who settled in England in 1931. Principally a portraitist, his work is among the most distinctive of any contemporary figurative painter.

Frink, Dame Elisabeth b.1930
British sculptor and printmaker, working mainly in bronze.

Frith, William Powell 1819–1909
English painter. He turned with enormous success from history paintings to anecdote-crowded contemporary scenes, such as *Derby Day*.

Fry, Roger 1866–1934
English art critic and painter. His two exhibitions of Post-Impressionism in 1910 and 1912 showed the work of painters such as Cézanne and Van Gogh in London for the first time.

Fuseli, Henry (Johann Heinrich Füssli) 1741–1825
Swiss painter and draughtsman, active mainly in England, where he was a key figure of Romanticism. His chief inspirations were derived from literature and myth.

Gainsborough, Thomas 1727–88
One of the greatest and best-loved English painters, active in his native Suffolk, Bath and London. He maintained that landscape was his first love, but his output consisted mainly of portraits, which were financially more rewarding.

Gaudier-Brzeska, Henri 1891–1915
French sculptor, some of whose short but influential career (he died in World War I) was spent in England.

Gauguin, Paul 1848–1903
French painter, sculptor and printmaker, one of the founding fathers of modern art. His rejection of the naturalism of the Impressionists in favour of subject matter provided by the imagination and depicted by Expressionist means was a momentous contribution to the development of modern art.

Gentileschi, Orazio 1563–1639
Italian Caravaggesque painter who settled in England in 1626. His daughter **Artemisia** (1593–c.1652), arguably the greatest of all women painters, visited him in England in 1638–40.

Géricault, Théodore 1791–1824
French painter and graphic artist, one of the founders of Romanticism. His highly-charged subject matter and his powerful and spontaneous brushwork became hallmarks of the Romantic style.

Gertler, Mark 1891–1939
He was one of the most individual British artists of his generation, and folk art was one of the influences on his complex style. He committed suicide after the failure of an exhibition.

Gheeraerts, Marcus the Younger 1562–1636
Flemish-born portrait painter, the son of the engraver **Marcus the Elder** (c.1530–c.1590), with whom he came to London in 1568. In the 1590s he became the most fashionable portraitist in London.

Gibbons, Grinling 1648–1721
Dutch woodcarver and sculptor who settled in England in about 1667. He was a virtuoso craftsman and his renown is such that most good English woodwork of roughly the right date has been attributed to him at one time or another.

Gibson, John 1790–1866
English Neoclassical sculptor, based in Rome for most of his career. He was a protegé of Flaxman.

Gilbert, Sir Alfred 1854–1934
English sculptor. He was a virtuoso metal worker, and the sinuous plant forms he often employed are among the finest expressions of Art Nouveau.

Gill, Eric 1882–1940
English sculptor, engraver, book illustrator and designer of printing types. A Roman Catholic convert, he tried to revive a medieval religious attitude towards art.

Gilman, Harold 1876–1919
English painter, a founder-member of the Camden Town group. He emulated Sickert in the choice of working-class subject matter and unconventional, informal composition, but favoured much brighter colours.

Gilpin, Sawrey 1733–1807
English painter of horses. He tended to endow his animals with human emotion, a trait that differentiated him from the more scientifically-minded Stubbs. His brother, the **Reverend William** (1724–1804), was an amateur draughtsman and an influential writer on the Picturesque.

Gimson, Ernest William 1864–1919
English designer, one of the outstanding
figures of the Arts and Crafts movement.
He is best known for his furniture
designs, which often make brilliant use of
marquetry inlay.

Ginner, Charles 1878–1952
English painter, a founder-member of the
Camden Town group. His favoured
subject matter was the townscape.

Giorgione da Castelfranco
1476/78–1510
Venetian painter, who was one of the
first artists to paint small pictures for
private collections. The mood of his
works, usually one of poetic reverie, is
often more important than the subject.

Girtin, Thomas 1775–1802
English landscape watercolourist. With
Turner he was chiefly responsible for
freeing watercolour from its dependence
on line drawing and making it into an
independent medium.

Girtin, *Portrait by Opie, c.1800,*
London, NPG

Giulio Romano 1499–1546
Italian painter and architect, the chief
pupil and assistant of Raphael and one of
the most important Mannerist artists. An
indication of his fame is that he is the
only contemporary artist mentioned in
Shakespeare ("That rare Italian master
Julio Romano", *The Winter's Tale*, v.2,
105).

Gore, Spencer 1878–1914
English painter, a founder-member of the
Camden Town group. Influenced by Van
Gogh and Gauguin, he moved further
towards abstraction than any of his
Camden Town colleagues. His son,
Frederick (b.1913), is also a painter.

Goya y Lucientes, Francisco de
1746–1828
Spanish painter and printmaker, the
most powerful and original European
artist of his period. His work developed
from charming Rococo scenes to

devastating indictments of human
cruelty and corruption.

Goyen, Jan van 1596–1656
Dutch painter, a pioneering figure in the
development of realistic landscape.

Grant, Duncan 1885–1978
British painter and designer, a close
associate of Roger Fry and co-director of
the Omega Workshops.

Greaves, Walter 1846–1930
English painter. He was a pupil and
assistant of Whistler and is particularly
noted for his river scenes (he came from a
boatbuilding family and used to ferry
Whistler across the Thames).

Greco, El (Domenikos Theotokopoulos)
1541–1614
Painter, sculptor and architect, born in
Crete and trained in Italy, but considered
one of the greatest artists of the Spanish
school.

Greuze, Jean-Baptiste 1725–1808
French painter. His anecdotal genre
scenes made him the most popular
painter in mid 18thC France.

Grimshaw, John Atkinson 1836–93
English painter of landscapes,
townscapes and dockyards, usually seen
by moon or lamplight, or at sunset. His
highly distinctive style was much
imitated, notably by his sons **Arthur**
(1868–1913) and **Louis** (1870–1943?).

Guardi, Francesco 1712–93
The best-known member of a family of
Venetian artists. He painted various
subjects, but he is remembered almost
exclusively for his views of Venice.

Guthrie, Sir James 1889–1930
Scottish painter. He began as a landscape
painter in the open-air tradition of
Bastien-Lepage, but turned to portraiture
with great success.

Hals, Frans 1581/5–1666
The first great painter of the 17thC
Dutch school and one of the greatest of
all portraitists.

Hamilton, Gavin 1723–98
Scottish Neoclassical history painter,
Classical archaeologist and art dealer.
Based in Rome from about 1755, he
earned his living chiefly by selling Old
Master paintings and Classical antiquities
to British collectors making the Grand
Tour.

Hamilton, Richard b.1922
English painter, best known as one of the
earliest and leading exponents of Pop art.

Haydon, Benjamin Robert 1786–1846
English history and portrait painter. He
continually promoted the cause of history
painting, but his own works often lapsed
into clumsy melodrama.

Hayman, Francis 1708–76
English painter and book illustrator. He is

best known for his conversation pieces and small informal portraits, which influenced Gainsborough's early works.

Henry, George 1859–1943
Scottish painter. He was a prominent member of the movement known as the "Glasgow Boys", which took a keen interest in the latest developments in painting on the Continent.

Hepworth, Dame Barbara 1903–79
English sculptor. Most of her work is abstract, but her hollowed-out forms suggest organic growth.

Herkomer, Sir Hubert von 1849–1914
Bavarian-born English painter. He is best known for his social realist scenes, but he also designed for the stage and produced sets for the early cinema.

Heron, Patrick b.1920
English painter. From the late 1950s his work has been entirely abstract and primarily concerned with the interaction of colour.

Herring family
Family of English sporting and animal painters flourishing in the 19thC. The best-known members were **John Frederick Senior** (1795–1865) and his son **John Frederick Junior** (d.1907).

Hilliard, Nicholas 1547–1619
English miniaturist, the greatest English painter of the 16thC. He worked for Elizabeth I and James I and portrayed many of the leading figures of his times. His exquisite miniatures often have elaborate jewelled cases, which are probably his own work (he trained as a goldsmith). Hilliard's son **Lawrence** (1582–after 1640) was also a miniaturist.

Hitchens, Ivon 1893–1979
English painter. He mainly painted landscapes in a highly distinctive style – the scene is evoked in broad brush strokes on a wide canvas forming a semi-abstract panorama.

Hobbema, Meindert 1638–1704
Dutch landscape painter. He was very popular and influential in England in the 18thC and 19thC.

Hockney, David b.1937
English painter, draughtsman, printmaker, photographer and stage designer, an internationally successful artist since the early 1960s. The best-known British artist of his generation.

Hogarth, William 1697–1764
English painter and engraver, one of the most influential figures in establishing the status of the British school. A fine portraitist, his most original works were his serial picture stories exposing the follies and vices of the day. These reached a wide audience through engravings (mostly by Hogarth himself) and he became the first British artist to achieve international acclaim.

Holbein, Hans the Younger 1497/8–1543
German painter and designer of woodcuts, the greatest portraitist of the Northern Renaissance. He visited England in 1526–8 and settled there permanently in 1532 as court painter to Henry VIII. He had an enormous influence on English painting, especially on Hilliard.

Honthorst, Gerrit van 1590–1656
Dutch painter. He is best known as one of northern Europe's leading followers of Caravaggio, but in the 1620s he changed his style completely and became a successful court portraitist.

Hooch, Pieter de 1629–84
One of the most popular of Dutch genre painters.

Hoogstraten, Samuel van 1627–78
Dutch painter, a pupil of Rembrandt, active in London and other European capitals, as well as several Dutch cities.

Hoppner, John 1758–1810
English portrait painter. He was one of the chief successors of Reynolds and a rival to Lawrence.

Hudson, Thomas 1701–79
English painter, the most fashionable London portraitist of the 1740s and early 1750s, until he was overtaken by his former pupil Reynolds.

Hughes, Arthur 1830–1915
English Pre-Raphaelite painter and illustrator.

Hunt, William Holman 1827–1910
English painter, one of the founders of the Pre-Raphaelite Brotherhood. He was the only one of the Pre-Raphaelites to maintain his early idealism throughout his career.

Innes, James Dickson 1887–1914
Welsh painter. He was a friend of Augustus John and painted with him in North Wales. His paintings are always on a small scale, with a decorative refinement recalling Japanese prints.

John, Augustus 1878–1961
Welsh painter, principally renowned as a portraitist. One of the most colourful figures of his generation, he was identified in the first quarter of the 20thC with all that was more rebellious in British art.

John, Gwen 1876–1939
Welsh portrait painter, the sister of Augustus John, active mainly in Paris. She worked on a small scale in neutral colours, showing a sensitivity to tone comparable to that of Whistler, with whom she studied.

Johnson or **Jonson, Cornelius** (Janssens

van Ceulen) 1593–1661
English painter of Dutch parentage, one of the leading portraitists of his period. He left England during the Civil War and settled in Holland.

Jones, David 1895–1974
English painter, writer and calligrapher. He was a friend of Gill.

Jones, Inigo 1573–1652
English architect, stage designer, draughtsman and painter. He is principally famous for revolutionizing English architecture by introducing a fully mature Classical style, but he was also the finest British draughtsman of his time.

Jones, Thomas 1742–1803
Welsh landscape painter. He lived in Italy from 1776–83 and his most notable works are the spirited oil sketches he made in and around Rome and Naples. They are the earliest British oil sketches to survive in any quantity.

Kauffmann, Angelica 1741–1807
Swiss painter, active in England from 1766–81. She began as a portraitist, but branched out to paint pioneering pictures illustrating Homer, Shakespeare and English history.

Kent, William 1685?–1748
English architect, interior designer, landscape gardener and painter.

King, Jessie Marion (Mrs E. A. Taylor) 1876–1949
Scottish illustrator, painter and jewellery designer. She was among the leading Art Nouveau illustrators.

Kneller, Sir Godfrey (Gottfried Kniller) 1646–1723
German-born portrait painter who settled in England in 1674. By the mid-1680s he had become Lely's successor as the country's leading portrait painter, his well-organized studio producing a prodigious volume of work.

Knight, Dame Laura 1877–1970
English painter. She is best known for her colourful scenes of gypsy life, the circus and the ballet. Her husband, **Harold Knight** (1874–1961), was also a painter, principally of portraits.

Kokoschka, Oskar 1886–1980
Austrian painter and writer. He painted a wide variety of subjects in an energetic Expressionist style and also wrote several plays. From 1937–48 he lived in England.

Laguerre, Louis 1663–1721
French decorative painter, working in England 1683/84.

Lancret, Nicholas 1690–1743
French painter, with Pater the chief of Watteau's imitators.

Landseer, Sir Edwin 1802–73
English painter, sculptor and engraver, mainly of animal subjects.

Laroon, Marcellus the Younger 1679–1772
English painter and draughtsman of genre and portraits. His father, **Marcellus the Elder** (1653–1701/2), was a portrait painter – an assistant and follower of Kneller.

Lavery, Sir John 1856–1941
Irish-born painter, active mainly in Glasgow, London and Tangiers (where he had a studio and usually spent the winter). He was one of the most successful portraitists of his day and also painted landscape and genre works.

La Thangue, Henry Herbert 1859–1929
English landscape and rustic genre painter. He was a friend of Stanhope Forbes and had similar ideals to the painters of the Newlyn school.

Lawrence, Sir Thomas 1769–1830
English painter, Reynolds' successor as the most fashionable portraitist of the day.

*Lawrence, Self-portrait, c. 1810,
London, Royal Academy*

Lebrun, Charles 1619–90
French painter, the most important artist of Louis XIV's reign and the chief formulator of French academic doctrine.

Leighton, Frederic, Lord 1830–96
English painter and sculptor of historical and mythological subjects. He was the prime exponent of the vogue for Classical subjects.

Lely, Sir Peter 1618–80
English portrait painter of Dutch origin; though he painted Charles I, Cromwell and leading figures of the Interregnum, he is particularly associated with the luxurious Restoration court of Charles II. He was immensely successful and operated a highly organized studio, often

painting no more than the head in works that bear his name.

Leonardo da Vinci 1452–1519
Florentine artist, scientist and writer, one of the greatest of Renaissance painters and perhaps the most versatile genius who has ever lived. His immense prestige and fame helped to raise the status of the visual arts.

Le Sueur, Hubert c. 1595–c. 1650
French sculptor with great skill as a bronze caster who settled in England in 1625 and was patronized by Charles I.

Lewis, Percy Wyndham 1882–1957
English painter and writer. He was the central figure in the Vorticist movement.

Loutherbourg, Philippe Jacques de 1740–1812
French painter who settled in England in 1771 and became a friend of Gainsborough. His most characteristic works are dramatically charged landscapes, but he also painted battle scenes and literary and biblical episodes.

Lowry, Lawrence Stephen 1887–1976
One of the most popular and distinctive of 20thC English painters. His work represents a personal response to the northern industrial environment in which he lived.

Mackintosh, Charles Rennie 1868–1928
Scottish architect and designer, working mainly in Glasgow. He was one of the most original artists of his time, and one of the finest and most influential exponents of Art Nouveau.

Maclise, Daniel 1806–70
Irish painter and lithographer, living in London after 1827. He achieved eminence in two very different fields – lithographic caricature and grandiose history painting.

McTaggart, Sir William 1835–1910
Scottish landscape painter, renowned for his coastal scenes.

Manet, Edward 1832–83
French painter and graphic artist, one of the most important artists of the 19thC and often regarded as the father of modern painting.

Mantegna, Andrea c. 1430–1506
Italian painter and engraver, one of the most renowned artists of the early Renaissance. His paintings reveal his devotion to Classical antiquity.

Marshall, Benjamin 1767–1835
English sporting painter, a follower of Stubbs, who concentrated mainly on horse racing.

Martin, John 1789–1854
English romantic painter and mezzotint engraver. He specialized in intensely melodramatic scenes depicting

Martin, *Portrait by H. Warren, c. 1839, London, NPG*

cataclysmic events, often from the Bible or Milton.

Matisse, Henri 1869–1954
French painter, one of the greatest and most influential artists of the 20thC. He sought to eliminate illusionistic description of volume and space from his work, emphasizing instead the flatness of the picture surface and the abstract purity of line, decorative pattern and colour. Although crippled by arthritis, he worked until his death, and was a forceful sculptor and illustrator as well as a painter.

Memlinc or **Memling, Hans** c. 1430/40–94
German-born Netherlandish painter, a popular and prolific artist.

Mengs, Anton Raffael 1728–79
German history painter and portraitist. He was one of the key figures of Neoclassicism, but his writings were generally more important than his paintings.

Michelangelo Buonarroti 1475–1564
Florentine sculptor, painter, architect, draughtsman and poet, one of the supreme giants of world art. His contemporaries called him "divine", and his influence on European art has been incalculable.

Millais, Sir John Everett 1829–96
English portrait, landscape, genre and history painter. He was a child prodigy and one of the leading lights of the Pre-Raphaelite Brotherhood. Subsequently he became an immensely successful society portrait painter.

Millet, Jean-François 1814–75
French painter and graphic artist. He was of peasant stock and is best known for his depictions of rural life.

Monet, Claude Oscar 1840–1926
French painter, often considered the

Impressionist *par excellence* because his commitment to the ideas of the movement was total throughout his career.

Moore, Albert 1841–93
English painter. His most characteristic paintings depict statuesque Grecian maidens, singly or in groups. Whistler was influenced by his work.

Moore, Henry b.1898
English sculptor and graphic artist, the most renowned British artist of the 20thC. His work, both figurative and abstract, is noted for its monumental grandeur, and often forms a powerful visual relationship with its setting, particularly when placed in a landscape.

Mor, Anthonis 1519–75
Netherlandish painter, active at numerous European courts as the leading international portraitist of his day (he is also known by the English and Spanish versions of his name – Sir Anthony More and Antonio Moro).

Morisot, Berthe 1841–95
French Impressionist painter, best known for quiet family scenes. She was influential in persuading Manet (her brother-in-law) to take up outdoor painting.

Morland, George 1763–1804
English painter of rustic genre, especially interiors of stables and scenes at ale-house doors.

Morris, William 1834–96
English writer, painter, designer and printer. One of the great Victorian reformers, he looked to medieval traditions to restore art as an essential part of human well-being and progress. His firm, Morris and Company, founded in 1861, made carvings, fabrics, tapestries, stained glass, furniture and wallpaper – anything that satisfied his credo: "Have nothing in your home that you do not know to be useful or believe to be beautiful."

Munnings, Sir Alfred 1878–1959
English painter specializing in scenes with horses. He was a traditionalist and made use of his position as President of the Royal Academy to attack modern art.

Murillo, Bartolomé Esteban 1618–82
Spanish painter, best known for two types of painting – sentimental genre scenes of peasant children and devotional paintings appealing to popular piety.

Mytens, Daniel c.1590–1647
Anglo-Dutch portrait painter, born in Delft and active in England c.1618–c.1634.

Nash, Paul 1889–1946
English painter and printmaker. He created memorable paintings as an official war artist in both world wars and was also one of the finest book illustrators of the 20thC.

Nasmyth, Alexander 1758–1840
Scottish painter and landscape artist, active mainly in Edinburgh. His son **Patrick** (1787–1831) was a landscape painter, known (in spite of the fact he was a Scot) as "the English Hobbema".

Nevinson, Christopher Richard Wynne 1889–1946
English painter. His finest works are his depictions of World War I, which employ a powerful angular style.

Nicholson, Ben 1894–1982
English artist, one of the pioneers and most sensitive exponents of abstract art in Britain. As well as paintings, he produced shallow reliefs in white plaster. His father, **Sir William** (1872–1949), was a painter and poster designer, best known for his delicate still lifes.

Nollekens, Joseph 1737–1823
English Neoclassical sculptor, the most distinguished member of a family of artists originally from Antwerp. His brilliantly characterized busts made him the leading portrait sculptor of the day.

Northcote, James 1846–1831
English painter. He was principally a portraitist, but in addition he painted historical pictures and also moralizing scenes that unsuccessfully tried to emulate Hogarth's pioneering works.

O'Conor, Roderic 1860–1940
Irish painter, active principally in France. He was influenced by Van Gogh and Gauguin.

Oliver, Isaac before 1568–1617
English miniaturist of French origin, Hilliard's pupil and his successor as the leading miniaturist of the day. His son **Peter** (c.1594–1647) was also a miniaturist.

Opie, John 1761–1807
English portrait, history and genre painter.

Orchardson, Sir William Quiller 1835–1910
Scottish painter who settled in London in 1862. He began with historical genre subjects, but later specialized in scenes of psychological tension in upper-class married life.

Orpen, Sir William 1878–1931
Irish painter, active mainly in London, where he enjoyed enormous success as a fashionable portraitist. His paintings done as an official war artist in World War I reveal a very different side to his talents in their grim objectivity.

Osborne, Walter Frederick 1859–1903
Irish landscape and portrait painter. He is noted for his vigorous handling and

unaffected charm. His father **William** (1823–1901) was an animal and portrait painter.

Parmigianini (Girolamo Francesco Maria Mazzola) 1503–40
Italian painter and etcher, one of the most elegant and distinctive of Mannerist artists.

Palmer, Samuel 1805–81
English painter and etcher of pastoral scenes. He is famous for the work produced during a period (1827–35) when he lived at Shoreham in Kent; inspired by Blake, he painted mystical landscapes of hallucinatory intensity. The rest of his career was much less memorable.

Paolozzi, Eduardo b. 1924
Scottish sculptor and printmaker. Much of his work shows a fascination with machinery and he was a key figure in the development of Pop art.

Pasmore, Victor b. 1908
English painter. He was a founder of the Euston Road school, but was less interested in documentary Realism than in poetic, almost Whistlerian effects of light. Later he became one of the leading British exponents of abstract art.

Pater, Jean-Baptiste 1695–1736
French painter, the pupil of Watteau and with Lancret his principal imitator.

Paton, Sir Joseph Noel 1821–1901
Scottish painter, most notable for his whimsical fairy pictures and his rather cold and severe religious paintings.

Pellegrini, Giovanni Antonio 1675–1741
Venetian painter, a prolific and slapdash decorator who worked in Austria, England, Holland, Germany and France.

Phillip, John 1817–67
Scottish painter of genre scenes, whose Spanish scenes earned him the title "Phillip of Spain".

Picasso, Pablo 1881–1973
Spanish painter, sculptor, graphic artist, ceramicist and stage designer. The most renowned artist of the 20thC, whose protean development encompassed the majority of its progressive movements. His prodigious capacity for work and his fluency of invention have perhaps exceeded those of any other artist.

Piero di Cosimo 1462–1521
Florentine painter, one of the most charmingly idiosyncratic painters of his time.

Piper, John b. 1903
English painter, designer and printmaker who has worked in a number of fields, including abstract painting (he was one of the leading British practitioners in the 1930s) and stained glass design.

Pissarro, Camille 1830–1903
French painter, one of the leading Impressionists. His son **Lucien** (1863–1944), a painter and book illustrator, settled in England in 1890.

Poussin, Nicholas 1593/4–1665
French painter, active in Rome for almost all his career. He was the chief formulator of the French Classical tradition in painting, his works being based on a profound study of ancient literature and art. His ideal landscape paintings, like those of Claude, were extremely influential in England.

Poynter, Sir Edward 1836–1919
One of the most successful English painters of his period, chiefly known for his large historical canvases.

Raeburn, Sir Henry 1756–1823
Scottish portrait painter who achieved a status in the Scottish art world similar to that of Reynolds in England.

Ramsay, Allan 1713–84
Scottish painter, active mainly in London, one of the most sensitive portraitists in the history of British art. In the 1750s and early 1760s he was a rival to Reynolds, particularly in portraits of women.

Raphael (Raffaello Sanzio) 1483–1520
Italian painter and architect, in whose works are found the most complete embodiment of the ideals of the High Renaissance. For three centuries after his death he was almost universally regarded as the greatest of all painters.

Ravilious, Eric 1903–42
English painter, graphic artist and designer. He was one of the most versatile artists of his period, and his bold, almost poster-like style is highly distinctive. An official war artist in World War II, he was reported missing when on a flying patrol off Iceland.

Rembrandt Harmensz, van Rijn 1606–69
Dutch painter, etcher and draughtsman, one of the supreme geniuses in the history of art. He was extraordinarily versatile, but his greatness comes out most forcibly in his portraits (including an incomparable series of self-portraits) and his religious works.

Reni, Guido 1575–1642
Bolognese painter. His pure classical style brought him immense fame, and in the 18thC he was considered by many critics to be second only to Raphael.

Renoir, Pierre Auguste 1841–1919
French Impressionist painter. His sensuous appreciation of colour and light, his ample glowing nudes, and the charm and poetry of his works have made him one of the best-loved artists of the 19thC.

Ribera, Jusepe (José) **de** (called Lo Spagnoletto) 1591–1652
Spanish painter, draughtsman and etcher, all of whose career was spent in Italy, particularly Naples.

Ricci, Sabastiano 1659–1734
Italian late Baroque painter of religious, historical and mythological subjects. He worked in several European countries, including England, as well as various Italian cities. His nephew **Marco Ricci** (1676–1730) was a landscape painter and often collaborated with his uncle. He also worked in England.

Riley, John 1646–91
English portrait painter, appointed Principal Painter to William and Mary jointly with Kneller in 1688.

Roberts, William 1895–1980
English painter. He was a member of the Vorticist group and after World War I applied a geometric style to scenes of everyday life.

Rodin, Auguste 1840–1917
French sculptor. Single-handedly he brought sculpture back to the mainstream of art after it had occupied a secondary position for half a century.

Romney, George 1734–1802
English painter, mainly of portraits, active in the north of England until 1762, then mainly in London.

*Romney, Self-portrait, 1782,
London, NPG*

Rosa, Salvator 1615–73
Neapolitan painter and etcher, best known for the creation of a new type of wild, rugged landscape. He was a poet, actor and musician and one of the prototypes for the Romantic concept of the artist. His work was popular and influential in Britain in the 18thC.

Rossetti, Dante Gabriel 1828–82
English painter and poet, a founder member of the Pre-Raphaelite Brotherhood. The most characteristic of

his later works are paintings of heavy-lidded sensuous women – images that were a potent influence on late 19thC Aestheticism.

Rothenstein, Sir William 1872–1945
English painter. He is best known for his early works – sombre portraits and figure compositions.

Roubiliac, Louis-François c.1705–62
French sculptor who settled in England in the early 1730s. He was the greatest sculptor working in England in the 18thC.

Rowlandson, Thomas 1756–1827
English draughtsman, printmaker and caricaturist, the finest pictorial satirist of his period. His output was enormous.

Rubens, Sir Peter Paul 1577–1640
The greatest Flemish painter of the 17thC and the dominant figure of Baroque art in northern Europe. Charles I of England, who first met him in his capacity as a diplomat, became an important patron.

Ruisdael, Jacob van 1628/9–82
The greatest Dutch landscape painter of the 17thC. He had immense influence in England, notably on Gainsborough and the Norwich school.

Ruysdael, Salomon van c.1600–70
Dutch landscape painter, the uncle of Jacob van Ruisdael (the difference in spelling occurs in their signatures). Like van Goyen (with whom his work has been confused), he was a master of the depiction of atmosphere through subtle muted colours.

Rysbrack, John Michael 1694–1770
Flemish-born sculptor who settled in England in about 1720. He was the undoubted head of his profession until Roubiliac and Scheemakers began to overtake him in popularity in the 1740s.

Sandby, Paul 1725–1809
English topographical watercolour painter and etcher. He was one of the first artists to achieve real distinction and a large output as a watercolour specialist. His brother **Thomas** (1721–98) was also an accomplished watercolourist.

Sargent, John Singer 1856–1925
American painter, based in London for most of his career. He was the most celebrated society portraitist of his time and immensely successful. His other work includes murals, landscape watercolours and paintings done as an official war artist in World War I.

Scheemakers, Peter 1691–1781
Flemish sculptor active mainly in England. Tomb sculpture accounted for the bulk of his large output. His brother **Henry** (d.1748) and his son **Thomas** (1740–1808) were also sculptors.

Scott, William Bell 1811–90
Scottish painter, poet, book illustrator
and writer on art, active mainly in
London and in Newcastle upon Tyne,
where he was head of the Government
School of Design. His father **Robert**
(1777–1841) was an engraver and his
brother **David** (1806–49) was a history
painter and book illustrator.
Seurat, Georges 1859–91
French painter, the instigator and the
most important practitioner of Neo-
Impressionism (or Pointillism).
Sickert, Walter Richard 1860–1942
English painter, born in Munich of
Danish parents. He was a pupil of
Whistler and knew Degas well, and he
played an important role in bringing
French influence to English art. After
settling in London in 1905, his studio
became a focus for many younger
painters, including those who were to
form the Camden Town group.
Sisley, Alfred 1839–99
French-born Impressionist painter of
English parentage.
Smith, Sir Matthew 1879–1959
English painter. He is best known for his
bold, non-naturalistic use of colour.
Spear, Ruskin b. 1911
English painter. He has worked in various
fields, but is best known for his colourful
portraits.
Spencer, Sir Stanley 1891–1959
English painter, one of the most original,
eccentric and distinctive of 20thC British
artists. He is best known for scenes from
the Bible, set in his native village of
Cookham, Berkshire, and vividly painted
with simplified sculptural modelling. His
brother **Gilbert** (1892–1979) was also a
painter.

Stanley Spencer, *Self-portrait, 1913,*
London, Tate Gallery

Stanfield, Clarkson 1793–1867
English painter. one of the finest
seascape painters of his day.
Steen, Jan 1626–79
Dutch genre painter. He was highly
prolific, and his work displays robust good
humour.
Steer, Philip Wilson 1860–1942
English painter. He painted in a personal
version of Impressionism and is best
known for his beach scenes.
Stevens, Alfred 1817–75
English sculptor, painter, decorator and
architectural designer.
Stubbs, George 1724–1806
English animal painter and engraver,
celebrated as the greatest of horse
painters. He was able to convey the
nobility of animals without
sentimentalizing them.
Sutherland, Graham 1903–80
English painter, graphic artist and
designer, whose varied achievements
made him one of the leading figurative
artists of the 20thC. He is well known for
his portraits, landscapes and religious
works, and was an official war artist in
World War II.

Teniers, David the Younger 1610–90
Flemish painter. He painted almost every
kind of picture and was highly prolific,
but he is best known for his peasant
scenes. His father, **David the Elder**
(1582–1649), was also a painter.
Thornhill, Sir James 1675/6–1734
English decorative painter who competed
successfully with visiting foreign artists
during the brief period (c. 1690–c. 1725)
when large-scale decorative painting was
popular in Britain. Hogarth was his pupil
and son-in-law.
Thorvaldsen, Bertel 1770–1844
Danish Neoclassical sculptor, active
mainly in Rome.
Tiepolo, Giambattista 1696–1770
The greatest Italian (and arguably
European) painter of the 18thC and the
last of the great line of fresco decorators.
His output was enormous, and he was a
superb etcher and draughtsman as well as
a painter.
Tijou, Jean a. 1689–1712
Ironmaker of French origin, active in
England. All his known work was
executed in England, including
balustrades at several great country
houses and at St Paul's Cathedral in
London.
Tintoretto, Jacopo (Jacopo Robusti)
1518–94
Venetian painter, with Veronese the
city's leading artist after Titian's death.
He produced a prodigious amount of work
in a bold and dramatic style.

Tissot, James Jacques Joseph
1836–1902
French painter and engraver who settled
in England after the Franco-Prussian War
of 1870. He is best known for his highly
finished society scenes.
Titian (Tiziano Vecellio) d. 1576
The greatest Venetian painter and one of
the most celebrated names in art history.
In every department of painting he
reigned supreme, and he revolutionized
the oil technique, giving it an expressive
life of its own, independent of any
representational function.
Toulouse-Lautrec, Henri de 1864–1901
French painter and graphic artist, an
aristocrat by birth and one of the most
colourful figures in 19thC art. An
accident in childhood left him stunted.
Tuke, Henry Scott 1858–1929
English painter, active mainly in his
native Cornwall. Most of his paintings
reflect his fascination with the sea, but he
is best known for his male nudes.
Turner, Joseph Mallord William
1775–1851
English painter, one of the greatest and
most original of landscape artists. He
began as a painter of conventional
topographical views, but in the course of
a long and productive career he
developed a style of extraordinary
imaginative power, expressed in a
technique of unprecedented freedom and
subtlety.

Uccello, Paolo 1396/7–1475
Florentine painter. His virtuoso skill with
perspective places him in the scientific
current of the Renaissance, but his love
of decorative display is typical of
International Gothic.

Van Dyck, Sir Anthony 1599–1641
With Rubens the most important 17thC
Flemish painter. From 1632 he worked
mainly in England as court painter to
Charles I. The elegance and refinement
with which he invested his sitters became
the model for society portraitists until the
time of Sargent.
Van Gogh, Vincent 1853–90
Dutch painter, one of the greatest and
most influential artists of the 19thC. The
emotional intensity of his work, his
integrity as an artist, and his battles with
poverty and mental instability, have made him
one of the great cultural heroes of modern
times.
Varley, John 1778–1843
English watercolour landscapist. As well
as being a fine painter, he was an
important teacher and published several

books on landscape painting. His brother
Cornelius (1781–1873) was also a
watercolourist.
Vasari, Giorgio 1511–74
Italian painter, architect and writer. He
is best remembered for his *Lives of the
Most Eminent Painters, Sculptors and
Architects* (1550, revised 1568), the first
great work of art history.
Velde, Willem II van de 1633–1707
The most famous member of a Dutch
family of painters, and perhaps the most
celebrated name in marine painting.
With his father, **William I** (1611–93),
also a marine painter, he settled in
England in 1672 under the patronage of
Charles II. His brother **Adrian**
(1636–72) was a versatile landscape
painter.
Velazquez, Diego Rodriguez de Silva y
1599–1660
One of the greatest Spanish painters.
Almost all his career was spent as court
painter to Philip II, and the prestigious
posts with which he was burdened limited
his output as an artist.
Vermeer, Jan 1632–75
Dutch genre painter. Among Dutch
artists he is now ranked second only to
Rembrandt, but he was almost totally
forgotten for two centuries after his
death. His paintings – quiet, small scale
interior scenes – are images of perfect
serenity, clarity and balance.
Veronese, Paolo (Paolo Caliari)
1528–88
Italian painter, named after his
birthplace Verona, but active mainly in
Venice, where with Tintoretto he was
the leading painter after Titian's death.
Verrio, Antonio 1630–1707
Italian decorative painter, active in
England from 1671.

Wallis, Alfred 1858–1942
English naive painter. A seaman for most
of his life, he taught himself to paint at
the age of 70.
Ward, James 1769–1859
English Romantic painter and engraver,
the brother-in-law of Morland. His finest
and most original works are pictures of
wild animals in dramatic natural settings.
Waterhouse, John William 1849–1917
English painter. He is best known for his
romantic scenes from literature and
myth, which have much in common with
late Pre-Raphaelitism.
Watts, George Frederick 1817–1904
English painter and sculptor. He was one
of the last representatives of the tradition
that attempted to express the loftiest
moral qualities through ideal forms, and
his most characteristic works are often
abstruse allegorical figures.

Watteau, Jean-Antoine 1684–1721
French painter, one of the greatest of
Rococo artists.
West, Benjamin 1738–1820
American painter, active mainly in
England, where his successful career was
crowned (1792) with the Presidency of
the Royal Academy. He is best known for
his history paintings.
Westmacott, Sir Richard 1775–1856
English Neoclassical sculptor, after
Chantrey the most successful sculptor of
his period. His father **Richard**
(1747–1808) and his son, another
Richard (1779–1872), were also
sculptors.
Weyden, Rogier van der
1399/1400–1464
Netherlandish painter, one of the
greatest and most influential artists of the
mid-15thC. He is best known for
religious works, but he was also a superb
portraitist.
Whistler, James Abbot McNeil
1843–1903
American painter and graphic artist,
working principally in England. A dandy
with an acerbic wit and a gift for
showmanship, he was one of the leading
figures of Aestheticism.

J.A.M. Whistler, *Self-portrait, 1867,*
Detroit Institute of Arts

Whistler, Rex 1905–44
English painter and illustrator. He is best
known for his commercial work and
illustration. His brother **Lawrence**
(b.1912) is a celebrated glass engraver.
Wilkie, Sir David 1785–1841
Scottish history painter mainly active in
London. He achieved great success with
his small-scale humorous and anecdotal
subjects in the manner of 17thC
Netherlandish artists.
Wilson, Richard 1713–82
Welsh painter, the outstanding British

landscape specialist of the 18thC. He
produced Claudean landscapes reflecting
his stay in Italy (1750–57), but his finest
and most original paintings are ones in
which he applied the principles of
classical composition to the landscape of
England and Wales.
Winterhalter, Franz Xaver 1805–73
German painter and lithographer, based
in Paris for most of his career.
Wood, Christopher 1901–30
English painter. His paintings often have
a distinctive vein of lyric fantasy.
Woolner, Thomas 1825–92
English sculptor, painter and poet, the
only sculptor member of the original Pre-
Raphaelite Brotherhood. He is best
known for his portrait busts.
Wootton, John c.1682–1764
English sporting painter, the first artist to
obtain real distinction in the field.
Wright, John Michael 1617–94
English painter, mainly of portraits. He
travelled in Italy and was the only 17thC
British artist to be a member of the
Academy of St Luke in Rome.
Wright, Joseph 1734–97
English painter of portraits, scientific,
industrial and literary subjects and
landscapes, active mainly in his native
Derby, from which he takes his nickname
"Wright of Derby". The most remarkable
feature of his work is his fascination with
light effects.
Wyatt, James 1746–1813
English architect, a pioneer of the neo-
Gothic.
Wyatville, Sir Jeffrey (1766–1840)
Architect nephew of James Wyatt, who
practised with him and whose surname he
amended.

Yeats, Jack Butler 1871–1957
Irish painter and illustrator, brother of
the poet W.B. Yeats. He painted
prolifically in a highly personal style.

Zoffany, Johann 1734/5–1810
German-born artist, active mainly in
England. He made his name as a painter
of theatrical pictures, then raised the
conversation piece to new heights.
Zuccarelli, Francesco 1702–88
Italian landscape and mythology painter
who worked successfully in England.
Zucchi, Antonio 1741–1807
Italian decorative painter, active in
England from 1776–81. Like his wife
Angelica Kauffmann, he was often used
by Robert Adam to decorate his interiors.
Zurbarán, Francisco 1598–1665
Spanish painter, mainly of religious
works. His style combined severe and
sombre realism with spiritual intensity.

GLOSSARY

A

abstract art
Art that does not attempt to represent the appearance of objects, real or imaginary, although it may conjure up images for the viewer.

Aestheticism
Tenet which holds that the beauty of an art object is its own justification, that there is no need for a social or moral purpose – "art for art's sake". Aestheticism was at its peak in the late 19thC, and is often associated with affectation and foppishness, but was also a powerful factor in the work of important artists such as Whistler.

aisle
Lateral division of a church, flanking the nave or chancel on one or both sides.

altarpiece
Picture, screen or decorated wall standing on or behind an altar.

alabaster
Soft, semi-transparent stone (a form of gypsum), extensively used in sculpture in the later Middle Ages. Its most notable use was in small retables, which were made in great number in England (the industry was centered on Nottingham), many of them for export.

anamorphosis
Painting or drawing of an object distorted in such a way that the image becomes lifelike only when seen from a particular angle and by means of a special lens or mirror.

architrave
The lowest part of an entablature; also, more loosely, the moulded frame around a door or window.

Art Deco
The most fashionable style in interior decoration and design in the period between the two world wars (1918–39). It was characterized by the use of geometrical shapes and stylized natural forms, paying more heed to the demands of mechanized production than Art Nouveau, with less interest in craftsmanship.

Art Nouveau
Decorative style that influenced all areas of design in the 1890s and was popular until World War I. It was characterized by the use of asymmetrical sinuous lines based on plant forms.

Arts and Crafts movement
Decorative arts movement in Britain in the second half of the 19thC, the name deriving from the Arts and Crafts Exhibition Society founded in 1888. The intention was to reassert the worth of the handmade individual object in the face of increasing industrialization and mass-production. William Morris was its leading apostle.

B

Baroque
Term broadly characterizing Western art produced from the beginning of the 17thC to the mid 18thC, or, more precisely, applied to the most dominant stylistic trend within that period. Its salient qualities are dynamic movement, overt emotion and self-confident rhetoric. The Baroque, which originated in Italy, is closely associated with the Catholic church and never fully took root in Britain.

Bloomsbury group
Group of writers, thinkers and artists who were highly influential in British cultural and intellectual life from about 1910 to the early 1930s. Of those attached to the art world, the most significant were the painters Vanessa Bell and Duncan Grant and the critics Roger Fry and Clive Bell.

C

Camden Town group
Group of British artists, founded by Bevan, Gilman, Ginner and Gore, that held its first exhibition in 1911. They applied a style derived from Post-Impressionist painters, particularly Gauguin, to scenes of working-class life.

capital
The topmost part of a column or pilaster, often elaborately carved.

Capriccio
Term (from the Italian for caprice) used to describe imaginary compositions partly based on real scenes.

cartoon
A full-scale drawing, the outlines of which could be transferred to establish the design of a painting, or tapestry, stained glass window etc.

caryatid
In architecture and decorative sculpture, a female figure that acts as a pillar, supporting an architectural feature.

cassone
A large chest, either given as a wedding present or used to contain a bride's dowry. *Cassoni* were usually richly decorated, and painted panels from them are now often found as separate pictures.

chancel
Part of a church reserved for clergy and containing the altar and choir; or, more generally, the whole of the church E of

the nave.

Chiaroscuro
Term, from the Italian for "bright-dark", used to describe light and shade effects in painting.

Chinoiserie
Style of interior decoration and design using Chinese (or pseudo-Chinese) motifs, particularly popular in the Rococo period.

choir
Part of a church where services are sung, generally in the W part of the chancel.

Classicism
Term used to describe the qualities of order, clarity and harmony associated with the art of ancient Greece and Rome. In its broadest sense, the term is used as the antithesis of Romanticism, denoting art that places adherence to accepted canons of beauty above personal inspiration.

conversation piece
Informal group portrait, often showing members of a family in their domestic surroundings. Such paintings were particularly popular in 18thC Britain.

corbel
A bracket or block projecting from a wall to support a roof beam, vault or other feature. Corbels are often carved.

crypt
A room beneath the main floor of a church (but not necessarily underground) often used as a burial chamber or as a repository for relics.

Decorated
Term applied to the middle period of English Gothic architecture (between Early English and Perpendicular), lasting from the mid-13thC to the second half of the 14thC. it is so called because window tracery then reached its heights of richness and variety.

diptych
A painting or other work of art consisting of two panels, often hinged together.

Early English
Term applied to the earliest phase of Gothic architecture in England, lasting from the 1170s until the mid 13thC. It is generally simpler and more austere than the Decorated style that succeeded it.

enamel
Smooth, glossy material made by fusing glass to a metal of similar base; also any object made with or decorated by this material.

engraving
Term referring both to the process of cutting a design into metal or wood and to the print taken from a plate or block so cut.

entablature
In classical architecture, the arrangement of three horizontal bands (architrave, frieze and cornice) that rests on the columns.

etching
Term describing the process of biting out a design in a metal plate with acid, and also the print that results. The plate is coated with acid-resistant wax, in which the design is drawn with a needle. When the plate is immersed in acid, only the parts exposed by the needle are attacked by the acid, so the design is transferred to the plate. Etching allows greater spontaneity than other engraving processes, as the needle can be handled almost as freely as a pen.

Euston Road school
School of painting and drawing opened in London's Euston Road in 1937 by Coldstream and Pasmore. Influenced by Sickert and the Camden Town group, they stressed the value of an objective approach to reality in opposition to the current trends of Abstraction and Surrealism. The school closed in 1930.

figurative art
Art that represents recognizable subjects – the opposite of abstract art.

fresco
Method of wall painting using water-based paint applied to wet plaster. Because fresco deteriorates in damp conditions, it has been much less practised in Britain than in Mediterranean countries.

frieze
Part of the entablature between the architrave and the cornice; also, a similar decorative band along the upper part of an internal wall.

genre
Term used to describe paintings of everyday life.

Gothic
Style of art and architecture prevailing in Europe from the mid 12thC to the 16thC. It is characterized chiefly in terms

of architecture, above all by the use of pointed arches. Gothic survived in some parts of Britain into the 17thC, was revived in the spirit of Rococo in the 18thC (the term "Gothic" is sometimes applied to this stage), and taken up with archaeological earnestness in the 19thC, when it was used for public and domestic buildings as well as churches.

Grand Tour
Extended tour of Continental Europe, undertaken by young aristocrats, particularly British, during the 18thC. The main purpose was to complete a broad education by viewing at first hand the Classical glories of Italy and the "Sublime" landscape of the Alps.

grisaille
Painting executed entirely in tones of grey or neutral greyish colours.

History painting
Painting depicting scenes from history, real or imaginary. As well as representations of historical events, the term includes ancient myths, religious legends, and scenes from great literature, such as Dante's and Shakespeare's works. Modern history works with figures in contemporary dress date from the 18thC.

illumination
Decoration of manuscripts (and some early printed books) with ornamental letters, borders and miniature paintings. Gouache and tempera were the usual media used for illumination.

Illusionism
The use of pictorial techniques to create a deceptively convincing sensation of real space and form on a two-dimensional surface.

impasto
Thickly applied paint that creates a textured surface.

Impressionism
Late 19thC movement in painting, originating in France, which sought to produce a spontaneous impression of a scene or object rather than a calculated, detailed portrayal.

International Gothic
Style of painting and sculpture that flourished from the late 14thC to early 15thC in most of Europe. Essentially a courtly style, it was characterized by elegance, refinement and a development of interest in secular subjects.

Lady Chapel
A chapel dedicated to the Virgin Mary; it is usually at the E end of a church, forming an extension of the chancel or an aisle.

lithograph
Print produced from a design drawn or painted onto a limestone block or metal plate.

lunette
A semi-circular window or, more generally, any flat semi-circular panel.

Mannerism
The dominant style in European art from about 1520 to the end of the 16thC. It was characterized by hypersophistication and self-consciousness, often with emotional overtones, marking a reaction from the serene harmony of the High Renaissance.

mezzotint
Engraving process producing soft tonal areas rather than lines.

misericord
A bracket (often elaborately carved) projecting from the underside of the hinged seat of a church choir stall, to provide support for clergy during long services (*misericordia* means "compassion" in Latin).

naive art
Painting in a childlike or untrained fashion, characterized by a careful, descriptive style, non-scientific perspective and simple bright colours.

Neoclassicism
Movement dominating European art and architecture in the late 18thC and early 19thC. It was marked by an heroic severity of tone – a reaction against Rococo frivolity – and by the use of archaeologically correct detail.

New English Art Club
Artist's club founded in London in 1886 to exhibit paintings reflecting some degree of French influence. The club, which exhibited twice a year and attracted a wide range of artists, became associated with English Impressionism and was seen to challenge the traditions of the Royal Academy. Its importance declined after World War I.

Newlyn school
Group of painters who worked in and around the fishing village of Newlyn in Cornwall in the last two decades of the 19thC. Their style was strongly influenced by French outdoor painting.

Norwich school
Regional school of British painters, established in Norwich by "Old" Crome in 1803. It held annual exhibitions from 1805–25, with Crome and Cotman as its principal contributors. The Norwich school painters depicted the Norfolk countryside in a manner reminiscent of 17thC Dutch artists such as Hobbema.

Omega Workshop
Company formed in 1913 by Roger Fry to provide regular employment for young painters in the decorative arts. Never a financial success, the workshops were closed in 1919.

Op Art
Type of Abstract art that exploits the optical effects of pattern.

Palladianism
Style of architecture derived from the buildings and publications of the 16thC Italian architect Andrea Palladio, particularly applied to British architecture in the period c.1715–50. Palladian architecture, which in Britain and Ireland was used mainly for country houses, is characterized by symmetry, regularity and correctness of detail. Adherence to its principles produced some superb and refined architecture, but also much that was repetitive and dull.

pediment
A low-pitched triangular gable above an entablature; a similar triangular or segmented feature over a window, doorway or other architectural feature.

Perpendicular
Term applied to the final phase of English Gothic architecture, originating in about 1330, flourishing into the 16thC, and surviving into the 17thC in some places. It is so called because of the prominence of vertical lines in the window tracery.

Photorealism
Style of painting or sculpture, popular from the 1960s, in which the subject matter, usually banal, static and contemporary, is reproduced with minute exactitude, a high finish and a smooth, bland surface. Superrealism is an alternative name for the same style.

Picturesque
Term that became popular in Britain in the 18thC to describe an aesthetic approach that took pleasure in roughness and irregularity of form. It was applied particularly to rustic landscapes and crumbling buildings. A large body of literature grew up around the concept, which had great influence on landscape painting, architecture and gardening.

Pietà
Representation of the Virgin supporting the dead Christ on her lap; the word is Italian for "pity".

plein-air
Term (French for "open-air") used to describe paintings that have been executed outside rather than in a studio.

polyptych
A painting or other work of art consisting of four or more panels or sections, often hinged together.

Pop art
Artistic movement celebrating the imagery and techniques of the mass media, advertising and popular culture. It arose in Britain and the USA in the 1950s.

Post-Impressionism
General term describing the various movements in painting, particularly in France, that developed out of Impressionism or reacted against it in the period from about 1880 to about 1905. The term was coined by Roger Fry for his important exhibition *Manet and the Post-Impressionists*, held at the Grafton Galleries, London, in 1910.

predella
One or more small panels fixed to the bottom of an altarpiece. The scenes shown generally relate to the main scene depicted above.

Pre-Raphaelite Brotherhood
Small but influential group of English painters, formed in 1848 and so named because they wanted to recapture the simplicity and moral content of painting before Raphael. They sought to combat what they considered the sterile English academic tradition and the prevalence of trivial genre painting. The group had virtually disbanded by 1853, but there was a second wave of Pre-Raphaelitism in the 1860s and after, marked by a preference for pseudo-medieval subjects and languorous female beauties.

Realism
Term used is a general sense to describe unidealized and objective representation,

and more specifically to a movement in mid 19thC art, particularly in France. Realist painters rebelled against the idealized subjects of mythological and historical paintings and turned to contemporary themes.

relief
Sculpture that projects from, but is still attached to, a background. It is usually classified as high, medium or low relief according to how far it projects.

Renaissance
Intellectual and artistic movement inspired by a rediscovery and reinterpretation of Classical culture; it originated in 14thC Italy and became the driving force behind the arts throughout most of Europe. The early 16thC in Italy is known as the High Renaissance, when the works of the three giants – Leonardo, Michelangelo and Raphael – reached a peak of harmony and balance. In Britain, Renaissance influence was hardly felt before 1500, and in the 16thC was expressed mainly in decoration. Inigo Jones, in the 17thC, was the first British artist whose work expresses a full understanding of Renaissance ideals.

reredos
An altarpiece that rises from ground level behind the altar.

retable
An altarpiece that stands on the back of the altar or on a pedestal behind it.

Rococo
The style, characterized by intimacy of scale, asymmetry, lightheartedness and grace, that in the early 18thC superseded the more formal grandeur of the Baroque.

Romanesque
Style of art and architecture prevailing in Europe in the 11thC and 12thC. Romanesque is characterized chiefly in terms of its architecture, which is massive and round arched. The term "Norman" is often applied to English Romanesque architecture, as the style quickly became dominant after the Norman Conquest.

Romanticism
Artistic and literary movement that flourished in Europe from the late 18thC to the mid 19thC. Romantic art is characterized by the importance attached to the expression of the artist's personal feelings.

rood screen
Screen separating the chancel from the rest of the church, so-called because it would originally have been surmounted by a rood (crucifix).

Royal Academy of Arts
The leading British art institution from its foundation in 1768 (with Reynolds as the first president) until the late 19thC. By the late 19thC it was increasingly considered academic and reactionary.

S

sarcophagus
A stone coffin or chest-shaped tomb, often decorated with sculpture.

Sheila-na-gig
Female fertility symbol with exaggerated and lewdly displayed genitals, found particularly in churches in Ireland, but also elsewhere in Britain and Continental Europe.

spandrel
The triangular surface or area between two arches or between an arch and a wall.

stucco
Light, malleable plaster reinforced with powdered marble, used for architectural decoration and for sculpture.

Surrealism
Movement in art and literature, at its peak in the 1920s and 1930s, that used incongruous juxtapositions of images in an effort to explore the subconscious.

T

tondo
A circular painting or sculpture; the word is Italian for "round".

tracery
Intersecting ornament used in architecture or decorative work, particularly in Gothic windows.

transept
Either of the two projecting arms of a cross-shaped church.

triptych
A painting or other work of art consisting of three panels or sections, often hinged together.

trompe l'oeil
Term (French for "deceive the eye") used to describe the application of illusionistic skill to persuade the spectator that a painted object is a real one.

tympanum
The space between the flat top of a doorway and the arch above it.

V

vault
An arched roof or ceiling.

Vorticism
Short-lived British avant-garde art movement, at its peak in 1914–15. Vorticist artists, the foremost of whom was Wyndham Lewis, worked in a harsh mechanistic, sometimes semi-abstract style.

INDEX

ACKNOWLEDGMENTS

Cover: The Tate Gallery, London/John Webb.
7.1: Leighton House. 7.2: Edwin Smith. 28: The Tate Gallery, London. 29: The National Trust, Petworth/Courtauld Institute of Art. 72: The Tate Gallery, London. 73: Trustees of The National Gallery, London. 75.1: Nigel O'Gorman. 75.2: Nigel O'Gorman. 76.1: Nigel O'Gorman. 76.2: Nigel O'Gorman. 77.1: Nigel O'Gorman. 77.2: The Henry Moore Foundation/John Gay. 87.1: J. Allan Cash. 87.2: J. Allan Cash. 97.1: Irmgard Pozorski. 97.2: Clive Friend/Woodmansterne. 97.3: By courtesy of the Dean and Chapter of Winchester Cathedral. 98.1: Victoria and Albert Museum/Crown Copyright. 98.2: By courtesy of the Trustees, The National Gallery, London. 98.3: Courtauld Institute Galleries, London/Lee Collection. 99.1: Mitchell Beazley/Angelo Hornak. 99.2: By courtesy of the Earl of Pembroke/The Bridgeman Art Library. 99.3: By courtesy of His Grace the Duke of Buccleuch/Pilgrim Press Ltd. 100.1: National Gallery of Ireland, Dublin. 100.2: Walker Art Gallery, Liverpool. 100.3: By courtesy of the Trustees, The National Gallery, London. 101.1: National Museum of Wales, Cardiff. 101.2: The Greater London Council as Trustees of the Iveagh Bequest, Kenwood. 101.3: Goodwood House by courtesy of the Trustees. 102.1: National Gallery of Ireland, Dublin. 102.2: By courtesy of His Grace the Duke of Atholl/Pilgrim Press Ltd. 102.3: National Museum of Wales, Cardiff. 103.1: Derby Art Gallery. 103.2: Walker Art Gallery, Liverpool. 103.3: The Tate Gallery, London. 104.1: The National Trust/The Bridgeman Art Library. 104.2: National Galleries of Scotland, Edinburgh. 104.3: Sudeley Castle. 105.1: Norfolk Museums Service (Norwich Castle Museum). 105.2: Castle Museum, Nottingham. 105.3: Ipswich Museums and Galleries. 106.1: Southampton Art Gallery. 106.2: Bristol Museum and Art Gallery. 106.3: Aberdeen Art Gallery and Museums. 107.1: By permission of the Syndics of the Fitzwilliam Museum, Cambridge. 107.2: Tyne and Wear County Council Museums 107.3: Torbay Borough Council, Torquay. 108.1: Hunterian Art Gallery, University of Glasgow. 108.2: Ulster Museum, Belfast. 108.3: National Galleries of Scotland, Edinburgh. 109.1: By permission of the Syndics of the Fitzwilliam Museum, Cambridge. 109.2: Leicestershire Museums, Art Galleries and Records Service. 109.3: National Museum of Wales, Cardiff. 110.1: Irmgard Pozorski. 110.2: Irmgard Pozorski. 110.3: Irmgard Pozorski. 111.1: The National Trust. 111.2: Bristol Museum and Art Gallery. 111.3: Imperial War Museum. 112.1: Sainsbury Centre for Visual Arts, University of East Anglia, Norwich. 112.2: The Henry Moore Foundation/Irmgard Pozorski. 112.3: © David Hockney 1975. 127: The Campden Trust. 160: Bradford Art Galleries and Museum. 161: Ironbridge Gorge Museum. 171: The British Museum/Fotomas Index. 198: Victoria & Albert Museum. 199: Royal Academy of Arts, London. 241.1: Hunterian Art Gallery, University of Glasgow. 241.2: Glasgow School of Art. 241.3: Hunterian Art Gallery, University of Glasgow. 268.1: Irmgard Pozorski. 268.2: Courtauld Institute of Art. 269.1: Trinity College Dublin/Weidenfeld Archive. 269.2: Trinity College Dublin/Weidenfeld Archive. 277: National Portrait Gallery. 278: National Portrait Gallery. 281: National Portrait Gallery. 283: The Royal Academy. 284: National Portrait Gallery. 287: National Portrait Gallery. 288: National Portrait Gallery. 290: Detroit Institute of Arts.